張大千回顧展

辛未冬 夫約傅申

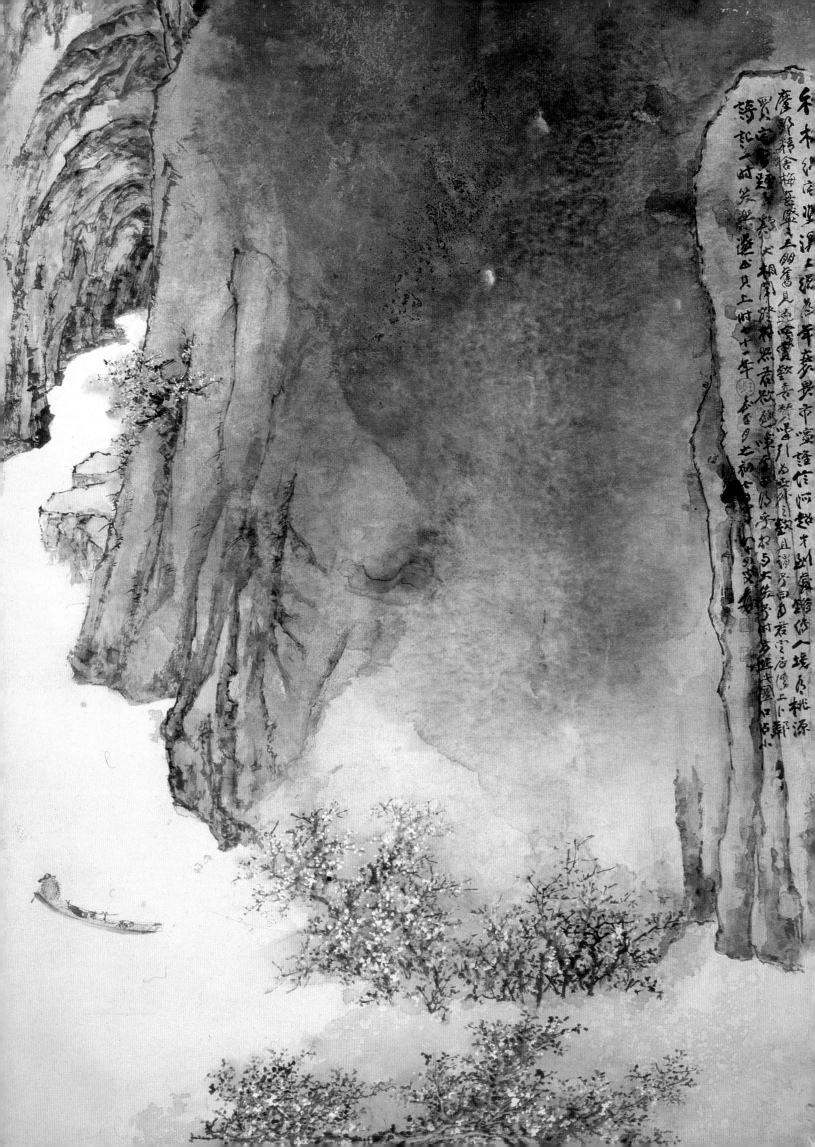

Challenging the Past

THE PAINTINGS OF

Chang Dai-chien

Shen C. Y. Fu

with major contributions and translated by
Jan Stuart

selected poems and inscriptions translated by
Stephen D. Allee

Arthur M. Sackler Gallery
Smithsonian Institution, Washington, D. C.

in association with
University of Washington Press
Seattle and London

Printed in Italy.
Cover: *Crimson Lotuses on Gold Screen* (entry 80), 1975; collection of Yon Fan, Hong Kong.
Frontispiece: *Peach Blossom Spring* (entry 85), 1983; collection of Cemac, Ltd., Edmonton, Alberta

Photo credits
Roy Shigley, San Francisco: figs. 1, 54; Yan Weicong: figs. 3, 9; Dafeng Tang Archive: figs. 4, 6–8, 15, 19, 20, 25, 29, 33, 34, 37, 40, 41, 46–49, 51–53, 58–60, 69, 75, 81, 84; James C. M. and Lucy L. Lo, Princeton, New Jersey: figs. 5, 112; Freer Gallery of Art, Smithsonian Institution, Washington, D.C.: figs. 10, 23, 63, 87, 89, 105; Dr. Dzung Kyi Ung, Hong Kong: fig. 12; Yue Shuren: fig. 13; Liaoning Provincial Museum, Shenyang: fig. 21; Yon Fan, Hong Kong: fig. 30 and entries 9, 13, 14, 17, 19, 27, 30, 31, 40, 60, 66, 80, 82, 84; Gao Lingmei, Hong Kong: fig. 31; Mr. and Mrs. W. B. Fountain, Piedmont, California: figs. 45, 110; © 1991 ARS N.Y. / SPADEM: fig. 61; The Metropolitan Museum of Art, New York: fig. 80 and entries 1, 6, 11; C. C. Wang, New York: fig. 97; Wang Fangyu and Sum Wai, Short Hills, New Jersey: fig. 98; Shen C. Y. Fu: fig. 102; Arthur M. Sackler Gallery, Smithsonian Institution, Washington, D.C.: figs. 107, 108, 113 and entries 2–4, 10, 18, 28, 33–36, 38, 45, 49, 50, 52, 57–59, 61, 63, 65, 67, 69, 75, 77, 85; Photographed by Steve Williams, New York: entries 5, 20, 29, 48, 53; Chung Kit Fok, Vancouver: entries 7, 81, 86; National Museum of History, Taipei: entries 8, 15, 22, 24, 25, 32, 37, 39, 41, 43, 44, 47, 51, 55, 56, 62, 64, 68, 70–74, 76, 78, 83, 87; Musée Cernuschi, Paris, photographs by Hubert Josse: entries 23, 54; Honolulu Academy of Arts, Hawaii: entry 12; The British Museum, London: entry 42; Yale University Art Gallery: entry 16; Jung Ying Tsao, San Francisco: entry 21; Chun-Hsien and Meng-Hua Chiang, Taipei: entries 26, 79; Chuang Ling, Taipei: entry 46.

Library of Congress Cataloging-in-Publication Data

Fu. Shen. 1937–
Challenging the past : the paintings of Chang Dai-chien / by Shen C.Y. Fu : with major contributions and translated by Jan Stuart : selected poems and inscriptions translated by Stephen D. Allee.
 p. cm.
 Catalog of an exhibition held at the Arthur M. Sackler Gallery, Nov. 24, 1991–Apr. 5, 1992, and at the Asia Society and the St. Louis Art Museum.
 Includes bibliographical references (p.) and index.
 ISBN 0-295-97124-X (cloth : alk. paper).—ISBN 0-295-97125-8 (paper : alk. paper)
 1. Chang, Ta-ch'ien, 1899– –Exhibitions, 2. Chang, Ta-ch'ien, 1899– –Criticism and interpretation. I. Chang, Ta-ch'ien, 1899–
 II. Stuart, Jan. 1955– . III. Arthur M. Sackler Gallery (Smithsonian Institution) IV. Asia Society. V. St. Louis Art Museum. VI. Title.
ND1049.CA4523A4 1991
759.951–dc20 91-16474
 CIP

Contents

Foreword

FEW ARTISTS have led as colorful a life as Chang Dai-chien, nor have many provoked such an abundance of questions about the nature of the artistic process. Chang Dai-chien was not a man of moderation in either his art or his personal life. He traveled not only to the deserts and mountains of China but also to scenic points around the world. He married four women and fathered sixteen children. He built elaborate gardens in many of the places he lived: China, Brazil, the United States, and Taiwan. And he created some thirty thousand paintings—original works, as well as works in the style of past masters, copies of earlier paintings, and forgeries.

In many ways, Chang Dai-chien can be considered the last of the Chinese scholar-connoisseur artists known as literati. He had affected the dress and appearance of a literatus when he was twenty, and he looked much the same at the end of his life. It was a rather self-conscious pose, however, and it accompanied a lifestyle of continual travel, good food, and well-furnished houses in exotic locations that today we might associate with public celebrities.

Chang Dai-chien's paintings were nonetheless deeply rooted in Chinese traditions, and familiarity with the history of Chinese art since the fifth century enriches our reactions to his work. All of his paintings refer in some way to the past. Even the great splashed-ink-and-color images that are so immediately impressive to twentieth-century viewers, and so completely contemporary, are related to the splashed-ink images of eighth-century Chinese artists. They also evoke, however, twentieth-century American action paintings; this ability to join the ancient and the contemporary, or the Asian and the European or American, makes the artist particularly interesting.

Chang Dai-chien learned from the past by copying works of Chinese master artists, eventually acquiring many of these works for his extraordinary Dafeng Tang collection. His ability to understand and re-create works by the greatest artists led to a subsidiary career as a forger—an activity looked upon differently in China than in Europe or the United States. In China, Chang's success at forgery enhanced his career; there, it was thought that only a great artist could successfully imitate the works of other great artists. And, after all, such imitation was a goal of early artistic training. Examining Chang's career therefore forces us to acknowledge that definitions of creativity and artistic originality vary in different cultures.

The Arthur M. Sackler Gallery is delighted to present this survey of the paintings of Chang Dai-chien. It is the result of several years of work and travel by its curators and organizers, Dr. Shen C. Y. Fu and Jan Stuart. The Gallery is grateful as well to the Scholarly Studies Program of the Smithsonian Institution for the support of these research activities. Without the substantial contributions of the Smithsonian Special Exhibition Fund and the National Museum of History, Taipei, this project could not have happened. The Gallery also welcomes the participation of the Asia Society and the Saint Louis Art Museum in offering the works of Chang Dai-chien to a wider audience.

MILO CLEVELAND BEACH
Director
Arthur M. Sackler Gallery and Freer Gallery of Art

Preface

BEFORE THE modern artist Chang Dai-chien caught my interest, my research focused almost entirely on ancient Chinese painting and calligraphy. Naturally, when I was teaching art history, I began in the usual way with remote antiquity. The fragility of paper and silk has meant that few authentic examples of early painting and calligraphy have survived, and since documentary evidence from ancient times is often suspect as well, my students found it understandably difficult to relate to all the speculation involved in studying ancient art. Since that time, I have always thought that in future classes I would reverse the chronology. By beginning with modern art, I could present authentic works and capitalize on my student's enthusiasm for the art of their own time. Gradually I would be able to trace the history of painting back to its origins.

The more distant an artist is in time, the less likely that original works by that artist still survive. Since contemporary, or near contemporary, criticism of an artist's style and methods may be the only documentation a historian has to reconstruct the art of an ancient painter or calligrapher, I believe that art historians today have a responsibility to collect, organize, and evaluate materials relating to the artists of our times. The scholar who studies and evaluates contemporary painting and calligraphy is preparing a foundation for future colleagues, and it is in this spirit that I have chosen to study Chang Dai-chien.

Most people agree that Chang Dai-chien possessed the broadest range and command of styles and techniques of any Chinese artist in history. Although not all art historians consider him the premier painter of his generation, in his best works, Chang interwove elements from disparate models, achieving a grand synthesis that even his most critical detractors admire. Chang is also well known as a master forger. Since his forgeries are part of numerous museum and private

collections, learning to detect Chang's brilliant imitations is a continual challenge to all students, scholars, and connoisseurs of Chinese painting, whether their primary interest is ancient or modern art.

Challenging the Past: The Paintings of Chang Dai-chien introduces the major events that shaped Chang's career, and it presents discussions on eighty-seven works that are featured in the exhibition organized by the Arthur M. Sackler Gallery. Within the limitations of time and space, this book and exhibition attempt a general overview of Chang Dai-chien's art. However, since the complexity of Chang's career clearly necessitates additional and more sophisticated study, I will undoubtedly continue writing in the future about various aspects of his life and art. Without question Chang Dai-chien is the most inexhaustible artist I have ever encountered.

Any major retrospective exhibition and related book must suffer certain limitations. The amount of available floor space in a museum is one type of constraint, as is the cooperation one receives from potential lenders, whether private or institutional. The current market value of Chang Dai-chien's art, for example, means that his paintings change hands quickly. Often I would contact a collector to find that the piece I wanted had already been resold, and sometimes I would track down the new owner only to be disappointed by an individual who did not want to lend.

Within these limitations, I have tried to select paintings that represent the full range of Chang's diverse career and highlight the development of his individual style. Great masterpieces and minor works are each important for demonstrating different stages in Chang's stylistic evolution, so both are present in this volume. However, since Chang Dai-chien successfully essayed virtually every genre and style of traditional Chinese painting and copied all the major masters, I have had to restrict myself to works that illustrate only the most salient

aspects of his career.

Scholars of ancient Chinese art expect copies, imitations, and dubious attributions as part of an artist's corpus. Few, however, hold the same expectation for a twentieth-century artist. As early as 1938, one of Chang Dai-chien's students forged one hundred paintings, signed them with his teacher's name, and sold them in Shanghai. Such forgeries of Chang's work were gradually dispersed throughout China, so that after some fifty years, forgeries by students and followers of his are still a challenge to detect. Recently, as the value of Chang Dai-chien's art has increased, forgeries of his original works have become more common and again offer a critical test for scholars and connoisseurs.

Chang Dai-chien is an important modern calligrapher as well as painter, but to study Chang's calligraphy properly would require an entire book in itself; consequently, I have not analyzed that aspect of his career in this volume. Chang was also a poet and, although the inscriptions on the paintings have been translated for this book, I have not attempted a systematic survey or analysis of his literary talent.

Chang Dai-chien was an extremely vital and energetic man. During his long life, his affable and loquacious nature led him to show off for friends and the press alike, thus generating innumerable photographs and newspaper stories, articles, and books about him. Several biographies have been published in Chinese, and Carl Nagin, at Harvard University, has just written a biography in English. Thus, I have only drawn attention to those aspects of Chang's life that most directly affected his painting.

When I was an art student, I deeply admired Chang Dai-chien and was lucky enough to meet him on four occasions between 1967 and 1971. In 1967, at the National Palace Museum, Taipei, I was doing research on the tenth-century painter Juran and discovered several forgeries that Chang had made of Juran's work. I decided at that point to begin an investigation into the career of Chang Dai-chien. As a graduate student at Princeton University in 1970, when I started researching the seventeenth-century painter Shitao, I once again discovered innumerable forgeries by Chang Dai-chien, and my fascination with his career and talents deepened. My only conversation with Chang occurred in late 1971, when I was working at the National Palace Museum. He came to the museum to view ancient paintings that were brought out of storage especially for him, and we discussed the thorny issue of authenticity. Sixteen years later, in 1987, I finally began a systematic and comprehensive study of Chang Dai-chien, which has culminated in part with this book.

Chang Dai-chien painted for some sixty years and was exceptionally prolific; moreover, the remarkable excellence of his work has ensured that his paintings have been collected internationally. The study of Chang Dai-chien has proven to be the most consuming and ambitious project I have ever undertaken.

SHEN C. Y. FU
Senior Curator of Chinese Art
Arthur M. Sackler Gallery and Freer Gallery of Art

Acknowledgments

WHEN THOMAS LAWTON was director of the Arthur M. Sackler Gallery, even before it opened to the public in 1987, he encouraged me to initiate a proposal for a major Chinese art exhibition to be held in the new museum. From among the topics I first suggested, Dr. Lawton was instantly supportive of a retrospective of Chang Dai-chien. When Milo Beach became director of the Sackler in 1988, he also gave me official encouragement for the project, and that encouragement has been steadfast. I wish to thank Dr. Lawton and Dr. Beach for their assistance, which has been instrumental.

I tried to retrace Chang Dai-chien's steps in order to document and understand his career. I am indebted to many institutions and people for their help in this task. I traveled to Argentina, Brazil, Britain, China, France, Germany, Hong Kong, India, Japan, Malaysia, Sweden, and Taiwan. I would like to thank the sources who funded this research: the Committee on Scholarly Communication with the People's Republic of China and the Smithsonian Institution Scholarly Studies Program were both very generous. I would also like to thank the Smithsonian Institution for a grant from the Special Exhibition Fund, which covered many of the logistical costs of the exhibition. In addition, the National Museum of History, Taipei, made a generous contribution to the project. Without these supporters the exhibition would not have come to fruition.

The people and institutions who have assisted me are too numerous to list by name, but I want to especially thank Chang Dai-chien's family and students as well as private collectors, museum directors, and curators, who generously gave of their time. The collectors who have lent their paintings to the exhibition also deserve special mention, especially those who knew Chang and provided me with some insights into his life and art. My deepest appreciation is due to Chang Dai-chien's widow, Chang Hsu Wen-po, and to his son Paul. Friends and students who should be singled out include: Xie Zhiliu, Ye Qianyu, Mi Gengyun, Yan Weicong, and Xu Weida. Yon Fan generously provided many color transparencies for the book.

The directors and curators of the following institutions were most helpful as I conducted my research: The British Museum, London; Chongqing Municipal Museum, Chongqing; Honolulu Academy of Arts, Honolulu; Jilin Provincial Museum, Changchun; Liaoning Provincial Museum, Shenyang; The Metropolitan Museum of Art, New York; Musée Cernuschi, Paris; Musée d'Art Moderne de la Ville de Paris; Museum für Ostasiatische Kunst, Berlin; Museum für Ostasiatische Kunst, Cologne; Museum of Far Eastern Antiquities, Stockholm; Museum of Fine Arts, Boston; National Museum of History, Taipei; National Palace Museum, Taipei; The Palace Museum, Peking; Shanghai Museum, Shanghai; Sichuan Provincial Museum, Chengdu; and Yale University Art Gallery, New Haven.

For assistance with the enormous task of turning my research into a book and producing a large loan exhibition, I invited my colleague Jan Stuart to help. I was delighted that she was subsequently appointed assistant curator of Chinese art at the Freer and Sackler galleries. Jan Stuart undertook translating and editing my Chinese manuscript; of greater importance, however, she made original, scholarly additions that have improved the manuscript. Jan has been the most important collaborator on both the book and the exhibition.

Special thanks also must go to Stephen D. Allee, whose background in Chinese literature prepared him to translate Chang Dai-chien's poetry into English, which he did in a masterful way. Moreover, with rare commitment and finesse, Stephen helped Jan and me with the footnotes and bibliography, checked romanization, and ordered photographs for the

book; he also handled myriad organizational details for the exhibition. Another person who deserves special credit is Hsu Fang-fen, whose keen bibliographic skills and knowledge of calligraphy proved invaluable to this project. I also want to thank Melissa Walt Thompson for her role in organizing the production of the figure illustrations and their captions. Melissa also prepared an excellent index for the book.

Carl Nagin, who is writing the most detailed biography of Chang Dai-chien to appear in English, has been a helpful sounding board and we have exchanged some research materials.

Andrew Pekarik, former director of the Asia Society, New York, provided the inspiration for the title of the book and exhibition.

This book has been immeasurably improved by the participation and unflagging effort of the staff of the Freer and Sackler publications department. I thank Karen Sagstetter as the editor-in-chief. The major burden of editing and organizing this book was undertaken by Mary Kay Zuravleff. Her work deserves the highest praise. She never lost her good humor, even when presented with complicated and rough text. I am indebted to her for the embarrassment she has saved me. I also thank Ann Hofstra Grogg for her thoughtful contribution to the editing, and Rebecca Kingery, whose vital help enabled us to meet our deadlines. For the elegant and lucid design of the book, I wish to thank Carol Beehler. I am also grateful for the assistance of Lily Kecskes, head librarian, and her staff, especially Kathryn Phillips and Reiko Yoshimura, for their support and assistance. Kim Nielsen, former head of the photography department, Jeff Crespi, Jim Hayden, Denise Howell, and Dabney Carr provided superb original photographs and reproductions of existing transparencies.

For the organization and display of the exhibition at the Arthur M. Sackler Gallery, I owe thanks to many individuals. The professional expertise of the registrar's office under the direction of Bruce Young has been invaluable. Rebecca Gregson, associate registrar, admirably orchestrated the complex arrangements for the loans, insurance, and shipping. Rocky Korr, Tim Kirk, and George Rogers undertook the problems of handling the art and installation. Great expertise was offered by the Conservation and Technical Laboratory, especially the East Asian Painting Studio and Gu Xiangmei, who remounted some scrolls, and Jane Norman, who prepared the condition reports.

John Zelenik, head of the design department, Yael Gen, Jeff Baxter, Betsy Chretien, Richard Skinner, Cornell Evans, John Bradley, Francis Smith, Charles Noble, James Horrocks, Kathryn Campbell, and other members of the tremendously talented staff produced this large exhibition without a glitch, showing each work of art to its best advantage. Sarah Ridley, assistant head of education, offered valuable guidance concerning didactic materials and the presentation of the exhibition; Lucia B. Pierce, head of education, was also a great resource. Susan Bliss and Mary Patton in public affairs devoted their skills to the exhibition. I am grateful for the participation of Peter Button, Chinghwa Chang, Cherry Chan, Christine Lee, and Li Lundin in various details of the research project. Organization of fund raising was carried out by Laurel Muro. Finally I would like to thank Patrick Sears, assistant director for exhibitions and facilities, Sarah Newmeyer, assistant director for administration, and Forrest McGill, former assistant director of the Arthur M. Sackler Gallery, for their expert advice on this exhibition project.

I must also thank the Asia Society, New York, and the Saint Louis Art Museum for presenting this exhibition. I particularly appreciate the contributions at the Asia Society of the former director, Andrew Pekarik, interim acting director, Allen Wardwell, and the current director, Vishakha N. Desai, for their encouragement. I thank Hongnam Kim, Rockefeller Curator at the Asia Society, for suggesting that the exhibition go to New York and for her guidance. At the Saint Louis Art Museum, I am most thankful to James D. Burke, director, and to Steven D. Owyoung, curator of oriental art. The museum staffs at both institutions have demonstrated tremendous energy and talent.

SHEN C. Y. FU

Reader's Note

THE CHINESE manuscript by Shen C. Y. Fu was translated by Jan Stuart. Certain poems and quotations were translated by Stephen D. Allee and have the initials SDA below them. The initials JS and SDA together signify a collaboration between Jan Stuart and Stephen Allee.

With a few exceptions, Chinese characters in this book are rendered using the pinyin system of romanization. Some Chinese individuals have devised a personal system of romanization for their names; for example, the subject of this book wrote his name as "Chang Dai-chien" when living in the West. The pinyin equivalent is Zhang Daqian. For other individuals with personal romanizations, we followed their spellings. Chang Dai-chien's relatives are referred to using "Chang" as the romanization for their surnames. If family members did not develop their own customs of romanization for their given names, we used pinyin. Key modern figures, such as Sun Yat-sen and Chiang Kai-shek, appear with these internationally recognized spellings. Appendix 4 provides Chinese characters for the major people mentioned in the text. Place names in the text appear in pinyin with the exception of Peking and Taipei.

Chinese and Japanese names follow the traditional order of surname first, followed by the given name. Exceptions occur for collectors who prefer the reverse order and for Chinese individuals who use a Western given name, such as Chang Dai-chien's son Paul Chang.

Chinese artists are generally referred to by their proper names. Where an artist's courtesy name (*zi*) or sobriquet (*hao*) appears in a quotation, we have supplied the proper name in brackets. The notable exception to this rule is Chang Dai-chien. Although his proper name is Chang Zhengchuan, he used the sobriquet "Dai-chien" so often that it has become universally recognized. Appendix 4 includes some *zi* and *hao* of important artists next to their proper names.

Life dates or approximate dates of activity are provided when an individual is first mentioned in the essay and/or in each catalogue entry; however, no life dates are given for the lenders to this exhibition. For many of Chang Dai-chien's contemporaries, it has been impossible to provide any dates. A selected list of Chinese individuals and their life dates is included in Appendix 4.

We have translated painting titles where they appear as part of an inscription; where no title exists, we have assigned one based on our understanding of the painting. Western calendar equivalents have been calculated for the lunar dates that Chang Dai-chien inscribed on his paintings. Measurements for a painting are exclusive of the mounting; height precedes width. If known, the present location or collection of each painting mentioned is given. There is an active market for Chang Dai-chien's paintings; because of publication deadlines, our information is accurate to May 1990.

Dynastic Chronology

Shang dynasty, 1700–1050 B.C.

Zhou dynasty, 1050–221 B.C.

 Chu kingdom, ca. 11th cent.–223 B.C.

Qin dynasty, 221–206 B.C.

Han dynasty, 206 B.C.–A.D. 220

Six Dynasties period, 220–589

 Three Kingdoms, 220–280

 Western Jin dynasty, 265–316

 Northern and Southern Dynasties, 317–589

 Eastern Jin dynasty, 317–420

 Northern Wei dynasty, 386–534

Sui dynasty, 581–618

Tang dynasty, 618–907

Five Dynasties, 907–960

Song dynasty, 960–1279 Xixia dynasty, 1038–1227

 Northern Song, 960–1127

 Southern Song, 1127–1279

Yuan dynasty, 1279–1368

Ming dynasty, 1368–1644

Qing dynasty, 1644–1912

Republic of China, 1912–

People's Republic of China, 1949–

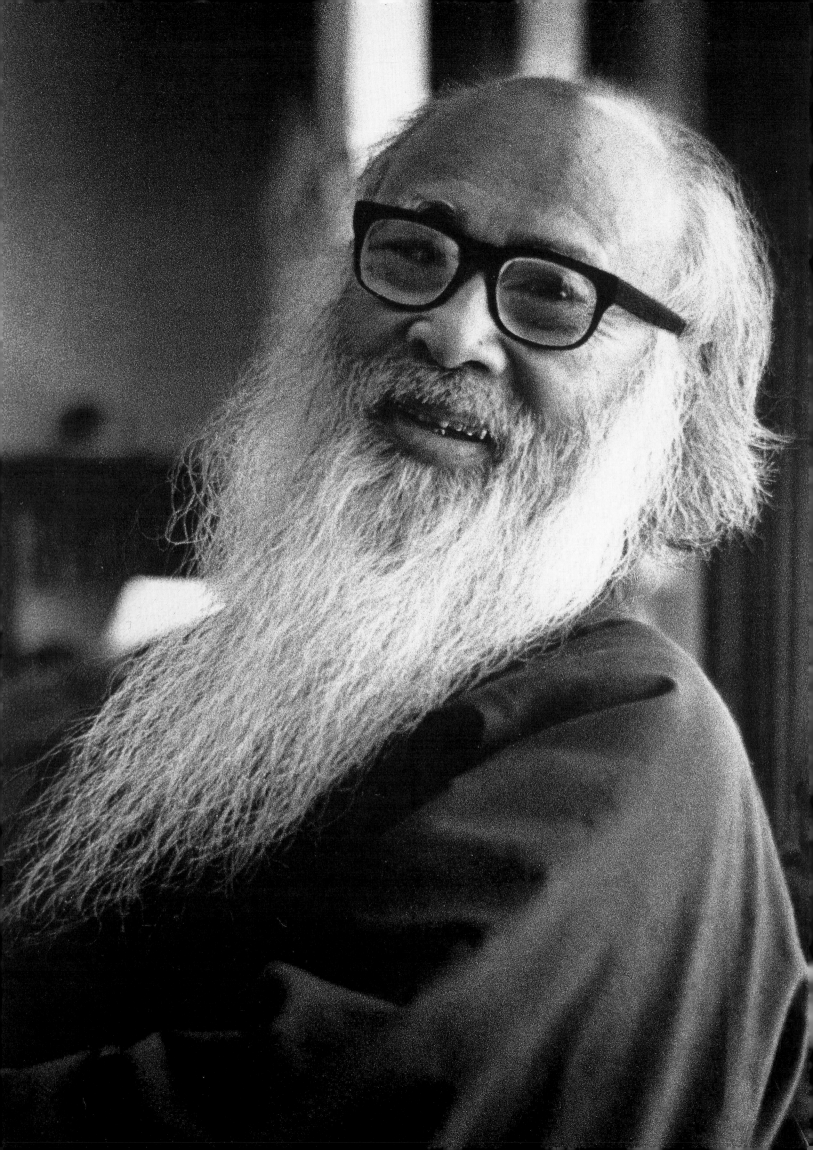

1 A Lion among Painters

CHANG DAI-CHIEN (1899–1983) was surely one of the most versatile, prolific, best-trained, and well-traveled artists in the history of Chinese painting (fig. 1). More than anyone else, Chang transformed traditional Chinese painting into a contemporary idiom. He was both the last great traditionalist of literati painting and an internationally acclaimed modernist, the most avant-garde of his generation.

Affecting the garb of an ancient scholar, Chang Dai-chien looked like an anachronism. His floor-length robe and tall cap were modeled after the poet Su Shi (1036–1101), and with flowing white beard and gnarled wooden staff, Chang looked like a figure in a Song dynasty painting. While fervently continuing tradition, he also fully participated in modern life. For example, after 1949, when he expatriated from China, he began traveling worldwide; stepping aboard a jet dressed in his ancient garb, he symbolized the coalescence of tradition and modernity. Creating the same striking synthesis of old and new in his painting brought Chang world fame. Each time he arrived at an airport, fans, reporters, and family welcomed him, snapping pictures and demonstrating enthusiasm for this genius who gave the best of past and present new expression by combining them in his work.

The root of Chang Dai-chien's phenomenal success was self-challenge. In everything he undertook, whether it was painting, cooking, or building a garden, he was determined to surpass famous ancient scholars and artists. Chang believed that imitating past masters was like practicing artistic alchemy in hopes of transmuting the iron of raw talent into gold. During his career, Chang often copied and even forged the ancient masters to enhance his skill, his reputation, or his income. Chang was capable of making virtually identical copies of ancient works, yet he insisted that a true artist should transform the ancient models—sometimes only subtly—into a personal expression. His forgeries were rarely stroke-by-stroke imitations; usually they were creative reinterpretations of the past. Chang's career is a continuum beginning with the copies and forgeries he made of ancient models and ending with his brilliant innovation of splashed-ink-and-color painting. This innovation, akin to abstract expressionism, was the ultimate transformation: under some influence from the West, Chang Dai-chien advanced the Tang dynasty *pomo,* or "splashed-ink," technique of painting by spattering ink and pigments into semiabstract compositions that have won international acclaim.

The scholar and painter Xie Zhiliu (b. 1910) once conservatively estimated that his friend Chang Dai-chien painted five hundred works a year; Chang's career total is a mind-boggling thirty thousand paintings.[1] Discounting unrecorded paintings and those lost, especially during the Cultural Revolution in China, Chang's corpus still numbers around five thousand works. But it is for diversity and quality more than prodigious output that Chinese painters have acclaimed Chang Dai-chien as "a lion among painters." He worked in virtually every major style, such as fine-line (*gongbi*) and loose-brush (*xieyi*) techniques, as well as painting from life (*xiesheng*) and copying other works (*lin*). He also painted all subjects: secular and religious figures, landscapes, birds-and-flowers, and animals. In calligraphy, he practiced the five major types of script and occasionally he carved seals. Ultimately Chang synthesized his cumulative experience to create a powerful style of his own.

Chang Dai-chien was one of the few twentieth-century artists to master the Three Perfections—painting, calligraphy, and poetry—and weave them together. Even his poetry, which Chang practiced the least, earned the praise of literary critics.

Fig. 1. Chang Dai-chien, 1975. Photograph by Roy Shigley, San Francisco.

The concept of the Three Perfections has traditionally been the purview of literati-artists who painted as an avocation, but Chang Dai-chien was unabashedly a professional painter. He benefited from the examples of Qi Baishi (1864–1957) and Wu Changshuo (1844–1927), who supported themselves by painting and yet cultivated a scholarly aura. Unlike those two artists, who altered the literati tradition by mixing classical and popular—even folk—elements in their work, Chang was determined to revive the elite tradition of literati painting as practiced by scholars in the Song through the mid-Qing dynasties and make it appealing to the modern audience.

Chang Dai-chien's oeuvre is a virtual survey of the history of Chinese painting. In modern art he stands out for his innovations, while in ancient painting he is represented both as a major collector and as a talented forger. Moreover, his own paintings reflect styles from every era. Thus a single volume can only present a general evolution of his painting style and a few of the highlights of this astonishing man's life.

Note

1. Although thirty thousand works might sound like hyperbole, the artist Wang Yani (b. 1975) was said by her father to have painted ten thousand works by age fourteen.

2 A New Era in China

WHEN CHANG DAI-CHIEN was born in 1899, China was at a low ebb. Western countries, with their advanced transportation, communication, and military networks, were threatening China's independence; meanwhile, the accelerated pace of the modern world was challenging the country's veneration for the past and its cultural traditions, which had endured for thousands of years. The political and cultural upheavals that marked the first half of Chang Dai-chien's life—the collapse of the Qing dynasty, a shaky period of republican control threatened by civil and foreign war, and the rise of communism—hastened the death of many traditions and the introduction of new values, some from the West.

By nature Chang Dai-chien had the agility to juggle the old and the new, deftly manipulating custom and experimentation, East and West. Chang's unique balance of convention and modernity is hard to account for. His family background, as well as innate talent, scholarly training, and dedication all contributed to his success, but the dramatic events of his lifetime must not be forgotten. The chaos of modern China, which forced Chang to leave his homeland, was a crucible that could easily have destroyed such a talent; in Chang's case, China's turmoil strengthened him both as an artist and as an individual.

At the beginning of the twentieth century, China was struggling to define its relationship with the rest of the world. The historian Jonathan Spence has explained that:

> elements of old and new existed side by side. At many levels the pace of change seemed overwhelming and irreversible. Steamboats plied the Yangzi . . . military academies were training young officers in Western tactics, scientific textbooks were rolling off the presses. . . . Victorious in a series of wars, the Western powers had imposed their presence on China and were now beginning to invest heavily in the country, especially in mines, modern communications, and heavy industry. The impact of foreign imperialism was profound.[1]

In reaction to Western imperialist designs on China, such as the British takeover of Hong Kong in 1841, a fervent antiforeign movement culminated in 1900 in the Boxer Rebellion. Because so many Western inroads in China had been made in the name of Christian evangelism, foreign missionaries and their converts were singled out as victims. Chang was not directly affected by the rebellion. He was only about a year old at the time, and although his family had converted to Catholicism, they were not in the path of the Boxers.[2] Ironically, the rebellion only accelerated Western interference. Unable to control the violence, the Manchu rulers of the Qing dynasty watched in humiliation as military forces drawn primarily from Japan, Russia, Great Britain, France, and the United States intervened. Victorious, the foreign powers demanded steep reparations and increased extraterritorial rights. With an ever-stronger foreign presence, China began to change irrevocably. The devastating ineptitude of the Qing dynasty court brought forth a wave of hatred toward the Manchu rulers, and the overthrow of the dynasty followed a decade later.

Chang Dai-chien was too young to be politically involved in the revolution, but his brother Shanzi (1882–1940), who was seventeen years older and almost like a father to Chang, belonged to the Tongmeng Hui (Revolutionary Alliance) of Sun Yat-sen (1866–1925) and was active in the movement that overthrew the Qing emperor. China became a republic in February 1912, with Yuan Shikai (1859–1916) as president. Thus Chang Dai-chien began adolescence in a new era.

China was being pushed into the modern age not only by Europe and the United States in the West and by Japan in the East, but also by forces within China. The Chinese are historically minded people who respect tradition; consequently, proponents of change usually allude to the past. Twentieth-century reformers such as Kang Youwei (1858–1927) pressured the Qing dynasty court for a modern army and a national

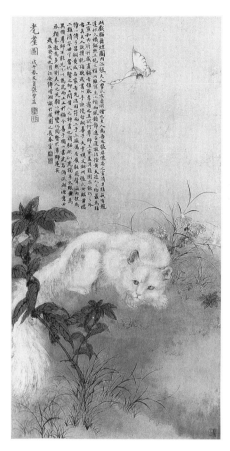

Fig. 2. Zeng Youzhen, *Cat and Butterfly,* 1918. Hanging scroll; ink and color on paper; Chang Dai-chien Memorial Residence, under the auspices of the National Palace Museum, Taiwan, Republic of China.

industrial base by pointing out that Confucius had not been against social advancement. In the art world, there was also a move to incorporate new influences without disregarding the past. The work of the painter Huang Binhong (1864–1955), whose recognition proved important in launching Chang's career, has recently been described as "innovation within tradition,"[3] a phrase that aptly characterizes the ethos of Chang Dai-chien as well.

Family

Chang Dai-chien's genealogy has not been elaborated, but his distant ancestors were scholar-officials in Panyu County,[4] Guangdong Province, who eventually relocated to Hubei Province. In 1683, Chang's tenth-generation ancestor was posted as prefect of Neijiang in Sichuan Province. Although

the family lost its status as officials several generations before Chang Dai-chien was born, Neijiang remained the family homestead, and both of Chang's parents were from Neijiang. Dai-chien's father, Chang Zhongfa (1860–1925), was a salt merchant, but when his business failed he was forced to become a common laborer.[5] Dai-chien's mother, née Zeng Youzhen (1860–1936), bore nine sons and two daughters; five of these children died in infancy. Chang Dai-chien's parents named him Zhengchuan. According to Chinese custom, since Chang was the eighth son, his friends called him Eighth Brother instead of by his given name. His first calligraphy teacher in Shanghai gave him the name Chang Yuan (Gibbon Chang) in 1919, and the appellation Dai-chien was given to him by a Buddhist abbot in the same year. Dai-chien grew up with three elder brothers, an elder sister, and a younger brother.

Zeng Youzhen helped support the family by selling her paintings of animals and flowers as well as embroidery and textile designs. She was locally admired for her delicate, brightly colored paintings in the fine-line *gongbi* technique (fig. 2) and earned the laudatory sobriquet Chang Huahua, "The Chang who can paint flowers." Several children followed her example. Shanzi, who was proficient in landscape and figure painting, achieved the most fame for his animals, especially tigers (fig. 3), and he taught Dai-chien how to paint figures and horses.

Another of Dai-chien's older brothers, Chang Wenxiu (1885–ca. 1970), was gifted at calligraphy in the style of the eleventh-century poet Su Shi, and he stimulated Dai-chien's interest in both calligraphy and Su Shi. When Dai-chien went to boarding school in his early teens, Wenxiu presented him with a copy of the seventeenth-century woodblock-printed *Mustard Seed Garden Manual for Painting.* With its instructive illustrations and commentary, the *Mustard Seed Garden Manual* was an important contribution to Dai-chien's early artistic training.

Chang's talent for calligraphy was already so great as a schoolboy that it set him apart from his classmates. Traveling home in 1916 for summer vacation from boarding school in Chongqing, Chang was captured along the road by bandits. They ordered him to write a letter home asking for money, and Chang's dazzling skill with the brush and his elegant locutions convinced the bandit chief to make him his personal secretary. Such preferential treatment allowed Chang to use the nearly one hundred days of captivity to read poetry that he found in the houses the bandits looted.

Chang Dai-chien's sister Chang Zhengheng (ca. 1892–1911), who was better known by her sobriquet Chang Qiongzhi, painted birds and flowers. Although she died

before turning twenty, she had an indelible influence on her younger brother. One of Dai-chien's clearest memories about learning to paint was of her insisting that he study the anatomy of birds and flowers and paint them from life.

Another gifted painter and calligrapher in the family was the youngest son, Chang Junshou (1902–1922). Junshou and Dai-chien both studied calligraphy with Zeng Xi (1861–1930) in Shanghai during 1919. Never known for false modesty, Dai-chien once said that Junshou was the more talented of the two. Unfortunately, Junshou committed suicide at twenty, and his work is exceedingly rare. The older Chang brothers decided to spare their mother the news of Junshou's death, and Dai-chien periodically wrote to their mother, imitating Junshou's calligraphy. The letters were posted from various cities in China and abroad, a ploy that created an excuse for Junshou's absence. Chang Dai-chien's forgeries were so convincing that his mother never suspected the truth.

The artistic skills and accomplishments of his family undoubtedly helped steer Chang Dai-chien toward a course as a professional artist, in spite of the family's desire that he should enter the textile industry. From childhood, Chang was continually advised by family members on the methods of brush and ink. When Chang was about twelve, he received his first painting commission. An itinerant fortune-teller noticed Chang's talent for drawing and asked him to paint a new deck of divining cards to replace her tattered one.

By the time Chang made his first trip to the major art center of Shanghai, he was already adamant about his desire to be a professional artist. But on this visit, which occurred in 1917, he was only passing through on his way to honor his family's wish that he study commercial weaving and textile dyeing in Japan. The two years Chang spent in Kyoto did nothing to alter his artistic ambition; immediately after his return to China, Chang went to Shanghai to ask Zeng Xi and subsequently Li Ruiqing (1867–1920) to take him as a student. At the age of twenty, Chang Dai-chien had already committed himself to a career as an artist.

The Influence of Japan on China

Especially during the first decade of the twentieth century, Japan greatly influenced China. The late-Meiji government proved successful at overcoming foreign threats from the United States and Europe and adapting Western political thought and technology without sacrificing Japan's cultural identity. In addition, Japan had orchestrated a smashing victory in the 1894–95 Sino-Japanese War, the spoils of which included China's cession of Taiwan. In 1904–05 the Japanese

likewise defeated the Russians. Chinese intellectuals were eager to emulate a country that had so quickly mastered Western technologies and strategies. The number of Chinese students in Japan jumped dramatically in the years following the Sino-Japanese War, from two hundred in 1895 to eight thousand in 1908.[6]

Prior to World War II—when Japan intensified its imperialist designs on China—the island nation was a political arena and a safe haven in which Chinese revolutionary ideas could ferment. Sun Yat-sen had used Japan as a staging area for his revolution. Then in 1915, when China's first president, Yuan Shikai, led a coup to end the republic and to reestablish a dynastic order with himself as emperor, Japan again became a sanctuary for political dissidents. Chang Dai-chien's brother Shanzi had opposed Yuan Shikai and fled for safety to Japan. Shanzi continued to visit China, however, and in 1917 he took Dai-chien with him to Japan and enrolled him as a student in a commercial art school in Kyoto to study textile manufacture. Although Chang Dai-chien had grown up at a time when Western ideas were gradually permeating China, this was the

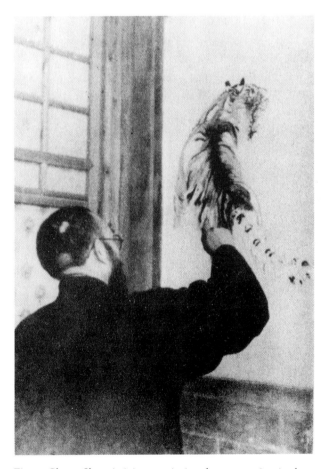

Fig. 3. Chang Shanzi giving a painting demonstration in the United States in 1940.

first time he was directly exposed to a foreign culture. He never became fluent in Japanese, but Japan's rice diet, Buddhist customs, and the adaptation of certain Chinese conventions made him feel welcome. Years later, after his self-exile from communist China, Chang Dai-chien often returned to Japan, finding comfort in its familiarity and close cultural ties with China.

Before Chang Dai-chien moved to Kyoto, the first wave of Japanese influence had just passed over the Chinese art world. The clearest evidence is in the Japanese training of Chang's older contemporaries, the founders of the Lingnan (Canton) School: Gao Jianfu (1876–1951), Gao Qifeng (1889–1933), and Chen Shuren (1883–1948). In Japan these artists had encountered Western styles of art not available in China. In Tokyo, the Japanese Watercolor Society and the Pacific Painting Society promoted Western styles of art. *Nihonga,* or Japanese-style painting, was also being transformed by awareness of Western art. The Japanese Kano School adopted greater realism, direct shading, and modern subjects such as airplanes into the traditional repertoire. Similar effects filtered into Chinese art through the Lingnan School.

In addition to the painters of the Lingnan School, other artists brought new currents into Chinese painting. Xu Beihong (1895–1953), who had been encouraged in his early career by Gao Jianfu, diverged from his mentor. After a short trip to Japan, Xu went to Paris where he studied realistic, academic oil painting. When he returned to China in 1925, Xu helped initiate a trend toward social realism, and he also adapted his oil painting studies to suit Chinese brush and ink, thus creating a new hybrid of Eastern and Western art. Chang Dai-chien had no desire to emulate either the painters of the Lingnan School or Xu Beihong, but they were a strong presence in the art communities of Japan and Shanghai, where Chang lived during the influential years of his youth.

Chang directly benefited from the theoretical and practical knowledge of pigments and fabrics that he gained in Japan, although he never admitted as much. After 1940, when he began using a brilliantly colored palette, and again in his late career, when he used pools and splashes of color in his semi-abstract work, Chang was well served by his technical training. Some of Chang's pigments required exact methods of preparation similar to those of a textile dyer.

Chang's training in Japan was also crucial to his successful forgeries of ancient paintings. To fashion convincing counterfeits, Chang had to replicate not only the style of the ancient brushwork, composition, and signature but also an aged painting surface. Chang taught himself to dye clean, new silk and paper to make them look stained by exposure to light, smoke from incense, and dust.

The sojourn in Japan introduced Chang Dai-chien not only to trends of Western art but also to ukiyo-e woodblock prints, which Chang never acknowledged as an influence but which seem to have provided a fresh source of inspiration for such paintings as *Afternoon Rest* (entry 44). At the same time, currents in Western and Japanese art had infiltrated Chang Shanzi's painting, which became another source of Japanese influence on Dai-chien. And in Japan, Chang was exposed to a style of Chinese painting that was better represented in Japanese than in Chinese collections. A few painters of the Southern Song dynasty, such as the Chan (Zen) Buddhist artists Liang Kai (act. early 13th cent.) and Muqi (early 13th cent.–after 1279), had been appreciated in Japan even after falling out of favor in China. Chang's exposure to their style is evident in *Sleeping Gibbon, Signed as Liang Kai* (entries 11 and 12).

Chang returned to China at a time when the opportunities to see and purchase ancient paintings were gradually becoming more numerous. Masterpieces that had been smuggled out of the imperial palace during the final years of the Qing dynasty were circulating in the private market. In 1925, another event significantly changed the study of art in China. With the development of a National Palace Museum, the imperial collections were transferred to the status of national property; thus, the public began to have unprecedented access to this treasure trove of art. Meanwhile, modern printing and photography were gradually making reproductions of painting and calligraphy widely available for the first time in history. The transformation of the palace collection into a museum, the availability of reproductions, and the convenience of modern transportation made it possible for Chang to see more ancient Chinese paintings than any artist before him. This exposure provided the basis for his incredible self-training in painting.

Religion, Marriage, and War

Chang Dai-chien's religious training and personal beliefs suggest an ecumenical spiritual portrait. In the course of his lifetime, Chang was exposed to an eclectic mixture of Confucian, Buddhist, Daoist, and Christian traditions. Just as in his art, where he adapted the past to suit his own needs, Chang was able to extract values from each of the religions he studied, although Buddhism had the greatest influence.

The religious beliefs of Chang's father are unrecorded, but Chang's mother was a devout Catholic. Chang's elder brother Shanzi also became an active Catholic. When Shanzi was in New York in April 1939 to raise funds for China's fight against

Japanese aggression, he painted *Jesus as a Shepherd* and *The Ascent of Jesus into Heaven* to present to Fordham University, a Catholic school.

Chang Dai-chien was taught at home until he was twelve, when he was enrolled in the Fuyin Catholic School. After three years he transferred to a boarding school, the Qiujing Academy, in Chongqing, which signaled the end of his formal Christian training. In spite of his early indoctrination, he was neither baptized nor confirmed. However, years later, Chang had no objection when his mother began to call one of his sons after the apostle Paul (Baoluo in Chinese).

Although he was not active in any Western church as an adult, Chang made some calligraphies of Bible verses in the 1960s, and six years before his death he painted an album of twelve plants, fruits, and trees mentioned in the Song of Solomon. On these album leaves Chang wrote the name of a plant or a short biblical quote. He also wrote the chapter and verse, which he often misremembered. On the last leaf he wrote, "The beams of our house are cedar; chapter 1, verse 7," but that quote is actually from chapter 1, verse 17 (fig. 4). Chang built each image by applying soft, glistening color washes or by puddling ink, creating an impressionistic effect. Without the inscriptions, the paintings would seem to be the usual flower and plant studies that Chang painted throughout his career and especially during his later years (see entries 62 and 67). The inscribed passages reveal that Chang remembered some of his Christian childhood and carried it with him until the end of his life.

Chang Dai-chien's most profound religious experience occurred during the winter of 1919. After he returned from Kyoto and began studying calligraphy with Zeng Xi in Shanghai, he was called home to Sichuan to marry a young woman named Ni. Chang was defiant; his childhood sweetheart and fiancée, Xie Xunhua, had died in 1918 while Chang was away, and the new bride his family had chosen (following the traditional system of arranged marriage) was mentally unstable. Chang vowed to remain celibate; he impetuously decided to become a monk and ran off to a Buddhist temple in Songjiang, a suburb of Shanghai. Ironically it was Chang's passion for life and the loss of his childhood love that turned him toward the world of religious quietude. The rashness with which he was ready to give up the secular world typifies Chang's volatile nature when he was young.

At this time, the temple abbot, Yilin, gave Chang a Buddhist name: Dai-chien. Yilin chose this name from a passage in the *Da Zhidu lun* that expounds on the boundless world of the Buddha's spirit, described as "three thousand times infinity" (*sanqian daqian*, or *san-chien dai-chien* in Chang's own system of transcribing Chinese). Many of Chang Dai-chien's

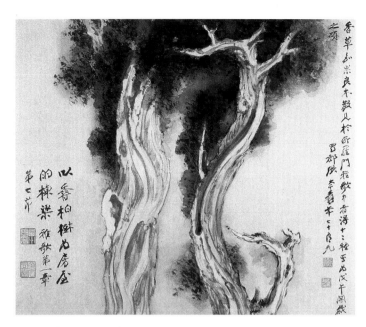

Fig. 4. Chang Dai-chien, *The Beams of Our House Are Cedar,* 1977. Album leaf; ink and color on paper; collection unknown.

paintings have a seal with this phrase.

After one hundred days as an acolyte, at the temple in Songjiang and then at a temple in Shanghai, Chang voiced objections to the rites of passage necessary to become a monk. A novice was tonsured, after which lit sticks of incense were touched to the newly shaven head. Chang asked to be exempted from this ritual tattooing, noting that Indian Buddhists did not practice such a custom, but the abbot insisted. Meanwhile, Chang's brother located him, and Chang returned to Sichuan, where his parents had chosen a new bride for him. In 1920 Chang Dai-chien wed Zeng Qingrong (1901–ca. 1960).

Their marriage was passionless and although they eventually had a daughter, Chang Dai-chien chose in the meantime to marry a second wife, an old Chinese custom practiced when a marriage produced no children. In 1922 he married Huang Ningsu (b. 1907), who bore nine children. When Chang went to Peking in the late 1920s, he did not take his wives, and while looking for a model to paint, he met a songstress named Yang Wanjun (1917–after 1985), whom he married in 1934. Chang's multiple marriages earned him notoriety among the urbane society of Peking—attention that he deliberately wanted at this stage of his career. Chang Dai-chien was to marry again, and it was his fourth wife, Hsu Wen-po (b. 1927), whom he met in 1945 and married three years later, who accompanied him when he expatriated in 1949 (see entry 25). Chang and Hsu Wen-po had four children.

Chang occasionally lived under one roof with several wives, but usually they kept separate households. Nonetheless, the children of all of the marriages see themselves as one family.

Once Chang Dai-chien began to earn money from his painting, he assumed financial responsibility for his brothers as well as his burgeoning immediate family. Chang also invited his students to live and eat in his household, and he continued to support his children, nieces, nephews, and students even after they married and had children. The advantage of the huge household was the help Chang Dai-chien received from his family and students. They ground his ink, prepared pigments, washed the brushes and inkstones, and dyed paper. To speed the drying process of each layer of color or wash that Chang applied, his assistants held paintings over a fire; later they performed the same task with an electric hair dryer. They located requested seals among the hundreds in Chang's collection and sometimes impressed them, sparing Chang the effort so he could continue to paint. Chang Dai-chien enjoyed his audience of family and students, and their aid and enthusiasm bolstered his output. Hsu Wen-po was especially helpful; her interest in assisting Chang as he painted was one reason he had proposed to her. Throughout their long marriage, when Chang had a dream that inspired him to paint, she would accompany him to the studio at any hour to prepare the necessary materials.

Chang Dai-chien maintained his ties to Buddhism by making sojourns to various temples for quiet retreats, where he could control his time and apply himself to painting without distraction. In 1940 Chang set out to see the Buddhist murals in the Mogao Caves at Dunhuang, in Gansu Province. News of his brother Shanzi's death caused Chang to turn back. He left for Dunhuang again in 1941, and for two and a half years Chang stayed at the desert outpost, which had been a major stop and religious center on the Silk Route during the Tang dynasty. By the Ming dynasty, Dunhuang had been virtually forgotten, but the arid climate preserved a vast number of the ancient wall murals. Chang went to Dunhuang to study painting, but he was also prompted to travel to this remote site because the war prevented him from visiting major urban art centers and he was determined not to waste his time.

Without his Buddhist convictions, Chang might not have endured the hardships of desert life; surrounded by the religious images at Dunhuang, Chang's own devotion increased. Chang recruited Tibetan monks from Qinghai Province to help him copy the wall murals (fig. 5). These specialists in Buddhist painting prepared large sheets of semitransparent paper that Chang used to trace the murals, and they sized sheets of cloth that worked better than paper for making large-scale copies. Under Chang's supervision the monks prepared pigments and helped color the images he had drawn. Chang's work at Dunhuang proved instrumental in renewing interest in the almost disregarded site, and it personally convinced him of the validity of ancient art, a discovery that profoundly affected his painting. Almost a decade later, Chang Dai-chien visited the Buddhist caves in Ajanta, India, and created works based on the paintings there.

Chang made references to Buddhism throughout his life. In 1954 he initially named his garden in Brazil the Garden of Mount Mojie—partly after Wei Mojie (Vimilakirti), the most famous Buddhist layman. Later names for the garden also had Buddhist origins (see entry 59). Chang named his final residence, in Taiwan, Moye Jingshe, combining the Buddhist terms for "illusion" (*moye*) and "meditation hut" (*jingshe*); it is commonly translated as Abode of Illusion.

Chang Dai-chien's main interaction with Daoism took place in Sichuan, where he returned in 1938 after the Japanese occupied Peking. The collapse of the Qing dynasty, inept as it was during the nineteenth and twentieth centuries, would have seemed to augur well for China, but the new government was terribly unstable. In 1922 battles between the Guomindang (nationalist) forces and powerful warlords who unofficially controlled large areas of China enervated the country. After Sun Yat-sen's death in 1925, Chiang Kai-shek (1888–1975) led the Guomindang in battles against the warlords, the Chinese communists, and the Japanese. The Japanese turned Manchuria into a military base from which they could attack China, and Tokyo established the puppet government of Manchukuo there in March 1932. Puyi (1905–1967), who had abdicated the Qing dynasty throne as a boy in 1912, was chosen as the "chief executive" of the new state. On July 7, 1937, war was declared between China and Japan, and it lasted for eight brutal years.

The war closed access to the major art centers of Peking and Shanghai, making it nearly impossible for Chang to interact with his contemporaries. At mid-career Chang Dai-chien was thus forced to be self-reliant, a development that deepened his commitment to study the past. When the Japanese soldiers took over Peking in 1937, Chang was living in Yihe Yuan, the former imperial summer palace. Yihe Yuan had been turned into a residential development with the multiple pavilions available for rent. Ten months of negotiation passed before Chang was given the papers to travel freely. He immediately left for Shanghai, where he embarked on a trip to Sichuan via Hong Kong in hopes of avoiding areas of battle.

In Sichuan Province, Chang first visited Chan Buddhist temples in the suburbs of Chengdu, but he soon moved to the Qingcheng Mountains, several hours outside the city, where he stayed in a famous Daoist temple called Shangqing Gong.

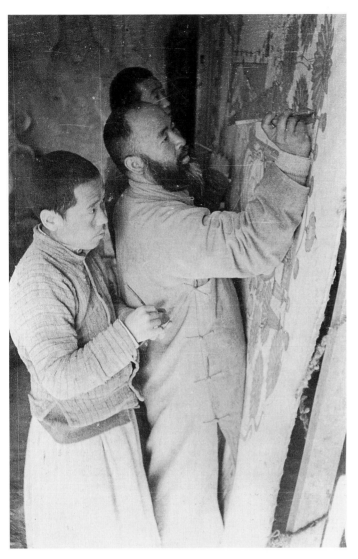

Fig. 5. Tibetan monks from Qinghai helping Chang Dai-chien at Dunhuang, 1942–43. Photograph by James C. M. and Lucy L. Lo, Princeton, New Jersey.

Chang lived there intermittently from 1938 to 1940 (before he traveled to Dunhuang) and from 1943 to 1948. While there, Chang ardently discussed Daoist philosophy with the temple abbot. Chang found the solitude of the temple delightful, and he brought only a few students and family members with him. The countryside inspired him to paint nature scenes, but he also painted Daoist figures, a practice he continued even late in his life in works such as *Patriarch Lü Dongbin* (entry 69).

Chang Dai-chien's life oscillated between secular periods, when he lived as an aesthete, and religious periods, when he sought the otherworldly calm of a Buddhist monk or Daoist hermit. During his religious periods he often lived in temples. Chang ardently followed whichever path he found himself on.

The balance he struck between profane pleasure and religious conviction is no different from the harmony he achieved in combining tradition and experimentation in his art.

Early Training and Reputation

When Chang Dai-chien went to Shanghai in the summer of 1919 it was explicitly to study calligraphy; family lessons had already given him a foundation in painting. Following the adage "a famous teacher produces a mighty disciple," Chang Dai-chien sought calligraphers who had lofty reputations and could be important mentors to him. In the catalogue of his retrospective exhibition held at the Avery Brundage Collection (now the Asian Art Museum of San Francisco) in 1972, Chang discussed his teachers.

> After my return to China [from Japan] at age twenty, I made my home in Shanghai in order to study under two distinguished masters, Zeng Nongran [Zeng Xi] from Hengyang and Li Meian [Li Ruiqing] from Linchuan. Among other things, they taught me the ancient scripts preserved on bronzes and stones from the three dynasties [Xia, Shang, and Zhou] and from the Western and Eastern Han dynasties. They also taught the [style] of writing engraved on stelae from the Six Dynasties period and the early-, mid-, and high-Tang dynasty.[7]

Zeng Xi and Li Ruiqing specialized in calligraphy that followed ancient epigraphic inscriptions in stone and metal, as well as on bamboo slips; Han dynasty clerical script and stela inscriptions from the Northern Dynasties were important models in their work (figs. 6 and 7). Chang Dai-chien quickly absorbed his teachers' lessons, and he especially benefited from Li's range of calligraphy, which Zeng Xi once described: "There is not a single type of ancient or modern calligraphy that Li Zhongzi [Li Ruiqing] has not studied, and there is nothing that he cannot imitate with perfect likeness. Moreover . . . he surpasses others."[8] Soon people would say the same of Chang Dai-chien.

After less than a year of copying Li Ruiqing's individual style of calligraphy, an energetic and eclectic mixture of ancient scripts, Chang Dai-chien possessed a mimetic skill that amazed his teacher. Few beginning artists have the ability that Chang demonstrated by reproducing both the general tenor and all the subtle nuances of a model. Chang, who was right-handed, also showed off by writing impressive calligraphy with his left hand.

Both Zeng Xi and Li Ruiqing encouraged Chang Dai-chien to study Shitao (1642–1707), whose assertive calligraphy with its cherished awkwardness significantly influenced him. Other models that deeply affected Chang include the famous

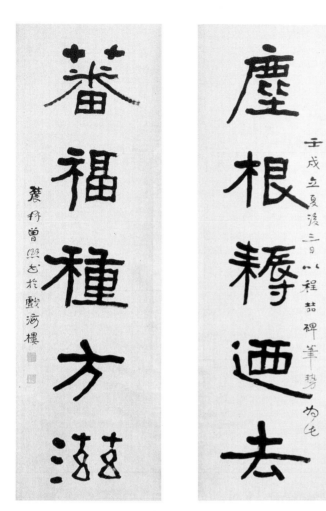

Fig. 6. Zeng Xi, *Couplet in Modified Clerical Script*, 1922. Pair of hanging scrolls; ink on paper; collection unknown.

Yihe ming (Inscription for Burying a Crane) cliff inscription from the early sixth century and also Huang Tingjian (1045–1105), who himself had studied the *Yihe ming*. Chang was attracted to the way Huang mixed the rounded brush strokes of seal script with the swift momentum of cursive script.

By age fifty, Chang had developed his own personal style, which not only embodied the plain tranquillity of early calligraphy but also possessed a complex rhythm that seemed to freely contract and expand to create a unified and dynamic design. Chang's lengthy inscription on *Picking the Fungus of Immortality at Tong Village* (entry 46) is one example.

Zeng Xi and Li Ruiqing were classically trained scholar-artists. Along with instructing Chang in calligraphy, they shared their knowledge of history and literature and encouraged Chang to compose poetry. In 1930, after both teachers had passed away, Chang sought instruction from the respected poet Chen Sanli (1853–1937). Chang Dai-chien

explained the association between literature and painting when he wrote, "To cast off vulgarities, cleanse away superficialities, and eliminate an artisan's aura in painting, first you must read books; second you must read more books; and third you must systematically and selectively continue reading."[9] Chang's painting student, Sun Jiaqin (b. 1938), who is now a professor at the University of São Paulo, Brazil, recorded Chang Dai-chien's beliefs.

A successful and great artist must have an impeccable personal character and be open minded and knowledgeable . . . cultivation comes from memorizing many books. . . . Moreover, it is imprudent to stop with just one genre or type of book. In the past, great artists were all lofty and full of integrity. . . . Their painting followed suit; if a man throws off vulgarity then his work will be flawless. Therefore [an artist] should read every kind of book.[10]

The contemporary scholar Liu Taixi has judged Chang's verse equal to a "true poet," as opposed to a painter who merely dabbles in poetry. According to Liu Taixi, when Chang Dai-chien moved to South America in the early 1950s he shipped twenty-seven large crates from Hong Kong, in which he packed the Thirteen Classics, the Twenty-four Dynastic Histories, and important anthologies of poetry and literature. Chang's wide knowledge of literature impressed Liu Taixi to remark that Chang's "paintings have a learned quality and such ability in a painter is what makes him surpass everyone else and lose all traces of vulgarity."[11]

Chang Dai-chien achieved an exceptional prominence during his lifetime that was due almost as much to his courtship of fame and influential friends as to his talent. His generous, easygoing personality and erudition gained him access into the circle of learned gentlemen and artists in Peking and Shanghai. As a young artist, Chang Dai-chien was painfully aware of the Chinese predilection to overlook the talent of an unknown artist.

To have a chance to become an artist in China, one definitely must have a name that is well known and be of a venerable age. . . . Only if you are famous will your paintings be treasured; if you are not famous, although your contemporaries may recognize the value of your work and hang your paintings on the wall, the next generation will not value them seriously, and after a time the paintings will be allowed to collect dirt and become old. Nobody will know who the original recipient was, and so consequently the paintings will not receive any esteem.[12]

The Chinese association between age and fame prompted Chang Dai-chien to start growing a beard at twenty-six to make himself look older. He also shrewdly dedicated his paintings to people whose importance would enrich the value

Fig. 7. Li Ruiqing, *Copy of Zhang Menglong Stela*, 1919. Hanging scroll; ink on paper; collection unknown.

Baishi, who died at ninety-three, had succumbed during his sixties, then his fame would have been sorely diminished. To whatever extent a person can control his lifespan, Chang Dai-chien was determined to live a long time. He also set out to achieve fame at a much younger age than Qi Baishi. Chang Dai-chien's older brother Chang Shanzi, a recognized painter, introduced him to a circle of artists, and Chang Dai-chien's teachers did the same. Works that Chang created in the style of ancient artists were accepted as genuine, and when viewing private collections with well-known connoisseurs, Chang took delight in pointing out his forgeries. Chang Dai-chien's efforts had a snowball effect: once his name was recognized, his fame grew exponentially, and by age thirty-five Chang had a national reputation.

Chang Dai-chien was sometimes a braggart, but his talent as a raconteur won him many listeners and gave him innumerable chances to promote himself. When he lived in Shanghai or Peking, it was because he wanted to receive visitors, and his dining table was crowded with scholars, aesthetes, renowned craftsmen, painting mounters, dealers, and reporters. Chang Dai-chien enjoyed painting as people watched, although he periodically forsook social pressures for quiet mountain life. Toward the end of his life, he was constantly wooed by Chinese journalists, who found the public loved to read about him.

Chang often calculated ways to attract publicity; for example, he knew marrying his third wife would stir up attention. Whenever possible, he did things in a grand way. On his journey to Dunhuang, a trip newsworthy in itself, he was accompanied by about twenty assistants, including his third wife and several children and nephews. In France in 1956, he visited Pablo Picasso partially for the media possibilities—he sensed that the press would describe the encounter as master Eastern painter meets greatest living Western painter. Indeed, the photograph of the meeting is one of the most commonly published images of Chang Dai-chien (fig. 8).

Chang made sure he gave his paintings—often self-portraits—to people who could help promote him, although he was also generous about giving works to his friends regardless of their status. Chang made it a practice to personally supervise the mounting of his best works as scrolls before presenting them as special gifts. The total impression—that of a beautiful painting in a beautiful mounting—ensured that these gifts would not be rolled up and stuck in a drawer. Chang also asked famous people to write inscriptions on his paintings, thereby guaranteeing that they would be carefully preserved for the historical importance of the colophon if not for his artwork.

of his art. These people, of course, were flattered to receive Chang's paintings as gifts. His friends included not only high officials but major opera stars. Chang was a genuine opera fan who took advantage of the attention opera enjoyed in the 1920s and 1930s. In the same way, Chang used his skill and reputation as a cook and gourmet to cultivate friends among famous chefs and restaurant owners. He gave them paintings to hang in their restaurants, creating private galleries for himself that important potential sponsors would see. Ultimately, as Chang's own fame increased, these associations became mutually beneficial.

Chang Dai-chien once noted that if the long-lived Qi

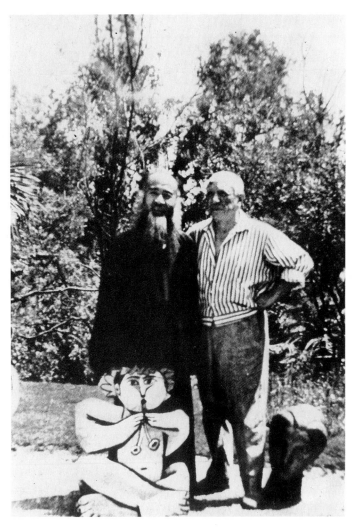

Fig. 8. Chang Dai-chien with Picasso at Picasso's home near Cannes in 1956.

Many Travels, Many Homes

The value of travel for an artist was perhaps best articulated by Dong Qichang (1555–1636), who said that a painter must "read ten thousand volumes and travel ten thousand miles" to be able to transmit nature's "spirit resonance" and "animation" through a painting. Chang Dai-chien took this advice seriously, and he listened to his teacher Li Ruiqing, who once told Chang, "Seeing the clouds in the Yellow Mountains and the sunrise at Mount Tai were the most marvelous experiences in my life."[13] With his daring personality and access to modern transportation, Chang probably traveled more extensively than any other artist.

Chang Dai-chien's childhood home in Neijiang had only gentle hills, and when he went to school in Chongqing, the grand mountains elsewhere in Sichuan Province captivated him. After he began studying art as a young adult in Shanghai, he traveled back and forth to Sichuan on the Yangzi River, passing through the Three Gorges, which provided inspiration for radiantly colored landscapes such as *Clear Autumn in Wu Gorge* (entry 14). But the Yellow Mountains in Anhui Province enchanted him most, and he painted these quirky peaks several hundred times in works like *Wenshu Plateau in the Yellow Mountains, Signed as Mei Qing* (entry 6), *Overhanging Pine in the Yellow Mountains* (entry 57), and *Self-Portrait in the Yellow Mountains* (entry 58). His special affinity for this site was twofold: first, Chang believed the peaks of the Yellow Mountains were more mutable and surprising than any in the world. He loved to watch the waves of clouds continually form and vaporize, and he defiantly set out to capture the elusive scenery in his art. Second, Chang particularly admired Shitao, Hongren (1610–1664), and Mei Qing (1623–1697), all of whom had painted the Yellow Mountains. When Chang painted these peaks, his perceptions were shaped by the vision of the seventeenth-century masters.

In his lifetime Chang Dai-chien visited most of the major peaks in China, as well as Diamond Mountain in Korea, the Himalayas in India, the Swiss Alps, the Andes in South America, and the Adirondacks in North America. His great stamina, fearlessness, and sense of balance enabled him to climb mountain summits and leave the mountain trails to seek the most sensational views. His extensive travel contributed to the diversity of his art; whereas most ancient painters concentrated on landscape in a single region, Chang Dai-chien forced himself to develop a variety of techniques suited to the terrains he witnessed firsthand.

In addition to his travels, Chang moved frequently. He was particular about his residences, since he painted at home and his environment affected his art. Among his many residences there were a few in which he invested a great deal of time and money to create the ideal home (see App. 3).

Inspired by the ancient principle that a painter should have "bamboo in his breast" and "hills and streams deep within his chest," Chang built traditional Chinese gardens that were a microcosm of the world—rocks were mountains, streams were rivers. An accomplished landscape designer, Chang joined the ranks of past literati-painters, such as Wang Wei (701–761), Ni Zan (1301–1374), and Shitao. His home in Brazil, with its artificial lake, viewing kiosks, Chinese rocks and plants, and gibbons, was an especially lavish venture.

Ming dynasty artists likened designing a garden to the act of painting, and Chang Dai-chien emphatically agreed. The garden plot was like a sheet of paper on which the gardener arranged rocks, trees, and flowers, just as a painter brushed them. Because in a Chinese painting each ink brush stroke is

immutable, Chang imagined garden design was like working with oil paint: everything could be obliterated and changed. Chang once said that if an artist planted enough in his garden he would not need to travel, yet he always did both.

Chang Leaves China

The war between Chiang Kai-shek's Guomindang army and the communist forces of Mao Zedong (1893–1976) escalated after the end of World War II. When it became clear that the communists were going to win, Chang Dai-chien decided to expatriate. His belief in individual freedom spurred him to leave, but no doubt he was well aware that his epicurean temperament was ill suited to the new regime. In fact, he was branded as "useless" and "bourgeois"; his low character was allegedly evident in his hobby of raising animals and flowers as models for his painting when people were starving. Chang was also challenged for his gourmet interests. He knew he would not be able to paint freely if he stayed in China.

Some of Chang's contemporaries did stay. Xu Beihong, for example, was promoted by the communists to head the Central Art Academy in Peking in 1949. But Xu Beihong's art was fundamentally different from Chang's and well suited to the aims of the communist state. As early as 1928 Xu had pioneered social realism with *Tian Heng and His Five Hundred Retainers,* painted using Western perspective and anatomical drawing, which the communists promoted. Others who remained in China, such as Huang Binhong, Yu Feian (1888–1959), and Qi Baishi, were relatively unaffected by the push toward social realism, but even the youngest of these three was Chang's senior by more than a decade. At fifty years old, Chang was brimming with creative energy, and he was not willing to risk the repression of a communist lifestyle. In late 1949 Chang left his native land, taking one of his children, his youngest wife, Hsu Wen-po, and a selection he hurriedly made from his collection of both his own paintings and the ancient masterpieces he owned. Chang Dai-chien subsequently lived in India, Hong Kong, Argentina, Brazil, the United States, and Taiwan and made frequent sojourns to Japan and Europe. He never returned to China.

For Chang Dai-chien, self-exile was a dramatic turning point. He was familiar with some Western habits, especially as he had grown up in a Catholic home and attended parochial school for a few years, but he was not enamored of, or entirely comfortable in, a foreign setting. Despite extensive travel, Chang's life in the West remained insular: he surrounded himself with Chinese friends, assistants, and Japanese gardeners. He developed his skill as a landscape designer to physically re-create China in his various elaborate residences. Even the fine cuisine he had enjoyed in China continued to grace his table, as he honed his own skills as a chef and supervised the household cooking.

While some people have thought that Chang was too much an aesthete to connect his art to politics, his reactions to the physical and cultural displacement that he experienced are evident in his painting after 1949, although the clues are subtle and intermittent. Chang never allowed political content to dominate the lyric forms, colors, and brushwork. Indeed, Chang believed that a beautiful image was the best way to touch a viewer's heart with a subtle message. Chang was not polemical.

China's history is full of lofty scholars who, exiled from court, vented their sorrow and moral outrage in literature and painting. The literati's protest was usually veiled in poetic allusions or in the careful choice of a symbolic subject. Like these lofty scholars, Chang Dai-chien usually chose an indirect language of protest.

Among Chang's contemporaries, political statements were more an exception than the rule. Huang Binhong's dense landscapes had no particular message beyond the enjoyment of brush and ink. When Xu Beihong was not painting didactic murals, he brushed simple pictures of cats, fowl, and bamboo. Occasionally Chang Dai-chien donated the profits from his painting exhibitions for famine relief, but he was not inclined to become involved directly with organized political movements. After a series of natural disasters struck China in 1934 and 1935, he willingly helped the victims, but the only time he organized an exhibition to aid the Japanese resistance movement was in 1938. This action was at the request of Chang Shanzi, an outspoken political activist, whose overtly political *China Stands on Mount Fuji and Roars Ferociously* (fig. 9) was a call for action against the invading Japanese.

Like Chang Shanzi, a few other twentieth-century painters forcefully expressed their opinions. *Skulls Crying over the Nation's Fate,* painted in 1938 by Gao Jianfu, depicts skulls decaying in a field with the inscription: "Alas, the rich become richer, the poor become poorer. People of every sort would be better equal. I and the skeletons cry together."[14]

As disillusioned with modern China as Gao Jianfu, Chang Dai-chien expressed his feelings in a different way. In several instances, he used the leitmotif of the famous "Peach Blossom Spring" by Tao Qian (365–427). The story describes a fisherman coming upon a cave hidden in a profusion of flowering peach trees. Stepping out of his boat the fisherman follows a long tunnel and finally arrives in an idyllic world of a past golden age, a world untouched by the turbulent events of the fisherman's own time. When the fisherman tries to find the

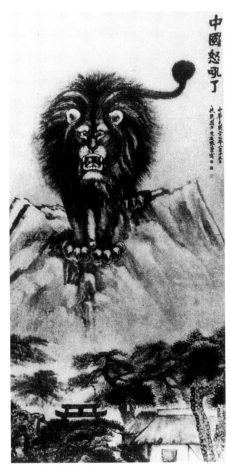

Fig. 9. Chang Shanzi, *China Stands on Mount Fuji and Roars Ferociously.* Hanging scroll; ink and color on paper; collection unknown.

utopia again, it has disappeared.

The "Peach Blossom Spring" motif had been used by generations of poets and painters. Chang Dai-chien owned a painting on this theme by Shitao, which is now in the Freer Gallery of Art (fig. 10). In 1933 Chang wrote a colophon on the painting that openly records his sadness at China's plight and the loss of the traditional values.

> The world is already without the [utopia of the] Peach Blossom Spring; where then is the little boat drifting? I don't even have a skiff; I sigh hopelessly as I unroll this scroll. . . . Every time I think about China roiling with the wind and waves, I feel mortally wounded in my breast.

Chang frequently painted the "Peach Blossom Spring" theme; as late as 1982 he was still using it to express disillusionment (see entry 85) and to affirm that within his heart, at least, the values of China's past were safe.

One of Chang's clearest political statements is in *Autumn Mountains* (fig. 11), painted in the fall of 1950. Its scratchy, dry brushwork underscores his anguish over events that were occurring in China. The concluding lines of his poem read:

> I've been told that, for the moment,
> all the dogs and chickens have died;
> Lost in the fog and tangled in mist,
> I stare toward China's sacred realm.
> SDA

Another poignant statement is his inscription in 1965 on a self-portrait for his close friend Guo Youshou (b. ca. 1900).

> No day's been set for going home,
> but my love for home is deep;
> Getting together year after year,
> this feeling can't be helped.
> You ask me for my dusty portrait,
> but dust has covered my face;
> So many old friends are starving,
> and I am too full of concern.
> SDA

During the twenty-five years that he lived in the West, Chang frequently painted Chinese scenery from memory. The creative act psychologically linked him with China, which, no matter how distant, was still central to his being. Some of these paintings have deeply felt inscriptions. In the Qingcheng Mountains in Sichuan Province there is a village that was famous for its many octogenarians. On a painting he made of this village, Chang wrote:

> Taking to the wilds, I've begged
> my food for ten years of hardship;
> Though I dream of going home, the
> Qingcheng hills cannot be climbed.
> And the old folks of the village
> must certainly all be dead by now;
> I hold this brushtip in my mouth,
> and recall my homeland with tears.
> SDA

One of Chang's most direct condemnations of Mao Zedong is inscribed on *Copy of Nesting Clouds by Gao Kegong,* which Chang painted in 1967 (fig. 12). Chang was recalling his beloved collection of ancient paintings that he had been forced to leave behind in China. Chang painted from memory a copy of a work by Gao Kegong (1248–1310), which he inscribed: "Recently Mao [Zedong] and Lin [Biao] have maimed China and are destroying all its cultural relics. I think this handscroll [by Gao Kegong] must have been thrown into the fire, too." The destruction of relics during the Cultural Revolution, from 1966 to 1976, was agony for Chang.

Fig. 10. Shitao, detail, *Peach Blossom Spring.* Handscroll; ink and color on paper; Freer Gallery of Art, Smithsonian Institution, Washington, D.C., 57.4.

An inscription written in 1972 was just as direct. That year Chang planted nearly a hundred plum trees in his Pebble Beach garden, Huanbi An, and he commemorated the event in a poem that described his tears as he looked at the flowers and thought of his homeland. He concluded the poem:

> How altogether stupid and perverse they look to me, everyone who does not acknowledge the plum is the national flower.
> SDA

Chang's political message is clear: the plum is the national emblem of the Republic of China, based in Taiwan, and Chang rejected anyone who did not recognize the Taiwan government as the legitimate ruler of China. When Chang wrote this poem, diplomatic tensions between mainland China and Western nations were beginning to ease, and visitors from China could travel to California to see Chang. Yet no one could persuade him to return to China even for a short stay. By flying the Republic of China's flag over his door, he made it clear that he still found the communist regime repugnant.

Even Chang's last major painting, the enormous *Panorama of Mount Lu* (entry 87), has political content. Chang initially painted two scholars in the landscape (fig. 13); later, he splashed ink over their images, turning the spot where they had been into a rock. Chang commented on his decision, "Today there are no lofty scholars left behind on Mount Lu." While the painting appears to be a colossal tribute to nature, those who know that the figures of the scholars have been obliterated can recognize a statement of Chang's hostility for the anti-intellectual regime of the communists.

The communist victory in China clearly propelled Chang

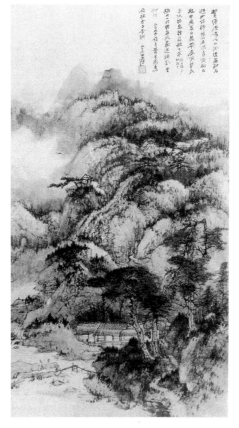

Fig. 11. Chang Dai-chien, *Autumn Mountains,* 1950. Hanging scroll; ink and color on paper; collection of Gao Lingmei, Hong Kong. From Gao Lingmei, *Chang Dai-chien hua* (Hong Kong: Dongfang yishu gongsi, 1961), 55.

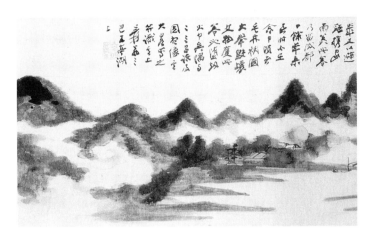

Fig. 12. Chang Dai-chien, detail, *Copy of Nesting Clouds by Gao Kegong,* 1967. Handscroll; ink on paper; collection of Dr. Dzung Kyi Ung, Hong Kong.

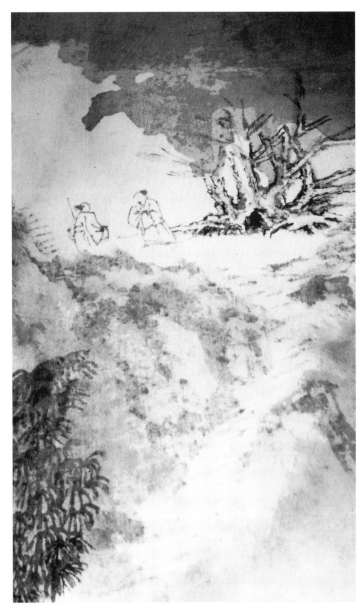

Fig. 13. Scholars initially painted in *Panorama of Mount Lu.* Photograph by Yue Shuren dated October 11, 1982.

toward the West, and no doubt his long sojourn in the West exposed him to new art currents and caused him to perfect skills that he might not have taken as seriously had he remained in China. In trying to appeal to the Western market in the 1950s and 1960s, he deliberately adapted Western painting styles. This economic incentive, combined with his failing eyesight and his knowledge of the Tang dynasty splashed-ink technique, resulted in Chang's innovative splashed-ink-and-color paintings. Once Taiwan became stable and relatively wealthy, Chang again directed his art to Chinese patrons, although he continued to create splashed-ink-and-color works.

Chang Dai-chien was a pivotal, innovative artist for his generation, yet he saw himself as a traditionalist. In 1972, when the Avery Brundage Collection (now the Asian Art Museum of San Francisco) held a retrospective of his work, Chang named in the catalogue preface some twenty artists he esteemed as his peers. They were all traditional, even conservative, literati artists such as Wu Hufan (1894–1968) and Puru (1896–1963). Thinking himself to be a traditionalist, Chang was able to reinvent the past, bringing his fresh perceptions to painting styles that originated as early as the Tang dynasty. In his "invention" of splashed-ink-and-color paintings, Chang ultimately created a brilliant new style based on antiquity. Chang Dai-chien will always be regarded among the leaders of the modernization of Chinese painting, and while new generations of painters may take a different direction from Chang, his genius for using the past as a source of liberation instead of as a straitjacket opened new doors in the Chinese art world.

Notes

1. Jonathan D. Spence, *The Search for Modern China* (New York: W. W. Norton, 1990), 224.

2. Some sources indicate that Chang Dai-chien's mother first converted to Protestantism and then switched to Catholicism.

3. Jason Kuo, *Innovation within Tradition: The Painting of Huang Pin-hung* (Williamstown, Mass.: Hanart Gallery in association with Williams College Museum of Art, 1989).

4. A variant reading is Fanyu County.

5. Publications from mainland China stress that Chang Dai-chien was a "laborer's son"; however, the emphasis seems an effort to redeem Chang politically from the taint of a bourgeois family. More accurately, Chang Dai-chien was born into an educated family that had fallen on hard times.

6. Ralph Croizier, *Art and Revolution in Modern China* (Berkeley: University of California Press, 1988), 25.

7. Translated by Jan Stuart based on the Chinese text and translation in René-Yvon Lefebvre d'Argencé, *Chang Dai-chien: A Retrospective Exhibition* (San Francisco: Center of Asian Art and Culture, 1972), 9.

8. Quoted in Ma Zonghuo, comp., *Shulin zaojian;* reprinted in Yang Jialuo, comp., *Yishu congbian,* vol. 6 (Taipei: Shijie shuju, 1966), 12:448b.

9. Translation by Jan Stuart; Chinese text and another translation appear in Chang Dai-chien, "Dai-chien jushi huashuo," in Gao Lingmei, ed., *Chang Dai-chien hua ji* (Hong Kong: The East Society, 1967), n.p.

10. Sun Jiaqin, "Diaozai sannian; shi en si hai," in Zhu Chuanyu, ed., *Chang Dai-chien zhuanji ziliao,* vol. 6 (Taipei: Tianyi chubanshe, 1985), 178a.

11. Liu Taixi, *Wuxiang'an zaji xuji,* in ibid., vol. 3, 67b.

12. Quoted in Feng Youheng, *Xingxiang zhi wai: Chang Dai-chien de shenghuo yu yishu* (Taipei: Jiuge chubanshe, 1983), 231.

13. Quoted in Xie Jiaxiao, *Chang Dai-chien de shijie* (Taipei: Shibao wenhua chuban gongsi, 1982), 53.

14. Translation by Jan Stuart based on Croizier, *Art and Revolution in Modern China,* 146–47 and pl. 64.

3 Painting Theory

DESPITE HIS literary accomplishments, Chang Dai-chien never wrote a systematic treatise about painting for fear that he would be unable to express his deepest convictions. The inscriptions he wrote on his paintings, however, often touch on aesthetic theory and include advice about painting methods and materials. The prefaces he occasionally wrote for exhibition catalogues were slightly more discursive, the most revealing being the preface that accompanied his retrospective in 1972 at the Avery Brundage Collection (now the Asian Art Museum of San Francisco). The majority of his essays address problems of connoisseurship, not aesthetic theory. The longest of these essays, "Gugong minghua duhou ji," was written in 1959 and originally appeared in a daily newspaper. The essay is preserved in Yue Shuren's *Chang Dai-chien shiwen ji.*

Some of Chang Dai-chien's friends diligently preserved his oral pronouncements on painting theory and methodology. The most notable are Gao Lingmei, an editor who published two separate volumes in Hong Kong recording Chang's comments,[1] and Zeng Keduan, a well-known poet and calligrapher who helped record Chang's maxims for Gao's earlier book. Selected reproductions of Chang's paintings accompany the texts. The earlier volume is similar to a traditional painting manual (*huapu*); didactic text and demonstration sketches are paired for each topic, including landscape, figure, bird-and-flower, and animal painting. Reproductions of Chang's paintings are interspersed throughout. Gao Lingmei's 1967 publication, *Chang Dai-chien hua ji,* repeats some of the text from the earlier volume but is not arranged as a manual. It includes different paintings as illustrations and a valuable sixteen-point discourse that condenses Chang Dai-chien's thoughts on painting. Unless otherwise indicated, quotations in this chapter are from that discourse.[2]

Chang Dai-chien espoused that "the main principle of painting is to express beauty,"[3] and every facet of his career reflects this attitude. The artist forcefully decreed, "Paint only that which is truly beautiful and cast away the ugly."[4]

For Chang, a work of art had to have three virtues: greatness (*da*), indirectness (*chu*), and radiance (*liang*). The first two terms were borrowed from literary criticism, but Chang recast them to fit painting theory. *Da* means "large" and "great," and by extension Chang used it to mean "monumental spirit." He applied the term equally to works of any size, saying that every painting should be majestic and vigorous. Chen Congzhou (b. 1918), who is best known as a historian of gardens, was one of Chang's first students in Shanghai. He once described the vitality of his teacher's painting using *da* three times: "Chang Dai-chien's painting has monumentality, powerful brushwork, and great dynamism."[5]

To possess the quality of *chu* a painting must go beyond attractive visual details to include cultural and art historical references. A great painting should offer a new sensation to the viewer each time it is studied. Chang believed that the viewer's reaction was a measure of the artist's success in conveying knowledge, personal cultivation, and life experiences. But the viewer also tests his or her own erudition and capacity for responding to the multiple layers of meaning an artist may encode into a painting. Chang Dai-chien's paintings often have layers of art historical and cultural allusions. Chang's *Light Snow at Tongguan* (entry 29), for example, re-creates a painting by Dong Qichang (1555–1636), who was in turn following Yang Sheng (act. 713–741) and his method of creating forms with color washes instead of outlines, a technique that ultimately derived from the work of Zhang Sengyou (act. 500–550).

The third virtue that Chang Dai-chien demanded of a painting, *liang,* was a term borrowed from the performing arts. The word means "radiant," "lustrous," and "clear," and

applied to opera, it means "stage presence." The moment when a performer first steps on stage for the audience to admire his deportment is called *liangxiang*. If the impression is favorable, it is spoken of as *piaoliang*, which in everyday conversation means "pretty" but in this context suggests a radiant presence. Whenever Chang Dai-chien displayed one of his paintings, he would ask, "Is it radiant?"

Although the basic meaning of *liang* concerns the visual perception of light, Chang seems to have been the first to apply it to painting. He did not restrict "radiant" to mean only the effects of light or color in a painting; he used it to refer to vibrancy and harmony of brushwork and composition as well.

To Chang a radiant painting exuded balance and restraint; he believed a work of art should be "gentle but not effete, unimpeded but not wild, and profound yet clear." He also instructed artists to "avoid using the brush fussily." The ink itself "should exude elegance and luster."

Chang Dai-chien discussed composition in terms of yin and yang dualities and the harmonious complement they create. He warned, "Symmetry and overall evenness should be proscribed. Instead, observe the rule that one should juxtapose the principle and the subordinate elements, the dense and the sparse, the pale and the dark, the heavy and the light, the subdued and the animated, the nearby and the far, and the high and the low."

Great painting is not solely a product of innate ability; nor is it entirely dependent on technical expertise. In fact, Chang was fond of saying that an artist's success is seven parts endeavor and three parts natural talent. Following the creed of traditional literati-painters, Chang also stated that "art is the natural expression of one's feelings and a revelation of self. An artist should on a daily basis cultivate his good nature and temperament; if one merely perfects technique he can still sink to the lower rank."

In the discourse on painting that Gao Lingmei published in 1967, Chang Dai-chien also stressed the value of reading and studying literature systematically, selecting the most appropriate works. He paired the value of travel with that of reading, citing both as inspiration to a painter. In addition, Chang believed that an artist must know his subject firsthand, a rule instilled in him by his sister Zhengheng, who insisted that he paint flowers from life. When Chang Dai-chien painted *Horse and Groom* (entry 26) he was bold enough to think, based on his knowledge of horses, that his horses were better than those of the master painter Zhao Mengfu (1254–1322). Chang's theory of painting harks back to early Daoist philosophy, which proclaims that the "level of knowledge [is] similar to that of the aesthetic experience in which the self merges

empathically into the world of external objects."[6] Through such union the artist can know the "spiritual essence" of his subject, which according to Chang Dai-chien was "of first importance to the artist."

In his quest for monumentality, layered meanings, and radiance, Chang Dai-chien began searching China's artistic past for examples of beauty forgotten. Chang held the principle of *fugu*, or returning to the past, as the foundation of his personal creativity. This principle is intimately linked with the tradition of copying ancient art, which Chang Dai-chien credited as the basis of his successful career. He explained:

> To study painting, first select one old master and carefully choose from his works to build a foundation [for yourself], then gradually study other famous masters to expand your horizons . . . ultimately transform the old masters' styles into something personal, thus creating an independent, individual style.

Whenever Chang Dai-chien felt his art was growing stale, he delved further back in China's art history in search of neglected styles. In the early 1940s, after he had learned the techniques and subject matter of the Yuan through Qing dynasties, he found inspiration in the Tang dynasty murals in the caves at Dunhuang. In these Buddhist murals the disciplined, "iron-wire" outlines filled with rich colors were a refreshing change from the fluctuating calligraphic brush strokes and soft washes of color he had previously mastered.

When Chang felt the need for a new challenge, after he had perfected the meticulous, decorative manner of the Dunhuang caves, he looked again to the past. His splashed-ink-and-color paintings were derived from the nearly forgotten splashed-ink, or *pomo*, technique that some Tang dynasty eccentrics had promulgated. By adding color, Chang developed a semi-abstract style that he believed was based in China's past. He observed, "During every period in Chinese painting, what is newest is that which has come down from the past."[7]

The Artistic Tradition of Imitation and Forgery

In China, artists learn painting and calligraphy by copying ancient masterworks. Before photography, meticulous freehand imitations were the best assurance that perishable works of art would be preserved and circulated. The value of copying as a pedagogical tool brought it to a level of honor in China, although there were always dissenting voices. In the long history of Chinese art and literature, the debate over the intrinsic value of copying has been one of the most contested

issues, and until the beginning of the twentieth century, the proponents of copying were a powerful majority. This majority, which included Chang Dai-chien, insisted that studying the ancients and copying their works provided the insights and techniques essential for personal expression.

The value of copying as a method of learning is perhaps most easily understood in the case of calligraphy. When writing a Chinese character, a student learns by rote the combination of dots and lines and the proper order in which to brush them. By reproducing the work of masters—first copying individual elements and then whole components—a student learns to recognize patterns and the difference between good and bad calligraphy. Gradually the student is able to work independently, inflecting a personal cadence into the brushwork.

Copying is not, however, merely a stage in learning; it is valued in itself. This value is difficult for Westerners to appreciate. Western attitudes generally maintain that copying is evidence of a lack of imagination and forgery is fraud. It is perhaps only in the performing arts that the combination of repetition and originality are appreciated. An actor may gain distinction for reciting a Shakespeare soliloquy; in playing or copying a work that has been performed thousands of times, a musician is judged on personal interpretation. Success on the stage depends on technique and imagination, and these are equally important in the visual arts. The Chinese recognize that copying allows an artist—whether painter, calligrapher, actor, or musician—to benefit from cumulative experience. They embrace the idea that the past can fructify the present. In China it is a major challenge for an artist to renew the past, just as in the West it is a triumph for a musician to make Beethoven live again with each performance.

Chang Dai-chien elaborated on his position on the value of painting copies.

> If you want to learn painting, you must first become skilled at making detailed copies of ancient masterpieces; the time you spend making stroke-by-stroke copies will result in your familiarity with how to make all kinds of outline and texture strokes and allow you to understand all the rules and methods of painting.[8]

And in the comments that Gao Lingmei published, Chang defended the practice.

> Those who criticize copyists of ancient paintings by claiming that they are dependent on someone else are quite shallow and base. Copying is very similar to studying and memorizing texts or studying examples of calligraphy. Have you ever seen anyone who can compose a good essay who has not read and memorized books, or met someone who has a good hand but has not practiced copying a range of calligraphers?

Chang once stated: "You should not study just one painter or limit yourself by choosing only models whose styles fit your own personal bent. Think analytically and take the essence from famous works, then you must transform them."[9] Transformation is the difference between merely copying and challenging the past. But to achieve the ultimate level of transformation, Chang cautioned that an artist had to study his model from the inside out and seek the original creative spark. In order to do this Chang believed it was necessary to not only replicate but also manipulate the constituent elements in a model. Chang instructed his student Hu Yan: "Choose a painting and hang it up and then follow these three steps: first, make a reduced-size copy of the model, then make an enlargement of the original. Last, make a copy the same scale as the original, trying to reproduce it exactly."[10]

This was the three-stage process Chang had used to teach himself how to copy a painting. Altering the scale of the original in the first two steps was Chang's own approach to the practice of copying, an exercise similar to music students playing the same work in different tempos or Western art students drawing objects using a range of proportions and perspectives.

Throughout his career, Chang Dai-chien continued to copy works he admired, though there are proportionally more copies from his early years. He even applied the principle of copying to his own work, typically creating more than one version of a painting (with the exception of his splashed-ink-and-color compositions). Many of Chang's contemporaries, perhaps under the influence of the West, worried that copying limited creativity. Yet while they eschewed this practice, they often fell into mindless repetition of the prevailing fashion. Chang Dai-chien's solution of *fugu,* or returning to the past, enhanced his creativity, but only because he accepted copying as a viable artistic tradition.

The difference between a copy and what is thought of in the West as its "criminal sibling," forgery, is not always clear.[11] The major distinction is in the copyist's intent—any copy might be turned into a forgery under certain circumstances. In Chinese art there are three major categories of copies, and Chang Dai-chien practiced all of them. The first category is *lin* (close copy), in which an artist confronts an original and imitates it as closely as possible without the aid of tracing or mechanical means. Chang's *Clear Morning over Lakes and Mountains* (entry 43), a copy of a work by Liu Daoshi (act. 10th cent.), is a good example of *lin*. The second type of copy is *fang* (free-hand imitation), a method that involves a slightly greater degree of personal interpretation than the first. In spite of the fact that Chang called *Blissful Old Age* (entry 18) a close copy (*lin*) of a work by Zhu Da (1626–1705), it is an

example of a free-hand imitation. A third category of copy is *zao* (creative reinterpretation), in which a copyist assumes the style of an ancient master to paint a "new" work instead of reproducing something in the master's extant corpus. Each of Chang's *Four Mounted Fans* (entry 8) is an example of *zao*. These terms are sometimes randomly interchanged or, as in the case of *fanglin,* combined.

An artist may sign any type of imitation with his own name and/or an acknowledgment of his source. But often a copy will have no signature, or alternatively the artist may copy the signature of the ancient master alone. If the purpose of signing the ancient master's name is deceitful, then the copy is a forgery, or *wei* (see entries 1, 6, 11, 12, 16, 42, and 45). If the copyist falsely antiques the paper or silk and adds spurious seals and bogus inscriptions in order to sell the work at an exaggerated price, such a work is considered a forgery both in the East and West. The notion of "buyer beware" is stronger in China than in the West; it is not so much the seller's responsibility to guarantee authenticity as it is the buyer's to recognize it. Chang Dai-chien produced forgeries for a variety of reasons: to express his admiration for an ancient master, to test his personal skill, to assess someone else's connoisseurship, or to make a profit.

Anecdotes of Chinese artists from the past reveal that the motives for copying and forgery in China are historically complex and that traditionally forgery has even been admired in certain circumstances. One of the earliest stories tells about Wang Xianzhi (344–386) forging the calligraphy of his father Wang Xizhi (ca. 303–ca. 365), who has been immortalized as the calligraphy sage.

> Before Wang Xizhi left for the capital he wrote an inscription on the wall that Zijing [Wang Xianzhi] secretly erased and replaced with his own version, all the while congratulating himself that his writing was close to his father's. When Xizhi returned home and saw the inscription he sighed and said, "When I left I truly must have been very drunk." Zijing felt privately ashamed.[12]

Many incidents concerning forgeries are associated with the master calligrapher, painter, theoretician, and art collector Mi Fu (1051–1107), who recorded such events in his *Shu shi* (History of Calligraphy).

> Every time I go to the capital, Wang Shen [ca. 1046–after 1100] invites me to his residence to review a stack of calligraphy with him and he asks me to copy [*lin*] some of the pieces. When I was looking through the paintings and calligraphies in his storage cabinet, I spotted my own copy of Wang Zijing's [Wang Xianzhi] *Flock of Geese,* the hemp-fiber paper of which [Wang Shen] had had dyed and creased to look antique. My copy had been mounted with brocade and jade knobs on the roller;

colophons, which had been cut from [genuinely ancient] calligraphies had been attached to my copy. I also saw that my copy of Yu Shinan's [558–638] writing had been dyed, mounted, and given to men of stature, who were asked to write colophons for it. When I saw this I laughed, but Wang Shen grabbed it from my hand.[13]

While Mi Fu's "honest" copies were being turned into forgeries behind his back, he was producing other imitations, whose purpose was to test both his own skill as a calligrapher and his audience's level of connoisseurship.

> Mi Yuanzhang [Mi Fu] was especially skilled at copying [*lin*], even to the point that his copies were confused with the originals. He frequently borrowed ancient works from other people in order to copy them. He would return the original and his copy together to the owners and instruct them to pick out the original, but usually the collector could not distinguish between them.[14]

Another story about Mi Fu illustrates the tolerance and admiration for imitation—including forgery.

> The son of Chen Boxiu [late 11th cent.] . . . loved to practice calligraphy. Once he took a small screen and made a free-hand imitation [*fang*] on it of Mi Yuanzhang's [Mi Fu] calligraphy. . . . One day Yuanzhang came by, and when he saw it he was startled. . . . Yuanzhang was so delighted [that he instructed Chen in the methods of calligraphy].[15]

These examples refer to calligraphy, but the same attitudes are true for painting. A seventeenth-century record by Zhou Lianggong (1612–1672), the major patron of the period, reveals that the art of making forgeries could promote a painter's recognition.

> Wang Shigu's [Wang Hui; 1632–1717] . . . imitations [*fanglin*] of Song and Yuan dynasty [masters] hardly differ [from the originals]. The people in Wu used to ask him to paint and then mounted his paintings in the fashion of old master's works, thus making forgeries [*wei*] to fool the connoisseurs. Even those who were experienced connoisseurs did not realize the work was by a contemporary. . . . Shigu is a great genius and his experience full; therefore, when he puts his brush to paper he can stay abreast of the ancients. He is the greatest to have appeared in a century.[16]

Zhou Lianggong so admired Wang Hui's mimetic skill that it was the first accomplishment he cited in recognizing the painter. Likewise, Chang Dai-chien received early recognition as a forger, especially of Shitao's work, and Chang used this notoriety to promote himself. In the early 1920s, when the famous connoisseur and painter Huang Binhong mistook Chang's *Through Ancient Eyes, Signed as Shitao* (entry 1) for

an original, Chang realized what could be gained by making forgeries.

Chang Dai-chien could visualize paintings that he had only briefly seen years before, an ability that enabled him to make copies of many works as a training method to learn ancient styles. He also remembered collectors' seals and colophons on the ancient works he had seen, thus making it easy to turn a copy into a forgery whenever he so desired.

In the early 1930s Chang Hsueh-Liang (b. 1898), a powerful military official who collected ancient paintings, realized that he had several forgeries by Chang Dai-chien, and so he invited the artist to a banquet. He introduced Chang by saying, "This man is a specialist in imitating the works of Shitao. My painting collection contains many false works by Chang."[17] Contrary to the Western expectation, Chang Hsueh-Liang's introduction was a compliment. A long friendship grew out of this meeting, and Chang Dai-chien painted several works for his friend, including *The Sound of Autumn* (entry 15) and *Illustrated Menu* (entry 83).

Late in life Chang Dai-chien still used his ability as a copyist-forger to gain recognition and satisfaction. In 1968 the University of Michigan Museum of Art, which had organized an exhibition of Shitao's work, invited Chang to attend a symposium. While there, Chang delighted in pointing out that several paintings in the exhibition were his own copies. At a lecture on Zhu Da given by Aschwin Lippe of the Metropolitan Museum of Art in the 1960s, Chang, although he could not understand English, rose several times during the slide presentation to excitedly claim an image as his work. Not only was Chang proud of his forgeries of Zhu Da, but also it was a joy for him to point out how he had fooled the audience of scholars and connoisseurs. Chang Dai-chien used forgery as a way to compete with the ancients, and as Zhou Lianggong said of Wang Hui, to "stay abreast" of them. The only objective way to measure such accomplishment was the reaction of esteemed connoisseurs.

Chang Dai-chien's purpose in making forgeries changed according to the situation: recognition, self-challenge, and testing others were the initial motivations to turn the "honest" copies, which he made to train himself, into forgeries. But a desire for profit followed. Ever since the open art market began to flourish in the late Ming dynasty, forgeries have proliferated. The practice was so pervasive in the seventeenth century that people even wrote poems and plays about art forgery, and Chang was tempted to enter this ethos.[18] After 1925, it occurred to him that he could make money by forging art. That year he stopped accepting financial support from his older brothers, whose shipping business had to pay steep reparations for a boat accident. Chang was a spendthrift and his

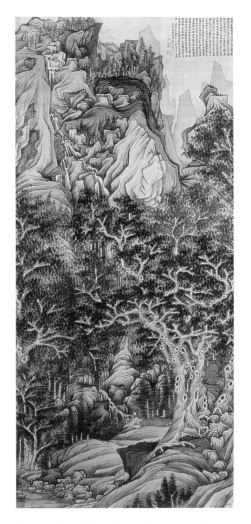

Fig. 14. Chen Hongshou, *Mountain of the Five Cataracts*. Hanging scroll; ink on silk; The Cleveland Museum of Art, John L. Severance Fund, 66.366.

passion for collecting ancient art was greater than he could support by sales of his paintings. Chang began to sell his forgeries, using the money to purchase ancient paintings, which he would copy and learn from; thus, he felt he was following the ancient adage "to take a painting and exchange it for another."

Chang Dai-chien's reputation as a forger has reached almost legendary proportions; consequently, scholars are both tempted to invoke his name and wary of suggesting that problematic paintings may be his forgeries. Any unusual ancient Chinese painting is in danger of being dismissed as "another of Chang Dai-chien's forgeries."

Chang was, in fact, so good at imitating the styles of ancient painting and calligraphy, and his range was so broad, that it is difficult to securely identify his forgeries. Yet doing

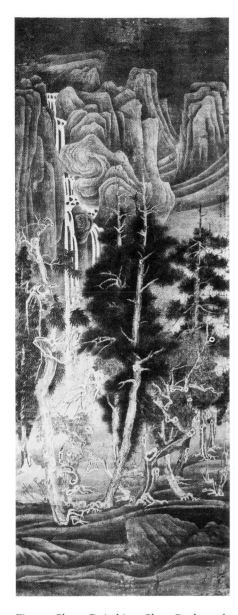

Fig. 15. Chang Dai-chien, *Sheer Peaks and Deep Valley, Signed as Wang Shen*. Hanging scroll; ink and color on silk; collection unknown. Special thanks to Carl Nagin for bringing this photograph to the author's attention.

not suppress even when trying to recall exactly the manner of an ancient master. The forgeries fall into line with Chang's general development as a painter, for he used the same models for his creative interpretations and his contemporaneous forgeries. The ancient masterpieces he acquired for his personal Dafeng Tang collection suggest both his current interests and the kinds of forgeries to look for at any given time. Chang also tended to produce more forgeries in times of personal financial hardship, so that the acquisitions of Chinese paintings by museums and collectors during those years deserve close scrutiny.

Chang's genius probably guarantees that some of his forgeries will remain undetected for a long time to come. By creating "ancient" paintings that matched the verbal descriptions recorded in catalogues of lost paintings, Chang was able to paint forgeries that collectors had been yearning to "discover." In some works, he would transform images in totally unexpected ways; he might recast a Ming dynasty composition as if it were a Song dynasty painting. For example, Chen Hongshou's (1598–1652) *Mountain of the Five Cataracts* (fig. 14) reappears as a painting ascribed to the eleventh-century painter Wang Shen in Chang's *Sheer Peaks and Deep Valley, Signed as Wang Shen* (fig. 15).

In the course of his career Chang Dai-chien imitated ever earlier artists, but during the 1920s and 1930s the models for his forgeries were mostly from the Ming and Qing dynasties and only occasionally from the Yuan and Song dynasties. Chang forged the works and style of Shitao most of all. Some of the other artists whose works he copied and forged during this period include: Jin Nong, Hua Yan, Li Shan, Gao Fenghan, Zhu Da, Mei Qing, Kuncan, Hongren, Zhang Feng, Dai Benxiao, Gong Xian, and Cheng Sui of the Qing dynasty; Huang Daozhou, Ni Yuanlu, Chen Hongshou, Dong Qichang, Chen Shun, Xu Wei, Tang Yin, Qiu Ying, Lin Liang, and Wu Wei of the Ming dynasty; Sheng Mou, Wang Meng, and Zhao Mengfu of the Yuan dynasty; and Lou Guan, Liang Kai, Ma Lin, Yi Yuanji, and Mi Fu of the Song dynasty. Chang's favorite models when forging calligraphy were Jin Nong, Gao Fenghan (especially his left-handed works), and Xu Wei, along with some other less accomplished Ming and Qing dynasty artists, such as Chen Zhenhui, Mao Xiang, Fang Yizhi, and Hou Fangyu.

Chang Dai-chien's sojourn at Dunhuang from 1941 to 1943 was a watershed. When he returned from studying the Tang dynasty paintings there, he concentrated on early masterworks. Coincidentally, the dispersal of paintings after World War II created opportunities to see and purchase many ancient scrolls, thus pushing Chang in a new direction for both his independent work and his forgeries. Although he is

so refines scholarly understanding of genuine paintings and of Chang's development as a modern painter. Moreover, his forgeries are further evidence of Chang Dai-chien's accomplishments as an artist.

The forgeries must be studied in combination with "honest" copies, such as *Blissful Old Age* (entry 18) and *Clear Morning over Lakes and Mountains* (entry 43), which help establish idiosyncrasies in brushwork and coloring that Chang could

much better known for his forgeries of the later periods, he made a considerable number of fine "Tang" and "Song" dynasty paintings (see App. 2).

Chang Dai-chien's earliest forgeries were purchased by Chinese and Japanese private collectors in the 1920s and 1930s. Chang needed money when he left China in 1949; because his Chinese patrons were also facing hard times, the market for his original work shrank. The costs of relocating his large household were so pressing that in 1952 he sold some of his favorite paintings from the Dafeng Tang to Asian collectors and even (through middlemen in Hong Kong) to the Chinese Cultural Relics Bureau. Even these sales did not fulfill his financial needs, and so Chang began to sell other paintings from the Dafeng Tang to Western museums. Collecting Chinese art was a new field in the United States; consequently, the prices were disappointing. Moreover, museums were uneasy about buying some of the paintings in Chang's collection simply because the works were anonymous. Chang reckoned that a signed work by a known master brought the best price, and he found that his forgeries fared well. During the 1950s, Chang produced imitations of works by famous artists of the Tang, Five Dynasties, and Northern Song periods. He passed the works through Chinese and Japanese dealers, often in Hong Kong or New York.

Chang Dai-chien had methodically developed the skills and acquired the materials he needed to make forgeries of ancient art. He collected old paper, silk, and ink, so a technical analysis of his materials would suggest an ancient date. From his textile training in Japan, he taught himself to prematurely age and darken silk and paper. Chinese paintings are typically mounted into scrolls or sometimes framed Western style, but even so they must be backed with paper and have silk surrounds added, as is done in making a scroll. Chang had the help of skilled craftsmen for this task. While still living in China, Chang had often visited Zhou Longcang in Suzhou, whose skill at mounting new paintings to look old, by using old silks and adding marks of wear, was exceptional. In Brazil, Chang Dai-chien asked a professional mounter to join his household.

At the beginning of his career Chang carved his own name seals and copies of ancient seals, but as he produced more forgeries, he hired seal engravers to assist him. The quality of Chang's already impressive fake seals improved when he began photographing genuine seal impressions and making photoengraved seals that perfectly reproduced the originals. Chang ultimately had at least 970 fake seals. The majority were Ming and Qing dynasty collectors' seals, but there were also early seals and some imperial seals in his collection. For the famous Ming collector Xiang Yuanbian (1525–1590),

Chang had about one hundred fake seals, with at least forty-seven different legends (see entry 45). He also manufactured name seals of about thirty different artists. Except for the infamous forgery workshop of Tan Jing, which was active during the 1930s in China, few seal collections could equal what Chang Dai-chien had fabricated.

Materials and Tools

For both his forgeries and his original work, Chang Dai-chien believed that the tools and materials he used to create a painting played an important role in the success of the work. He studied paper, ink, brushes, pigments, seals, seal paste, and scroll mountings in exacting detail. When he wrote an inscription on a painting, he sometimes included a postscript describing the type of paper, the age and origin of the ink, or the provenance of the pigments he had used.

Chang ordered his painting materials in bulk from a few trusted craftsmen, frequently commissioning special orders for a particular type of paper or brush. Indeed, Chang spent considerably more money and effort than most artists on supplies; few other artists have a comparable record for consistently using the highest quality materials.

Chang discussed paper and ink in some of his comments on painting techniques. In 1938 Chang went to the Qingcheng Mountains, near Chengdu in Sichuan Province, to escape from some of the major battles of the Sino-Japanese war. Chang preferred to paint on *xuan,* an absorbent vegetable-fiber paper, the best of which was made in Anhui Province. *Xuan* was unavailable in the Qingcheng Mountains during the war, and so Chang invited a chemist friend to Jiajiang, Sichuan's papermaking center, in hopes of improving the local paper. Their experiments were successful, and Chang was able to use Jiajiang paper for his painting and calligraphy without sacrificing quality. The innovations Chang and his friend engineered resulted in a permanent improvement in the quality of Jiajiang paper.

After Chang expatriated, he once again had to find new sources of paper. He tested paper made in Thailand, and when he was living in Darjeeling, he used paper from Nepal. But Japanese papermakers provided the closest substitute for Chinese paper, which is absorbent and strong enough to resist tearing, even from the tension of sweeping brush strokes. Chang specially ordered from Japan handmade paper bearing the watermark "Dafeng Tang." In the last years of his life, in Taiwan, he occasionally used paper made with unusual fibers, such as pineapple leaves.

Ink was of special concern to Chang Dai-chien. On his way

home from a trip to the Yellow Mountains in Anhui Province, he stopped at Shexian, the most famous producer of inksticks in China. He placed an order for custom-made inksticks with the inscription "Returning Home from the Yellow Mountains." Chang also collected antique inksticks, but while most collectors of Ming dynasty and Qianlong period (1736–1795) specimens treasure and display their inksticks as they would a porcelain or painting, Chang actually ground the ink and used it to paint. Admirers and connoisseurs often presented him with antique inksticks, although after receiving one such gift, Chang asked his secretary to write a thank-you note and dictated the line, "Old Man [Dai-]chien has himself collected enough [ink] to last a lifetime."[19]

Chang Dai-chien cherished particular types of brushes, believing the correct brush would make possible a virtuoso performance on paper. After he left China, Chang used Yang Zhenhua brushes, which he ordered in large batches from Hong Kong; these animal-hair brushes hold their point particularly well. Precise manufacture and careful selection of quality hair affect the ability of a brush to soak up ink and, when pressed to paper, release the inky fluid in smooth lines. For Chang, who was so concerned with line quality, a good brush was crucial to his art. He also ordered brushes from Japan. On a visit to England, Chang was introduced to a special paintbrush made from the hair of an ox's ear. The material delighted Chang, but he was not satisfied with the construction of the Western brush so he had the ox hairs shipped to Japan for his trusted brush makers to use in traditional Eastern brushes. He named the new product "Leader of the Art World."

Chang Dai-chien's manufacture and collection of spurious seals has already been discussed; however, he also generated a large assortment of personal name seals. As his time to carve seals was limited, he commissioned most of them from the professional carvers of the day. He was fastidious about the overall appearance of each seal as well as the engraving of the calligraphy legend. Chang became a connoisseur of seal paste and studied the placement of seals on paintings to be sure he could impress his seal so as to augment the painted image.

Chang Dai-chien was so particular about the mounting of his work that during several periods of his career he had a scroll mounter in his household. After 1950 Chang often took his paintings to Japan to have them mounted, since Japanese methods are similar to those used in China. But Chang always personally discussed his requirements before entrusting a painting to the Japanese mounters. He specified the weave, pattern, and color of the silk that would surround the painting, as well as the scroll knobs and the size and proportions of the painting borders. Such intimate involvement in the mounting process ensured that the Japanese craftsmen achieved almost the same effect as Chinese mounters. From beginning to end, Chang Dai-chien's paintings reflected his personal standards and tastes.

Collecting Ancient Masterpieces

Chang Dai-chien's belief that an artist should copy the best master paintings to build his skills required familiarity with a corpus of major works. For Chang, this requirement became an addiction. His voracious appetite for collecting led him to establish relationships with all the major dealers in China, Japan, and Hong Kong, and to embark on numerous quests for works owned by private collectors. He once crossed the country, north to south, in pursuit of *Rock and Fungus of Immortality* (collection unknown) by Shitao that he had heard was available. Each time he got close, he learned it had been resold. Chang acquired the greatest number of works while he lived in China, but he continued collecting until the late 1960s, not long before he moved to the United States. He sold his own paintings and forgeries to finance his passion for collecting. Only after he moved to Taiwan, a few years before his death, did Chang stop acquiring new works.

From 1955 to 1956 Chang published reproductions of the ancient paintings in his collection in four volumes called *Dafeng Tang mingji* (Masterpieces of the Dafeng Tang). Printed in Japan, the set initiated a vogue for publications of private collections. In the preface Chang explained his passion for collecting.

> If I come across a treasure, I realize I absolutely must have it for my own collection; in fact, I feel like my life depends on making the acquisition and day and night I dream of it. I am willing to go into debt if need be; it is hard to change this old habit and yearning. My addiction for collecting [paintings] is like Mi Fu's [of the Song dynasty].[20]

Even as a young artist in 1920, Chang was already a formidable collector, acquiring a rare masterwork by Ni Zan (1301–1374) called *Twin Trees by the South Bank* (fig. 16).[21] The ethereal, dry brushwork and unrestrained mood of this work are especially prized. *Twin Trees* is among the few works attributed to Ni Zan that is generally accepted to be genuine, and Chang's astuteness in acquiring it is powerful testimony to his skill as a connoisseur. In 1951 Chang wrote a colophon on the *shitang* (sheet of paper above the painting) explaining the circumstances of the acquisition.

> This is a genuine work from the brush of the lofty scholar Ni; I bought it in 1920 when I went to Sichuan to see my family. I

purchased it from Lu Xuetang in Yuzhou [Chongqing]. At the time I was just beginning to collect paintings and calligraphies, and this cost me three thousand cash. I took it with me to Shanghai for my late teacher Zeng Xi to appreciate. He admiringly said, "My student is just at the threshold of adulthood and his connoisseurship is already this good, so my studio is augmented by his presence."

War and political instability exacted a heavy toll, however, and several times Chang had to rebuild his collection. He lost the bulk of his first collection in the 1930s when the Japanese occupied Suzhou, where he had lived with Chang Shanzi and was storing the paintings in Wangshi Yuan. Dai-chien had left the collection in his brother's care as he traveled, but Shanzi was forced to evacuate Wangshi Yuan so quickly that he could not take the paintings with him. Only the works that Chang had with him in Peking were preserved. He was able to save them from the Japanese because a German friend who had a car helped him remove the paintings and ship them to Shanghai. From there Chang took them to Sichuan.

The end of World War II provided Chang Dai-chien with unparalleled opportunities for acquiring art. When the Qing dynasty collapsed in 1911, a few ancient paintings had illicitly entered the market from the palace collection, but the real boon occurred when Puyi sold some of his most remarkable holdings following the dismantling of the Manchukuo government at the conclusion of the war. Moreover, private collectors seeking to recoup war losses were unusually amenable to selling major pieces that had been in family collections for decades and even centuries. This availability of ancient paintings was timed just right for Chang Dai-chien, who could once again travel freely in Shanghai and Peking. By 1945, Chang was a well-established painter and connoisseur with the knowledge, contacts, and financial resources to acquire major works of art.

When Chang first returned to Peking in 1946, he intended to buy a house with his savings, but he abandoned the idea when he saw the selection of ancient art that he could buy. Through a broker he purchased two masterpieces that came from Puyi's palace in Changchun, Manchuria (now Jilin Province). The first, *The Xiao and Xiang Rivers* (fig. 17), is attributed to Dong Yuan (act. 937–976) and depicts the fertile hills of Jiangnan—literally China's "south of the [Yangzi] river" region. Dong Yuan's long, "hemp-fiber" texture strokes would become one of Chang's most expressive landscape idioms. The second masterpiece was *The Night Revels of Han Xizai* (fig. 18) attributed to Gu Hongzhong (act. 943–960). *Night Revels* is a most exquisite and delicately colored figure painting, a perfect model for Chang in developing his technique for fine-line drawing and precise coloring.

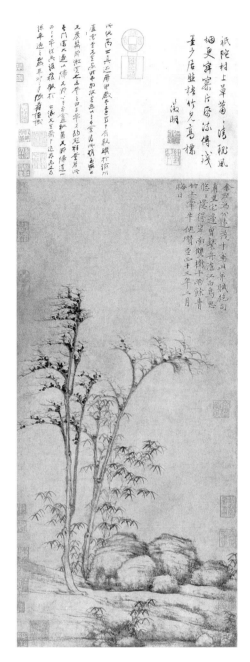

Fig. 16. Ni Zan, *Twin Trees by the South Bank,* 1353; colophon above painting by Chang Dai-chien, 1951. Hanging scroll; ink on paper; The Art Museum, Princeton University, gift of Mr. and Mrs. Wen C. Fong in honor of Mrs. Edward L. Elliott, y1975-35.

On occasion, especially when he needed cash to build his garden in Brazil, Chang Dai-chien sold paintings from his collection, but he seldom bought art as an investment. He collected paintings as a way of inviting the artists of the past into his studio to teach him. His collection was a yardstick

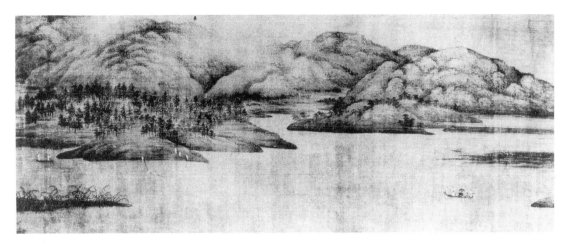

Fig. 17. Attributed to Dong Yuan, detail, *The Xiao and Xiang Rivers*. Handscroll; ink and color on silk; Palace Museum, Peking. From *Dafeng Tang mingji*, vol. 1 (Kyoto: Benrido Co., 1955–56), pl. 4.

against which Chang measured himself. Whenever he traveled on a trip of any length, he took some ancient masterpieces with him, not to ensure their safety but simply because he did not want to be without the inspiration of the old masters.

In Chang's preface to the first volume of *Dafeng Tang mingji,* he explained the second time his beloved collection was dismantled.

The paintings that I collected in Sichuan were scattered by the turn of events in 1949. . . . I packed what I could in my luggage and took them with me, always adding to the collection on my way. The pieces date from the Tang to Qing dynasties, and they have been carefully selected. A total of thirty-seven artists are represented in thirty-eight works . . . but this is less than one percent of my old collection.[22]

To have a collection of nearly four thousand paintings sounds like hyperbole, but Chang Dai-chien's life is marked by excesses and extremes.

Chang Dai-chien is incontestably a giant among twentieth-century collectors, and museums in China and the West have many fine works from his collection. His collection was never published in its entirety. In 1944, the year after Chang Dai-chien returned from Dunhuang, he prepared an unillustrated catalogue of his collection, *Dafeng Tang shuhua lu* (Record of Paintings and Calligraphies in the Dafeng Tang), and had his students, sons, and nephews record the measurements, inscriptions, and colophons of each work. One hundred ninety-four items were included. But an exhibition of Chang's collection of ancient paintings and calligraphies sponsored by the Chengdu City Council on March 15, 1944, included several works not in Chang's catalogue.

The four-volume publication from 1955–56, *Dafeng Tang mingji,* is an illustrated catalogue that includes paintings Chang took with him when he left China in 1949 and works

he had bought since then. The second volume is devoted entirely to the paintings and calligraphy of Shitao and expresses the depth of Chang's admiration for this artist. There are ten hanging scrolls, five handscrolls, and forty-two album leaves from five albums reproduced in this volume. These fifty-seven items were not all the works by Shitao that Chang owned; current research now suggests he may have had close to one hundred.

The third volume of *Dafeng Tang mingji* reproduces works by Zhu Da, including seven hanging scrolls, three handscrolls (one of which is eight album leaves mounted as a handscroll), and fifty album leaves from five albums. Again this is only a portion of Chang's lifetime collection of Zhu Da.

The fourth volume of *Dafeng Tang mingji* illustrates forty works from the Tang dynasty and Five Dynasties period up to the Qing dynasty. Ironically, when *Dafeng Tang mingji* was published, Chang had already sold some of the paintings to museums and private collectors such as the late John M. Crawford. Crawford formed the basis of his important collection, which he bequeathed to the Metropolitan Museum of Art, New York, with works Chang had collected. Crawford also unwittingly bought some of Chang's forgeries, such as *Through Ancient Eyes, Signed as Shitao* (entry 1) and *Wenshu Plateau in the Yellow Mountains, Signed as Mei Qing* (entry 6). However, Chang never reproduced his forgeries in *Dafeng Tang mingji.*

When Chang Dai-chien was living in Brazil, he listed two hundred ancient paintings in an unillustrated catalogue; some titles repeated paintings in his earlier catalogues, but there were many new entries. In 1983, Chang Dai-chien's will announced the presentation of his private collection to the National Palace Museum, Taipei. This bequest included seventy-five paintings attributed to various Tang, Song, and Yuan dynasty masters. The most important was the Dong

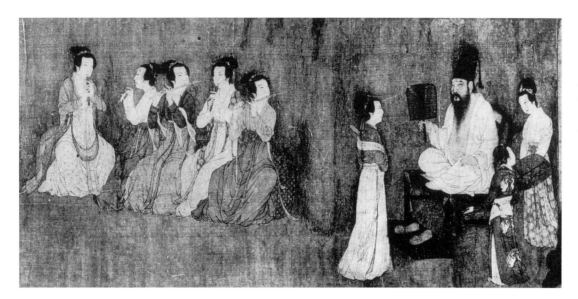

Fig. 18. Attributed to Gu Hongzhong, detail, *The Night Revels of Han Xizai.* Handscroll; ink and color on silk; Palace Museum, Peking. From *Dafeng Tang mingji,* vol. 1 (Kyoto: Benrido Co., 1955–56), pl. 5.

Yuan attribution, *Along the Riverbank at Dusk* (see fig. 95). Many paintings in this generous gift are minor, including Japanese copies of ancient Chinese paintings that Chang purchased in Japan and some of Chang Dai-chien's own forgeries (see App. 2).

Chang Dai-chien's versatility as a painter was enhanced by his passion as a collector and connoisseur, and he considered himself the best judge of painting in five hundred years. Obviously his attitude toward ancient art was different from that of many of his contemporaries, who believed that ancient art was undesirable baggage and never entertained the notion of collecting it. Chang, however, passionately absorbed the art of the past. By surrounding himself with ancient masterpieces, he deepened his appreciation and connoisseurship of painting and reinforced his technical training. His phenomenal Dafeng Tang collection was like a laboratory in which he could study the development of various styles and observe the spiral pattern of history, where style after style built one upon another and each innovation called for a new synthesis.

Photography

Chang Dai-chien's belief that a painter should train by copying ancient models did not limit his willingness to adopt new methods and devices. He was one of the first artists to use a camera, a gadget that was still new in China at the beginning of the 1930s.

Lang Jingshan, whose work was acclaimed in China's first photography exhibition, became a close friend of Chang Dai-chien and Shanzi; when they were living in Suzhou during the early 1930s, Lang was a frequent guest. There is no evidence that Lang Jingshan taught Chang Dai-chien the art of photography, but they enthusiastically discussed art and aesthetics so it seems likely that Lang encouraged Chang. Conversely, after their friendship was established, Lang's photography became more painterly; sometimes Lang made photomontages, superimposing a scene from one photograph onto another.

Chang Dai-chien's first known photographs date to 1931 from his second trip to the Yellow Mountains. Chang and Shanzi took a hand-held camera and a tripod model and shot more than three hundred pictures. The film was developed by the well-known professional, Zou Jingsheng, who said that not a single frame was wasted or poorly composed. He declared that Chang Dai-chien had the potential to become a professional photographer.[23]

That same year Chang and Shanzi published twelve of their best photographs from this trip as a folio set called *Huangshan huaying* (Photo Impressions of the Yellow Mountains). One of the landscapes that Chang photographed served as the prototype for the mounted fan *In the Style of Hongren* (entry 8) and provides evidence for dating the work to 1931–32. An inscription along the border of each print includes a title and sometimes the date. Chang also submitted one of his photographs to the World Expo in Belgium, where he took the gold prize. The subject was the marvelous "cloudsea" in the Yellow Mountains; Chang demonstrated an exceptional command of the interpretive qualities of black-and-white photography—the contrast of highlights and shadows, shapes, textures, and patterns.

Chang produced a second photo folio in the 1930s of Mount Hua, but later in the decade, on a trip to Mount Emei with Huang Junbi, Chang's interest in taking photographs began to wane. He did not bring a camera with him, but he advised Huang on the best views to photograph.[24] As Chang's fame increased during the next decade, professional photographers and photojournalists began to accompany him on his trips, and he relied on their photographs to serve as a record. Chang used his time to confront the landscapes directly and make sketches.

Chang's instant success in creating dramatic tonal intensities in black-and-white photography is directly related to his skill in painting with ink. He believed that photography was a valuable tool for a painter and examined what it could provide that painting could not. At the same time, Chang maintained that painting had an ineffable quality which more closely captured the spirit of the subject than photography.

It is fundamental when you paint an object not to seek too close a correspondence, but at the same time you must not deliberately try to avoid resemblance. In the achievement of mimesis, painting naturally does not equal photography, but if you try to make something unrecognizable, why bother to paint it at all? Somewhere along the continuum from accurate resemblance to fictional representation, [the painter] can capture the spirit and transcribe the spark of heaven.[25]

Examining early twentieth-century photographs, Chang recalled the centuries-old adage of Chinese painters that "distant water has no waves, distant mountains have no texture, and distant people have no eyes," and he recognized that this saying was borne out by the camera. When camera technology advanced, Chang was thrilled by the zoom lens, which provided him with a fresh interpretation of Shitao's paintings.

Shitao had a unique method of sometimes reversing things and he would paint the foreground in a blurred, amorphous manner almost as if it were a void; but he would paint the midlevel and background clearly and realistically. . . . This is like a zoom lens on a camera; if [the camera lens] focuses on the distance, [then what is far away] becomes clear and the foreground naturally will become blurred.[26]

Until the end of his career, Chang Dai-chien continued to turn to the compositional and lighting solutions of photography as inspiration for his painting. Many of his landscapes are cropped top and bottom—a view he may have first seen through the lens of a camera. His ability to integrate concepts from photography into Chinese paintings is an example of the paradox of his career as a modern traditionalist.

Painting from Life

Chang Zhengheng was about seven years older than her brother Dai-chien, and she tutored him in scholastics and flower painting, her specialty. One of Chang Dai-chien's clearest memories was being handed a bunch of flowers by his sister, who insisted that he examine their structure petal by petal so that he could understand each part of the flower. This training in *xiesheng,* or painting from life, stayed with him throughout his life, and he often stopped and examined the physical attributes of his subject before he painted it. Conversely, he sometimes painted in sweeping brush strokes whose rhythm suggested (rather than accurately drafted) the structure of the flower or fish that was his subject. In the early 1930s Qi Baishi once pointed out Chang's errors in painting more than six joints in a shrimp's exoskeleton and, in Chang's painting of a cicada on a willow branch, in depicting the cicada in an unlikely pose.[27] From this time on, Chang made a concerted effort to follow nature in painting flowers, insects, and animals, although he also maintained that anatomy could be rendered in an impressionistic way.

In the late 1940s one of Chang Dai-chien's students recorded how he painted a flower new to him.

[First Chang] took the flower and dissected it, pulling apart the petals, calyx, and stamens, which he placed on the painting table so that he could study them until he thoroughly apprehended the flower's structure. Then he looked at how the flower was positioned on the branch and from what angles it looked best, before lowering his brush to paint it. When Chang painted a subject directly from nature he not only considered the details of the flower and its leaves, but also the stem, branch, or trunk.[28]

Instructing his students in flower painting, Chang Dai-chien explained:

For each type of flower that you choose to paint, you must learn to convey each stage of development—from a sprout first coming up, to the advent of small buds, to when the leaves burst forth and the flower appears. You must present in their entirety the nuances of each flower's individual beauty and demeanor and the manner of its growth.[29]

Chang's emphasis on studying real flowers and painting from life was not for the purpose of replication (fig. 19). Instead he sought an empathy between artist and subject. He believed the painter must know a flower so well that he could fathom every aspect of its potential growth. When the artist's brush traced a stem on paper, the action must accord with the growth of the plant.

Xiesheng is also apparent in Chang Dai-chien's animal

paintings; this concern stemmed from the childhood instruction he received from his older brother Chang Shanzi. Most of the subjects in Dai-chien's repertoire are animals that he raised at one time or another: cats, dogs, monkeys, horses, cattle, birds, and gibbons.

The scenery Chang Dai-chien absorbed on his many mountain hikes also provided him with notes for later paintings. Li Fu, who had spent time with Chang both at Dunhuang and Chengdu, observed: "No matter where [Chang] went he always carried a small loose-leaf sketchbook with him, and as soon as he saw a striking mountain, forest, or any kind of majestic scenery, he instantly sketched the image while it was before him."[30] Chang used pencils for most of his sketches, but occasionally he used a brush. Ye Qianyu in Peking has a collection of handscrolls that Chang based on his sketches of actual scenery. The topics include fantastical tree roots in front of a Japanese temple, a view of Mount Hua (fig. 20), and a panorama of Yihe Yuan, where Chang lived when he was in Peking during the 1930s.

The Grand Synthesis

Most art historians have emphasized the importance of the seventeenth-century individualist painters—Shitao, Mei Qing, and Zhu Da—on Chang Dai-chien's development as an artist, and Chang himself acknowledged the influence. Without doubt their spirit and independent mannerisms encouraged Chang's self-expression. But Shitao's defiant statement that he used only his own method, or no method at all, was antithetical to Chang Dai-chien.

From the mid-1930s, as Chang's collection of ancient art grew, he began to formulate a plan to systematically study all the great masters and to reconcile and combine their strengths into a grand synthesis to bring painting to a new brilliance. Such ambition was not new; Dong Qichang had contended that "the painter who imitates ancient masters already belongs to the Upper Vehicle [a term borrowed from Buddhism to indicate the correct path],"[31] and he argued that using antique styles to paint a landscape imbued it with a spirit of harmony and beauty. In actuality, some of Dong's own paintings seem to reject both nature and the ancients in favor of a new style, in which he painted landscapes with formal, geometric patterns. Nonetheless, his theory held generations of painters spellbound, and it was Dong's theory more than his work that captivated Chang Dai-chien and drove him to strive for his own synthesis of ancient styles and nature.

Chang's inscriptions on paintings such as *Light Snow at Tongguan* (entry 29) reflect his appreciation of Dong

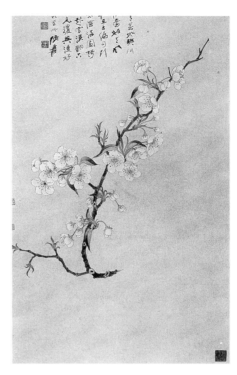

Fig. 19. Chang Dai-chien, detail, *Pear Blossoms*, 1951. Hanging scroll; ink and color on paper; collection of Chang Hsu Wen-po, Taipei.

Qichang, and Chang's appraisals of paintings sometimes include language and syntax closely modeled on the master. Chang learned to imitate Dong's painting and calligraphy, and when forging an ancient painting, he could easily add a spurious connoisseur's pronouncement from "Dong." One of Chang's most memorable copies of Dong Qichang is *Copy of Nesting Clouds, after Dong Qichang* (fig. 21).

Chang Dai-chien read Dong Qichang's treatise on painting, the *Huashuo,* with careful attention. Certain passages seemed especially important to Chang.

To execute level distance, follow Zhao Danian [Zhao Lingrang; act. 1070–1100]; for layered mountains and rising peaks, emulate Jiang Guandao [Jiang Shen; ca. 1090–1138]; for texture strokes, use the hemp-fiber strokes of Dong Yuan or the dotting strokes and texture he employed in *The Xiao and Xiang Rivers.* For trees, use the methods of Beiyuan [Dong Yuan] and Ziang [Zhao Mengfu; 1254–1322]. For rocks follow the method of Senior General Li's [Li Sixun; 651–716] *Waiting for the Ferry by an Autumn River,* and for a snow scene follow Guo Zhongshu [ca. 910–977]. Li Cheng's [919–967] methods include two kinds of painting—monochrome renderings and the heavily colored blue-and-green style, both of which deserve emulation. If one is able to gather all of the above and form a synthesis with one's own creative powers, and practice like this for four or five years, then certainly Wen [Zhengming; 1470–

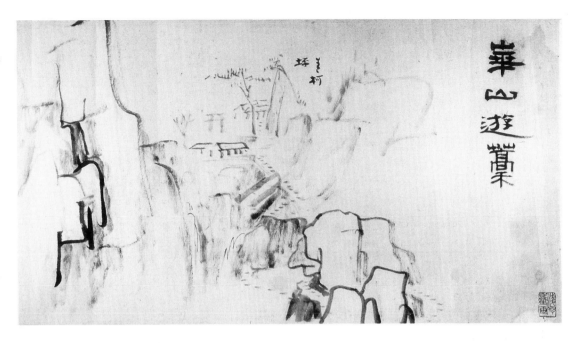

Fig. 20. Chang Dai-chien, detail, *Sketches of Mount Hua*, 1935. Handscroll; ink on paper; collection of Ye Qianyu, Peking.

1559] and Shen [Zhou; 1427–1509] will not continue to stand alone in our region of Wu.[32]

Dong Qichang seldom copied the past directly, but he selectively lifted the best passages from past works to express his inner vision. His view that nothing could be started anew and that all artistic invention is framed by ancient methods appealed to Chang Dai-chien. As James Cahill has explained, "Taking some old style instead of nature as a referent was no more inhibiting and gave just as much latitude for creative transformation of the received image."[33] Dong Qichang was able to transform the individual visions of the great masters into a personal style that acknowledged the formal characteristics of abstract shapes and spatial relationships. Chang Dai-chien followed the same process, but the grand synthesis he achieved in his painting looks nothing like Dong Qichang's. Ultimately, Chang's grand synthesis culminated in his semiabstract splashed-ink-and-color landscapes.

Xiao Jianchu recorded some of the instruction that Chang Dai-chien gave him when he was a student.

> To study tradition is the single most important thing. The history of traditions in Chinese painting is truly lengthy. Some major works have come down from the great masters of the past epochs and dynasties, and no matter during what period or stage of social development an artist lived, every artist exerted his vitality trying to accumulate a multitude of experiences. We should try to master all of these rich experiences ourselves and apply them directly to our art; thus we can develop from each study we make [of the past]. Gradually you will build an individual style, which is a lifetime business and, if undertaken without a willingness to accept the bitter struggles that will ensue, cannot succeed.[34]

While stressing attention to the past, Chang also instructed his students, "When you study the ancients, you must be able to select their virtues and cast off their weaknesses."[35]

Chang Dai-chien accepted ideas from Dong Qichang about which painters to emulate. But he also criticized Dong Qichang's dismissal of the Song dynasty painters Ma Yuan and Xia Gui. Chang formulated his own lineage of "correct" painters, updating the list and filling the lacunae left by Dong Qichang. Chang included more landscape painters and expanded his list to include religious and professional schools of painting.

The broad range of models that Chang Dai-chien used for his synthesis is suggested by a set of twelve hanging scrolls that Chang did for Fan Zhuzhai of Tianjin in March 1938. He painted this "wall screen" in exchange for some antique paintings from Fan's collection, and it was one of his first major works to move beyond Ming and Qing dynasty models. Chang emulated four artists each from the Tang, Song, and Yuan dynasties. For the Tang dynasty he copied Yan Liben, Wang Wei, Yang Sheng, and Li Zhaodao; for the Song, he chose Fan Kuan, Mi Youren, Shen Zifan, who wove pictorial tapestries in the *kesi* technique, and an amalgamation of Ma Yuan and Xia Gui. For the Yuan, Chang followed Zhao Mengfu, Sheng Mou, Ni Zan, and Wang Meng.

The Qing dynasty artist Wang Hui had also echoed Dong Qichang's sentiments but had never completed his own grand synthesis. Chang believed his ambition, energy, and talent were superior to Wang Hui's. Moreover, with modern printing and photographic reproductions, Chang had more oppor-

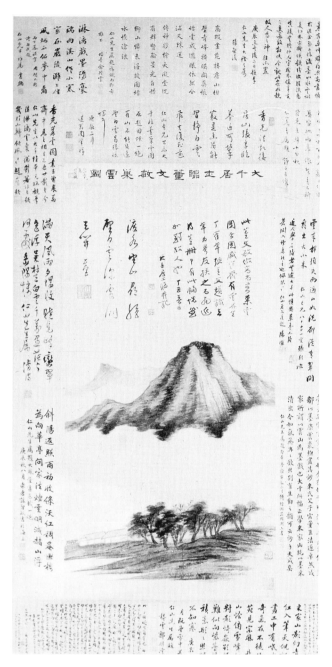

Fig. 21. Chang Dai-chien, *Copy of Nesting Clouds, after Dong Qichang.* Hanging scroll; ink and color on paper; Liaoning Provincial Museum, Shenyang.

Wen Zhengming's followers, who were most active during the sixteenth and seventeenth centuries. Chang believed that painting had become thin and saccharine after the Ming dynasty, with many artists lacking audacious spirit.[36]

Even before Dong Qichang had articulated his famous theory of synthesis, the concept had a long history. Zhao Mengfu had developed a painting style that incorporated past models with highly expressive personal brushwork, which Chang Dai-chien admired. Zhao Mengfu, Dong Qichang, and Wang Hui had each lived in a tumultuous age when social and political structures were in rapid flux and the economy was unstable. As the status quo crumbled and new rulers took over, collections of art shifted hands, increasing the opportunities for artists to see ancient masterpieces. Similarly, Chang lived in a time of great change, and he aggressively sought opportunities to study a wide range of ancient art. Few of his contemporaries shared this passion and ambition, perhaps because they were looking mainly to the West for inspiration.

It seems unlikely that any artist will attempt such a grand synthesis in the future. When Chang Dai-chien was creating copies of works such as the Dunhuang murals, these images were new to his public. Although the works of famous Song and Yuan dynasty artists were better known than the wall murals, nonetheless Chang often copied paintings that had previously only been known by a very small group of collectors and connoisseurs. Thus Chang's copies—both his close copies and his freely interpretive ones—caused great excitement among his patrons. Chang rediscovered the past in order to preserve it. Now that museums and art publications have made ancient art readily accessible, everyone has an opportunity to directly study past art. It is no longer necessary for artists to copy the past so that a new generation may appreciate famous works; likewise, the past is too familiar to the general public to be considered fresh subject matter. Chang Dai-chien's deeply held belief that the past is the most important springboard for personal creativity is no longer apt to find adherents; the familiarity of past art has actually made artists and the public more indifferent to it. Chang Dai-chien lived during the period before reproductions of great works and the works themselves were widely circulated—the combination of his abilities, training, ambition, and timing resulted in a singular integration of tradition and innovation that is not likely to reoccur.

tunities than Wang had to see ancient art. Wang Hui limited himself to the landscapes of Dong Qichang's orthodoxy while Chang embraced every genre and used models Dong had not recommended. Chang faulted Wang Hui for his "anemic color scheme" and "paltry spirit." Thus Chang virtually ignored Wang Hui and the other orthodox masters of the Qing dynasty who are collectively known as the Four Wangs. For the same reason, Chang also ignored the popular school of

Notes

1. Gao Lingmei, ed., *Chang Dai-chien hua: Chinese Painting, with the Original Paintings and Discourses on Chinese Art by Chang Dai-chien* (Hong Kong: Dongfang yishu gongsi, 1961), and *Chang Dai-chien hua ji* (Hong Kong: The East Society, 1967). Two other sources for Chang Dai-chien's art theories are: Xue Huishan, "Chang Dai-chien huayu lu," in *Chang Dai-chien jinian wenji*, ed. Ba Dong and Huang Chunxiu (Taipei: Guoli lishi bowuguan, 1988), 1–5; and Feng Youheng, *Xingxiang zhi wai: Chang Dai-chien de shenghuo yu yishu* (Taipei: Jiuge chubanshe, 1983).

2. Chang Dai-chien, "Dai-chien jushi huashuo," in Gao Lingmei, *Chang Dai-chien hua ji*, n.p. The translations are by Jan Stuart based on Gao Lingmei's; in a few cases Gao's translations are quoted directly.

3. Quoted in Xie Jiaxiao, *Chang Dai-chien de shijie* (Taipei: Shibao wenhua chuban gongsi, 1982), 241.

4. Ibid., 239.

5. Chen Congzhou, "Bo da jing shen," in Bao Limin, ed., *Chang Dai-chien de yishu* (Peking: Sanlian shudian, 1986), 47.

6. Kang-i Sun Chang, "Chinese 'Lyric Criticism' in the Six Dynasties," in Susan Bush and Christian Murck, eds., *Theories of the Arts in China* (Princeton, N.J.: Princeton University Press, 1983), 216.

7. Quoted in Feng Youheng, *Xingxiang zhi wai*, 142.

8. Quoted in Xie Jiaxiao, *Chang Dai-chien de shijie*, 235–36.

9. Ibid., 237.

10. Quoted in Bao Limin and Wang Zhen, "Chang Dai-chien nianpu," *Duoyun* 19 (1988): 102.

11. "Criminal sibling" is the term coined by Anthony Grafton; see his *Forgers and Critics: Creativity and Duplicity in Western Scholarship* (Princeton, N.J.: Princeton University Press, 1990).

12. Ma Zonghuo, comp., *Shulin jishi;* reprinted in Yang Jialuo, comp., *Yishu congbian,* vol. 6 (Taipei: Shijie shuju, 1962), 2:26b.

13. Mi Fu, *Shu shi;* reprinted in ibid., vol. 2, 56.

14. Ma Zonghuo, comp., *Shulin jishi;* reprinted in ibid., vol. 6, 2:57b.

15. Ibid., 2:58b–59a.

16. The translation is based on Hongnam Kim's excellent study "Zhou Lianggong and His 'Duhua lu' (Lives of Painters): Patron, Critics, and Painters in Seventeenth Century China" (Ph.D. diss., Yale University, 1985), 90. The original quotation is from Zhou Lianggong, *Duhua lu;* reprinted in Yang Jialuo, *Yishu congbian,* vol. 14, 2:20.

17. Quoted in Xie Jiaxiao, *Chang Dai-chien de shijie,* 83.

18. Wai-kam Ho, "Late Ming Literati: Their Social and Cultural Ambience," in Chu-tsing Li and James C. Y. Watt, eds., *The Chinese Scholar's Studio* (New York: Asia Society Galleries, 1987), 31.

19. Draft of a private letter to the journalist and collector Yang Rude; transcribed by author.

20. Translation by Jan Stuart; Chinese text and another translation are in Chang Dai-chien, ed., *Dafeng Tang mingji,* vol. 1 (Kyoto: Benrido Co., 1955), n.p.

21. See Wen Fong, Alfreda Murck, Shou-chien Shih, Pao-chen Chen, and Jan Stuart, *Images of the Mind: The Calligraphy and Painting Collection of the Edward L. Elliott Family and John B. Elliott at Princeton University* (Princeton, N.J.: The Art Museum, Princeton University, 1984), 290, pl. 10.

22. Translation by Jan Stuart; Chinese text and another translation are in Chang Dai-chien, *Dafeng Tang mingji,* vol. 1, n.p.

23. Min San, "Chang Dai-chien zai Jiashan wangshi shiling," in *Chang Dai-chien shengping he yishu* (Peking: Zhongguo wenshi chubanshe, 1988), 229.

24. Huang Junbi, "Chang Dai-chien shi feichang ren," in *Chang Dai-chien xiansheng jinian ce* (Taipei: Guoli gugong bowuyuan, 1983), 292.

25. Quoted in Xie Jiaxiao, *Chang Dai-chien de shijie,* 239.

26. Ibid., 241.

27. Feng Youheng, *Xingxiang zhi wai,* 121–22.

28. Yu Zhizhen, "Chang Dai-chien laoshi de huaniao hua yishu," in Bao Limin, *Chang Dai-chien de yishu,* 65.

29. Ibid.

30. Quoted in Li Yongqiao, "Xin'gan qingyuan shou tuxing," *Dacheng* 149 (1986): 10–11.

31. Dong Qichang, *Hua Chan Shi suibi,* reprinted in Yang Jialuo, *Yishu congbian,* vol. 28, 37.

32. The *Huashuo* is often misattributed to Mo Shilong (ca. 1538–1587) instead of Dong Qichang. The Chinese text is reprinted in Yang Jialuo, *Yishu congbian,* vol. 12, 309–10.

33. James Cahill, *The Compelling Image* (Cambridge, Mass.: Harvard University Press, 1982), 57.

34. Xiao Jianchu, "Zhigen chuantong buduan chuangxin," in Bao Limin, *Chang Dai-chien de yishu,* 52.

35. Ibid.

36. See Chang Dai-chien's inscription on his 1947 painting *River Crossing on an Autumn Evening;* Christie's auction catalogue, Hong Kong, January 1989, 117, lot 140.

4 Genres and Techniques

CHANG DAI-CHIEN was a versatile artist who diligently mastered the many genres and techniques of traditional Chinese painting. With his brother, mother, and sister as his first teachers, Chang was introduced to figure and bird-and-flower painting. As his skill increased and a love for travel led him to spectacular sights, Chang mastered landscape painting, the genre for which he is most famous:

Chang painted in all three of these genres throughout his life. In addition, he displayed a brilliant understanding of all of the traditional techniques of painting: *xieyi* (literally "writing the idea"), which employs spontaneous, free brushwork; *gongbi,* which requires detailed brushwork and precise coloring; *baimiao,* or fine-line ink brushwork; *mogu,* or "boneless" painting, which creates forms by color rather than with ink outlines; and *pomo,* or "splashed-ink." While using the last technique, Chang innovatively added color, thus pioneering his semiabstract splashed-ink-and-color technique.

Figure Painting

The development of Chang's figure painting falls into three stages. In his early works the figures, which were derived from the attenuated figures of Qing dynasty paintings, have a light, sometimes even listless appearance. By mid-career Chang's brush strokes were as strong and precise as iron wire, and the proportions of the figures were more anatomically correct. His late figure paintings are schematic in contrast. They often exhibit Liang Kai's method of abbreviated brushwork, combining rapid brush strokes with occasional flings of ink. The figures tend to be squat, and they are unexpectedly vibrant; the dark, wet ink gives them a fullness. Chang painted few figures after 1980 due to occasional hand tremors

that made it difficult for him to render expressive details such as the eyes or mouth.

Chang's goals were different from the major twentieth-century figure painters like Xu Beihong, who sought to mix Western realism with traditional Chinese idioms and create a modern, expressive form. Instead, Chang wanted to revitalize earlier traditions. Fu Baoshi (1904–1965) and Chang both painted lofty scholars dressed in traditional clothing, but Fu effectively used graded color washes to give his figures realistic facial features with highly individual, sometimes exaggerated expressions (fig. 22). By contrast, Chang purposely depicted his figures as pure and aloof. He was not interested in portraying them as individuals; instead, he saw his figures as types representing an ancient period. Chang cherished the ideal of a golden age, and he hoped that he could resurrect the values of earlier painting. Fu Baoshi had the latitude to strike out in a completely new direction, while Chang wanted to both capture the perfection of the past and make it appealing to a modern audience.

None of Chang Dai-chien's paintings survive from his childhood, when his brother Shanzi began to teach Dai-chien how to paint figures and animals. One of the first figure painters whose influence can be ascertained in Chang Dai-chien's work is Ren Yi (1840–1896); his technical virtuosity and prolific output made him the undisputed leader of the Shanghai School. Despite *Set of Hanging Scrolls* (entry 3), probably painted between 1926 and 1929, Chang vehemently denied ever having been influenced by Ren Yi. By the late 1920s Chang was actively distancing himself from the popular Shanghai School painters, believing that the majority of Ren Yi's followers were routine technicians, whose figures were insipidly sweet looking. For Chang, the Shanghai School had become too glib. Other more minor Qing dynasty painters such as Gu Luo (1763–after 1837) and Gai Qi (1774–1829),

who specialized in "female beauties," exerted some influence on him as well at this early stage of his career.

The one lasting effect Ren Yi had on Chang Dai-chien was to lead him to the work of Chen Hongshou (1598–1652). Chen's quirky, attenuated figures had been a source for Ren Yi, who injected them with a new realism and immediacy. Chang struck out in the opposite direction, diligently pursuing Chen's most antiquarian mannerisms. During the late 1920s and early 1930s, when Chang Dai-chien first tried to excise the relaxed brushwork popular among the Shanghai School from his repertoire, he practiced Chen Hongshou's manner of *gongbi,* or fine-line painting, a manner which he continued in works like *Seeking the Perfect Phrase* (entry 34), dated 1949.

Simultaneously, Chang Dai-chien was also attracted to Hua Yan (1682–1756) and Zhang Feng (act. 1628–1662). He admired their compactly drawn figures, where a few tensile brush lines convey both concreteness and lively animation (fig. 23). Chang painted *Scholar Admiring a Rock* (entry 5) in the style of Zhang Feng. Also, the name Dafeng Tang, which Chang used for himself, his studio, and his collection of masterpieces, came from Zhang Feng. Until the mid-1930s, Chang followed Hua and Zhang, as his inscription on *Lofty Scholar under Wutong Trees and Bamboo,* painted in 1934, records. "Dafeng's [Zhang Feng] brushwork is tensile and rhythmic, while Xinluo's [Hua Yan] is elegant but not facile; within the last three hundred years, among those who have painted figures, there are only these two." While the depth of Chang's respect for Zhang and Hua was genuine, this statement is excessively adulatory.

Chang gradually moved toward earlier models, first studying Ming dynasty artists, then Yuan dynasty, and finally Song and Tang dynasty painters. His selection of Ming dynasty artists was eclectic, including Tang Yin (1470–1524), Qiu Ying (ca. 1494–1552), and Du Jin (act. late 15th–early 16th cent.), all of whom could execute extremely refined paintings, as well as Zhe School painters, such as Wu Wei (1459–1508) and Guo Xu (1456–after 1528), with their more audacious manner.

Just as Dong Qichang in the seventeenth century had developed a "genealogy" for landscape painters, Chang Dai-chien outlined in 1937 his first systematic view of a lineage of figure painters. Chang inscribed the following comment on *Figure under a Tree* (fig. 24).

The paintings of Gu Changkang [Gu Kaizhi; ca. 345–ca. 406] have all disappeared; a few paintings by Wu Daoxuan [Wu Daozi; act. 710–760] and Yan Liben were copied as stone engravings, so we can still imagine what the originals looked like; Li Longmian [Li Gonglin; ca. 1049–1106], Zhao Oubo [Zhao Mengfu], Zhang Shuhou [Zhang Wu; act. 1336–1364], Tang Ziwei [Tang Yin], Qiu Shifu [Qiu Ying], Zhang Dafeng

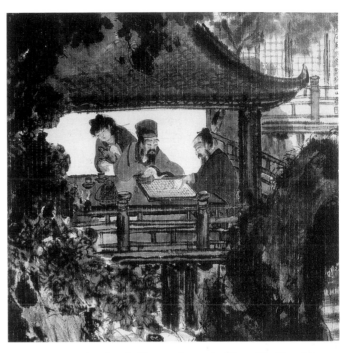

Fig. 22. Fu Baoshi, detail, *Playing Go at the Water Pavilion.* Hanging scroll; ink and color on paper; The Metropolitan Museum of Art, New York, gift of Robert H. Ellsworth, 1988.324.3.

[Zhang Feng], and Hua Qiuyue [Hua Yan] are all from the same bones and flesh—one family. Their [works] may have a different appearance, but the spirit is the same. To paint figures, one must start from this understanding and not thrust them into separate camps.

The absence of Chen Hongshou's name reflects Chang Dai-chien's uneasiness that Chen's painting was perhaps too eccentric, a concern that gradually deepened until 1975 when he explicitly said as much.

Toward the end of 1932, when Chang and his brother Shanzi lived in Wangshi Yuan in Suzhou, they became friends with the famous connoisseur Ye Gongchuo (1880–1968), who was living in the other half of the garden complex. Ye Gongchuo challenged Chang Dai-chien to bypass the flamboyantly calligraphic brushwork of Ming and Qing dynasty artists and rekindle the greatness of Yuan dynasty and earlier figure painting. He later recorded his advice to Chang in a colophon on the *Nine Songs,* an album of paintings once attributed to Zhao Mengfu that Chang acquired.

Figure painting today has already reached a dead end; who can shoulder the responsibility [for improving it]? Dai-chien has a plentiful collection of art and his skill is profound and deep. . . . When I think of some person opening the way and walking the road alone, I think it must be [Chang] who will bear that responsibility.

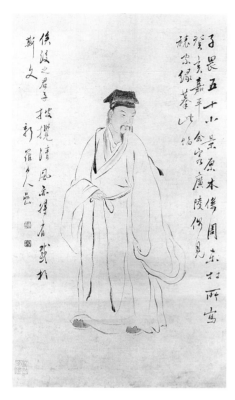

Fig. 23. Hua Yan, *Portrait of Tang Yin,* 1743. Hanging scroll; ink and color on paper; Freer Gallery of Art, Smithsonian Institution, Washington, D.C., 81.26.

Ye Gongchuo's bold praise and high expectations for Chang, who was nineteen years his junior, primed Chang's interest in early painting.

In the winter of 1939, Chang Dai-chien purchased the *Nine Songs* album (The Metropolitan Museum of Art, New York), which exerted an extraordinary influence on his development as a figure painter. Chang was adamantly convinced that Zhao Mengfu had painted it, although today most scholars consider it an anonymous fourteenth-century work. Each leaf depicts a god or goddess mentioned in the "Nine Songs," ritual and shamanistic poems from the ancient state of Chu; the figures are depicted with a flawless linear beauty, brushed with ink alone. Chang's *Lady of the Xiang River* (entry 78) was indirectly inspired by this album. The controlled, sweeping lines of the figures in *Nine Songs* so affected Chang Dai-chien that he decided to follow the style back to its origins. He studied Song and Tang dynasty painting and then traveled to Dunhuang, where he spent two and one-half years studying Buddhist figure painting primarily of the Tang dynasty.

When Chang Dai-chien reached Dunhuang, he found hundreds of caves covered with ancient Buddhist murals on the walls and ceilings. Chang traced images and made freehand copies, in both the original size and reduced scale, to improve his technical facility. He developed a new sensitivity for certain details, especially hands, which were prominent in Buddhist painting because of the religious significance of *mudras,* or symbolic hand gestures. He also began to pay more attention to costume, jewelry, and accouterments. These lessons were easily adapted to the secular figures that are the core of Chang Dai-chien's figure repertoire. Some features, however, were applicable only to Buddhist painting, such as the hieratic scale (where the most important figure is painted as the largest regardless of the rules of perspective), the flowing robes and elaborate jewelry of some Buddhist costumes, and exaggerated physical characteristics, like the Buddha's long earlobes and the grimaces of the *lokapala*s, or directional guardians.

Chang's studies of Buddhist painting at Dunhuang prompted his insistence that costumes be portrayed with historical accuracy, a concern that few literati painters had. In 1960, Chang castigated Mi Fu for admitting in the *Hua shi* (History of Painting) that he and Li Gonglin had painted Jin dynasty scholars wearing Tang dynasty fashions. Chang's criticism is ironic, since he refused to paint twentieth-century clothing on the grounds that it was ungainly, and so painted his modern figures and himself in the garb of earlier eras.

After Chang Dai-chien left Dunhuang in 1943, he began collecting secular figure paintings and, with the dispersal of Puyi's imperial collection, was able to see and sometimes purchase masterpieces of figure painting. Chang acquired one of the most preeminent figure paintings of all time, *The Night Revels of Han Xizai* (see fig. 18), attributed to Gu Hongzhong. While the painting depicts a licentious party in full swing, the artist used exquisite delicateness and a sedate brush rhythm to record each detail, and the rich colors were applied with subtle restraint. Han Xizai's guests include the fashionable young scholars of his day and even a monk; all the guests seem to enjoy the company of the coy songstresses, female musicians, and dancers. This wide variety of male and female characters provided Chang Dai-chien with a wealth of material for his own painting.

The zenith of Chang Dai-chien's figure painting occurred after his return from Dunhuang in 1943 and before his sight was impaired in 1957. That year, while Chang was working in his garden in Brazil, he tried to move a rock, and the physical strain caused some weakened capillaries behind his retina to rupture. The fact that his eyes were vulnerable to this injury was due to his diabetes. Time and eventually laser therapy improved his sight, but the loss in visual acumen was acute enough that he rarely painted delicate lines again. Chang

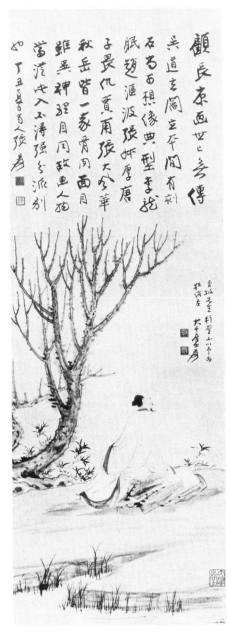

Fig. 24. Chang Dai-chien, *Figure under a Tree,* 1937. Hanging scroll; ink and light color on paper; collection unknown. From *Chang Dai-chien hua ji* (Hong Kong: Tsi Ku Chai, 1982), 33.

and ink, created with splashy, energetic brushwork, such as *Master Hanshan in Silent Repose* (entry 84).

In 1975 Chang Dai-chien wrote a preface to *Compendium of Painting and Calligraphy by Ye Xia'an,* a book written by his old friend Ye Gongchuo. Chang's comments reveal his deep bias in favor of early painting.

> One school of figure painting, from Wu Daoxuan to Li Gonglin, was already completely exhausted after Li. Qiu Shifu's [Qiu Ying] fault was that his work was too charming; Chen Laolian's [Chen Hongshou] fault was that his work was too eccentric, and during the three hundred years of the Qing dynasty there has been no one at all.[2]

In 1940 Ye Gongchuo had declared in his colophon on the *Nine Songs* that the state of modern figure painting was at a "dead end," but Chang Dai-chien was far more extreme here, discounting everyone who had painted since the early twelfth century, including Qiu Ying and Chen Hongshou, both of whom had previously been his models. Few artists after the Yuan dynasty achieved Chang Dai-chien's exquisite linear precision and fluent lines, whose subtle variations in rhythm alone conveyed a corporeal presence.

Chang Dai-chien painted more self-portraits than any other figure painter, an emphasis rare in China where self-portraiture traditionally had little appeal. Chang found painting self-portraits emotionally satisfying, and unlike a typical literatus, who might have shared the interest, Chang had the technical ability to render a convincing figure. Chang Dai-chien painted at least one hundred self-portraits, among them *Self-Portrait in the Yellow Mountains* (entry 58), *Nesting in a Pine* (entry 68), and *Self-Portrait with Saint Bernard* (entry 75). His passion for the genre was at least as deep as Rembrandt's, who is said by H. W. Janson to have painted in excess of sixty self-images.

Chang's instincts for self-promotion inspired him to give self-portraits as gifts. Before long, people began requesting them. Chang once commented: "Many people have painted my portrait, and all of them better than I, though I think I do the best at painting these few stray hairs on my head."[3] Such droll self-deprecation reveals much about Chang's character.

The most realistic group of self-portraits include full-length, three-quarter, and bust images, which Chang usually painted with graded color washes, especially around the nose, to create the illusion of shadow. Chang typically painted his face in detail while rendering the body more schematically. One memorable self-image from 1937, *Self-Portrait under a Pine,* is meticulously detailed throughout (fig. 25).

A more playful self-portrait, *The Artist Holding an Alms Bowl* (fig. 26), was painted in the fourth lunar month of 1973.

mourned the loss of his ability to paint fine-line figures.[1] Although he shifted toward a bold new style in landscapes, a similarly individualistic style in figure painting was not his goal; he had sought, instead, to forge a link with the past.

After 1957 Chang returned to Zhang Feng and Liang Kai as an inspiration, and his figures are looser than in his earlier work. His later figures are virtuoso performances of brush

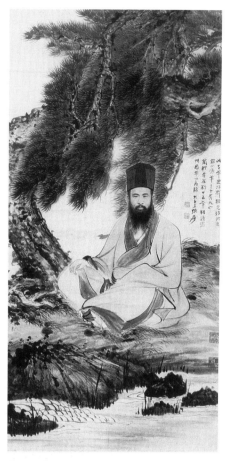

Fig. 25. Chang Dai-chien, detail, *Self-Portrait under a Pine*, 1937. Hanging scroll; ink and color on paper; collection unknown.

Chang's self-portraits often date to the fourth lunar month, which was the month of his birth. In this work, Chang depicted himself holding an alms bowl, a reference to the time he almost became a monk and an expression of his continuing Buddhist devotion. The self-portrait also relates to Chang's chosen career as a professional artist—the alms bowl alludes to Chang's "begging" for food and money in exchange for his paintings.

The greatest number of Chang's informal self-portraits depict his head and shoulders in profile. Most of these abbreviated portraits are small, often painted on an album leaf, and they usually possess a modicum of humor. Many were meant as one leaf in a composite album, but sometimes friends requested a self-portrait and were delighted by even a single album leaf. After Chang turned fifty, he painted these images more often than other types of self-portraits.

The album *Spontaneous Images, Playing with Ink,* dated 1956, contains one of Chang's most fanciful album leaves,

which he inscribed with the unusually vernacular title, *Me and My Gibbon* (fig. 27). Using rapid movements, Chang sketched his face and shoulders in tones of gray. He dotted the pupils of his eyes with dark ink, conveying an impish sparkle, and he added a few dark hairs to the beard to make it appear bushy. The disembodied head of a gibbon overlaps his shoulder. The animal's fur, rendered by dark, wet ink and textured on top with dry ink, is irresistibly plush. The swift brushwork and ebullient mood of the charming *Me and My Gibbon* are typical of Chang's busts of himself.

When Chang Dai-chien depicted a figure in a landscape, that figure is generally a self-portrait, although the physical resemblance is not always immediately clear. Chang often revealed the identity in the inscription, though the figure may look like a generic image of a bearded scholar. Such paintings often record trips Chang made. Chang painted *The "Welcom-*

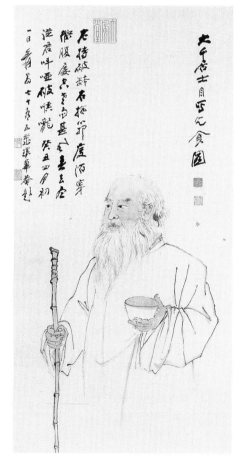

Fig. 26. Chang Dai-chien, *The Artist Holding an Alms Bowl,* 1973. Hanging scroll; ink and color on paper; National Palace Museum, Taiwan, Republic of China. From *Chang Dai-chien xiansheng jinian zhan tulu* (Taipei: Guoli gugong bowuyuan, 1988), 43.

Another type of self-portrait is described by James Cahill as a double-image portrait, consisting of a recognizable self-portrait superimposed onto a conventional image of a famous or mythical person. Chang was especially inclined to create double-image portraits of himself and the semilegendary

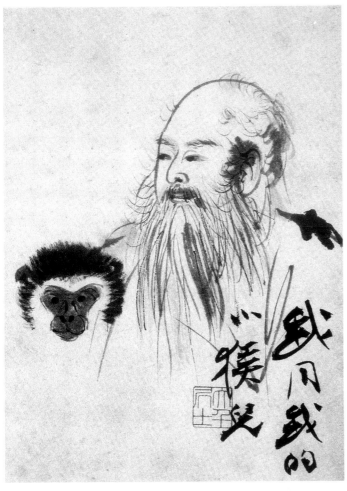

Fig. 27. Chang Dai-chien, *Me and My Gibbon*, from *Spontaneous Images, Playing with Ink*, 1956. Album leaf; ink on paper; National Museum of History, Taiwan, Republic of China. From *Chang Dai-chien jiushi jinian zhan shuhua ji* (Taipei: Guoli lishi bowuguan, 1988), pl. 34–12.

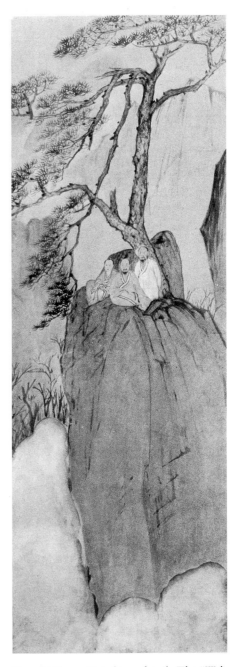

Fig. 28. Chang Dai-chien, detail, *The "Welcoming Guests" Pine in the Yellow Mountains*, 1931. Hanging scroll; ink and color on paper; collection unknown. From René-Yvon Lefebvre d'Argencé, *Chang Dai-chien: A Retrospective Exhibition* (San Francisco: Center of Asian Art and Culture, 1972), 27.

ing Guests" Pine in the Yellow Mountains (fig. 28) after climbing the Yellow Mountains in 1931. Identifying the figures would be no more than conjecture without the aid of Chang's inscription, which distinguishes the figures as himself, his brother Shanzi, and his nephew.

Searching for Poetic Inspiration in Darjeeling and *Listening to Cawing Crows in Darjeeling* (fig. 29), both painted in 1950, are extreme examples. These self-portraits only marginally resemble Chang, who even replaced his trademark floor-length *changpao* robe with an earlier fashion of clothing. In paintings, Chang found ancient dress, with wide sleeves and girdled and tucked waist, the most amenable for showing off graceful, curving lines; it is intriguing to speculate just how many of Chang Dai-chien's scholars in ancient dress are veiled self-images.

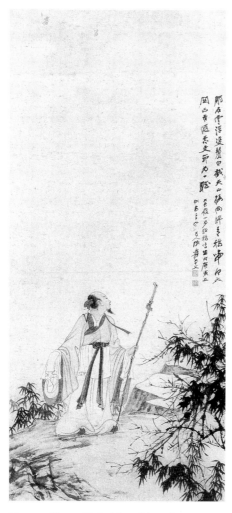

Fig. 29. Chang Dai-chien, *Listening to Cawing Crows in Darjeeling,* 1950. Hanging scroll; ink and color on paper; collection unknown.

a house on Duanwu jie. Chang may have hoped that he someday would have the great notoriety that Zhong Kui achieved.

Chang Dai-chien's interest in human nature led him to enjoy painting portraits of people whom he respected. From his mother and sister, Chang had early training painting flowers from life, which no doubt enhanced his ability to paint portraits. One of Chang's first portraits was painted from a photograph of his teacher Li Ruiqing. Painting a posthumous portrait from a photograph was a popular practice in China, as *Portrait of the Artist's Father* (entry 50) demonstrates. In Chang's portrait of his father, the dark shadows around the eyes and exaggerated creases around the nose reflect the unduly harsh contrast of light and shadow in early photographs. Photography and a subtle use of chiaroscuro were two Western techniques that Chang was exposed to during his student days in Japan. Although he absorbed some Western practices of using graduated color washes and

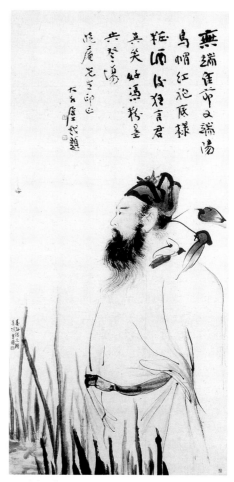

Fig. 30. Chang Dai-chien, *Self-Portrait as Zhong Kui,* ca. 1930. Hanging scroll; ink and color on paper; collection of Yon Fan, Hong Kong.

Zhong Kui (act. 618–627), a scholar who was popularly known as the Demon Queller (fig. 30), although Chang also painted *Demon Presenting a Plum Bough to Zhong Kui* (entry 4) without casting himself as the scholar. Dai-chien's brother Shanzi mentioned these double-image portraits in an inscription on *Tiger in Red Ink,* dated 1936: "For Tianzong Festival [Duanwu jie], to fulfill the request of a friend, Dai-chien playfully borrows the image of Presented-Scholar [*jinshi*] Zhong for his self-portrait." Chang Dai-chien may have chosen Zhong Kui because of their superficial resemblance. When Chang started growing his beard at twenty-six, people were impressed by the novelty, since Chinese men typically do not grow beards until late in life. Chang playfully associated himself with Zhong Kui, the most famous bearded scholar in China, since it is good luck to hang an image of Zhong Kui in

Fig. 31. Chang Dai-chien, *Elegant Gathering in the Western Garden,* 1945. Wall screen comprised of four hanging scrolls; ink and color on paper; collection of Gao Lingmei, Hong Kong.

shadows, Chang kept Western techniques to a minimum, preferring to rely on the Chinese solution of employing the momentum of sweeping ink lines to animate a sitter.

Most of Chang Dai-chien's portraits were of men, and he received commissions from many celebrities within the art community, such as the famous seal carver Chen Julai and the photographer Lang Jingshan, whose photographs of Chang Dai-chien are widely published. A rare subject was the modern hero Yu Peilun, one of the seventy-two martyrs of the revolution that overthrew Manchu rule in 1911.

Chang's favorite category of portraiture was images of scholar-gentlemen, the backbone of the traditional repertoire of figures in China. Most of Chang's figures were generic types, but sometimes he painted a cultural hero like the poet and moral exemplar Tao Qian or the literary statesman Su Shi. Chang often chose significant background elements for his portraits; a willow tree paired with Tao Qian, for example, alluded to Tao's poem in which he called himself Mr. Five-Willow. Usually a brief inscription confirms speculations about the identity of a figure.

Chang painted groups of scholars, as in *Ten Sages* (entry 52), and literary gatherings, such as the celebrated assembly of Song dynasty scholars in *Elegant Gathering in the Western Garden* (fig. 31) and *Literary Gathering* (entry 25). He also painted narratives, such as the story of Xiao Yi's deceit in *Stealing the Lanting Manuscript by Trickery* (entry 31). Just as

frequently Chang painted individual figures or small groups, sometimes choosing to focus on one or two figures taken from a group theme like the Seven Sages of the Bamboo Grove. For example, in *Stopping the Zither to Listen to the Moon Lute* (entry 22) he painted the third-century scholar-musicians Xi Kang and Ruan Xian as a duo instead of depicting them with the other Sages of the Bamboo Grove.

Chang painted many works depicting religious figures, mostly as a result of his Dunhuang sojourn. His 1950 trip to the Ajanta Caves in India inspired other Buddhist figures, such as *Dancer in the Style of the Ajanta Caves* (entry 40). Perhaps the earliest Buddhist figures that Chang painted date to the 1920s, when he was influenced by the bluntly powerful images that Jin Nong (1687–1763) painted of Bodhidharma and *luohan,* or Buddhist disciples. Chang's teacher Li Ruiqing was a disciple of Jin Nong and encouraged Chang to follow the same course; Jin's influence on Chang Dai-chien is clear throughout the 1930s.

During the 1930s, Chang had access to early Buddhist and Daoist paintings. In particular, he saw the *Birth and Presentation of the Buddha* in the Abe Collection, in the Osaka Municipal Museum, Japan, which is attributed to Wu Daozi. He also saw two versions of Wu Zongyuan's (d. 1050) *Celestial Rulers of Daoism,* which are now in C. C. Wang's collection (fig. 32) and the Xu Beihong Memorial Museum, Peking. These so impressed him that he gradually abandoned the

plain assertiveness of Jin Nong for the antique elegance of fine-line, *baimiao* drawing, a style he used extensively in his Dunhuang-style works. The brightly colored, ornamental techniques from Dunhuang are evident in Chang's *Guanyin of the Water Moon* (entry 21), in which he depicted the popular Bodhisattva of Compassion as a bejeweled form in flowing robes. Even as an old man, however, Chang occasionally returned to Jin Nong's manner to depict Bodhidharma.

When he sought a retreat, Chang Dai-chien often stayed in Buddhist and Daoist temples in China. Such sacred environments encouraged him to paint religious figures, and he used his paintings to thank the abbots for their hospitality. At the Daoist Shangqing Gong temple in the Qingcheng Mountains, near Chengdu, the priests had some of Chang's paintings engraved on stone stelae. Stylistically Chang's religious figures have the same brushwork and proportions as his images

of lofty scholars and beautiful women. He painted several versions of the Daoist female divinity Magu as well as *Patriarch Lü Dongbin* (entry 69), one of the most popular of the Daoist Eight Immortals.

Chang Dai-chien's versatility extended beyond the standard figure genres to include characters from the Peking opera. Paintings such as *Opera Character* (entry 17) portray some of his most energetic figures. Since he was an avid opera buff, Chang had ample opportunities to store the repertoire of stage gestures in his mind. Most of his paintings of opera performers have flying brushwork, but each stroke and flick of the brush is assured and never extraneous. Chang's portraits rival the success of the highly acclaimed studies of opera performers by Guan Liang (1899–1986), whose work is so successful because of its witty and childish innocence. Chang's miscellaneous opera characters display a technical brilliance not found in Guan's work, and yet the mood is as candid and carefree as Guan Liang's. It is regrettable that Chang did not spend more time developing this kind of rapid sketch, because he had a special gift for combining verisimilitude with parody and abbreviated character studies.

As a young painter Chang Dai-chien was playfully called "Chang the Beauty" in appreciation of his paintings of women. Women have appeared in Chinese painting since the beginning of the history of painting. During the Six Dynasties period they usually appeared in paintings that illustrated a discourse on virtuous moral conduct. During the Tang dynasty, artists began using female subjects to illustrate the luxurious refinement of life at court. By the Song dynasty the new subgenre of "beauties" arose. The women were not intended to be overtly erotic but to be appreciated as aesthetic objects—like a flower. This tradition was still popular when Chang began his career.

Fig. 32. Wu Zongyuan, detail, *Celestial Rulers of Daoism.* Handscroll; ink on silk; collection of C. C. Wang, New York.

Chang Dai-chien used either the free *xieyi* or the detailed *gongbi* manners of brushwork to portray feminine charm, often achieving a remarkable verisimilitude. The well-known bird-and-flower painter, Yu Feian, has said that painters and connoisseurs savor Chang Dai-chien's figures of women. Yu Feian noted:

> If he paints a young maiden then she looks like a young maiden, but if he paints a young married woman, then she looks like a young married lady. Moreover both the young girls and young wives are beautiful, and each has an individual appearance. The reason is that Chang Dai-chien has intimately observed the female psyche.[4]

Chang's attention to individual character elevated his best paintings above the rank of the compliant ladies that artists of the Shanghai School were popularly producing. But by

Fig. 33. Chang Dai-chien, *Lady Red Whisk,* 1944, with painted border by Paul Chang. Hanging scroll; ink and color on paper; collection unknown.

ancient paintings, female opera characters, and women he personally knew. In the 1920s, Chang Dai-chien began using his wives as models. Late in the decade, in search of models in Peking, he met songstress Yang Wanjun and married her in 1934. His last wife, Hsu Wen-po, is also featured in some of his paintings. Chang also used Japanese woodblock prints as a source, as in *Afternoon Rest* (entry 44), and he even used glamour magazines. The latter provided the impetus for his paintings of languid women wearing flimsy garments, the most erotic images to be painted by a "respectable" artist and a source of controversy that was probably as much over the flaunting of established painting conventions as it was over the sensual content.

Chang's love for Peking opera strongly affected his paintings of women. Traditionally men played women's roles on the stage; they dressed in feminine costumes and wore heavy, colorful makeup. Chang sometimes adapted the makeup and the stylized gestures of the opera performers to enhance his portraits of women. The opera makeup was based on Tang dynasty fashion: a bright white patch on the forehead, nose, and chin, with heavy rouge on the cheeks. Such highlights made even a flat nose and sunken cheeks prominent. Chang strove for this same finely chiseled effect when painting

Fig. 34. Chang Dai-chien, *Heavenly Females Scattering Flowers,* 1933. Hanging scroll; ink and color on paper; collection unknown.

today's standards, some of his images of women deserve to be faulted for an idealized image of female beauty that denies emotion and intelligence. This failing is derived from the models Chang followed. Women were traditionally portrayed arranging a flower in their hair, listlessly leaning against a willow, or coyly holding a fan. Chang helped establish a wider range of styles for portraying women, and he painted some modern, sensual images of women while ostensibly reviving classical Tang dynasty style figures.

Chang Dai-chien drew upon several sources, including

women. He also found that the exaggerated gestures of opera performers—an elegantly raised arm, pursed lips—were perfect for giving a stage presence to his solo figures, who were depicted against a blank background.

Chang Dai-chien knew that costume was an important element in painting figures, and his polemical views on fashion were well recognized. He admired Tibetan ethnic costume, for example, because of its timeless elegance (see entries 23 and 24). He generally preferred antique garb or the traditional dress of Japanese, Indian, and Nepalese women, and he detested Western style dress. Occasionally he painted women wearing contemporary Chinese fashion, such as the tight-fitting *qipao,* a dress with a high neck and long side slits, which provided a rare opportunity to paint a woman's legs. After his Dunhuang sojourn, he often painted textile designs influenced by the decorative patterns and the floral scrolls that appear in the cave paintings. One example is the dazzling phoenix cloak that Chang depicted in *Lady Red Whisk,* a portrait of a valiant lady of the early Tang dynasty (fig. 33).

Chang Dai-chien formulated his standard of female beauty by combining characteristics he saw in ancient paintings with traits he admired in real women and women depicted by his contemporaries. He once remarked: "I don't dare say that I am the one who can best judge a woman's charm, only that when I scrutinize and regard a beautiful woman and search for a model for my painting, I am more exacting than other people."[5]

A convenient watershed between Chang's early and middle period paintings of women is 1933, the year he painted *Heavenly Females Scattering Flowers* (fig. 34) in the style of Wu Zongyuan's *Celestial Rulers of Daoism* (see fig. 32). Wu's ancient painting depicts a procession of regal-looking women and their attendants in the fine-line *baimiao* tradition. After emulating *Celestial Rulers* and then working through models from the Ming dynasty, especially Tang Yin, Qiu Ying, Du Jin, Wu Wei, and Guo Xu (see entry 7), Chang gradually turned toward Yuan, Song, and Tang dynasty models.

Toward the end of the 1930s Chang's interest in Yuan dynasty painting grew; Zhao Mengfu and Qian Xuan (ca. 1235–after 1300) became two of his major models, especially the paintings of the corpulent Tang dynasty beauty Yang Guifei that were ascribed to Qian Xuan. Chang developed a new flair for painting using tensile, even-width lines known as "iron wire" and supple lines described in Chinese literature as "spring worms spinning silk." When painting with these types of brushwork, Chang liked to embellish his women's costumes with decorative color or designs. After he returned from Dunhuang, his paintings of women reached their height, with meticulous fine-line brushwork and opulent colors.

After he expatriated in 1949, Chang began to favor looser brushwork and more schematic figures. But he still occasionally produced a masterpiece using *gongbi* brushwork and bright colors, such as the mid-1950s portrait of a beautiful modern-day courtesan described in the twentieth-century novel *Nihai hua* (Flowers in a Sea of Sin).

The final category of figure painting in Chang's oeuvre is comprised of works depicting children. The father of sixteen children, Chang had ample models, yet he painted many of the youngsters using detailed brushwork based on Su Hanchen's (act. 1101–1125) work. Chang often painted subjects, such as a boy holding a melon with many seeds, to give a young couple as a wish for multiple progeny (fig. 35). Occasionally he employed Liang Kai's inky, abbreviated brushwork to paint a herdboy watching a water buffalo or playing.

Fig. 35. Chang Dai-chien, *Children Playing under a Pomegranate Tree,* 1948. Hanging scroll; ink and color on paper; collection of Gao Lingmei, Hong Kong. From Gao Lingmei, *Chang Dai-chien hua* (Hong Kong: Dongfang yishu gongsi, 1961), 111.

Bird-and-Flower Painting

Chang Dai-chien's genius in bird-and-flower painting was to exploit the ornamental beauty of his subjects without severing them from the natural world. In addition to their decorative role, paintings of flowers and birds in China often have implied symbolism. Ever since the Zhou dynasty compilation *Shijing* (The Book of Songs), a collection of some three hundred poems, certain flowers began to accrue meaning. The plum blossom, for example, became an emblem of triumphant purity, since tender plum branches courageously bloom while snow is on the ground. The short life of its delicate blossoms also became a metaphor for the transience of feminine beauty. When the Republic of China chose the plum blossom as its national flower, plum blossoms also began to have a political connotation.

Chang Dai-chien imbued his flower paintings with the meanings implicit in ancient poetry and literati painting, but he never felt constrained by underlying messages. He believed that the creation of a "language of flowers" in Chinese art was vastly different from and superior to the tradition of Western botanical painting.[6] Nonetheless, Chang's major consideration in flower painting was aesthetic appeal, and, no matter what style, his flower paintings have a decorative radiance.

Chang Dai-chien usually accompanied his floral images with a poem, which might be a transcription of some classical favorite or a verse of his own. Including poetry was particularly important to him in flower painting, for while he wanted to create decorative images with a broad audience appeal, he also insisted that his paintings should be meaningful enough to please the most erudite scholar. The plants, blossoming trees, and flowers that appear most often in Chang's paintings are the ones most common in traditional literati painting.

Chang fortified his skill as a painter by firsthand knowledge of aviculture and horticulture. He had cages of songbirds, and he was always particular about selecting the flowers for his gardens. But Chang also had art historical referents; his bird-and-flower paintings, like works in other genres, integrated realism with ancient models. Style itself was both a formal and an expressive element. Chang's early family training in bird-and-flower painting has led to the erroneous assumption that when Chang first became a professional painter, he began with this genre;[7] in reality, his first paintings were of figures.

Chang Dai-chien often referred to a Qianlong edition of *Guang chunfang pu* (Extended Compendium of Flowers) when he painted floral images, and he also owned all ninety-five volumes of the Japanese *Honzu zufu* (Compendium of Flowers), which he consulted frequently (fig. 36). The conventions of the woodblock illustrations may have had an indi-

Fig. 36. Iwasaki Tsunemasa (1786–1842), *Cockscomb*. Woodblock print; ink and color on paper. From *Honzo zufu*, vol. 12 (Tokyo: Iwamoto Yonetaro, 1916–22), 4.

rect effect on his painting, most apparent when he used Western lithography to produce *Red Persimmons* (entry 77). But the chief value of the manuals was the lessons Chang learned about the structure of flowers from their detailed drawings.

Chang claimed Chen Shun (1483–1544) had inspired his pursuit of flower painting.[8] Chen Shun sometimes painted in ink alone, but he was best known for paintings in the *mogu*, or "boneless," technique, in which he painted forms by using color alone without ink outlines. In Chen Shun's work, flowers brushed in vibrant, rich hues spread across the paper. The moistness of his color washes made the images seem delicate despite the exuberant mood. Chang Dai-chien made numerous imitations of Chen Shun's flowers during his early career (fig. 37).

During the spring of 1933, Chang was challenged to demonstrate his understanding of Chen Shun. Chang's friend Xie Jinyu (1899–1935) saw in Chang Dai-chien's collection a long handscroll by Chen Zun (act. 1600–1617), whom he believed had perfectly embodied Chen Shun's style. Xie asked Chang to copy Chen Zun's painting, and the result was a brilliant display of Chen Shun's style through the intermediary of Chen Zun (fig. 38).

In 1981, Chang Dai-chien saw this painting again and wrote a long comment.

Among those who could paint elegant, free-style flowers in the Ming dynasty, I regard Chen Daofu [Chen Shun] as the best. His works have the highest, most refined quality; even Old Shitian [Shen Zhou] should give up his seat in deference to Chen. The second-place master is Xu Qingteng [Xu Wei; 1521–1593]. Bada Shanren [Zhu Da] spent his youth trying to be like Baiyang [Chen Shun], and during his mid-years he was even more diligent in dedicating himself to capturing Qingteng's style. Therefore he became a great master of his period, as would be expected. My painting began with Baiyang and Qingteng; during the late Ming dynasty only Chen Ruxun [Chen Zun] was a direct disciple of Baiyang's style and able to copy him. My late friend, Xie Yucen [Xie Jinyu] . . . said that within the last three hundred years only [I], Dai-chien, have been capable of grasping the essence of the two Chens and Xu [Wei], the three master painters [of the Ming].

Chang Dai-chien's second-place master, Xu Wei, was less restrained than Chen Shun, and some of his most brilliant masterpieces were executed without color. With rapid brush-work, which included broad inky swaggers of the brush as well as controlled, thin lines and layers of wet wash, Xu Wei developed a style that recognized the principles of organic flower painting and yet went beyond likeness in form to explore the abstract values of tonality and shape. One of Chang Dai-chien's early free-form flower paintings is a forgery of Xu Wei (fig. 39). Following the examples of Chen Shun, Xu Wei, and Chen Zun, who painted long handscrolls with parades of flowers, one for each month, Chang Dai-chien seldom painted fewer than twelve flowers on a handscroll.

In most subjects Chang first studied Qing dynasty models, but with flower painting he started with the Ming painters.

The lessons of several Qing painters—for example, Jin Nong's loquats and Zhu Da's lotuses—were nonetheless important for Chang's early development in flower painting. Shitao, Chang's first model for landscape painting, also influenced his flower painting. Shitao painted flowers by first applying ink, and when the image was dry, he would add layers of soft color on top. On one leaf in an album by Shitao, Chang wrote:

> The longer I look at Qingxiang's [Shitao] flowers, fruits, and vegetables, the more I can savor their flavor. They don't fall into the mold of Baiyang [Chen Shun] and Qingteng [Xu Wei], but are truly independent. Even the flower specialists like Nantian [Yun Shouping; 1633–1690] and Wang'an [Wang Wu; 1632–1690] rate a lower rank. On these four leaves [Shitao] first applied ink [brush strokes] and ink washes; next light, suffuse color [washes] were laid on top. This method is well-recognized as a technique for landscape painting. But after Nantian became known, his technique of [boneless] painting became very popular, leaving aside Shitao's method. Autumn of the *xinmao* year [1951].[9]

Many of Chang Dai-chien's studies of single flowers follow Shitao's technique. After using ink, Chang washed hues of blue and soft brown on top to evoke a moist succulence; he was particularly fond of this method for lotuses.

Like Chen Shun, Yun Shouping often painted in the boneless technique. Yun's pure colors brought a new intensity and richness to flower painting, and his luxuriant images dominated the later Qing dynasty. Although he championed Shitao's delicacy, Chang Dai-chien was also partial to *mogu,*

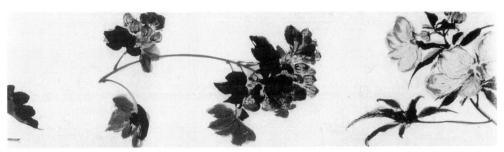

Fig. 38. Chang Dai-chien, details, *Flowers of the Four Seasons*, 1933. Handscroll; ink and color on paper; collection unknown. From *Chang Dai-chien shuhua ji*, vol. 6 (Taipei: Guoli lishi bowuguan, 1980–90), 62–63, pl. 30. Chang's 1981 colophon is pictured on 64, pl. 30-1.

or "boneless," painting. However, the flowers that he painted with layers of color tend to be more impressionistic than those of Yun Shouping, who loved to paint in dazzling color and with careful, realistic description.

Ming and Qing dynasty flower painting generated popular appreciation for spontaneous, seemingly effortless images, which the Shanghai School artist Ren Yi enhanced with sensual effects of rich, wet color and moist ink that Chang considered too exaggerated and extreme. Although Chang was one of the twentieth-century masters of the "jeweled" style of painting characterized by the use of heavy, mineral pigments, such as in *Blue Peony* (entry 35), he rejected the Shanghai School in favor of what he called the "cool, subtle elegance" of the early Qing dynasty artist Hua Yan. Typically, at the same time that he was emulating Hua Yan's restraint, he was also imitating Zhu Da's assertively bold images of flowers and animals.

Around 1930 some of Chang Dai-chien's contemporaries criticized him for having mastered only the loose-brush *xieyi* style. They encouraged Chang to train himself as a draftsman and gain precision with the brush in order to produce controlled, fine lines. Chang followed their advice, and during the early and mid-1930s when he was in Peking with Yu Feian, Chang turned toward *gongbi*, or detailed, painting. As with figure painting, he looked to Chen Hongshou as a model. Gradually Chang delved deeper into the past, studying the Northern Song academy masters and Five Dynasties painters; Chang emulated their style known as "magical realism" in *Songbird and Red Leaves* (entry 19). He frequently copied Teng Changyou (ca. 850–after 930), Emperor Song Huizong (r. 1100–1125), Li Di (act. 1163–1225), and Lin Chun (act.

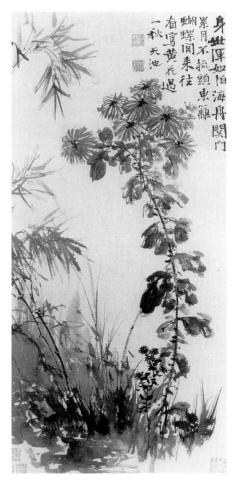

Fig. 39. Chang Dai-chien, *Chrysanthemum, Signed as Xu Wei.* Hanging scroll; ink and color on paper; Liaoning Provincial Museum, Shenyang. From Yang Renkai and Dong Yanming, eds., *Liaoning bowuguan cang hua* (Shanghai: Shanghai renmin meishu chubanshe, 1986), pl. 57.

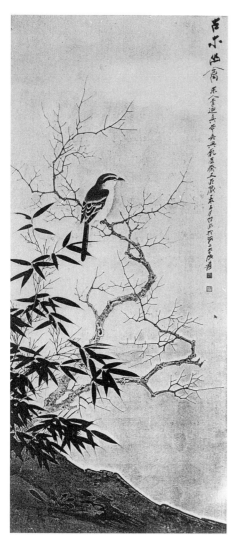

Fig. 40. Chang Dai-chien, *A Winter Bird in a Snowy Tree, after Li Di,* 1947. Hanging scroll; ink and color on paper; collection of Yon Fan, Hong Kong.

1174–1189). One of Chang Dai-chien's favorite Song dynasty paintings was *Myna Birds in a Secluded Valley* attributed to the Emperor Song Huizong, which he copied in 1948. In his inscription Chang expressed awe for Song Huizong's ability to go beyond mimesis and embody the spirit of the bird. Chang often felt his own copies, such as *A Winter Bird in a Snowy Tree, after Li Di,* captured the same insight (fig. 40).

Chang did not limit his studying to the masters of the past. During the 1930s he frequented the Peking temple markets where several days a week the courtyards were bustling with people buying and selling plants and birds. Chang studied the rare and exotic birds and began buying flowers and birds to raise at home as painting models. His progress was so rapid that in 1935 he wrote on a painting that he believed he had

surpassed the famous Ming dynasty court artists Lü Ji (act. 1490–1506) and Lin Liang (ca. 1430–ca. 1490), who were known for their combination of realism and decorative appeal in bird-and-flower subjects. This turning point was a major breakthrough for Chang in bird-and-flower painting.

In 1942, when Chang was in the desert climate of Dunhuang, he recalled the verdant woods of the Qingcheng Mountains where he had lived previously, and he painted works like *Autumn Foliage and Twin Sparrows* (fig. 41). His inscription reveals bold self-confidence, as he compared himself with two of the highest luminaries in bird-and-flower painting: "I feel I am among my equals with Cui [Bo; act. 1024–1070] and Huang [Quan; ca. 903–965]." Chang considered the 1940s to be the pinnacle of his bird-and-flower painting, and he created vibrant, meticulously painted birds and flowers until 1949, when he left China and temporarily turned his attention more exclusively to landscape painting.

When he returned to floral subjects, Chang shifted to the free *xieyi* manner. His mature *xieyi* works display a brilliant sense of timing for each brush stroke, with a rhythmic sweep and a balance between wet and dry. Every detail was perfectly placed. During his years in the West, Chang returned to the triumvirate of Chen Shun, Xu Wei, and Zhu Da as models.

Chang Dai-chien's most innovative flower paintings employ the methods of splashed ink and splashed-ink-and-color. In his early career, Chang mastered the loose brushwork and "improvisational" compositions of *xieyi* painting as well as the techniques of applying opaque color and color washes required in *mogu,* or "boneless," painting. During the late 1950s Chang extended these techniques and developed splashed-ink-and-color, a method he used to fashion both landscape and flower paintings. Chang's large lotus compositions, such as *Ink Lotuses on Gold Screen* (entry 65) and *Crimson Lotuses on Gold Screen* (entry 80), display his creativity and prodigious energy during his expatriate years.

A list of the plants Chang most commonly painted testifies to his diversity: narcissus, flowering plum trees, tree peonies, herbaceous peonies, wild orchids, chrysanthemums, begonias, lotuses, and hibiscuses. Less common subjects include magnolias, day lilies, Easter lilies, jade-hairpin lilies, yellow cassia flowers, and others. In addition, Chang painted plants and vegetables such as banana leaves, bamboo shoots, Chinese cabbages, mushrooms, taro roots, radishes, and cucumbers. Fruits that took succulent form under his brush include loquats, grapes, chestnuts, peaches, cherries, persimmons, pomegranates, apples, and watermelons. He depicted a series of plants in *Illustrated Menu* (entry 83) and the albums *Flowers and Landscapes* (entry 62) and *Flowers, Fruits, and Vegetables* (entry 67).

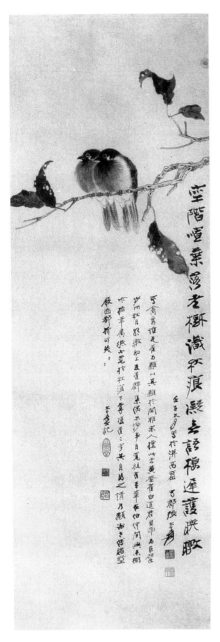

Fig. 41. Chang Dai-chien, *Autumn Foliage and Twin Sparrows*, 1942. Hanging scroll; ink and color on paper; Chongqing Municipal Museum.

The Chinese genre of bird-and-flower painting encompasses much of nature, including paintings of fish and insects as well as animals. Chang was attracted to each of these subjects. His *Joy of Fish* (entry 51) was a tribute to Zhu Da's sprightly little fish. Chang often painted monochrome studies of minnows darting across the paper; a few abbreviated brush strokes would complete a picture, which was bursting with the energy of the fish swimming through water. The test of his

artistry was that Chang, like Zhu Da, never painted ripples or waves but implied the presence of water through the animated bodies of the fish.

Although Chang occasionally painted shrimp and insects, which were in vogue following Qi Baishi's grand success with these small creatures, they were not Chang's forte. A few paintings of beautiful ladies include a butterfly (a favorite composition of Chen Hongshou's), but studies of an insect on a branch are exceedingly rare in Chang's oeuvre. Fearing he could not surpass his older contemporary, Chang preferred not to paint these small denizens of the everyday world.

Chang often featured animals in his works, and most of his animal subjects he had studied firsthand. Chang's father raised dogs, and as children Chang and his brothers had their own pets. As an adult, Chang made pets of exotic animals, such as panthers and gibbons, and when he lived in Peking, his menagerie included birds, squirrels, and deer. Chang's fondness for animals and his amusement watching their antics nourished his painting. He once said, "Because I love to paint horses, gibbons, and dogs, I also love to raise horses, gibbons, and dogs."[10]

After 1938, when Chang left Peking and moved into the Qingcheng Mountains, he raised three panthers and a bear. Abhorring the confinement of caged animals, he left them free to roam so he could observe their natural majesty. When he lived in the West, he raised mostly gibbons, cats, and dogs.[11] Several of Chang's gibbon paintings are forgeries, such as two versions of *Sleeping Gibbon, Signed as Liang Kai* (entries 11 and 12), though he also created original works, such as *Gibbon* (entry 30). Chang's dogs were primarily Tibetan mastiffs and Saint Bernards, which he depicted in *Tibetan Women with Mastiff and Puppy* (entry 23), *Seated Tibetan Women with Mastiff* (entry 24), and *Self-Portrait with Saint Bernard* (entry 75). A few animals in Chang Dai-chien's repertoire appear so rarely as to deserve separate mention. His turtles, goats, and deer usually embellish paintings of the Daoist sages, who frequently associate with these creatures.

The master horse painter Han Gan (ca. 715–after 781) said that he did not follow ancient painters but took the horses in the imperial stables as his teachers. The early lessons in horse painting Chang had received from his older brother Shanzi encouraged him in this direction. In Han Gan's day, the weight of tradition was easier to shed than more than a millennium later when Chang was active. Even as Chang claimed that real horses were his teachers, he had so thoroughly absorbed literati painting theory and the notion of "style as meaning" that, as with every other genre, he achieved a union of realism and ancient style.

Water buffaloes pulling plows were a common sight in pre–

World War II China, and Chang often painted them. With the strength and speed of a hawk attacking prey, Chang would sweep a brush heavily laden with wet ink onto paper. In a few twisting and pressing motions he built up the body of the water buffalo in graduated ink tones. He then added two or three precise features for the face and horns to bring the beast to life.

Chang's early *xieyi* paintings of water buffalo were highly animated, but gradually his depictions of the creatures became standardized. It took a change of scenery to refresh his painting. In India in 1950, Chang saw the large East Indian wild oxen, or gaur, roaming through the villages. Unlike Chinese water buffaloes, these sturdy oxen have a pronounced hump on their neck and shoulders. Chang was inspired to paint them in a manner different from the way he had painted the Chinese buffalo. Chang also drew on images he had assimilated from ancient painting, especially the handscroll by Han Huang (723–787) of *Five Oxen* (Palace Museum, Peking), a procession of various types and postures of oxen. Chang was so fond of the scroll that he once made a forgery of it, which is in the Ohara Museum, Japan.

One of Chang's most antique-looking oxen is a direct descendant of an ox by Han Huang; it appears pulling a cart in Chang's painting *Laozi Leaving the Pass* (fig. 42). Chang did not sign this work, which is so convincingly archaic looking that it has traditionally been credited as an anonymous ancient painting. It is tempting to think that the physical resemblance between Laozi and Chang Dai-chien is more than coincidence; perhaps Chang intended the painting as one of his double-image self-portraits.

Chang's mother and older brother were experts at painting cats, especially in meticulous brushwork, and Chang absorbed this skill. But he seems to have preferred Zhu Da's cats painted with only a few swift, deft strokes and a superior imagination that conveyed the enigmatic feline personality. Chang emulated this technique in paintings like *Cat and Day Lily, in the Style of Zhu Da* (fig. 43).

In addition to capturing an animal's physical form, Chang tried to evoke the personality of an animal, whether he was painting in ink or ink and color, with *gongbi* fine lines or *xieyi* sweeping brush movements. Although animals constitute only a small part of Chang's oeuvre, he was a master at conveying an animal's lively spirit in works that also fulfilled his own requirements of formal aesthetic beauty and decoration.

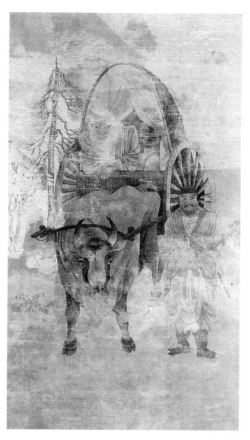

Fig. 42. Chang Dai-chien, formerly attributed to the Five Dynasties, *Laozi Leaving the Pass*, ca. 1930. Hanging scroll, ink and color on silk; National Palace Museum, Taiwan, Republic of China. From *Dafeng Tang yizeng mingji tezhan tulu* (Taipei: Guoli gugong bowuyuan, 1983), pl. 33.

Landscapes

Chang Dai-chien's greatest passion was for painting landscapes. Although he came to the subject after he had already proven himself as a figure and bird-and-flower painter, landscape consumed more of his energy and eventually became the genre that earned him the most accolades. Since the Five Dynasties, landscape has held the central place in Chinese art. The literati in the eleventh century tentatively began formulating dictums about the meaning of art and shifting the previous emphasis from realism and spiritual accord, which was appropriate to the early preference for figure painting, to self-expression through brushwork, which was well suited to "mind image" landscapes admired in the Song dynasty and later periods. Still, Chinese artists often began painting by copying masterworks, and painting styles gradually devel-

oped a morphology independent of the objects depicted. Why landscape was chosen above other genres as the primary vehicle for visual self-revelation is complex, paralleling the phenomenon in literature, where poets used nature to express the concept of self. Landscape more than portraiture or bird-and-flower painting easily dissolves into abstract coordinates—shape, pattern, color, light, and space—which provide ample latitude for a painter's inner vision and self-revelation. An artist with Chang Dai-chien's power of observation, imagination, and wealth of poetic feeling was inevitably drawn toward the literati theory of landscape painting. But Chang was not limited by literati taste; he pursued the styles of many masters and time periods and ultimately invented his own semiabstract landscape style.

Chang Dai-chien's teacher Zeng Xi, who was a Shitao enthusiast, established the first direction in landscape painting that Chang followed (fig. 44). Chang's long career ultimately encompassed innumerable styles, but until his death he continued to invoke the paradigm of Shitao's landscapes. When Chang began painting landscapes in the early 1920s, he

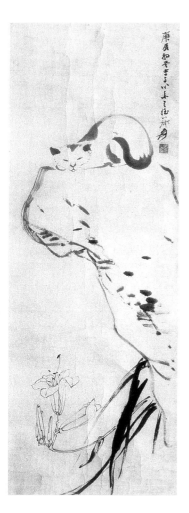

Fig. 43. Chang Dai-chien, *Cat and Day Lily, in the Style of Zhu Da,* 1950. Hanging scroll; ink on paper; collection of Yan Weicong. From *Chang Dai-chien yizuo xuan* (Chengdu: Sichuan meishu chubanshe, 1985), 57.

immersed himself in the genre—listening to his teachers Zeng Xi and Li Ruiqing, studying masterpieces from the past, reading ancient treatises on landscape, and traveling to the places that he wanted to paint. His landscapes were substantial and vivid, and they were anchored by technical excellence, a direct apprehension of nature, and art historical knowledge. Chang painted within the system of orthodox rules and methods, paying special attention to established methods such as texture strokes, but even so his images are not trite.

Chang Dai-chien was fond of remembering an aphorism by Guo Xi (ca. 1001–1090) that his son Guo Si recorded.

> It is a generally accepted opinion that among landscape paintings there are those through which you may travel, those in which you may see the sights, those through which you may wander, and those in which you may live, . . . but that those suitable for traveling and sightseeing are not as successful in achievement as those suitable for wandering and living.[12]

Chang arranged the details in his landscapes to create a spacious feeling, so that a viewer could mentally wander through the painting. He frequently designed his landscapes in order to trigger associations with famous landscape paintings of the past, and he sometimes expanded on these allusions in poetic inscriptions. After 1949, many of the poems he inscribed on paintings contained political comments on his emigré status.

As with figure and bird-and-flower painting, Chang commanded a formidable array of techniques in landscape painting with equal success at the precision of *gongbi* painting and the unbridled brush performances of *xieyi* painting. Moreover, he revived *pomo,* or "splashed-ink," painting from a state of near oblivion, as well as helping to promote a twentieth-century renewal of *mogu,* or "boneless," landscape painting. A combination of these last two styles inspired Chang's splashed-ink-and-color idiom.

One of the best colorists in all of China's history, Chang Dai-chien applied color in a great variety of techniques. One method involved brushing a thin wash on top of dark ink; blue tints, for example, washed over and blended with ink needles gave his clusters of pine needles a sense of three dimensions. Chang's applications of heavy blue and green mineral colors and gold accents—colors that had been favored by ancient painters—were exquisitely refined. His personal landscape style was marked by the gemlike quality of the colors he used.

Chang Dai-chien continually adopted new styles of landscapes, but he seldom rejected any already in his repertoire until impaired vision forced him to give up fine, detailed work. His varied styles make his landscapes difficult to arrange chronologically, although distinct stylistic features,

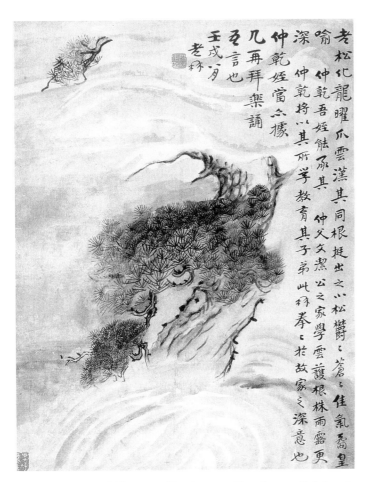

老松化龍曜爪雲漢其同根挺出之小松欝に蒼に佳氣喬皇

喻仲乾吾姪骸䏶其仲父文潔公之家學雲䕶根抹雨露更

深仲乾姪當念攄教育其子弟此秤拳に於故家之深意也

几再拜樂誦

至言也

玉成八月老秤

Fig. 44. Zeng Xi, *Old Pine in Clouds*, 1922. Hanging scroll; ink and color on paper; The Metropolitan Museum of Art, New York, gift of Robert H. Ellsworth, 1986.267.132.

circumstantial evidence, and changes in signature provide dating clues. Chang's development can be roughly summarized by noting that he initially favored landscapes with a sound "bone structure," which he captured using linear brushwork to construct interlocking units of dramatic scenery. Late in his career, Chang preferred to paint with puddled ink and color in an effort to communicate atmospheric effects rather than terrain.

In his earliest landscapes, which he began painting in the 1920s, Chang mainly followed Shitao, but he also emulated the Qing dynasty landscape painters Mei Qing, Kuncan, Zhu Da, and Hongren. In addition to honest imitations, he also made forgeries of these artists' works, such as *Through Ancient Eyes, Signed as Shitao* (entry 1). When Chang began to look toward earlier models, Tang Di (ca. 1286–ca. 1354) was one of the first Yuan dynasty painters he emulated (fig. 45).

Chang traveled in the Yellow Mountains in 1927, 1931, and 1936, and after each trip he painted from the sketches he made

there. At the same time, he continued to follow his models of the 1920s, all of whom had painted the Yellow Mountains, blending past art with his own direct experience of the landscape.

Chang was gradually creating a personal style, especially by combining elements from two or three of his Qing dynasty models into a single work (fig. 46). Most of Chang's forgeries of Shitao, Mei Qing, and Kuncan date from around 1930, such as *Wenshu Plateau in the Yellow Mountains, Signed as Mei Qing* (entry 6) and *A Thousand Meters Up, Signed as Kuncan* (entry 16).

Chang soon found new inspiration by reviving boneless landscape painting, which Dong Qichang had championed during the late Ming dynasty. In 1934 Chang painted *Mount Hua* (fig. 47) by puddling and layering color wash to build each form without outline. He painted other landscapes of Mount Hua during 1934 and 1935 following his trips there. In 1935 Chang painted *Clear Autumn in Wu Gorge* (entry 14) as a boneless landscape.

At the same time Chang's paintings in the blue-and-green landscape tradition reached their peak. Paintings in this style are decorated with azurite blue and malachite green pigments accented by gold contour lines. The mountains are bounded by fine, angular lines that divide each major rock face into a series of facets. With the exception of a few masters in the Yuan, Ming, and Qing dynasties, proficiency in blue-and-green landscapes had waned, so Chang's revival of this style was quite novel. In Dunhuang, Chang improved his skills in preparing the mineral pigments and gold by working with Tibetan monks who favored this palette in their religious paintings.

Throughout the 1930s and into the following decade Chang refined his skills as a colorist. Chang loved sumptuous colors but sought to employ them with restraint; thus his highly colored paintings unite the scholar's taste with decorative art. His mastery of color made way for his development of splashed-ink-and-color paintings beginning in the late 1950s and continuing to the end of his life. In these, color is integral to structure, whereas traditionally color has had more of a subordinate and purely ornamental role in Chinese painting.

As Chang Dai-chien delved deeper into the past, he emulated the landscapes of Zhao Mengfu, Sheng Mou (act. 1310–1360), and Wang Meng (ca. 1308–1385). And in 1938, about three years before his trip to Dunhuang, he had already begun copying the landscapes of Tang dynasty artists, such as Wang Wei, Li Zhaodao (act. 670–730), and Yang Sheng. While diligently re-creating the landscapes of the past, Chang also painted more independent works. These reflected nuances from Shitao and Kuncan, and through them back to Wang

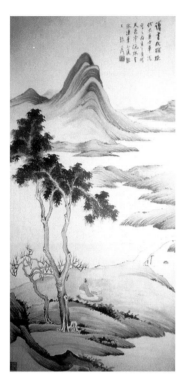

Fig. 45. Chang Dai-chien, *Reading under an Autumn Tree, in the Style of Tang Di.* Hanging scroll; ink and color on paper; collection of Mr. and Mrs. W. B. Fountain, Piedmont, California.

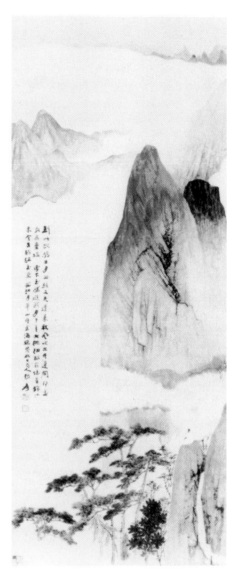

Fig. 47. Chang Dai-chien, *Mount Hua,* 1934. Hanging scroll; ink and color on paper; collection unknown.

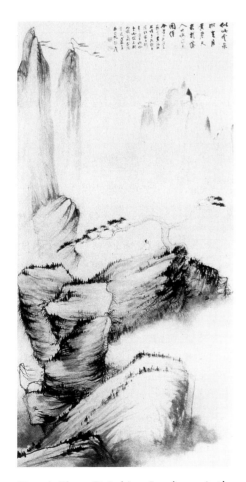

Fig. 46. Chang Dai-chien, *Landscape in the Style of Mei Qing and Shitao,* 1928. Hanging scroll; ink and color on paper; collection unknown.

Meng's vision of landscape densely textured with lines and dots that agitate the surface to suggest nature's dynamic force.

During his sojourn in Dunhuang, Chang did not lose interest in landscapes, as is evident in *Three Perils Mountain* (entry 20). Undoubtedly the fact that his landscapes sold well enough to subsidize his stay in Dunhuang also prompted him to continue painting mountains and streams. As free time permitted, he painted in the styles of Wang Meng, Fang Cong-yi (act. 1340–1380), Liu Songnian (ca. 1150–after 1225), Shitao, and Kuncan. Chang also began to explore a new archaizing landscape style based on features in the Tang dynasty murals around him. Bird's-eye views of open terrain and mountains naively fashioned from stacked triangles had

for Chang the fresh appeal that so-called primitive art had for some Western painters. There was no true receding ground plane in the Dunhuang murals; the zigzag of a river implied spatial recession with each turn, by leading the viewer's eye higher—and thus seemingly farther—into the landscape. Chang began to exploit this vision and the vivid colors of Tang dynasty landscape murals in his own work, such as *Quiet Autumn on a Sichuan River* (entry 37).

For the first two years after Chang returned to Sichuan, images from Dunhuang so preoccupied him that figure painting dominated his repertoire. But he continued to paint landscapes in the style of Shitao and in the idiom he had developed by combining elements from Shitao and Kuncan. In 1938, Chang had lived in the scenic Qingcheng Mountains, and the following year he traveled to major tourist spots north of Chengdu, to Guangyuan, and south, to Mount Emei. He returned to Mount Emei many times in the 1940s. Sichuan's mountains, so different from the craggy rocks and gnarled pines of the Yellow Mountains, invigorated him and his work. The more that Chang absorbed from these Sichuan landscapes, the more his personal style began to diverge from Shitao's heritage. Along with this independence from the Qing dynasty models came a stronger pull by the lofty landscapes and far vistas of the tenth-century painters Dong Yuan, Juran (act. 960–980), and Jing Hao (act. 870–930). Mount Emei's three major peaks—rounded massifs with ragged cliff faces and dense, virgin forests—offered him a new challenge, leading in 1955 to an exciting combination of Dong Yuan's gentle, rhythmic texture strokes with Jing Hao's stippled, harsh landscape idiom in *Mount Emei* (entry 54).

With the end of World War II, Chang Dai-chien returned to metropolitan Peking and its active art market. He concentrated on collecting the works of Dong Yuan, Juran, and their followers, hoping to deepen his knowledge of landscape painting; he was moving away from the seventeenth-century artists who specialized in painting the Yellow Mountains. He acquired two important attributions to Dong Yuan, *Along the Riverbank at Dusk* (see fig. 95) and *The Xiao and Xiang Rivers* (see fig. 17), as well as Liu Daoshi's *Clear Morning over Lakes and Mountains* (see fig. 97). He copied these works often during the next five or six years, as well as copying Juran's *Seeking the Dao in the Autumn Mountains* (see fig. 96). Chang made both imitations and forgeries; during the early 1950s his forgeries of tenth-century masters reached their peak in works like *Dense Forests and Layered Peaks, Attributed to Juran* (entry 42).

Along with his esteem for Dong Yuan and Juran, Chang also nurtured an interest in the Northern Song dynasty painters Li Cheng (919–967), Fan Kuan (ca. 960–1030), and

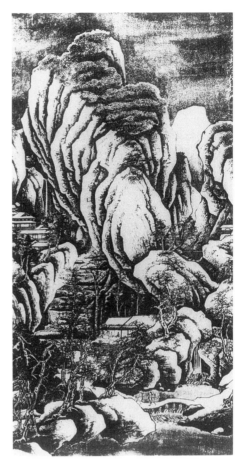

Fig. 48. Chang Dai-chien, *Copy of Winter Landscape by Fan Kuan.* Hanging scroll; ink and light color on paper; collection unknown.

Guo Xi, who developed styles for depicting the majestic terrain of northern China. From Li Cheng and Guo Xi, Chang developed a keen eye for the play of atmosphere and light as well as learning their trademark idioms of craggy pines and "cloud" rocks. He also learned ways to apply ink wash. From Fan Kuan he learned how to compose a landscape from solid blocks of terrain that connect into a logical unit (fig. 48); while simplifying nature's complexity, Fan Kuan still managed to suggest a cosmic scheme. Chang was also partial to the lyrical, dazzlingly colorful blue-and-green paintings of Wang Ximeng (1096–1119), Emperor Song Huizong, and Gao Keming (act. 1008–1053), whose imposing landscapes he copied as direct imitations and creative re-interpretations (fig. 49). In the late 1940s Chang's monumental landscapes in the style of the Northern Song dynasty reached a peak.

Since the Northern Song dynasty landscapes are from the most realistic phase of painting in China's history, Chang's study of Song landscape coincided with the period of his own

most realistic work. In 1947 he visited Xikang, which is in western Sichuan near the Tibetan border. The rugged peaks of Xikang beg to be painted with the monumentality of Northern Song landscapes, so Chang created a large, vertically proportioned album called *Walking Excursion to Xikang* (fig. 50), which follows Northern Song painting schema and carefully reproduces the topographical uniqueness of Xikang.

In the winter of 1949 Chang Dai-chien left China, never to return. Instead of self-exile reducing Chang's passion for painting his native land, the mountains and rivers of China became his primary theme. His voluntary exile forced him to be a "citizen of the world," and he traveled in Europe, Japan, Hong Kong, and Taiwan and lived in India, Argentina, Brazil, the United States, and Taiwan. While he enjoyed the stimula-

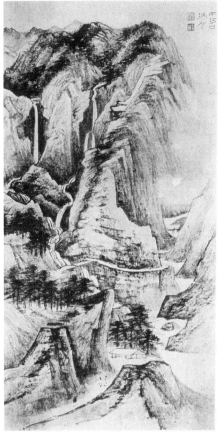

Fig. 50. Chang Dai-chien, *Mountain Cataracts,* from *Walking Excursion to Xikang,* 1947. Album leaf; ink and color on paper; Sichuan Provincial Museum, Chengdu. From Chang Dai-chien, *Xikang youji* (Taipei: Guoli lishi bowuguan, 1980), n.p.

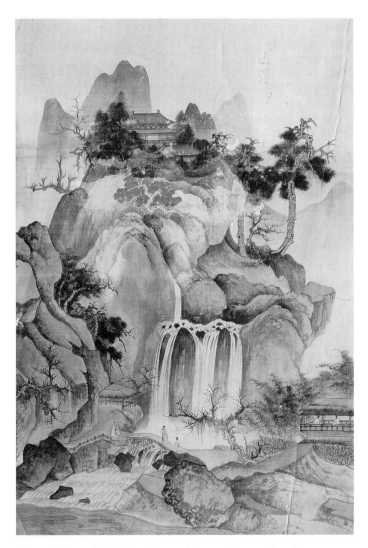

Fig. 49. Chang Dai-chien, *Copy of a Song Dynasty Landscape.* Hanging scroll; ink and color on silk; collection unknown.

tion of foreign lands, the core of his being was Chinese, and he was always looking to reaffirm that.

In the first year of his exile, Chang painted scenes of the Indian countryside in works like *Deer Park* (fig. 51). He also painted Nikko and Matsushima, which he visited in Japan in 1951 (fig. 52). After Chang Dai-chien transformed his land near São Paulo, Brazil, into a Chinese-style garden with miniature mountains and Chinese plants, he often painted that microcosmic world. Only rarely did Brazil's natural landscape find expression under his brush. Gradually some of the scenery that he saw in the West filtered into his consciousness. Surprising landscape subjects in the 1950s and 1960s include *Niagara Falls* (entry 48), *Mohawk Valley, New York* (entry 61), and the pines and junipers of Carmel, California. He also painted the Swiss Alps on numerous occasions throughout the 1960s (see entries 64, 66, 70, 71, and 72). These paintings were Chang Dai-chien's travelogue of his new lifestyle.

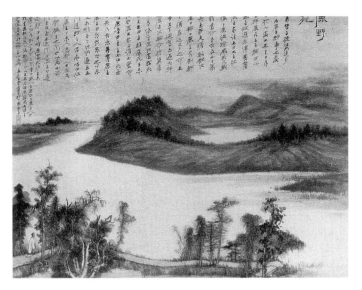

Fig. 51. Chang Dai-chien, *Deer Park,* 1950. Album leaf; ink and color on paper; collection unknown.

Chang still felt a keen loss for China; as a result, he paid special attention to Taiwan, which he often visited during the 1960s. He painted all of the island's famous scenic spots, such as views of the mountainous East-West Highway that snakes along a towering rock ledge (fig. 53), the rugged, monumental Mount Ali, and the coastal highway near Hualian that looks out over the turquoise ocean. Whether it was nationalism or aesthetics, Chang praised the mountain scenery in Taiwan above that of the Swiss Alps.

In the last phase of Chang Dai-chien's career, he turned increasingly to painting the "landscapes within his breast," a Chinese aphorism suggesting total empathy between the painter and the landscape, or, as an important Daoist art theory, the merging of self and nonself. A cluster of unusually large paintings marks the second half of the 1960s. Some of these huge works display pools of rich color and ink that Chang worked into stunning and unexpected compositions; they are so impressive as to almost overshadow the tranquil paintings of his early career. Splashed-ink-and-color is particularly well suited to a monumental scale. Practical reasons may have prompted Chang; for example, his painting studio in Brazil was the most spacious he ever had. Just as important, Chang had the time for such undertakings: his life in Brazil was relatively quiet, his children were grown, and only a few friends passed through, so obligations to work on small paintings for visitors abated. But Chang's motivation to create large paintings may also have been a desire to challenge himself and prove that in spite of worsening sight, he was still in his prime.

Chang Dai-chien spent most of the early 1970s in the United States, finally moving to Taiwan in 1976. He continued to paint zealously, but most of his works were on a smaller scale. The splashed-ink-and-color technique had an important presence in his oeuvre; however, in response to the tastes of his patrons in Taiwan, he began to interject more traditional Chinese brushwork into his paintings. The drawback to living in Taiwan was that his many friends and fans were anxious to visit him. As Chang aged and became weaker, he was besieged by more social pressures. The demand on him for new paintings was so great that it froze his spontaneity. Only rarely during his last years could he produce a heartfelt masterpiece such as the majestic *Peach Blossom Spring* (entry 85).

In 1981, at the age of eighty-two, he fulfilled his final challenge, a monumental wall mural in handscroll format nearly two meters tall and eleven meters wide. Chang did not finish *Panorama of Mount Lu* (entry 87); nonetheless, the rich plays of ink and luminous colors are so successful that the National Museum of History in Taipei exhibited the work in 1983, three months before his death. *Panorama of Mount Lu* was the antidote to Chang's frustration over the deluge of requests

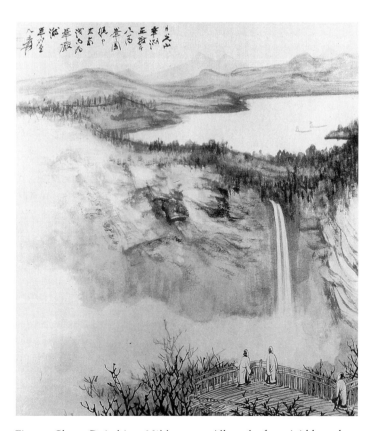

Fig. 52. Chang Dai-chien, *Nikko,* 1951. Album leaf on rigid board; ink and color on paper; collection unknown.

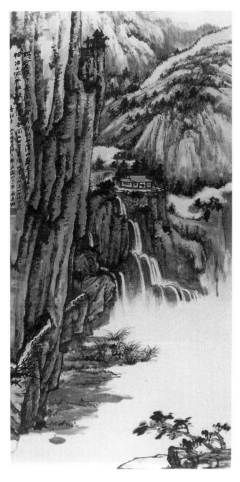

Fig. 53. Chang Dai-chien, *The Temple of Everlasting Spring near Taroko Gorge,* 1959. Hanging scroll; ink and color on paper; collection unknown.

for obligatory paintings, minor works done out of politeness to friends and visitors. Old and ill, he found a source of inner strength when addressing China's sacred Mount Lu, a place he had never been and had seldom painted. It is only fitting that Chang Dai-chien's last important painting was a departure. Though the work physically strained him and he had to take medicine and rest periodically to carry on, he remained undaunted. When the director of the National Museum of History visited him a month before his death, Chang bravely promised to produce a second work as large as *Panorama of Mount Lu* and said the subject would be Mount Huang.[13]

Splashed-Ink-and-Color

Chang Dai-chien's vibrant splashed-ink-and-color paintings are dramatic proof of his power to transmute ancient art

styles into an individual idiom. Sacrificing mimetic detail, Chang spilled and flicked ink and color onto the painting surface (paper or silk), only minimally affecting their natural course by regulating the volume of the liquid pigments and by rotating the surface to channel their flow. In the best paintings, it is almost impossible to decompose the elements—shapes, seemingly without individual boundaries, flow together creating a dynamic rhythm. Chang brilliantly brought such images back from the threshold of total abstraction by adding a few simple details, such as tree branches or a rooftop, with a traditional Chinese brush. These concrete elements amid swirling patterns of color and ink define a painting as a landscape. Chang's aim was to expand the range of traditional Chinese painting, not to break with it. Unlike abstract expressionists, who were trying to overthrow their Western artistic heritage, Chang wanted his new method of semiautomatic painting to fit within Chinese tradition.

Several factors—internal and external—generated Chang's development of this style in the late 1950s. The impetus most often cited, even by the artist himself, was the damage to his vision that occurred in 1957. He wore an eye patch to protect the worse eye (fig. 54), and, although his sight improved with time and laser therapy, his visual acuity was rarely sharp enough for detailed *gongbi* work. In 1961, with glistening, wet ink and bold brushwork, Chang wrote an inscription on his 1956 album leaf *Latter Ode on the Red Cliff* (fig. 55) that describes how the change in sight affected him: "My eyes have been diseased for four years; it is fair to say that I've been scribbling painting like a blind person."

Chang often ascribed his new painting style to this change in vision. He told a newspaper reporter in Taiwan in the spring of 1968 that his visual impairment had recently led to a change of expression in his painting. And in 1970 he wrote in an inscription on *Mount Hehuan,* "My sight becomes more blurred every day, I cannot regain the ability to paint using fine lines, but this rough, broken-ink method allows me to express what is in my breast."[14]

In spite of Chang's emphasis on his deteriorating vision, the change in his sight may have been more the catalyst than the genesis of his new painting style. Consider one of the most influential painters of the Ming dynasty, Wen Zhengming. He, too, suffered some loss of vision at the end of his life, yet he still wrote exquisite and delicate script. It is impossible to think of the refined and stern Wen Zhengming flinging ink. But during the 1920s Chang Dai-chien was already showing a predilection for a bold, uninhibited use of ink. Chang's early *xieyi* paintings prefigure his dynamic, gestural painting method of the 1960s.

Another motive for Chang's change in style may have been

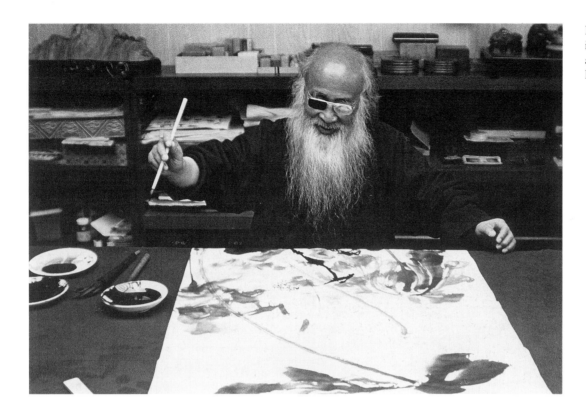

Fig. 54. Chang Dai-chien wearing an eye patch while painting a lotus, 1975. Photograph by Roy Shigley, San Francisco.

financial. In the 1960s the market for traditional Chinese paintings was flat. Chang needed to find a way to appeal to Western buyers, who were the greatest art patrons of the period. Moreover, since living in the West, he had become increasingly sensitive to the ethos of Western painting. In fact, he spent about a third of his total career living in the West, a much greater proportion than the time Xu Beihong spent in Paris before returning to China. Xu was a leader in amalgamating the arts of East and West, but he had never considered making a career in the West. For Chang the situation was different; after he left China he had little hope that he would ever return, and it was necessary for him to develop a Western clientele.

Chu-tsing Li, one of the first art historians to review modern Chinese art, has emphasized that while Chang Dai-chien utilized Chinese painting methods as a foundation, he was sensitive to trends in Western art. Chang realized he could assimilate aspects of both traditions with his own creative impulses, which were predicated on Chinese tradition.[15] Chu-tsing Li mentions Chang's partial loss of vision as a factor, but he also credits Chang's new style to personal evolution and the influence of international art.

On Chang's many trips to Europe he frequented museums and galleries. Since he spoke only Chinese, he had little direct interaction with Western artists except for the much-vaunted visit to Picasso, which was motivated by the opportunity for publicity as much as by an interest in Picasso's art. Through different means, Chang hoped to achieve the level of epochal innovation for which Picasso was famous.

Even before Chang Dai-chien had emigrated from China, his paintings had been exhibited in the West. Several were included in a contemporary Chinese painting exhibition held at the Musée Cernuschi in 1946, foreshadowing Chang's later connection to the Paris art world. In 1956 the Musée d'Art Moderne held a major exhibition of Chang's work in one hall and a Matisse retrospective in another, a juxtaposition that suggests recognition of a sympathy in expression between Chang's work and Western art. Chang was not directly affected by Matisse or other modern masters, but their formalist approach to the value of color, decorative shapes, and kinesthetic brushwork attracted Chang and suggested one path to follow when his vision became blurred.

Well versed in the history of Chinese landscape, Chang Dai-chien was able to immediately graft Western abstract expressionism onto a Chinese mode of painting by reviving the method of Tang dynasty eccentric painters who splattered ink. Even before his vision changed, Chang had begun to move in this direction. He was restless during the 1950s, having so thoroughly apprehended most methods of traditional Chinese painting that he became afraid he would reach a dead

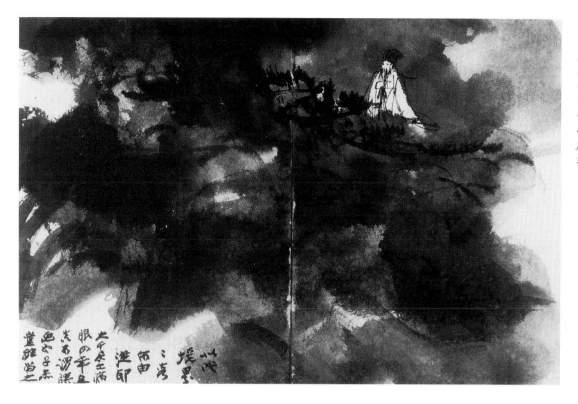

Fig. 55. Chang Dai-chien, *Latter Ode on the Red Cliff,* from *Album of Miscellaneous Images,* 1956. Album leaf; ink on paper; National Museum of History, Taiwan, Republic of China. From *Chang Dai-chien jiushi jinian zhan shuhua ji* (Taipei: Guoli lishi bowuguan, 1988), 98, pl. 35–12.

end with no new challenges ahead. He began painting large folding screens depicting lotus ponds. He adapted traditional painting techniques to fit the large brushes he was using, which were generously loaded with ink and required exaggerated physical gestures for him to cover the surfaces of the screens with breathtaking, windswept lotuses. These paintings heralded an internal evolution in style that external conditions then accelerated.

When his vision changed, Chang was ready to recall the late-eighth-century painter Wang Xia, who was known as Wang Mo, or Ink Wang. A brief comment by the Tang dynasty scholar Zhu Jingxuan illustrates the close correspondence between Wang Xia's painting and Chang's goal.

> Whenever he [Wang Xia] wanted to paint a picture, he would first drink wine, and when he was sufficiently drunk, he spattered the ink onto the painting surface. Then, laughing and singing all the while, he would stamp on it with his feet and smear it with his hands, besides swashing and sweeping it with the brush. The ink would be thin in some places, thick in others; he would follow the shapes produced by brush and ink, making them into mountains, rocks, clouds, or water. Responding to the movements of his hand and following his whims, he would bring forth clouds and mists, wash in wind and rain, with the suddenness of creation. It was exactly like the cunning of a god; when one examined the painting after it was finished no traces of the puddles of ink could be seen.[16]

While similarities to Chang Dai-chien's painting are obvious, neither the spirit nor the technique is identical. What Chang had in common with the splashed-ink painters like Wang was a method intended to take advantage of accidental effects. But while Wang painted in a drunken catharsis, Chang Dai-chien's splashed-ink-and-color paintings were conscious statements of a new aesthetic theory.

None of Wang Xia's works are extant, but some of the audaciously bold, inky landscapes by the Buddhist monk Yujian (act. mid-13th cent.) have remained. His *Mountain Village in Clearing Mist* (fig. 56) epitomizes the style, which died out in China at this period, to be renewed later in Japan. In this regard, Chang Dai-chien's student years and later travels in Japan assume great importance, as examples of Yujian's work and his Japanese followers were more available in Japan than in China. But Chang broke more completely with mimesis than did his Tang and Song dynasty predecessors. Yujian's *Mountain Village* is instantly recognizable as a "real" landscape, concerned with three-dimensionality and depth recession in a way that Chang Dai-chien's outpourings of ink and color are not. Chang's use of color was another innovation. It reflects his personal love of the decorative appeal of bright colors as well as his assimilation of the tendency in Western art to use color as a major element in the overall structure of a painting.

Fig. 56. Yujian, detail, *Mountain Village in Clearing Mist*. Hanging scroll; ink on paper; Idemitsu Museum of Arts, Tokyo. From *So Gen no kaiga*, 2d ed. (Kyoto: Benrido Co., 1971), pl. 123.

While the technical process of splashed-ink-and-color is swift, some of these paintings took literally years to complete. Every time Chang splattered pigment on the painting surface he studied the random effects before proceeding to the next step. Ultimately painting like this required more time than a composition rendered using traditional methods.

One of Chang's earliest paintings in the splashed-ink-and-color style was *Grand View of the Qingcheng Mountains* (fig. 57). Completed in 1962, this work is a wall screen comprised of four hanging scrolls. Chang splashed and spattered ink to create the major elements of the landscape, and he added light color on top. Chang's color technique displays the restraint that marked his earliest experiments in this style. Some of his most significant splashed-ink-and-color works of Asian scenery painted between 1964 and 1969 include *Passing along Taiwan's East-West Highway* and *Four Famous Scenic Spots in Sichuan,* both wall screens composed of hanging scrolls; *Ten Thousand Miles of the Yangzi River* (fig. 58), an exceptionally long handscroll; *Mount Huang* (fig. 59), also a handscroll; and *Three Massifs of Mount Emei,* a large horizontal panel designed to fit into an architectural setting. Except for *Passing along Taiwan's East-West Highway,* these paintings depict scenery that Chang Dai-chien had not seen for years, and he

exercised wide latitude in departing from reality. Chang used splashed-ink-and-color to depict these places that he knew, as well as imaginary places such as the mountains in *Peach Blossom Spring* (entry 85).

Chang Dai-chien also painted sights of the West using splashed-ink-and-color, especially the snowy peaks of the Swiss Alps. Among these works are *The Road through Switzerland and Austria* (entry 64), *Swiss Landscape* (entry 70), *Approach of a Mountain Storm* (entry 71), and *Snowy Mountains in Switzerland* (entry 72).

Although his sight improved in the 1970s, Chang nonetheless continued in pursuit of this technique's limits. His last work, *Panorama of Mount Lu* (entry 87), brings together Chang's talent for monumental works, landscapes real and imagined, and, of course, the stunning hues of his splashed-ink-and-color works.

Paintings to Fulfill Social Obligations

The complex Chinese network of familial and interpersonal relationships and social etiquette emphasizes the exchange of gifts and favors, and this ethos weighed heavily on Chang Dai-chien. Once a painter in China is famous, it is all too easy for family, friends, and visitors of sufficient standing in age or social prestige to burden the artist with requests for gratis or reduced-fee paintings. The nature of *xieyi*-style painting, which can be completed in just minutes, only makes such

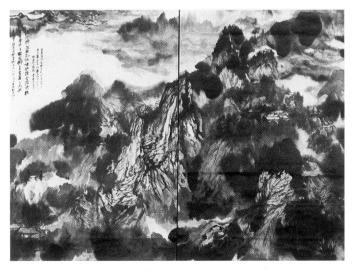

Fig. 57. Chang Dai-chien, detail, *Grand View of the Qingcheng Mountains*, 1962. Wall screen comprised of four hanging scrolls; ink and color on paper; collection of Paul Chang. From René-Yvon Lefebvre d'Argencé, *Chang Dai-chien: A Retrospective Exhibition* (San Francisco: Center of Asian Art and Culture, 1972), 104–5.

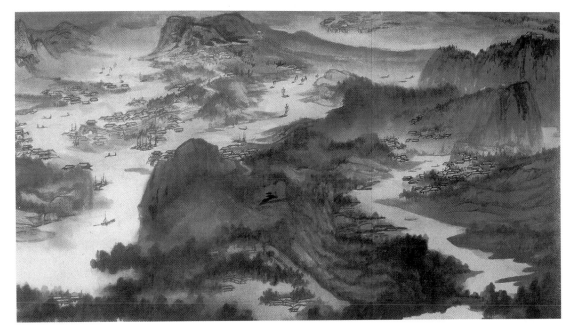

Fig. 58. Chang Dai-chien, detail, *Ten Thousand Miles of the Yangzi River,* 1968. Handscroll; ink and color on silk; collection of Zhang Chun, Taipei.

requests more frequent. As Chang Dai-chien became famous, the number of people who asked him for a "simple" painting as a memento or special favor multiplied. In his early career, these requests and his magnanimity in responding assured a wide distribution of his works and attracted important patrons. But ultimately the social network that buoyed him up would burden him with too many requests, sapping both his concentration and his time.

Traditional literati values hold that painting should be practiced as an avocation and make it a point of honor not to sell art. Theoretically such paintings, with money not a consideration, will be heartfelt. There are some examples of scholar-painters bartering paintings to gain food and wine or silk, and even to make money on the sly. Chang Dai-chien, however, was unabashedly a professional painter, who even advertised the prices for his paintings. Still, the literati heritage and his own generous nature continually induced him to give his work away.

In an inscription on a painting from 1948 Chang acknowledged the pressures these obligatory works put on him.

In preparation for my return to Chengdu, on the eve before I leave here, I must complete some paintings and calligraphies, and the paper and silk are heaped about me like an untidy mountain. I quickly dash this off for Master Shaochun [unidentified] and am apologetic that I have no time to add color.[17]

When Chang moved to Taiwan in 1976, the requests came at an even faster pace, and his advanced age made the strain all the more difficult. He wrote to a friend in Carmel:

Taiwan is really too hot, and moreover those who are seeking my paintings are too numerous; it is a burden to accept the obligations. Recently I went to Xitou [forest] to escape all these requests for paintings, but I found my life in the mountains was even busier than elsewhere. The ancients said, "To wear a cassock is to find yourself yet more involved in the affairs of the world." How true![18]

Personal retreats did not protect Chang, nor did price lists that specified the amount of money he expected to receive for paintings in various sizes and styles. People were so accus-

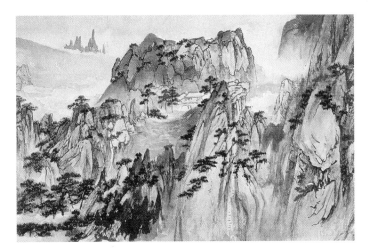

Fig. 59. Chang Dai-chien, detail, *Mount Huang,* 1969. Handscroll; ink and color on silk; collection of Li Haitian, Yokohama.

tomed to asking for his paintings that they largely ignored the fee schedule. Chang did not feel he could press the point, and he virtually never turned down a request.

On his eightieth birthday Chang made a rare admission by stating that he had wasted much energy on these trivial paintings. He was in the hospital for tests, and his secretary read to him a laudatory essay that Tai Jingnong had written in honor of Chang's prodigious age. Chang responded by confessing, "I honestly feel very abashed [to hear this]; my everyday paintings are all to fulfill requests and really none of them springs from my heart."[19] His reaction to Tai's praise reveals less about Chang's social obligations than his far-reaching ambition. There were so many new projects he wanted to try, and the time spent on trifling paintings secretly annoyed him. If "obligatory" paintings are included in Chang's oeuvre, the overall quality of his corpus is reduced. But as they did not have the artistic commitment of his other work, they should be judged separately.

The chief characteristic of these paintings is rapid-fire execution. The subjects are banal and repetitious, and the brushwork is often slick (fig. 60). Occasionally, however, when Chang was in the right mood, his artistic genius could make even a small obligatory painting a lively performance in ink and color. The lighthearted purpose of such a painting was sometimes a release. Chang was free to brush whatever came to his mind, his hand instantly responding without need for caution. The result could be an unusually fresh rendering of a humble subject, such as the vegetables in *Illustrated Menu* (entry 83) or even a sophisticated animal like *Gibbon* (entry 30).

Chang's distinction between the paintings that sprang from his "heart and mind" and those that did not is sometimes unclear. Having people around did not necessarily interfere with his serious work. Chang was accustomed to painting with family and students at hand, and sometimes it was precisely because he was talking to a friend while painting that the work blossomed into something special. Conversely, some of his largest and most lavish paintings, such as *Ink Lotuses on Gold Screen* (entry 65), were done as gifts for special occasions, such as the marriage of his daughter. Occasionally, a work of social obligation became a purely personal statement as he worked on it. This was the case with *Ten Thousand Miles of the Yangzi River* (see fig. 58), which a group requested for their mutual friend Zhang Chun.

The conditions that stimulated a masterpiece rather than a minor painting among Chang's obligatory works included the timing of the request, Chang's mood as he was painting, and, most important, the character of the recipient. Just as the ancient calligrapher Sun Guoting (ca. 648–ca. 703) claimed,

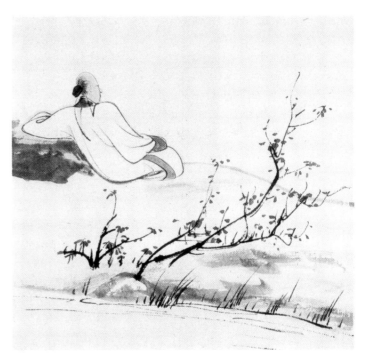

Fig. 60. Chang Dai-chien, detail, *On a River Bank*, 1947. Hanging scroll; ink and color on paper; collection unknown.

one prerequisite for producing great art was knowing you were creating it for a bosom friend.

Price List

Chang Dai-chien decided to become a professional painter while he was still a teenager, and by his mid-twenties he had begun to support himself and his family with his art. This was a major accomplishment, for a household the size of his was expensive to maintain. In addition to his wife (or wives while he was still living in China) and sixteen children, Chang provided for his students and household help—a scroll mounter, gardener, and chef. Moreover, he raised pet gibbons and a menagerie of birds and animals, and he was always entertaining. His addiction to collecting ancient paintings was costly, as were the building and maintenance of his exquisite gardens and, after 1949, his frequent international trips. The materials he used in painting were also expensive.

The historic Chinese tension between professional and amateur status for a painter did not bother Chang Dai-chien much. In the spirit of the Eight Eccentrics of Yangzhou, who lived during the eighteenth century in one of China's most commercial ages, Chang was uninhibited about discussing the price of his works. From his first commission at age twelve,

when he painted a deck of fortune-telling cards and spent the eighty coins on meat snacks, until the end of his life, Chang never considered that putting a price on a painting diminished its artistic or spiritual worth.

Chang's teachers Zeng Xi and Li Ruiqing had both been Qing dynasty officials who turned to professional calligraphy when the empire collapsed. That calligraphers of their stature could put a price on their work shows how the historic conflict between professionalism and amateurism had ceased to be a vital issue. In 1925 Chang Dai-chien held his first one-person show, which was sponsored by the cities of Shanghai and Ningbo. He exhibited one hundred paintings of different sizes and subjects and charged twenty Chinese dollars for each. He later explained this policy.

> In the early exhibitions where I sold paintings, I always put up one hundred paintings; within a month's time they would all be gone. Landscapes, figures, bird-and-flowers were all represented. . . . I had one rule, . . . the buyer could not select the painting that he would purchase; [rather] each prospective buyer took a number, and the luck of the draw determined which painting he bought.[20]

The year before this exhibition Chang Dai-chien had made a name for himself in the Shanghai art circle, and his wealthy Shanghai friends enthusiastically bought his works. In early twentieth-century Shanghai, painters, calligraphers, and epigraphists all worked according to a price list. Following the custom of the time, Chang placed an advertisement in 1926 in a Shanghai newspaper to announce himself as a professional artist and give notice that he would post a price list for his paintings in major bookstores and art supply stores around Shanghai.

Chang Dai-chien's niece Chang Xinsu and her husband, Yan Weicong, have a joint price list that Dai-chien and his older brother Shanzi published in 1929. Since Shanzi had been painting much longer than Dai-chien and was well established by that time, his paintings should have commanded a higher price, but the list shows the brothers' paintings equally priced. Shanzi must have been promoting his brother by lowering his own prices. According to this list, landscape and figure paintings were priced the same, one and one-half times more than bird-and-flower paintings. The scheme for prices was determined by subject matter, format, and size. The seven formats included were: large hanging scrolls (*tangfu*); wall screens composed of multiple hanging scrolls (*pingfu*); horizontal panels (*hengfu*); narrow hanging scrolls (*qintiao*); handscrolls (*juanzi*); albums (*cezi*); and round fans and folding fans (*tuanshan, zheshan*). Only Chang Dai-chien listed a price for calligraphy scrolls, which was half as much as a landscape painting, but the paired scrolls of a poetic couplet (*duilian*) were more expensive.[21]

An article referring to Chang's prices in 1935 recounts:

> Mr. Chang, with his brush in hand, is a very affable person, who has numerous friends and contacts in the news media. Most of his paintings in this exhibition cost between two and three hundred dollars and some go for as much as five and six hundred. At Chang's exhibition, bankers and major investors . . . immediately reserved several paintings, and they also introduced their friends [to his art]. . . . Before three or four days were over, more than a hundred paintings had red [sold] tags attached to them.[22]

The cost of one of the less expensive paintings could have provided enough noodles, the staple of northern Chinese, to feed a family of six for two years.

In 1943, Chang Dai-chien held an exhibition of his Dunhuang copies, which boosted his reputation and stimulated interest in his work. Chang developed a new price list and composed a preface written in the prose style current during the Six Dynasties period.[23] Although the text of the preface survived, the price list itself did not.

Some price lists are extant, including those from a 1944 exhibition in Chengdu and from 1947 and 1948 in Shanghai. The rapid inflation and price fluctuations of those years make it difficult, however, to translate dollar amounts into real buying power. In relative terms, the most expensive painting cost ten times more than the least expensive.

Although Chang Dai-chien was making a profit, he had many expenses. During his sojourn at Dunhuang, for example, he had to buy pigments and painting tools as well as pay his and his workshop's living costs and stipends to his helpers. In addition to what he earned, Chang was forced to borrow from wealthy friends and supporters. The total of his debts has been estimated at five thousand taels of gold (one tael is equivalent to 1.33 ounces).[24] To finance his garden project in Brazil, Chang sold most of his antique paintings in the Dafeng Tang during the 1950s, earning $1.75 million in United States dollars.[25]

In the summer of 1970, Chang Dai-chien issued a new price list, which he called "Selected Price List for Chang Dai-chien's Paintings."[26] In the preface he explained:

> Here I am seventy-two [*sui*] living in an overgrown, uncultivated place, and each day I become a touch weaker and my eyesight day by day becomes more blurred. When it comes to reds and greens [i.e., painting], I am an old man, so that gradually my painting is slower, but the requests for it are many. It is difficult to fulfill these obligations, and if I do not set prices, I will exhaust my resources. So I have written out this list, and hope that I will not be ridiculed by those who have a special craving for my flawed works. The summer of 1970.

Chang listed his prices in United States dollars since he was cultivating international recognition and wanted the most universal denomination of currency. The prices seem modest by today's standards, but at the time Chang Dai-chien was the highest paid Chinese artist in the world.

Flower Painting
Large hanging scrolls: $150 per square foot
Wall screen as a set of hanging scrolls: $200 per square foot
Horizontal panels: $150 per square foot, but if it is narrower than one foot high, charge as for a handscroll
Albums: $600 per square foot
Handscrolls: $400 per square foot

Landscape and Figures
Large hanging scrolls: $200 per square foot
Wall screen as a set of hanging scrolls: $300 per square foot
Horizontal panel: $200 per square foot
Albums: $800 per square foot
Handscrolls: $800 per square foot

Flowers, figures, and landscapes will be done in the abbreviated, spontaneous *xieyi* style; requests for special subjects are priced double; requests for gold paper are also double; no folding fans; no detailed *gongbi* brushwork; inferior paper or silk is unacceptable; if the size is an inch or more over a foot then the price is calculated according to the next full foot. These prices are calculated in United States dollars. Add a 20 percent surcharge for an "ink-grinding" fee. Payment is to be received prior to agreeing on a completion date. The fastest delivery possible is six months; no rush jobs. For something special or splashed-and-broken-ink technique, the price must be personally discussed.

Calligraphy
Standard script and semicursive script are the same price; clerical script is double the price; and seal script is double the price of clerical script.

Sets of hanging scrolls: $60 per square foot
Horizontal panels: $50 per square foot; if it is narrower than one foot apply the price for a handscroll
Couplets: $120 for three feet; $160 for four feet; $200 for five feet; $240 for six feet; $280 for seven feet; $320 for eight feet; $360 for a yard and $400 for two yards.
Albums: $100 per square foot
Handscrolls: $100 per square foot
Scroll labels, book titles: $100 each

No folding fans; no name cards; no shop signs; inferior paper is unacceptable; I will choose the text to be written; gold paper is double price; plaques for buildings, studio names, stela inscriptions, and gravestone inscriptions must be discussed in person.

Connoisseurship and Authentication
Verbal appraisals: $100 each
Inscriptions for colophons: $500 each, but no inscription longer than 100 words. I will not inscribe copies.

The format of this list remained his standard from 1970 on, although every time Chang reissued it there were minor changes. During Chang's last years in Taipei, the booming economy induced more affluent people to commission his work. But at eighty he was no longer prolific, so the lack of supply inflated his prices.

That Chang Dai-chien's paintings sold well during his lifetime is a tribute to his artistic imagination and to his innovative and technical brilliance. Some might counter that art that sells as well as Chang's is likely to be trite or banal in order to garner wide popular appeal. But in spite of the mercantile aura of Chang's price lists, his paintings have the soul of China's greatest classical art.

Conclusion

To summarize the career of any artist who painted for sixty-five years would be difficult, but when that artist is Chang Dai-chien, the task is monumental. While paying homage to more than a millennium of tradition, his art profoundly altered the course of twentieth-century Chinese painting. His work achieved an almost incredible balance among formal aesthetic principles, technical perfection, and a depth of human spirit.

Chang Dai-chien first concentrated on *xieyi* painting, conquering its impetuous, relaxed brushwork and rich gradations of wet ink and color washes. He gradually began to pursue the painstaking, polished manner of *gongbi* painting, becoming one of the greatest champions of decorative painting and reaching a personal zenith in this manner between the ages of forty and fifty. Such a range is uncommon. Chang Dai-chien was one of the last practitioners of literati painting, and during the last few centuries literati dogma honored the unrestrained quality of *xieyi* painting over *gongbi*. The disregard of mimesis resulting from the artist's rapid brushwork was equated with attaining spirituality; therefore, Chang displayed courage and independence in practicing both *xieyi* painting and its less respected alternative, *gongbi* painting.

When he was nearly sixty, Chang Dai-chien changed direction again. Spurred by a visual impairment and the styles of Western art, he began painting images that were more abstract than any China had known. He used color in a new way, as a structural part of a painting, rather than as a subordinate or purely ornamental element, as in traditional Chinese art. He combined his splashed-ink-and-color painting with the relatively more controlled *xieyi* method, possibly to reemphasize that his art was always Chinese.

Zeng Keduan, a poet and friend of Chang's, claimed that before Chang reached thirty, his paintings were "refreshing, attractive, and spontaneous." Before age fifty, they were "radi-

antly beautiful and imposing." According to Zeng, the last stage of Chang's work was "august and profound."[27]

Some of Chang Dai-chien's prominent contemporaries, such as Xu Beihong, first studied Western art and then turned to traditional modes of literati painting or a combination of the two. But Chang Dai-chien developed in reverse, learning Chinese tradition first. Because he was already an expert in literati painting style when he first encountered Western art in the form of abstract expressionism during the 1950s and 1960s, he was not uneasy with its lack of mimesis. Centuries earlier the Chinese had decreed that representation was less important than either self-expression or the abstract beauty of a calligraphic line. Chang, therefore, readily assimilated the abstract expressionist's use of color and bold shapes; however, he added touches of recognizable landscapes to his semiabstract compositions. For Chang, the relationship of man and nature was the basis of creative expression.

The famous Song dynasty landscape painter Fan Kuan once said, "Learning from other [artists] cannot compare to learning from nature; learning from nature cannot compare to learning from your heart."[28] The painter and critic Lü Foting (b. 1910) applied Fan Kuan's formula to Chang Dai-chien, and in essence said that before Chang was forty he studied the past, between forty and sixty he took nature as his teacher, and finally he followed his own heart.[29] Of course, a key to Chang's success was his ability to work from these three sources of inspiration simultaneously. But it is true that before age thirty Chang learned from his family, his Shanghai teachers, and the work of other artists. At this point, Chang had already made the transition from student to nationally known artist. From thirty to sixty, he expanded his style by integrating what he had learned with what he observed in nature. This was a period of many travels, including Dunhuang, and many homes, particularly his lavish residence in Brazil. After the age of sixty, although he still studied antiquity and the world around him, he gradually came closer to painting from his heart. When he was nearly eighty, Chang Dai-chien moved to Taiwan, where he could more easily live a Chinese way of life and be surrounded by his countrymen. In this last stage of his career, he was no longer directly harnessing the old masters to express himself, but he had so thoroughly assimilated the past that ancient styles were subliminal forces in his painting.

Chang Dai-chien succeeded in achieving the same degree of fame that was accorded his favorite models of the past. He lived his entire life in the pursuit of art, restoring the past in a vivid new expression that was both thoroughly Chinese and entirely his own.

Notes

1. For example, see his 1974 re-inscription of the 1946 painting, *Asking the Way under the Pine*, in *Chang Dai-chien zuopin xuanji* (Taipei: Guoli lishi bowuguan, 1976), 21.

2. Reprinted in Chang Dai-chien, *Chang Dai-chien shiwen ji*, ed. Yue Shuren (Taipei: Liming wenhua shiye gongsi, 1984), 125.

3. Quoted in Tao Pengfei, "Guan Dai-chien jushi qishi you si zihua xiang," in Zhu Chuanyu, ed., *Chang Dai-chien zhuanji ziliao*, vol. 3 (Taipei: Tianyi chubanshe, 1985), 72a.

4. Quoted in Bao Limin, "Yu Feian zan Chang Dai-chien," *Dacheng* 149 (1986): 3.

5. Quoted in Chen Xiaojun, "Chang Dai-chien lun meiren," *Dacheng* 45 (1977): 31.

6. Feng Youheng, *Xingxiang zhi wai: Chang Dai-chien de shenghuo yu yishu* (Taipei: Jiuge chubanshe, 1983), 94. Apparently Chang was unaware of the iconography of flowers in Western art.

7. An example of this erroneous belief is in ibid., 93.

8. Chang Dai-chien made this statement in an inscription on his album of flower paintings done around 1954 for Tai Jingnong (1902–1990); viewed and partially transcribed by the author in Mr. Tai's private collection.

9. Inscription published in Lao Tianbi, ed., *Zhile Lou shuhua lu, Ming yimin zhi bu* (Hong Kong: Heshi Zhile Lou, 1973), 20b–21a.

10. Quoted in Gao Lingmei, ed., *Chang Dai-chien hua: Chinese Painting, with the Original Paintings and Discourses on Chinese Art by Chang Dai-chien* (Hong Kong: Dongfang yishu gongsi, 1961), 80.

11. Lin Weijun, ed., *Huanbi An suotan* (Taipei: Huangguan chubanshe, 1979), 251–61.

12. Guo Si, *Linchuan gaozhi*; reprinted in Yang Jialuo, comp., *Yishu congbian*, vol. 10 (Taipei: Shijie shuju, 1967), 6. Translation adapted from Susan Bush and Hsio-yen Shih, eds., *Early Chinese Texts on Painting* (Cambridge, Mass.: Harvard University Press, 1985), 151–52.

13. Li Yongqiao, *Chang Dai-chien nianpu* (Chengdu: Sichuan sheng shehui kexueyuan chubanshe, 1987), 518.

14. In Chinese, the terms "broken-ink" and "splashed-ink" (both romanized *pomo* but written with different characters) are often used interchangeably, especially in modern times.

15. Chu-tsing Li, "Chang Dai-chien yu xifang yishu," in *Chang Dai-chien xueshu lunwen ji* (Taipei: Guoli lishi bowuguan, 1988), 52–59.

16. Zhu Jingxuan, "Tangchao minghua lu," in Yang Jialuo, *Yishu congbian*, vol. 8, 37. Translation adapted from Alexander Soper, "T'ang Ch'ao Ming Hua Lu: The Famous Painters of the T'ang Dynasty," *Archives of the Chinese Art Society of America* 4 (1950): 20.

17. Transcribed by the author from a painting in a private collection.

18. Quoted in Lin Weijun, "Huanbi An ku dashi," in Zhu Chuanyu, *Chang Dai-chien zhuanji ziliao*, vol. 6, 166a.

19. Quoted in Feng Youheng, *Xingxiang zhi wai*, 216–17.

20. Quoted in Xie Jiaxiao, *Chang Dai-chien de shijie* (Taipei: Shibao wenhua chuban gongsi, 1982), 75.

21. Chang Xinsu, "Wo fu Chang Shanzi xiansheng he wode bashu Chang Dai-chien xiansheng," *Dacheng* 173 (1988): 4.

22. See excerpts from Zhao Xiaoyi's 1983 article, "Nan Chang bei Pu de youlai," quoted in Li Yongqiao, *Chang Dai-chien nianpu*, 85 n. 7.

23. Yue Shuren, *Chang Dai-chien shiwen ji*, 110.

24. Li Yongqiao, *Chang Dai-chien nianpu*, 175.

25. Xie Jiaxiao, *Chang Dai-chien de shijie*, 375.

26. Feng Youheng, *Xingxiang zhi wai*, 132–35.

27. Zeng Keduan, preface to *Chang Dai-chien jinzuo zhanlan* (Hong Kong: The East Society, 1966), n.p.

28. Quoted in *Xuanhe huapu*; reprinted in Yang Jialuo, *Yishu congbian*, vol. 9, 11:291.

29. Lü Foting, "Dai-chien jinzuo pingyu: Cangmang hunlun daqi pangbo," reproduced in Zhu Chuanyu, *Chang Dai-chien zhuanji ziliao*, vol. 2, 137b.

Chronology of Chang Dai-chien

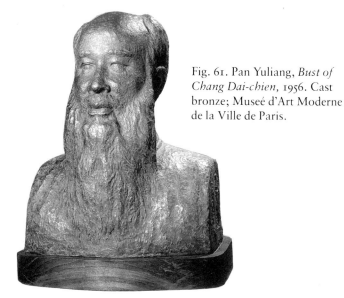

Fig. 61. Pan Yuliang, *Bust of Chang Dai-chien,* 1956. Cast bronze; Museé d'Art Moderne de la Ville de Paris.

1899–1919 Early Years: From Sichuan to Japan

1899
Born Chang Zhengchuan on May 10 in Neijiang, Sichuan Province, the eighth son of Chang Zhongfa and Zeng Youzhen.

1905
Chang's mother, brother, and sister begin teaching him to paint.

1911
Sun Yat-sen leads the movement that overthrows the Qing dynasty. Chang's elder brother, Shanzi, is a member of Sun Yat-sen's Revolutionary Alliance.

Chang attends school, instead of continuing lessons at home with a traditional-style Confucian tutor.

1916
Returning home from boarding school, Chang is captured by bandits for ransom. Serves bandit chief as secretary. Released after one hundred days.

1917
Travels to Kyoto, Japan, with Chang Shanzi. Dai-chien enrolls in a commercial art academy to study textile dyeing and weaving, and he stays until 1919.

1918
Childhood sweetheart and fiancée, Xie Xunhua, dies.

1919–1940 Rise of a Master Painter: From Shanghai to Peking

1919
Chang moves to Shanghai to study calligraphy with Zeng Xi and Li Ruiqing. Zeng Xi gives Chang the name Chang Yuan.

Chang's family arranges a marriage with a woman named Ni. He returns to Neijiang to meet her, but he refuses to marry and flees to a Buddhist temple in Songjiang outside Shanghai. Temple abbot names him Dai-chien. Leaves the monastery after one hundred days.

1920
Returns to Neijiang, at his parents' request, to marry Zeng Qingrong. Resumes studying art in Shanghai; develops interest in the work of Shitao and Zhu Da. His influential teacher Li Ruiqing dies.

Returns to Sichuan, where he begins assembling one of the most important twentieth-century collections of ancient art.

1921
Returns to Shanghai.

1922
Marries second wife, Huang Ningsu, in Sichuan.

1923
Moves to Songjiang with his brother Shanzi and father.

1925
Father dies. Chang holds his first one-person exhibition in Shanghai. Starts to grow a beard to look older and advance his reputation.

1926
Uses the name Dafeng Tang.

1927
Makes first trip to the Yellow Mountains in Anhui Province. Visits Korea and climbs Diamond Mountain.

1928
Climbs Mount Tai in Shandong Province. Goes to Peking, where he meets Puru. In summer moves to Jiaxing, Zhejiang Province.

1929
Visits Japan. Serves on committee for the First National Art Exhibition in Nanjing, Jiangsu Province.

1930
Chang's influential teacher Zeng Xi dies. Chang is recognized by the painting cognoscenti in Shanghai and Peking for his ability to forge Shitao's paintings.

1931
Makes second journey to the Yellow Mountains, where he sketches and photographs. Serves as delegate to the government-sponsored Exhibition of the Art of the Tang, Song, Yuan, and Ming Dynasties, which was sent to Japan.

1932
Moves to Wangshi Yuan, a garden residence in Suzhou, with his brother Shanzi. Befriends the calligrapher and collector Ye Gongchuo, who encourages Chang to study figure painting and *gongbi*-style brushwork. Moves to Yihe Yuan, the former summer palace, in Peking.

1933

Visits Mount Heng in Hunan Province. Participates in the Chinese painting exhibition at the Musée du Jeu-de-Paume in Paris. The museum purchases his *Lotus*.

1934

Holds his first exhibition in Peking. Marries third wife, Yang Wan-jun, in Peking. Appointed a professor at National Central University in Nanjing, where he teaches until 1936. Climbs Mount Hua in Shaanxi Province; travels to Korea.

1935

Visits the Longmen Buddhist Caves in Henan Province; visits Mount Hua again. Participates in an exhibition in London.

1936

Returns to live at Yihe Yuan in Peking. Exhibits in Shanghai. Makes third trip to the Yellow Mountains. Spends time living at Yihe Yuan in Peking. Mother dies.

1937

Visits the Yandang Mountains in Zhejiang. War is declared between China and Japan, and Japanese soldiers take over Peking, including Yihe Yuan. Japanese occupation forces detain Chang for ten months.

1938

Returns to Sichuan. Spends time at the Zhaojue Buddhist temple in Chengdu; moves to the Shangqing Gong Daoist temple in the Qingcheng Mountains near Chengdu.

1939

Travels to Mount Emei in Sichuan Province with Huang Junbi. Exhibits in Chongqing in Sichuan Province.

1940

Begins journey to the Buddhist Mogao Caves at Dunhuang, Gansu Province, but news of his brother Shanzi's death reaches him enroute. Returns to Chongqing.

1941–1951 Great Synthesis: From Dunhuang to India

1941

Reaches Dunhuang; spends two and a half years copying and studying the ancient Buddhist murals.

1942

Goes to Qinghai to invite Tibetan monks to assist him in copying the Dunhuang murals. Becomes one of the first artists to paint scenes of the Tibetan minority peoples.

1943

Leaves Dunhuang, stops at the Yulin Caves for over a month to copy the Buddhist murals, and returns to Sichuan. Continues to work on unfinished paintings from Dunhuang. Exhibits Dunhuang-style paintings and publishes his sketches of the murals. Intermittently lives at Shangqing Gong in the Qingcheng Mountains until 1948.

1944

Art Association of Sichuan exhibits Chang's Dunhuang paintings and publishes a catalogue. Returns to the Qingcheng Mountains for six months. Second visit to Mount Emei.

1945

Lodges at the Zhaojue Buddhist temple in Chengdu. Third visit to Mount Emei. Paints several huge paintings and sets of scrolls, such as *Giant Ink Lotuses* (National Museum of History, Taipei). Exhibits in Chengdu.

1946

Based in Tuoshui Village, Sichuan. Visits Peking. Exhibits in Shanghai. Fourth visit to Mount Emei. Contributes to Contemporary Chinese Painting Exhibition at Musée Cernuschi, Paris, and UNESCO Exhibition at the Musée d'Art Moderne, Paris; Chinese paintings from the latter travel to London, Geneva, and Prague.

1947

Exhibits in Shanghai. Visits Xikang in western Sichuan Province.

1948

Visits Hong Kong and exhibits paintings there. Marries fourth wife, Hsu Wen-po. Fifth trip to Mount Emei. Exhibits in Shanghai.

1949

Buys first house, called Shuiniu An, in Sichuan. Visits and exhibits in Taiwan for the first time. Spends time in Hong Kong. When communist victory seems inevitable, leaves China with Hsu Wen-po and his child Xinpei.

1950

Moves to India. Exhibits in New Delhi. Studies and copies murals at the Buddhist caves in Ajanta, India. Moves to Darjeeling. Exhibits in Hong Kong.

1951

Sojourns in Hong Kong. Visits Taiwan and Japan.

1952–1975 Life in the West: From South America to North America

1952

Moves to Godoy Cruz, near Mendoza, in Argentina. Exhibits in Buenos Aires.

1953

Makes first trip to the United States; travels through New York State, visiting scenic parks on the way to Niagara Falls. Exhibits in Taipei and visits Japan. Presents twelve paintings to the municipality of Paris. Buys farm in Mogi, Brazil, near the city of São Paulo. Family members in Sichuan donate 125 of his copies of the Dunhuang murals to the Sichuan Provincial Museum.

1954

Moves to his farm in Brazil and begins transforming it into the Chinese-style garden, which he names Bade Garden.

1955

Visits Japan; publishes his private collection of masterpieces of ancient Chinese painting *Dafeng Tang mingji* in Tokyo and exhibits his own work there. Visits Taiwan.

1956

In Tokyo, exhibits copies of the Dunhuang murals, which are then exhibited at the Musée Cernuschi, Paris. Exhibits thirty major works at the Musée d'Art Moderne, Paris. Visits Switzerland and makes first pan-European tour. Meets Picasso.

1957

Returns to Brazil via Hong Kong and Japan. His vision is affected by diabetic retinopathy (ruptured capillaries in the retina). Loss of visual acuity serves as a catalyst for him to further refine and develop his method of splashed-ink-and-color painting.

1958

Travels to New York City to receive the Gold Medal from the International Council of Fine Arts. Visits Japan.

1959

Represented by twelve major works in the Permanent Exhibition of Contemporary Chinese Art at Musée Cernuschi, Paris. Visits Japan and Taiwan; tours Europe.

1960

Visits Taiwan and makes first tour of the East-West Highway through the Central Mountains. Exhibits in Paris, Brussels, Athens, and Madrid.

1961

Tours Japan, especially Matsushima. Exhibits in Geneva and tours Switzerland. Exhibits in São Paulo. Special exhibition of his *Giant Lotuses* in Paris. Museum of Modern Art, New York, acquires *Lotus,* an ink painting on paper. In Hong Kong, works with Gao Lingmei to publish two volumes of his paintings and discourses on Chinese art.

1962

Exhibits in Hong Kong at the inauguration of the City Hall Museum. Has large exhibition at the National Museum of History, Taipei. Tours Matsushima and other sites in Japan.

1963

Exhibits in New York, Singapore, and in Malaysia in Kuala Lumpur, Ipoh, and Penang. Reader's Digest Company purchases a six-panel painting of lotuses, paying the highest price to date for a contemporary Chinese painting.

1964

Visits Japan and Taiwan; travels again on the East-West Highway. Exhibits in Thailand and Germany.

1965

Exhibits in London. Goes to United States for gallstone operation.

1966

Exhibits in Brazil and Hong Kong.

1967

Exhibits in California at the Stanford University Museum and at the Laky Gallery in Carmel. Attends exhibition of Shitao's paintings and symposium at the University of Michigan Museum of Art. Exhibits at National Museum of History, Taipei.

1968

Awarded honorary degree from the College of Chinese Culture in Taipei. Exhibits at Frank Caro Gallery, New York; S. H. Mori Gallery, Chicago; and at the Alberts-Longdon Gallery, Boston. Demonstrates and lectures on painting at Princeton University. Buys a house in Carmel, California, which he calls the Keyi Ju.

1969

National Palace Museum, Taipei, exhibits copies of Dunhuang murals that Chang donated to the museum. Exhibits in New York.

1970

Attends international symposium on Chinese painting at the National Palace Museum, Taipei. Exhibits at Laky Gallery, Carmel.

1971

Moves to the home he calls Huanbi An in Pebble Beach, California, and fashions the property into a Chinese-style garden and painting studio. Tours national parks and canyons in Nevada. Exhibits in Hong Kong.

1972

Major retrospective exhibition at the Center of Asian Art and Culture, the Avery Brundage Collection (now the Asian Art Museum of San Francisco).

1973

Exhibits at the National Museum of History, Taipei.

1974

Exhibits in Hong Kong and Tokyo. Awarded honorary degree from the University of the Pacific, in Stockton, California. Learns lithography.

1975

Exhibits twice at the National Museum of History, Taipei; one exhibition focuses on his early works. Exhibits at the National Museum of Modern Art, Seoul.

1976–1983 Last Years: From North America to Taiwan

1976

Moves to an apartment in Taipei. National Museum of History, Taipei, holds a "homecoming" exhibition.

1977

Purchases the land and begins building new garden residence, the Moye Jingshe, in the Taipei district of Waishuangxi. Publishes *Qingxiang Laoren shuhua bienian* in Hong Kong, which is a chronological list and plates of Shitao's painting and calligraphy.

1978

Moves into the completed Moye Jingshe. Exhibits in Taiwan and in Seoul.

1979

Exhibits in Hong Kong and Singapore with the work of Puru and Huang Junbi.

1980

Exhibits at the National Museum of History, Taipei.

1981

Exhibits again at the National Museum of History, Taipei, and at the Musée Cernuschi, Paris. Begins last major painting, *Panorama of Mount Lu* (entry 87); redesigns studio to accommodate the work's giant size.

1982

Presented with a Presidential Medal in Taiwan. Continues work on *Panorama of Mount Lu.*

1983

On January 20, the National Museum of History, Taipei, premieres the unfinished *Panorama of Mount Lu.* Chang Dai-chien dies April 2 from a heart attack. Chang's ashes are interred on April 16 in Moye Jingshe, beneath the boulder bearing his calligraphic inscription, "Plum Hill." His will bequeaths a collection of ancient art and the Moye Jingshe to the National Palace Museum, Taipei.

Catalogue

1 Through Ancient Eyes, Signed as Shitao

ca. 1920–22
Hanging scroll; ink and light color on paper
33.3 x 33.3 cm (13 x 13 in.)
Inscription and signature:
 Through the eyes of Jing [Hao] and Guan [Tong]; Qingxiang Laoren [Shitao].
The Metropolitan Museum of Art, New York; bequest of John M. Crawford,
Jr., 1988; 1989.363.189

ONE OF Chang Dai-chien's earliest works, *Through Ancient Eyes, Signed as Shitao* may also be his first forgery. Chang signed the painting as Shitao (1642–1707), and although from a modern perspective the work is not a totally convincing forgery, it is a plausible imitation, especially considering that Chang was in his early twenties when he painted it. There is virtually nothing in Chang's brushwork or composition that relates to the paintings of Jing Hao (act. 870–930) and Guan Tong (act. 907–923) as suggested in the inscription; the reference to Jing and Guan is borrowed from an inscription on another of Shitao's works.

On two separate occasions, Chang Dai-chien recounted the genesis of this painting. In the 1950s, Chang told his Hong Kong friend Zhu Shengzhai (ca. 1902–1970) one version, and in 1968 he told Xie Jiaxiao, a journalist in Taiwan, a second account. Both versions reveal a man eager to test his skill against the great masters of the past and against the expertise of connoisseurs. The tales also document the milieu of China's old-style literati, of which Chang Dai-chien was among the last true representatives.

Chang Dai-chien said that the creation of *Through Ancient Eyes* was triggered by a painting presented to Zeng Xi (1861–1930), one of Chang's teachers in Shanghai. Shen Zengzhi (1852–1922) gave Zeng Xi a small landscape by Kuncan (1612–ca. 1673). According to Zhu Shengzhai:

> Zeng Xi wanted a composition by Shitao that was about the same size as the Kuncan, so that he could mount them together as a handscroll. Li Ruiqi [act. 1910–1930] . . . said that Huang Binhong [1864–1955] had just the thing in his collection. Zeng Xi . . . dashed off a letter to Huang Binhong; but Huang Binhong was unwilling to part with his Shitao, which he felt was a special treasure. Chang Dai-chien at this time possessed a long handscroll by Shitao, and he copied a section of that handscroll onto paper that had been made in Guangdong and was rather old. Chang even copied Shitao's calligraphy to write on the painting, "Through the eyes of Jing and Guan," and Chang tampered with two of his own name seals to simulate Shitao's seal. . . . Chang Dai-chien then presented the painting to Zeng Xi for critical comments and review. The next day, Huang Binhong happened to visit Zeng Xi and saw Chang's copy on the table. Huang offered to trade the Shitao in his collection . . . for the painting on the table, but Zeng would not promise to the exchange. Huang Binhong was insistent and Zeng Xi finally gave in. When Chang Dai-chien found out, he visited Huang Binhong to learn what had so attracted him about the painting. Huang complacently explained that Shitao had three phases in his career: in his youth he copied the ancient masters; in midlife he was in his prime and established his own identity; and in his late years his paintings bordered on the exaggerated, a precursor to the Eight Eccentrics of Yangzhou. Huang Binhong said the scroll he had just acquired from Zeng Xi was from Shitao's prime, and he noted that only a true cognoscenti would be qualified to pass judgment on it.[1]

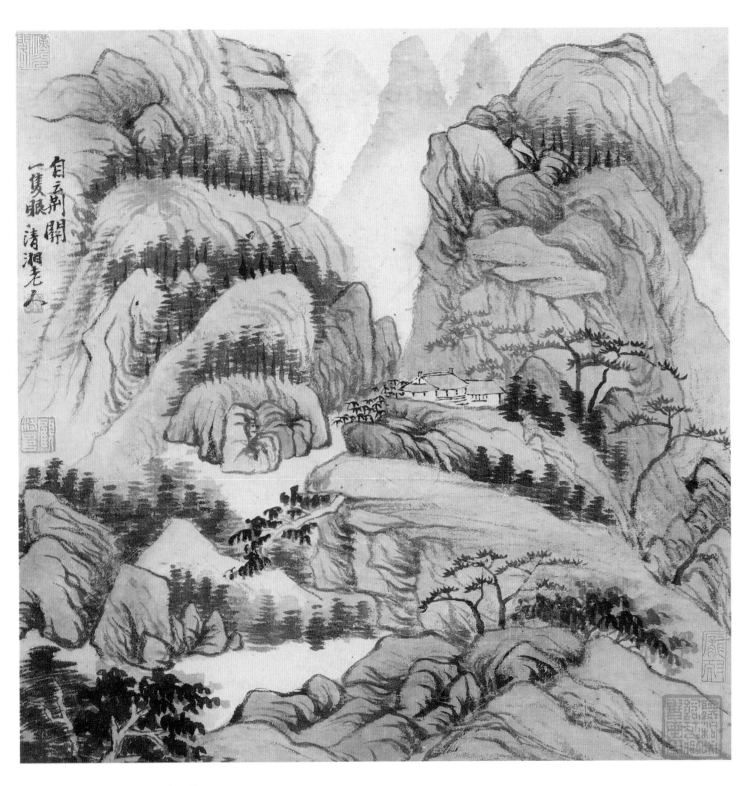

自云削開
一隻眼 清湘老人

Through Ancient Eyes, Signed as Shitao

Chang Dai-chien told a similar story to Xie Jiaxiao in 1968 as they traveled to visit the painter and scholar Chen Dingshan (1897–1989) in Taizhong, Taiwan. Xie Jiaxiao recorded the story in Chang's words.

Huang Binhong and Luo Zhenyu [1866–1940] of the senior generation were good friends with my teachers, Zeng Xi and Li Ruiqing [1867–1920]. Both Huang Binhong and Luo Zhenyu had important collections of Shitao's paintings, and of their generation they were the connoisseurs par excellence of his art. . . . I was not planning to fool my esteemed elders; my original plan was to show them my painting and seek instruction. Once I went to Huang Binhong in order to borrow a marvelous painting by Shitao that was in his collection. I planned to take it home to carefully copy and study, but Huang Binhong refused me. I wasn't really surprised by this, but I was disconcerted and unwilling in my heart to accept defeat. So I thought to myself if Huang won't lend me this painting, I can still imitate Shitao's art. I worked hard copying sections from another handscroll by Shitao and I even made a spurious seal of his. On the painting I wrote "Through the eyes of Jing and Guan," and I presented the painting to my teacher Zeng Xi for his review. My plan was simply to seek instruction from my teacher.[2]

Xie Jiaxiao recounted how Huang Binhong accidently saw Chang Dai-chien's copy at Zeng Xi's home and, not knowing it was Chang's work, took it with him as a treasure. Zeng Xi instructed Chang to visit Huang.

This situation was not something I had expected. . . . I went to see Huang Binhong and asked him to tell me why he admired this handscroll so much. The venerable gentleman said, "This Shitao painting is a major accomplishment in the artist's life and is not something that those who do not understand are able to judge for themselves." I thought to myself if a connoisseur of the stature of Huang Binhong can believe that my copy is genuine, then I have achieved perfection in the imitation of the master. Huang Binhong inquired how much money I wanted for the scroll and I lowered my head and said, "If, venerable sir, you so like the painting, who am I not to let you have it; if you agree I will trade this Shitao for the one that I had requested to borrow from you previously, but which request you had refused." I was playfully testing him, and if he did not agree, then so be it. But who would have thought that he would so quickly agree that the exchange was accomplished on the spot. Later, the story that I had exchanged my spurious copy of Shitao for a genuine one owned by Huang Binhong was broadcast widely.

Chang Dai-chien often made several versions of a painting, and so we cannot be sure if his friends' accounts refer specifically to this *Through Ancient Eyes*. Chang may have painted a group of similar forgeries at the same time, one of which fooled Huang Binhong.

Through Ancient Eyes depicts two stalwart mountains framing a scholar's dwelling. Rather than compress the huge landscape into the confines of the small sheet of paper, Chang Dai-chien cropped the mountains, making them seem unfathomably large. Chang washed soft shades of indigo, burnt sienna, and grass green over the lush landscape, and he used long, wavy "ropes" of ink to describe the fertile soil. The calligraphy is a close copy of Shitao's modified standard script derived from Ni Zan (1301–1374).

Chang's brushwork, both in painting and calligraphy, is a bit too tender and lacking in dynamism to pass for Shitao's work (fig. 62). With more practice, Chang quickly lost such unripeness. The coloring, too, is close to Shitao, but no exact parallel exists. The succulent moistness and bleeding between indigo and burnt sienna are typical of Chang's personal manner of painting, whereas Shitao used less water so he could better control his color washes. In addition to the painting style, the method and materials of the scroll mounting, especially the ivory roller knobs, are evidence of Chang's hand. He used mates to these knobs on other of his forgeries, as well as on some of his signed works.

Some discrepancies exist in the stories Chang told Zhu Shengzhai and Xie Jiaxiao; however, assuming the two versions accurately reflect the painting's creation, we can deduce the date. Zhu Shengzhai mentioned that Shen Zengzhi's gift of a painting by Kuncan to Zeng Xi began the whole incident. Shen died in 1922, making that the latest date for Chang Dai-chien's forgery. The earliest date is 1920: Chang Dai-chien began to study calligraphy with Zeng Xi in 1919, and several months must have elapsed before teacher and student had established the relationship alluded to in these narratives.

Zhu Shengzhai astutely perceived a psychological bond between Chang Dai-chien and Shitao, who was a monk. Chang Dai-chien spent three months in a monastery in 1919, and it was a Buddhist monk who called him "Dai-chien," which refers to the all-pervasiveness of the Buddhist world. Also, Chang inherited an interest in Shitao from his teachers, who collected and sometimes followed Shitao's art. Copying works by Chinese masters was considered a tribute to them and a means to increase skill. When Chang Dai-chien told Xie Jiaxiao about the creation of *Through Ancient Eyes*, he concluded:

From this story you can see that at the time I was fortunate because I wanted to exchange my painting for another painting and not for money, otherwise how could I be pardoned or face my teachers. This was [an example of the adage] "to take a painting and exchange it for another painting," and both parties were better off. Huang Binhong was known for his keen connoisseurship and he sought after me of his own will, so who is to blame?

Fig. 62. Shitao, *Landscape*. Album leaf; ink on paper; collection unknown. From *Bada Shanren Shitao Shangren hua he ce* (Shanghai: Youzheng shuju, [1930]), n.p.

Eventually this work was exchanged for money—John Crawford, who bequeathed *Through Ancient Eyes* to the Metropolitan, purchased the piece as a genuine Shitao painting. Zhu Shengzhai addressed the consequences of Chang's early success at forgery.

After this, Chang Dai-chien naturally became proud and bold. When he went to Peking he dared to specialize in copying Shitao, Kuncan, and Zhu Da [1626–1705] as a means to make a living.

Zhu Shengzhai noted that Chang Dai-chien continued making forgeries until paintings he signed with his own name surpassed the value of early Qing dynasty art. This claim is somewhat hyperbolic, although Chang did make fewer forgeries as his art appreciated in value. However, with a few exceptions, the paintings Chang Dai-chien sold during his life did not command an equal price with the best work of the Qing dynasty. What we can discern from Zhu Shengzhai's observation is that, with his personal fame secure, Chang had less interest in making forgeries. Zhu Shengzhai wrote:

The dealers from Liulichang [Peking's market for books, antiques, and paintings] continuously flocked to see Chang Dai-chien. Luo Zhenyu, who was a famous epigraphist from Tianjin, bought a number of Chang's forgeries of Shitao and sent them to his Japanese friends, who admired the paintings and reproduced them. Therefore, among the paintings by Shitao and Zhu Da that have been published in Japan, many are actually by Chang Dai-chien. Even his first forgery was published as an original. Certainly Huang Binhong's connoisseurship was not poor, and he misjudged Chang's painting

because of Chang's miraculous ability to paint as if he were Shitao.

No exact model for *Through Ancient Eyes* has been found. The collector Bao Xi (act. 1900–1930), from Hebei Province, owned a small landscape album by Shitao that probably provided inspiration for the inscription. The second leaf of the album bears the words "Through the eyes of Jing and Guan"; however, the composition is unrelated to Chang's forgery. Chang probably lifted the inscription from Bao Xi's album and used some other painting by Shitao as the pictorial source. Later, Chang painted creative derivations and "invented" convincing paintings by Shitao, but surely he was not that facile within a few years of his arrival in Shanghai.

When Chang painted this work, he was probably influenced, if not directly guided, by Li Ruiqi, the younger brother of his teacher Li Ruiqing. Li Ruiqi had proved himself a skilled copyist, sensitively choosing paper, ink, and colors that fit his models.[3] Chang Dai-chien once wrote a title slip for an album comprised of copies Li Ruiqi made of Shitao's figure and flower paintings. Li fabricated Shitao's seals on his copies, just as Chang did on *Through Ancient Eyes*.

Chang Dai-chien was at an impressionable age when he met Li Ruiqi, who forged Shitao both to study art and to express his admiration for the past. Chang also was challenged by Huang Binhong's snub. Eager to dazzle the older generation with his skill, Chang could not pass up the chance to let his copy be accepted as an original Shitao, thus pitting himself against the ancients and against the connoisseurs. The discovery that he could fool even so elevated a senior as Huang Binhong boosted the young Chang Dai-chien's ego, preparing him for an extremely ambitious career.

1. Zhu Shengzhai, "Ji Dafeng Tang zhuren Chang Dai-chien," *Yiwenzhi* 126 (March 1, 1976): 18–19; reproduced in Zhu Chuanyu, ed., *Chang Dai-chien zhuanji ziliao*, vol. 1 (Taipei: Tianyi chubanshe, 1985), 12 a,b. Subsequent Zhu Shengzhai quotes are from this source.

2. Xie Jiaxiao, *Chang Dai-chien de shijie* (Taipei: Shibao wenhua chuban gongsi, 1982), 80–81. Subsequent Xie Jiaxiao quotes are from this source.

3. The relationship between Chang Dai-chien and Li Ruiqi is discussed in Marilyn and Shen C. Y. Fu, *Studies in Connoisseurship* (Princeton, N.J.: The Art Museum, Princeton University, 1973), 202–3.

2 Pine, Plum, and Fungus of Immortality

July 14–August 11, 1923
Hanging scroll; ink and color on paper
77 x 33.1 cm (30³/₈ x 13 in.)
Inscription and signature:

> Once I saw a painting of a flowering plum tree by Huang Quan. The
> ancients said Xu Xi's [act. 937–975] painting is untrammeled and Huang
> Quan's is rich and decorative like lustrous pearls and gemstones. In this
> painting, I imitated Huang Quan and Shen Zhou. I present it to my
> "brother," the connoisseur Huishu, to critique. Sixth lunar month of the
> *guihai* year; Chang Ji Yuan.

Arthur M. Sackler Gallery, Smithsonian Institution, Washington, D.C.;
S1988.48

Fig. 63. Anonymous, *Phoenixes and Peonies,* Ming dynasty. *Kesi*
tapestry; polychrome silk; Freer Gallery of Art, Smithsonian Institu-
tion, Washington, D.C., 11.635.

Without Chang Dai-chien's signature, the bold and brightly colored graphic design of *Pine, Plum, and Fungus of Immortality* might easily be attributed to another artist. One of Chang's earliest known dated works, this painting reveals a surprising versatility in the brushwork of an artist not yet twenty-five years old.

The lapidary brush strokes and jeweled colors of the plum tree contrast with the other elements in the scene, which Chang Dai-chien painted by combining impressionistic brushwork and moist washes of light color. Chang painted the pine tree in a series of rapid steps. He delineated the whole tree, then brushed pale ink inside, and while the ink was still damp, he added a layer of light color. Immediately after that, Chang made accents by dabbing the tree with his ink-laden brush. The final blurring of ink and color suggests light and shadow, giving the pine a three-dimensionality the plum tree does not display.

In a technique that reflects the influence of Li Shan (act. 1711–1762), Chang painted the rocks from inside out. First he swiped pale ink on the paper, and then before the ink was dry, he made the contour strokes, which blended with the interior wash. Finally he added a touch of warm ocher.

The plum tree was the result of a patient process in which each step had to dry before the next could be started. Chang outlined the tree with dark ink, and then, for texture, he added dots and lines within and along the perimeter of the trunk. Layers of unmodulated indigo fill the trunk and branches; Chang painted the plum blossoms bright vermilion. The sensational and unexpected color of the plum tree elicits comparison with the Fauves, Chang's French contemporaries who were famous for similar bold experiments with color. Chang Dai-chien unknowingly shared their goal of balancing representationalism with colorful, abstract design in painting.

Chang Dai-chien's inspiration came from his love of color and decoration and his admiration of Chinese textiles, in particular for *kesi* weft-woven tapestry (fig. 63). In *kesi* tapestry, the weft threads do not run from selvage to selvage, but interlace with the warp threads only where that color is needed in the design. This allows for maximum freedom to change colors in a design, thus making *kesi* ideal to produce "woven" painting and calligraphy. Weavers use threads of pure, unmodulated color and black to create a textile, and they often manipulate the black thread in a design to mimic the effect of ink outlines in a painting. Chang studied textile dyeing and commercial weaving in Japan between 1917 and 1919, and the graphic, elegant designs produced in *kesi* tapestry had a powerful impact on him. The crisp (but slightly heavy) outlines and dazzling hues of the flowering plum, as well as the relative isolation of each element in *Pine, Plum, and*

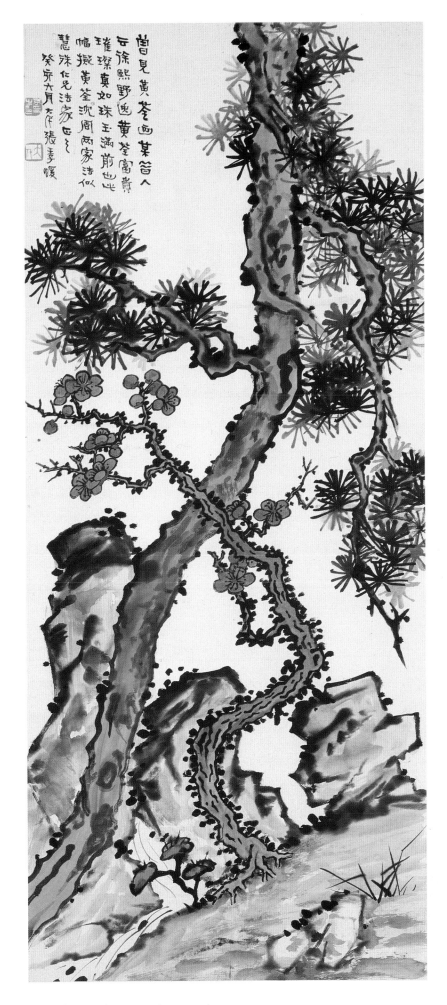

Pine, Plum, and Fungus of Immortality

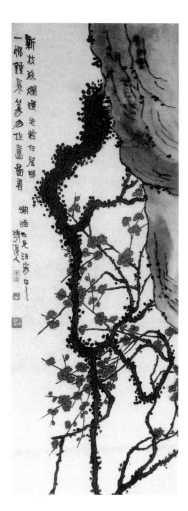

Fig. 64. Li Ruiqing, detail, *Plums*. Hanging scroll; ink and color on paper; collection of Robert H. Ellsworth. From Robert H. Ellsworth, *Later Chinese Painting and Calligraphy: 1800–1950*, vol. 2 (New York: Random House, 1987), 85, pl. 056–02.

In addition to practicing calligraphy, both of my teachers liked to paint in leisure time. Master Li was addicted to [the work of] Zhu Da [1626–1705] and was fond of painting flowers, bamboo, pines, and rocks; also, he used the method of seal script to paint the image of Buddha. Master Zeng was partial toward Shitao [1642–1707] and painted pines and flowering plum trees.

Seal script when describing a painting technique refers to slowly drawn, rounded brush strokes. Chang used this technique in *Pine, Plum, and Fungus* to delineate the plum tree. Li had already been dead three years when Chang painted *Pine, Plum, and Fungus,* yet his sway continued to be strong. Li Ruiqing's *Plums* (fig. 64), which has strong, flat colors and weighty brush strokes drawn with the brush tip centered as in seal script, displays the same method that Chang used in the plum tree in his painting. Chang's calligraphy, which mixes elements from clerical and standard scripts, also reflects Li Ruiqing's personal style.

Paintings of traditional botanical motifs, especially those like the pine and fungus that convey a wish for longevity, and even immortality, were popular among the Shanghai School. Wu Changshuo (1844–1927) was a member of the Shanghai School, and the brilliant success he had with botanical motifs no doubt influenced Chang. *Pine, Plum, and Fungus* superficially resembles Wu's achievements, but Chang Dai-chien rejected Wu Changshuo's emphatically pleasing images, which were painted in a combination of calligraphic brushwork, heavy ink, and vivid color washes. Chang Dai-chien had a more complex vision of art that demanded a revival and transformation of the past, whether the source was textile art, Five Dynasties bird-and-flower painting, or Ming dynasty literati art. Chang's deliberate interweaving of diverse sources became a distinguishing mark of his creative approach.

Fungus, resemble *kesi* pictures, although the suffused ink and color washes of some elements mitigate the textile effect.

In his inscription, Chang Dai-chien ascribed other sources for this work. Chang Dai-chien had Shen Zhou (1427–1509) in mind for the substantial ink outlines of the flowering plum tree and he derived the jeweled colors from Huang Quan (ca. 903–965); however, we would not necessarily see these influences if he had not mentioned them in the inscription. Chang had had little opportunity to seriously study either Huang Quan or Shen Zhou before painting *Pine, Plum, and Fungus.* Throughout his career, Chang routinely mixed nuances from different artists, although the combination of these two painters' styles was a novel experiment.

Another influence evident in this work is that of Chang's calligraphy teachers, Zeng Xi (1861–1930) and especially Li Ruiqing (1867–1920). Chang Dai-chien wrote a preface in 1972 for the Avery Brundage Collection (now the Asian Art Museum of San Francisco) retrospective of his work. In that preface, Chang wrote:

3 Set of Hanging Scrolls

ca. 1926–29
Three hanging scrolls from a set of four; ink and color on paper
106 x 51.5 cm each (41³/₄ x 20¹/₄ in.)
Inscriptions and signatures:

Plum Blossom Studio
 A studio beneath the plum blossoms; Dai-chien jushi brushed this.
Boating under the Red Cliff
 The river flowed noisily, the banks rose sheer for a thousand feet;
 The moon was small between the high mountains, and stones stood out
 from the sunken water.[1]
Composing Poetry beneath a Pine
 What is the Old Man from Mount Chaisang up to? Beside the flowing brook
 he searches for a fresh line of verse. Wind gusts through the pines, his
 contemplation is pure; Dai-chien jushi.

Arthur M. Sackler Gallery, Smithsonian Institution, Washington, D.C.;
S1988.50–52

THESE SCROLLS, which originally belonged to a set of four paintings, document a brief period in Chang Dai-chien's career when he was influenced by the painters of the Shanghai School. Ren Yi (1840–1896) is specifically evoked in these scrolls, but Ren Xiong (1820–1857) and Wu Changshuo (1844–1927) also influenced Chang at the time. As soon as Chang Dai-chien began to develop his artistic independence, he condemned these painters in favor of studying the past.

On stylistic grounds, the three scrolls are related by the unified treatment of the figures, but physical evidence also confirms their relationship. The dimensions, methods, and materials of the scrolls and their mountings are identical. At the turn of the century, sets of scrolls, or "wall screens," like these were popular in Shanghai. Artists created wall screens continuing a composition from one scroll to the next in a series, or, as Chang Dai-chien did here, they presented sympathetic themes in a unified style. Chang illustrated important poets: Lin Bu (965–1026) in *Plum Blossom Studio*, Su Shi (1036–1101) in *Boating under the Red Cliff*, and Tao Qian (365–427) in *Composing Poetry beneath a Pine*. Zhang Dingchen, the collector from Hong Kong who was the previous owner of these scrolls, sold the fourth painting separately. He remembers that the now-missing scroll portrayed a woman, but no reproduction exists. It is customary for one scroll in a set to bear a date—Zhang Dingchen vaguely recalls the absent scroll was dated 1929. Judging from some of the awkward details in the landscape and the youthful calligraphy, circa 1926 is a more appropriate date.

Ren Yi and his Shanghai School compatriots often composed a scene with large-scale figures set in a shallow picture plane (fig. 65). Sometimes they left the background blank or indicated it by a minimal device, such as a clump of bamboo or one rock. In the dreamy scene of *Plum Blossom Studio*,

Chang Dai-chien portrays the plum-loving poet Lin Bu wrapped in a warm cloak and hood, gazing from a window at flowering trees. Chang indicated the poet's studio by showing only a hint of a moon-shaped window and billowing curtains; thus, Lin Bu seems to be one with the plum flowers, his personal identity sublimated to the objects of his admiration. The poet and blossoming trees stand out in relief against a winter-gray sky, which Chang achieved by a liberal application of ink wash.

Chang admired the immediacy of Ren Yi's close-up focus; in *Boating under the Red Cliff*, he intensified the intimate relationship between the spectator and the painted scene by cropping the head of one figure. Within a decade after his move to Shanghai in 1919, Chang rejected most of the Shanghai School influences; however, throughout his long career, Chang continued to favor the close perspective and large-scale figures employed by the Ren family.

Chang Dai-chien's rendering of the faces and drapery in these scrolls clearly registers his indebtedness to Ren Yi, whose figures often have sensitively portrayed expressions and a healthy mix of convention and realism. Ren Yi developed a characteristic shorthand of painting people with melon-shaped faces and long chins, their eyes and noses compressed and centered in the middle of their faces. The subtle color shading and crisp, dark lines of ink for Lin Bu's eyes and nose in *Plum Blossom Studio* reveal Chang Dai-chien's assimilation of this practice. Ren Yi was also inclined to portray

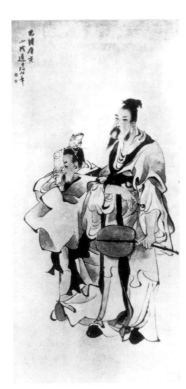

Fig. 65. Ren Yi, *Scholars*, 1890. Hanging scroll; ink and color on paper; collection unknown. From *Ren Bonian hua ji: Chen Zhichu cang* (Singapore: Privately published, [1953]), 19, pl. 10.

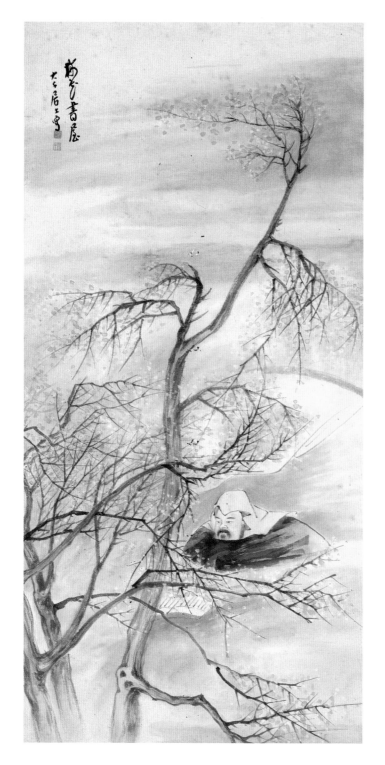

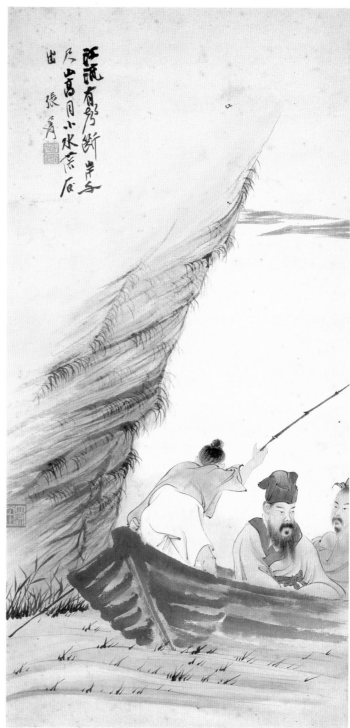

Plum Blossom Studio

Boating under the Red Cliff

figures from the side and back, similar to the pose Chang used for the pole boy in *Boating under the Red Cliff*.

Followers of the Shanghai School promoted figure and bird-and-flower painting over the orthodox tradition of landscape painting. During the late Qing dynasty, the Ren family and Wu Changshuo were the best proponents of the *xieyi* manner of exuberant, loose brushwork, which was often combined with moist color washes. Chang Dai-chien followed their free style of painting and their preference for popular, decorative themes, although he also decried the lack

of proper training in their sometimes flamboyant brushwork. As he matured, Chang insisted on taking models for both figure and bird-and-flower painting from the past.

As late as 1937, forty years after Ren Yi's death, Chang Dai-chien was still condemning the virtual monopoly of the Shanghai School on the Chinese art world. That autumn, on a painting for his student Shao Youxuan, Chang Dai-chien wrote in an inscription:

The generations of artists who have followed Ren Bonian [Ren

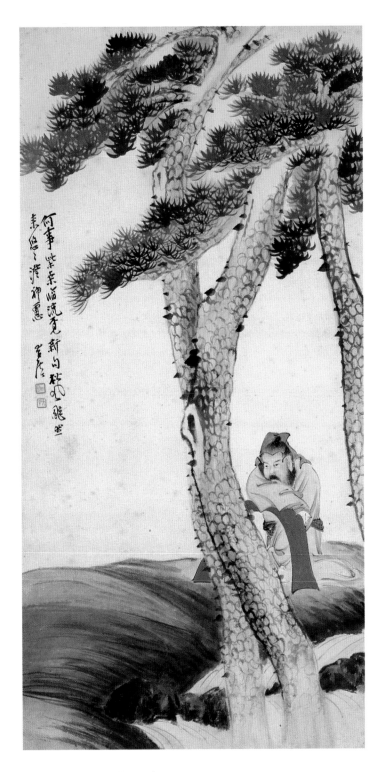

Composing Poetry beneath a Pine

poraries praised him as going back to the Six Dynasties period without showing the brushwork of the Song and Yuan dynasty masters. From an inscription on a copy Chang made of one of Chen Hongshou's paintings, Chang made it clear that his choice of antique models was not universally acclaimed.

> This painting is not anything that Ren Weichang's [Ren Xiong] generation could dream of; today's world lacks an appreciative admirer for it—they think I am a crazy man.

Chang Dai-chien used a conventional composition for *Boating under the Red Cliff;* however, his choice of large-scale figures and his cropping of one figure evince a contemporary look. These features and the brushwork and physiognomy of the figures follow Ren Yi, but the color and brushwork of the landscape were influenced by Shitao (1642–1707). Chang Dai-chien textured the side of the cliff with dry, charcoallike strokes and wet accents to describe the crumbly soil, and he left the top face of the cliff blank. This area served as a cartouche and was a pun on the ancient tradition of carving monumental inscriptions into polished mountainsides (*moyai*). The awkward perspective of the boat is the only clue that Chang Dai-chien was still at an early stage.

The figure under the tree in *Composing Poetry beneath a Pine* is the poet-recluse Tao Qian, who is identified in Chang Dai-chien's inscription as the Old Man from Mount Chaisang. Even if Chang had not named him, the iconography of a slightly inebriated poet beneath a pine tree—especially someone wearing a cloth hood—would be suggestive enough. Tao loved his wine and typically had a large pot beside him. Once when he had no strainer with him, Tao took his gauze hood and used it to filter out the dregs of his wine. The lacquered wooden armrest that Tao leans on is the weakest detail; Chang painted it more as a starched cloth than as an architectonic form. But the brilliant red of the armrest draws attention to the figure, whom Chang again portrayed in Ren Yi fashion, with a round face and compacted features drawn in dark ink.

The simplified, wet treatment of the pine needles in *Composing Poetry beneath a Pine* reveals Chang Dai-chien's early interest in Shitao, who characteristically rendered his pine trees in this manner. Ultimately Chang focused most of his attention on China's artistic heritage. Once Xie Zhiliu (b. 1910), a fellow painter-scholar and friend of Chang Dai-chien, stumbled upon one of Chang's early paintings that evoked Ren Yi. When Xie showed it to Chang, he angrily tore it apart. Thus, these scrolls represent a short, suppressed stage in Chang's development.

1. From *Later Ode to the Red Cliff* by Su Shi, trans. A. C. Graham, in Cyril Birch, ed., *Anthology of Chinese Literature* (New York: Grove Press, 1965), 383.

Yi] and Zhu Menglu [1826–1900] in painting *xieyi* bird-and-flower paintings, whether they were from the north or south, all have followed an unchanging routine; except [that this style of painting] is getting wilder day by day and the Shanghai School is the worst.

By the mid-1930s Chang had cast off the Shanghai School to search to the root of the Ren family style, which was derived from Chen Hongshou (1598–1652), and to pursue ever more antique models. In spring 1940, he was so accomplished at sensitive renditions of early painting that some of his contem-

4 Demon Presenting a Plum Bough to Zhong Kui

June 13, 1926
Hanging scroll; ink and color on paper
113.5 x 45.7 cm (44³/₄ x 18 in.)
Inscription and signature:

> Hejing [Lin Bu] loved plum blossoms[1] and so does this old man. Is this
> recipient of the *jinshi* degree [Zhong Kui] really a lofty scholar? Otherwise
> why would the small demon present him with a branch from a plum tree?
> Recently I owned a painting by Shitao, *Zhong Kui in a Wintry Forest*. It is
> antique and unadorned; it is also refined and untrammeled. I playfully make
> this copy to hang on the wall on the fifth day of the fifth lunar month.
> [Zhong Kui's] ferocious appearance can repel all the demons, but I don't
> dare to praise my brush and ink. Eve of the Midsummer Festival, in the
> *bingyin* year; Dai-chien Chang Yuan.

Arthur M. Sackler Gallery, Smithsonian Institution, Washington, D.C.;
S1988.49

HAIR AND beard bristling, Zhong Kui (act. 618–627) brims with fierce energy, but his scholar's clothing mitigates his menacing presence. Zhong Kui was a high-ranking scholar who met an untimely death. Once he appeared in a dream to Emperor Xuanzong (r. 712–756) and purged the palace of evil demons. Subsequently, Zhong Kui became known as the Demon Queller and assumed mythic proportions: a custom developed of using his image to protect a household during the Midsummer Festival (*Duanwu jie*) that falls on the fifth day of the fifth lunar month, a date considered ominous in ancient times.[2]

Chang Dai-chien's Demon Queller gazes with bulging eyes at the supplicant, who offers him a plum branch. This is far less conventional than most portraits of Zhong Kui. Chang painted the household deity with a modicum of humor and a finesse that is surprising considering his young age.

Chang essentially had a crib sheet for this work; he owned a *baimiao*, or plain-line drawing, by Shitao (1642–1707) called *Zhong Kui in a Wintry Forest* (fig. 66). Shitao's Zhong Kui vividly crushes a demon; the small creature's toes splay out and his eyes bulge. In contrast, Shitao surrounded the brutish incident with calm and pleasant scenery. Chang rendered Zhong Kui as less horrific and rearranged a few elements of the composition, softening it with color. Although his brushwork in the landscape reflects Shitao's influence, Chang altered many details. He depicted a stream, changed the position of the gnarled tree root, and placed greater emphasis on the old tree's twisted trunk, which sweeps across the painting just above the midpoint. Instead of copying Shitao's blank background, Chang opted for a somber and threatening sky.

The power of Chang's brush strokes is appropriate to capture the spirit of the infamous Demon Queller. As he painted Zhong Kui, Chang gripped the brush so tightly that to control its speed, he sometimes had to pull back on the brush, and this resulted in slightly tremulous strokes. Zhong Kui is seated calmly, yet Chang conveyed Zhong's tremendous strength and impetuosity through the pulsating brushwork. The brushwork in Shitao's Zhong Kui is not nearly so exaggerated; however, Chang directly modeled the cursive lines of the sleeves after Shitao. Chang borrowed the wizened grimace, horns, and hair of Shitao's demon, but he had to freely adapt the features, since Shitao partially hid the creature beneath Zhong Kui and depicted him in profile.

Chang Dai-chien must have had Shitao's scroll before him as he worked; even a small detail such as the plum branch in the demon's hands evokes Shitao's painting, which has a flowering bough at the top. Chang transformed the plum spray into the demon's offering, thereby depicting Zhong Kui as lauded by demons rather than slaughtering them.

1. Chang depicted the poet Hejing (Lin Bu; 965–1026) in *Plum Blossom Studio* (entry 3).

2. Derk Bodde, *Festivals in Classical China* (Princeton, N.J.: Princeton University Press, 1975), 308. Westerners often call *Duanwu jie* the Dragon Boat Festival.

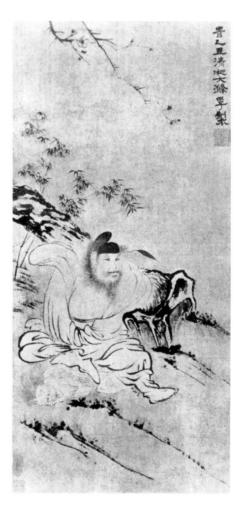

Fig. 66. Shitao, *Zhong Kui in a Wintry Forest*, 1685. Hanging scroll; ink on paper; Shanghai Museum. From *Qingchu si huaseng jingpin ji*, vol. 1 (Shanghai: Yiyuan duoying, 1987), 14.

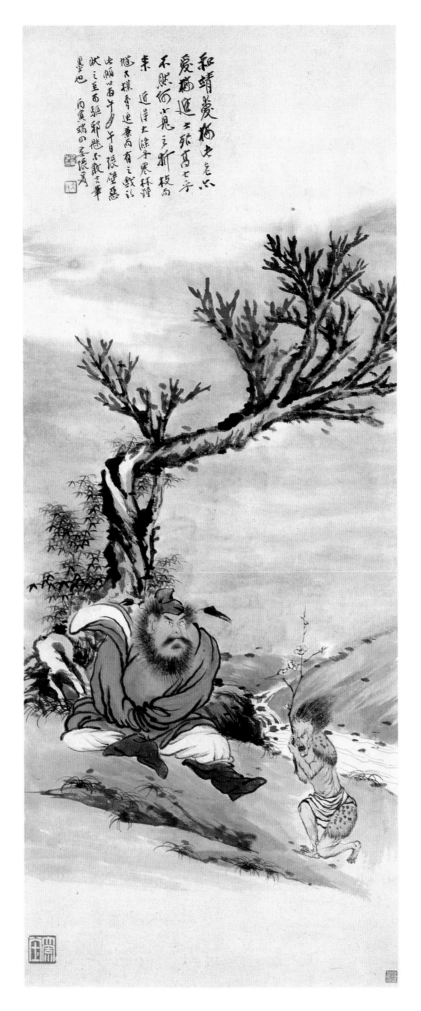

Demon Presenting a Plum Bough to Zhong Kui

5 Scholar Admiring a Rock

April 20, 1928
Hanging scroll; ink on paper
55 x 28 cm (21⁵/₈ x 11 in.)
Inscription and signature:

> My intent was to copy my relative "old" Dafeng [Zhang Feng]. Some say
> the painting looks like that of Mengjin [Zhang Ling], who studied with Liuru
> [Tang Yin]; but Mengjin was not as restrained and elegant as this. Vigor and
> boldness were Mengjin's strengths. My "brother" Guangli, who was
> returning to Hunan, begged me to add this inscription, so that he could
> later cherish the work as a memento. Therefore, I submitted this to him
> for his critique. First day of the third lunar month of the *wuchen* year;
> Dai-chien jushi Chang Yuan.

Collection of Wang Fangyu and Sum Wai, Short Hills, New Jersey

THE LATE Ming dynasty painter Zhang Feng (act. 1628–1662) exerted an indelible influence on Chang Dai-chien. While *Scholar Admiring a Rock* is one of the earliest paintings to reveal that connection, it is an atypical example. Chang usually followed Zhang Feng's best-known style of dry linear brushwork to depict grand landscapes interspersed with small-scale figures.

As a young adult, Chang admired both Zhang Feng's moral character and his sensitive, plainly elegant style of painting. Chang Dai-chien adopted Zhang Feng's sobriquet, Dafeng, and he and his elder brother Shanzi agreed upon it as a designation for their household. Dafeng means both "big wind" and "grand manner," qualities that aptly describe Chang Dai-chien's personality. The words *da* and *feng* each have several positive connotations, and they sound melodious. The characters are easy to write, allowing Chang Dai-chien a lot of leeway for calligraphic expression. Dafeng is not only Zhang Feng's sobriquet but also the name of a ballad, composed by Emperor Han Gaozu (r. 206–195 B.C.), which contains the line "A great gust of wind [*dafeng*] arises, clouds soar and dissipate." Some authors have erroneously suggested that Chang Dai-chien chose the name because of the ballad, although it may have been Zhang Feng's source.

With Shanzi, Chang Dai-chien began collecting Zhang Feng's painting in the 1920s. Zhang Feng and Chang Dai-chien share a surname (only the romanization differs), and so Chang fantasized a distant family tie, which is unlikely considering their ancestors were from different locales. Zhang Feng was a native of Nanjing, Jiangsu Province; he had passed the entry level examinations enroute to an official government career and was preparing for the advanced *jinshi* degree when the Ming dynasty collapsed. Sympathizing with the Ming loyalists, Zhang Feng burned his papers, dedicated himself to art, and followed the lifestyle of an impoverished Buddhist adept. Zhang Feng's strong *yimin* (literally "leftover citizen") loyalties and refusal to serve the newly founded Qing dynasty enthralled Chang Dai-chien. Zhang Feng belonged to a coterie of highly gifted men in Nanjing, the members of which admired his landscape and figure painting. A later critic, Zhang Geng (1685–1760), succinctly described Zhang Feng as an "unfettered immortal," an opinion that Chang Dai-chien applauded.

Chang Dai-chien and his brother Shanzi used Dafeng Tang as a name for their joint art studio in Shanghai, and after his brother's death, Chang Dai-chien continued to call his own studio Dafeng Tang. Since Chang Dai-chien's·fame overshadowed his brother's, people often assume that only Chang Dai-chien used this sobriquet. In fact, the name is most widely known because Chang Dai-chien called their distinguished

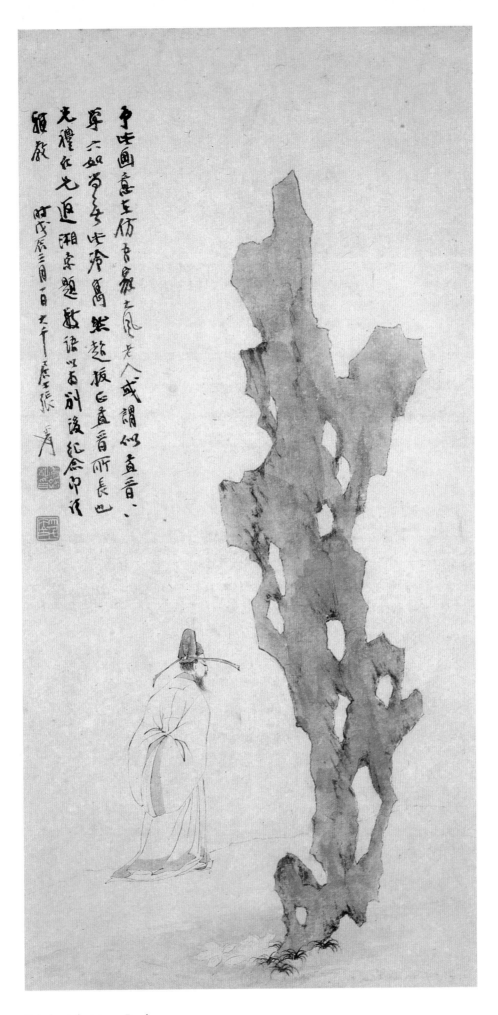

Scholar Admiring a Rock

collection of ancient art the Dafeng Tang; again, after Shanzi died, Chang Dai-chien continued to use the name for his own art collection. According to Shanzi's daughter, Chang Xinsu (ca. 1915–1989), her father and uncle first used the name in 1927 when they hung a painting by Zhang Feng in their Shanghai studio.[1] Actually Chang Dai-chien used the name Dafeng Tang in a painting inscription dated 1926 and as a seal legend on a landscape he painted the same year in the style of Shitao (1642–1707).

Scholar Admiring a Rock is a casually playful work on a small scale; the thin, wispy outlines snap with energy. The bearded official contemplates a large garden rock, which exhibits the three qualities the Chinese most prize in a large stone: a slightly top-heavy shape that tapers at the bottom (*sou*); holes that make the rock sound like a jade chime when struck (*lou*); and twisted contour and rough texture that simulate a mountain with roads and caves (*tou*). There is a traditional motif in Chinese painting of the scholar Mi Fu (1051–1107) paying homage to a rock; however, Chang's official is not bowing to the rock, which is the convention.

It is easy to see how some of Chang Dai-chien's contemporaries could miss this work's indebtedness to Zhang Feng. However, Chang himself rejected the suggestion that the vivid brushwork of Zhang Ling (act. 1498–1531) was the model for the stately elegance of his approach. Little is known about Zhang Ling except that he was a close friend and follower of Tang Yin (1470–1523); this is the only connection with Zhang Feng, who also sometimes adopted Tang Yin's manner. The assured brushwork in *Scholar Admiring a Rock* exudes an early self-confidence that helped Chang develop a style outside the mainstream, which was dominated by the Shanghai School (see entry 3). The combined strength and restrained elegance in the brushwork demonstrate how Chang was beginning to revive the astringent style of Zhang Feng.

According to Chang Dai-chien's records of his collection of ancient painting, he acquired in the spring of 1925 a Zhang Feng handscroll of a figured landscape. During the 1920s and 1930s, Chang idolized Zhang Feng as one of China's premier painters; he stated as much in an inscription he wrote on *Lofty Scholar, Bamboo, and Phoenix Tree* in 1934.

Dafeng [Zhang Feng] has strength and harmony; Xinluo [Hua Yan; 1682–1756] is elegant, but not slick. Within the past three hundred years there are only these two.

Chang made a similar point, also in the 1930s, on *Scholar beneath a Tree.*

Of the figure painters since the Shunzhi reign [1644–1661], Shangyuan Laoren [Zhang Feng] holds first place; next is Hua

Xinluo [Hua Yan], who caught his untrammeled quality. This painting of mine is between the brushwork of these two.

Especially after Chang Dai-chien studied Tang dynasty figure painting in the Buddhist caves at Dunhuang, he adopted a style of figure painting even more refined and antique than Zhang Feng's. However, Chang sometimes still evoked "old Dafeng" when painting a landscape with small figures or perhaps a scholar in a cursory landscape with a single pine. Chang so consistently followed Zhang Feng's clean, supple brush strokes that this style became a personal idiom for Chang Dai-chien.

According to Chang's inscription, *Scholar Admiring a Rock* was painted on request for a friend, Guangli, who has not been identified. Chang Dai-chien frequently painted while talking to guests and then presented the work to some onlooker. Such "social obligation" paintings usually comprise a figure with a simple backdrop, such as a pine, willow, or banana tree, and the brushwork is invariably indebted to Zhang Feng (fig. 67). Though Chang may have been engaged in conversation as he created this work, the result is a beguiling painting that shows Chang's expanding search for past models.

1. Chang Xinsu, "Wode fuqin Chang Shanzi xiansheng he wode bashu Chang Dai-chien xiansheng," *Dacheng* 173 (April 1988): 5.

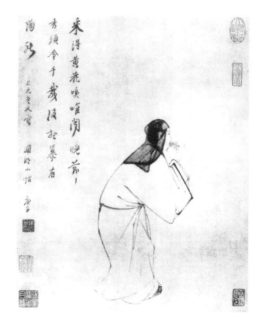

Fig. 67. Zhang Feng, *Tao Qian Smelling Chrysanthemums,* 1660. Hanging scroll; ink on paper; collection unknown. From *Dafeng Tang mingji* (Kyoto: Benrido Co., 1955), vol. 1, pl. 30.

6 Wenshu Plateau in the Yellow Mountains, Signed as Mei Qing

ca. 1930
Hanging scroll; ink and color on paper
105.5 x 40.5 cm (41½ x 16 in.)
Inscription and signature:
 Wenshu Plateau is an earthen spot in the center of the Yellow Mountains;
 to its left is the Heavenly Citadel Peak [Tiandu] and to its right is Lotus Peak
 [Lianhua]. Thirty-six peaks range below them in the four directions.
 Suddenly a sea of clouds can cover everything, a wondrous sight indeed;
 Qushan [Mei Qing].
The Metropolitan Museum of Art, New York; bequest of John M. Crawford,
Jr., 1988; 1989.363.186

CHANG DAI-CHIEN first came to know China's magnificent Yellow Mountain range in Anhui Province through the paintings of Shitao (1642–1707). The cadence of Shitao's brushwork and soft colors gave Chang a clear image of the mountains, and in 1927 he was able to explore them himself. The Yellow Mountains are famous for spectacular peaks and craggy pines that boldly cling to the sheer rock face. Chang was so mesmerized by the scenery there that it became one of the most common subjects in his long career.

During the 1920s, Chang Dai-chien had become increasingly enamored of a group of artists who had taken the Yellow Mountains as a mainstay of their repertoire. Chang expanded his studies beyond Shitao to include Mei Qing (1623–1697) and Hongren (1610–1664), all members of the so-called Anhui School. Chang diligently copied them all—sometimes he even forged them. More often, Chang painted the Yellow Mountains in a style that mixed the scenery he had personally witnessed with allusions to the Anhui School painters. In an inscription from 1935 on *The Nine Dragon Waterfall in the Yellow Mountains,* Chang wrote:

> The peaks of the Yellow Mountains are thrusting, thin spires covered from top to bottom by pine trees. . . . Jianjiang [Hongren] captured their bone structure; Shitao captured their spirit, and Qushan [Mei Qing] captured their ceaseless change.

These words reveal a deep understanding of the Anhui masters. Mei Qing was from a successful literati family whose lineage included the noted scholar-poet Mei Yaochen (1002–1060). From his youth, Mei Qing was encouraged to excel in painting and poetry; his many depictions of the Yellow Mountains earned him an exalted place in Chinese painting. In 1666, Mei Qing made a final attempt to pass the highest level of official examinations. When he failed, he freed himself from the goal of officialdom, and he visited the Yellow Mountains, becoming acquainted with the circle of luminary artists, including Shitao, who favored the site.

When Mei Qing painted the scenery of the Yellow Mountains, he tended to both eliminate unnecessary detail and exaggerate a few select features. Mei Qing boldly juxtaposed solid and void, light and dark, and wet and dry in his paintings. Whereas Hongren developed a linear style that celebrates the structure's monumentality, Mei Qing's full-bodied ink washes and energized brush strokes capture the endless variety of the mountains. Ribbons of clouds threading among the peaks and altering the visage of the mountain range were a specialty of his.

Chang Dai-chien was particularly impressed by Mei Qing's versatile brushwork, which ranged from meticulous to loose and free. Chang liked to quote Mei Qing's style of painting

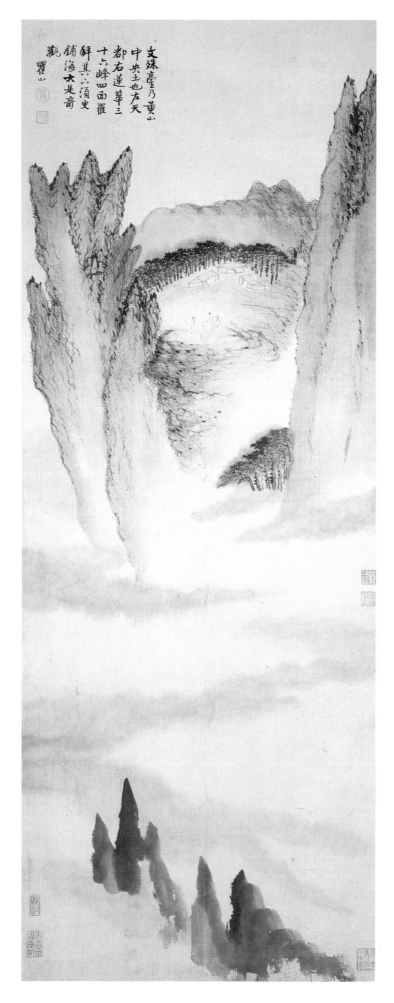

文殊臺乃黄山
中央土也左天
都右蓮華三
十六峰四面羅
鮮其六須史
鋪海大是奇
觀
瞿山

Wenshu Plateau in the Yellow Mountains, Signed as Mei Qing

100

trees and rocks; he painted both free interpretations of Mei Qing's style and actual copies of his paintings. Chang Dai-chien forged Mei Qing's signature and seals on *Wenshu Plateau in the Yellow Mountains, Signed as Mei Qing;* however, subtle clues in the brushwork reveal Chang's hand.

The Wenshu Plateau, named for the Boddhisatva of Wisdom, is high above the famous "sea of clouds" that forms in the midlevel peaks of the Yellow Mountain range. The viewer's eye is drawn to the top portion of Chang's rendition, in which he painted the dramatic peaks in an H-shaped configuration connected by the horizontal crossbar of the Wenshu Plateau. Three scholars sit on the ground conversing, and the pine-enshrouded Wenshu temple is in the background. Waves of white clouds against a dark sky fill the lower section of the painting. At the bottom, five needle-shaped peaks, whose bases are an unfathomable distance below the border of the painting, project into the cloud ceiling. With a vast distance between the plateau and the dark peaks at the lower edge, the composition assumes a lofty monumentality. This effect is Chang Dai-chien's own, since the Mei Qing painting he copied has a tighter composition that fits neatly within a square.

Two different paintings inspired *Wenshu Plateau.* Chang Dai-chien was seldom content to copy something stroke by stroke. From the first leaf of Mei Qing's *Album of the Yellow Mountains* (Palace Museum, Peking), which contains a depiction of the Wenshu temple, Chang borrowed his inscription, substituting plateau (*tai*) for temple (*yuan*). For the pictorial image, Chang closely reproduced—altering only proportion and scale—another of Mei Qing's paintings of the Wenshu Plateau (fig. 68).

An additional forgery by Chang Dai-chien, a virtual clone of *Wenshu Plateau,* was previously in the collection of Nagahara Oriharu in Japan as a genuine work by Mei Qing. On that version, Chang transcribed a poem from a Mei Qing work called *Wenshu Temple* (Museum of Far Eastern Antiquities, Stockholm). Chang appended a line of his own to that poem: "In depicting Wenshu Plateau in the Yellow Mountains, I followed the essence of Huanghe Shanqiao's [Wang Meng] brush."

Chang Dai-chien was, therefore, aware of the close stylistic connection between Mei Qing and Wang Meng (ca. 1308–1385), although his two forgeries do not reveal any direct influence from Wang Meng. The source for Mei Qing's "unraveled rope" and "ox-hair" texture strokes is in Wang Meng's work. When Chang painted these forgeries in about 1930, he had not seriously studied Wang Meng, which in turn impoverished his ability to imitate Mei Qing. Chang Dai-chien's brush strokes are thin, agitated lines that do not have

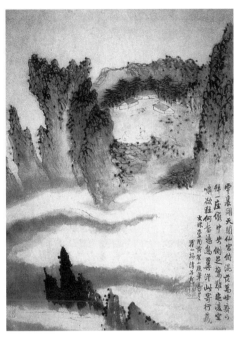

Fig. 68. Mei Qing, *Wenshu Plateau.* Album leaf; ink and color on paper; collection of Sun Daguang, Suzhou. From Gao Yun and Huang Jun, *Zhongguo minjian micang huihua zhenpin* (Jiangsu: Jiangsu meishu chubanshe, 1989), pl. 40.

the strength to "penetrate" into the paper, and ultimately they taint his version with a slightly slick and charming superficiality. These strokes, which are characteristic of Chang's style during his early career, led scholars to recognize *Wenshu Plateau* as a forgery.

The physical condition of the scroll mounting is another piece of evidence. Written on the outside wrapper label are eight characters in semicursive script that translate as: "Mei Yuangong's [Mei Qing] *Wenshu Plateau*—an authentic work." The writing imitates the style of collector Yi Bingshou (1754–1815); however, traces of Chang Dai-chien's brushwork are evident in the writing. In addition, the silk mounting and the ivory roller knobs are the same as those on *Through Ancient Eyes, Signed as Shitao* (entry 1).

7 Xie An and Musicians at East Mountain

Early 1930s
Hanging scroll; ink and light color on paper
188.5 x 95.2 cm (74¼ x 37½ in.)
Inscription and signature:
 Chang Dai-chien brushed this at the Dafeng Tang.
Collection of Chung Kit Fok, Vancouver

EAST MOUNTAIN, or Dongshan, is near Kuaiji, in Zhejiang Province; Chang did not date or title this painting, but a similar work bears the inscription "Music at Dongshan" (*Dongshan sizhu*).[1] East Mountain was the home of the prominent Eastern Jin dynasty literatus, Xie An (320–385). The scintillating and brilliant Xie was repeatedly summoned to join the Eastern Jin court, but he preferred lofty reclusion and refused government service until late in his life. As a hermit Xie gained a reputation for integrity, quick wit, and unrestrained behavior. Depicting Xie An's pleasure in the company of female musicians became a traditional theme in Chinese painting. In *Xie An and Musicians at East Mountain*, Chang interpreted this theme in a fresh manner that combines the twentieth-century taste for large-scale figures with an antique elegance.

The three tall and slender figures are languorously strolling along a riverbank; Xie An now pauses to listen to a melody one of the women plays on the *pipa*, a kind of lute. Chang Dai-chien depicted the robes with gathers of brush lines at the hems to suggest the rustling of silk with each footstep, especially clear in the image of the *pipa* player. Chang painted each figure in a different stance—one musician is seen from the front, one is seen from the back, and Xie An is painted in profile. Chang's smooth brush lines and soft washes have a gossamer quality.

This work contains some references to Qing dynasty painting, but it also reflects nuances of style popular in the Ming dynasty. The Qing dynasty painter Fei Danxu (1802–1850) specialized in studies of women seen from the back. Chang relied on Fei Danxu's successful solutions when he tried to express feminine charm in a rear view, as in this painting. Chang explained:

> It is not easy to paint a rear or three-quarters view skillfully . . . in a back view everything must be expressed entirely by the waist and the small of the back. . . . [These features must] convey a slender woman's graceful poise.[2]

Chang probably derived the simple grace of the figures in his painting from *Ladies on Dongshan*, a "plain-line drawing," or *baimiao*, by Guo Xu (1456–after 1528) that is now in the National Palace Museum, Taipei. Guo's brushwork is slightly coarse and aggressive; Chang's strokes are no less strong but smooth as silk. Chang's moist, round brush strokes for the figures suggest their corporeal mass, and he used brush strokes derived from Southern Song dynasty painting when he depicted the mountain with broad, angular slashes. Although these oblique strokes successfully serve as both contour and texture, Chang seldom invoked this artistic vocabulary.

Xie An and Musicians is not dated, but it must predate Chang's Dunhuang period, when he turned to even more antique sources for his figures. Stylistically, the painting dates to the early 1930s and, if so, the work is one of Chang's best figure paintings from that period. Chang painted the figures exceptionally large, and he showed a greater sensitivity to facial expressions than in many of his other figure paintings.

1. Chang Dai-chien painted at least three versions of this work. Chang's student Sun Yunsheng also painted a close copy of the version in Chung Kit Fok's collection; see *Sun Yunsheng hua ji* (Taipei: Guoli lishi bowuguan, 1979), 28.

2. Gao Lingmei, ed., *Chang Dai-chien hua* (Hong Kong: Dongfang yishu gongsi, 1961), 98.

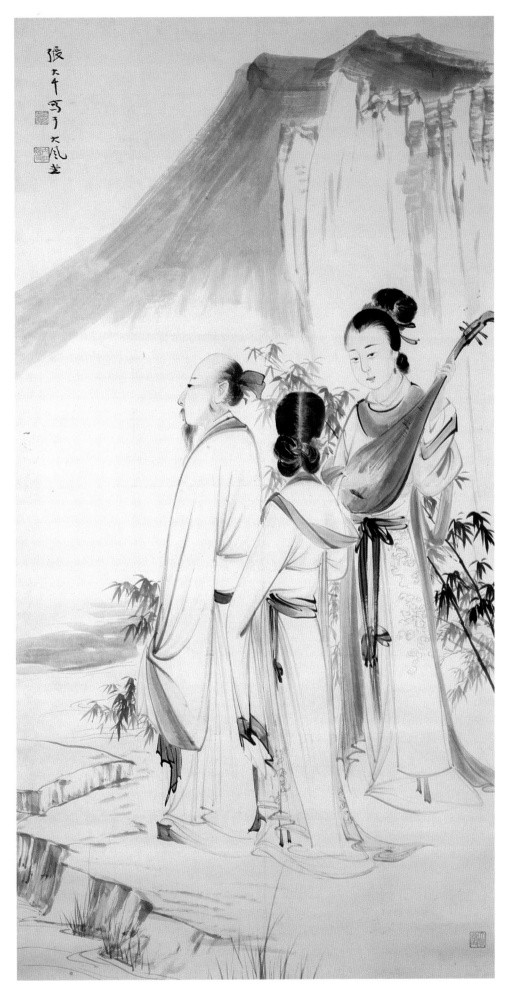

Xie An and Musicians at East Mountain

8 Four Mounted Fans

1931–32
Folding fans mounted as album leaves; ink and color on paper, except for *In the Style of Jin Nong*, which is ink on paper
Each 22.8 x 63.5 cm (9 x 25 in.)
Inscriptions and signatures:

In the Style of Hongren
High atop the brush tips of stone, foliage sways;[1] Hongren.
SDA

In the Style of Zhu Da
[Painted at] the solstice of the *renwu* year [1702]; Bada Shanren [Zhu Da].

In the Style of Shitao
Rivers and hills, the country of talented men;
Flowers and plants, beautiful women in autumn.

Lines from Qu Wengshan [Qu Dajun; 1630–1696]; Dadizi [Shitao].
SDA

In the Style of Jin Nong
The wind is soft and mild,
The rain is fine and thin,
Bamboo branches, bamboo branches,
The girls of Xiang are sad.

Master Dongxin [Jin Nong]
SDA

Collection of Tien-tsai Hwang, Taipei

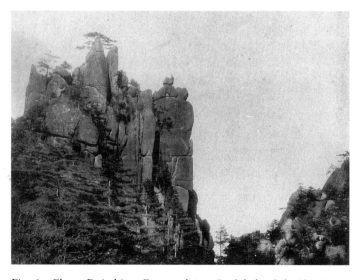

Fig. 69. Chang Dai-chien, *Extraordinary Peak behind the Shizi Lin,* 1931. From Chang Dai-chien and Chang Shanzi, *Huangshan huaying* (Shanghai: Privately published, 1931).

I N PAINTING these fans, Chang Dai-chien paid tribute to four master painters. Three of them—Hongren (1610–1664), Zhu Da (1626–1705), and Shitao (1642–1707)—were among the Four Eminent Monk-Painters. The fourth painter Chang emulated was Jin Nong (1687–1763), one of the Eight Eccentrics of Yangzhou (called eccentrics because of the unorthodox spontaneity some of their works revealed). Chang imitated their distinct styles of painting and calligraphy with equal finesse. Probably he originated these compositions rather than directly copying works of these four masters; Chang was so adept at painting in their styles he could inventively paraphrase them. At first glance it is virtually impossible to believe that the fans are not antique originals, especially since Chang signed them with the ancient painters' names. But in this case Chang Dai-chien asserted his authorship, placing his name seal beneath each of the signatures.

The mountainscape that imitates Hongren's manner is in the "outline fill-in" technique. Chang used precise ink brush strokes to delineate the forms, which he filled with soft color washes. Major peaks of the Yellow Mountains command the left side of the composition; an evergreen grove thrives there, extending below the bottom of the fan. Without roots, the pines are immeasurably tall, imparting a monumental expanse to this fan despite modest physical dimensions. Smaller peaks on the far right thrust skyward—Chang opened the middle of the composition by depicting a misty valley in the fan's center.

Hongren's sparse, linear style is well suited to the crystalline peaks of the Yellow Mountains, to which Hongren bestowed an architectonic emphasis. On more than one occasion, Chang Dai-chien remarked that Hongren had captured the skeleton, or bones, of landscape. This imitation proves that Chang mastered Hongren's austere style.

The fan after Zhu Da is typical of Zhu's blunt, unadorned approach. On the left side of this mountain landscape, two buildings and a pine tree stand in the foreground. A wooden bridge spans the center of the fan. Chang strategically placed the little bridge so that its curvilinear shape repeated the arc of the open fan. The top of the fan cuts off a wall of rock that blocks the distance; from the kiosk situated in front of the rock screen, a viewer would have a panoramic river view.

Chang's brushwork is completely unrelated to his imitation of Hongren's thin, sharp strokes on the previous fan. Each brush stroke in the Zhu Da fan is round and weighty, and while there may not have been any specific paradigm for this landscape, even the light touch of the coloring faithfully evokes Zhu Da.

The third fan could easily be mistaken as a genuine Shitao. Boulders, dense vegetation, and trees mark the foreground of

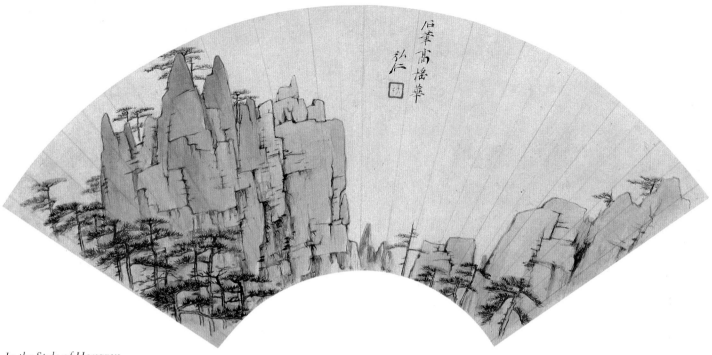

In the Style of Hongren

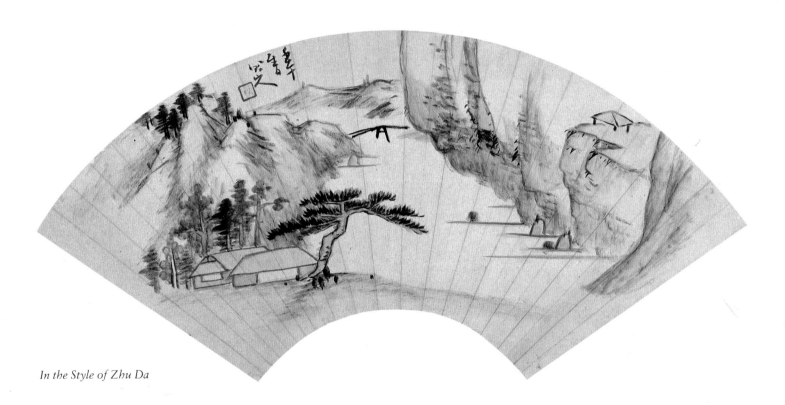

In the Style of Zhu Da

a river village scene. A veil of clouds separates the village from the distant mountains, portrayed as cones of wet blue color. Chang's moist brushwork is sympathetic to the lush river scene. Even Chang's inscription matches Shitao's typical free-form standard script.

The last fan is an imitation of Jin Nong, whom Chang first copied when he was twenty. Initially Chang practiced Jin Nong's trademarks—his distinctive clerical script and his paintings of loquats and Buddhist *luohan,* or "disciples."

Gradually Chang embraced Jin Nong's entire repertoire including bamboo.

Several branches of jet black bamboo contrast with those brushed in pale ink. The spray of bamboo follows the shape of the fan paper: the bamboo in the center is tightly clustered, but at the ends where the paper is wider, the stalks thin out and fill the space. Chang skillfully portrayed depth with gradations of ink. Dark leaves appear to fill the foreground, while lighter ones seem more distant. Short, plump bamboo

leaves that point skyward are traditionally called a "phoenix tail" and describe the look of bamboo on a sunny day.

Chang mimicked Jin Nong's calligraphy as successfully as he did his painting methods. Jin's "lacquered writing" has a uniform lustrous black tone and looks as if it had been slowly and deliberately brushed using a sticky, recalcitrant medium like lacquer instead of ink. Chang copied the words of the inscription from a hanging scroll of bamboo by Jin Nong; however, the bamboo on that scroll bears no resemblance to this fan.[2]

Chang's astonishing ability to re-create Hongren's linear brushwork, Zhu Da's weighty yet dry strokes, Shitao's succulent moistness, and Jin Nong's "carved" brush strokes came equally by dint of assiduous study and ineffable natural talent. During his early career, Chang frequently copied Zhu Da and Jin Nong, though he practiced Shitao's style most of all. He rarely copied Hongren because he had less access to Hongren's paintings. Although the fans are all undated, Chang wrote an explanatory inscription in 1978 on the mounting of the Jin Nong bamboo fan.

I did this in my twenty-sixth year just after I arrived in the old capital [Peking], where I stayed with Wang Shensheng [Wang Rong; 1896–1972]. Wang excelled in painting birds and flowers in the style of Xinluo [Hua Yan; 1682–1756] and he delighted in my imitations of Shitao, Bada [Zhu Da], and Jianjiang [Hongren]. He also especially liked my calligraphy after Dongxin [Jin Nong]; therefore, he took out some folding fans and pressed me to paint them. At the time I thought they could be mistaken for genuine paintings, but today when I look at them, I immediately break out in a sweat. The eleventh day of the first lunar month of the *wuwu* year, the sixty-seventh year [of the Republic of China], [February 17, 1978] during a cold spell in winter in Taipei; Dai-chien jushi Yuan.

In the preface to the retrospective held in 1972 at the Avery Brundage Collection (now the Asian Art Museum of San Francisco), Chang also mentioned his friend Wang Rong. Speaking of those bird and animal painters he respected he mentioned Wang Mengbo (1887–1938) and Wang Rong "for the liveliness of their brush strokes, which made the birds seem to chirp and the gibbons leap." When Chang painted these fans at the request of his friend, he was eager to show his skill in front of a man he so respected as an artist.

In the inscription Chang stated that he was twenty-six *sui* when he made the Jin Nong painting; it is unclear if this refers to the ink bamboo or to all four fans. Despite Chang's excellent memory, a date of 1924 is problematic. The fans are quite different from his other paintings that date to around 1924 and are much closer to his work from the 1930s.

The composition of the Hongren fan has a specific model, although it is not a painting by Hongren but a photograph of the Yellow Mountains that Chang took himself, and this prototype helps establish a date for the four fans. With his brother Shanzi, Chang Dai-chien visited the Yellow Mountains in 1927 and again in 1931. On the second trip the brothers brought two cameras with them—one used with a tripod and one hand-held model—and they both photographed and sketched the scenery. Together they shot more than three hundred photographs; from these, they selected twelve to publish in an album for their friends. On the left border of each print, a caption identifies the photographer and sometimes the date, most of which read autumn 1931.

One photograph in the album is so close to the Hongren fan that it must have been the prototype (fig. 69). The caption reads:

Behind the Lion Forest are amazing mountain peaks; in spirit the scene looks like [something that] Yunlin [Ni Zan; 1301–1374] [would have painted when] imitating Jing Hao [act. 870–930]. The ambiance is elegant but mighty. Even Dachi [Huang Gongwang; 1269–1354] did not obtain such an [effect]. Photographed and inscribed by Dai-chien.

Thus Chang painted the fan no earlier than 1931. Since the four fans are preserved as a single unit and dedicated to Wang Rong, they should have the same date. Chang Dai-chien visited Wang during the tenth lunar month of 1932 when he painted a twelve-leaf album of the Yellow Mountains for him (probably this is the visit that Chang is referring to in his 1978 inscription on the Jin Nong fan). Therefore, we can surmise that Chang painted the four fans around 1931 after his trip to the Yellow Mountains and before 1932 when he visited his friend. His memory of painting them upon request in 1924 must have been faulty.

These fans are an important example of how Chang Dai-chien integrated new and old. While creating the Hongren fan, Chang simultaneously drew inspiration from ancient painting and the modern technology of photography. While Chang may be called the last traditionalist, he also perpetuated tradition by updating it, as with the fan in a seventeenth-century style that presents a view of nature as seen through a camera lens. Chang refined the camera's nakedly honest view of nature with a veneer of antiquity. In the spirit of Hongren, who always favored sparse compositions, Chang edited superfluous details seen in the photograph from the version he painted on the fan, and he expertly copied the soft color washes and brushwork of Hongren.

A second reason these fans are so important is as a demonstration of Chang's mimetic ability. Chang's imitations of ancient painting styles fall into two groups, those he freely admitted were copies, such as these fans that bear his name

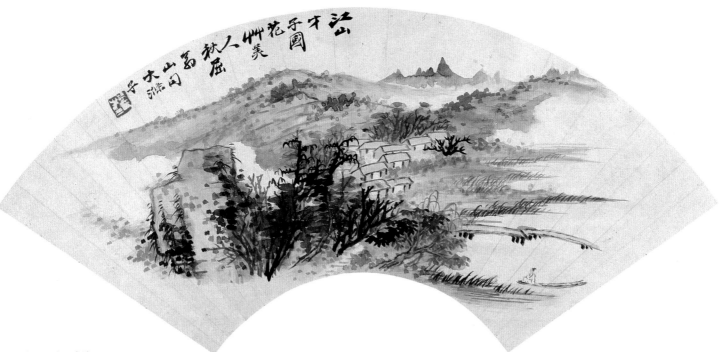

In the Style of Shitao

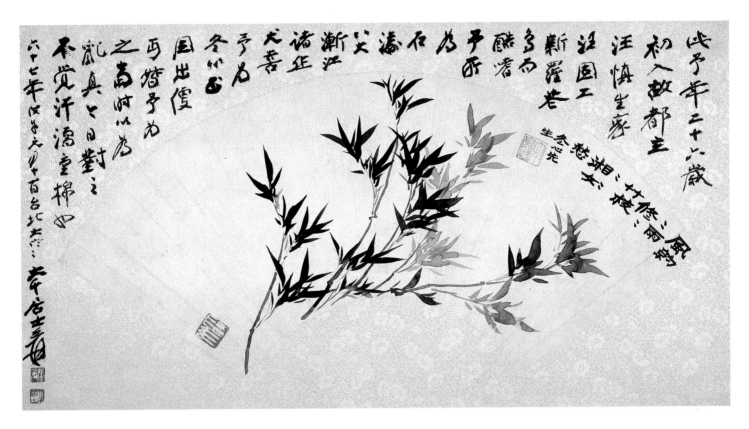

In the Style of Jin Nong

seals, and those he created as forgeries and did not confess to creating. Signed imitations are the best evidence for establishing the limits of his ability to copy, since they reveal some personal artistic traits that he was consistently unable to restrain, such as his use of color. In conjunction with *Through Ancient Eyes, Signed as Shitao* that Chang created in ca. 1920–22 (entry 1) and *Blissful Old Age,* a Zhu Da copy from

1940 (entry 18), these fans can assist scholars in establishing other forgeries of Chang Dai-chien.

1. "Brush tips of stone" may refer to the Yellow Mountain peak known as *Meng bi sheng hua,* or "flower blooming from a brush tip in a dream," which has a single pine at the crest.

2. Jin Nong's painting is illustrated in Zhu Shengzhai, *Yiyuan tanwang,* 2d ed. (Hong Kong: Shanghai shuju, 1972), 177.

9 Majestic Peaks

ca. 1931
Hanging scroll; ink and light color on paper
219.6 x 95.3 cm (86¹/₂ x 37¹/₂ in.)
Inscriptions and signatures:

A

A thousand peaks lift from earth
in ranks of green and azure,
Ancient pine trees sigh and moan
across their layered slopes.
These winding, convoluted ridges
seem wondrous and fantastic,
Cascades spurt a thousand meters
dangling from the Milky Way.
Round and round, the narrow path
pierces the banks of clouds,
As face to face twin peaks arise
suspending a hanging bridge.
Under clouds the path recedes to
some secluded, unknown spot,
Where homes of the immortals lie
in the deep and dark ravines.
As the evening sun sets westward
and hills grow cold at dusk,
Boundless windblown mists arrive
at the railing where I lean.

Painted in the autumn of the *bingxu* year [1706] at the Gengxin Caotang;
Shitao Ji.
SDA

B

[Shitao] did not claim that this [scene] is the Yellow Mountains; nonetheless,
the peaks are steep rock spires with the spirit of the Yellow Mountains. Dai-
chien jushi copied this while in Shanghai.
Collection of K. S. Lo, Hong Kong

IN THIS large hanging scroll Chang Dai-chien created a monumental landscape of sheer peaks towering above a thick swath of clouds. The foreground has a red-roofed pavilion from which two scholars have emerged to climb the grand landscape; they appear halfway between the pavilion and the mountaintops. Chang Dai-chien orchestrated a rich interplay of textures in this painting. Pines with starbursts of needles painted in wet ink coexist with leafy trees, whose foliage is rendered by dots, lines, or pools of ink. Heavy clouds float throughout the landscape, reserving a large portion of the landscape for unpainted space. *Majestic Peaks* simultaneously evokes nature's calm and the vibrant energy of the physical world, so clearly visible in the rhythmic dotting on the mountainsides and the profusion of foliage and brush.

Chang Dai-chien copied the ebullient style of this landscape from Shitao (1642–1707), whose name Chang signed beneath the lengthy poem, along with a date of 1706. Chang probably painted this hanging scroll around the same time as his fan *In the Style of Shitao* (entry 8). Chang mimicked Shitao so closely that the painting could have been a forgery had Chang so wished; however, the two seals beneath the so-called Shitao poem are seals that Chang used when he made "honest" copies of Shitao. Chang also wrote and signed a two-line inscription to the right of the longer text; the size and place of this inscription suggest it may have been an afterthought.

In traditional China, proving expertise in imitating past masters was an accepted means of gaining legitimacy. Because Chang Dai-chien was still too young in 1931 to be considered an accomplished artist, he attempted to jolt his audience into acknowledging that he was the equal of the great Shitao. Chang may have first intended this hanging scroll to be a forgery, but ultimately he decided to use his own name and be recognized for bringing the past to life.

Chang's calligraphy and painting style go beyond the technical perfection of mimesis. Chang's work seems to possess Shitao's spirit—it is as if Chang imitated the very process of Shitao's imagination. He had copied the seventeenth-century master so frequently and zealously that by 1931 he had internalized Shitao's manner; as a result, *Majestic Peaks* exudes the freshness of an original work.

When Chang Dai-chien published a list of his Dafeng Tang collection (without any plates) in 1943, no description relates to *Majestic Peaks*. Yet in his inscription on the hanging scroll, Chang used the word *lin*, which usually connotes a freehand copy based on a direct model; thus, a prototype is implied. As of yet, no specific model has been found among Shitao's oeuvre for either this landscape or poem.

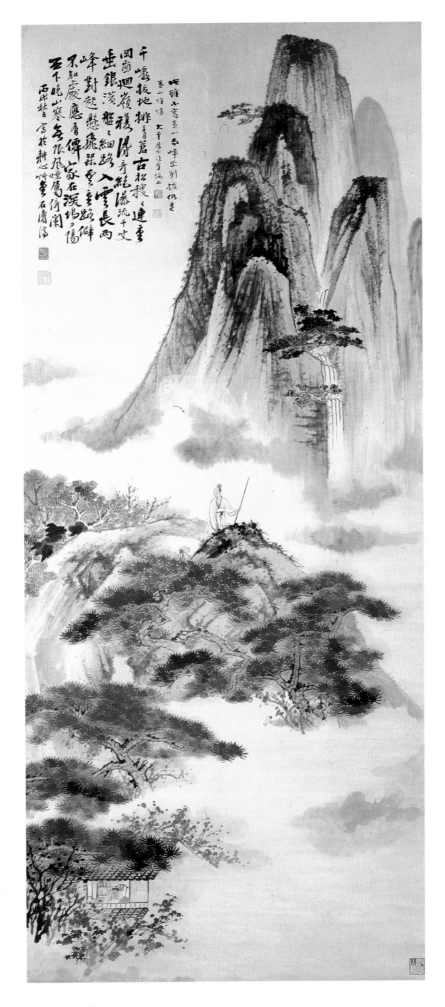

Majestic Peaks

10 Landscape Album Painted with Puru

October 29–November 27, 1932
Album leaves; ink and color on paper
Each leaf approximately 29 x 19 cm (11 1/2 x 7 1/2 in.)
Inscriptions and signatures:

Temple
 Xinyu [Puru] depicted the temple.
Autumn Trees by a Brook
 Xinyu; Yuan [Chang Dai-chien].
Moonlight on Autumn Mountains
 Xinyu made the autumn forest.
Sailing Past the Temple
 Ru [Puru]
Strolling on a Mountain Path
 Xinyu
Kiosk
 Puru
River Scene
 Dai-chien jushi Yuan
Mountain Pass
 Xinyu
Scholar Walking through the Fields
 Xishan Yishi Ru [Puru]
Two Scholars on a Bluff
 Xinyu
Watching the River
 Xinyu
Ascending the Path to the Temple
 In the tenth lunar month of the *renshen* year, I brushed twelve views of
 landscape, which Dai-chien completed; Ru.

Collection of Dzung Kyi Ung, Hong Kong

IN THE 1930s, only two other artists rivaled Chang Dai-chien's varied accomplishments as painter, calligrapher, poet, collector, and connoisseur. One contender was Puru (popularly known as Pu Xinyu, 1896–1963),[1] who lived in North China; the other was Wu Hufan (1894–1968), who lived in the South. With his broad range of painting styles and subjects, Puru was more like Chang Dai-chien, while Wu Hufan specialized in the orthodox landscape tradition as handed down from the Qing dynasty painters known as the Four Wangs. From a scholarly family in Suzhou, Wu moved to Shanghai and achieved great fame as a painter, collector, and teacher.

Puru became a lifelong friend of Chang Dai-chien. He was a great-grandson of the Daoguang emperor (r. 1821–1851) and cousin to the last emperor, Puyi (r. 1908–1912). Puru's privileged youth allowed him into the precincts of the palace, where he had access to the imperial painting collection. He studied this extensive group of masterworks, ultimately claiming to be a "self-taught" artist, and the past strongly influenced all of his work. By about 1925, Puru was widely recognized in Peking for his diverse skills as painter, calligrapher, and poet. When Puru befriended Chang Dai-chien in 1928, it was a great boost to Chang's rapid rise.

In 1919 Chang Dai-chien left his home in Sichuan Province for the siren call of Shanghai, the southern art center of China, where he quickly established a name for himself. Regional loyalties were so strong in China that artists needed loyal patrons in both the North (Peking) and the South (Shanghai) to become national celebrities. In less than a decade Chang left Shanghai for Peking, where his talent and natural social grace destined him for meteoric rise.

As Chang began to establish himself in Peking's art circle, he was introduced to Puru. Both subscribed to the theory of returning to the past to nourish artistic development, and they impressed each other by their equally diverse talents. Soon after meeting, they began occasionally to collaborate; this album of 1932 is among their earliest joint works.

In 1935 Yu Feian (1888–1959), a prominent Peking artist and friend of Chang Dai-chien's, promoted Chang and Puru as equals. Yu wrote an essay entitled "The South has Chang and the North has Pu," which sparked Chang's immediate national recognition. Yu Feian appraised Chang's painting as "bold, free, and untrammeled," while Puru's style was "polished and courtly." Others echoed this sentiment. Chang's peer, Cao Jingtao, wrote an essay called "Record of Paintings in the Wangshi Yuan" (the Wangshi Yuan was a Suzhou garden where Chang temporarily lived), in which he said:

The country has only two famous painters who were born

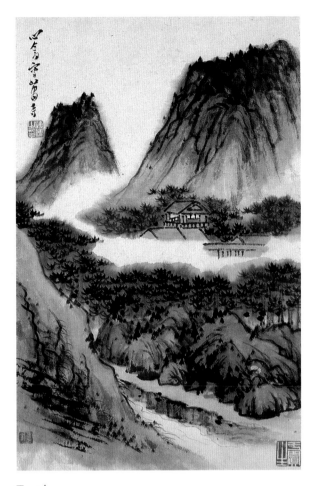

Temple

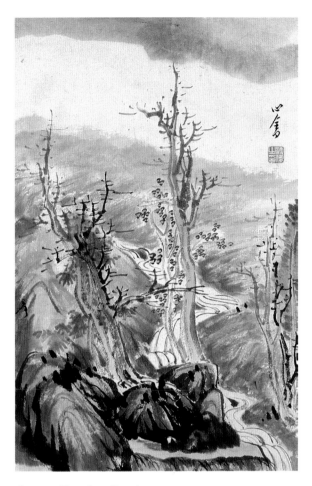

Autumn Trees by a Brook

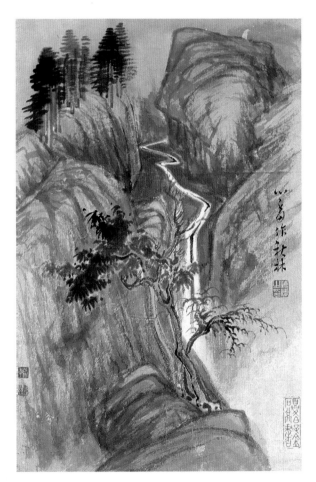

Moonlight on Autumn Mountains

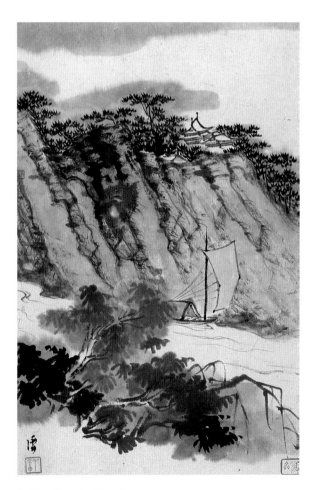

Sailing Past the Temple

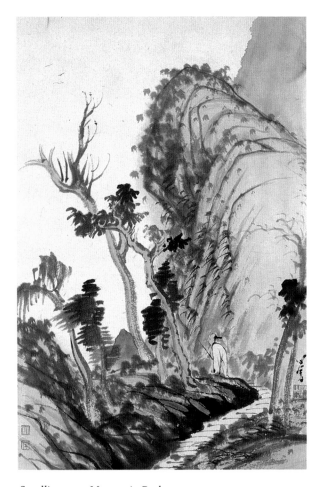

Strolling on a Mountain Path

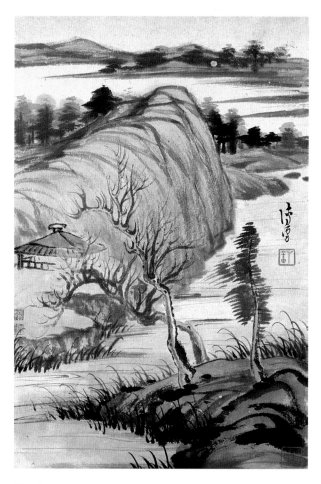

Kiosk

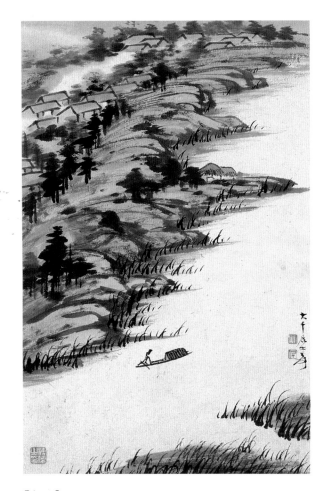

River Scene

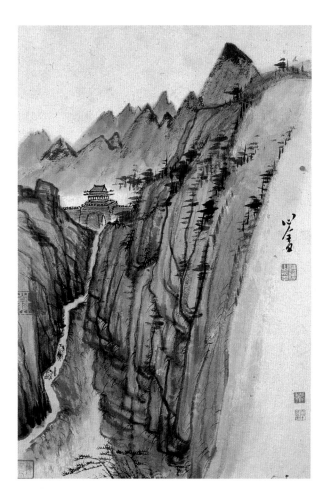

Mountain Pass

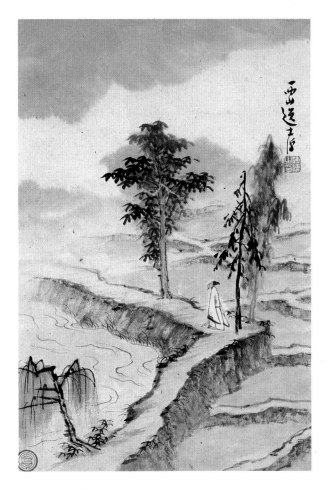

Scholar Walking through the Fields

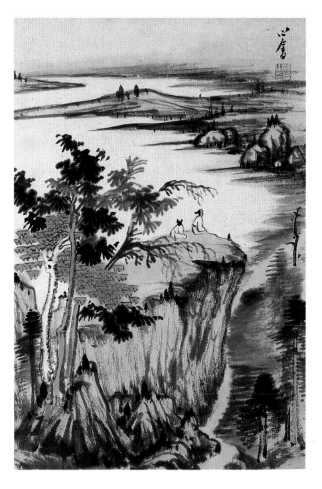

Two Scholars on a Bluff

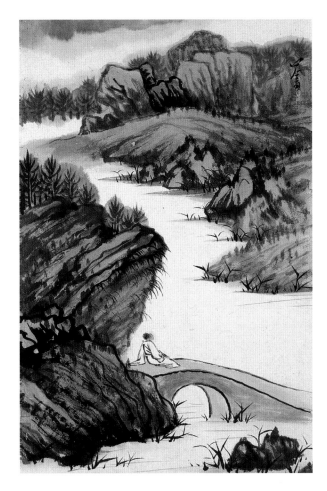

Watching the River

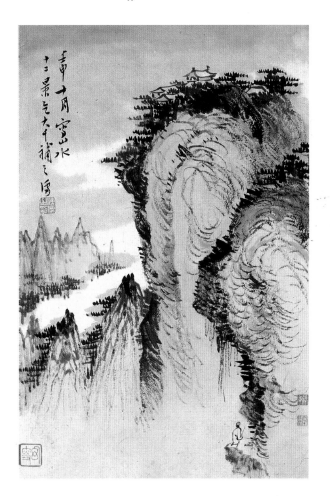

Ascending the Path to the Temple

with talent and yet who also study diligently—Chang Dai-chien and Pu Xinyu. . . . Basically Xinyu embodies extreme loftiness, while Dai-chien has exceptional antiquity. Xinyu is elegant and restrained, while Dai-chien is freely expressive.

Eventually Chang Dai-chien and Puru became neighbors. Sometime around 1933 Chang moved northwest of Peking into the Yihe Yuan, which had been the imperial summer palace prior to the collapse of the Qing dynasty. The many pavilions and residential buildings of Yihe Yuan were divided into a number of private dwellings and Puru also lived there. Chang rented a pavilion called Listening to the Orioles, and he and Puru met to discuss art and to collaborate. Sometimes collectors who were anxious to obtain a collaboration between "Puru of the North and Chang Dai-chien of the South" presented blank paper to whichever artist they knew better. Once that artist finished, the collector would take the work to the other to complete the composition; thus, many of the joint works of Chang and Puru were accomplished without direct communication between them.

Although the majority of their collaborations were instigated by Chang Dai-chien, Puru initiated *Landscape Album Painted with Puru*. In this case, Chang was responsible for the major share of painting on each leaf. Puru painted only a few trees or a schematic building in each composition and then relinquished them to Chang. Like a storyteller who is given one line and asked to weave a complete tale, Chang Dai-chien revealed his imagination and talent in the successful solutions he created.

Both Puru and Chang Dai-chien put their seals on each leaf. With the exception of *Autumn Trees by a Brook* and *River Scene,* on which Chang signed his name, Puru was responsible for the calligraphy. In some cases the calligraphy explicitly acknowledges those elements Puru painted and also provides a date. Even without Puru's accounting of what he painted, we can identify Chang Dai-chien's contribution by his distinct painting style. Chang's aqueous color washes and his preference for blue and pinkish tan tones are consistent with his other works of the early 1930s, indicating that all the color in the album is from Chang's brush. Puru tended to apply color with more restraint and less water. Most of the brushwork is exuberant and wet, like that of Shitao (1642–1707), Chang's first ancient model and not someone Puru emulated. Puru preferred graceful brush strokes that demanded tight linear control. Chang Dai-chien's weighty, impulsive brushwork dominates each painting.

Despite its small dimensions, the first leaf is a monumental composition. A narrow path beside a stream cuts deep into the mountains, where a temple—the only part of this leaf painted by Puru—is partially hidden by mist and luxuriant pines. Large peaks dominate the background and draw attention by the network of dark veins that texture the surface and the large "moss dots" on the summits. There is little recession into depth; instead, the intractable brushwork and cool, reserved blue wash seem to float on the surface of the paper. This effect and the calm mood inspired by Chang's color choices contribute to the impression that *Temple* is a "mind image" rather than an attempt to show a specific place.

The trees in *Autumn Trees by a Brook* can be assigned to Puru on stylistic grounds, since Puru claimed responsibility on another leaf for similar trees. Chang constructed a rich context by adding a limpid mountain brook and a heavily soil-laden bank. This album leaf is the only one signed by both artists: Puru's signature is obvious, while Chang Dai-chien made his name more obscure by writing it on top of a rock in the middle left. Such humility may indicate Chang's special regard for and deference to his older friend; however, in later years Chang boldly asked favors of Puru, even to the extent of dictating what Puru should write on a painting label.

Puru again painted the trees in *Moonlight on Autumn Mountains,* while Chang Dai-chien modeled the rest of the scene after Shitao, based on an album leaf in his brother Shanzi's art collection.[2] A small crescent moon is just visible above the peak on the right. Chang colored the landscape in shades of green; he used an especially vibrant emerald color on the top face of the mountain, which seems to sparkle with a sheen of pure white moonlight.

On *Sailing Past the Temple,* Puru painted the foreground trees and temple buildings in the midground, while Chang built a mountain to accommodate them. Chang depicted pine trees around the buildings using a characteristic shorthand of his, where triangular dabs of dark ink suggest the dense pine needles, and he also painted the river and the boat gusting downstream. The composition is exceptionally well balanced between the areas of rich, wet ink and the unpainted portions that represent mist.

On *Strolling on a Mountain Path,* Puru painted hoary trees with two roosting birds, depicted as little more than connected dots, and a few lone birds in flight. Chang completed the scene by adding ground beneath the trees and a large bluff and mountain in the background. Chang also painted a scholar walking on a mountain path. The figure is clearly Chang's work when compared with figures that Puru claimed to have painted on *Scholar Walking through the Fields* and *Watching the River.* The appealingly soft blue and green of *Strolling on a Mountain Path* is typical of Chang's taste during the early 1930s. Puru painted the trees on *Kiosk* with a lively calligraphic rhythm, and Chang Dai-chien painted a

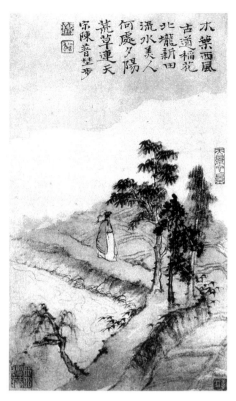

Fig. 70. Shitao, *Walking in the Country*.
Album leaf; ink and color on paper; collection unknown. From *Dafeng Tang mingji*
(Kyoto: Benrido Co., 1955), vol. 2, pl. 39.

kiosk and high ridge, which he described by crisscrossed threads of ink and lightly colored with green and warm beige.

Breaking with the pattern in the preceding leaves, Chang Dai-chien signed *River Scene* instead of Puru, although both artists stamped their name seals. Puru began the composition, contributing a boat with a scholar and a few sketchy houses. Chang turned these elements into a bird's-eye view of a typical Jiangnan river scene, with softly sloping banks, water reeds, and a vista of open water.

Puru painted a mountain pass—a gate house atop a crenelated wall—on *Mountain Pass,* to which Chang responded by creating a deep mountain ravine. At the bottom a scholar and servant advance along a path toward the pass. Chang painted the left cliff, but it is less obvious who painted the towering bluff on the right.

On *Scholar Walking through the Fields,* Puru depicted a gentleman standing on a dike between rice fields. Chang Dai-chien filled in a landscape following a Shitao composition from *Album Inspired by Song and Yuan Poetry* in which Shitao illustrated the Song poem "Walking in the Country" (fig. 70) by Chen Pu (1244–1315). Puru's figure is somewhat

akin to Shitao's, implying that Puru may have thought of this connection himself. Chang modified Shitao's composition to fit the placement of the figure, but he painted the same kind of rice paddies and trees along the dikes as had Shitao, rearranging the trees and adding ripples to the water. In the next few years, Chang painted this composition as a hanging scroll.[3]

On *Two Scholars on a Bluff,* Puru again painted the trees and Chang painted the rest, while for *Watching the River,* Puru painted a scholar on a culvert. The quick, buoyant strokes for water reeds that Chang painted on *Watching the River* mark the course of the river. Chang used heavy wet coloring for the cliffs and in some areas laid dry charcoallike strokes on top to create an interesting texture.

Puru dated the last leaf, *Ascending the Path to the Temple,* and painted the cloud-shaped cliff topped by a temple and trees. For the finale, Puru expended more time on detail, texturing the eroded cliff with "ox-hair wrinkles" that recall the luxuriant brushwork of Wang Meng (ca. 1308–1385). Chang Dai-chien depicted the sharp peaks and cloud cover on the left, and he painted a scholar who is just beginning the climb to reach the temple, which seems as high as the roof of the world. Chang darkened part of the sky with blue wash to create a veil of clouds in reserve against the blue.

Landscape Album Painted with Puru documents the general nature of collaborations between Puru and Chang Dai-chien. The two friends continued to meet even after they left Yihe Yuan; during the 1950s Chang Dai-chien occasionally visited Puru in Japan and they made joint paintings. When Chang settled in the West, they saw less of each other but they continued to correspond, and when Puru died in 1963, Chang Dai-chien traveled across the world to his friend's grave in Taiwan in order to pay his final respects.

1. Puru is a Manchu name and is sometimes written Pu Ru.

2. Illustrated in *Zhongguo hua* 28 (1983): pl. 41.

3. Illustrated in Sotheby's, New York, June 1982, no. 90.

11 Sleeping Gibbon, Signed as Liang Kai
ca. 1934
Hanging scroll; ink on paper
163.6 x 67.1 cm (64¹/₂ x 26¹/₂ in.)
Signature: Liang Kai
Colophons by Puru (1896–1963):

A

Liang Kai's *Sleeping Gibbon* is a genuine work of the divine class; it is the best painting collected for the Dafeng Tang. Xinyu [Puru] inscribed [this].

B

Slashing sharply, the autumn wind,
 rain like threads of silk;
Bitter frost has withered through
 the barren winter branches.
The dark gibbon rising from sleep
 will make a mournful wail;
For it is a time when vines decay
 and all the trees collapse.

Inscribed by Xinyu.
SDA
Collection of Mr. and Mrs. Myron S. Falk, Jr., New York

12 Sleeping Gibbon, Signed as Liang Kai
ca. 1934
Hanging scroll; ink on paper
131.2 x 45.6 cm (51⁵/₈ x 18 in.)
Signature: Liang Kai
Spurious colophon by Chang Dai-chien:
 Liang Fengzi's [Liang Kai] *Sleeping Gibbon* is of the divine class; Liao Yingzhong.
Colophon by Wu Hufan (1894–1968)
Colophon by Ye Gongchuo (1880–1968)
Honolulu Academy of Arts, Hawaii; the Wilhelmina Tenney Memorial Collection, 1956; 2217.1

WITH A minimum of brush strokes, Chang Dai-chien painted these *Sleeping Gibbon* scrolls. The simplicity of the gibbon form and the modest landscape reflect Chang's attempt to create a calm mood rather than imitate nature. This effect is enhanced by the soft posture of the gibbon, the furry brushwork, and the moment Chang chose to capture, the animal on the brink of dozing off. Chang also left almost two-thirds of each scroll empty, and this blanket of space intensifies the stillness.

The swift, wet brush strokes of each painting and the emphasis on negative space are typical of Southern Song dynasty art, and, in fact, Chang signed the name of Liang Kai (act. early 13th cent.) to the right of the gibbon in both works. Chang's personal manner of *xieyi*, or loose brushwork, makes it clear that these are forgeries Chang executed during the first half of the 1930s. Chang took considerable trouble to disguise the paintings by aging the paper and adding suitable colophons.

Chang's close friend Puru (1896–1963) boldly inscribed the colophons on the Falk painting. In spite of Puru's apparent enthusiasm in colophon A, he was not necessarily expressing his own opinion. Chang Dai-chien habitually prevailed upon and badgered Puru into writing authentications. Sometimes Chang even dictated the text of Puru's inscriptions, which accounts for the large number of Chang forgeries that Puru blessed, either knowingly or unwittingly. It is somewhat unusual that Chang had Puru mention the Dafeng Tang in the colophon, as he usually tried to disassociate himself from his forgeries. Perhaps he felt so secure about this work that he could afford to have himself mentioned as the collector.

Although these scrolls are virtually identical, Chang eventually admitted forging the slightly more energetic version, which entered the Honolulu Academy of Arts in 1956. Both scrolls bear Liang Kai's signature and the same spurious seal of Zhu Fu (act. late 14th cent.). The Honolulu painting, however, has more seal impressions, and the colophon on the same paper as the painting was purportedly written by Liao Yingzhong (act. 1250–1270), one of the most famous connoisseurs in Chinese history.[1]

That brief colophon can irrefutably be traced to Chang Dai-chien. The writing is not like Liao Yingzhong's calligraphy or any example of Southern Song dynasty writing. The structure of the individual characters reflects Chang's tutelage under Zeng Xi (1861–1930), his first calligraphy teacher, who was an authority on Northern Dynasties calligraphy. The epitaph on the tomb of Zhang Heinü, which Zeng Xi used as a model, also served as Chang's model for Liao's calligraphy. The slightly awkward proportions and bluntly articulated strokes of Northern Dynasties calligraphy camouflaged

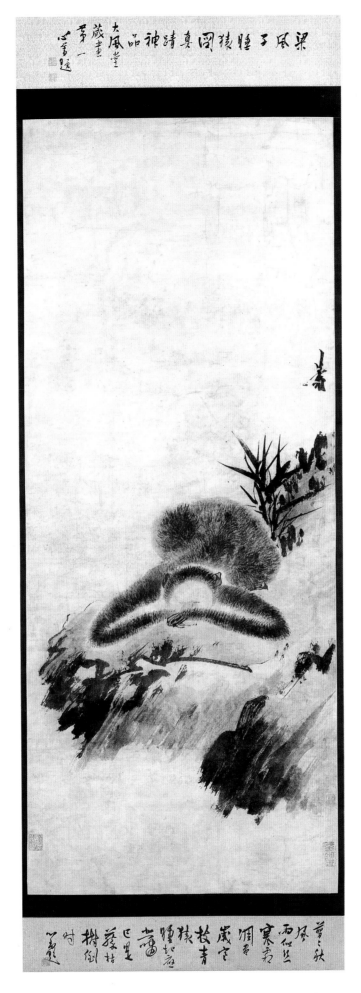

果風了睡猿圖 真詩神品 大風堂藏畫第一 心畬題

萬之秋 風雨似江 寒喬 佩實 歲寒 技青 猿啼 睡起時 菖 巳生 發枝 樹鳥 時 心畬

Sleeping Gibbon, Signed as Liang Kai (11)

Chang's own fluent style of writing. But Chang's relationship to Zeng Xi exposes Liao's authentication as a ruse.

The painting was convincing to many. Like Myron Falk's version, which bears Puru's stamp of approval, the Honolulu scroll also has the endorsement of an important twentieth-century connoisseur. Wu Hufan (1894–1968) wrote a few lines in small standard script on the silk mounting to the left of the painting. Dated spring 1935, Wu's colophon claims that the painting had been purchased in Hangzhou in 1892 by his grandfather Wu Dacheng (1835–1902). Wu Hufan undoubtedly inherited his grandfather's seal, and so the presence of Dacheng's seal on the painting is not conclusive evidence that Wu Hufan received the painting from his relative. Wu Hufan was notorious for exaggerated claims that bolstered his connoisseurship, and he may have used Wu Dacheng's seal simply to add weight to his own judgment that this was a thirteenth-century painting. Later Wu Hufan recognized that the painting he had so sincerely hoped was an original work by Liang Kai was, in fact, a modern forgery.

Another colophon, written on a separate sheet of paper mounted above the Honolulu painting, also asserts its authenticity, but the inscription was no doubt written at Wu Hufan's behest. Ye Gongchuo (1880–1968), a collector and connoisseur who lived in Suzhou at the same time as Chang Dai-chien, proclaimed in large writing that *Sleeping Gibbon* was "the number one Liang Fengzi under heaven."

Chang Dai-chien was known to boast to friends that he was the artist of the *Sleeping Gibbon* that is now in the Honolulu Academy. Probably because he had lost track of the twin forgery, he only took credit for the one painting. In 1958, the Hong Kong scholar and collector Zhu Shengzhai reported Chang's confession in an essay "Difficulties of Authenticating Art" in the journal *Zhongguo shuhua*. Chang's personal secretary, Feng Youheng, recorded that even as an old man, Chang enjoyed renewing his claim that the gibbon in the Honolulu Academy of Arts was his work.[2]

In the 1950s when Chang visited the respected scholar Gustave Ecke, curator at the Honolulu Academy of Arts, Chang directly acknowledged the forgery. Ecke was not surprised; he was well aware of the controversy surrounding the painting, which he had seen in Nanjing in 1936, and when the Honolulu Academy acquired *Sleeping Gibbon* from the artist and collector Jiang Ershi, Ecke labeled it an attribution.

Chang fused elements from different models to create these *Sleeping Gibbon* paintings. There are no paintings or even attributions to Liang Kai that depict a large-scale gibbon; instead, Chang's prototype was a scroll in a triptych attributed to Muqi (early 13th cent.–after 1279) that Chang saw in Japan (fig. 71). The triptych has two paintings of gibbons

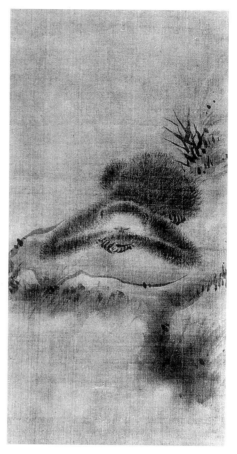

Fig. 71. Attributed to Muqi, *Sleeping Gibbon on a Rock*. Hanging scroll from a triptych; ink on silk; Fukuoka Art Museum. From *Kokka* 425 (April 1926): 91.

flanking a scroll of Weituotian, one of the heavenly Veda, defenders of Buddhist law. The three paintings have swift, moist brushwork in the manner of the monk-painter Muqi, although the quality casts doubts on the attribution. The triptych was probably by a close contemporary of Muqi's. Chang Dai-chien was attracted by the peaceful composition, and ignoring the less than exemplary execution, he applied Liang Kai's rapid, saberlike brushwork to his creation.

The best collections of paintings by Muqi and to a lesser extent by Liang Kai are in Japan, and before reproductions of Japanese collections were widespread, Chinese connoisseurs were at a disadvantage to judge works by Muqi and Liang Kai. Chang capitalized on the Chinese connoisseurs' ignorance when he used a composition ascribed to Muqi to fashion a Liang Kai forgery. Chang also knew that the rarity of Liang Kai's work in China made collectors eager for it; indeed, Wu Hufan paid a considerable sum for *Sleeping Gibbon*, which increased Chang's confidence as a painter.

The terminus ad quem for the Honolulu *Sleeping Gibbon* is 1935, the date Wu Hufan wrote his inscription. The paintings are so similar one date should apply to both of them. Without Wu's inscription, it would still be possible to date the scrolls to before 1940, when Chang began to follow the famous gibbon painter Yi Yuanji (act. mid-11th cent.) as a model.

Puru's poem, colophon B on the painting in Myron Falk's collection, provides another clue for the date. Although the poem seems like a reflection on nature, it has a timely and pointed theme. The tone suggests a gibbon confronting the destruction of his lush forest home ravaged by winter's arrival. The poem's mournful tone foreshadows an imminent loss of peace and security; however, Chang painted the gibbon in a serene pose. The contrast between the visual image and the poem is so great as to be disturbing.

Perhaps Puru was thinking of his cousin Puyi, who had been the emperor in 1912 when the Qing dynasty collapsed and who retook the throne in 1934 by claiming himself emperor of Manchukuo, a puppet state established in northeastern China by the Japanese. Puyi had played into a Japanese scheme to conquer China, and Puru's fretting poem reflects his fear as he watched China and his cousin veer toward disaster. Puru's vision of impending destruction would date to about 1934, the time of Puyi's second enthronement.

Whether we accept 1934 or 1935 as the date, the two *Sleeping Gibbon* paintings were probably Chang's first forgeries of a Song dynasty painting and his first gibbon paintings. Since Liang Kai and Muqi were both known for a spontaneous style and since Chang's early personal style emphasized bold, wet strokes in the *xieyi* manner, Chang logically combined aspects of Liang Kai and Muqi when he began his pursuit of Song dynasty painting. In the mid-1940s Chang turned toward the more detailed and polished *gongbi* style of brushwork, never again forging this particular style of Southern Song dynasty painting.

1. Liao Yingzhong served as an in-house art connoisseur and director of calligraphy rubbings for the powerful Song dynasty official Jia Sidao (1213–1275), one of the most acquisitive collectors of all time.

2. Feng Youheng, *Xingxiang zhi wai: Chang Dai-chien de shenghuo yu yishu* (Taipei: Jiuge chubanshe, 1983), 227.

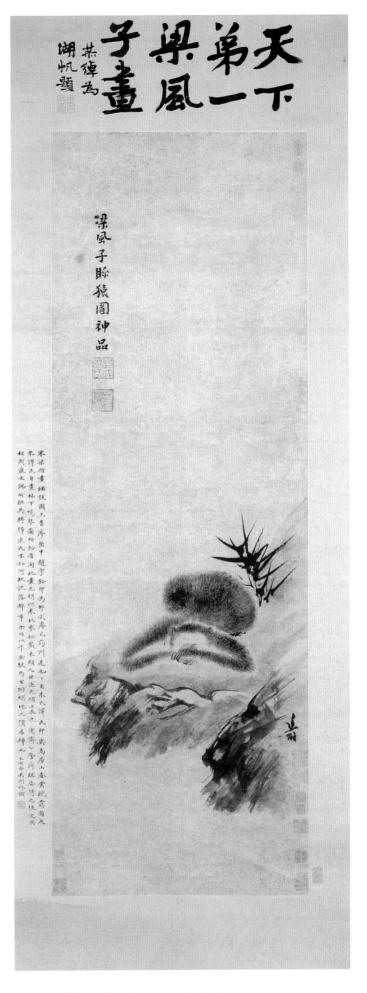

Sleeping Gibbon, Signed as Liang Kai (12)

13 Precipitous Cliffs

March 5–April 2, 1935
Hanging scroll; ink and color on paper
81.3 x 33 cm (32 x 13 in.)
Inscription and signature:
 For my "elder brother" Yucen [Xie Jinyu] to smile at. Second lunar month of
 the *yihai* year; "younger brother" Yuan.
Collection of C. P. Lin, Hong Kong

CHANG DAI-CHIEN signed this subtle landscape with only a brief dedication to avoid overburdening the small, narrow hanging scroll. The angular, crystalline mountains and rocks immediately evoke Hongren (1610–1664), who was a celebrated painter of the Anhui School, so named because its devotees often painted scenes of the Yellow Mountains in Anhui Province. Hongren perfected a distinctive sparse, linear style to express the grand monumentality of the Yellow Mountains; he depicted them as an architectonic mass. Although Chang Dai-chien had trained himself to re-create the styles of Shitao (1642–1707), Zhu Da (1626–1705), Kuncan (1612–ca. 1673), and Hongren, he had the least opportunity to copy Hongren. Thus, *Precipitous Cliffs* documents a less well-known aspect of Chang's formative studies of art.

Chang Dai-chien painted with ocher and ink brush strokes, one inside the other, to depict the landscape, then he washed color over the top. As a last step, Chang judiciously added horizontal dashes that enrich the landscape but do not disturb the tranquil mood of the scholars contemplating a waterfall.

Chang Dai-chien's dedication refers to Xie Jinyu (1899–1935) from Wujin in Jiangsu Province, whose younger brother is the well-known calligrapher-painter and scholar Xie Zhiliu (b. 1910). Xie Jinyu and Chang were the same age and had a common devotion to painting, calligraphy, and poetry. Xie Jinyu once described their friendship: "In Shanghai we lived near each other, and loving painting as much as life itself, every time Chang came to my studio, he would linger all day as we recited poetry."[1]

Chang Dai-chien's friends and acquaintances often requested paintings from him; Xie was an exceptional friend for whom Chang Dai-chien frequently painted works. After the death of his wife in March 1932, Xie commissioned Chang Dai-chien to paint one hundred scrolls of lotuses. (Madame Xie's father named her Pure Lotus because the family's lotus pond burst into blooms of white flowers at her birth.) When Xie requested these scrolls, he was already confined to bed in his home in Wujin, and Chang, who lived a considerable distance away in Suzhou, took a train every other day in order to visit and paint for Xie Jinyu. Even this effort was not enough to satisfy Xie's insatiable demand for Chang's paint-

ings.[2] No one knows how many works Chang dedicated to Xie; however, few still exist. *Precipitous Cliffs* was completed a month before Xie died. The fact that Chang chose to imitate Hongren's style on a work for an honored friend indicates that Chang held Hongren in considerable esteem.

Xie Jinyu was known for his jovial nature, artistic talents, and erudition. He was an expert calligrapher who wrote in a style imitative of bronze inscriptions, and he developed a highly distinctive semicursive script. Xie Jinyu made a mark on the art world when he invited eight friends to join him in 1934 to create a club in imitation of the late Ming dynasty group known as the Nine Friends of Painting. The club was named the Society of Nine and among the most notable members were Tang Di (1878–1948) as the senior member, plus Chang Shanzi (1882–1940), Zheng Wuchang (1894–1952), Lu Danlin (1897–1970), and, of course, Chang Dai-chien. These artists were all dedicated to keeping traditional literati values alive and invigorating the past with selective modern elements; unfortunately, Xie's death in 1935 meant the end of the club as well.

1. Chang Dai-chien, "Yucen yi gao xu," in *Chang Dai-chien shiwen ji*, ed. Yue Shuren (Taipei: Liming wenhua shiye gongsi, 1984), 110.
2. Ibid.

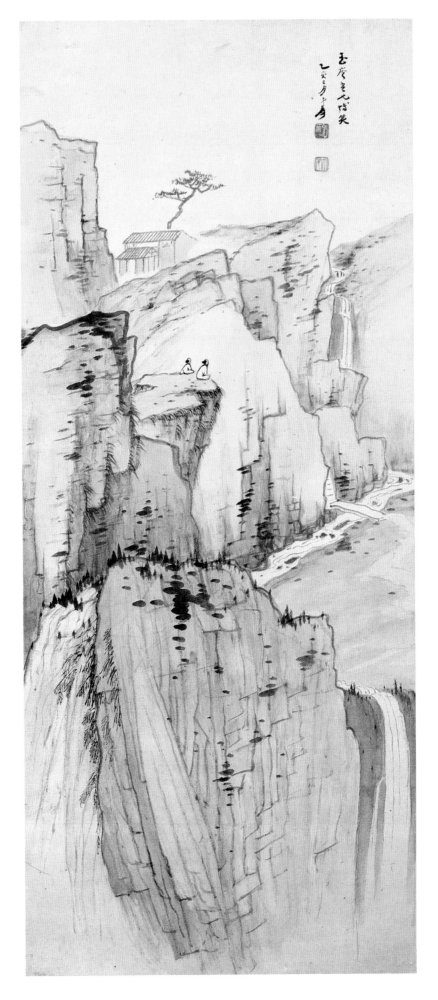

Precipitous Cliffs

Spring 1935
Hanging scroll; ink and color on paper
76 x 37.7 cm (29⅞ x 14⅞ in.)
Inscriptions and signatures:

A

Clear Autumn in Wu Gorge painted after Wang Jinqing [Wang Shen]; for the connoisseur Mr. Yangru to critique, Chang Yuan.
SDA

B

The Well Net Stars at high autumn
 hide in the glow of evening:
My little sail, wherever it fares,
 recalls the howling gibbons,
And who says I shouldn't think of
 going home to my old fields?

At White Emperor, colored clouds,
 I zigzag up along to heaven,
At Yellow Ox Gorge, muddy billows,
 I lose the road three times:
What I hear of family and friends
 has left me lately in doubt.

[To the tune of] *Huan xi sha* [Washing Silk in the Stream]; spring of the *yihai* year, Dai-chien jushi.
SDA

Collection of K. S. Lo, Hong Kong

CHANG DAI-CHIEN began to experiment using the *mogu*, or boneless, technique to paint landscapes around 1934. In this technique, forms are built up entirely of tinted washes and applications of opaque colors, rather than by outlining shapes. *Mogu* has long been a popular technique for painting flowers; a single brush stroke or layers of wet washes may simultaneously define the boundaries and color the interior of petals, leaves, and stems. Less often the *mogu* technique has been applied to landscape painting, although it was used in this way as early as the Six Dynasties period. Chang Dai-chien traced the technique first to Wang Shen (ca. 1046–after 1100) and then back to its founders, Zhang Sengyou (act. 500–550) and Yang Sheng (act. 714–742). Few of Chang's contemporaries painted boneless landscapes; the last major artist to use *mogu* for landscapes was Dong Qichang (1555–1636), whose work Chang acquired in the 1930s and 1940s (see entry 29).

During the 1930s, Chang Dai-chien often traveled by boat between Shanghai and his family home in Sichuan Province. He followed the Yangzi River through the Three Gorges, of which Wu Gorge, the longest and most dramatic of the three, is in the middle between Xiling and Qutang. Autumn is stunning in the steep gorges; the sunset brings out warm golden colors and glistens on the snowcaps of the highest peaks. The saturated colors Chang saw while traveling on the river inspired him to try the boneless technique; he knew that ink outlines on the landscape would detract from the suffused gemlike effect for which he strove. Chang's *mogu* work was

so successful that he painted many similar landscapes during the 1930s. A palette of red, white, green, blue, and ocher was all Chang Dai-chien needed to re-create the radiant sunset over Wu Gorge.

Wu Gorge is east of Sichuan Province, near Mount Danwu in Hubei Province. Sheer walls of rock tower over both sides of the river so that the sun is visible only at noon when it is directly overhead. Of the twelve peaks that comprise Wu Gorge, Mount Shennü (Goddess Peak) is the steepest and most marvelous; Chang painted this summit as the focus in *Clear Autumn in Wu Gorge*. The gorge was once haunted with the shrieks of gibbons who lived in the mountain forests. Chang was a fan of gibbons; he carried the sound of the gibbon as part of his memory of the gorge.

Until recently, travel through Wu Gorge was both dangerous and exhilarating; boats sometimes smashed into the cliffs as they tried to navigate the waters studded by jutting rocks, whirlpools, and narrow passages. Chang Dai-chien stored images of the dramatic scenery from each trip, but during his early career he was virtually obsessed with perfecting the styles of Shitao (1642–1707) and the other Anhui School masters. In hopes of capturing their muse, Chang resisted painting the Three Gorges in favor of the Yellow Mountains in Anhui Province. During the 1930s, Chang turned to the subject of the Three Gorges, and he painted the scene frequently for a decade or so.

According to Chang's inscription on *Clear Autumn*, he was following Wang Shen; however, there is no evidence that Wang ever painted a landscape in the *mogu* manner. The only specific references to Wang's use of color are records of paintings done in the blue-and-green or green-and-gold style. Chang Dai-chien once owned *Fishing Village at Xisai* (The Metropolitan Museum of Art, New York), which has been attributed to Wang Shen. Although it has rich blue and green colors, *Fishing Village at Xisai* is not a boneless landscape like *Clear Autumn*.

Chang Dai-chien borrowed elements from various ancient models for *Clear Autumn*, and he also revealed his predilection toward decorative effect in this work. Chang devoted himself to mastering color from an early stage. Even before the 1940s, when he studied the brilliantly colored Buddhist murals at Dunhuang—a pivotal point in his use of color—he already had an extremely refined approach to using pigments. Between about 1930 and 1950, Chang often used the boneless technique for landscapes; such a celebration of rich color fit his aesthetic theory. In the years to come, Chang Dai-chien would reach a creative breakthrough by introducing splashed-ink-and-color painting, a technique that stretched the *mogu* style to its dramatic and aesthetic limit.

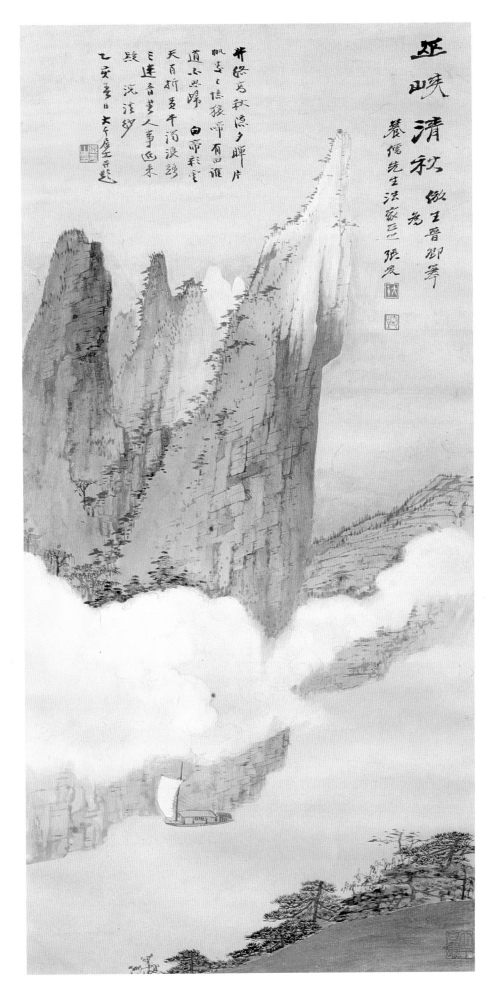

Clear Autumn in Wu Gorge

15 The Sound of Autumn

November 26–December 25, 1935
Handscroll; ink and color on paper
34.5 x 178.1 cm (13⅝ x 70⅛ in.)
Inscription and signature:
 The Sound of Autumn. In the eleventh lunar month of the *yihai* year,
 painted and given to connoisseur Yian [Chang Hsueh-Liang] to critique;
 "younger brother" Dai-chien Chang Yuan.
Colophon by Shou Xi (1889–1950)
Collection of Chang Hsueh-Liang, Taipei

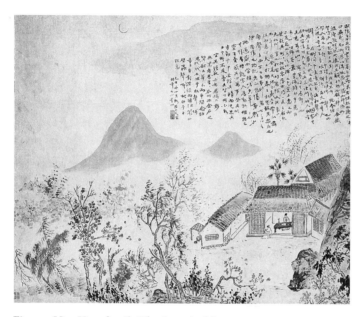

Fig. 72. Hua Yan, detail, *The Sound of Autumn,* 1755. Hanging scroll; ink and color on paper; Osaka Municipal Museum of Art. From *Min Shin no kaiga* (Kyoto: Benrido Co., 1964), pl. 136.

The Sound of Autumn

ALTHOUGH *The Sound of Autumn* is a small handscroll, it is one of Chang Dai-chien's most important early works because of its independence from ancient models; only a trace of the old masters is evident. The trees and rocks echo *The Sound of Autumn* by Shitao (1642–1707), and vague mannerisms evoke a composition by Hua Yan (1682–1756) on the same theme (fig. 72). It was Chang's innovation to crop both the top and bottom of the composition, thus simulating the view through the zoom lens of a camera. In his future work, Chang would often repeat this bold schema. *The Sound of Autumn* has a rarefied atmosphere; the cliff at the beginning of the handscroll, on the right, serves to isolate the mountain retreat from worldly concerns. Fluttering crimson leaves and the slanting boulders and trees direct the viewer toward the thatched dwelling. Inside, a scholar looks up from his book and a young serving boy stands at the open door listening to the autumn wind.

Chang's subject is clearly recognizable as an illustration of the autobiographical prose-poem by Ouyang Xiu (1007–1072), "The Sound of Autumn," which begins:

One night when I was reading I heard a sound coming from the southwest. I listened in alarm and said:
 "Strange! At first it was a patter of drops, a rustle in the air; all at once it is hooves stampeding, breakers on a shore . . . in a sudden downpour of wind and rain. When it collides with something it clatters and clangs . . . and then it is as though soldiers were advancing against an enemy, running swiftly with the gag between their teeth, and you hear no voiced command, only the tramping of men and horses."
 I said to the boy, "What is this sound? Go out and look."
 The boy returned and told me:

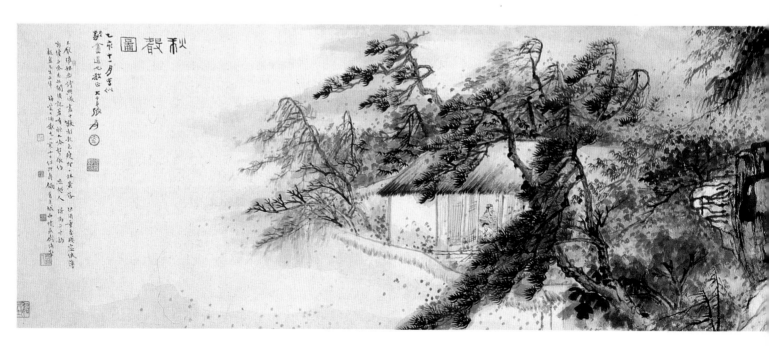

"The moon and stars gleam white and pure, the bright river is in the sky [Milky Way], nowhere is there any sound of man; the sound is over among the trees."[1]

The prose-poem mournfully reflects on autumn's punitiveness, a metaphor for the transient nature of human life. By the end of the work, Ouyang Xiu has reconciled himself to the cycle of the seasons and human life, proclaiming, "Why should we complain against the sound of autumn?" The boy has fallen asleep—only the plaintive chirping of the insects acknowledge Ouyang's melancholy. By closing in on the scene, Chang Dai-chien created a psychological alliance between the viewer and Ouyang Xiu. The lyrical brushwork and soft crimson and russet coloring transcend the opening mood of sorrow in the poem and the viewer greets Ouyang at the moment of his resolution.

Yang Qishan commissioned this painting in late 1935 to give to his friend Chang Hsueh-Liang (b. 1898), no relation to Chang Dai-chien. Chang Hsueh-Liang was a powerful general; by the late 1920s, he virtually controlled Manchuria. He was concurrently commander in chief of the Northeast Peace Preservation Forces and chancellor of the Northeast University of Mukden; in addition, he served as director of the War College in Peking for a few years. In the early 1930s, Chang Hsueh-Liang realized that his collection of Shitao paintings included some of Chang Dai-chien's forgeries. Rather than being angry, he was delighted to meet such a skillful artist. When Dai-chien painted *The Sound of Autumn*, they were only acquaintances; they became fast friends after 1960 (see entry 83).

When Chang Dai-chien finished *The Sound of Autumn,* Yang Qishan asked the prominent Peking poet and epigraphist Shou Xi (1889–1950) to write a poem on the scroll. Shou's colophon is dated January 6, 1936, but Yang was unable to deliver the scroll. In 1934 Chang Hsueh-Liang had taken a post as deputy commander in chief of anti-communist operations in Xi'an. Worried that his home base of Manchuria was inadequately defended from Japanese encroachment, Chang Hsueh-Liang illicitly met with the communists, who were advocating a united coalition with the nationalists to fight foreign aggression. Because of his political involvement, it was difficult for his friends to reach him.[2]

After 1936 the history of *The Sound of Autumn* is unclear, but in 1980 it surfaced for sale in Hong Kong. Hu Huichun purchased the scroll and recognized the sobriquet Chang Dai-chien used to refer to Chang Hsueh-Liang in the dedication on the painting. Hu Huichun's father had been a close friend of Chang Hsueh-Liang. Hu asked the prominent Taiwan official Zhang Chun (1889–1990), also a close friend of Chang Dai-chien's, to deliver the painting. Chang Hsueh-Liang had gone to Taiwan in 1949 with the nationalist forces, and almost fifty years overdue, in March 1983, *The Sound of Autumn* was joyfully received by Chang Hsueh-Liang.[3]

1. James T. C. Liu, *Ou-yang Hsiu* (Stanford: Stanford University Press, 1967), 139–40.

2. Howard Boorman, ed., *Biographical Dictionary of the Republic of China*, vol. 1 (New York: Columbia University Press, 1967), 61–68.

3. Wen Guangsheng, "Tian nan di bei," *Dacheng* 113 (April 1983): 23.

16 A Thousand Meters Up, Signed as Kuncan

ca. 1936
Hanging scroll; ink and color on paper
99.7 x 44.5 cm (39¼ x 17½ in.)
Inscription and signature:

> I've spent ten days a thousand meters
> up among these yellow peaks,
> Where the mist and vapors like a tent
> screen my thatched-roof hut.
> How could I stay confined and cramped
> between the carriage shafts,
> Or turn my back ungratefully on these
> thirty-six lotuslike peaks.
>
> Suddenly I'm roaming off into the sky,
> my heart and mind open wide;
> Crouching on the peak, I lift my head
> and let loose a crazy shout.
> Who is it who's dotting the firmament
> with all these blots of ink?
> All at once, the master of the clouds
> displays his many wonders.
>
> Bringing a thousand azure miles
> of the sky's emerald ethers,
> He scatters it in variegated patterns
> across the dark blue depths:
> Don't you see
> Where it spills down one hundred feet
> like a roll of silken cloth,
> While a tangled spray of cold jade rises
> up into fair-weather clouds?

Done in the ninth lunar month of the *xinchou* year [1661] at the Tianque Shanfang [in Nanjing]; Tianrang Shiqi Can Daoren.
SDA

Yale University Art Gallery, New Haven, Connecticut; Mr. and Mrs. J. Watson Webb, Class of 1907 Fund; 1978.42

CHANG DAI-CHIEN zealously studied the seventeenth-century individualist painters, Mei Qing (1623–1697) and the Four Eminent Monk-Painters: Shitao (1642–1707), Zhu Da (1626–1705), Hongren (1610–1664), and Kuncan (1612–ca. 1673). It was not until about 1930 that Chang imitated Kuncan—the scarcity of Kuncan's works hindered Chang's attention to him. Kuncan was an ascetic who devoted himself to Chan (Zen) Buddhism and used landscape painting both to express his spiritual convictions and to commemorate scenic excursions with friends, particularly in the area of Nanjing, where he spent most of his life.

Especially during the 1930s and 1940s, Chang followed Kuncan. On a copy Chang made of a Kuncan landscape in 1935, Chang's inscription shows his deep admiration.

> Shiqi's [Kuncan] painting is craggy, lush, thick, and dense; it combines the good points of Zijiu [Huang Gongwang; 1269–1354] and Shanqiao [Wang Meng; ca. 1308–1385].

Chang's insight into the Yuan dynasty sources of Kuncan's art motivated him to pursue Huang Gongwang and Wang Meng as well.

Around 1935 Chang began painting both forgeries of Kuncan and "honest copies." Chang was determined to prove that he was the equal of his predecessors. That meant sometimes he signed his own name to ensure that his skill as a superlative copyist would be recognized, and other times, as with *A Thousand Meters Up,* Chang signed Kuncan's name to see whether his painting might dupe at least some connoisseurs. Money was also a factor prompting Chang's forgeries, although it seems to have become more of an inducement during the 1950s after Chang Dai-chien left China.

The imitations of the Qing dynasty masters that Chang painted and signed with his own name enhanced his reputation. His copies of Kuncan, in particular, were so good that even the Kuncan expert Huang Junbi (b. 1898), a painter and collector from Guangdong, was impressed and asked Chang for a painting in Kuncan's style in late 1939.

A Thousand Meters Up has the superficial appearance of a seventeenth-century work; Chang adroitly replicated the tactile quality and sense of unchecked growth and mountain wilderness that marked Kuncan's style. When it came on the market in 1978, the author recognized it as a forgery and recommended that the Yale University Art Gallery acquire the painting as an example both of Chang's superior imitative skill and of the art historical problem of real versus fake.

Subsequently a hanging scroll by Kuncan, *Reading a Book in a Waterside Pavilion,* was published (fig. 73), allowing the author to discover Chang's prototype. Chang freely copied both painting and poem; however, he introduced a change in

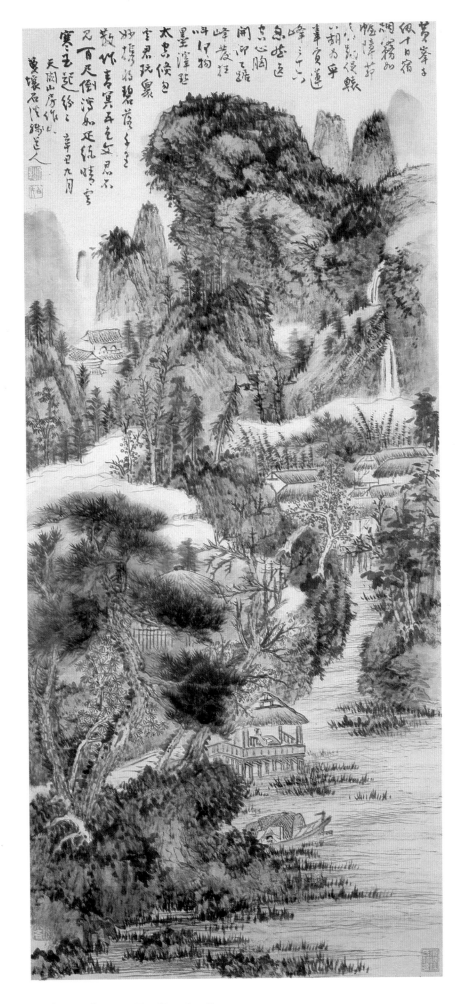

A Thousand Meters Up, Signed as Kuncan

Fig. 73. Kuncan, *Reading a Book in a Waterside Pavilion*, 1661. Hanging scroll; ink and color on paper; Guangdong Provincial Museum. From Guangdong Provincial Museum, *Guangdong sheng bowuguan canghua ji* (Peking: Wenwu chubanshe, 1986), pl. 141.

the mood of the painting. While Kuncan's text is contained in the upper left corner, Chang spread the calligraphy across the breadth of the paper, virtually obscuring the sky. Chang also eliminated one figure in the lower left corner. Chang dated the scroll to 1661, the same date as *Reading a Book in a Waterside Pavilion*. Chang flawlessly reproduced the general cadence of Kuncan's calligraphy; however, the structure of the individual characters reveals the influence of Chang's teacher Li Ruiqing (1867–1920).

Chang invariably altered some details or modified the tone in his copies, because he knew the existence of two identical

paintings would make people suspicious. By rearranging the inscription so that it filled the open space above the mountains—a technique Chang used in his honest copies of Kuncan—Chang eliminated a sense of open space and flattened the forms in his landscapes into a more graphic pattern than Kuncan's landscape. This change helps disassociate the forgery from the original.

Chang Dai-chien's brushwork in *A Thousand Meters Up* is spontaneous and self-confident. Although this brushwork echoes the feeling of Kuncan, Chang actually invested a fair amount of his personal style into the painting. The elegant coloring, grayish blue to bright indigo and ocher, and the slick fluency of the brush lines are Chang's traits. Kuncan had a step-by-step, controlled method for applying color, but Chang Dai-chien brushed wet color with sweeping gestures on top of ink details, such as the pine needles. This method is typical of his work during the 1930s. Compared to Kuncan's painting, Chang's pine bark consists of more tightly drawn circles, and the pine needles are denser and more attenuated than the ones Kuncan painted. In general, Chang's brushwork is more rapid, sharp, and uniform than the original. The rhythm of Chang's dots along the rock surfaces echo Kuncan's dots and strokes, but Chang's dots are closely spaced and pointed instead of ragged and stubby. The swift brushwork of the bamboo behind the thatched buildings also betrays Chang's brush.

A Thousand Meters Up must belong to the period when Li Ruiqing's influence on Chang's calligraphy was still strong, prior to about 1940. Other works from around 1936 display a similar use of line and color, which, therefore, suggests such a date for this work. After Chang Dai-chien mastered Kuncan's style to the stellar degree seen here, he experimented with combining the independent attributes of Kuncan and Shitao to create a singular style. His mixture of Kuncan's craggy textures and Shitao's alluring colors and emphatic brushwork was dubbed "painting of the Two Stones," since Shitao's and Kuncan's sobriquets each contain the word *shi* (stone). Chang became especially partial to this hybrid style during the 1940s, further evidence that *A Thousand Meters Up,* with its pure Kuncan quality, dates to the 1930s. Once Chang mastered Kuncan's approach, he began to reinvest past art with new life by transmuting Shitao's and Kuncan's individual nuances into a brilliant new landscape style.

17 Opera Character

December 30, 1938
Hanging scroll; ink and color on paper
104 x 61 cm (41 x 24 in.)
Inscription and signature:

> You open your mouth and leap,
> performing the bit roles,
> And though I am not a singer,
> I understand its essence.
> Your voice circles the beams,
> amazing all the audience,
> In you the Skylark is reborn
> whose cry reaches heaven.
> Before the hill or behind it,
> and searching everywhere,
> The final notes linger, both
> bringing pain and smiles.
> There is no one in the world
> who can compete with you,
> For Yanheng has already died
> and Shuyan has grown old.
> When I give you this picture,
> you collapse in laughter;
> But how many actors are there
> who can claim such expertise?

Ninth day of the eleventh lunar month in the *wuyin* year, painted playfully under lamplight to earn a smile from Ban Lou, my "elder brother in the Way" [of opera]; Dai-chien Yuan.
SDA

Collection of Alice King, Hong Kong

CHANG DAI-CHIEN depicted a broad range of people, most often idealizations of lofty scholars and classical women, and he used different styles for each subject. Chang's occasional portraits of opera characters are an especially vibrant category of his figure paintings. He invariably portrayed them in a rapid, excited manner, letting his brushwork echo the brusque movements and lusty singing of some of his favorite opera performers. The opera figures were not true portraits, although Chang sometimes depicted a performer he knew. Chang wanted to capture the essence of the role; the identity of the individual performer was a secondary concern.

Chang Dai-chien wrote a long inscription on *Opera Character* in a mixture of cursive and semicursive scripts—the text assumes nearly equal visual weight with the figure—but Chang's writing does not identify the performer or title of the opera. By comparing this painting to a similar work Chang painted in April 1963 during a Hong Kong visit to his friend Shen Weichuang, we can unravel some of the specifics. When Chang and his friend began deliberating about opera, Shen requested a painting, and the result parallels the work from 1938 in virtually every detail, including costume, palm-leaf fan, posture, and facial makeup.[1] Chang Dai-chien inscribed the painting from 1963: "Long ago I once saw Lü Yueqiao play

a role in *Ximi zhuan* and I admired his singing and stage gestures, which so successfully imitated those before him."

From the dedication that Chang wrote on *Opera Character*, in 1938, it may be possible that the performer depicted is Ban Lou, for whom Chang made the painting. Ban Lou seems to have been an opera singer and friend of Chang's, but no specific information about him has come to light. It is also possible that the performer is Lü Yueqiao.

Ximi zhuan is an opera skit performed by a soloist as a prelude to the main program. It is a medley of improvisations, often witty, in which the performer sings and acts bit roles from famous operas in the styles of famous masters. The audience judges the performer by whether or not he is able to reincarnate on stage the beloved singers of the past. Lü Yueqiao, whom Chang painted in 1963, had a grand reputation for his nimble skill at switching from part to part.

Although *Ximi zhuan* has no plot, the performer plays the comic role of a buffoonish gentleman. Each time Chang painted a performance of *Ximi zhuan*, he depicted the singer in a long black robe and folded square cap of a type popular among scholars since the late Ming dynasty. Chang depicted the character squatting, the voluminous skirt of his robe spilling into his open lap and forming a sharp v-shaped fold. A three-tufted beard attracts attention to the performer's face, especially by the exaggerated loop of the wire that holds the beard in place. Stage makeup is a crucial indicator in Peking opera of the nature of a character; here, Chang Dai-chien depicted the light makeup of a clown with a few quick strokes and light color.

Opera Character is exuberant but not unstudied. Chang used broad swags of an inky brush to map out the general area of the singer's costume, then he applied controlled, narrow strokes to connect the ink blots into a plausible rendering of human form. Chang created a thoughtful contrast between light and dark, wet and dry, and thick and thin brush strokes, revealing that even in a painting with a spontaneous look, Chang calculated the effect of each brush stroke.

Chang Dai-chien had been an opera enthusiast since he was a child. Growing up in Sichuan Province, he first became a fan of the local, distinct opera style, and as he began to travel in his late teens, he learned to appreciate Peking opera. When Chang went to Shanghai to study calligraphy in 1917, he at first hesitated to admit his love for opera, fearing it might seem frivolous to his strict teacher Li Ruiqing (1867–1920). However, Li encouraged Chang Dai-chien to attend opera, noting a striking similarity between the arts of opera and calligraphy. Li Ruiqing likened the trill of a long note, which when sung perfectly makes three dips in tone before concluding, to the technique of the ideal brush stroke. Chang

Opera Character

Although Skylark Tan had died a couple of years before Chang was born, his reputation endured. Skylark frequently played "bearded roles," which can be any character from general to judge, who would appear on stage wearing a beard. Skylark's famous voice was lauded as "piercing the clouds," which earned him the sobriquet of a bird whose cry is said to reach heaven.

Chang Dai-chien referred to Skylark in the poem on *Opera Character;* he also gave other clues to his knowledge of opera by mentioning Chen Yanheng (1868–1933), a follower of Skylark Tan. Also famous as a musician, Chen was sometimes called the Erhu Sage in praise of his skill with the stringed *erhu,* one of the most important instruments to accompany Peking opera. Yu Shuyan (d. 1943) was the only opera star Chang mentioned who was still living in 1938; he was the most renowned of Tan's school during the 1920s and 1930s but had retired sometime before Chang Dai-chien painted *Opera Character.*

Chang Dai-chien had been in Peking in early 1938; however, he must have painted *Opera Character* from memory. Once he escaped the Japanese occupation of Peking in summer 1938, he returned home to Sichuan Province. By December Chang was probably at the Shangqing Gong Daoist temple in the Qingcheng Mountains outside of Chengdu, where there is no reason to expect Peking opera to have been performed.

Opera Character is a minor work, but a subject which held great appeal for Chang Dai-chien. Not only did he paint a similar version in 1963, but he rendered the same figure on a gold-paper fan. Li Ruiqing claimed that watching opera could improve calligraphy; however, we still have no way to prove that Chang's strong calligraphy was indeed influenced by opera. A subtle but nonetheless more direct association is evinced in some of Chang Dai-chien's paintings of women. The extremely stylized gestures and costumes of feminine opera roles appealed to Chang as a distilled, if nonetheless exaggerated, embodiment of the "perfect woman," and some of his female figures seem as histrionic as the Peking opera stars Chang Dai-chien so admired.

1. The painting was published on the cover of *Dacheng* 5 (1963).
2. *Dacheng* 51 (February 1978): 39.

Dai-chien was instructed by his teacher to "ponder and learn to understand the secrets of opera, which will help your calligraphy." Li Ruiqing used the calligraphy terms "dots," "right and left diagonals," "pulsating rhythm of a brush stroke," "turns," and "concealed end of a stroke" to describe opera singing and he concluded that whoever "watched the famous singer known by the stage name Skylark Tan [1808–1887] would be enlightened"[2] as to the comparison between calligraphy and opera.

18 Blissful Old Age

Spring 1940
Hanging scroll; ink on paper
131.8 x 52 cm (51⁷/₈ x 20¹/₂ in.)
Inscriptions and signatures:

A
At peace in the evening [of life], Shaowen [Zong Bing] painted his rooms
with all the scenery he had wandered and roamed. This is the ambition [of
this painting]; Bada Shanren [Zhu Da].
JS and SDA

B
In calligraphy, Bada Shanren was a descendant of both Daling [Wang
Xianzhi; 344–386] and Yongxing [Yu Shinan; 558–638]. In painting, [Bada
Shanren] followed Huating [Dong Qichang; 1555–1636] and harked back
to Zijiu [Huang Gongwang; 1269–1354]. Everything [he made] was spare
and lucid, limpid and spontaneous, just as he was as a person. Copied and
inscribed at the end of spring in the *gengchen* year; Yuan Dai-chien *jushi*. I
leave this to my wise nephew, [Yan] Weicong.
JS and SDA

Freer Gallery of Art, Smithsonian Institution, Washington, D.C.; SC-PA-151

Fig. 74. Zhu Da, *Frontispiece to Landscape, Bird, and Flower
Album*, 1694. Album leaf; semicursive script in ink on paper; Sen-
oku Hakko kan, Kyoto, Sumitomo Collection. From *Bunjinga sui-
hen*, vol. 6, *Hachidai Sanjin* (Tokyo: Chuo Koronsha, 1977), 144,
fig. 15.

WITHOUT READING inscription B, on the left of this
painting, even a connoisseur might mistake *Blissful
Old Age* as a plausible original by Zhu Da (1626–1705). The
blunt brush strokes, cursory rocks, trees, and dwellings
mimic Zhu Da's spare manner, in which he reduced objects to
their bare essentials. In addition to re-creating Zhu Da's
painting, Chang Dai-chien adroitly imitated his calligraphy
and used words from one of Zhu Da's paintings in inscription
A on the right. Chang even reproduced Zhu Da's quixotic
signature, in which the four characters of his sobriquet, Bada
Shanren, flow together in a design that suggests a face turning
from a smile into a sudden frown. Chang's imitation of Zhu
Da's calligraphy is truly astonishing; the only warning that
the inscription is not genuine is the absence of Zhu Da's seals.

Inscription B is a short discourse on Chang's appreciation
of Zhu Da. Chang used the Chinese word *lin* for "copied,"
which usually means that an artist is imitating a specific
work, rather than painting in the general style of an early
master. Chang Dai-chien did have a direct prototype for *Bliss-
ful Old Age,* but Zhu Da's painting was a small album leaf. In
fact, Chang usually followed Zhu Da only when he was paint-
ing a small work depicting a pine tree, flower, or fish (see
entry 51). The only other large masterpiece that proves Chang
Dai-chien's accomplishment in mimicking Zhu Da's style is
Thatched Hut (formerly in the collection of Nagahara Ori-
haru, Japan), which he painted as a forgery during the
early 1930s.

Chang took great freedom in transforming Zhu Da's small,
square album leaf into the tall, narrow dimensions of a hang-
ing scroll. Chang's prototype is the first painting in an album
of landscapes, flowers, animals, and fish, which Zhu Da
painted in 1694. Chang preserved the opening title and com-
ment (fig. 74) in inscription A on *Blissful Old Age.* As Chang
elongated Zhu Da's design to fit the proportions of a hanging
scroll, he adjusted the composition and brushwork to make
them more weighty, but he faithfully reproduced the details in
Zhu Da's painting (fig. 75), such as the diminutive trees on the
crest of the distant bluff.

The dryly brushed, charcoallike ink that Chang Dai-chien
used in the landscape is fairly rare in Chang's oeuvre and
shows how carefully Chang was imitating his prototype. He
usually painted in a wetter technique modeled after Shitao
(1642–1707); the wet, dark ink in the foreground trees and the
moist moss dots in *Blissful Old Age* are still within the bound-
aries of Zhu Da's style. Chang's success in imitating both
Shitao and Zhu Da and switching at will between these brush
techniques is exceptional; few Chinese painters were equally
accomplished at opposite brush techniques.

The theme of the painting was established by Zhu Da's

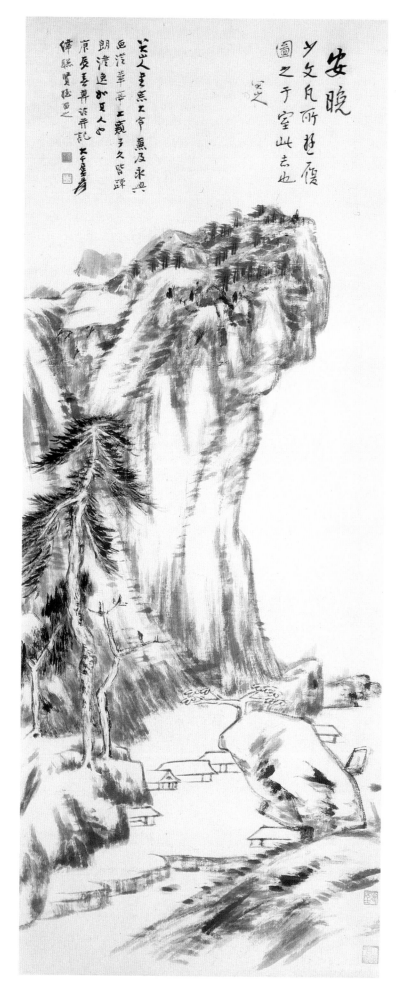

Blissful Old Age

Fig. 75. Zhu Da, *Landscape*. Album leaf; ink on paper; collection unknown.

allusion to the famous Buddhist/Daoist adept Zong Bing (375–443), who is renowned for developing the concept of "dream journeys" in Chinese art. The notion of a dream journey, which Zong Bing called *woyou* (literally "to travel while lying down") resulted from his infirmities of age. In his prime, Zong Bing hiked among mountains in search of quiescence, but when he became too old to leave his room, he had a revelation that the landscape paintings on his walls were equivalent to actual landscape scenes and looking at them afforded him the same sense of spiritual communion as walking in nature. This was the "bliss of old age" to which Zhu Da and Chang Dai-chien referred.

Chang Dai-chien dedicated *Blissful Old Age* to Yan Weicong, who married Chang's niece, Chang Xinsu (ca. 1915–1989), the eldest daughter of Chang Shanzi (1882–1940). Chang Dai-chien and his brother Shanzi coddled Chang Xinsu because her mother died while she was still a child; even after she grew up, Chang Dai-chien continued to favor her. Chang Xinsu's husband, Yan Weicong, was a chemist from her hometown, Neijiang, in Sichuan Province. When they got married in early 1940, Chang Shanzi was traveling in Europe and America raising funds for the Chinese war effort against the Japanese, and so Chang Dai-chien stood in as father of the bride at the wedding ceremony. He also gave her four scrolls for her dowry, one landscape and three floral motifs. The flowers had symbolic associations appropriate for a new bride: a lotus as an emblem of harmony; a citron in the shape of the Buddha's hand, which was symbolic of good

wishes; and a daylily, the dispeller of sorrow and a charm to wish a bride many sons.

Soon after Chang's niece was married, Chang Dai-chien left Sichuan Province to study the Buddhist caves in Dunhuang. News reached him while enroute that Chang Shanzi had died on October 20, 1940. Chang Dai-chien turned around to attend the funeral at Chongqing, and he stayed there for the period of mourning. Chongqing was an active war target, so Chang, his niece, and her husband sought refuge in a suburb called Xiaozhuang, where it was quiet enough for Chang to paint. Yan Weicong was an amateur painter, and he and Chang Dai-chien readily became good friends. Chang encouraged him to follow the spare manner of Zhu Da, which he deemed especially appropriate for a dilettante; he presented *Blissful Old Age* to Yan Weicong as a model, as well as giving several other paintings to his niece and nephew during the Chongqing period. Yan Weicong is still painting and following Chang Dai-chien's advice today.

When Chang Dai-chien emigrated from China in 1949, his niece and Yan Weicong stayed behind. At first they could not communicate with Chang Dai-chien; eventually, Chang was able to correspond with them by letter. In 1981, although Chang had already moved from the United States to Taiwan, he invited his niece to California to meet her cousins who were still there. Chang asked a dealer who sold paintings for him in Hong Kong to act as middleman and see that his niece received money for the airfare. Chang Dai-chien was also planning to pay her expenses in the U.S. The arrangements turned into a debacle: Chang Xinsu's visa was about to expire and still she had not received the money from Chang Dai-chien. Therefore, Xinsu and Yan Weicong sold some of Chang's paintings, including *Blissful Old Age,* to the Peking shop Rongbao Zhai in order to finance her trip. Yan Weicong regretted parting with this scroll, but his wife had an excellent trip. She particularly enjoyed her visit to the White House, where her father had once been a dinner guest of Franklin Roosevelt. Chang Shanzi had presented the president with a painting of a tiger that represented China's will to overcome the Japanese.

The Freer Gallery acquired *Blissful Old Age* at a Sotheby's auction in New York in 1988. On a trip to Shanghai, the author mentioned the painting to Chang Dai-chien's student Mi Gengyun. Word reached Yan Weicong, who still treasured the painting and requested photographs of it from the Freer. Yan Weicong pointed out the rare value of *Blissful Old Age,* which is one of Chang Dai-chien's few large paintings in the style of Zhu Da.

19 Songbird and Red Leaves

Spring 1941
Hanging scroll; ink and color on paper
58.4 x 25.4 cm (23 x 10 in.)
Inscription and signature:
 Imitated after the Song dynasty artist, Teng Changyou. Spring of the *xinsi*
 year, Chang Dai-chien Yuan.
Collection of C. P. Lin, Hong Kong

CHANG DAI-CHIEN first mastered the spontaneous *xieyi* method for depicting birds and flowers through studying Xu Wei (1521–1593), Zhu Da (1626–1705), and Hua Yan (1682–1756); then in the early 1930s he turned his attention to the polished, intricate style of *gongbi* painting. Chang did not take long to conquer the technically demanding method of *gongbi,* which requires tight control over both brushwork and color application as well as the precise preparation of pigments. The zenith of his *gongbi* style occurred between about 1935 and the early 1950s, when Chang's eyesight faltered. Although still fairly early in this period, *Songbird and Red Leaves* epitomizes his accomplishment, which echoes the great era of Song dynasty bird-and-flower painting. After Chang's eyesight weakened, he returned to the *xieyi* idiom to render birds and flowers.

Chang Dai-chien's admiration of Chen Hongshou (1598–1652), whom he took as a painting model, led to his pursuit of *gongbi* painting. Chen Hongshou's art reveals multiple influences from the Song dynasty, which prompted Chang, as he indicated in his inscription, to study bird-and-flower painters of the Five Dynasties and Song dynasty, such as Teng Changyou (ca. 850–after 930) and Lin Chun (act. 1174–1189).

In addition to the lessons Chang Dai-chien learned by copying ancient artists, he also directly observed nature. When Chang lived in Peking, he often visited the busy markets that sold pet birds to watch them preening their colorful plumage. Observing a subject in nature before painting it was a major tenet in Chang Dai-chien's art theory. Chang's original influences were his mother, brother, and sister, who all painted birds, flowers, and animals, and who all emphasized the importance of real-life observation.

When Peking was enveloped in the war with Japan, Chang Dai-chien left the metropolis in 1938 for a secluded place in his home province of Sichuan. He moved to the Qingcheng Mountains, not far from Chengdu, and on his frequent hikes he would explore the plentiful varieties of wild flowers and exotic birds. Chang also began to raise birds as models for his painting. *Songbird and Red Leaves* was painted while Chang was in the Qingcheng Mountains, shortly before he went to Dunhuang in Gansu Province to study ancient Buddhist cave paintings.

Songbird and Red Leaves exudes a sense of relaxed self-confidence; the modest-size painting has no element of showmanship. Chang created an intimate portrait of a perky bird, whose uplifted tail suggests imminent motion just before flight. The stunning crimson of the leaves and their pale undersides are perfect decorative touches, not belabored or overly meticulous. The tree in *Songbird and Red Leaves* is a species that Chang observed in the Qingcheng Mountains; however, the pert songbird is less easily identified. Sometimes Chang combined details he noted in actual birds with features gleaned from his study of early paintings. Chang mixed and matched elements from different species in order to create an ideal subject for painting.

Chang Dai-chien surpassed most of the bird-and-flower painters of his generation, a fact he immodestly acknowledged when he proclaimed himself equal to the ancients. In late 1941, Chang painted a pair of sparrows at Dunhuang, which he inscribed:

> Among birds, urban [literally, roof-tile] sparrows are a challenge because of the difficulty of making them appear elegant. Great masters who could do this during the Song dynasty were Huang Quan [ca. 903–965], Cui Bo [act. 1024–1070], and Daojun Huangdi [Emperor Song Huizong; r. 1100–1125]. Sometimes on an autumn day in Shazhou [Dunhuang] as the sun is rising, I paint a gathering of urban sparrows. I feel that I am able to compete on the same level as the generation of Cui and Huang.

The same could be said of *Songbird and Red Leaves:* when Chang Dai-chien wanted to paint a delicate bird, a subject he enjoyed but rendered less frequently than others, he could capture the refinement of a Song dynasty painting. The Song dynasty court artists developed a style with exquisite definition and fastidiously applied color, which has been dubbed "magic realism." This term emphasizes the unexpected vibrancy that these painters conveyed while using a technique which actually reduced the subject matter to colored silhouettes. Chang Dai-chien understood the principles of the Song dynasty academic painters, and he freely mixed these with elements from modern painting; for example, in this work he compressed the blank space that Song dynasty artists typically left at the top of a painting. Also, Chang freely added elements derived from his training in *xieyi* painting, such as the dark ink and aqueous blue moss dots along the tree branch. In *Songbird and Red Leaves,* Chang Dai-chien showed a remarkable ability to evoke the feeling of a Song dynasty bird-and-flower painting without restricting himself to a mechanical copy.

做荣人滕昌祐筆
華之春日張
大千居

Songbird and Red Leaves

20 Three Perils Mountain

June 25–July 23, 1941
Hanging scroll; ink and light color on paper
96.5 x 33 cm (38 x 13 in.)
Inscription and signature:

> In his *Commentary to [the Classic of History]*, Kong Anguo [2d cent. B.C.] [writes], "Sanwei [Three Perils] is a mountain on the western marches; [the Emperor] Shun 'drove the Sanmiao [tribes] into Three Perils [district].'" It is the [place to which the] "Yugong" [chapter of the *Classic of History* refers]: "The Three Perils [district] was made habitable." In the "Treatise [on Geography" in the] *History of the Sui Dynasty*, there is a Three Perils Mountain under the entry for Dunhuang county. Nowadays, it is commonly called Shengyu Mountain, and is located thirty *li* southeast of the town [of Dunhuang]. It has three peaks which stick up vertically and seem to be in imminent peril of falling; thus the name. The sixth lunar month of the *xinsi* year; escaping the summer heat [I have come to] the Mogao Caves, where I face the Three Perils every day and night, so I've painted this; Yuan.
> SDA

Collection of Wang Fangyu and Sum Wai, Short Hills, New Jersey

THE TOWN of Dunhuang in Gansu Province was a sleepy desert outpost when Chang Dai-chien arrived there in June 1941, after arduous travel from Sichuan Province. Without easy routes of access and lacking most modern conveniences, Dunhuang had almost been forgotten since its heyday in the Tang dynasty, when Dunhuang was a major oasis and Buddhist pilgrim stop on the Silk Route connecting China and points west. Chang traveled to Dunhuang because he had heard that Buddhists had hollowed out cave chapels in the rock and covered the walls and ceilings with incredible paintings. Dunhuang had been an active place of worship roughly from the sixth to the thirteenth centuries, with peak activity during the Tang dynasty. Besides Chang's fascination with what he had heard of the art at the remote site of Dunhuang, its seclusion was appealing. The war between China and Japan that began in 1937 prevented Chang from visiting the art centers of Shanghai and Peking, and the war eventually disrupted what calm he could find in provincial Sichuan. Therefore, it was an opportune time to strike out and visit Dunhuang.

After Chang Dai-chien arrived at Dunhuang, he paid the requisite social calls and met government officials while he anxiously awaited a chance to rush to the Buddhist site properly known as the Mogao Caves, a long night's trek by donkey cart from the center of town. The weather was too hot to travel by day, and so Chang and his party left in the evening, reaching their destination the following morning. Chang surveyed some of the caves with a lantern. He was staggered by the incredibly intricate paintings that covered the walls and ceilings. There were far more caves than Chang had imagined, and he immediately decided to lengthen his stay beyond the three months he had allotted. Faced with such a wealth of material, Chang made it his first order of business to register

and record the content of the caves. Chang's system facilitated his study of different periods and iconographic programs—by the end of 1941, Chang had recorded 309 caves.

Chang Dai-chien spent the daylight hours aided by lanterns inside the caves, which fortunately were well insulated from the burning sun. Using brush and ink, Chang made freehand sketches of large sections of the caves—some of these copies were made to scale, while others were reduced. At night in his camp near the caves, Chang continued to paint by the light of a kerosene lamp. Most of these works were unrelated to Dunhuang—they were painted to fulfill requests that had accumulated or to sell at an upcoming exhibition scheduled in Chengdu, Sichuan Province. Chang's Dunhuang project depended on income from such sales.

The desert scenery of Dunhuang and the caves struck the well-traveled Chang Dai-chien as novel. Everyday from his camp near the caves, Chang watched Dunhuang's limpid river, the area's main source of water, cut through the flat desert studded with sand dunes. In the far distance he saw Three Perils Mountain.

Intent on studying and copying the Buddhist paintings, Chang Dai-chien made few landscape paintings like *Three Perils Mountain;* the quick, casual nature of the painting reflects the pressure on his time. Chang's inscription reveals that he had studied the local history before going to Dunhuang, and his comments echo a typical entry in an old local gazetteer, which he probably memorized. The importance of Three Perils Mountain in ancient history compelled Chang to paint its vivid form.

Chang Dai-chien painted the parched desert scene with red ocher, a mineral pigment, using a dry brush. A sandy bluff with ragged scrub partially fills the foreground, opening to a view of the river. On the far shore three scholars and an attendant approach a stupa relic mound, constructed following Indian prototypes. Few places east of Dunhuang have such structures, since pagoda architecture supplanted the form throughout most of China. Chang Dai-chien once visited the temple on the summit of Three Perils Mountain. On a painting Chang made of the directional guardians, or *lokapalas*,[1] his inscription notes that the image was copied from a wall painting in an early Song dynasty pagoda at a temple at Three Perils. The inscription also comments, "The time was not long enough at the time I copied this, so I was unable to add color." This clearly elucidates the pressure Chang felt while at Dunhuang, and it helps explain the rarity of landscapes like *Three Perils Mountain*.

1. Reproduced in *Chang Dai-chien xiansheng jinian zhan tulu* (Taipei: Guoli gugong bowuyuan, 1988), pl. 41.

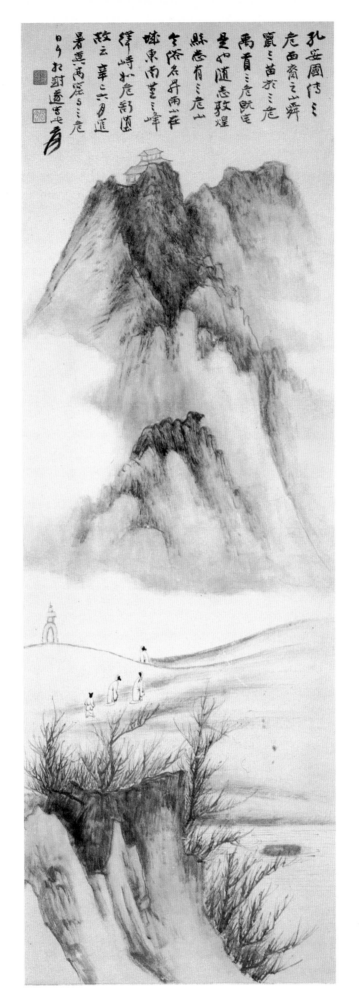

孔安國傳之
危西裔之山舜
竄三苗於三危
禹貢三危既宅
里如道志敦煌
縣志有三危山
今俗名升雨山在
城東南菫三峰
譯峙秋危彰顯
故云辛之六月匯
暑蕪禹窟S三危
日り剝逸雲葊
爰

Three Perils Mountain

21 Guanyin of the Water Moon

Autumn 1943
Hanging scroll; ink, color, and gold on cotton
156 x 86 cm (61½ x 33⅞ in.)
Inscription and signature:
Respectfully I paint this image of the Bodhisattva of the Water Moon, in the autumn of the *guiwei* year and dedicate it to Mr. [expunged name]; Chang Dai-chien Yuan of Shujun [Sichuan Province].
Collection of Ying Tsao Jung, San Francisco

Fig. 76. Chang Dai-chien, *Guanyin of the Water Moon, after Cave Number One at Yulin,* 1943. Hanging scroll; ink and color on cloth; collection unknown. From *Chang Dai-chien linmu Dunhuang bihua,* 2d ed., vol. 1 (Taipei: Dafeng Tang, 1982), pl. 12.

AZURITE, MALACHITE, and gold pigments in this scene seem to reflect the cool radiance of a full moon, which is suggested by the outer halo surrounding the reclining figure of Guanyin (Avalokiteshvara), the Bodhisattva of Compassion. Association with the moon indicates this is Guanyin of the Water Moon, one of the thirty-three manifestations that this bodhisattva can assume in order to aid sentient beings. The celestial orb symbolizes the unreality of all phenomena, which are as illusory as moonlight on the water.

Chang Dai-chien modeled this painting after his close copy of a fragmentary mural in the Yulin Caves in Anxi, Gansu Province. The Buddhist site, which was most actively patronized during the Xixia dynasty, is a three-day journey by cart from Dunhuang. Chang first stopped at Yulin in summer 1941 while enroute to Dunhuang, and he went back for twenty days at the end of that year to copy the murals. On his return home from Dunhuang in 1943, Chang again visited Yulin, staying about a month and a half to copy more paintings and devise a numbering system for the twenty-nine caves. During that time he painted a replica of the Guanyin in Cave 1 (fig. 76). That faithful copy was a prelude to several personal interpretations of the subject, including this *Guanyin of the Water Moon.*

Before studying the art at Yulin, Chang had little or no experience painting this particular manifestation of Guanyin, although, after he was nearly ordained as a monk at the age of twenty, Chang frequently painted Buddhist subjects, especially Guanyin. Throughout his life he relished painting the bodhisattva both for religious reasons and because he enjoyed painting elegant women. Before Chang studied the murals at Yulin and Dunhuang, he produced several works in which Guanyin embodies beatific calm and feminine charm. Given his admiration of ornamental detail, Chang must have especially enjoyed the intricacies of depicting the bodhisattva's jewelry and tiara; the literati women Chang usually portrayed were not as bejeweled as this Buddhist deity.

Chang first exhibited his copy of the Yulin Guanyin when he stopped in Lanzhou in 1943 on his journey home to Sichuan Province from Dunhuang. Between August 14 and August 24, 1943, he exhibited thirty-one original works loosely based on Dunhuang wall paintings and twenty-one faithful copies of the murals at both Yulin and Dunhuang. All thirty-one of his original paintings sold, but Chang did not offer the mural copies for sale despite the generous sums offered by prospective customers.

Guanyin of the Water Moon is similar to Chang's Yulin copy, but the work exhibits more of the artist's personal style; for example, Chang's Guanyin exudes a saccharine passivity, which can also be noticed in many of his images of secular

Guanyin of the Water Moon

women. Chang gave the composition a stronger vertical orientation, and he eliminated the figure of Sudhana, who is depicted in the Yulin copy standing on a cloud worshiping Guanyin. Chang masterfully balanced quiet dignity with both luxuriant colors and ornamental detail in this depiction of the bodhisattva. Harmonizing elements from the scholar-painting tradition, such as simplicity and restraint, with those from lavish religious art was one of Chang's great achievements.

Chang Dai-chien painted this *Guanyin of the Water Moon* assisted by monks, family members, and students who had worked with him at Dunhuang to record the murals. Chang and his workshop traveled as a group from Dunhuang as far as Lanzhou, where this work was painted, before dispersing. All the major outlines of the painting and the most sensitive areas of color, such as the face, are Chang's own work, while his helpers prepared the pigments and applied some areas of color.

The materials Chang chose for *Guanyin of the Water Moon* clearly reflect advice from the Tibetan monks, who encouraged him to employ the traditional materials of Tibetan *thanka* paintings—gouache on sized cotton—for most of his Dunhuang- and Yulin-style paintings. Chang even designed a *thanka*-style mounting for *Guanyin of the Water Moon.* The strips of cloth surrounding the picture were attached by thread instead of with backing paper and glue in the Chinese scroll tradition (the original mounting has been replaced).

Chang Dai-chien was so pleased with his first copy of the Guanyin in Cave 1 at Yulin that he exhibited it again in early 1944 when he returned to Chengdu in Sichuan Province. In that exhibition Chang showed forty-four copies of murals at Dunhuang and Yulin. In late 1945, Chang mounted an exhibition of his recent works based on ancient Buddhist models; this show included a *Guanyin of the Water Moon* painted in 1945 that is similar to this one from Jung Ying Tsao's collection. The 1945 version was sold and donated by the owner to the Temple of Precious Light (Baoguang Si) in a northern suburb of Chengdu, where it currently hangs above an altar table.[1] In both the 1943 and 1945 renditions of *Guanyin of the Water Moon,* Chang's technique is exalted and serves him to express his religious devotion.

1. Chang Dai-chien painted at least two more versions based on the Guanyin in Cave 1 at Yulin (one was auctioned in January 1989 at Christie's in Hong Kong, lot no. 270). Chang's student Xiao Jianchu has also painted Guanyin of the Water Moon based on Chang Dai-chien's many versions.

22 Stopping the Zither to Listen to the Moon Lute

ca. 1944
Hanging scroll; ink and color on paper
83 x 41 cm (32⅝ x 16⅛ in.)
Inscription and signature:
 Qiu Wenbo [Qiu Yuqing] from Guanghan painted *Stopping the Zither to Play the Moon Lute* and Zhao Wuxing [Zhao Mengfu] once copied it; this in turn is a close copy [*lin*] of Zhao's [painting], Yuan.
Collection of Paul Chang, Pebble Beach, California

A MOOD OF antique elegance pervades this quiet scene of two scholars sitting on leopard-skin mats and enjoying the music they play. The scholars' flowing robes sparkle with flashes of sapphire- and jade-colored silk on collar, belt, and cap. The zither (*qin*) player presses on a string to still the instrument's vibrations; he has just stopped his tune so that he may listen to his companion play the four-stringed *ruan*, or moon lute (also called a Chinese guitar). Chang intensified the aura of ancient refinement by using gossamerlike strokes to suggest ripples in the stream and long, silky outline strokes for the trees. These techniques are based on the painting traditions popular during the Six Dynasties period and are distinct from the thickening-and-thinning, calligraphic brushwork popular since the Yuan dynasty. The jeweled blue and green coloring on the shore and rocks picks up the trim on the scholars' clothing, but Chang also chose the colors for their antique association. Mineral blue and green were a mainstay of the palette used by Six Dynasties period painters.

Music has traditionally been an emblem of personal cultivation in China. No doubt Chang took subtle pleasure in painting musician-scholars since he occasionally played the zither himself and enjoyed performances by his youngest wife, Chang Hsu Wen-po, and son Paul, who owns this painting. Chang also collected ancient zithers, including the celebrated Tang dynasty zither named Spring Thunder. A Chinese scholar was once expected to be musically literate either as a connoisseur or a performer; consequently, literati artists often included musical instruments in their paintings.

In *Stopping the Zither*, Chang depicted the traditional story of how Xi Kang (223–262) once stopped the sound of his zither to listen to Ruan Xian (234–305) strum the moon lute. Xi Kang and Ruan Xian were two of the Seven Sages of the Bamboo Grove, a group of scholars in the Six Dynasties period who were renowned for their witty, philosophical discourse known as "pure talk" (*qing tan*). Skilled at playing the *pipa*, or Central Asian lute, Ruan created a new Chinese lute with a round sound box based on the *pipa*. This instrument was named *ruan* after him and came to be called a moon lute. The other scholar, Xi Kang, is frequently depicted with the attribute of a zither, which was the subject of a famous prose-

poem, or rhapsody, that he composed. In addition to the zither, Xi Kang practiced poetry, painting, and calligraphy.

Chang's inscription on *Stopping the Zither*, which he painted around 1944, explains the source of its style. Since the painting by Qiu Yuqing (act. 933–965) was not extant, Chang tried to evoke its mood through the intermediary of Zhao Mengfu (1254–1322). Several works on the theme of "stopping the zither" have been attributed to Zhao Mengfu since the late Ming dynasty. Some of these extant works are old but none is genuinely by Zhao Mengfu; nonetheless, similar elements in the many versions suggest that there was once a common prototype. One of the highest quality versions is in the Palace Museum, Peking; however, that could not have served as Chang's direct model since Xi Kang is posed differently and there is a large pine tree over the figures (fig. 77).

Although Chang did not mention Qiu Ying (ca. 1494–1552) in his inscription, Chang may have seen at least one version of *Stopping the Zither* attributed to him. A Qiu Ying attribution dated 1549 shows Xi Kang in the same posture as Chang's figure (fig. 78).

Considering that in his inscription Chang used the word *lin* for "copy," which implies the presence of a direct model, an exact prototype by Zhao Mengfu should exist for Chang's *Stopping the Zither*. However, an inscription that Chang wrote in 1949 on a painting almost identical to *Stopping the Zither* reveals that he used *lin* rather loosely. The later inscription states that Chang had never seen Zhao Mengfu's *Stopping the Zither*.

Zhao Wenmin [Zhao Mengfu] painted *Stopping the Zither to Play the Moon Lute* and *Listening to the Moon Lute*, both of which have been recorded by men of previous generations. They are no longer extant, so I created my painting based on an idea [of what I thought Zhao's painting would have looked like]. I can make something similar but not exactly identical. Let the viewer be like Jiufang Gao [act. 660 B.C.] when he judged a horse; from a general outline [he could see] all heaven and earth. Spring of the *jichou* year; Dai-chien Chang Yuan.

Chang mentioned Jiufang Gao's story to admonish the viewers to judge Chang's painting for its spiritual resonance with Zhao Mengfu rather than for its superficial likeness. Jiufang Gao was asked by King Mu (d. 621 B.C.) of the State of Qin to select the best stallions and mares in the empire, but he gave a muddled report to the king. The king's advisor then explained that Jiufang Gao's vision was so superior that he perceived the inner truth of a being rather than appearances.

Chang's inscription from 1949 indicates that he based both his earlier and later *Stopping the Zither* paintings on his memory of several antique works, including whichever Zhao Mengfu attributions Chang had seen, and on his imagination

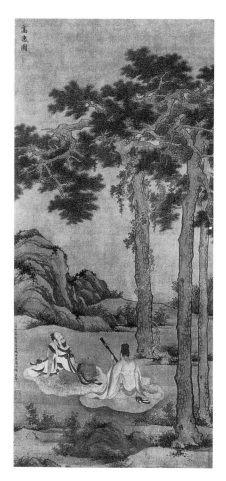

Fig. 77. Attributed to Zhao Mengfu, *Lofty Scholars*. Hanging scroll; ink and color on silk; Palace Museum, Peking. From Xu Bangda, *Gu shuhua wei'e kaobian,* vol. 4 (Jiangsu: Jiangsu guji chubanshe, 1984), 116, pl. 15–22.

Stopping the Zither to Listen to the Moon Lute

of what he thought Zhao's painting should have looked like. Chang altered only the background when he painted his second version of *Stopping the Zither;* there, the scholar-musicians are surrounded by an enclave of lush trees painted with weightier, rhythmically fluctuating brushwork.

In both versions, Chang used certain features inconsistent with painting styles prior to the Ming dynasty, demonstrating that he never intended the word *lin* to be taken literally. For example, in the version from around 1944, Chang cropped the phoenix trees in a typically twentieth-century manner that effects a close-up focus. The large scale for both the figures and background elements was uncharacteristic of Yuan dynasty painting. And the blue and green coloring, although borrowed from ancient tradition and used by Zhao Mengfu, betrays a subtle shift in technique. During the Yuan dynasty, artists applied the blue azurite and green malachite pigments more thickly and uniformly than Chang later did; he eschewed the heavily jeweled look of early painting in favor of a more subtle decoration. Thus Chang rendered part of the ground and the neighboring trees in muted ink tones, using bright colors only for the rocks. He repeated this contrast on the scholars' robes, which he delineated with plain ink lines and accented with gemlike hues. From 1941 to 1943, Chang studied the Buddhist wall paintings at Dunhuang, which date from the Tang dynasty and earlier. The brilliant colors of these works inspired Chang to experiment with decorative embellishments, though always in moderation.

When Chang painted *Stopping the Zither* in the mid-1940s, he had reached a zenith in figure painting. Even without a specific model by Zhao Mengfu, Chang was able to achieve the balance between refinement and dynamic energy that made Zhao's figure paintings so renowned. In fact, Chang's brushwork and his use of color to create a subtle interplay between elements in the fore- and backgrounds make his painting superior to the version attributed to Qiu Ying (see fig. 78). In his *Stopping the Zither,* Chang synthesized the lessons he learned at Dunhuang, his understanding of the literati painting tradition of Zhao Mengfu, and his study of mor distant sources, such as Qiu Yuqing.

Fig. 78. Qiu Ying, *Stopping the Zither to Listen to the Moon Lute,* 1549. Hanging scroll; ink on paper; National Palace Museum, Taiwan, Republic of China.

23 Tibetan Women with Mastiff and Puppy
24 Seated Tibetan Women with Mastiff

23 Tibetan Women with Mastiff and Puppy
January 14–February 12, 1945
Hanging scroll; ink and color on paper
109 x 75 cm (42⁷⁄₈ x 29¹⁄₂ in.)
Inscription and signature:

A picture of Tibetan women leading a mastiff. Twelfth lunar month of the *jiashen* year; Chang Yuan Dai-chien fu of Shujun [Sichuan Province].
Musée Cernuschi, Paris; M.C.8709

24 Seated Tibetan Women with Mastiff
Late 1946–early 1947
Mounted for framing; ink and color on paper
102.5 x 61 cm (40³⁄₈ x 24 in.)
Inscriptions and signatures:

A
Previously, when I was at Sanjiao Cheng in Qinghai Province, I saw these two beautiful Tibetan women. Although I had wanted to paint them at the time, I never did, so just now I call on my memory to make this; Dai-chien jushi.

B
The roving herders coming home
 beneath their tents of felt,
Sing a melody so sweetly
 it makes me drunk as mud.
I most love the image of
 their misty windblown locks,
They're the new little sisters
 of Liu Yi's lovely bride.
Yuan
SDA
Collection of Chang Sing S., Kuala Lumpur

WHILE TRAVELING in Gansu and Qinghai provinces in the early 1940s, Chang Dai-chien was struck by the gay, elegant costumes of Tibetan (*Cang*) women. Chang, who may have been the first modern artist to paint portraits of Chinese minority peoples, helped inspire a trend, which the government of the People's Republic of China championed for its propaganda value; Chang's interest, however, was purely aesthetic. Paintings such as *Tibetan Women with Mastiff and Puppy* and *Seated Tibetan Women with Mastiff*, representative of a group of Chang's works devoted to Tibetan and Mongolian women, met with instant acclaim as invigorating explorations of the classic theme of "beautiful women."

For *Mastiff and Puppy* and *Seated Tibetan Women*, Chang used the same technique and palette. In spite of their similarities, the works exemplify two opposing aspects of Chang's creative process: relying on life experience and borrowing from ancient art.

Chang Dai-chien explicitly described his working method in inscription A on *Seated Tibetan Women*. Chang claimed to have worked entirely from memory; however, he may also have used sketches made during his northwestern travels. In some inscriptions on similar paintings, Chang thought it important to note that he never included anything that he had not actually seen for himself.

Seated Tibetan Women can be dated to around 1946 based on the style of Chang's calligraphy. One seal on the painting points to a date later than December 1946, when Chang acquired *The Night Revels of Han Xizai*, attributed to Gu Hongzhong (act. 943–960). Chang treasured this work so highly that under the inscription on *Seated Tibetan Women* he impressed a seal that reads *ni yan lou*, literally, "the pavilion of wishing to hug the banquet-revels [painting] close to me."

Chang wove his real-life observations into a complex tapestry that included elements from past art. In *Mastiff and Puppy*, Chang arranged the two standing women, a long, low-to-the-ground mastiff, and his taut, diagonal leash into a tight, stable form. Although the composition could be a true genre scene, there is an uncanny similarity to *Envoys from Western Countries Bringing a Mastiff in Tribute to the Emperor, after Yan Liben* (fig. 79), a work attributed to Qian Xuan (ca. 1235–after 1300). In that painting, a man walks with a fabulous creature—part Tibetan mastiff and part imaginary being—while a companion carries a puppy. The imperial scion Puru (1896–1963), who was a close friend of Chang Dai-chien's, once owned the work. Therefore, although *Mastiff and Puppy* is nominally a recollected experience from Chang's northwestern travels, Chang's memory of *Envoys from Western Countries*, which he must have seen, shaped the image. Chang mimicked the idea of a figure with a leashed dog and a companion cradling a puppy, but he chose to cast the scene with women. In the Qian Xuan attribution the figures are arrayed along an imaginary line against a void. Chang created a modern painting by enlarging the figures to almost fill the picture and creating a tight triangular composi-

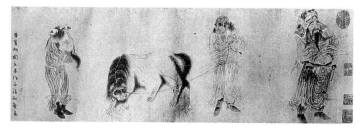

Fig. 79. Attributed to Qian Xuan, detail, *Envoys from Western Countries Bringing a Mastiff in Tribute to the Emperor, after Yan Liben*. Handscroll; ink and color on paper; collection unknown. From Osvald Siren, *Chinese Painting: Leading Masters and Principles*, vol. 6 (New York: Ronald Press, 1958), pl. 32a.

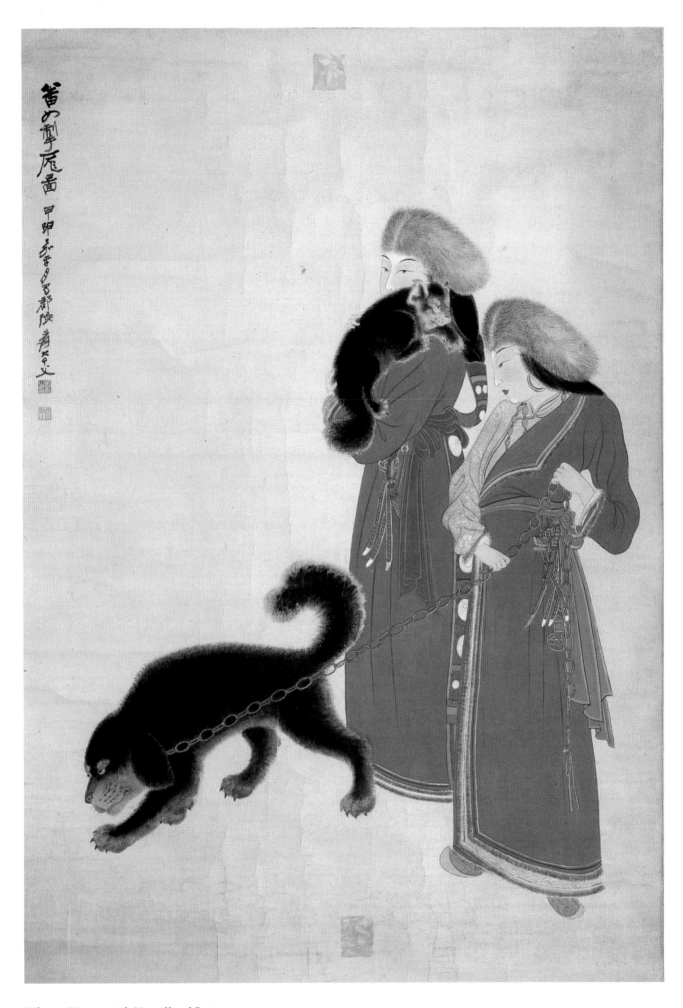

Tibetan Women with Mastiff and Puppy

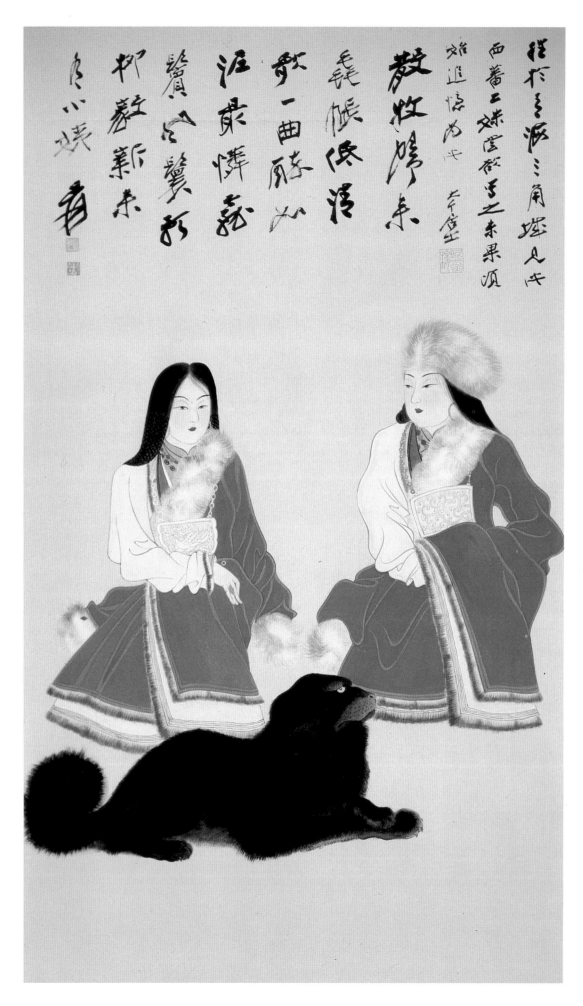

Seated Tibetan Women with Mastiff

tion, heightening a sensation of imminent motion and realism.

Chang Dai-chien introduced another major change by rejecting the antiquated notion that non-Han Chinese were barbarians; in *Envoys from Western Countries,* the figures have grotesquely bulbous craniums and wiry hair. Chang pictured the Tibetans as elegant, milky-skinned women, reflecting an idealized reality that encompasses Chang's theory that everything in a painting should be beautiful.

Chang painstakingly executed *Seated Tibetan Women* and *Mastiff and Puppy.* To convey the softness of fur, Chang laid a foundation of color on top of which he applied numerous slender, hairlike strokes. In order to achieve the deep red and black tones in the paintings, Chang Dai-chien had to patiently layer the ink and colors. He also went out of his way to choose a special kind of ink noted for producing a matte finish with a velvety rich tone. The striking contrast between red and black helps establish tension between the delicate beauty of the women and the brute force embodied by the powerful dogs.

Chang Dai-chien fastidiously rendered Tibetan ethnic dress. The women are dressed like herders in a *bacha,* an animal-skin cap, and a fur-lined, wraparound robe. The right sleeve is traditionally worn empty and hangs loosely against the wearer's thigh.

Chang recorded his attraction to the timeless quality of Tibetan dress in an inscription on *Tibetan and Mongolian Women Standing Together,* which he painted in late summer 1943.[1] Chang spent several months in the winter of 1941–42 journeying from Dunhuang to the Buddhist temples in Qinghai Province. He was first exposed to Tibetan herders on this trip, which he took in order to invite Tibetan monks who specialized in temple art to assist him. They returned to Dunhuang with him to help copy the wall murals.

The inscription on *Tibetan and Mongolian Women Standing Together* describes the Lantern Festival, which fell on March 1, 1942, at the end of Chinese New Year.

To celebrate the Lantern Festival at Taer Temple in Lushaer, the Tibetans and Mongolians assembled on the fifteenth day of the first lunar month. The women gathered like billowing clouds and their clothing and ornaments had antique beauty. Once I painted a picture of the Tibetan women's "drunken dance."[2] Recently I examined the sketches I made last year in Lanzhou, and then I painted a Mongolian and a Tibetan woman together. Everything in [the painting] is taken from what I saw; I have not added a single extraneous detail to the costumes.

Chang viewed the stability of the Tibetan costume as a welcome contrast to the capriciousness of modern fashion. The long inscription includes this observation.

In recent times those who discuss Chinese painting consider the vast majority [of painters] to have so closely copied the ancients that they are incapable of establishing anything especially new. In fact, if we go by what the Six Principles [of Xie He; act. 479–502] state, everything starts with drawing from life [*xiesheng*]. But, in addition, there are also aesthetic considerations and one has to decide what to include and what to eliminate. Still, within the past several decades, styles of dress in China have altered rapidly in a myriad of details. From one year to the next, the changes follow the wind and what is current disappears in a flash. What was beautiful yesterday makes you cover your eyes today. The dictates of fashion, whether or not they suit our taste, are fickle; even if someone has the ability to paint a portrait that captures [the sitter's] spirit and his brushwork stirs the mind and moves the soul, won't the [beautiful] Xishi turn into [the dowdy] Wuyan, or the phoenix transform into an owl? Fashion and taste do not last the twinkle of an eye, so even if Hutou [Gu Kaizhi; ca. 345–ca. 406] or [Lu] Tanwei [act. 460–early 500s] were to be reborn, or Yan [Liben; ca. 600–674] and Wu [Daozi; act. 710–760] were alive to continue [painting], they would not be able to continue doing what they were good at. But the Tibetans and Mongolians are set in their customs, and since we all find the same things attractive to the eye, let's see if [their traditional costume] isn't something we too can appreciate.
JS and SDA

Xie He's ancient principles have been recalled by innumerable artists, and Chang Dai-chien truly followed the sage advice that figure painting must be based on personal observation. After his trip to Qinghai Province, Chang saw Tibetan herdsmen camping near Dunhuang. To his delight, a group of herdsmen set up a camp of round felt tents near the Buddhist caves. One or two strong black mastiffs were chained outside each tent, and their fierce loyalty and strength attracted Chang. He resolved to bring some of the dogs back to Sichuan Province as models for his painting, and in October 1943 friends from Qinghai Province presented him with a pair of mastiffs, who appear in several of Chang's works. Chang also brought back many sketches of the herdsmen's camp that later inspired paintings such as *Dogs Being Trained* and *Tibetan Sisters.*[3]

1. *Tibetan and Mongolian Women Standing Together* sold at Butterfield's Auction House in San Francisco on March 15, 1989, lot no. 884.

2. Chang painted several versions of *Drunken Dance;* one was painted five months after *A Tibetan and a Mongolian Woman.* See Richard E. Strassberg, *Master of Tradition: The Art of Chang Dai-chien* (Pasadena: Pacific Asia Museum, 1983), 23, pl. 2.

3. Chang Xinzhi, "Chang Dai-chien Dunhuang xing," in *Chang Dai-chien shengping he yishu* (Peking: Zhongguo wenshi chubanshe, 1988), 75–76.

25 Literary Gathering

Summer 1945
Hanging scroll; ink and color on paper
113 x 76 cm (44 1/2 x 29 7/8 in.)
Inscription and signature:
> This *Literary Gathering* has been incomplete for fifteen years; currently my eyesight is getting more blurred every day. [I] inscribe this and entrust it to Wen-po to preserve. Winter of the *xinchou* year [1961]; Yuan.

Collection of Chang Hsu Wen-po, Taipei

I N *Literary Gathering,* Chang Dai-chien depicted elegantly dressed ladies and scholar-gentlemen meeting in a lush garden courtyard to examine antiquities, compose poetry, and play music. Chang balanced ornamental and narrative detail, weaving together rich colors, decorative patterns, and a variety of foliage into a harmonious tapestry.

Most of the figures are assembled around a wide platform over which the host presides; his red robe indicates he is a high-ranking official. His face, which is shaded with soft color, frowns in concentration as he tries to compose a poem—the blank paper lies before him, and freshly ground ink glistens on the inkstone. A woman behind him arranges a flower in her hair; another woman adjusts her billowing coiffure. At the host's right, a young scholar reading from an open scroll has found a listener, who tilts his head in exaggerated interest, a theatrical flourish typical of Chang Dai-chien's approach to figure painting. On the other side of the platform, a bearded scholar nurses a cup of tea, which a woman has just served from a red lacquer tray. A moon lute lies before him, awaiting his inspiration.

Two other guests converse in the foreground. The man sitting on the small dais holds a scepter, a fashion among cultivated gentlemen since the Six Dynasties period when debaters held a "discussion wand" to signal that the right to speak had been granted. A servant holds a bundle of scrolls. Although these two figures are in the foreground, Chang Dai-chien painted them smaller than those in the distance, thus utilizing the archaic principle of hierarchic scale, which presents the most important person as the largest regardless of perspective.

Chang Dai-chien painted *Literary Gathering* at the end of World War II, and it is one of his most complex mixtures of styles, including influences from his own life circumstances, as well as models from Qing, Song, Five Dynasties, and even Tang dynasty painting. *Literary Gathering* evokes the aura of a Tang dynasty literary gathering, and the bright mineral colors derive from Chang's study of Tang painting at the Dunhuang caves, from which he had only recently returned. The relatively recent source of Chen Hongshou (1598–1652) is

also obvious in the taut outlines and the exaggerated burl of the large trees.

The most obvious influences on *Literary Gathering* derive from paintings attributed to artists of the Five Dynasties and Northern Song periods. The meticulous technique of first outlining forms with tightly controlled brush strokes and then filling in color was popular during these times, but it declined with the rise of calligraphic painting during the Yuan dynasty. Chang Dai-chien deliberately looked for sources to help him revive the antique elegance of pre-Yuan painting, and several renditions of *Literary Gathering at a Festival Meal* were vital to Chang Dai-chien. The earliest is a painting in the National Palace Museum, Taipei, which is ascribed to the Tang dynasty; however, the best-known version of this composition is another painting in the National Palace Museum that bears a poem by Emperor Song Huizong (r. 1100–1125) and his signature, although it may be an anonymous work that the emperor merely inscribed. Another source Chang used was a

Fig. 80. Geng Zhaozhong, *Literary Gathering at a Festival Meal.* Hanging scroll; ink and color on silk; collection of Mrs. Ann Margaret Rosenfeld Frija, North Miami Beach, Florida.

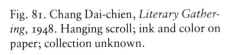

Fig. 81. Chang Dai-chien, *Literary Gathering*, 1948. Hanging scroll; ink and color on paper; collection unknown.

Literary Gathering

Fig. 82. Attributed to Zhou Wenju, detail, *Ladies of the Court*. Handscroll; ink on silk; The Cleveland Museum of Art, John L. Severance Fund, 76.1.

painting in his own Dafeng Tang collection (fig. 80). This work is by the collector and artist Geng Zhaozhong (1640–1686), who said he was copying Zhou Wenju (act. 961–975).

Chang Dai-chien re-created the essence of *Literary Gathering at a Festival Meal* but reworked many details. Chang's painting has shallower pictorial space and the scale of the figures is larger, a modern approach associated with the twentieth-century Shanghai School. Chang cropped the garden trees, which seem to extend beyond the picture plane, thus creating the effect that the viewer is close to the subject. While the early paintings portray a banquet table set for twelve—with cups in stands, individual plates, and wine pots—Chang instead included the accouterments of a literary gathering: scrolls, inkstones, and antiques. He also added three aristocratic ladies to what is an all male gathering in the early paintings. Chang even substituted girls for the male servants, giving himself the opportunity to paint brocaded costumes and sumptuous silk scarves, the kind of rich decoration that fulfilled Chang's fundamental desire to create visually appealing paintings. At the time Chang painted *Literary Gathering,* he had three wives and numerous women assistants and students, so it was natural for him to paint mixed company. This kind of modernization of ancient art was a major aspect of Chang's painting.

Chang Dai-chien believed that his *Literary Gathering* was closest to that of Zhou Wenju, whom Geng Zhaozhong credited as the originator of his literary banquet composition. On a version of *Literary Gathering* that Chang painted in early 1948 (fig. 81), he inscribed: "Zhou Wenju's *Literary Gathering* served as my model; Chang Dai-chien from Sichuan Province." Catalogues record a *Literary Gathering* by Zhou Wenju, but no extant attributions fit this title. However, Chang was familiar with Zhou Wenju's plain-line (*baimiao*) composition *Ladies of the Court* (fig. 82). Chang's figures of a woman pinning a flower in her hair and one adjusting her coiffure were lifted from *Ladies of the Court. Literary Gather-*

ing is a pastiche of anonymous Tang dynasty sources; the paintings of Zhou Wenju, Emperor Song Huizong, and Chen Hongshou; and modern life. This level of complexity causes a spectator to greet Chang's rendition as a new, independent piece, rather than a hackneyed revival of the past.

Literary Gathering can be dated to summer 1945, when a friend of Chang's introduced him to a Mr. Hsu, who invited Chang to live at his residence thirty miles outside of Chengdu. Chang was able to better concentrate in this suburb, far removed from the Japanese bombing raids on Chengdu. Hsu Wen-po, the young daughter of Chang's host, assisted Chang by grinding his ink. The garden courtyard in Chang's painting reflects the Hsu residence, which had fragrant cedar trees and plantains, neither of which appeared in the antique paintings of *Literary Gathering at a Festival Meal. Literary Gathering* is one of the most important paintings from this period of quietude, and Chang worked on it intermittently for at least six months. He never finished it to his satisfaction, so he did not sign it, but he entrusted the painting to Hsu Wen-po.

In 1948 Chang Dai-chien married Hsu Wen-po, his fourth wife, and shortly thereafter, in late 1949, the couple expatriated from China, taking with them a selection of the Dafeng Tang collection and as many paintings by Chang Dai-chien as they could carry. *Literary Gathering* was among those that Hsu Wen-po brought with her, but it was not until winter 1961 that Chang finally inscribed and signed it.

If we accept Chang Dai-chien's assertion that he painted *Literary Gathering* fifteen years before inscribing it, then the painting would date to 1946; however, Chang resided at the Hsu household during the war, which ended in August 1945, providing the terminus ad quem.

The *Literary Gathering* that Chang Dai-chien painted in 1948 was exhibited that May in Shanghai. That version is extremely close to the painting from 1945; the addition of a few woody bushes, with horizontal dots for foliage in front of the cedar trees, is the only new element. A controversial version of *Literary Gathering* dated 1951 also exists. That painting appeared at auction at Sotheby's, Hong Kong, in November 1982. The composition is identical to the rendition from 1945, but its inscription matches what Chang wrote in 1948. The only difference in the text is the date. The existence of a third version of the same composition is not unusual in Chang Dai-chien's oeuvre; ironically, the brilliant painter and forger claimed that the *Literary Gathering* dated 1951 was a bogus copy of his work. Was one of his students, who often made legitimate copies of their teacher's art, marketing a forgery? The painting dated 1951 is nearly convincing; however, the calligraphy, whose authorship is unresolved, detracts from its credibility.

26 Horse and Groom

January 3–February 1, 1946
Mounted for framing; ink and color on paper
94.5 x 46.3 cm (37¼ x 18¼ in.)
Inscriptions and signatures:

A
Piebald horse, black and dappled gray,
Purple ribbons in his three-tufted mane,
With silvery hooves and dragon's back,
His white steps slant through the mists.
Alas how he ambles and shambles along,
Slowly pacing through mulberry and hemp;
Why doesn't he, a thousand miles away,
Leap and bound beyond the sky's horizon?

Painted in the twelfth lunar month of the *yiyou* year, in Tang dynasty style, together with this text; Chang Dai-chien Yuan from Shujun [Sichuan Province].
SDA

B
For my kind "elder brother," the expert Weishi, to critique; done by Dai-chien Chang Yuan at Kunming Lake [in Peking].
SDA

Colophon by Puru (1896–1963):
Slender grasses on the level plain are
 greener than the heavens;
Of dragon's breed, the piebald black is
 reined in and can't advance.
He whinnies shrilly into the wind, and
 neighs kicking and stamping;
He must be remembering Jade Gate where
 he broke the enemy siege.

Inscribed in the second lunar month of spring in *bingxu* [March 4–April 1, 1946] at the request of my kind "elder brother" Weishi; Puru.
SDA

Colophon by Wang Zhuangwei (b. 1909):
. . . When this painting was displayed in the Chunming shopping district [of Peking] in the early spring of 1946 just after the war, it immediately created quite a stir, and soon someone who had the means purchased it for the asking price. A couple of months later, Xishan [Puru] added his colophon.

When I came across [the painting] in Taiwan some ten years later, I obtained it by pawning some of my furs. As Mao Dake [Mao Qiling; 1623–1716] stated emphatically in his *Hou Guanshi lu* about the getting and losing of things, "Does the man of means always get what he wants, while a man without means does not?" Now having acquired this steed despite my own extreme poverty, upon seeing him here in my mountain studio, I cannot help but stare at him in happy wonder. And if the piebald only knew, he would be pleased at having gotten me for a master.

As a person Dai-chien is extremely generous. Though a painting is very large and exquisitely composed, he will give it to someone out of hand without the slightest sign of reluctance. On the whole, pictures received like this as gifts are not just rough sketches either, while those obtained for money are not necessarily his most intricately executed. He decides these things however he pleases, but cost and quality need not be one and the same, for in the kindness and liberality of his heart there is no one like him. In recent years, whenever he has given me one of his latest paintings, something convoluted and immense and exploring new territory, I hang it on the wall to look at opposite this meticulous and sublime piece, and it can truly be said that each is absolutely marvelous in its own way. Inscribed twenty-six years after [it was painted], in the winter of the *renzi* year [1972]; Tongjie Laoren [Wang Zhuangwei].
SDA

Collection of Chun-Hsien Chiang, Taipei

SINCE THE Shang dynasty, the Chinese have venerated the horse, which became a symbol of political power perhaps due to its military importance. Scholar-officials also adopted the horse as a metaphor for the emperor's beneficence—a well-treated stallion was an analogue for a well-treated scholar, and an emaciated beast represented imperial abuse. Symbolic significance and inherent grace led the horse to enjoy great prominence in literature and the visual arts. Tang dynasty artists were renowned for spectacular equestrian images, so Chang Dai-chien turned to that period when he portrayed what is known in Chinese legend as a "thousand-mile-a-day horse" (*qianli ma*) in *Horse and Groom*.

According to the colophon by Wang Zhuangwei (b. 1909), a previous owner of *Horse and Groom*, "When this painting was displayed . . . in the early spring of 1946 . . . it immediately created quite a stir, and soon someone who had the means purchased it for the asking price." The archaistic style of *Horse and Groom* astounded Chang Dai-chien's audience, who were accustomed to contemporary horse paintings by Xu Beihong (1895–1953). That artist rendered frolicking steeds in calligraphic brushwork and was influenced by Western anatomical drawing from his training in Paris. Chang's audience also appreciated literati horse painting as derived from Li Gonglin (ca. 1049–1106). Chang studied Tang dynasty murals at Dunhuang in Gansu Province during the early 1940s, and his revival of Tang dynasty horse painting was unexpected and innovative. It was also in Dunhuang, where Chang Dai-chien relied on horses and donkeys for transportation, that Chang learned firsthand about horses. Chang maintained such knowledge was essential for an artist. He discredited all the horse painters after the Tang dynasty, except for Li Gonglin, even castigating the master Zhao Mengfu (1254–1322) for his lack of direct experience with horses.

Tang dynasty artists often created lucid patterns in their paintings, especially by using unmodulated gemlike colors. Chang Dai-chien exploited this stunning technique, spreading malachite pigment across the entire background of *Horse and Groom*, creating an endless pasture. This sheet of opaque color effectively flattens the picture plane, and even subtle variations in the intensity of color near top and bottom do not mitigate the painting's surface orientation.

The two-dimensional background imparts a stronger graphic appeal to the horse. The struggle between a groom and his powerful black charge is depicted straight on while the ground is seen from an aerial perspective. The absence of ink texture strokes, the shallow picture plane, and the extreme clarity of elements in *Horse and Groom* reflect the landscape murals at Dunhuang, which Chang creatively adapted to the intimate scale and format of a painting for a domestic interior.

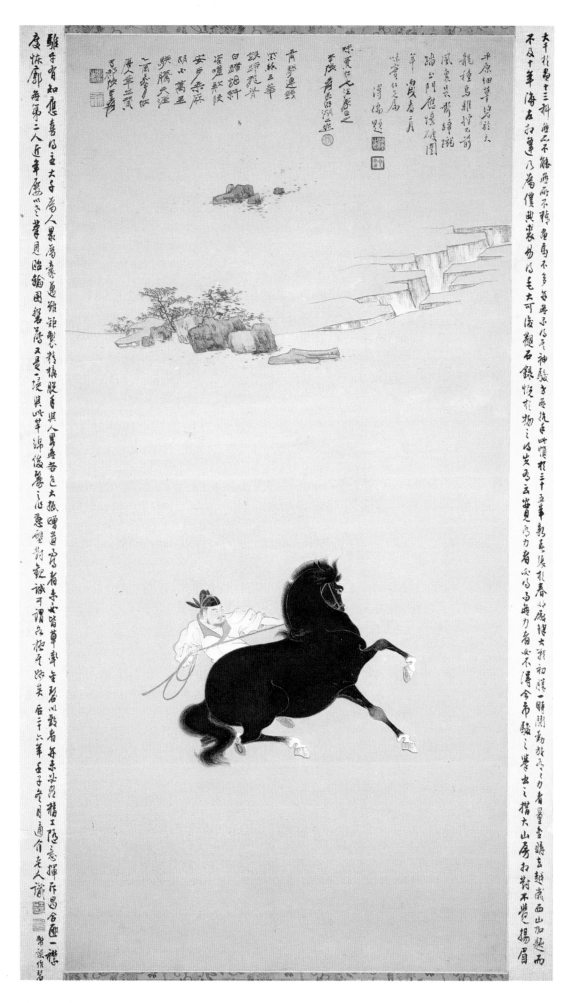

Horse and Groom

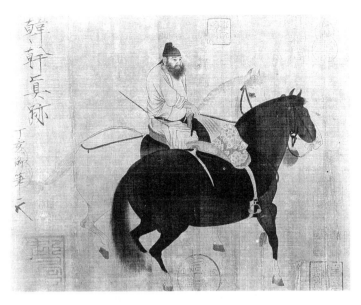

Fig. 83. Han Gan (attribution by Emperor Song Huizong), *Groom and Two Horses*. Album leaf; ink and color on silk; National Palace Museum, Taiwan, Republic of China.

Chang Dai-chien's revival of Tang dynasty style was technically demanding. The pigments required meticulous preparation and special methods of application. For the background, Chang first applied a layer of red ocher and then by putting varying thicknesses of malachite pigment over it, he created shades of green. The earth's cleft and the rocks and plants evince precisely controlled brushwork and color; the fissure is red ocher touched with gold. The azurite rocks and cinnabar bushes resemble the carefully crafted assemblage that one expects in a Chinese garden. The cleft is flamboyant decoration, but it also punctuates a division of foreground and background, which the flat surface plane otherwise denies.

Chang Dai-chien was very sensitive to materials and even collected ancient ink. To achieve a rich but matte finish for the horse, Chang had to use ink made with a specific ratio of carbon to glue and special ingredients; in *Horse and Groom* Chang applied several layers of ink so the horse would literally stand out.

After the collapse of the Tang dynasty, few artists continued to paint horses and their settings in such a meticulous, polished style. Chang relied on assiduous practice; during the summer and fall of 1945, he painted at least two images of horses that had backgrounds almost identical to *Horse and Groom*. However, the versatile Chang Dai-chien chose to model the horses themselves after *Raven Black Steed* by Liu Yongnian (act. 1030–1060) instead of a Tang prototype.

The stallion in *Horse and Groom* reflects other sources than the Dunhuang paintings or Liu Yongnian; works attrib-

uted to the master horse painter Han Gan (ca. 715–after 781) were a prime model for Chang Dai-chien (fig. 83). Chang caught the same fiery spirit that emblazons Han Gan's paintings by depicting the horse straining furiously against the groom's control. One foreleg arches high, while the other acts as a brace; the white fetlocks glisten against a raven body. The supple curve of the animal's muscular neck is repeated in the ripples of the tail. Horse and groom merge in an unbroken rush of energy. Chang Dai-chien shows great artistry in revealing both the psychological and physical affinity of man and beast.

Chang Dai-chien composed the poem he wrote on *Horse and Groom* while living in Dunhuang during the early 1940s. The poem praises spirited horses; however, although Chang painted a raven black steed, his poem cites a "piebald horse, black and dappled gray." An artist's poems were often chosen to complement the mood of a painting and rarely were meant as an exact description of the pictorial image.

Chang Dai-chien considered that he had reached a sublime level in *Horse and Groom* by achieving the dramatization of raw power in the horse against the foil of an elegant and decorative background. When his Hong Kong friend Gao Lingmei asked him to compile a painting manual in 1960, Chang rendered the horse for that sketchbook in the same pose as the stallion in *Horse and Groom*.

27 On the Min River

October 25–November 23, 1946
Hanging scroll; ink and color on paper
78.74 x 30.5 cm (31 x 12 in.)
Inscriptions and signatures:

A

The hills around me are inky-black and cold
 As springtime haze greets the break of dawn;
Closed in fog and murk for a thousand miles,
 They gleam like lotuses on a pond of clouds.
Green trees flourish like banners on parade
 And the rushing stream enters hidden depths;
I want to sail my boat out on the Min River,
 As, wrapped in misty waves, I dream of home.

Tenth lunar month of the *bingxu* year, painted as I was about to return home to Shu [Sichuan Province]; Dai-chien jushi at the Ouxiang Guan [studio in Shanghai].
SDA

B

For my dear "elder brother" Zibin, the connoisseur, to critique; Dai-chien Chang Yuan.

Collection of C. P. Lin, Hong Kong

TWO MONTHS before Chang Dai-chien painted *On the Min River* he had been enjoying his third trip to Mount Emei. His traveling companions included one of his wives, his son Paul, and some students. Shortly after arriving at Emei, Chang was called away by a friend arranging for Chang's first postwar exhibition in Shanghai, where Chang exhibited eighty scrolls, mostly based on the Buddhist mural paintings he had studied at Dunhuang in the early 1940s.

During this exhibition, Chang stayed with the family of the painter Li Qiujun (1899–1971). The Ouxiang Guan studio, where Chang produced *On the Min River,* was her painting studio.[1] Chang also came to know Li Qiujun's brothers well; one of the brothers eventually became an art broker for him.

Chang felt comfortable with all the family members and often stayed with them in Shanghai, although at the time he painted *On the Min River,* Chang was feeling homesick. This longing comes across in the last two lines of the poem in his inscription. The painting visually embodies Chang's wish to return home; the idealized Min River beckons the viewer to follow its course to Chengdu, Chang's home base in the mid-1940s. Fingers of mist slip between the verdant peaks suggesting spaciousness in spite of the painting's small size. Chang Dai-chien painted long hemp-fiber strokes to create an impression of fertile soil on the mountains, and he used muted blues and greens. Even where the pigment is thick, the color is softly luminous, a technique Chang learned through his interest in boneless, or *mogu,* landscape painting, in which forms are created by color alone, without outline. Paintings with mineral blue and green pigments, including some of Chang

Dai-chien's works, are traditionally accompanied by sharp, angular brushwork; however, for *On the Min River,* Chang favored round, smooth brush strokes. In this he was following his current interest in the Southern School painters Dong Yuan (act. 937–976) and Juran (act. 960–980) as well as in Wang Meng (ca. 1308–1385).

Although Chang Dai-chien began studying Dong Yuan and Juran during the late 1930s, he had still not perfected their styles in 1946. *On the Min River* reflects a transition in Chang's career as he moved away from the brightly colored compositions inspired by the Buddhist caves at Dunhuang toward the antithetical style of the Southern School, long considered by the literati as the orthodox painting tradition. During the 1940s, Chang Dai-chien revealed a broad, eclectic range, and *On the Min River* is among Chang Dai-chien's first paintings to show the influence of Dong Yuan and Juran.

1. Li Qiujun was a talented artist particularly well known as the cofounder and head of the Society of Female Painters. In addition to painting, Li Qiujun was a teacher and social worker who was active in the resistance against the Japanese during World War II. Li Qiujun painted landscapes in the detailed *gongbi* style, but she sometimes followed the examples of Dong Yuan and Dong Qichang (1555–1636). Li occasionally painted Tang dynasty style female figures. Although Chang Dai-chien was her contemporary, she looked to him as a teacher in painting.

On the Min River

November 24–December 22, 1946
Hanging scroll; ink and color on paper
140.8 X 56 cm (55³/₈ x 22¹/₈ in.)
Inscription and signature:
 Huanghe Shanqiao's [Wang Meng] *Elegant Gathering by a Mountain Stream* was previously in the collection of Wang Yanke [Wang Shimin; 1592–1680]. Dong Wenmin [Dong Qichang; 1555–1636] praised it, saying it "belongs on the right side of *Dwelling in the Qingbian Mountains*." Today the scroll has come back to Hu Lengan [Hu Peihen] in Peking from whom I borrowed the scroll to make a copy. The eleventh lunar month of the *bingxu* year at Kunming Lake [in Peking]; Chang Yuan of Shujun [Sichuan Province].
Collection of Mr. and Mrs. R. I. C. Herridge, Andorra

STARTING AROUND the mid-1930s, Chang Dai-chien began to copy Wang Meng (ca. 1308–1385) with particular zeal. On one imitation of Wang Meng that he painted in 1937, Chang wrote:

Of the Four Masters of Yuan Painting, Huanghe Shanren [Wang Meng] was the most capable and far-reaching. There was no one in the Ming and Qing dynasties who did not follow him; even the unconventional masters, the Two Stones [Shitao and Kuncan], were not excluded; they could not reach beyond his scope.

Chang Dai-chien knew if he wanted to succeed in capturing Wang Meng's style, he must first acquire some original works. Chang collected at least nine paintings for the Dafeng Tang that he believed were genuinely by Wang Meng. Although contemporary art historians do not agree with all of Chang's opinions about their authenticity, Chang did assemble important paintings that well represent Wang Meng. Even the most avaricious collectors of the Ming and Qing dynasties did not equal Chang Dai-chien's efforts to build a repository of Wang's painting.

Between 1937 and 1967 Chang Dai-chien copied at least sixteen of Wang Meng's compositions. Because he believed that Wang's luxuriant, tactile brushwork was the ideal, Chang diligently copied Wang's paintings—crafting several versions of Wang's most important works—and he managed to surpass the achievements of most of the artist's earlier followers. Some of Chang's favorite models included: *Reading in a Hut in a Spring Mountain* (Shanghai Museum); *Dwelling in the Summer Mountains* (Freer Gallery of Art); *Residing in the Mountains on a Summer Day* (Palace Museum, Peking); *Lofty Recluses in Summer Mountains* (Palace Museum, Peking); *Dwelling in the Qingbian Mountains* (Shanghai Museum); and *Elegant Gathering by a Mountain Stream* (fig. 84; collection unknown).

A close copy of the last painting, which Chang believed was the original but which was by an anonymous follower of Wang Meng, was the prototype for Chang's *Elegant Gathering by a Mountain Stream*. The Herridge version was the second copy of the composition he made that year. Chang finished a third copy in 1950, but the second copy was his closest imitation of the pulsating rhythm of Wang's dense composition and his ox-hair texture strokes. In Chang's second copy, tall pines stand on a foreground knoll and reach to the midpoint of the composition; tucked behind them to the left is a scholar's dwelling where friends gather. Chang compressed the painting, virtually eliminating the midground, and pushed the background massif close to the surface. Chang's technique reflects Wang Meng but is even more surface oriented. Wispy, ox-hair texture strokes suggest lush grass growing on the mountain.

Chang Dai-chien described the genesis of the second copy in the painting's inscription. When Hu Peihen saw how deeply Chang Dai-chien cherished Wang Meng's *Elegant Gathering*, Hu decided to give it to him, though, unbeknownst to Hu, it was not genuine.[1]

Chang Dai-chien rated Wang Meng as one of the masters of Song and Yuan dynasty painting; his rich, dense style accorded with Chang's vision that art should be ebullient, the result of brushwork and color. A painting like *Elegant Gathering by a Mountain Stream* marks the crucial role Wang Meng played in Chang's career: he was a bridge between Chang's early study of the Four Eminent Monk-Painters of the Qing dynasty, especially Shitao and Kuncan, and Chang's immersion in the past, which led to his pursuit of Dong Yuan (act. 937–976) and Juran (act. 960–980). Chang Dai-chien's copies of Wang Meng were instrumental in the synthesis of early masters that became the basis of Chang's independent, mature style.[2]

1. Hu Peihen had received the scroll from the famous Manchu collector Duanfang, but in spite of the excellent provenance and Chang Dai-chien's seal of approval, that version of *Elegant Gathering* is not genuine. Wang Meng's authentic version had belonged to Geng Zhaozhong in the Qing dynasty and was in Chang Hsueh-Liang's collection earlier this century; its current location is unknown. Chang Dai-chien was not aware of the existence of two versions and accepted the authenticity of the scroll he received from Hu Peihen.

2. A more detailed discussion of Chang Dai-chien's study of Wang Meng is provided in Shen C. Y. Fu, "Dai-chien yu Wang Meng," *Chang Dai-chien xueshu lunwen ji* (Taipei: Guoli lishi bowuguan, 1988), 129–76.

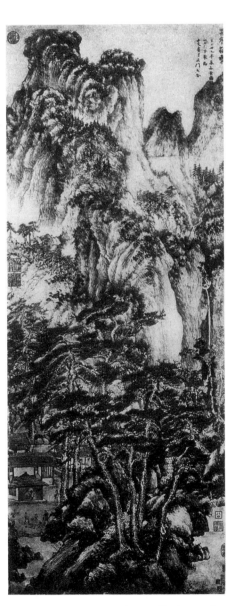

Fig. 84. Wang Meng, *Elegant Gathering by a Mountain Stream*, 1367. Hanging scroll; ink and color; collection unknown.

Elegant Gathering by a Mountain Stream

29 Light Snow at Tongguan

February 21–March 22, 1947
Hanging scroll; ink and color on paper
122.5 x 44.5 cm (48¼ x 17½ in.)
Inscriptions and signatures:

A

Light Snow at Tongguan by Yang Sheng of the Tang dynasty is a boneless [*mogu*] painting in blue and green with no outline; this [technique] originated with [Zhang] Sengyou, who is from the same lineage as I am. Dong Wenmin [Dong Qichang] copied [Yang's painting] again and again, and I have made a further copy, this time imitating Wenmin. Second lunar month of the *dinghai* year; Chang Dai-chien Yuan.

B

Dong Qichang was the most venerable
 patriarch and master of his age,
His plain style was suited best for
 wasted trees and withered hills.
Who'd believe that, when he started
 to paint *Light Snow at Tongguan*,
He would use such vibrant color and
 produce this grand magnificence?

Inscribed again by Dai-chien jushi.
SDA
Collection of Wang Fangyu and Sum Wai, Short Hills, New Jersey

Chang Dai-chien inscribed *Light Snow at Tongguan* twice, each time emphatically identifying Dong Qichang (1555–1636) as his source. He alluded to other more distant models as well, disclosing that Dong Qichang had copied Yang Sheng (act. 714–742) and that Yang Sheng's style was in turn derived from a technique Zhang Sengyou (act. 500–550) may have originated called *mogu*, or "boneless painting," in which forms are created by color alone rather than with outlines. Although boneless painting is widely embraced to depict flowers, the greatest champions of *mogu* landscapes were Yang Sheng and Dong Qichang until Chang Dai-chien and a few others revived it. Liu Haisu (b. 1896), for example, copied Dong Qichang's *Light Snow at Tongguan* in 1956 (fig. 85); Liu's painting is similar to Chang's version, which Liu may or may not have seen. In fact, Liu may have copied the same painting by Dong that Chang had used. Even though Liu Haisu was older than Chang Dai-chien, Liu more than once found himself following Chang as a trendsetter.

The history of boneless painting is plagued by a lack of early works, but it is generally accepted that Zhang Sengyou painted wall murals in this technique; according to literary evidence, he was renowned for religious and figural subjects as well as for flowers and landscapes in the boneless manner. The scholar Zhang Yanyuan (ca. 810–ca. 880) wrote in *Record of Famous Painters of All the Dynasties* that when Zhang Sengyou painted flowers over a doorway in Yicheng Temple in Nanjing, the distinctive style without outlines caused a great stir. Zhang apparently modeled the flowers using opaque and semitransparent washes of color, and he created strong contrasts in tone to simulate the effect of light and shadow. Such vivid three-dimensional illusion was dubbed *aotu hua* ("receding-and-protruding painting"). Although nothing by Zhang is extant, some of the Buddhist murals that Chang studied at Dunhuang are from the same period and preserve the general tenor. The flowers on the ceiling of Cave 428 correspond to Zhang Yanyuan's description of Zhang Sengyou. Some scrolls that are attributed to Zhang Sengyou also suggest what his landscapes must have looked like. One of the best examples is *Snowy Mountain with Red Trees* in the National Palace Museum, Taipei, but it is, alas, a late copy.

Yang Sheng, a court painter active in the Kaiyuan reign (713–741) of Emperor Xuanzong (r. 712–756), was the next master of boneless landscapes. Yang lived during an affluent era when exotic, sumptuous goods were plentiful, and the jewellike effect of boneless landscapes suited the times. Unfortunately, no original from Yang Sheng's brush exists. Chang Dai-chien was aware of the rarity of Yang's work and claimed to have seen only one painting that he accepted as

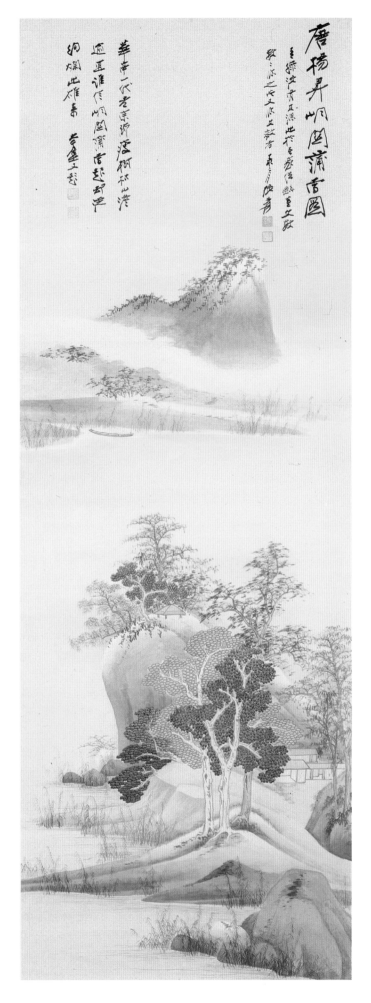

唐楊昇峒圖蒲雪圖

Light Snow at Tongguan

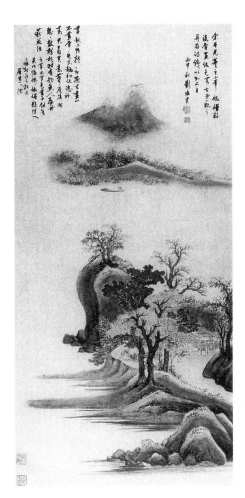

Fig. 85. Liu Haisu, *Light Snow at Tong-guan*, 1956. Hanging scroll; ink and color on paper; collection unknown. From Zhan Huijuan, ed., *Liu Haisu zuopin xuanji* (Peking: Renmin meishu chubanshe, 1983), n.p.

genuine, but he did not specify which one.[1] Modern art historians generally concede that no original by Yang has survived. To study Yang Sheng we have to rely on later attributions such as the handscroll *Snowclad Mountains and Pine Trees* (fig. 86). Although Chang Dai-chien never mentioned this painting, the affinity to his *Light Snow at Tongguan* suggests that he knew it.

The catalogue of the National Palace Museum, Taipei, describes *Snowclad Mountains and Pine Trees*.

[*Snowclad Mountains and Pine Trees* is painted] in blue and green with white clouds: the peaks are blue, the tree trunks are red, and the pine needles are dark green. The painting has thatched huts and streams with little boats. It is rich and the gold and green shine.[2]

Lou Guan wrote a colophon on *Snowclad Mountains and*

Pine Trees in 1227, which assesses the relationship between Zhang Sengyou and Yang Sheng.

When Zhang Sengyou of the Tianjian period [502–519] in the Liang dynasty [painted] on silk, he did not use ink on his brush; moreover, using only blue, green, and heavy colors, he created mountain peaks, waterfalls, and rocks in the boneless technique. Over time it was only Yang Sheng who was able to study and obtain the secret of this method. This painting is the same as making dark blue come out of light blue [i.e., a student who surpasses his teacher].

Boneless landscape painting declined after Yang Sheng and was not explored again until Dong Qichang did so. Dong and followers such as Sheng Maoye (act. 1625–1640)[3] initiated a temporary but important revival; however, until Chang Dai-chien, boneless landscapes were rare.

Dong Qichang painted several works after Yang Sheng, including *Boneless Landscape After Yang Sheng* (Nelson-Atkins Museum of Art, Kansas City), which bears the inscription:

I once saw a genuine work by Yang Sheng with mountains done in colored washes without outline [*mogu*]. From that, one realizes the striking effect of the ancient's playful, spontaneous brush that like a fleeting glow of rosy clouds is something rarely seen in this world. This is to imitate that.[4]

Dong Qichang particularly admired Yang Sheng's *Light Snow at Tongguan*, which he copied at least three times. According to Chang Dai-chien's catalogue of his Dafeng Tang collection, published in Chengdu in 1943, Chang owned two copies by Dong Qichang, one on paper and one on silk. The current location of these is unknown, but they must have been similar to Dong Qichang's *Light Snow at Tongguan* in the temple collection of the Jisho-in, Japan.[5]

Chang Dai-chien recorded in the Dafeng Tang catalogue that Dong Qichang inscribed the same comment on both of the works in Chang's collection: "I had a chance to see Yang Sheng's *Light Snow at Tongguan* and I followed its essence." In addition, a colophon by Chen Jiru (1558–1639) on the silk copy states that he and Dong Qichang saw Yang Sheng's painting when Zhu Dingguo owned it and that Chen was impressed by Dong Qichang's copy. Chen's colophon also touched on the origin of Yang Sheng's style: "[Yang Sheng] occasionally invoked the boneless style of Zhang Sengyou for mountains, but it is not something that today's painters can even dream of doing." When Chang Dai-chien copied Dong Qichang's version of *Light Snow at Tongguan*, his inscription A echoed Chen Jiru's colophon.

Dong Qichang's polemical views about painting and his division of artists into Northern and Southern schools

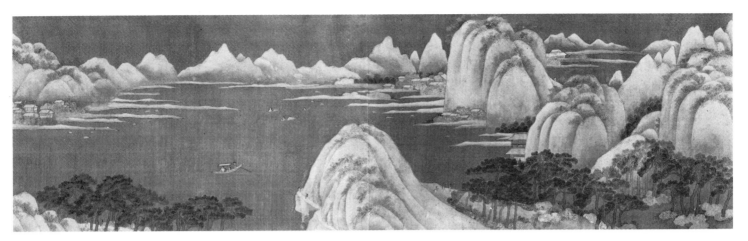

Fig. 86. Attributed to Yang Sheng, detail, *Snowclad Mountains and Pine Trees*, Ming dynasty. Handscroll; ink and color on silk; National Palace Museum, Taiwan, Republic of China.

affected his perception of Yang Sheng and caused him to revive Yang's manner selectively. Dong did not admire the Northern School, deriding it as too decorative, while artists of the Southern School exemplified the approach he considered crucial—innovation based on the study of past art. Dong Qichang endowed his boneless landscapes with a distinctly personal flavor by depicting the watery vistas and broad lowlands of his home in the Jiangnan region.

Dong Qichang made a clear distinction between the techniques of boneless landscapes and the style known as blue-and-green, which he associated with the Northern School; however, the distinction was probably not so clear during the Tang dynasty. The same pigments, malachite for the green and ultramarine and azurite for the blues, belong to both painting techniques, but in blue-and-green painting, colors are applied more thickly and assume a vitreous shine. In boneless painting the colors are usually soft, translucent, and liberally include white clouds and red trees, which are not common in blue-and-green style paintings. Dong Qichang and his followers associated the blue-and-green manner with the meticulous *gongbi* painting that was popular at the dynastic courts; however, they accepted boneless painting as suitable for scholars. Thus Dong Qichang treated boneless painting like a form of the exuberant and calligraphic *xieyi* method of painting. Ming dynasty boneless painting was intended to be more self-expressive than decorative.

Chang Dai-chien understood Dong Qichang's position. After practicing decorative blue-and-green painting during the late 1930s and early 1940s, he was ready to adopt Dong Qichang's subtle means of coloring a landscape. As early as 1937 Chang copied Dong Qichang's *Light Snow at Tongguan,*

which he inscribed:

Dong Wenmin [Dong Qichang] praised this painting by Yang Sheng [saying], "We could not stand to be without it but it is impossible to have another [one like it]." . . . I have seen many copies by Wenmin of Yang's work.

Just as Dong Qichang repeatedly copied Yang Sheng's *Light Snow at Tongguan,* Chang Dai-chien made multiple copies of Dong Qichang's work. In addition to the painting dated 1937 and this one dated 1947, another copy appeared at auction at Christie's, Hong Kong, in March 1990. Lifting boneless painting from oblivion, Chang conquered the idiom as practiced by Zhang Sengyou, Yang Sheng, and Dong Qichang, and then he developed his own version of boneless painting in semiabstract landscapes of splashed-ink-and-color in the late 1950s.

1. Wang Fangyu, "Cong Chang Dai-chien kan Zhang Sengyou," *Dacheng* 30 (May 1976): 32–38.

2. *Gugong shuhua lu,* vol. 2 (Taipei: Guoli gugong bowuyuan, 1976), chap. 4, 8.

3. For Sheng Maoye's boneless painting, see a work of 1632 reproduced in Suzuki Kei, comp., *Chugoku kaiga sogo zuroku,* vol. 2 (Tokyo: University of Tokyo Press, 1982), 101, S12–013.

4. Translation adapted from Kwan-Shut Wong, *Eight Dynasties of Chinese Painting* (Cleveland: Cleveland Museum of Art, 1980), 243.

5. Suzuki Kei, *Chugoku kaiga sogo zuroku,* vol. 4 (1983), 116, JT118–016.

30 Gibbon

March 23–April 20, 1947
Hanging scroll; ink and color on paper
107.6 x 53.7 cm (42³/₈ x 21¹/₈ in.)
Inscription and signature:
 A playful gibbon by Zhujiao Yi Yuanji from Changsha [Hunan]. [Presented
 to] "brother" Zhijiu [unidentified] at his gracious request; the intercalary
 second lunar month of the *dinghai* year, Dai-chien Chang Yuan.
Collection of Stewart S. T. Wong, Hong Kong

THROUGHOUT HIS adult life, Chang Dai-chien was equally well known as Chang Yuan, literally "Gibbon Chang," and he signed most of his art with a combination of both names. Chang's choice of character for "gibbon" was unusual, eliminating the pictographic component of the "canine radical" found in many animal names.

Chang was given the name Yuan by his Shanghai calligraphy teacher, Zeng Xi (1861–1930), with whom Chang began to study in 1919. Zeng's inspiration was a dream that Chang Dai-chien's mother had recounted. Just before Chang's birth, she dreamt a monk presented her with a gibbon. Believing that the human and animal realms are closely linked, Chang's mother came to think of her son as the reincarnation of a gibbon. At least since the Tang dynasty, the gibbon has been admired in China for its graceful movements and its pure and free life-style; thus Chang was flattered by the association.

Chang Dai-chien had been fond of animals since childhood, when his father had raised a large brood of dogs at home. Later Chang Dai-chien lived with his older brother Chang Shanzi (1882–1940), who specialized in painting tigers, and Shanzi raised these wild cats at their Suzhou home, dramatically expanding Dai-chien's interest in animals. As an adult Chang Dai-chien bred many kinds of animals, but he always reserved his greatest affection for gibbons, raising about thirty during his lifetime. Whenever he moved to a new home he designed a special area for their care. In Brazil, where he lived on a large estate during the 1950s and 1960s, the space and favorable climate made it possible for Chang to rear ten gibbons, the largest group he ever had. In the early morning Chang enjoyed strolling about his garden with the gibbons; the well-behaved ones were allowed to wander freely. When Chang painted in his studio, they often paused outside the window to watch him work.[1]

In 1978 Chang Dai-chien moved to a small property in Taiwan that he named the Abode of Illusion (Moye Jingshe), and there he continued to raise gibbons until the end of his life. Two of his pets still reside at his home, which is now a memorial museum, and they welcome the public with shrill whistles and cries.

The first gibbon Chang Dai-chien owned was a gift sent by a friend from Singapore just after the end of World War II in August 1945. It was a southern species of black gibbon not common in China. Chang traveled by plane many times between Shanghai and Sichuan Province with this pet, paying half fare for the gibbon, who was probably the model for *Gibbon,* painted in 1947.

The gibbon with a black face and white ruff perches on a jagged bough of what is probably a loquat tree, and playfully he swings his long arm. Chang Dai-chien's dedication indicates the work was painted at a friend's request, but *Gibbon* is no mere social obligation. Chang's vivid brushwork is extemporaneous and fluid, conveying the kinetic energy of the gibbon. The bamboo is also painted with great vigor. Chang let the wet ink puddle slightly at the beginning of each stroke, then deftly finished it with a swift upward movement to convey crisp and healthy leaves. The gleaming eyes of the gibbon—reserved white circles—are an innovation not found in the Song dynasty prototypes Chang often followed.

Chang's inscription explains that he was trying to capture the playfulness of the gibbons depicted by Yi Yuanji (act. mid–11th cent.), China's most famous gibbon and monkey painter. Yi Yuanji reputedly raised gibbons as models for his paintings, and he frequently traveled in the southern mountains to observe the animals in their habitat. Sometime before 1943 Chang Dai-chien acquired *A Pair of Gibbons in a Loquat Tree* (collection unknown), an important painting attributed to Yi Yuanji, which served less as a model than an example for Chang's *Gibbon.* Yi Yuanji's style combined clear descriptive details with sensitive attention to the animal's frisky nature; Chang used Yi Yuanji's technique as a starting point for his own interpretation of a gibbon. In his painting Chang abbreviated the setting as well as the amount of detail in the gibbon, relying instead on energetic brushwork to convey the character of his pet.

1. Lin Weijun, ed., *Huanbi An suotan* (Taipei: Huangguan chubanshe, 1979), 258–61.

162

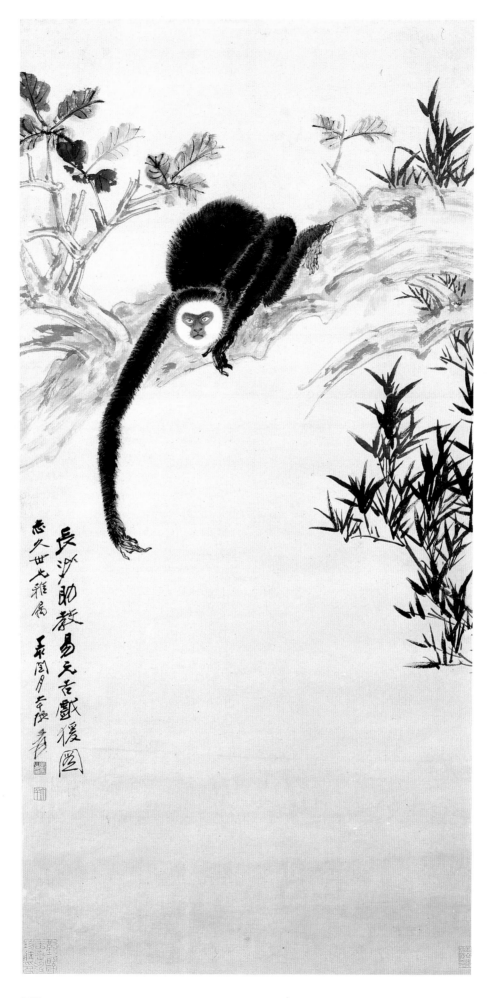

Gibbon

November 13–December 11, 1947
Mounted as hanging scroll; ink and color on paper
43.8 x 80.7 cm (17¼ x 31¾ in.)
Inscription and signature:
Xiao Yi Stealing the Preface to the Lanting Gathering Manuscript by Trickery, painted by Yan Liben.

The Lanting manuscript was up in the rafters,
But how could anyone in the world have known?
Nothing to do with the craftiness of Xiao Yi,
It was simply due to an old monk's stupidity.

Poem by Cheng Jufu [1249–1318] of the Yuan dynasty. Tenth lunar month of the *dinghai* year; Chang Dai-chien Yuan.
SDA
Collection of Stewart S. T. Wong, Hong Kong

Stealing the Lanting Manuscript by Trickery

Fig. 87. Anonymous, *Xiao Yi Stealing the Preface to the Lanting Gathering Manuscript by Trickery;* colophon by Wen Zhengming, 1553. Handscroll; ink and color on paper; Freer Gallery of Art, Smithsonian Institution, Washington, D.C., 10.6.

EMPEROR TANG TAIZONG (r. 626–649) conspired to obtain the prized calligraphy manuscript *Preface to the Lanting Gathering* by Wang Xizhi (ca. 306–ca. 361). The acquisition was first immortalized in painting by the Tang dynasty court artist Yan Liben (ca. 600–674). This composition is preserved only in copies, and Chang Dai-chien followed its tradition, creating a sumptuous rendition of the meeting between the old monk Biancai and the scholar-official Xiao Yi.

Wang Xizhi produced the famous Lanting calligraphy in 353, when he hosted a celebration for the Spring Purification Festival. According to the Tang dynasty scholar He Yanzhi, Wang Xizhi wanted to preserve the work, and he passed it down in his family. His seventh-generation grandson Zhiyong was a monk and, having no children, passed the calligraphy to his disciple, the abbot Biancai. At this time, Emperor Tang Taizong, who had a passion for Wang Xizhi's calligraphy, was casting a broad net to gather examples for the palace. Biancai hid *Preface to the Lanting Gathering* in a temple beam so the emperor would not take it. But the emperor's clever envoy Xiao Yi pretended to be an independent scholar and cultivated Biancai's friendship by discussing calligraphy with him. Xiao Yi showed Biancai some scrolls by Wang Xizhi from the palace, claiming they were from his own collection. Impressed by their authenticity, Biancai mentioned that Wang Xizhi had an even greater achievement and took *Preface to the Lanting Gathering* from its hiding place. Xiao Yi claimed the scroll for the emperor, who in appreciation bestowed Biancai's temple with an endowment for a new building. Virtually every educated Chinese knows this story, since the *Preface to the Lanting Gathering* has been used since the Tang dynasty as a model for calligraphy.

Chang Dai-chien depicted Biancai seated in an armchair fashioned from twisted roots and covered by an elegant brocade. His legs are tucked up in the chair seat, while his slippers rest on a black lacquered footstool inlaid with mother-of-pearl. Biancai faces Xiao Yi, who is dressed like a dignified scholar with no reference to his official rank. A young servant holds a scroll box that contains the treasured *Preface to the Lanting Gathering*. Suspicious of Xiao Yi, the boy nervously scratches his head yet dares not tell his master. An acolyte and a young servant, who prepare tea behind the monk's chair, share Biancai's congenial feeling and trust for Xiao Yi.

Chang Dai-chien deftly outlined the figures in the painting with sharp, thin lines, and he applied the color exactly, demonstrating great technical expertise. The soft coloring on Biancai's face gives him a spiritual radiance. The abbot's robe, with its deep red and yellow silk patches, draws additional attention to the figure. Chang Dai-chien used a lush color scheme throughout the painting—notice the azure

detail, *Stealing the Lanting Manuscript by Trickery*

dishes and the azure trim on the textiles—but he harmonized the colors lest too dazzling an effect offend his audience of traditional literati connoisseurs. Chang's colors are similar to those of Qian Xuan (ca. 1235–after 1300) who, like Chang himself, straddled the ornamental taste of the professional painter and the restrained taste of the scholar-painter.

Chang Dai-chien was familiar with early paintings of *Xiao Yi Stealing the Preface to the Lanting Gathering Manuscript by Trickery.* The earliest and most famous is a short handscroll in the National Palace Museum, Taipei, which is attributed to the Tang dynasty artist Yan Liben. Even if Chang saw that painting, and despite his invocation of Yan Liben in the inscription, he did not use it as a direct model. The attribution to Yan is considerably less polished than Chang Dai-chien's painting, and some of the figures are different. The brushwork and coloring Chang used reflect the taste of the Song dynasty court more than the Tang dynasty attribution.

One later composition that could have served as a prototype for Chang Dai-chien is in the Freer Gallery of Art (fig. 87). The Freer's painting is a sixteenth-century handscroll that combines a transcription by Wen Zhengming (1470–1559) of the *Preface to the Lanting Gathering* in tour de force calligraphy with an anonymous Ming dynasty painting of the meeting between Biancai and Xiao Yi. The Ming painting follows the tradition of Yan Liben but introduces changes. The scene of preparing tea is more elaborate, and the older monk accompanying Biancai in the Yan Liben attribution has been replaced by the servant who scratches his head as he holds the box of calligraphy. Chang Dai-chien's version maintains this figure but changes him into a cherubic boy.

Chang Dai-chien's composition may not have been modeled on the Freer painting, but his source was from the same recension. Chang's work is superior to the Ming dynasty painting, however. The lines are smoother and more assured, the facial expressions are more animated, and the color is not only richer but used actively to heighten the drama and evoke sympathy for Biancai.

32 Inspired by the Willow

ca. 1948
Hanging scroll; ink and color on paper
86 x 35 cm (33⁷/₈ x 13³/₄ in.)
Inscription and signature:

> Its light blossoms look like snow,
> Its airy greenery seems like mist;
> Not waiting for autumn wind to rise,
> What a pity, they come shaking down.
> Every year it suffers being plucked,
> Why then does it continue on and on?

> Poem on the willow by my late teacher, Li Wenjie [Li Ruiqing]; Chang Dai-chien Yuan.
> SDA

Collection of Paul Chang, Pebble Beach, California

A ROUGH OLD willow bough and a lacy curtain of leaves buffeted by the wind crowd the top third of this painting. Chang Dai-chien painted the heavy limbs with a worn brush and dark ink, but for the lithe, young branches, he switched to a smaller, sharp-tipped brush. The swaying tree is a perfect foil for the scholar, who is frozen in a final moment of concentration before starting to brush a poem. His brush has been freshly loaded with dark ink from the large, bell-shaped inkstone on the ground, and he comfortably leans on a small armrest, the leg of which is inlaid with semiprecious stones. The mat and lacquer tray that holds two scrolls are equally refined. Chang used pure mineral colors for the scholar's robe and accouterments to create a rarified atmosphere.

Inspired by the Willow fits into a traditional genre known as "lofty scholar painting," which keenly interested Chang Dai-chien beginning around 1935. The time-honored category includes literary gatherings and portraits of single scholars; Chang tended to paint compositions of a solitary figure with a simple background consisting of only a pine, willow, or banana tree.

Considering that Chang painted *Inspired by the Willow* nearly thirty years after the death of Li Ruiqing (1867–1920), Chang's inscription demonstrates the continual presence of his early teacher in his memory. The verse is by Li Ruiqing, whose words Chang used on many paintings of a scholar strolling beside or sitting beneath a willow tree. The willow has special significance in Chinese custom as a gift to a departing friend.

The demeanor, dress, and accouterments of the scholar in *Inspired by the Willow* bespeak an ancient model; the general tenor resembles antique depictions of the Seven Sages of the Bamboo Grove. In 1945 Chang saw a handscroll by Sun Wei (act. 880) entitled *Lofty Scholars* (Shanghai Museum) and was impressed by its elegant depictions of scholars engaged in conversation and thoughtful meditation. *Inspired by the Willow* cannot precede Chang's familiarity with Sun Wei's work, and based on both painting and calligraphy style, it should date to 1948. Chang must also have been influenced by *Seven Sages,* a handscroll attributed to Qian Xuan (ca. 1235–after 1300), for Chang's scholar closely resembles one of the figures in the handscroll (fig. 88). However, we do not know when Chang saw that work.

Inspired by the Willow marks Chang's ability to render the antique elegance of scholarly figures. Within a decade, Chang Dai-chien had the confidence to paint three scholars in *The Three Worthies of Wu,* a forgery of a Song dynasty work attributed to Li Gonglin (ca. 1049–1106). *The Three Worthies of Wu* entered the Freer Gallery of Art in 1957 as if it were a genuine Song dynasty painting. The first scholar in that work (fig. 89) owes much to *Inspired by the Willow;* in fact, Chang's personal accomplishment in painting antique figures led to his success as a forger.[1]

1. See Shen C. Y. Fu, "Chang Dai-chien's 'The Three Worthies of Wu' and His Practice of Forging Ancient Art," trans. Jan Stuart, *Orientations* 20, no. 9 (September 1989): 56–72.

Fig. 88. Attributed to Qian Xuan, detail, *Seven Sages.* Handscroll; ink and color on paper; National Palace Museum, Taiwan, Republic of China.

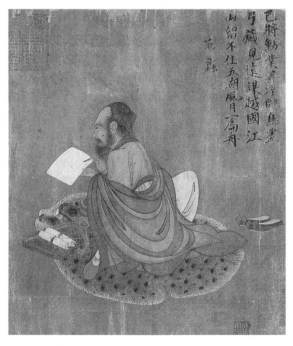

Fig. 89. Chang Dai-chien, detail, *The Three Worthies of Wu,* early 1950s. Handscroll; ink and color on silk; Freer Gallery of Art, Smithsonian Institution, Washington, D.C., 57.15.

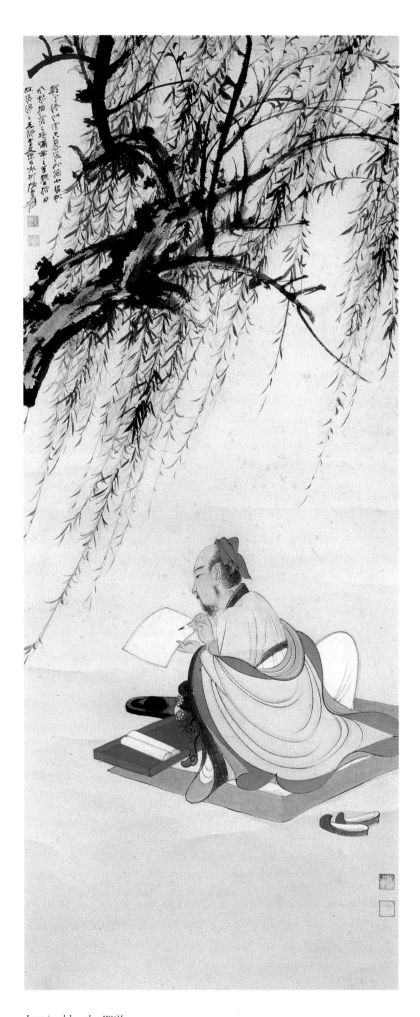

Inspired by the Willow

33 Summer Trees Casting Shade

Early April 1949
Hanging scroll; ink and light color on paper
116.5 x 56.8 cm (45⁷/₈ x 22³/₈ in.)
Inscription and signature:
 Summer Trees Casting Shade, [painted] on the eve of the Qingming Festival
 in the third lunar month of the *jichou* year; Chang Dai-chien Yuan.
Collection of Mr. and Mrs. Lee Chen-Hua, Westbury, New York

THE LUCID pattern of geometric components in *Summer Trees Casting Shade* has such forceful clarity that the aggregate effect is a monumentality unexpected from such a simple composition. A stand of trees laden with heavy summer foliage fills the foreground; across the river from the treetops, a scholar's retreat sits in a clearing surrounded by pines. No figures are present to enjoy this inviting elysium, whose only access is a steep mountain path leading up from the water. The hummock behind the garden-retreat is a strong vertical thrust that contrasts sharply with the stretch of low-lying hills on the horizon.

The composition's formal structure echoes tenth-century landscapes through the intermediary of later artists. Although Chang Dai-chien's inscription does not mention any model for the painting, the long hemp-fiber strokes, large dots, and drippingly moist, inky foliage indisputably point to Dong Qichang (1555–1636) and ultimately back to Dong Yuan (act. 937–976) and Juran (act. 960–980). Dong Qichang painted several compositions called *Summer Trees Casting Shade*, which he based on Dong Yuan. One of the best is in the National Palace Museum, Taipei; if that served as Chang Dai-chien's model, he considerably streamlined the composition.

Chang Dai-chien was inspired not only by Shitao (1642–1707) and the other individualist painters of the seventeenth century but also by the orthodox tradition derived from Dong Qichang. In fact, Chang was so strongly impressed by Dong Qichang's theories and art that he claimed the individualist painters' styles were adapted from Dong Yuan and Huang Gongwang (1269–1354) through Dong Qichang. During the 1930s and 1940s, Chang devoted himself to copying Dong Qichang's calligraphy and painting, achieving the same success as he did when copying Shitao, whose works he imitated most often.[1] Chang's admiration for Dong Qichang led to a preoccupation with Dong Yuan and Juran, whom he began to imitate in the late 1940s. Throughout his career, however, he continued to revive Dong Qichang's style.

Chang Dai-chien collected paintings by Dong Qichang, Dong Yuan, and Juran. During the summer of 1953 Chang painted another version of *Summer Trees Casting Shade* (collection unknown), which he acknowledged followed the brushwork of Dong Yuan. The composition is similar to Chang's 1949 version; but where the earlier composition is reductionist, the later is fuller and more detailed.

The practice of simultaneously following both the tenth-century masters and Dong Qichang's synthesis based on their manner led Chang Dai-chien to develop coherent compositions from abstract, almost flat geometric units, which he animated with rhythmic brushwork. While Dong Qichang's landscapes sometimes seem to be disjointed elements held together by sheer intellectual understanding of abstract form, Chang Dai-chien painted with greater sensitivity to descriptive function. Ultimately, his interest in geometric forms to define a landscape had percussive waves that reverberate in his works of the 1950s and foreshadow the abstraction of his splashed-ink-and-color landscapes.

1. See Shen C. Y. Fu, "Shenyang de Dai-chien hua," in *Liaohai wenwu xuekan* 7 (May 1989): 369–405.

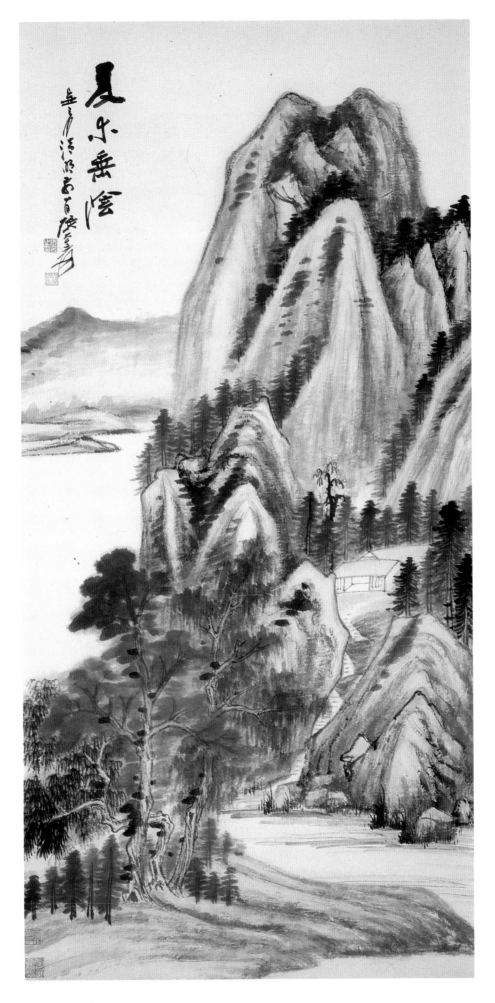

Summer Trees Casting Shade

March 29–April 27, 1949
Hanging scroll; ink and color on paper
85.7 x 34.3 cm (33³/₄ x 13¹/₂ in.)
Inscription and signature:
 Suddenly drawing the clear notes
 of autumn from phoenix-tree leaves,
 A cold wind blows in his sleeves,
 moving him to hum a little song.
 Routinely, as if carving insects,
 he selects these lines of verse;
 Heading home, the jade-hook moon
 descends through western blinds.

 Done in the third lunar month of the *jichou* year; Dafeng Tang, Dai-chien jushi Yuan.
 SDA
Collection of Mr. and Mrs. Lee Chen-Hua, Westbury, New York

THE TITLE of this work describes a scholar searching for poetic inspiration while contemplating a vase of lotus blossoms. The viewer is invited to sympathize with the scholar, who sits with his arms crossed on the table, brush and paper before him, temporarily unable to compose his thoughts. By rendering the scene close up with the phoenix tree extending beyond the picture frame, Chang brought the scholar into the viewer's immediate world.

The droll scholar in *Seeking the Perfect Phrase* has an elongated face, bulbous nose, and large ears. He seems ungainly because his legs are too short. And yet Chang's great artistry transformed these awkward features into a figure who does not seem inelegant. Also, details like the rugged stone table paired with a chair made of gnarled roots convey a cultivated rustic quality.

The roughhewn furniture is set off by an impressive antique bronze vase. Behind the vase is a bell-shaped inkstone, a shape called "wind stone" in Chinese because the form resembles the character *feng* ("wind"). Such inkstones were traditionally prized by scholars, who artfully chose the accouterments for their desks. The refined floral arrangement of lotus blossoms and leaves balanced with tiny blooms conveys a cultured ambience.

Chang Dai-chien painted the figure and foreground elements with a small, sharp-tipped brush, controlling the pressure to make the lines smooth and even. The traditional appellations of "floating silk filaments" and "iron wire" characterize these light, tensile brush strokes. For the phoenix tree and bamboo, Chang employed a contrasting technique of swift brush movements from the repertoire of spontaneous *xieyi* painting. Using a relatively large brush loaded with wet, dark ink, Chang painted the tree leaves quickly, not waiting for one stroke to dry before adding the next. While the ink was still damp, he colored the leaves with indigo wash. The effect of the pooled ink and color is a shady, inviting tree. The sharp leaves of the bamboo required slightly more precision, and here Chang's work resembles the quick, gestural strokes of calligraphy.

The main colors in *Seeking the Perfect Phrase* are soft: pale ocher, white, and indigo. But Chang Dai-chien, especially after his study of Tang dynasty art at the Dunhuang caves, liked to use bright pigments, at least as accents. Brilliant green lotus leaves, a red lacquer tray beneath the vase, and red shoes provide such decoration. Chang painted the upper part of the scholar's robe, as well as the root chair and stone table, in ocher, visually linking the scholar and his rarefied environment.

Chang's inscription complements the painting and emphasizes the meticulous skill that crafting a poem requires. He likened seeking the perfect phrase to the delicate work of carving a tiny insect.

Chang's inscription does not hint at a stylistic model, and that is unusual. The figure is strikingly unlike the handsome literati he usually painted; thus, Chang probably had a specific model in mind. He may have felt that his source was too obvious to need mentioning. The "iron-wire" brushwork and Chang's treatment of the scholar, the root chair, and the lotus derive from the individualist painter Chen Hongshou (1598–1652). A similar painting bearing Chen Hongshou's signature may well have been Chang's model (fig. 90). In this work, entitled *Artist at Work*, the scholar contemplates a vase of chrysanthemums as he strokes his beard.

Chang Dai-chien painted several similar versions of *Seeking the Perfect Phrase;* on one of these, his inscription directly mentions Chen Hongshou. A version in Hugh Moss's collection in Hong Kong was painted when Chang was in Japan in late summer 1953; another, known only through publication, dates to summer 1949. In that composition Chang substituted a Lake Tai rock for the bamboo; he also changed the style of the phoenix tree to "outline and color fill-in" instead of using wet pools of ink and color. The figures in all three versions are almost identical except that the scholars in the two later paintings wear a cap, as does the figure in Chen Hongshou's original. Chang used the same poem on all three paintings, but on the version from summer 1949, he also noted:

The method Laolian [Chen Hongshou] used to make outline strokes and his sense of composition derived from stone engravings of the Six Dynasties period; his application of color, however, did not reach beyond the rules followed by the painters of the Song and Yuan dynasties.

Because of his preference for vibrant Tang dynasty color

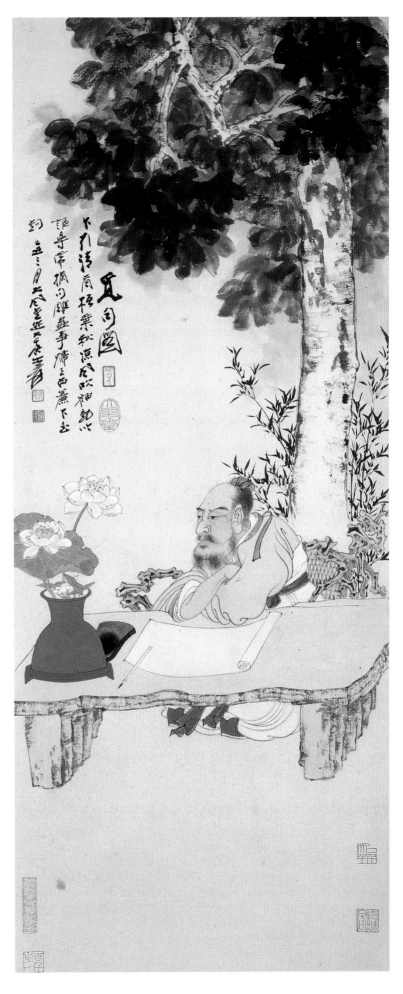

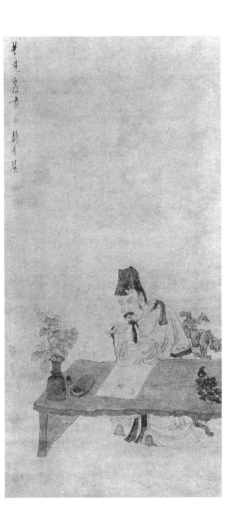

Fig. 90. Chen Hongshou, *Artist at Work.*
Hanging scroll; ink on paper; collection of
Mu-fei, Britain. From Cheng Te-k'un,
"Twenty Ming *yimin* Painters in the Mu-fei
Collection," *Journal of the Institute of Chi-
nese Studies of the Chinese University of
Hong Kong,* 8.2 (December 1976): pl. 9.

Seeking the Perfect Phrase

schemes—which he perfected during his Dunhuang sojourn— Chang disparaged what he saw as Chen Hongshou's timid coloring. Nevertheless, Chang avidly admired Chen. As early as 1934 Chang's enthusiasm was apparent in some painting inscriptions, which revealed that Chang looked to Chen as a model for controlled brushwork in the *gongbi* manner. When Chang first went to Peking, he was criticized for his heavy reliance on the bold *xieyi* style in painting bird-and-flower works, and he responded by sharpening his skill at meticulous *gongbi* brushwork. In addition, his friend Ye Gongchuo (1880–1968), a calligrapher, bamboo painter, and collector who had lived in the Wangshi Yuan in Suzhou in the 1930s at the same time as Chang, suggested he refine his skill in figure painting. Seeking an appropriate model for both bird-and-flower and figure painting, Chang chose the archaistic, hyper-refined style of Chen Hongshou, which in spite of antique mannerisms, related to the Ming and Qing dynasty styles Chang had already perfected.

At the same time that Chang Dai-chien began to study Chen Hongshou, he started to collect Chen's paintings. In 1937 he purchased *Lotus Flowers* from the Tianjin collector Fan Zhuzhai. By the time Chang left Peking in 1938, he had an amazing collection of some twenty-four paintings by Chen Hongshou, which he listed in the 1943 catalogue of the Dafeng Tang collection.

Among Chang's first creations to reflect his interest in Chen Hongshou is a close copy of Chen's *Two Lofty Scholars*. Chang's copy (Jilin Provincial Museum) dates to spring 1940 and bears the following inscription:

> Laolian's painting was derived from *Portraits of Emperors through the Ages* by Yan Liben [ca. 600–674], [the style of which] was founded during the Six Dynasties period and so does not show a trace of Song or Yuan painting. . . . This painting is nothing that Ren Weichang [Ren Xiong; ca. 1820–1857] or his generation could have even dreamt about. There is no one in the world now who can appreciate its tone, so they take me to be a stupid fool. Thus I throw down my brush and heave three sighs.

Chang continued to regard Chen Hongshou highly, and in summer 1950, he copied another of Chen's paintings of a lofty scholar. On this work, Chang wrote:

> Lofty, ancient, and elegant, [this style] washes away the sweet insipidness of Yuan and Ming dynasty paintings, but some people fault it for its strange awkwardness. Those who have seen little think that it is peculiar.[1]

In 1950 Chang wrote a colophon on Chen Hongshou's *A Meeting Between Kongming and Yuanming* (collection unknown), elaborating on Chen's technique.

The colors are wet washes and return to the style of Song dynasty painting. There is not even one trace of Qiu's [Ying; ca. 1494–1552] or Tang's [Yin; 1470–1524] brush habits.

Chang's strong avowal of Chen Hongshou demonstrates that by early 1940 he had completely rejected the twentieth-century Shanghai School, which had influenced his earliest work (see entry 3). During the 1940s Chen was Chang's model for studying past art, and by the 1950s Chang had rejected the Ming artists in direct emulation of Chen.

Yet in spite of his admiration for Chen, Chang Dai-chien was still sensitive to contemporary views that Chen was too eccentric. Although Chang refuted this claim, he usually eschewed Chen's mannered archaism and peculiar wit to please a wider audience. Even more important was Chang's belief in a golden mean, which dictated that painting should be neither sweet nor eccentric. Thus, although he had mastered Chen Hongshou's style, Chang painted few works that relate so directly to Chen as *Seeking the Perfect Phrase*.

1. *Chang Dai-chien shuhua*, ed. Guo Wei, vol. 1 (Taipei: Zhonghua shuju, 1972), pl. 13.

35 Blue Peony

March 29–April 27, 1949
Folding fan; ink and color on gold paper
34.3 x 49.7 cm (13^1/$_2$ x 19^5/$_8$ in.)
Inscriptions and signatures:

Front

Twenty years ago, in Qiangcun's [Zhu Guwei] studio, I once saw Daojun Huangdi's [Emperor Song Huizong] Buddha-head blue peony, which I have imitated from memory. Third lunar month of the *jichou* year; Chang Yuan from Shujun [Sichuan Province].

Back

[Chang Dai-chien inscribed a poem by Wu Wenying (ca. 1200–ca. 1260) of the Southern Song dynasty, written on the subject of the peony and composed to the song title, *Hangong chun*, "Spring in the Palace of Han."]

Written casually on the eleventh day of the fourth lunar month of the *jichou* year [May 8, 1949]; Dai-chien jushi Yuan.
SDA
Collection of Paul Chang, Pebble Beach, California

IN CHINA the tree peony (*Paeonia suffruticosa*) is called the King of Flowers and is a symbol of riches and honor. During the Tang dynasty, this late spring blossom was considered a "national treasure," which was avidly cultivated for its showy form and vibrant colors. Since that time Chinese artists have made the peony, with its jade leaves and luxuriant layers of soft, fluted petals, one of the most popular botanical motifs. It is an irresistible subject, as it is both decorative and bears wishes for good fortune. Like his predecessors and contemporaries, Chang Dai-chien adored the peony. He often painted the blossom meticulously, but *Blue Peony* stands out as one of his most sumptuous peony paintings.

Chang Dai-chien was an amateur horticulturalist, and his flower paintings reflect his specialized knowledge. His tree peonies, for example, are carefully distinguished from his portrayals of herbaceous peonies (*Paeonia arborea* or *Paeonia lactiflora*). Chang used different techniques for the two types of peonies. Comparing the two, he explained in an inscription on a peony painting of about 1960 that the herbaceous peonies have a "more tender, feminine appeal, which requires elegant, curved lines," while tree peonies have weightier, fuller blossoms. Chang painted the two types of peonies equally often, although the tree peony is traditionally more common in Chinese art.

Whenever Chang Dai-chien traveled, he sought out spectacular displays of flowers. On his way to study the Buddhist caves at Dunhuang in 1941 and on his return trip in 1943, he passed through Lanzhou, where he saw a stunning array of peonies in a temple garden. The memory stayed with him, as an inscription on a peony painting from fall 1949 shows.

> The Ruitan Daoist Temple in Gaolan [Lanzhou] had hundreds of tree peonies—all famous kinds—but the finest among them was a peony [the color of] splashed ink and purple. In late spring and early summer, thousands of flowers danced [in the breeze] and competed with each other in beauty. In the soft light at daybreak, while the dew was still moist on the blossoms, the rich and sophisticated charm of the peonies attracted ladies and gentlemen who came by noble steed and in perfumed carriages like waves of passing clouds. They were astonished and lingered until after sunset appreciating the sight.

Observing peony season was an annual ritual for Chang Dai-chien, and even after he expatriated from China in late 1949 he continued the custom. He went to Japan each year to see the plum blossoms and then stayed through the flowering of the tree peonies. Afterward, he often traveled to Paris to catch the herbaceous peonies in their season of full bloom.

No matter how familiar Chang was with the actual subjects of his painting—flowers, birds, or landscape sites—his art

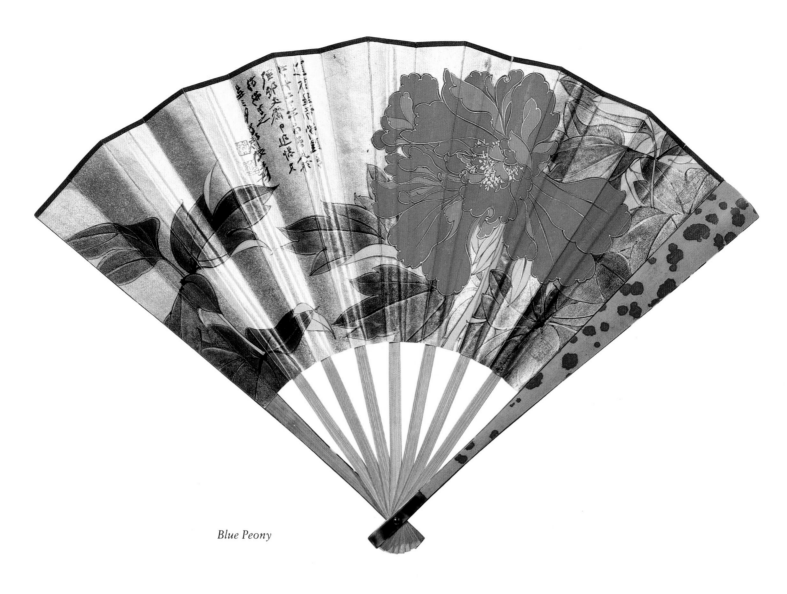

Blue Peony

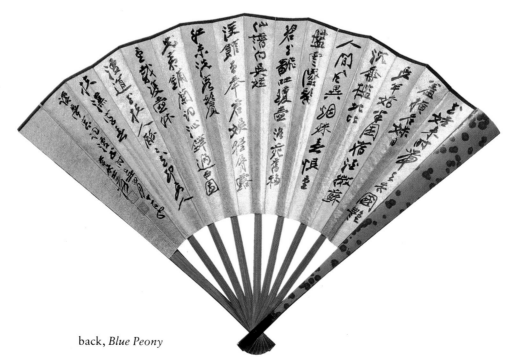

back, *Blue Peony*

was only partially shaped by actual observation, for he also relied on the precedents of ancient artists. In his early career he imitated the peonies of Chen Shun (1483–1544) and Xu Wei (1521–1593), using wet, loose brush strokes and rich ink. Around 1945 he tried another technique, with lush, heavy color and delicate brushwork. In the 1950s, especially as his eyesight began deteriorating, he changed techniques again, this time favoring soft color washes applied in the boneless (*mogu*) method that eschews outlines. The shift from the dazzling, heavy color of *Blue Peony* to the softer, charming *mogu* technique required command of an unusually broad range of methods.

Chang Dai-chien's friend Gao Lingmei, who recorded Chang's verbal lessons on painting, included this statement: "In the detailed *gongbi* style of painting flowers, tree peonies should be taken as a representative example. There are numerous types of peonies and the three [colors] that I most love to paint are palace crimson, inky purple, and Buddha-head blue."[1] "Buddha-head blue" refers to the ancient tradition of using azurite for the hair of the Buddha.

Blue flowers are rare, so a peony this color was especially attractive to Chang Dai-chien, as he mentioned in several different painting inscriptions. In late 1944 Chang wrote:

Tang dynasty artists painted tree peonies in the dazzling gold-and-green [technique] which were as radiant as the multicolored clouds [of dawn]. Previously when I was in the Shanghai studio of my elder friend Wang Xuechen, I saw a painting by Diao Guangyin [ca. 855–935] that depicted peonies in five different colors. In Old Man Qiangcun's [Zhu Guwei] studio I saw Daojun Huangdi's [Emperor Song Huizong; r. 1100–1125] Buddha-head blue peony. Both of these works imitate Tang painting. *Xieyi* painting, which has been in fashion since the Yuan and Ming dynasties, is elegant and charming but incapable of capturing the luxurious grace and brilliance due the sumptuous lady [the peony].[2]

The inscription reveals Chang's preference for the antiquated and sumptuous style of Tang dynasty painting as revived by Emperor Song Huizong, and this style was his model for *Blue Peony*.

Chang explained the formula for painting a work like *Blue Peony* in 1961: "To paint this type of image requires much patience; it is not something you can complete hurriedly or casually."[3] Preparing the mineral blue color and binding it with glue are specialized, time-consuming tasks. Skill and patience are required in applying multiple layers of pigment to create a color with the depth of beautifully dyed plush velvet. For *Blue Peony* Chang prepared the blue from powdered azurite and applied layers of it to form the body of each petal. Next, with a different shade of blue, he indicated the back sides of the windblown petals. As a final step, he outlined the petals in gold. When he finished the flower, Chang painted the leaves in ink and used touches of mineral green to represent their curled edges; he carefully avoided competition between the richness of the blossom and that of the leaves.

The mottled effect of gold dust on the fan paper around the flower and gold shining through the translucent ink wash of the leaves makes this painting especially lush. Chang was inventive in combining the flower, painted in heavy opaque colors, with leaves rendered in soft ink wash. His multiple techniques for painting a single flower make it appear alive, responding to daylight and wind.

Chang Dai-chien was partial to the folding fan format both for the challenge its shape presented to an artist and for the market appeal of fans. He occasionally held special exhibitions devoted to fan paintings, and he prepared *Blue Peony* for one of them. Before air conditioning became widely available, men in China kept cool with folding fans, while women more commonly used round fans. A fan by Chang Dai-chien had the distinction of being both beautiful and practical.

1. Gao Lingmei, ed., *Chang Dai-chien hua* (Hong Kong: Dongfang yishu gongsi, 1961), 30.

2. Li Yongqiao, *Chang Dai-chien nianpu* (Chengdu: Sichuan sheng shehui kexueyuan chubanshe, 1987), 199.

3. Gao Lingmei, ed., *Chang Dai-chien hua*, 30.

36 Blue-and-Green Landscape

April 28–May 27, 1949
Folding fan; ink and color on gold paper
47 x 77.6 cm (18½ x 30⅝ in.)
Inscriptions and signatures:

Front

Early summer of the *jichou* year, I followed the method of the Song dynasty artists; Chang Dai-chien Yuan, from Shujun [Sichuan Province].

Back

As geese arrive from the border,
I stand with hands behind my back
On this precipice in the autumn sky;
Four thousand miles away,
The high and lofty Throne star
Can be reached in a breath.
Below my feet, the rivers
 and hills dissolve into nothing,
Before my eyes the months
 and years fly quickly as a hawk.
I ask the drifting clouds
 where Chang'an might be found;
The western wind is swift.

Joy and sorrow grow
Acute in middle age,
Success and failure
Are close to us all;
Everywhere they wear ailanthus,
My feelings spill out in fine detail:
The fighting up in Jibei just
 adds to the wailing of ghosts,
And makes me think of
 my children off in the south.
Slowly growing large,
Evening clouds rise to my robes;
Dragon Pool is black.

[To the song title:] *Man jiang hong* ["Red Fills the River"]

Composed to show my fellow hikers on the ninth day [of the ninth lunar month] of the *yihai* year [1935] while climbing the precipitous summit of Mount Taihua [in Shaanxi], and casually written out one time in the third lunar month of the *jichou* year [March 29–April 27, 1949]; Chang Yuan Dai-chien fu from Shu [Sichuan Province].
SDA

Collection of Paul Chang, Pebble Beach, California

CHANG DAI-CHIEN planned to exhibit this fan at the same time as *Blue Peony* (entry 35), and he painted it one month later. The fans are similar in size, and both have frames of mottled bamboo. The landscape has more fan ribs and therefore more pleats across the surface, and while the peony was painted on paper densely treated with gold leaf, the landscape has a less ornate surface. The slick gold background in both made the paper difficult to paint.

Chang Dai-chien's terse inscription on *Blue-and-Green Landscape* does not mention any sources, but he must have been inspired by the rushing waterfalls and deep valleys of Li Cheng (919–967) and Guo Xi (ca. 1001–ca. 1090). Chang's skill is in his transformation of their monumental scenes into the small format of a fan. Stately pines command the right foreground. To the left a scholar and a servant cross a plank bridge to reach a thatched kiosk, from which they will survey the foaming waterfall. The mountain summit reaches beyond the top of the picture. At the mountain's foot an elegant pavilion surrounded by lush bamboo offers a concrete symbol of the dream of lofty reclusion.

The predominant colors in the painting are an opulent green and gold, their richness balanced by the simple warm brown of the tree trunks and buildings. Chang applied the malachite pigment thickly, except for a few spots of land, where the gold flecks look like sunlight on the grass. Sky, water, and bands of mist are all gold. The great Song dynasty masters of blue-and-green painting outlined their images in gold, but Chang's brushwork and color are so refined that the viewer does not notice the absence of gold outlines. Although decorative in the manner of Song dynasty court painting, the fan is restrained enough to appeal to the literati.

A month before he painted *Blue-and-Green Landscape*, Chang Dai-chien transcribed the poem on the back of the fan, which was a reversal of his usual sequence. The text recalls a fond memory of Chang's from 1935 when he climbed Mount Hua with a group of friends and wrote a poem for them. Whether the mountain in *Blue-and-Green Landscape* represents Mount Hua is unclear, since Chang did not include identifying features. The quiet resolve of the strolling scholar, however, fits the mood of the Double Nine Festival. During this festival, which falls on the ninth day of the ninth lunar month, scholars traditionally climb to a great height, where they stop to compose poetry and contemplate the past.

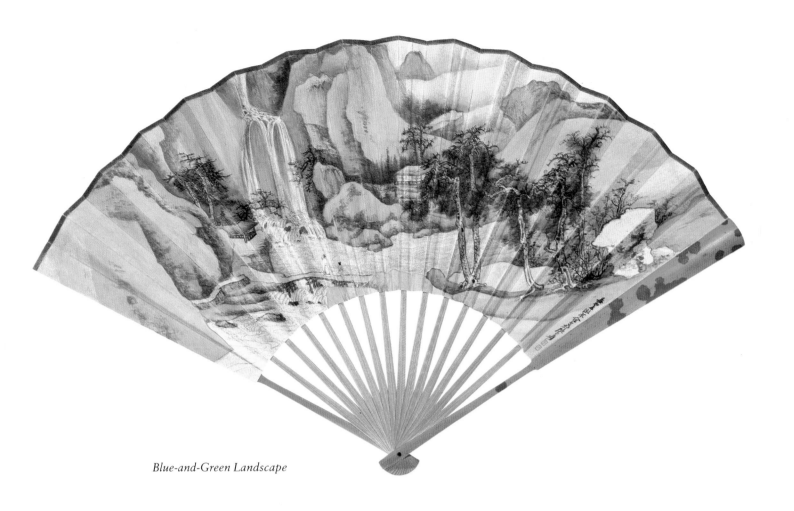

Blue-and-Green Landscape

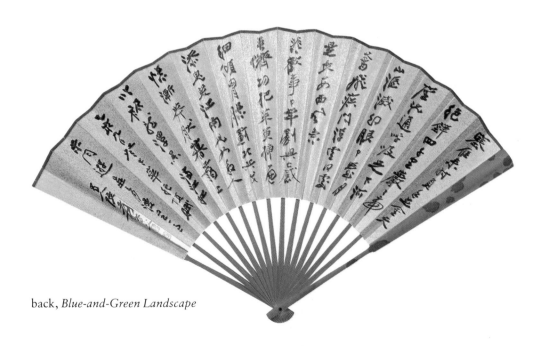

back, *Blue-and-Green Landscape*

37 Quiet Autumn on a Sichuan River

August 24–September 21, 1949
Hanging scroll; ink and color on paper
133 x 72 cm (52³/₈ x 28³/₈ in.)
Inscriptions and signatures:

A
In a biography of the painter Huang Quan, I happened to read of his handscroll called *Quiet Autumn on a Sichuan River*. Since I'm just about to leave Sichuan Province to journey south, I have taken up my brush to paint a version of it and inscribe it with this short poem:
 An empty boat lies along the sandy shoals,
 White rocks grow cold upon the level bluffs;
 Recently, the autumn flood's so very high,
 I've begun to think of going down the river.
Intercalary seventh lunar month of the *jichou* year; Dai-chien jushi Yuan at the Shuiniu [studio] in the western suburbs of Chengdu.
SDA

B
In the twelfth lunar month of the *xinchou* year [January 6–February 4, 1962], I presented this to my grandson Ni [Chang Wei-hsien]; Old Man Yuan.

Collection of Chang Wei-hsien, Los Angeles, California

CHANG DAI-CHIEN rarely painted this type of a limitless view of rivers and mountains. His more typical landscapes have a strong vertical axis. *Quiet Autumn on a Sichuan River,* however, has no towering peak; instead, the viewer follows a waterway meandering through soft hillocks toward the horizon. Boats on the river sail to little villages in the distance. Two scholars stand on an embankment near their thatched-roof residence, viewing the river. As in the ideal scholar's garden, bamboo surrounds the pavilion.

In inscription A, Chang Dai-chien mentions Huang Quan (903–965), a native of Chengdu, who was most famous for his bird-and-flower paintings but also excelled at landscapes. The Song dynasty imperial painting catalogue *Xuanhe huapu* listed him as a follower of Li Sheng (act. 908–925), the leading Sichuanese landscape painter. Reputedly Huang Quan used the boneless *mogu* technique (in which the artist builds forms using color washes and no outlines) for both landscape and bird-and-flower painting, although little of his work remains.

The Ming dynasty catalogue *Baohui lu* by Zhang Taijie records a painting entitled *Quiet Autumn on a Sichuan River* attributed to Huang Quan. The same attribution appeared as recently as 1928 in the catalogue *Sanchiu Ge shuhua lu* by Guan Mianjun; perhaps one of these catalogues contained the "biography" Chang mentioned reading in his inscription. The more recent catalogue recorded that Huang Gongwang (1269–1354) had written the following colophon on Huang Quan's painting.

The arrangement of the elements is pure and vast; the scenic motifs are laid out sparsely; some are partially hidden while others totally clear. There is a boundary and yet [the scene] is limitless, the rivers and sky cover ten thousand *li* and all on a few feet of silk.

Neither Zhang Taijie nor Guan Mianjun was entirely accurate in making attributions, and there is no way of knowing even if Huang Gongwang's colophon is genuine. The legitimacy of the painting is not at issue, however, since Chang Dai-chien worked from a literary account to copy the spirit of the painting. Chang's spatially expansive image recalls Huang Gongwang's description of Huang Quan.

The style of Chang's *Quiet Autumn* was influenced by the landscapes he had seen in the Tang dynasty murals at Dunhuang, Gansu Province, in the early 1940s. An eighth-century mural in Cave 172, depicting the story of Queen Vaidehi meditating upon the rising sun (fig. 91), has a landscape setting strikingly similar to that in *Quiet Autumn*. Both compositions rely on the device of a winding river to lead the viewer's eye toward a distant horizon, and both render large expanses of level ground and small hummocks in a washy technique with minimal texture strokes. *Quiet Autumn* is clear evidence of Chang's tendency during the mid- and late 1940s to incorporate features from Dunhuang in his painting.

When Chang arrived at Dunhuang in autumn 1941, he painted *Rivers and Mountains Without End,* a narrow hanging scroll on which he inscribed: "An autumn day in the *xinsi* year [1941] copying the Tang dynasty murals at the stone caves at Dunhuang; Chang Yuan." The landscape techniques of *Quiet Autumn* are derived from this painting he completed while at Dunhuang, while the brushwork incorporates hints of Song and Yuan dynasty art. In particular, the ink-dot texture strokes reflect post–Tang dynasty painting.

Quiet Autumn is one of the last paintings Chang Dai-chien completed before he expatriated. Although China was torn by war, Chang found the peace to paint *Quiet Autumn,* which has soft blue-and-green coloring and a relaxed, inviting mood. Only months later Chang was forced to flee from his country before the communists closed the borders.

An anonymous painter has paid Chang the compliment of forging *Quiet Autumn*. The counterfeit was mistakenly published as if it were Chang's original in *Chang Dai-chien yizuo xuan*.[1] Although the composition is the same, the execution is inferior. But the publisher was unaware of the original, which Chang Dai-chien had decided in 1962 to dedicate as a gift to his grandson Chang Wei-hsien, son of Paul Chang and his wife Li Xieke.

1. *Chang Dai-chien yizuo xuan* (Chengdu: Sichuan meishu chubanshe, 1985), 6.

Fig. 91. Detail of mural in Cave 172 at Dunhuang, Tang dynasty. From Anil de Silva, photography by Dominique Darbois, *The Art of Chinese Landscape Painting in the Caves of Tun-huang* (New York: Crown Publishers, 1964), 171.

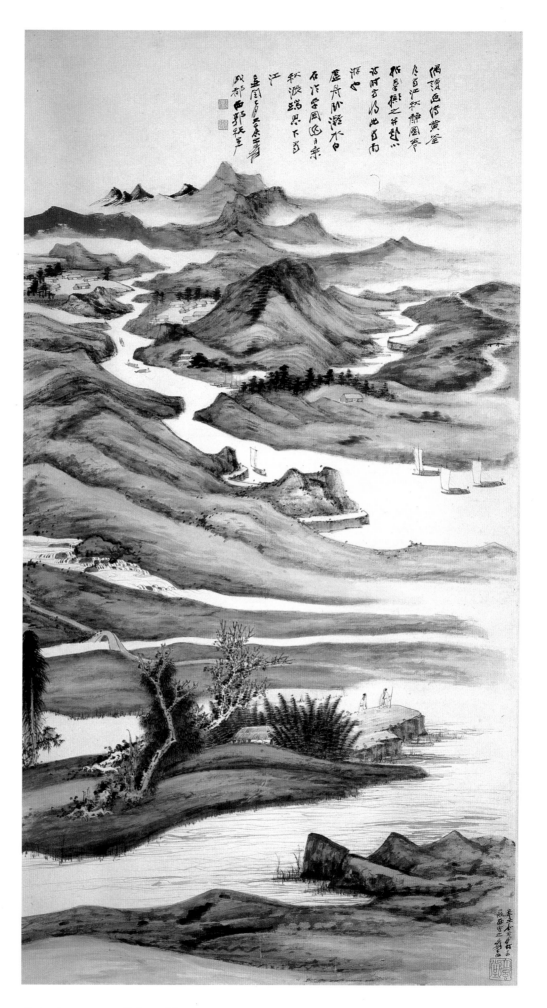

Quiet Autumn on a Sichuan River

August 24–September 21, 1949
Hanging scroll; ink and color on paper
163.3 x 51.5 cm (64¼ x 20¼ in.)
Inscription and signature:

> Solid green, the crags and cliffs
> reach right up to my study desk;
> I know these tall trees of bright
> blossoms come from sacred roots.
> As I climb the mountain, my lofty
> thoughts grow as warm as clouds;
> Smiling faintly in the quiet hall
> where traces of my dream remain.

Intercalary seventh lunar month of the *jichou* year; painted and inscribed by Dafeng Tang, Chang Yuan Dai-chien fu.
 SDA

Collection of Jiu-Hwa Lo Upshur, Ypsilanti, Michigan

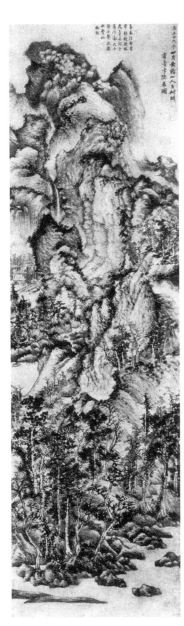

Fig. 92. Wang Meng, *Dwelling in the Qingbian Mountains*, 1366. Hanging scroll; ink on paper; Shanghai Museum. From Xu Bangda, *Zhongguo huihua shi tulu*, vol. 1 (Shanghai: Shanghai renmin meishu chubanshe, 1984), pl. 236.

ACCORDING TO the influential painter and critic Dong Qichang (1555–1636), the most marvelous painting under heaven by Wang Meng (ca. 1308–1385) was *Dwelling in the Qingbian Mountains* (fig. 92). The young Chang Dai-chien saw the famous Wang Meng scroll in 1919, soon after he began studying calligraphy in Shanghai. His teachers Zeng Xi (1861–1930) and Li Ruiqing (1867–1920) took him to visit the private collector Di Baoxian (1872–ca. 1940s), who owned *Dwelling in the Qingbian Mountains*. At Di's home, they perused more than a hundred paintings from the Song to Qing dynasties, but *Dwelling in the Qingbian Mountains* made the strongest impression on Chang. Twenty years later he was still haunted by it, even after building his own impressive collection of paintings by Wang Meng. Chang never owned *Dwelling in the Qingbian Mountains* and apparently never made a close copy of it, although some of his contemporaries did. Yet Chang's own *Dwelling in the Qingbian Mountains* was clearly inspired by the famous original.

Recognizing the brilliance of Wang Meng's luxuriant, dense brushwork, Chang devoted considerable effort to studying and copying him, especially during the later half of the 1940s. At least twice in 1946 Chang copied *Elegant Gathering by a Mountain Stream* (entry 28), which Wang painted in 1367. In 1947 Chang imitated three other paintings by Wang, including *Living in the Mountains on a Summer Day* (Palace Museum, Peking). Unlike those paintings, *Dwelling in the Qingbian Mountains* was never intended to be a close copy, and Chang did not mention Wang Meng in his inscription. In fact, unless the viewer is familiar with Wang Meng's work, the connection may not be apparent. Chang had so thoroughly internalized aspects of Wang's manner that he creatively reinterpreted the original masterpiece.

Chang used Wang's schema of a tall, narrow format with a mountain thrusting toward the upper left. But while Wang's peak twists and pitches, as if constantly reshaped by pressures deep inside the earth, Chang's peak is sedate, with fewer "alum-head" (*fantou*) rocks and more small trees. And where Wang perched a scholar's retreat precariously close to the left edge, surrounded by surging mountain forms, Chang tucked his scholar's retreat into gentle mountain folds in the center of the painting. The Yuan dynasty artist painted only in ink, while Chang added warm, inviting colors of autumnal red, light green, and ocher.

Wang Meng lived in a turbulent era, and his *Dwelling in the Qingbian Mountains* depicts the isolated refuge of a relative of his who sought to escape the collapsing dynasty. Although 1949 was no doubt equally chaotic, Chang chose to celebrate the serenity of a mountain retreat. Perhaps he reflected his own withdrawal into the Sichuan mountains, where he found peace enough to continue painting despite the civil war.

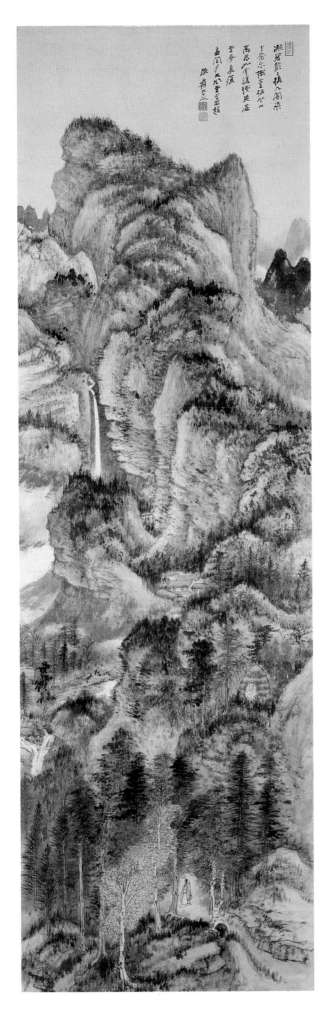

Dwelling in the Qingbian Mountains

Chang also diverged from Wang's original in the lower half of his painting. He eliminated the opening passage of water and rocks in the immediate foreground, thus bringing the mountain closer. He also reduced the number of foreground trees but painted them with such luxuriant foliage that they give the same impression as Wang's virgin stand.

On the right of his painting, about a third of the way up, Chang placed a beehive-shaped thatched hut that was not in Wang's original. This motif is not common in Chinese painting. It derives from the shape of Buddhist meditation huts and is found mostly in compositions that reflect a meditative mood or depict the theme of a lofty hermit called from reclusion to serve at court. In such works the hut symbolizes the reflective nature of its occupant. A beehive-shaped hut also appears in Wang Meng's *Retreat in the Yayi Mountains* (Shanghai Museum), which Chang creatively reinterpreted in 1954 (see entry 49). Part of Chang's genius lay in his ability to absorb elements from many sources and graft them into a unified composition.

The brushwork is also a hybrid. When Chang painted *Dwelling in the Qingbian Mountains,* he was avidly studying Dong Yuan (act. 937–976) and Juran (act. 960–980), and his texture strokes reflect their influence more than Wang Meng's. The foreground trees seem closest to the style of Gong Xian (ca. 1619–ca. 1689) several centuries later.

Dwelling in the Qingbian Mountains was one of the last paintings Chang finished in China before fleeing from communist rule at the end of 1949. He took this scroll with him to India, where, partially through the help of China's ambassador, Lo Chia-luen (1897–1969), Chang was invited to hold an art exhibition. Since Ambassador Lo was a well-known scholar-collector, Chang presented *Dwelling in the Qingbian Mountains* to him, calling it at that time simply *Autumn Mountains.* In a letter of thanks, Lo praised the painting's vigor and elegance and its deep resonance of Wang Meng's *Dwelling in the Qingbian Mountains.* Lo also composed a poem in honor of the painting and in admiration for the symbolic power Chang's example held for the Chinese compatriots who, like himself, had fled the communist regime.

On December 30, 1949, India formally recognized the communist regime of the People's Republic of China, so the Taiwan-based government of the Republic of China severed its relationship with India and recalled Lo Chia-luen. Chang Dai-chien eventually left India because of this change in government policy. Lo took Chang's painting back to Taiwan and willed it to his daughter. The sedate retreat of the scholar depicted in Chang's *Dwelling in the Qingbian Mountains* continues to please art lovers even though—or perhaps because—it portrays an imagined tranquillity.

39 Lodge of the Immortals at Huayang

October 31, 1949
Hanging scroll; ink and color on paper
148 x 71 cm (58¼ x 28 in.)
Inscription and signature:

> I once acquired a copy that Zhao Wendu [Zhao Zuo] made of the painting *Lodge of the Immortals at Huayang* by Beiyuan [Dong Yuan]. Zhao's brushwork is pure and moist, but lacks the grand refinement [of Dong Yuan]. Beiyuan has a style of monumental painting that is elegant and lively, not easy to master. Only after I acquired *Scene along the Riverbank at Dusk* and *Views of the Xiao and Xiang Rivers* [both by Dong Yuan] was I able to comprehend his brushwork, and so I made this painting. The day after the Double Nine Festival [an occasion for mountain excursions and picnics] in the *jichou* year; painted and inscribed by Chang Yuan.
> JS and SDA

Collection of Chang Hsu Wen-po, Taipei

Chang Dai-chien's inscription on *Lodge of the Immortals at Huayang* provides crucial information. Not only did he describe those qualities he most admired in the art of Dong Yuan (act. 937–976), but he explained that the ancient composition had been preserved through the intermediary of Zhao Zuo (1573–1644), Dong Yuan's original having disappeared long ago. Huayang Lodge was the retreat of the famous Daoist thinker and alchemist, Tao Hongjing (452–536). It was located on Mount Mao in Jiangsu Province. Chang's painting is a traditional landscape, with a conventional scholar's mountain villa and a temple in the distance and no iconography that relates to Tao. Yet *Lodge of the Immortals* has an antique appeal and is one of Chang's most successful revivals of tenth-century style.

During the mid-1940s Chang Dai-chien had the great fortune to acquire *Scene along the Riverbank at Dusk* (National Palace Museum, Taipei) and *Views of the Xiao and Xiang Rivers* (Palace Museum, Peking), which he accepted as genuine paintings by Dong Yuan. Today most art historians do not endorse their authenticity but concede that the paintings are nonetheless important early copies of the master. Chang's inscription reveals that only after he had acquired these works could he truly understand Dong Yuan. Chang's study of these paintings made him critical of the Ming and Qing followers of Dong Yuan, such as Zhao Zuo, whose pithy brushwork, Chang believed, lacked the vigor and elegance of the master. Chang therefore tried to escape the influence of these Ming dynasty painters, whom he felt had adulterated Dong Yuan's art, and to strive instead to reach directly back to Dong, who embodied the golden mean between raw strength and controlled elegance that was Chang's ideal. Chang believed art should display one's personal zest for life but that vitality was not to be achieved through wildness.

After Chang Dai-chien painted *Lodge of the Immortals* he was satisfied that he had successfully captured the elusive strength of Dong Yuan, thus surpassing Zhao Zuo. Indeed, Chang's supple, modest brush strokes that texture the soft folds of the earthen hills do avoid the conventional exaggerations of Ming dynasty brushwork. Chang developed a mode of brushwork that came closer than most Ming artists to imitating Dong's balance of realistic description and calligraphic rhythm. Chang's soft blue-and-green coloring, with crimson and azure trees, also predates the Ming dynasty.

None of Zhao Zuo's known paintings fit Chang's *Lodge of the Immortals* to the extent that they could have been his model, but an anonymous late Ming dynasty copy of Dong Yuan's *Summer Mountain before Rain* (fig. 93) represents the type of painting Zhao likely produced. A comparison of this work with Chang's *Lodge of the Immortals* reveals that Chang's models for his meticulously drawn architecture, fine net-patterned waves, and concern for descriptive detail and lyrical coloring predate Ming styles. In *Lodge of the Immortals,* Chang Dai-chien challenged himself to revive the distant past, and he believed that in this work he became the equal of Dong Yuan.

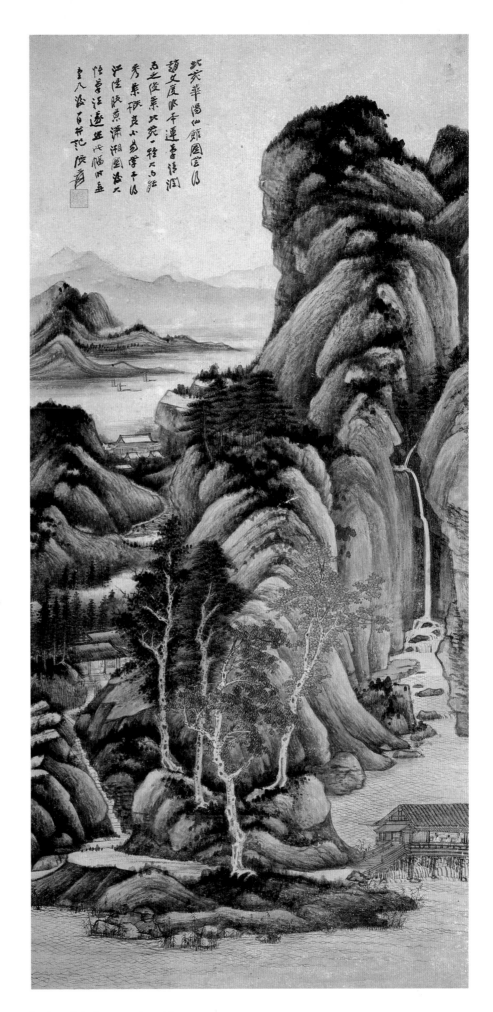

北苑華陽潝仙館圖茲乃
趙文度晚年運筆清潤
蒼老徑集北苑一種不乃謹
秀紫瑛良小為學干仿
江陸嚴烹瀟湘圖淡大
陸學汪遠並此幅附至
皇人淦百年陀張春

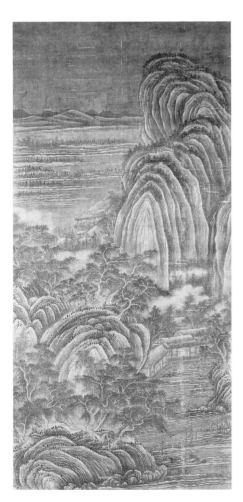

Fig. 93. Attributed to Dong Yuan, *Summer Mountain before Rain*. Hanging scroll; ink and color on silk; National Palace Museum, Taiwan, Republic of China.

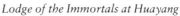

Lodge of the Immortals at Huayang

40 Dancer in the Style of the Ajanta Caves

ca. February 1950
Hanging scroll; ink and color on paper
93 x 43 cm (36⅝ x 17 in.)
Title and signature on outside wrapper:
 Ajanta Cave 1, Dancing Woman; Chang Dai-chien from Shu [Sichuan
 Province] copied this.
Collection of Yon Fan, Hong Kong

EVER SINCE Chang Dai-chien first studied the Buddhist murals at the Mogao Caves in Dunhuang during the early 1940s, he had yearned to compare them to their antecedents at the Ajanta Caves in India. An invitation to exhibit his works in New Delhi in January 1950 provided an opportunity. Chang had just left China because of the communists' victory, and he took only his fourth wife, Hsu Wen-po, and his youngest daughter, Xinpei, with him. The exhibition in New Delhi included Chang's paintings from his Dunhuang sojourn, including copies of the cave paintings and works inspired by them, and these attracted special notice among the Indian public. In the late winter of 1950 Chang traveled to Ajanta. He was amazed at the differences he saw between the Indian and Chinese murals and concluded that the Chinese artists at Dunhuang had completely cast off Indian style. Chang noted:

> In traditional China, the method of perspective differs from that used in India, which had absorbed influence from the West. The demeanor and attributes of the figures depicted at Dunhuang are traditionally Chinese; everything in the Jataka narratives [of the Buddha's former incarnations]—clothing, customs, architecture—is Chinese. Moreover the materials and tools used to make the wall paintings [in China and in India] are distinct.[1]

Dancer in the Style of the Ajanta Caves is dated to Chang's 1950 visit. The painting is an informal exercise in which Chang attempted to follow his Indian model closely. A title slip on the outside wrapper identifies it as a copy of a figure from Cave 1 at Ajanta, a late sixth-century depiction of the Mahajanaka Jataka (fig. 94). The tale recounts that Queen Sivali sent seven hundred concubines to King Mahajanaka in a vain attempt to dissuade him from taking a Buddhist vow to renounce the world. The dancer that Chang copied is one of the comely temptresses, portrayed by the Ajanta artist as gyrating to the music of an orchestra, which Chang eliminated. Since the lower part of the Ajanta figure was obscured by damage, Chang also left his dancer incomplete.

Chang Dai-chien preserved the basic features of the Indian model, but he allowed his personal views to influence the painting. The cut of the costume, open on both sides, is faithful to the original, but Chang changed its colors and pattern. He also eliminated the Indian dancer's mirrored thumb ring (*arsi*), since this type of ornament was unknown in China. He subtly altered the diadem and gave his dancer a more elaborate coiffure. Although the Indian dancer also had ribbons trailing from her hair, Chang's tauter, more sweeping lines reflect the linearity of the Chinese models he knew at Dunhuang. The skin of Chang's dancer is closer to the color of a Chinese, and her nose is more slender, again reflecting his own canon of beauty. Chang's dancer seems no longer Indian.

Chang Dai-chien had first painted an Indian dancer even before his trip to India. His friend Ye Qianyu brought him a sketch of a dancing woman that he had drawn in India, and on September 16, 1945, Chang used it as a model for a line drawing with light color, which he inscribed:

> She is suavely poised and beautiful but not wickedly sweet like a temptress's dance. I painted the palms of her feet and hands dark red, following the eighty notable physical characteristics of the Tathagata Buddha, whose hands and feet should be depicted copper red. When you look at the Northern Wei depictions of Buddha at the Mogao Caves near Dunhuang, you can sometimes see this.[2]

In 1945 Chang Dai-chien had freely shifted the manner of the Indian model and rendered the dancer in lithe lines more characteristic of Chinese painting. But while at Ajanta in 1950, Chang tried to follow the corporeal style of Indian art more closely. Nevertheless, though the hands of his Ajanta model were shaded in two flesh tones, Chang recalled his knowledge of Dunhuang and painted the palms of his dancer red, thus exaggerating the exotic allure of her movements. As his 1945 inscription reveals, even while painting an Indian subject Chang continued to think of Chinese art.

1. Xie Jiaxiao, *Chang Dai-chien zhi shijie* (Taipei: Shibao wenhua chubanshe, 1982), 182–83.
2. Gao Lingmei, ed., *Chang Dai-chien hua* (Hong Kong: Dongfang yishu gongsi, 1961), 107.

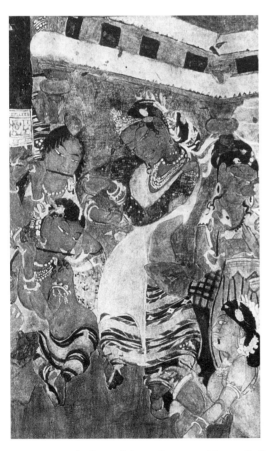

Fig. 94. Detail of mural from Cave 1 at Ajanta, India, late 6th century. From Madanjeet Singh, *Ajanta* (New York: Macmillan, 1965), pl. 47.

Dancer in the Style of the Ajanta Caves

Autumn 1950
Hanging scroll; ink and color on silk
198 x 117.5 cm (78 x 46¼ in.)
Inscription and signature:
 Along the Riverbank at Dusk by assistant director of the [Imperial] Rear Park, Dong Yuan of the Southern Tang dynasty, as copied by Chang Yuan from Shujun [Sichuan Province] in Darjeeling [India] on an autumn day in the *gengyin* year.
Collection of Chang Hsu Wen-po, Taipei

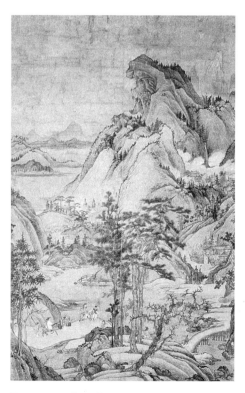

Fig. 95. Attributed to Dong Yuan, *Along the Riverbank at Dusk*. Hanging scroll; ink and color on silk; National Palace Museum, Taiwan, Republic of China.

Among the genuine and attributed works of Dong Yuan (act. 937–976), *Along the Riverbank at Dusk* (fig. 95) influenced Chang Dai-chien more than any other painting. Although modern art historians only admit that the painting is an important work in the style of Dong Yuan, to Chang Dai-chien the authenticity of this painting was unquestionable.[1] Chang first saw the work in Peking sometime between 1936 and early 1938, and it haunted him. He considered *Along the Riverbank* to be the pinnacle of Dong Yuan's marvelous ability to fuse elegance and raw strength. Chang desperately wanted to acquire the painting, but he had to leave Peking to escape the Japanese occupation. He could not return until the winter of 1945, after World War II had ended. Chang set out at once to locate the painting, and after two months of searching, he acquired it.

Chang was so impressed with *Along the Riverbank* that after learning how to copy its imposing foreground trees he used their likeness in some thirty paintings. He also made at least three copies of the complete composition: the first in spring 1946 and two, or possibly more, copies in fall 1950, in Darjeeling, India.[2] Of the various versions, this one from autumn 1950 is the closest to Dong Yuan's original. When Chang first copied *Along the Riverbank,* he described its meaning to him in a colophon whose wording parallels, with only minor exceptions, a colophon he wrote on the so-called original Dong Yuan composition.

Ten[3] years ago, while I was living in the former capital [Peking], I saw this painting on double-width silk by Dong Yuan. After the North and South [of China] had been engulfed [by the Japanese occupation], I took a roundabout route and returned home to Sichuan Province. During the years whenever I spoke to anyone about this [painting], I couldn't help but sigh in longing and admiration. But last fall the eastern invaders [Japanese army] were shattered and we accepted their surrender at Nanjing. In winter I could once again travel to the former capital. Swiftly I set about seeing the painting, but it took two whole months before I could acquire it for the Dafeng Tang. Whenever I recall the stress and anxiety [of those times] in my old age, this will console me. The story of Grand Tutor Xie [Xie An; 320–385] when he broke his clogs, expresses my feelings well.[4] Mi Yuanzhang [Mi Fu; 1051–1107] once stated that Dong Yuan's painting was "natural and unpretentious, as well as tranquil and full of marvels. In the Tang dynasty there was no one like him and he is superior to Bi Hong [act. 742–756]." Nowadays, when we speak of the Southern School of painting, we no longer have [works from] Jing [Hao; act. 870–930] and Guan [Tong; act. 907–923], not to mention the *Wangchuan Villa* [by Wang Wei; 701–761]. There is only this Dong Yuan to be a rare treasure in the world. I also own another painting on double-width silk [by Dong Yuan], *Dragon Emerging from a Storm,*[5] which has light colors; together with this painting it is like the reunion at the Yan[ping] Ferry.[6] They are the twin jewels of the Dafeng Tang.

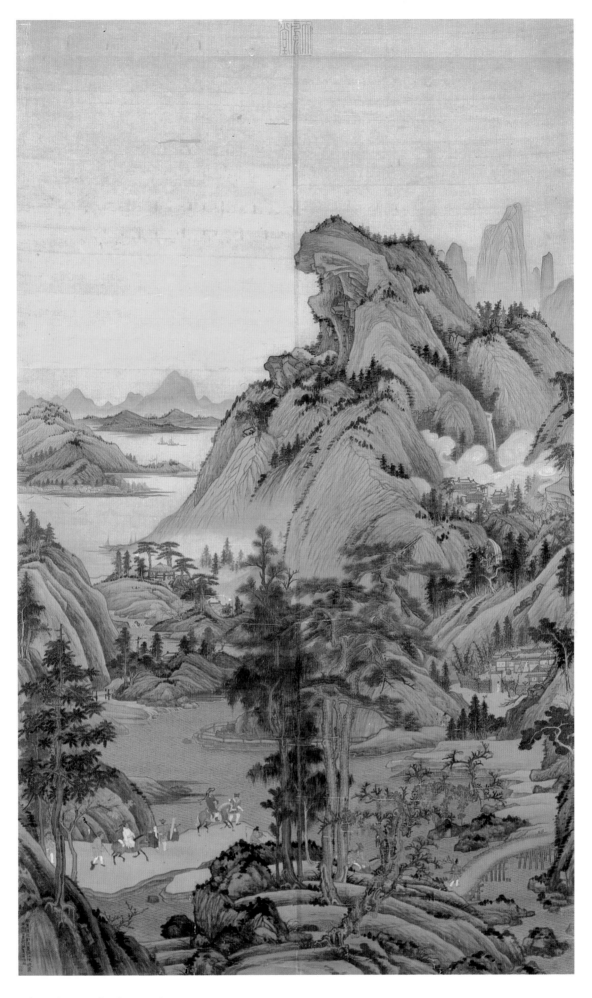

Along the Riverbank at Dusk

A spring day of the *bingxu* year [1946][7]; Chang Dai-chien from Shu [Sichuan Province].

js and sda

Once he had Dong Yuan's scroll in hand, Chang Dai-chien eagerly invited famous collectors and calligraphers to celebrate his acquisition by inscribing it. To his friend, the scholar-painter and historian Xie Zhiliu (b. 1910), Chang dictated a sentence to be written on the mounting above the painting (*shitang*): "The beauty of the flowing rivers, trees, and valleys in the painting outdistances other attributions to Dong Yuan."

Xie Zhiliu also wrote a colophon on the mounting below the painting, as did Puru (1896–1963), Pang Yuanji (1864–1949), Wu Hufan (1894–1968), and others. Xie Zhiliu discussed in his colophon a letter that Zhao Mengfu (1254–1322) had written to the calligrapher Xianyu Shu (1256–1301) in the Yuan dynasty, which is now in the National Palace Museum, Taipei.[8] Zhao Mengfu's letter touches on a painting by Dong Yuan entitled *Along the Riverbank at Dusk*. Zhao's description matched Chang Dai-chien's new acquisition so closely that Xie wondered if Chang may have picked up the same painting that Zhao Mengfu had seen. Therefore, Xie quoted Zhao Mengfu and said:

> Recently I saw a painting on double-width silk by Dong Yuan that was painted with bright colors, mostly strong blue and green; it is truly of the divine class. Compared to a person, it is like a relaxed and freely expressive Li Sixun [651–716; known for detailed blue-and-green landscapes]. Up to the edge of the mountains and down to the bottom of the silk, the whole [area] has finely drawn lines for waves amid which small river boats [appear]. How can it ever be matched?
>
> js and sda

The other colophons that Chang's colleagues wrote also accepted the painting as genuine, and after Chang's death his family presented it to the National Palace Museum, Taipei.

After acquiring *Along the Riverbank,* Chang Dai-chien immersed himself in the study of Dong Yuan. When he copied Song dynasty landscapes later in the decade, he used the hemp-fiber strokes that Dong had made famous. In this 1950 copy of *Along the Riverbank*, Chang's brush rhythm is only subtly different from his model's; he rejected the calligraphic flourish that appeared in Yuan dynasty painting and gradually became codified as part of the literati mode. In Yuan dynasty painting, texture strokes are not totally descriptive and almost function independently, each line with its own rhythm and beauty. Yet, Chang's brushwork in *Along the Riverbank* is wed to description. He also followed other archaistic mannerisms, such as using a net-pattern to depict water and tightly swirled lines to delineate the clouds.

Dong Yuan's bright mineral pigments in *Along the Riverbank* especially appealed to Chang Dai-chien. After his study of figure painting in the Buddhist caves at Dunhuang, Chang had become excited by the decorative potential of rich color. Chang practiced Dong's manner of color and in this painting proved his ability to manipulate the tones of blue and green to create the plush and soft look of velvet as well as the sparkle of faceted gems, as in the angular rocks on the mountain summit. The experience Chang gained in his project to copy works by Dong Yuan and other artists of the Five Dynasties shaped his mature, personal style of the 1950s and 1960s by providing a broad repertoire of compositions, brushwork, and coloring.

1. James Cahill cites the painting as an imitation in *An Index of Early Chinese Painters and Paintings* (Berkeley: University of California Press, 1980), 48.

2. Xu Huishan, "Wo kan Chang Dai-chien," *Yihai zazhi*, 13:12–19; reproduced in Zhu Chuanyu, ed., *Chang Dai-chien zhuanji ziliao*, vol. 1 (Taipei: Tianyi chubanshe, 1985), 16a–19b.

3. In the colophon on the Dong Yuan attribution (see fig. 95), Chang Dai-chien wrote "eight years ago."

4. Xie An was playing chess when he received news from the battlefield that his forces had been victorious. He had disciplined himself to show no emotion. When leaving the game, however, his excited state caused him to rush, and in his happiness he failed to notice that he had broken the teeth on his clogs. Like Xie An, Chang had a long-awaited victory—the joy of finally owning the painting made him so happy he wouldn't even have noticed if he had been walking on unbalanced shoes.

5. In the colophon on the Dong Yuan attribution (see fig. 95), Chang wrote, "I also own another painting . . . *Lakes and Mountains before Rain*." Despite the different title it is probably the same painting.

6. The reunion at Yanping Ferry refers to a pair of ancient swords that belonged to the minister Zhang Hua and his protégé in the late third century. Zhang's sword mysteriously disappeared after his death. When the son of Zhang's protégé, who inherited his father's sword, crossed the water at Yanping, he felt his sword leap from his hand and disappear under the water, where it was reunited with its mate, Zhang's missing sword.

7. The date on the colophon on the Dong Yuan attribution (see fig. 95) is: "The *jiwang* day of the second lunar month in the *bingxu* year [March 19, 1946] at Kunming Lake [in Peking] after a snowfall."

8. Letter by Zhao Mengfu to Xianyu Shu published in *Gugong fashu*, vol. 16, pt. 2 (Taipei: Guoli gugong bowuyuan, 1974), 14a–b.

42 Dense Forests and Layered Peaks, Attributed to Juran

ca. 1951
Hanging scroll; ink and color on silk
184.7 x 73.8 cm (72 ³/₄ x 29 in.)
Inscription:
 Dense Forests and Layered Peaks by the monk Juran from Zhongling.
The British Museum, London, 1961.12–9.01

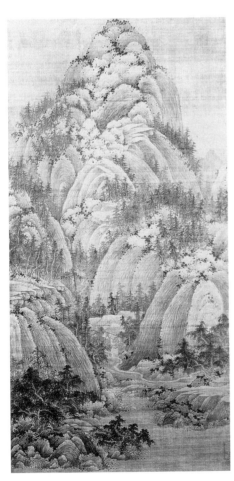

Fig. 96. Attributed to Juran, *Seeking the Dao in the Autumn Mountains*. Hanging scroll; ink and color on silk; National Palace Museum, Taiwan, Republic of China.

THIS LUSH mountainscape recalls *Seeking the Dao in the Autumn Mountains* (fig. 96), one of the preeminent and earliest attributions to the Northern Song dynasty painter Juran (act. 960–980), who was acclaimed for his depictions of misty, fertile hills. In *Dense Forests and Layered Peaks, Attributed to Juran,* Chang Dai-chien created an impression of rich topsoil and vegetation by depicting the mountains with long hemp-fiber strokes. These round, calligraphic lines typically have slender filaments projecting from the contour where brush hairs left light traces of ink: the effect resembles fibrous hemp rope. Juran was one of the first artists associated with this style of brushwork. He was a follower of Dong Yuan (act. 937–976), whom Chang Dai-chien had been copying for five years preceding this forgery of *Dense Forests and Layered Peaks.*

The foreground of this work contains trees weighted by heavy foliage rendered in wet ink. A long footbridge leads to a pavilion occupied by a scholar. A winding path guides the viewer along the rocky stream; abrupt turns in the course of the stream impart a physical depth to the mountain peaks, which are stacked from front to back almost like a staircase and lead the viewer up through the painting. The peaks have globular, "alum-head" (*fantou*) rocks, and dark dots represent vegetation along the summits.

When the British Museum acquired *Dense Forests and Layered Peaks,* scholars accepted the painting as ancient. The sense of depth perception, the landscape idioms, and the brushwork conform to the general notion of Juran's style. Parallels between *Seeking the Dao in Autumn Mountains* and *Dense Forests and Layered Peaks* go beyond structure and brushwork to the color of the silk, which in both cases seems dulled by age, making Chang's version more difficult to recognize as a forgery. But once Chang Dai-chien's habits in creating ancient scrolls are understood, it is apparent that *Dense Forests and Layered Peaks* is his.

The conditions that led to Chang's creation of this magnificent forgery began in the mid-1930s, when through his studies of Wang Meng (ca. 1308–1385) and Wu Zhen (1280–1354), who were both influenced by Dong Yuan and Juran, Chang started directing his attention to the tenth-century landscape masters. After his return from Dunhuang in 1943, Chang focused more than ever on Song dynasty and earlier painting, which he began collecting. In 1945 he acquired *Clear Morning over Lakes and Mountains* and attributed it to Liu Daoshi (act. 10th cent.; see entry 43), a pupil of Dong Yuan. This painting prompted Chang to aggressively study and copy the ancient masters of the Dong-Ju School. He made a faithful copy of the Liu Daoshi painting in 1945 and again in early 1951. Not long after Chang made the second copy, between

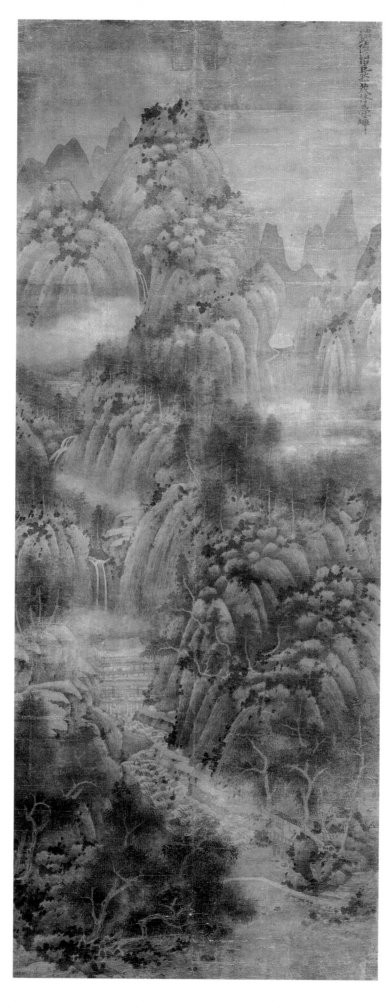

Dense Forests and Layered Peaks, Attributed to Juran

January 8 and February 5, 1951, he received a photograph that served as the prototype for *Dense Forests and Layered Peaks*. Chang's student, Tang Haolan, in Tianjin, sent him a photograph of *Myriad Ravines with Wind in the Pines* (Shanghai Museum), a work attributed to Juran. Chang accepted the work as a major monument in Juran's style, although most art historians now believe it is a Ming or early Qing dynasty copy based on a tenth-century work. Chang felt it was so similar in tone to his Liu Daoshi that they made a perfect pair.[1]

Chang used the composition of *Myriad Ravines* as the basis for *Dense Forests and Layered Peaks*. He was well prepared to imitate Juran's brushwork, as he had copied *Seeking the Dao in the Autumn Mountains* in 1949 and had subsequently painted other reproductions of Juran's works.

When closely examined, the brushwork bears traits of Chang's hand. The contrast between light and dark, which is harsher than in early paintings, gives Chang's landscape a flatter appearance than *Seeking the Dao in the Autumn Mountains*. The contours of the rocks and especially the hard edge of the distant mountains in *Dense Forests and Layered Peaks* are stiffer and more slick than in Northern Song dynasty painting. The harsh contours are more akin to Chang's personal style than to Juran's brushwork, and some of the landscape elements in Chang's forgery, including the same type of trees, occur in Chang's signed works.

Chang culled the title for his forgery from the Song dynasty imperial painting catalogue *Xuanhe huapu*. He wrote the title in a deliberately unpolished style of standard script (*kaishu*) reminiscent of Emperor Song Gaozong (r. 1127–1162). To complete the duplicity that *Dense Forests and Layered Peaks* was a long-lost work from the palace collection, Chang affixed forged imperial seals from different eras to the painting. Some of these, such as the purported seals of the Xuanhe reign period (1119–1125) of Emperor Song Huizong (r. 1100–1125) and the *siyin* half seal, also appear on another of Chang's forgeries, *Drinking and Singing at the Foot of a Precipitous Mountain* (Museum of Fine Arts, Boston), which bears an attribution to the painter Guan Tong (act. 907–923).

Ultimately, the calligraphy also reveals the painting's origin. Although it looks antique, the writing is uncomfortably similar to inscriptions on other "Tang" and "Song" paintings that have proven to be forgeries by Chang.[2]

The renowned scholar Michael Sullivan, who once believed *Dense Forests and Layered Peaks* was painted by Juran, typifies the difficulties in connoisseurship that Chang Dai-chien poses for the art world. Sullivan wrote in the July 1962 issue of *Apollo* that this painting

> holds wonderfully together as a painting either by Juran or by a Northern Song master working in his style. When we consider that no surviving published work has a better claim to be from the hand of Juran, we should be content. Above all, we should be profoundly grateful to the British Museum for having brought to Britain a masterpiece of Chinese landscape painting.

In 1986, Sullivan wrote to the author.

> Dr. Fu Shen has suggested that I write a footnote to my article. . . . I am particularly grateful. . . . At the time when I saw this particular painting in London I had not seen the major paintings in the Juran tradition, nor had Dr. Fu's own studies on Juran been published. Now, with the benefit of hindsight, this rather spectacular work clearly has nothing to do with tenth-century style, and can be seen as a brilliant pastiche from the hand of Chang Dai-chien, witness both to his skill and to his audacity.

Sullivan was not the first to be fooled. Chang had the painting mounted and the surface treated to look antique. After the painting traded hands a few times, it was bought by the collector Yan Shengbo (b. ca. 1910), who became well known in Hong Kong after he left China. Impressed with his treasure, Yan Shengbo showed it to connoisseurs; ironically he asked Chang Dai-chien to authenticate the painting. Chang usually avoided adding his seals or a colophon to one of his forgeries. The owner, believing in the work, had unwittingly asked the forger for his opinion; Chang was reluctant both to admit that he was the artist and to stir up any suspicion by associating himself with it. Although forgery is tolerated differently in China than in the West, Chang still felt it was inappropriate to use his reputation as a collector-connoisseur to convince other people of the veracity of his own forgeries. Yet in this case he could not refuse to write something without causing some misgiving. Finally, Chang agreed to write a colophon, but only on the silk mounting, not directly on the painting. Thus Chang hoped to reduce the extent to which he might be held responsible for his words, for comments written next to a hanging scroll are generally taken less seriously. A colophon not directly on a painting can be removed and remounted, and there is always the possibility that the writing was originally meant for some other image. In fact, this colophon was separated from the painting during the remounting; however, since it is still preserved in the British Museum, Chang's sentiments are known.

> The only authentic paintings by Juran are: this picture; two in the collection of the [National] Palace Museum [Taipei], which are *Seeking the Dao in the Autumn Mountains* and *Xiao Yi Stealing the Preface to the Lanting Gathering Manuscript by Trickery;* one in the Saito Collection in Japan, *Mountain Retreat;* and one handscroll in my modest collection, *Evening along Rivers and Mountains.* . . . This painting [*Dense Forests*

and Layered Peaks] is included in the *Xuanhe huapu*. Its inscription was written by Emperor [Song] Gaozong in his early years when he followed the calligraphy of Zhong Taifu [Zhong You; 151–230]; the [calligraphy] is ancient and tranquil. At the bottom of the painting there are seals, such as the *siyin* half seal and . . . the seal of Wang Yanke [Wang Shimin; 1592–1680]. The painting has a long history of being passed down and is truly worth treasuring. My friend and fellow connoisseur-collector, Shengbo, brought me here to appreciate this with him, and with delight I inscribe it; Chang Yuan.

Chang's testimony reveals that among the paintings he accepted as genuinely by Juran, he also daringly included two of his forgeries—*Dense Forests and Layered Peaks,* which he had to mention, and *Evening along Rivers and Mountains.*[3] The latter is a handscroll based on a Juran attribution that now belongs to Fu Xinian, who inherited it from his grandfather Fu Zengxiang (1872–1950). Chang's version, completed about 1945, follows the composition of the scroll in Fu Xinian's collection, but the brushwork is much more vibrant. Chang's version ended up in Hong Kong around 1946 or 1947, when the Hong Kong collector J. D. Chen acquired it as a genuine Juran.[4]

The earliest Chang could have painted *Dense Forests and Layered Peaks* is 1951, when he first saw the photograph of *Myriad Ravines with Wind in the Pines.* This year falls within the apogee of his study of Dong Yuan and Juran, which ranged from about 1945 until the mid-1950s. In that decade Chang Dai-chien created at least fifteen paintings, both forgeries and honest copies, of Dong Yuan and Juran.[5] Of these works, *Dense Forests and Layered Peaks* is among the finest.

1. A color illustration is included in Xu Bangda, "Connoisseurship in Chinese Painting and Calligraphy: Some Copies and Forgeries," *Orientations* 19, no. 3 (March 1988): 54–62, fig. 11.

2. The author addresses forgeries in his article, "Chang Dai-chien's 'The Three Worthies of Wu' and His Practice of Forging Ancient Art," trans. Jan Stuart, *Orientations* 20, no. 9 (September 1989): 56–72.

3. An illustration is included in Xu Bangda, "Connoisseurship in Chinese Painting and Calligraphy," fig. 3.

4. Ibid., 57.

5. Some of these paintings include *Drinking and Singing at the Foot of a Precipitous Mountain* (Museum of Fine Arts, Boston), which is attributed to Guan Tong but follows the style of Dong Yuan and Juran. Another important forgery is *Temple by Streams and Mountains*, a Juran forgery which Chang based on *Seeking the Dao in Autumn Mountains*. It was acquired by J. D. Chen in 1954, probably soon after Chang painted it. Another Juran attribution that is Chang's work is *Broad Shores and Distant Mountains*, painted around 1950, which the artist kept in his Dafeng Tang collection of ancient paintings. After his death, his family, who never questioned its authenticity, presented it to the National Palace Museum, Taipei. The author lists some of the Juran forgeries in "A Preliminary Study to the Extant Works of Juran," *National Palace Museum Quarterly* 2, no. 2 (1967): 11–24, 51–79. The author did not identify Chang, however, because at the time of publication Chang was still alive. An important signed, or "honest copy," of Juran that Chang produced in the 1950s is his *Mountain Retreat*, based on the painting in the Saito Collection, Japan.

43 Clear Morning over Lakes and Mountains

January 8–February 5, 1951
Hanging scroll; ink and color on silk
223.5 x 84 cm (88 x 33⅛ in.)
Inscriptions and signatures:

A

This is done in the brush style of Liu Daoshi of the Northern Song dynasty. Received tradition, however, considers it to be Juran's *Myriad Ravines with Wind in the Pines*. I acquired the painting from the home of Cai Sean from Xijiang. Upon carefully examining its brushwork and comparing it to another work, *Evening along Rivers and Mountains* [by Juran], which I acquired long ago, I realized that they are of one spirit; but the delicate refinement and moist beauty [of the Liu Daoshi] are different from [Juran's painting]. In both *Evening along Rivers and Mountains* and the National Palace Museum's *Seeking the Dao in the Autumn Mountains*, [Juran] made "alum-head" [rocks] and windblown reeds and scattered large moss dots about; none of these [stylistic elements] are like those in this painting. It has long been said that there was a contemporary of Juran's called Liu Daoshi from Jiankang [Nanjing], but all record of his given name has been lost. Both Liu Daoshi and Juran studied with Dong Yuan and Liu's painting was similar to Juran's. Liu Daoshi always put Daoists on the left, however, while Juran put [Buddhist] monks on the left. In this painting, since the figure is wearing a red robe and has a staff, he must be a Daoist; therefore, it can properly be distinguished [as the work of Liu Daoshi]. The last lunar month of the *gengyin* year, copied while in Darjeeling [India]. This is the second copy I made [of this painting by Liu Daoshi] and again I inscribed it; Chang Yuan Dai-chien fu from Shu [Sichuan Province].
JS and SDA

B

Ju[ran's] masterpiece *Myriad Ravines with Wind in the Pines* is in the home of a salt merchant in Gukou [Tianjin]. Recently my student Tang Haolan sent me a photograph of it and recorded the painting's measurements; it is a perfect mate for this painting [by Liu Daoshi]. In this abnormal state of revolt, who can say when the situation will turn around. So I do not know when I might be able to return [to China] and see that the painting by Liu Daoshi and the one in the photograph are united together in one collection like the reunion at the Yan[ping] Ferry [see entry 41, n. 6]. In the beginning of the new *xinmao* year [1951] inscribed again by Dai-chien jushi.
JS and SDA

Collection of Chang Hsu Wen-po, Taipei

DURING LATE 1945, several months after the Japanese surrender ended World War II, Chang Dai-chien returned to Peking, where eight years before he had made a harried escape from occupying Japanese forces. His visit was inspired by the appearance of ancient paintings in the art market, as collectors began selling their holdings to finance war losses. Chang Dai-chien purchased two paintings in 1946 that profoundly affected him: *Along the Riverbank at Dusk*, attributed to Dong Yuan (act. 937–976; see entry 41), and the ancient painting that was the model for *Clear Morning over Lakes and Mountains*, which Chang painted in the beginning of 1951. When Chang purchased the model it bore an attribution to Juran (act. 960–980). After study, however, Chang attributed the scroll to the little-known artist Liu Daoshi (act. 10th cent.) and gave it the title *Clear Morning over Lakes and Mountains* (fig. 97).[1]

In the early summer of 1946, Chang Dai-chien was staying in a rustic village named Tuoshui, near Chengdu in Sichuan Province. There, far from the bustling art market, he took time to articulate the reasons for his reattribution of what was thought to be a painting by Juran. He wrote his arguments on the scroll mounting and later transcribed the same text in inscription A of this painting.

Chang Dai-chien first copied *Clear Morning over Lakes and Mountains* in 1946, the year that he acquired the ancient version (Chang's 1946 copy is in a private collection in Shanghai). Five years later, he worked on this second copy in Darjeeling, India. Shortly after finishing the painting and the first inscription, Chang added inscription B.

Modern scholars continue to argue about the exact date and correct attribution of the original *Clear Morning*. They concede, however, that it represents an early recension of what is called the Dong-Ju School and that *Clear Morning* may be by Liu Daoshi, but since there are no other works by him, that remains a conjecture.

The Liu Daoshi attribution served as a direct model for Chang's masterful forgery *Drinking and Singing at the Foot of a Precipitous Mountain* (fig. 98), although Chang added an imperial inscription attributing the painting to Guan Tong (act. 907–923). The forgery is extremely close to this honest copy of *Clear Morning* from 1951; the major differences are the accretions that Chang used to make *Drinking and Singing* plausible as Guan Tong's work, such as an identifying inscription, a colophon supposedly by Zhao Mengfu (1254–1322), and various collectors' seals. When the Boston Museum of Fine Arts purchased Chang's forgery in 1957, neither Liu Daoshi's nor Chang's *Clear Morning* was well known.

The dividing line between Chang Dai-chien's candid copies of ancient paintings and his forgeries is slight. Once he had

acquired *Clear Morning,* Chang dared himself to reproduce
the complex, mannered composition of mountain ridges,
which shift and slide like molten lava still taking form. The
pulsating rhythm underlying the basic structure of the moun-
tain, plus a plethora of small details—trees, waterfall, mist,
temple buildings, and figures—particularly challenged and
attracted Chang Dai-chien. He saw copying this work as a
key opportunity to learn the technical craft of painting. After
twice copying *Clear Morning,* Chang decided to see if he
could produce a forgery that would be taken as a genuine
tenth-century work. When the Boston Museum of Fine Arts
acquired *Drinking and Singing at the Foot of a Precipitous
Mountain,* Chang Dai-chien knew he had learned well.

1. Chang Dai-chien sold the painting in spring 1951 to the Hong Kong collec-
tor J. D. Chen, who published it in two catalogues of his collection. The
work is illustrated in *Jingui canghua ji,* vol. 1 (Kyoto: Benrido, 1956), pl. 4;
commentary and notes are in *Jingui canghua pingshi,* vol. 1 (Hong Kong:
Dongnan shuju, 1956), 34–38. The New York collector C. C. Wang (b. 1907)
then acquired the painting, which he still owns.

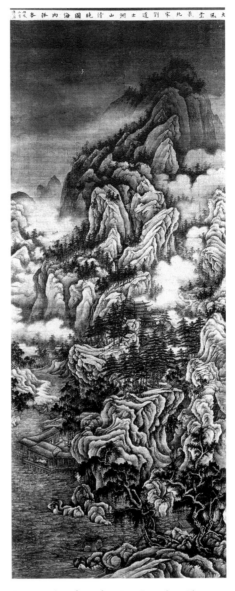

Fig. 97. Attributed to Liu Daoshi, *Clear
Morning over Lakes and Mountains.*
Hanging scroll; ink and color on silk; col-
lection of C. C. Wang, New York.

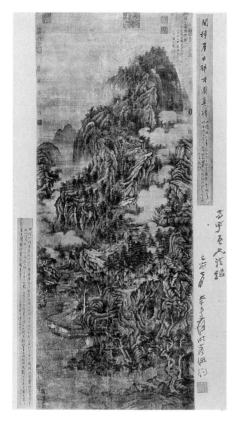

Fig. 98. Chang Dai-chien, *Drinking and Singing at the Foot of a Precipitous Mountain.* Photographic reproduction inscribed by Chang Dai-chien; collection of Wang Fangyu and Sum Wai, Short Hills, New Jersey.

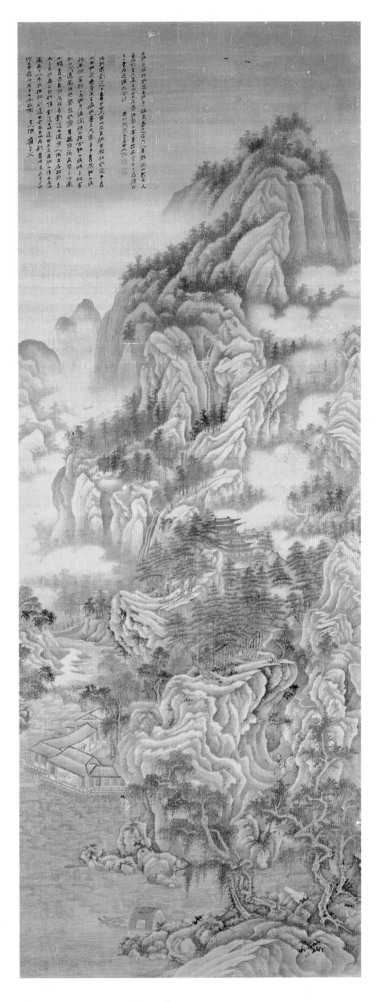

Clear Morning over Lakes and Mountains

44 Afternoon Rest

1951
Mounted for framing; ink and color on paper
46 x 29 cm (18⅛ x 11⅜ in.)
Signature: Chang Dai-chien, Yuan from Shu [Sichuan Province].
Collection of Paul Chang, Pebble Beach, California

IN *Afternoon Rest,* one of Chang Dai-chien's most opulent paintings, a beautiful woman languorously reclines amid bright colors that seem to shimmer in the summer heat. Her gown, loosely open at the neck, reveals one shoulder. Her dreamy eyes and pursed mouth add more individuality to the figure than is seen in most of Chang's portrayals of women; she mildly resembles his fourth wife, Hsu Wen-po. The figure's creamy skin and flowing black hair and her sensual yet demure nature represents Chang's ideal of feminine beauty.

To accommodate the busy design in this small painting, Chang compressed images into flat shapes and organized the composition by color and ornamental shapes. Directly behind the figure is a folding screen that Chang playfully embellished with flowers and a banana tree in fiery bloom. The garden images suggest outdoor space but twice removed—a garden in a painting of a painting. The drawing of the figure is assured and supple. Individual strands of hair and shading on the cheeks, collarbone, and arms help the figure stand out against the background. For her features Chang used lines of even width. The slender hands, each finger joint carefully delineated, recall the emphasis on painting hands seen in the Buddhist cave paintings that Chang had studied a decade earlier at Dunhuang. The woman wears a white gown and a floral-patterned cloth girdle, belted by a blue ribbon with flashes of gold at the edges and folds. The sinuous flow of the belt as it spills onto the carpet and the serrated "fish-tail" folds echo the scarves worn by Buddhist figures at Dunhuang. The elaborate pattern in the carpet, especially its border, also reflects designs he would have seen there.

In addition to invoking elements from Dunhuang, Chang Dai-chien had other sources. The rendering of the leaves of the banana tree in short lines with a staccato rhythm drew upon the painting of Chen Hongshou (1598–1652), which Chang had studied early in his career. An entirely unrelated model for *Afternoon Rest* is a type of Japanese woodblock print known as ukiyo-e (fig. 99). The folding screen, the woman's *obi*-like girdle, and even the melon shape of her face correspond to elements found in ukiyo-e; so does the pictorial conception of a flat picture space. Chang had a small collection of ukiyo-e prints and also knew Japanese art from his student years in Japan between 1917 and 1919 as well as from frequent later trips. Ukiyo-e had influenced Western painters in the early twentieth century, and as Chang was trying to

develop an international market for his paintings at the time he painted *Afternoon Rest,* his personal fondness for ukiyo-e was reinforced by its wide appeal.

Chang acknowledged only Chinese origins, however, for the style of *Afternoon Rest.* On a similar painting entitled *Spring Sleep,* which dates to 1949, he wrote:

> This painting method is from Zhou Zhonglang [Zhou Fang] of the Tang dynasty; this type of clothing and the accessories were then adopted in Japan, where they became a tradition. In China after the Yuan and Ming dynasties, [the tradition of painting beautiful women] became anemic, and no one followed Zhou Fang. In this painting, I followed the method of depicting decoration and interiors used during the Six Dynasties period and in early Tang dynasty paintings at Dunhuang. If I did not point this out, however, the modern viewer would suspect a Japanese source.

The Japanese did adopt and preserve into modern times aspects of Tang dynasty art and culture forgotten in China, thus Chang was correct to point out that paintings in the Tang dynasty manner would be similar to Japanese art. But the similarities pertain to costume and accessories, not to painting style. The images of elegant and demure women in palace interiors or gardens that Zhou Fang (ca. 730–ca. 800) painted are totally unrelated to the mildly erotic nature of *Afternoon Rest,* which is even more provocative than paintings by Chang's contemporaries in the 1950s. *Afternoon Rest* reflects Chang's understanding of Tang dynasty painting based on Zhou Fang and the Dunhuang murals, but the ukiyo-e tradition is the most direct source. The painting also reflects the relaxation of sexual mores that was beginning to change Chinese society during the 1950s. According to Chang's son Paul, *Afternoon Rest* was painted in Hong Kong, where an avant-garde spirit encouraged Chang Dai-chien to develop this new stylistic synthesis for rendering beautiful women.

Fig. 99. Hashiguchi Goyo (1880–1921), *Woman Combing Her Hair,* 1920. Woodblock print; ink and color on paper; collection of Watanabe Todasu, Tokyo. From *Nihon kaiga kan,* vol. 10, ed. Suzuki Susumu (Tokyo: Kodansha, 1971), 124, pl. 109.

Afternoon Rest

45 Emperor Xuanzong Enjoying a Cool Breeze, Attributed to Zhang Xuan

ca. 1952
Handscroll; ink and color on silk
53 x 146.9 cm (20⁷/₈ x 57⁷/₈ in.)
Title slip by anonymous calligrapher:
 Ming Huang Enjoying a Cool Breeze by Zhang Xuan.
Colophon by anonymous calligrapher:
 That we wished to fly to heaven, two birds with the wings of one,
 And to grow together on the earth, two branches of one tree.[1]
Colophon by anonymous calligrapher on separate piece of silk
Private collection

W HEN CHANG DAI-CHIEN painted *Emperor Xuanzong Enjoying a Cool Breeze, Attributed to Zhang Xuan*, he created one of his most persuasive and ambitious forgeries. The work depicts an intimate moment between Emperor Xuanzong (r. 712–756), better known as Ming Huang (Brilliant Emperor), and his love Yang Guifei (ca. 720–756). Yang was a petty functionary's daughter whose extraordinary beauty eventually led to her induction into Xuanzong's seraglio. Mesmerized by her charms, the emperor bestowed on her the title *guifei,* second only to the title of empress. Xuanzong allowed Yang Guifei to promote her family members, an indulgence that triggered a tragic rebellion at court and the end of the emperor's reign in 756. The loyal palace faction escaped with the emperor but demanded Yang Guifei's death in retribution for the emperor's infatuation. The placid composure of the figures in *Enjoying a Cool Breeze* belies the horrors of their destiny.

The silk of the handscroll is dark and damaged, consistent with ancient works, and the painting style is archaic. Chang

Emperor Xuanzong Enjoying a Cool Breeze, Attributed to Zhang Xuan

Dai-chien's choice of a scene portraying a private moment of court life, the bright mineral colors, and the even width of the "iron-wire" lines are entirely consistent with eighth-century painting. The great mastery of linear control that Chang evinced in his slow and deliberate brushwork, in which each stroke has a descriptive function and sedate rhythm, re-creates a style that waned in popularity after the Tang dynasty. Curved drapery lines, the opposite of the angular flourishes common since the Song dynasty, confirm the antique impression. Furthermore, the title slip, written in an awkward, squat style of early calligraphy, identifies it to be *Ming Huang Enjoying A Cool Breeze* by Zhang Xuan (act. 714–742). A seal stamped over the title reads "a treasure of the imperial study," implying the title slip was written by an emperor. Thus, when the painting appeared on the market, it caused a stir, and some connoisseurs believed it was a genuine Tang dynasty work.

The title, which Chang Dai-chien chose to match a theme in Zhang Xuan's oeuvre, does not accurately describe the subject of the scroll. The two lines of semicursive (*xingshu*) script that appear between the seated emperor and his standing consort reveal the true theme. The words are from "Song of Unending Sorrow," a long narrative verse by Bo Juyi (772–846) that chronicles the tragic love affair between Emperor Xuanzong and Yang Guifei. Bo Juyi's poem contains this pledge of love, which Chang Dai-chien depicted:

> On the seventh day of the Seventh-month, in the Palace
> of Long Life,
> We told each other secretly in the quiet midnight world
> That we wished to fly to heaven, two birds with the
> wings of one,
> And to grow together on the earth, two branches of one
> tree.[2]

Chang Dai-chien had only the last two of the above lines transcribed on the painting by a calligrapher who remains unknown. The second colophon, written on a separate piece of silk, quotes the entire poem. It seems the same calligrapher wrote the title slip and both colophons.

Fig. 100. Hashimoto Kansetsu, detail, *Song of Unending Sorrow,* 1929. Handscroll; ink on paper; Kyoto Municipal Museum of Art.

The seventh day of the seventh lunar month is called the Double Seventh Festival. By the Han dynasty this festival, originally for unmarried girls, had become known as the Festival of the Meeting of the Weaving Maiden and the Cowherd (two constellations) across the Milky Way, and by 751, when Xuanzong and Yang Guifei made their pledge, the Double Seventh Festival was the most important celebration for lovers. Women made special displays of brocade and prepared vegetarian feasts to place on altars, where they burned incense and prayed for divine instructions, especially for improvement of needlework. Couples prayed for eternal love.

Enjoying a Cool Breeze opens with two youthful handmaidens who stand behind the emperor ready to serve him. They wear multi-colored gowns that evoke the "rainbow skirts" mentioned in another part of Bo Juyi's poem. Their hair is parted in the center and coiled above their ears in Tang dynasty fashion. Each holds a white gauze fan, and one of the young women gestures toward the emperor with her fan, directing the viewer's attention to the painting's focal point.

The emperor, who also holds a white summer fan, is informally dressed in a white hat and lightweight red robe. He sits off-center in an elaborate chair that is supported by five cabriole legs on each side and is wide enough for two. A luminous yellow brocade is draped over the chair arms and back. We can imagine that Yang Guifei has just risen from the side of her lover. The inscription clarifies that she is taking her vows of love before an imaginary altar.

Yang Guifei is lavishly dressed in a gown with a semitransparent upper bodice that allows her delicate shoulders to be seen. Bright scarves and long streamers, colored like gemstones, cross over her chest. Her outer skirt displays a minute floral and geometric design often seen in Tang dynasty painting. The most distinctive feature of her costume, however, is the long white sleeves, which classical dancers and opera characters wear. Chang used the sleeves to draw attention to Yang's pose.

Chang Dai-chien followed an obscure model for *Enjoying a*

Cool Breeze. Although Chang spuriously attributed the painting to Zhang Xuan, the actual source is, as James Cahill has discovered, a virtually identical painting from 1929, *Song of Unending Sorrow* (fig. 100) by the Japanese artist Hashimoto Kansetsu (1883–1945). That scroll has five sections, the first of which is identical in composition to Chang's painting except for an altar with burning incense and lit candles that Hashimoto painted in front of Yang Guifei.

Chang Dai-chien was in Japan during 1929, and he may have seen Hashimoto's painting when it appeared that year in the Tenth Annual Imperial Art Exhibition in Tokyo or when it was reproduced in a catalogue. To transform Hashimoto's composition of ink and light color on paper into a painting in Tang dynasty style, Chang selected bright mineral pigments and silk. He dyed the silk a mossy brown and manufactured cracks and small losses. Where Hashimoto had painted with a gossamer touch, Chang painted taut lines, strong like wire, in imitation of antique style. But, impressed by the subdued tranquillity of Hashimoto's painting, Chang reproduced the mood. He covered the surface with seals that purport to belong to ancient emperors and astute private collectors of the Song and Ming dynasties.

Enjoying a Cool Breeze is difficult to distinguish as a forgery; however, Chang's use of Zhang Xuan's name is a clue. Chang chose Zhang Xuan because of his reputation as a brilliant court artist from Xuanzong's era. According to the Song dynasty painting catalogue *Xuanhe huapu,* Zhang Xuan excelled at painting court figures in the palace environment. The most plausible attributions of his style are two paintings that Emperor Song Huizong (r. 1100–1125) copied and thus preserved: *Ladies Preparing Newly Woven Silk* (Museum of Fine Arts, Boston) and *Lady Guoguo and Her Sisters on a Spring Outing* (Liaoning Provincial Museum, Shenyang), which includes a portrait of Yang Guifei. Neither correlates well with *Enjoying a Cool Breeze,* since in both paintings Zhang Xuan grouped the figures in ways to suggest recession in depth. It was from Hashimoto that Chang copied the single

file of figures. Also, Chang's painting of the faces lacks the naive purity of Tang dynasty figures.

When Chang Dai-chien first decided to copy Hashimoto's composition as a Tang dynasty work, he probably had not decided to whom he would attribute it. Finding that Zhang Xuan was recorded to have often painted scenes of Xuanzong's court and that *Xuanhe huapu* listed a painting by Zhang called *Ming Huang Enjoying a Cool Breeze*, Chang seems to have overlooked the fact that he had already had a line from Bo Juyi's "Song of Unending Sorrow" inscribed on the painting. To him the three white fans must have seemed enough justification for the title, "Ming Huang Enjoying a Cool Breeze," which he had the unknown calligrapher write on the title slip. The twentieth-century collector who bought Chang's scroll was apparently also not perturbed by the seeming contradiction between title and inscription.

Chang Dai-chien created an elaborate fake history for the painting through spurious seals. He placed seals of Emperor Li Yu (or Li Houzhu; r. 961–975) on the painting, as well as the seals of two Song emperors and the major private collector of the Southern Song dynasty, Jia Sidao (1213–1275). To document the scroll during the Yuan dynasty, Chang added more palace seals; for the Ming dynasty, he used imperial seals and also forty-seven seals purportedly belonging to the late Ming scholar-collector, Xiang Yuanbian (1525–1590). Intended to authenticate the painting, the seals also condemn it, since several of them appear on other forgeries by Chang Dai-chien, including *Dense Forests and Layered Peaks, Attributed to Juran* (entry 42) and *Drinking and Singing at the Foot of a Precipitous Mountain* (see fig. 98).

Enjoying a Cool Breeze is a forgery that has taken time to detect; only as the complex puzzle of Chang's forgeries emerged has it been possible to ascribe this handscroll to him.

1. Bo Juyi, "Song of Unending Sorrow," trans. Witter Bynner, in *Anthology of Chinese Literature,* ed. Cyril Birch, vol. 1 (New York: Grove Press, 1967), 269.

2. Ibid.

Summer 1953
Handscroll; ink and color on paper
24 x 187 cm (9¹/₂ x 73⁵/₈ in.)
Inscription and signature:

During summer, in the fifth lunar month of the *guisi* year, upon my return to Taiwan from faraway Mendoza [Argentina], I visited my fellow connoisseur "brother" Muling [Chuang Yen] at Beigou in Wufeng [near Taizhong, Taiwan]. We perused a broad range of famous works of art, from the beginning to the end [of time], past and present, until I forgot the misery of the blazing heat and the dusty fatigue [of my journey]. Since he spoke so highly of the beauty of the "golden phoenix" blossoms at Tong Village, we went into the mountains before dawn. We stopped until noon and then returned, and along the path we picked countless fungi of immortality. Yunlin [Ni Zan; 1301–1374] has a poem that reads:

Upon a rock, the fungus of immortality
blooms on triple stem,
I survey the river and climb the hills
never to know old age.

[Fungi] with triple stems were already hard to come by [in Ni Zan's time], so wasn't it a fantastic stroke of good fortune to have picked one here with nine caps! Master [Chuang Yen] wrote an account of [the event] and asked me to paint this picture. Those who accompanied us on our excursion were my close friend, "younger brother" [Zhang] Muhan [1900–1980], and my student Tang Hong; Dai-chien Chang Yuan.
JS and SDA

Frontispiece by Kong Decheng (b. 1905):
Picking the Fungus of Immortality at Tong Village, written for "brother" Muling in the winter of the *guisi* year.

Collection of Mrs. Chuang Yen, Taipei

CHANG DAI-CHIEN'S lengthy inscription explains that *Picking the Fungus of Immortality at Tong Village* commemorates a summer trip that Chang Dai-chien took with his friend, the eminent Chuang Yen (1898–1980). Chang did not paint this scene until after he returned home to Argentina, probably at the end of summer. It was complete by autumn, since he took the scroll with him to Japan to have it mounted. Chang inscribed a wooden box made to hold the scroll:

A picture of *Picking the Fungus of Immortality,* as a memento for my fellow connoisseur and "elder brother" Muling. The eighth lunar month of the *guisi* year [September 8–October 7, 1953]; "younger brother" Dai-chien Yuan.

When Chuang Yen received the scroll from Chang Dai-chien, he asked Kong Decheng (b. 1905), a lineal descendent of Confucius, to write the frontispiece. Kong's robust seal script is well balanced and stately.

The painting is an evocative distillation of an outing. The handscroll opens on the right with a rivulet, which marks a psychological division between the mundane world beyond and the remote, magical wilderness that the gentlemen in the painting have entered. The viewer's attention is arrested by a giant boulder, its striated outline of ink drawn with a split brush. The vivid contour stroke not only defines the boulder's jagged shape but also suggests volumetric form in its twists and turns. This quirky line leads the eye behind the boulder toward the trees, which have lush red blossoms. These may be the "golden phoenix" flowers mentioned in the inscription.

Picking the Fungus of Immortality at Tong Village

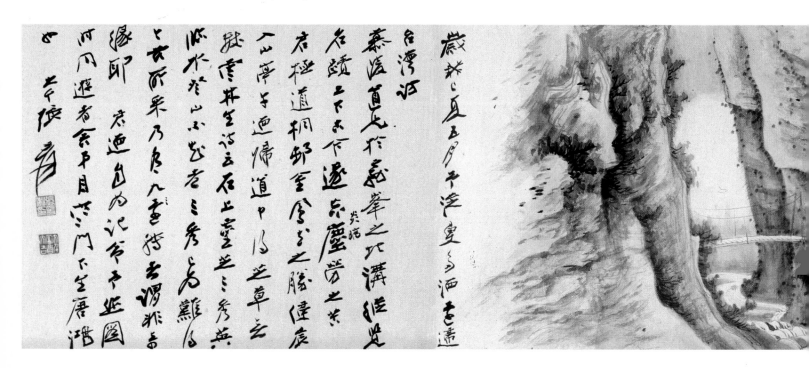

A narrow path emerges from the trees and skates between the folds of the peaks. Cropped at both top and bottom, the mountains seem immeasurable. Chang Dai-chien had favored this compositional formula since the 1920s, and he used it throughout his career. After the path reaches a suspension bridge it disappears from view, while a misty ravine provides an open space that breaks the rhythm of full peaks on either side. The last cliff is a wall of rock textured by a complicated network of ink lines that end abruptly halfway across the rock to leave space for Chang's signature and date.

The tiny village of Tong is nestled in the mountains, such a remote looking place that it is easy to imagine the rare nine-capped fungus of immortality hiding there. On the steep path behind the village, deep in the mountains, a figure bends down to pick the treasured fungus while his two companions watch. The composition is tightly paced and lucid, while the brushwork is relaxed, neither following any particular model nor advancing an innovative style. As an artist in his mid-fifties, Chang Dai-chien had practiced the ancients' styles of brushwork so often that even when he painted an actual experience, like this outing to Tong, he subliminally recalled past modes suited to the expression he wanted to convey.

After Chang Dai-chien and Chuang Yen both left mainland China, Chang often entreated his friend to write labels for the ancient masterpieces he collected for the Dafeng Tang. Chuang, one year older than Chang, was respected for his connoisseurship and calligraphy as well as for the vital role he had played in preserving China's art by helping to establish the National Palace Museum in 1925 and overseeing its harrowing moves from war-torn Peking to Sichuan and finally to Taiwan. After Chuang Yen had safely escorted the National Palace Museum collection into temporary hiding in Sichuan, the two friends were able to visit more often, since Chang was then also in Sichuan. When Chang acquired the Dong Yuan attribution *Along the Riverbank at Dusk* and wanted to compare it with Dong Yuan's work in the National Palace Museum, Chuang Yen made the arrangements.

In 1948 the nationalist government decided that the National Palace Museum collection should be shipped to Taiwan, and by 1950 Chuang Yen had successfully orchestrated its storage in the mountains of Wufeng, near Taizhong, Taiwan. The collection stayed there until 1965 when it was relocated to a permanent museum complex in Taipei. Until Chang Dai-chien moved to Taiwan in the 1970s, the two saw each other only on special visits.

Picking the Fungus of Immortality was completed on such an occasion. In 1953, Chang's friend Yu Youren (1878–1964), an official and poet-calligrapher, invited Chang to Taipei to hold a painting exhibition and review the holdings of the National Palace Museum. Chang visited with Chuang Yen on this trip, and the old friends went on an outing to the village of Tong. The painting is typical of Chang Dai-chien's artful integration of actual events and places—the secluded village and stooped figure picking a fungus—with a timeless view of nature's forms.

47 Playing the Zither under Cloudy Trees

August 9–September 7, 1953
Mounted for framing; ink and color on paper
92.5 x 61.5 cm (36³/₈ x 24¹/₄ in.)
Inscription and signature:
 Imitating the silk tapestry of Shen Zifan of the Song dynasty. The seventh
 lunar month of the *guisi* year; Dai-chien *jushi* Yuan.
Collection of Paul Chang, Pebble Beach, California

THE SUBJECT of *Playing the Zither under Cloudy Trees* is a solitary scholar. Seated on an animal-skin mat in a grove of phoenix trees, he strums a zither on his lap as oversized leaves fall from exaggerated trees. In fact, the painted landscape shows little concern for realism. Elements are treated as paradigms: fluffy white clouds look like thick cotton batting; leaves resemble jade pendants.

To render each element with utmost clarity, Chang Dai-chien employed the double outline (*shuanggou*) method. The brush strokes for the contours have a tensile strength; the forms themselves are filled in with strong colors. Two tones of blue—sapphire for the trim on the scholar's gown and turquoise for the ground cover—harmonize with the green foliage. Each leaf is arbitrarily divided into sections of light and dark green. Wisps of clouds are edged by a rosy hue that suggests sunrise. Since Chang Dai-chien was not concerned here with naturalistic depiction, he chose a parchment color for the sky to offset the gemlike colors of his subject and restrain the painting's decorative schema. The overall effect is a jeweled style, which is characteristic of Tang dynasty painting. Chang Dai-chien was not necessarily directly invoking Tang examples, but he was surely delighting in his love of decorative painting, which had been encouraged by his study of Tang dynasty art at the Buddhist caves at Dunhuang during the 1940s.

In his choice of subject, Chang may have been thinking of Tang dynasty poetry in which a sonorous zither vibrato echoing through the mountains is invoked as a common conceit. In Chang's painting it is almost as if the music shook the boughs free of leaves, which hover as if in a state of suspended animation.

Another layer of influence behind the archaistic and ornamental flavor in *Playing the Zither* was derived from Chen Hongshou (1598–1652), who painted quirky trees similar to these. Chen Hongshou's style has been described as "hyperrefined" by the art historian Sherman Lee, and the term applies as well to this work of Chang Dai-chien's. Chang treated each detail exquisitely but with little reference to reality. Chang did not mention Chen Hongshou in his inscription; instead, he invoked the name of Shen Zifan, a famous master weaver from the Song dynasty. Shen Zifan excelled at weaving scenes in the *kesi* weft-woven tapestry technique.

Traditionally the finest *kesi* tapestries are ascribed to Shen Zifan, although few are genuinely his. But even within a corpus of both genuine and attributed works, no tapestry has been found that has a composition related to *Playing the Zither*. Chang Dai-chien had admired Shen Zifan's tapestries since he was a young man, and textilelike emphasis on pattern and clear blocks of color in *Playing the Zither* probably reflect his interest in *kesi* weaving. Almost thirty years before he had painted *Playing the Zither*, Chang Dai-chien had already begun to exploit the heavy outlines and flat colors of *kesi* in *Pine, Plum, and Fungus of Immortality* (entry 2).

Chang Dai-chien's use of *kesi* tapestry was a playful twist on the established practice of weavers who copied existing paintings, even including calligraphic inscriptions and seal impressions, in tapestry. As a painter Chang was rare in his appreciation of a broad range of decoration and art media, and he was always open to innovation. Some of his contemporaries were so impressed with Chang's translation of the flat, brightly colored, graphic images of *kesi* tapestry into painting that they followed his lead. Chang had discussed the use of tapestry with his friend and colleague Yu Feian (1888–1959), some of whose paintings reflect textile design and owe their inspiration to Chang Dai-chien.

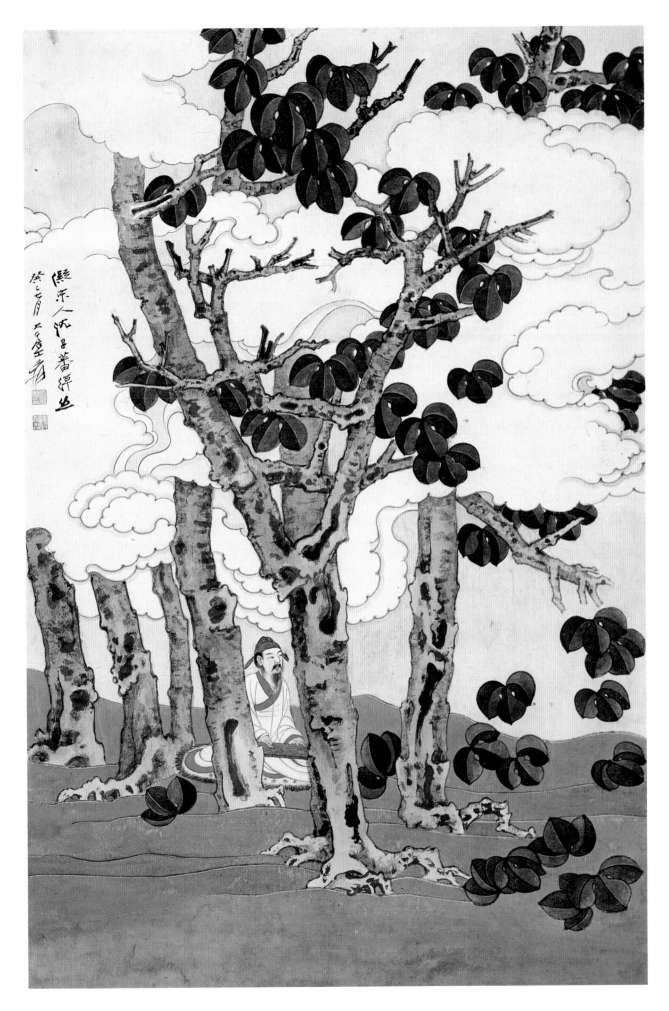

Playing the Zither under Cloudy Trees

48 Niagara Falls

Late 1953–early 1954
Rigid-board album leaf; ink and color on silk
52 x 38 cm (20¹/₂ x 15 in.)
Inscription and signature:

> Wrapped in the dense fogs of Chi You,
> like silk from the mermaid's palace;
> Lightning strikes, thunder rolling,
> and pearls of foam bubble and dance.
> The rainbow dragon sucks and blows,
> making the ocean waves stand on end;
> The giant tortoise puffs and pants
> and the mountains tremble and shake.
> The traveler from Shu sings wildly
> as the Milky Way comes pouring down;
> And Master Leather Sack is angrily
> rushing, white horses at the charge.
> Even one who plies ink freely with
> the utmost fluid strength and grace,
> Would still require a mighty brush
> and tremendous force to render this.

I composed this poem in the tenth lunar month of the *guisi* year [November 7–December 5, 1953], when I was visiting Niagara Falls in North America with several of my painter friends: Wang Yachen, C. C. Wang and his wife, and Zhang Mengxiu; Yuan.
SDA—Adapted from Wang Fangyu's translation

Collection of Wang Fangyu and Sum Wai, Short Hills, New Jersey

Chang Dai-chien was both a traditional Chinese painter and an international artist. His later splashed-ink-and-color paintings, which are akin to Western abstract expressionism, are a clear example of cross-cultural exchange. Some of Chang's quiet, simple works, however, such as *Niagara Falls,* reveal a subdued level of international influence found in many of his paintings from his émigré period. Chang eagerly painted breathtaking scenery throughout the world, and he insisted on the best quality materials for his works. Thus *Niagara Falls* is an American subject painted on a silk-covered, rigid-board album leaf made in Japan. Since the beginning of the Ming dynasty, Chinese artists have often painted views from their travels, and Chang Dai-chien extended the practice to include international travel.

Chang Dai-chien depicted the falls with accuracy, but all the figures in his painting wear the long gowns of ancient Chinese scholars. Chang himself affected this old-fashioned costume, insisting that modern clothing—whether Western dress or Chinese modifications of it—was unattractive. Even when painting a contemporary event he refused to depict current fashion. Thus, Chang's site-specific paintings are always a blend of reality and poetic vision.

Chang masterfully expressed the grand height of Niagara Falls in a small format painting. He extended the landscape to the very top, so that the rock cliff seems to reach directly to the border of heaven. Chang's ingenuity was challenged in this subject, since few paintings of waterfalls exist in the traditional Chinese repertoire. Historically, waterfalls have been treated as accents. In the monumental landscapes of the Northern Song dynasty, for example, a cataract invariably spills down a tall mountain. The contrast between ceaseless movement of water and immobile rock was thought to reflect the balance between yin and yang. The great painter Guo Xi (ca. 1001–ca. 1090) expressed the ideal relationship between water and mountains when he said water was like the earth's blood coursing through a mountain, and grass and trees were the mountain's hair. When taste in painting shifted toward the microcosmic views of nature prevalent during the Southern Song dynasty, artists continued to use water to make a landscape seem complete. The very word for "landscape," *shanshui,* literally means mountain and water. But in *Niagara Falls* Chang reversed the traditional relationship between land and water; here, water is the central focus.

Fu Baoshi (1904–1965) and Huang Junbi (b. 1898) frequently painted waterfalls, while Chang rarely did; he painted *Niagara Falls* to record a personal experience. Chang visited the falls in autumn 1953, coming from his home in Argentina to see his painter friends, Wang Yachen (1894–1983), C. C. Wang (b. 1907) and his wife, and Zhang Mengxiu (1912–1986), all of whom had expatriated from China to the United States. The group gathered in New York and drove along foliage-studded roads to reach Niagara Falls. There, they donned the rain gear provided to tourists and took the sightseeing elevator to the bottom of the falls. They walked along the wooden viewing platform that is faintly visible in Chang's painting behind a jutting rock and spraying water.

The trip inspired the men to make sketches, and afterward Chang Dai-chien painted three versions of the falls. This *Niagara Falls* is undated, but Chang noted in his inscription that he composed the verse at the time of his trip. Presumably the painting was done shortly thereafter.[1] It was rare for Chang Dai-chien to paint a landscape theme just three times; his depictions of the Yellow Mountains or Mount Emei number in the hundreds. The vigor of Niagara Falls fascinated him, but this most American of tourist attractions did not take root in his mind like images of his beloved homeland. After Chang moved to the United States in 1971, he visited Niagara Falls with some of his family and Zhang Mengxiu, who had been on the 1953 trip, but he was not inspired to paint the scene again.

1. A similar composition from a closer vantage point is also undated (current location unknown). In addition to these two paintings, still another Niagara Falls painting was recorded in an exhibition in Hong Kong in December 1954; a collector from Southeast Asia purchased the work (current location unknown).

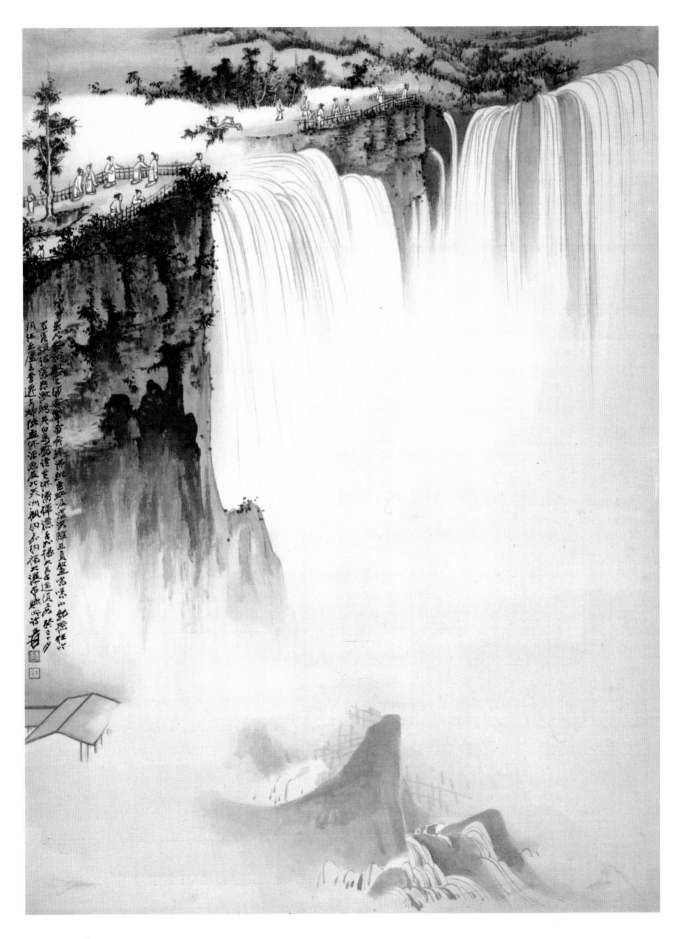

Niagara Falls

49 Retreat in the Yayi Mountains

Summer 1954
Hanging scroll; ink and color on paper
134 x 50.5 cm (52³/₄ x 19⁷/₈ in.)
Inscription and signature:
 Wang Shuming's [Wang Meng] *Dwelling in the Yayi Mountains* is a small
 scroll on paper. Twenty years ago in the old capital [Peking] I saw it; it
 completely follows Beiyuan [Dong Yuan] and is as marvelous as [Wang
 Meng's] *Dwelling in the Qingbian Mountains*. Painted from recollection on
 a summer's day in the *jiawu* year; Dai-chien jushi residing at São Paulo, in
 the town of Mogi.
Collection of Ching Yuan Chai; on extended loan to the University Art
Museum, University of California at Berkeley

WHEN CHANG DAI-CHIEN painted this scroll in summer 1954, his transformation of a tract of farmland in Mogi, Brazil, into a Chinese-style garden was beginning to bear results. Neither physical distance nor time ameliorated Chang's homesickness for China, which he fled after the communists' victory in 1949. Chang's memories of China sustained him, and *Retreat in the Yayi Mountains* was his re-creation from memory of a painting he had admired more than twenty years earlier in Peking.

According to Chang Dai-chien's inscription, he was following Wang Meng's (ca. 1308–1385) *Dwelling in the Yayi Mountains* (fig. 101), which he saw while it was still in a private collection.[1] But unless Chang's *Retreat in the Yayi Mountains* is placed next to Wang Meng's original, the relationship is difficult to ascertain. As a mature artist in mid-life, Chang felt self-reliant enough to alter his ancient models significantly, and this painting is among the freest copies he made.

Wang Meng commanded a broad range of brushwork. Usually he employed hemp-fiber and curly ox-hair strokes to texture the mountains he painted, although that is not the case in *Dwelling in the Yayi Mountains*. In that work, Wang Meng used a parched brush to describe the mountains with raspy strokes that resemble charcoal drawing. Chang Dai-chien, however, was interested in Dong Yuan (act. 937–976) at the time he painted *Retreat in the Yayi Mountains*, and so Chang substituted wet, fluent brush strokes derived from Dong Yuan for the dry brushwork of Wang Meng. As a finishing touch on the mountains, Chang employed short, wispy ox-hair strokes derived from Wang Meng, although Wang had barely used these texture strokes on his *Dwelling in the Yayi Mountains*.

Chang Dai-chien was most impressed by the composition of *Dwelling in the Yayi Mountains*, and his painting most closely resembles this aspect. Wang Meng, however, painted his mountains pressing close to the surface of the picture plane with a sense of bursting fullness, while Chang worked on a reduced scale. Chang also set the mountains farther back in space and eliminated a piece of shore that Wang Meng depicted in the left foreground. Chang's mountains seem more succulently fertile and have clumps of heavy "moss" dots, but this change derives from the style of brushwork rather than a desire to alter the composition. Chang's *Retreat in the Yayi Mountains* stands as an independent work rather than as a copy.

Chang's references to Wang Meng and Dong Yuan reflect both Chang's longing for China and his sincere delight in creating paintings with art historical references. Allusions to the past are endemic in the literati-painting tradition and provide an intellectual framework that challenges the viewer and thereby enhances the pleasure to be derived from a painting. References to paintings of earlier artists also produced some playfully eclectic compositions. For example, Chang reproduced the distinctive beehive-shaped hut from Wang's *Dwelling in the Yayi Mountains* not only in *Retreat in the Yayi Mountains* but also in a loose copy he made of Wang Meng's masterpiece *Dwelling in the Qingbian Mountains* (entry 38), which had no such hut. Chang seemed to regard Wang Meng's work as one large tableau from which he could choose elements at will for his own creations. In this manner Chang tested his audience's knowledge of the history of art. The challenge in *Retreat in the Yayi Mountains* might have eluded all but the best educated viewer, however, had the inscription not acknowledged Wang Meng.

1. The importance of the painting was not recognized until 1987, when the Group for Authentication of Ancient Works of Chinese Painting and Calligraphy published it in the catalogue *Zhongguo gudai shuhua tumu*, vol. 2 (Shanghai: Wenwu chubanshe, 1987), 120, pl. 1-0249.

Fig. 101. Wang Meng, *Dwelling in the Yayi Mountains*. Hanging scroll; ink and color on paper; Shanghai Museum. From Group for the Authentication of Ancient Works of Chinese Painting and Calligraphy, *Zhongguo gudai shuhua tumu*, vol. 2 (Peking: Wenwu chubanshe, 1987), 120, pl. 1–0249.

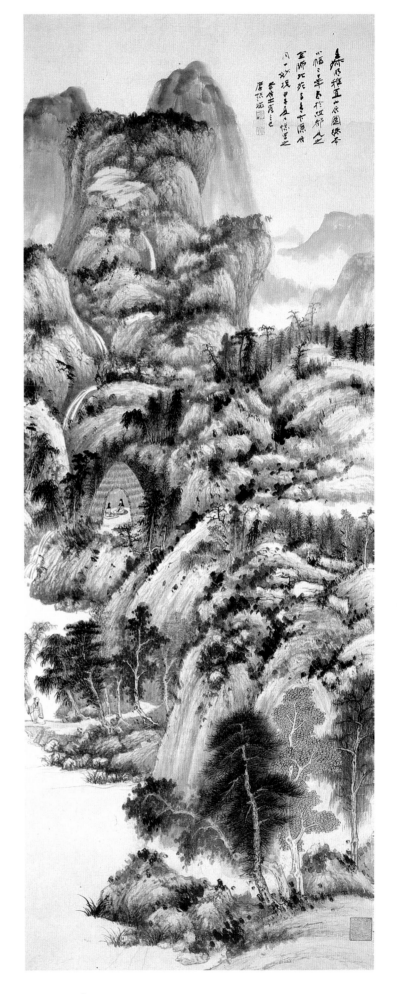

Retreat in the Yayi Mountains

50 Portrait of the Artist's Father

October 12, 1954
Hanging scroll; ink on paper
132 x 65.5 cm (52 x 25³/₄ in.)
Inscription and signature:
> A posthumous portrait from memory of the master for governance [Chang Zhongfa]; on the *jiwang* day of the ninth lunar month in the *jiawu* year by the unfilial son Zhengchuan.

Collection of Mr. and Mrs. C. Y. Lee, São Paulo, Brazil

I N 1683 Chang Dai-chien's scholar-official ancestors relocated from Hubei Province to take a post in Neijiang, Sichuan Province, where the family lived until Chang Dai-chien's generation. At that time they were no longer a scholar-official household. Chang's father, Chang Zhongfa (1860–1925), was a salt merchant who went bankrupt while Dai-chien was a boy. His mother, née Zeng Youzhen (1860–1936), helped support the family by selling her paintings of flowers and animals and designing embroidery.

Chang Zhongfa spent most of his life in Neijiang, but as an old man he followed his son Chang Shanzi (1882–1940) to Songjiang in Jiangsu Province, where Shanzi had been appointed prefect in 1923. "Master for governance" (*fengzheng gong*), as Chang Dai-chien referred to his father on this painting, was a "prestige title" (*sanguan*) related to Chang Shanzi's position and bearing no official duties. During the Ming and Qing dynasties, any official who completed three years of government service could use an appropriate prestige title and request that the same title be conferred, even posthumously, on his father and grandfather.

Little is known about Chang Zhongfa's personality except from casual remarks by Chang Dai-chien and his siblings. A few family resemblances are obvious, however, such as the full beard that both Chang Dai-chien and Chang Shanzi inherited from their father. From Chang Zhongfa's hobby of breeding dogs, the sons learned to have tender affection for animals. Both Shanzi and Dai-chien raised animals at their homes and made exotic pets of tigers and gibbons.

Chang Dai-chien lived for a while with his father and Chang Shanzi in Songjiang. In 1924, one year before Chang Zhongfa died, the brothers jointly painted his portrait depicting him beneath a willow tree near a lotus pond. Even after his father died, Chang Dai-chien continued to paint his likeness; the family commissioned a series of porcelain plates emblazoned with one of Chang Dai-chien's earliest posthumous portraits of Chang Zhongfa (fig. 102). *Portrait of the Artist's Father*, dated 1954, was painted more than a quarter century after Chang last saw his father. Like other posthumous portraits, it was based on a photograph.

In this portrait Chang Dai-chien painted his father wearing the traditional clothing of a late Qing dynasty gentleman. With light ink and sketchlike strokes, Chang brushed the image of his father in a frontal, three-quarter-length pose. Then, as a second stage, he loosely went over the same lines with dark ink, cleverly exploiting the effect of these double lines to give the impression of volumetric mass. Finally, Chang added light shading, especially on the brow and beneath the eyes. While most traditional Chinese portraits are idealized, Chang Dai-chien did not shy away from showing the details of age, such as crow's-feet wrinkles around the eyes. His father seems somber, even frail in this painting, but the emphatic dash of dark, wet ink that Chang applied when painting the beard hints at the inner vitality Chang Zhongfa possessed.

Chang Dai-chien was far from the world of his childhood when he painted this portrait. He had left China in 1949 and in 1954 had just settled in Brazil, where he was transforming his new property into a Chinese-style garden. While designing this garden, Chang kept searching his memory for favorite spots in China that he wanted to evoke in Brazil, and he dwelt on memories of family and scenery left behind.

The signature that Chang Dai-chien used on portraits of his father is not that which he used on other paintings. He signed the portraits with the name "Zhengchuan," often preceding it with the conventional, humble phrase "unfilial son." Zhengchuan was the name his parents gave him, but he rarely used it after he went to Shanghai in 1919, after which he was known either as Chang Dai-chien, a name given him by a Buddhist monk, or as Chang Yuan, a name given him by his calligraphy teacher. Out of respect for his father, Chang Dai-chien signed his childhood name.

As another gesture of filial respect, Chang did not place a seal mark beneath his signature on *Portrait of the Artist's Father*. A seal impression in red, an auspicious, joyful color, was traditionally taboo when someone was commemorating a deceased parent or in a period of mourning. In these cases, black or yellow seal-paste would be used, but Chang preferred not to use any seal. Perhaps by 1954 he no longer had a seal with Zhengchuan carved as the legend, since he so rarely used that name.

Fig. 102. Chang Dai-chien,
Portrait of the Artist's Father.
Porcelain plate; collection of
Chang Hsu Wen-po.

Portrait of the Artist's Father

51 Joy of Fish

September 27–October 26, 1954
Hanging scroll; ink on paper
91 x 45 cm (35⁷/₈ x 17³/₄ in.)
Inscription and signature:

A

Springtime on the dam above the river Hao
 Just calmly watching brings me joy.
 Fish are naturally so full of life,
Why talk of spewing each other with spit?
Ninth lunar month of the *jiawu* year; Chang Yuan.
SDA

B

In the second lunar month of the *yiwei* year [February 22–March 23, 1955],
given to my "niece" [Li] Xieke; Dai-chien Yuan.
Collection of Paul Chang, Pebble Beach, California

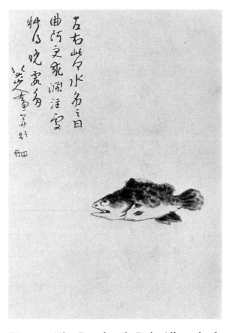

Fig. 103. Zhu Da, detail, *Fish.* Album leaf; ink on paper; Sen-oku Hakko kan, Kyoto, Sumitomo Collection. From *Bunjinga suihen,* vol. 6, *Hachidai Sanjin* (Tokyo: Chuo Koronsha, 1977), 32, pl. 28.

CHANG DAI-CHIEN's first ancient models for painting were the seventeenth-century individualist painters, especially Shitao (1642–1707) and, in a less pronounced but significant way, Zhu Da (1626–1705). Chang Dai-chien admired Zhu Da's abbreviated, enigmatic painting style and emulated his landscapes, rocks, and flora and fauna, especially birds, fish, fruits, vegetables, narcissus, lotuses, and banana and pine trees. Throughout Chang's entire career he enjoyed painting in Zhu Da's style and found his spontaneous, inky brushwork relaxing after working in a detailed, ornamental manner.

In *Joy of Fish,* Chang did not directly copy Zhu Da but evoked his spirit through subject and general manner. Chang Dai-chien believed that Zhu Da's paintings were best suited as a springboard for an artist; he did not copy Zhu Da's droll animal and fish images stroke by stroke as he did some of his ancient models. In *Joy of Fish* only the small fish are markedly close to Zhu Da's typical images (fig. 103). The large mandarin fish, which darts about with its fleshy lips parted, gills and tail almost visibly palpitating, is unique to this painting. Among Chang's images of fish—which number at least one hundred—this is probably the most realistic and largest he ever painted.

Joy of Fish was executed with a minimum of energetic brush strokes. The fish seem so animated that they imply the presence of water without a single direct brush stroke depicting water. The five small fish appear from different angles and have individual personalities. Some were rendered with pools of dark ink, while Chang used more controlled outlines for others. Succulent bamboo and bold, wet calligraphy at the top of the composition contribute mass to the otherwise sparse arrangement.

Six years after he painted *Joy of Fish,* Chang Dai-chien described his admiration for Zhu Da and explained what he wanted to express when painting this subject.

To paint fish, one must be able to express the ease and freedom with which fish move in water. If the fish should appear to be out of water, that would be tantamount to divorcing them from their natural instinct. If when painting one can create the sensation of water without delineating it, this is true finesse. Among the ancients, Yuan Yi [act. 923–936] of the Five Dynasties and Liu Cai [d. ca. 1123] and Fan Anren [act. 1253–1258] of the Song dynasty are famous for their skill in painting fish; they all painted in the detailed *gongbi* method. Indeed, their works are admirable as art and they have no faults. However, the one I adore is Bada Shanren [Zhu Da], whose superb technique enabled him to give full expression to fish by means of very simple compositions and brushwork and to reach the ideal state of being at one with his subject. Shanren's artistic accomplishment must have passed through innumerable hours making observations and pondering before he could transform his technique from the complex to the simple without impairing its full capacity for expression. Let us examine the mouth,

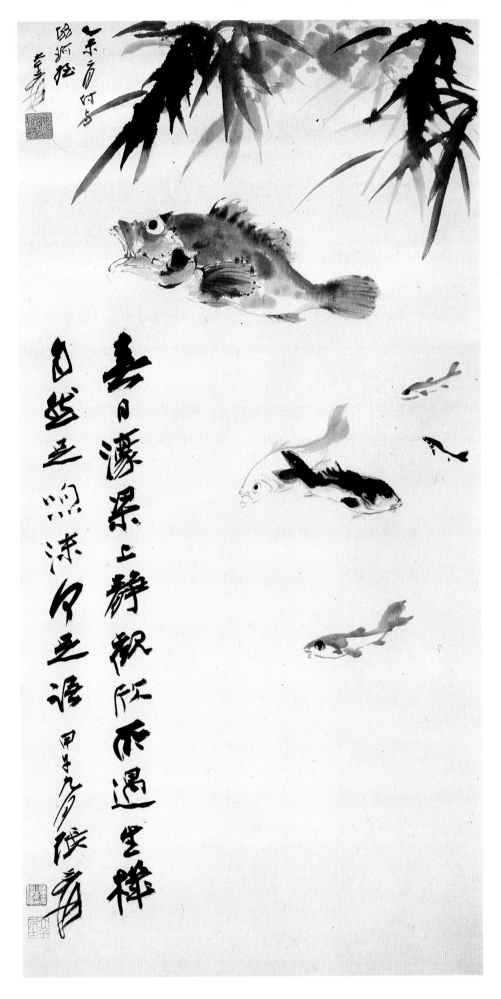

Joy of Fish

eyes, gills, dorsal fins, back, paddle fins, tail, and abdomen of the fish he has painted. Is there any of these that does not reflect the subtle ingenuity of the painter? Moreover, the fish are of various species, each having its own manner and appearance as it moves. Yet whatever Shanren painted, he never failed to capture all the wonder [of the fish]. We should take him as a master teacher forever, but that is not to say that we should exactingly copy him. We should study his devotion and attitude; otherwise, if we blindly imitate him, then we will just be slaves of the master.[1]

Emulating Zhu Da's creative approach but not necessarily his technique, Chang Dai-chien depicted subjects Zhu Da had never painted, and Chang captured the same vitality and humor that marked the seventeenth-century master. Gradually Chang felt he surpassed Zhu Da. In 1969 he inscribed a painting in which he had followed Zhu's manner to depict a bird on a rock and a swimming fish: "Even Geshan's [Zhu Da] most satisfactory work is not like this."

Often the subjects that Chang Dai-chien chose to paint were related to events in his life as well as to an intellectual desire to revive some mode of traditional painting. Chang painted *Joy of Fish* during his first year at his Brazilian farm, which he was developing into a Chinese-style garden. In 1954 he began excavating a large lake for fish and lotuses; it would eventually be surrounded by bamboo transplanted from Japan. Chang so enjoyed the fish that he built five kiosks around the lake from which he could watch them. The exuberance of *Joy of Fish*, like Chang's industrious garden-building project, attests to his physical and intellectual energies during the early 1950s.

Beyond the direct connection with his Brazilian garden, fish are a traditional motif in Chinese art. They are symbols of a life force, vitality, fertility, and abundance.[2] Certain metaphysical references to fish that appear in the third century B.C. text known as the *Zhuangzi* appealed to educated Chinese. Chang's inscription on *Joy of Fish* alludes to a famous passage in Book 17, "Autumn Floods," which recounts a conversation between Zhuangzi and Huizi as they walked along the Hao River in Anhui Province. Zhuangzi remarked:

"See how the minnows dart in and out so free and unconcerned. That's what fish enjoy."
Huizi replied, "You aren't a fish. How do you know what pleasures fish enjoy?"
Zhuangzi said, "You aren't me. How do you know I don't know what pleasures fish enjoy?"
Huizi said, "I'm not you, so I certainly don't know what you know. On the other hand, you are certainly not a fish—so that still proves you don't know what fish enjoy."
Zhuangzi replied, "Let's go back to your original question, please. You asked me how I know what fish enjoy—so you already knew it when you asked the question. I know it by standing here beside the Hao River."[3]

The last line in Chang's verse refers to "spewing spit," an image in *Zhuangzi* that suggests the generous actions of fish when trapped by circumstances of adversity. Zhuangzi remarked:

When the springs dry up and the fish are left stranded on the ground, they spew each other with moisture and wet each other down with spit—but it would be much better if they could forget each other in the rivers and lakes![4]

Thus Chang Dai-chien's painting and inscription call forth philosophical reflections both on humankind's ability to transcend the self and on the tension between social responsibility and freedom.

Chang Dai-chien kept *Joy of Fish* for a year before he presented it to his daughter-in-law, née Li Xieke (1928–1985). Li Xieke was married to Chang Dai-chien's son Paul; both were delighted with *Joy of Fish,* and Paul later commented to the author, "Bada [Zhu Da] could not necessarily achieve anything better than this."

Chang Dai-chien was a greater technician than Zhu Da, so he brought superior realism to *Joy of Fish*. In spite of Chang's mastery, his painting does not elicit the same response of deep serenity that Zhu Da's round, heavy brush strokes do. Indeed, Chang's skillfulness ultimately prevented him from capturing the naivete of Zhu Da, which was better suited to pose the question of whether a man can know the joy of fish.

1. Translation adapted from Gao Lingmei, ed. *Chang Dai-chien hua* (Hong Kong: Dongfang yishu gongsi, 1961), 78. The Chinese text appears on the same page.

2. Tseng Yu discusses the symbolism of fish in Chinese art in "Castiglione: First Western Painter of Underwater Fish," *Orientations* 19, no. 11 (November 1988): 52–60.

3. Translation adapted from Burton Watson, trans., *The Complete Works of Chuang Tzu* (New York: Columbia University Press, 1968), 188–89.

4. Ibid., 80 and 163.

52 Ten Sages

April 30, 1955
Handscroll; ink and color on paper
24.1 x 216.4 cm (9¹/₂ x 86¹/₈ in.)
Inscription and signature:

This year my young son Hsin-yin is five *sui* [four years old] and he has already taken up a brush to study painting. His precocious talent touches me as I reach the closing years of my life, and happy fulfillment comforts me. But I dare not praise him in front of others; I fear knowledgeable people will ridicule me, saying that I have the same malady that Mi Fu [1051–1107] showed when promoting his son [as a great painter]. One morning after getting up, I asked my young attendant to wash my inkstone; Hsin-yin suddenly brought a scroll of paper and cheerfully asked me to paint. Later, when he is grown up, [I hope he will] take it to a few of his father's closest friends for them to appraise and know the depth of this father's love for his son. The ninth day of the third intercalary lunar month of the *yiwei* year; Dai-chien jushi Yuan.

Collection of Chang Hsin-yin, Los Angeles, California

CHANG DAI-CHIEN depicted ten scholarly figures in this handscroll, which he began at the request of his ninth son Chang Hsin-yin. Hsin-yin, born in 1951, was the youngest of Chang Dai-chien's sixteen children, the only child born after Chang and his fourth wife Hsu Wen-po expatriated from China. Chang Hsin-yin was born in Hong Kong, but because he was conceived in India his parents used the word *yin*, which means "India," in his name. Chang Hsin-yin was a coddled child, and Chang's long inscription on *Ten Sages* reflects his affection for the boy.

Using neither background elements nor bright colors to embellish the figures, Chang Dai-chien evinced great artistry in making the ten sages seem so engaging. He arranged them in three groups and depicted them in various poses. Recalling the precedent of ancient paintings, Chang arrayed the figures across the paper against a void.

From the right, the first group consists of a straight-backed scholar and a stooped gentleman with a bamboo staff. The bent scholar wears a gauze hood like the poet-recluse Tao Qian (365–427) used to strain his homemade wine; the hood became a symbol of a lofty recluse. Chang owned a painting by Zhang Feng (act. 1628–1662) that depicted Tao Qian in a manner much like this scholar, suggesting at least one source for *Ten Sages* (see fig. 67).

In the second group of figures a white-haired gentleman faces two slightly younger, bearded gentlemen. Hanging from the pole balanced on the one man's shoulder is a bundle of fungus of immortality and herbs. Chang left a wide space between the herb gatherer and the final group of figures, which consists of four seated and one standing gentlemen. The vacant space is balanced by another that separates the tight group of seated figures and the upright sage. Those resting on the ground are presented from different angles; one is seen in strict profile and leans backward as if inebriated. One stern sage brandishes a fly whisk, a sign of erudition. The standing figure approaches this group hoping to join their conversation. All of the figures are bearded. Chang Dai-chien's long beard, something of a personal trademark, may explain in part his predilection for bearded figures.

The figures in *Ten Sages* are unusual for their variety and animation. Chang's scholars were often idealized and repetitious, but here he created distinct types: old, middle-aged, portly, lean, pensive, and tipsy. Only the style of dress is repetitive, with the loosened robe and the gauze hood of the stooped figure being the only exceptions.

In spite of the spontaneity and fairly rapid execution of *Ten Sages*, Chang Dai-chien successfully gave the figures corporeal mass. First he sketched them in light ink and pale red ocher made from iron oxide. Then he made final outlines in

detail, *Ten Sages*

Fig. 104. Anonymous, *Qu Yuan*, from *Nine Songs*. Album leaf; ink on paper; The Metropolitan Museum of Art, New York, Fletcher Fund, 1973.121.15a.

dark ink, exploiting the double, imperfectly superimposed lines to create an illusion of shading and three-dimensionality. Chang once commented that this technique, especially the use of red lines, was derived from Buddhist figure painting in the caves at Dunhuang, which he studied in the early 1940s. But one of his prized possessions, an album entitled *Nine Songs* that he believed to be by Zhao Mengfu (1254–1322), was also an inspiration (fig. 104). The figures in *Nine Songs* were sketched in light ink and retraced with dark ink. Chang copied this album in 1946 and on many occasions mentioned its influence on him (see entry 78).

Chang Dai-chien painted *Ten Sages* at his home in Brazil. He had just returned from Asia and was working to transform his farmland into a Chinese-style garden. Although he was in prime physical and intellectual condition at the time, this was to be one of his last small-scale, fine-line works before he began losing his eyesight. Years later he gave a similar work, painted about the same time, to his son Hsin-yin. Its postscript suggests Chang's recognition of his loss:

This was painted six years ago. I found it accidentally in my luggage and give it to Hsin-yin to keep. My eyes have not been well for three years. I inscribed this in the early summer of 1960 to commemorate my son Yin's tenth birthday.[1]

1. Quoted in René-Yvon Lefebvre d'Argencé, *Chang Dai-chien: A Retrospective Exhibition*, (San Francisco: Center of Asian Art and Culture, 1972), 84.

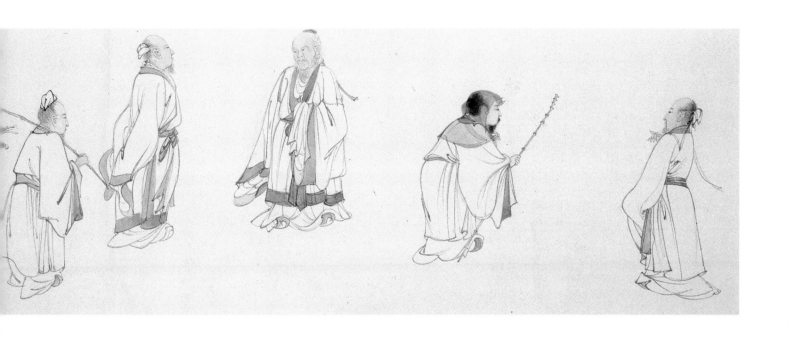

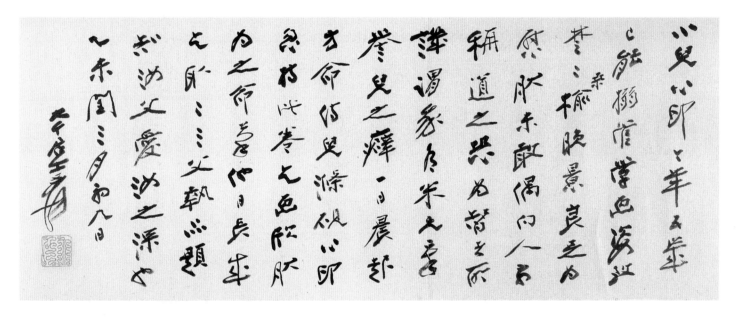

inscription, *Ten Sages*

September 29, 1955
Rigid-board album leaf; ink and color on paper
52 x 38 cm (20¹/₂ x 15 in.)
Inscription and signature:

An old fellow, wherever I have been in life,
I've been happy with my lot;
A hundred years have gone in a flash:
I eat well and talk well and even walk well,
So it needn't be my own country I gaze upon.

The scenery detains me, so I'll stay awhile,
And buy a wilderness garden;
Smiling at my sons, I set their task:
Plant a few *wutong* trees outside the bamboo,
Where the phoenix can roost and not go home.

[To the song title] *Feng qi wu* ["A Phoenix Roosts in the *Wutong* Tree."]

I composed these stanzas on moving from Mendoza [Argentina] to São Paulo [Brazil] in the second lunar month of the *jiawu* year [March 5–April 2, 1954]. That year I bought a hundred *mu* of poor land south of Mogi City [to cultivate] some mulberries and hemp, beans and wheat. I also had my sons and nephews plant flowers and bamboo so that I might forget somewhat my sorrow at being a refugee. Mid-autumn's eve of the *yiwei* year; Chang Dai-chien Yuan from Shu [Sichuan Province].
SDA—Adapted from Wang Fangyu's translation
Collection of Wang Fangyu and Sum Wai, Short Hills, New Jersey

CHANG DAI-CHIEN'S love of landscape found expression both in painting and in landscape design, and almost everywhere he settled he created a classical Chinese-style garden. In 1953 he purchased a farm in Mogi, Brazil, and *Planting Phoenix Trees in My Garden* represents Chang's dream of what the garden should look like when finished. The huge rocks that serve as imitation mountains, the surrounding bamboo evoking a lush wilderness, and the stream representing a mountain river all demonstrate Chang's faithful adherence to the principles of classical Chinese garden design and his lack of concession to the Brazilian landscape. The gigantic rock riddled with holes, for example, is the type of stone excavated from Lake Tai in China, not a Brazilian boulder. Where Chang actually had to be content with local substitutes, in *Planting Phoenix Trees* he could recapture his favorite rock specimens from his memory of Suzhou, where he had resided during the 1930s.

The stream in the painting meanders through the garden, crossed by occasional stone slabs. On the far side of the waterway, a worker with a hoe in hand waits for instructions from the garden proprietor, who represents Chang Dai-chien. The worker gently pats a phoenix tree (*wutong*), presumably one he has just planted, as the sprawling inscription suggests. The proprietor checks its placement.

About a month after Chang Dai-chien completed *Planting Phoenix Trees,* he transcribed the same poem on another painting of a similar subject, but he also noted, "In the small garden, myriad bamboo were planted so they could grow and proliferate, making a dense forest of jade."[1] Brazil's hot, humid climate and soil were ideal for growing bamboo, although it was not an indigenous plant. Chang brought bamboo shoots from Japan and, as the inscription attests, they flourished into a jade green screen.

Planting Phoenix Trees and the similar painting he finished a month later suggest that Chang still longed for China but that re-creating a traditional Chinese garden helped ease his homesickness. Both subject and style in *Planting Phoenix Trees* are personal; the painting is more independent of ancient models than most of Chang's previous work. Yet it has an antique elegance that is communicated not only by the old-fashioned style of clothing but by the brushwork itself. Chang Dai-chien had so assiduously copied the ancient masters in his early career that he made their "iron-wire" and "floating silk" brushwork his own.

However much he missed China, Chang was flexible enough to adjust to self-exile and to create a new life. The painting conveys both contentment with his new circumstances and abhorrence for the Chinese communists. The phoenix that Chang mentioned in the last line of his poem probably refers to himself. In Chinese lore, the phoenix is reputed to alight in a *wutong* tree (which is therefore called a phoenix tree in English) when there is righteousness. In Chang's view, after the Communist Revolution, China was no place for a phoenix—or for Chang himself—and the majestic bird, like Chang, had to go elsewhere to roost.

1. Gao Lingmei, ed., *Chang Dai-chien hua ji* (Hong Kong: East Society, 1967), 74.

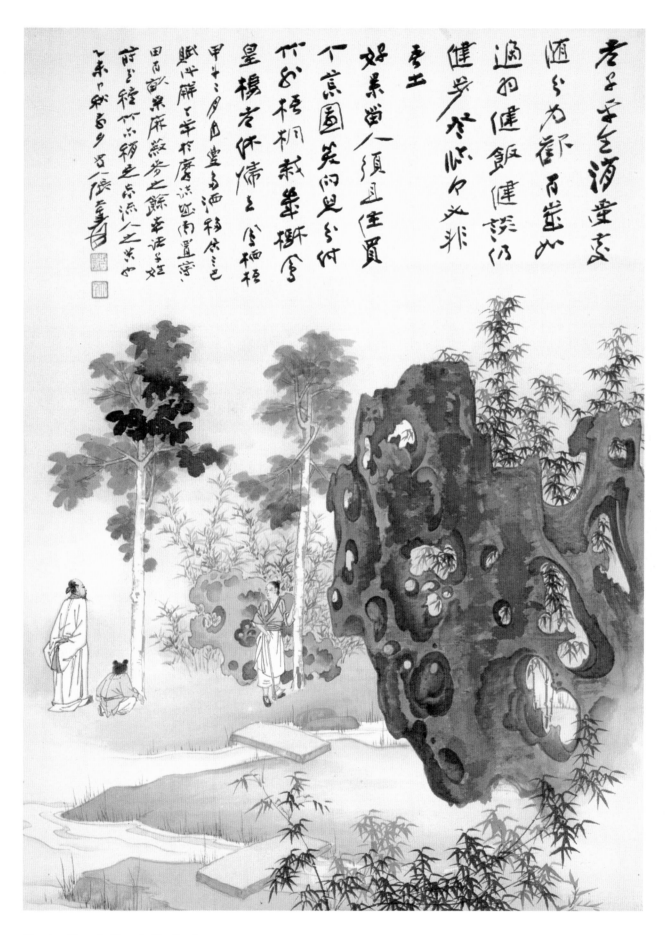

Planting Phoenix Trees in My Garden

54 Mount Emei

November 14, 1955
Hanging scroll; ink and color on paper
190 x 87.5 cm (74³/₄ x 34¹/₂ in.)
Inscription and signature:

> I called on Dong and Ju at the beginning,
> But Jing and Guan may look better suited.
> Among the clouds, the summit shows green,
> Its brows stretch, azure, across the sky;
> Spiraling aloft in majestic convolutions,
> It blocks out the sun and moon till late.
> And I myself am truly but a mustard seed,
> Whose tiny image fails to capture Sumeru.

Mount Emei is enveloped in clouds and mist throughout the year. So in order to capture the flavor of these spontaneous fluctuations, one must use the styles of Beiyuan [Dong Yuan] or Honggu [Jing Hao] in seeking [to depict] it. Painted on the first day of the tenth lunar month in the *yiwei* year in my rented rooms at the Hodaiso in Yushima, Tokyo; Chang Dai-chien Yuan from Shu [Sichuan Province].
SDA

Collection of Musée Cernuschi, Paris; M.C.8769

CHANG DAI-CHIEN frequently painted the majestic mountain scenery of his home province of Sichuan. Especially after 1949, when he lived abroad as an expatriate, his memories of oft-visited retreats in the Qingcheng and Emei mountain ranges inspired and comforted him. Chang painted *Mount Emei* while living in a rented house near Tokyo, but the cloud-capped peaks were rendered with such force that it is hard to believe he had not seen them for almost seven years. They lived in his memory, for he had visited Mount Emei four times to explore and to paint. The mountains had offered him not only the solitude to paint while the fighting between China and Japan raged around him but also the same kind of monumental landscape that artists of the Five Dynasties and Northern Song dynasty painted.

Mount Emei is a famous Buddhist pilgrimage site located about an hour's drive from the colossal Buddha at Leshan and 168 kilometers from the provincial capital of Chengdu. The mountains rise precipitously from a basin in the west of the province. Of Emei's three peaks, the best known is Jinding, or Golden Summit, which is 3,100 meters above sea level.

Although Mount Emei is close to Chang Dai-chien's childhood home, he did not explore it until his late thirties, just after he had fled the Japanese occupying forces in Peking. In the summer of 1939 he and his friend, the artist Huang Junbi (b. 1898), climbed Emei together. The trip lasted more than a month, as the two artists stopped at temples along the way and sketched the scenery and Huang took photographs. Chang made a second visit during autumn 1944 after he had returned from Dunhuang in Gansu Province. This time he took seven people with him including one of his wives, a

nephew named Peter, and other family and students. In early autumn 1946, Chang made a third trip, leading a gregarious group of more than twenty people. His companions again included one of his wives as well as several children, his older brother Chang Wenxiu (1885–ca. 1970), and students. They frequently stopped to paint the scenery, and they celebrated the Mid-Autumn Festival by climbing to the top of Jinding by candlelight and viewing the full moon. Later the same night, in their temporary mountain lodging, Chang was so exhilarated that he began to paint. This trip also lasted more than a month, and as the group descended, they stopped at the temples that had offered them hospitality so that Chang could present paintings to the abbots. His final and shortest trip to Emei was in 1948 with students and family members.

Like most other artists who painted Emei, Chang Dai-chien painted the well-known Jinding as the tallest peak, though it is not technically the highest. Chang also manipulated the truth by painting the three major summits as if they could be seen from a single vantage point. Perhaps this fanciful perspective derived from a flight during the war, when enemy fire between Chongqing and Chengdu forced the pilot to reroute the flight and circle Emei, enabling Chang to view the three peaks together as the pilot pivoted about them.

In his inscription Chang both explained the stylistic sources of *Mount Emei* and admired the complex geological forms that challenge painters. Chang depicted these forms with an unorthodox combination of past styles. He used long, supple hemp-fiber strokes derived from Dong Yuan (act. 937–976) to articulate the two tallest peaks. But for the surging form of the lower mount, which is heavily pitted and studded by stalactites, he recalled the choppy strokes and stippled dots of Jing Hao (act. 870–930).

Chang had learned that if he wanted to follow past conventions, he had to rework the styles in light of his personal experience. Chang seamlessly melded artifice and natural beauty in *Mount Emei*, which represents the pinnacle of his monumental landscapes.

Chang was particularly attracted to Mount Emei during the 1940s and early 1950s as he was studying monumental landscape paintings. To him art and nature were two elements on a continuum; what he saw in the real world influenced his painting, but at the same time what he saw in painting affected his perception of reality. As Chang Dai-chien sought to emulate Dong Yuan and Jing Hao, he looked to nature to provide him with appropriate subjects for their brushwork. And as the early artists typically painted a mountain with a "host" peak and two "guest" peaks, the steep rise of Mount Emei's three summits was ideal.

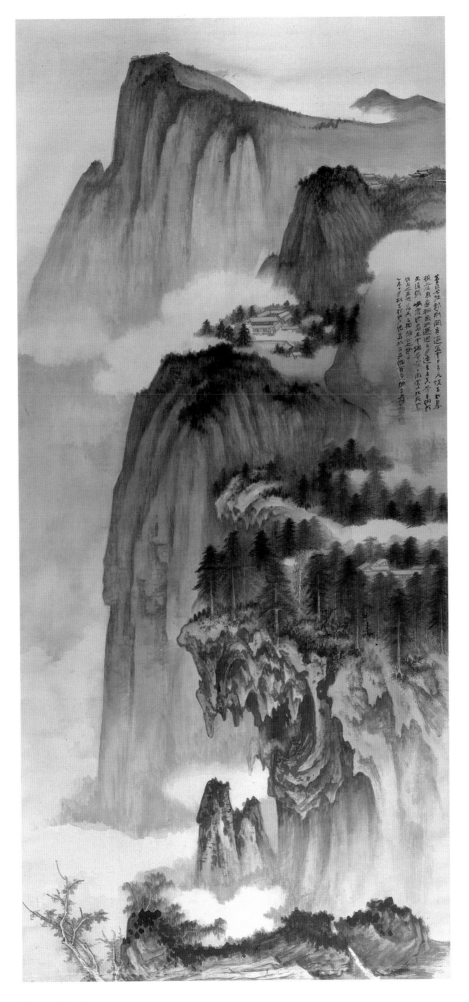

Mount Emei

September 21–October 19, 1960
Hanging scroll; ink on paper
133.5 x 65 cm (52⅝ x 25⅝ in.)
Inscription and signature:

> Mountain lads cut bamboo shoots
> and sell them at the window,
> And soon as we have bought some,
> we quickly have them cooked.
> There's only Master Huang Junbi
> who understands my meaning,
> Twenty years of mundane matters
> did not vanquish his desire.

Long ago, when Huang Junbi went with me on a trip to the Yandang Mountains [in Zhejiang Province], there were fresh bamboo shoots growing beside the trail which we cooked up as soon as they were dug. The excellence of their flavor was beyond anything even a famous chef could have concocted, for this was their true [natural] flavor.

> I beckoned to my fine companion
> to view the flying cascades,
> And we passed by the temples to
> Maiden Cao and Yu the Great.
> But while such happiness can be
> recaptured in our lifetimes,
> When will we cook bamboo shoots
> once again beside the trail?

In the *xinmao* year [1951], when I returned to Taiwan and took up residence on Yangming Mountain, I bought some bamboo shoots which were very sweet when cooked to eat. And since Junbi happened to come for a visit, I composed these two poems to gain his instruction. But now nine years have quickly passed again. Eighth lunar month of the *gengzi* year; Dai-chien *jushi* Yuan.
SDA
Collection of Chang Ch'eng-hsien, California

Tʜᴇ ᴡᴇᴛ succulence of the bamboo shoots, the clods of freshly disturbed soil, and the tangled grasses marking where the shoots were pulled are a visual testimony to Chang Dai-chien's inscription. With emphatic brushwork that seems to leap across the paper, Chang expresses his good humor and nostalgia. The spontaneity of the painting delights the viewer more than the accuracy of its representation, yet Chang's sharp strokes for the bamboo leaves and grass capture their fast-growing nature.

Since the painting was executed on the spur of the moment, Chang did not bother to note any precedents in his inscription; however, the uninhibited, kinesthetic brushwork of Xu Wei (1521–1593) is an obvious inspiration. Xu Wei often reduced nature to emblematic images, such as a single branch of bamboo (fig. 105) or a clod of earth with calamus grass against a blank background. He typically added a poetic inscription. Chang followed suit but with a fuller setting. As in Xu Wei's best paintings, Chang's ebullient brushwork—a world of abstract form—commands more interest than the subject itself.

Chang painted *Bamboo Shoots* in 1960 and inscribed the work with poems composed nine years earlier during a visit from his friend and fellow painter Huang Junbi (b. 1898). In 1951 Chang had been living in the outskirts of Taipei on bamboo-clad Yangming Mountain. He bought sweet bamboo shoots from a vendor, and when he and Huang tasted them they recalled a trip they had made in 1937 with three others—Fang Jiekan (1903–1987), Yu Feian (1888–1959), and Xie Zhiliu (b. 1910). The five artists had been in Nanjing to judge the Second Annual National Art Exhibition, and afterwards they made a scenic excursion to Zhejiang Province to see the Yandang Mountains and the renowned waterfalls of Dalong-jiu. The friends were separated in 1949, when Chang Dai-chien and Huang Junbi left China. *Bamboo Shoots* is a chain of memories: eating bamboo in 1960 reminded Chang of Huang's visit in 1951, which triggered a memory of their trip in 1937. Nostalgia for friends left behind in China makes even a simple painting like this a repository for deep emotion.

When Chang Dai-chien painted this work, he was living at Bade Garden in Brazil, where he had settled in 1954. His project to transform his Brazilian farmland into a Chinese-style garden was largely completed. The following year he began constructing a garden lake and introducing bamboo imported from Japan around its perimeter. The plants thrived; in fact, Chang may have painted *Bamboo Shoots* after picking the tender morsels in his Brazilian garden.

Soon after Chang painted *Bamboo Shoots*, he exhibited in Paris and Brussels, but he did not show this work there. Chang had learned that his audience wanted more elaborate paintings of landscapes or birds and flowers. Even a vibrant "ink-play" like *Bamboo Shoots* would not bring a high price, so Chang preferred to keep it for himself.

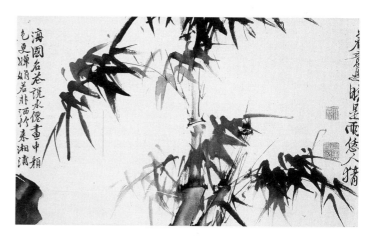

Fig. 105. Xu Wei, detail, *Twelve Plants*. Handscroll; ink on paper; Freer Gallery of Art, Smithsonian Institution, Washington, D.C., 54.8.

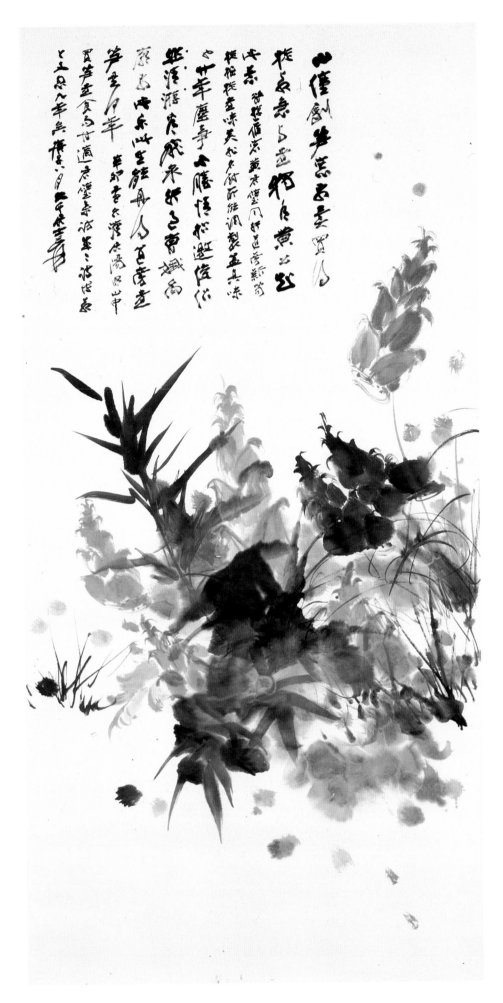

Bamboo Shoots

56 The Cave of Three Visitors

November 19–December 17, 1960
Hanging scroll; ink and color on paper
206 x 148 cm (81 1/8 x 58 1/4 in.)
Inscription and signature:

On rocky trails, I pole my way up a hundred turns,
 The sounds of the creek are blocked by nine bends.
Having come to look for the poems of Su and Huang,
 We rub the stela to decipher words by Yuan and Bo.
The chasm dark and drear is always full of clouds,
 Mountains crowd the springtime moon of long ago.
We plant our feet planning to lean on the railing,
 And cliffside flowers flutter by like lovely snow.

The Cave of Three Visitors at Yiling [Hubei Province] is located near the Xiling Gorge [on the Yangzi River] at the mouth of Xialao Creek. On different occasions, [the Tang dynasty poets] Yuan Weizhi, Bo Letian, and his younger brother [Bo] Xingjian, and [the Song dynasty poets] Dongpo [Su Shi], [Huang] Shangu, and Zhang Wenqian came here on excursion. Later generations have therefore named [the cave] for them.[1] In the third lunar month of the *guiyou* year [March 26–April 24, 1933], I passed by here with my second elder brother, Huchi [Chang Shanzi], my third elder brother, Licheng, and my fourth elder brother, Wenxiu. We were planning to return up the Yangzi River to [our family home in] Shu [Sichuan Province] but desisted because of military disturbances. I have painted the [view] from memory and inscribed this old composition of mine onto it. The tenth lunar month of the *gengzi* year; Dai-chien jushi Yuan, in the Mogi hills of São Paulo [Brazil].
SDA

Collection of Paul Chang, Pebble Beach, California

I N *The Cave of Three Visitors*, Chang Dai-chien portrayed the mountains of Yiling in Hubei Province in a personal style not readily associated with any previous master. The physical format is exceptionally large—this work is one of four huge hanging scrolls that Chang painted in 1960.[2] In order to preserve the grandiosity of the peaks even when seen from the distance a painting this size requires, Chang used coarse, raspy brushwork that holds up across a room. Mountain peaks press against the four borders of the frame; clouds and thin strips of unpainted paper depicting river and sky relieve the massive forms.

The clouds snake upward, directing the viewer's attention toward the top of the painting. Their curved shape is echoed in a cavern wall that arches over a pavilion and, again, in the round mouth of a cave to the right of the building. Although the cave is relatively inconspicuous, Chang's inscription reveals it as the subject of the painting. The grand framework around the cave is like the setting for a precious gem, which holds it secure and displays the jewel to advantage.

The brushwork in *The Cave of Three Visitors* is unorthodox; Chang Dai-chien rejected the familiar linear and calligraphic modes of literati painting in favor of a dramatic, highly tactile idiom better suited to such a large work. First he cursorily outlined the mountains with a large brush, then filled them in with light and dark washes. He added a few swiftly brushed trees and completed the work with stippled strokes and dots. To create the bristly, steel-wool texture, Chang employed a "split brush," pressing down on the brush to make the hairs spread out, so that each left a wisp of ink. The scumbled effect required layers of strokes. As a final step, Chang applied a light color wash to some areas.

A solitary boat is moored at the bottom of the painting, and Chang mentioned poling a boat in his inscribed poem. In 1933 Chang and his brothers traveled to their family home in Sichuan Province. The journey was interrupted by unexpected fighting on the road, and they took refuge in Yiling. According to the inscription, the brothers then decided to explore the Cave of Three Visitors, which they could reach by hiking from the temple at the bottom of the painting. The three gentlemen near the pavilion in the upper left may be the three wanderers for whom the cave was named, or they may be Chang Dai-chien's three brothers.

Except for Chang Shanzi (1882–1940), who was also a painter, Chang Dai-chien saw little of his brothers, and it was a rare event for them all to be together. Chang Licheng (1884–ca. 1970) was a businessman and Chang Wenxiu (1885–ca. 1970) a doctor of traditional Chinese medicine. After Chang Dai-chien left China in 1949, his memory of this trip with his brothers was especially dear. The work Chang Dai-chien painted when he was living in Brazil is often nostalgic of his life in China.

While investing his painting with deep personal emotion, Chang Dai-chien also had the public in mind. He exhibited *The Cave of Three Visitors* in 1961 at the Musée Cernuschi in Paris and felt sure that his painting would impress the audience with his personal creativity and independence from the ancient masters.

1. According to the prose account written by Bo Juyi (Bo Letian; 772–846) on April 8, 819, he and his brother Bo Zhitui (Bo Xingjian; d. 826) met their close friend and fellow poet Yuan Zhen (Yuan Weizhi; 779–831) at Yiling below the famous Three Gorges of the Yangzi River. They explored the nearby terrain and on the third night, they stayed in a cave they discovered. Before parting, each composed a poem to write on the cave wall and named the place the Cave of Three Visitors. Judging from Chang Dai-chien's inscription, in the Song dynasty the friends Su Shi (1036–1101), Huang Tingjian (1045–1105), and Zhang Lei (1046–1106) also visited the cave. SDA

2. The other three equally large paintings from 1960 are *Overhanging Pine in the Yellow Mountains* (entry 57), *Mount Emei*, and *Fisherman*. The last are illustrated in *Les Lotus Géants: grandes compositions de Tchang Ta-ts'ien* (Paris: Musée Cernuschi, 1961), pls. 3 and 4.

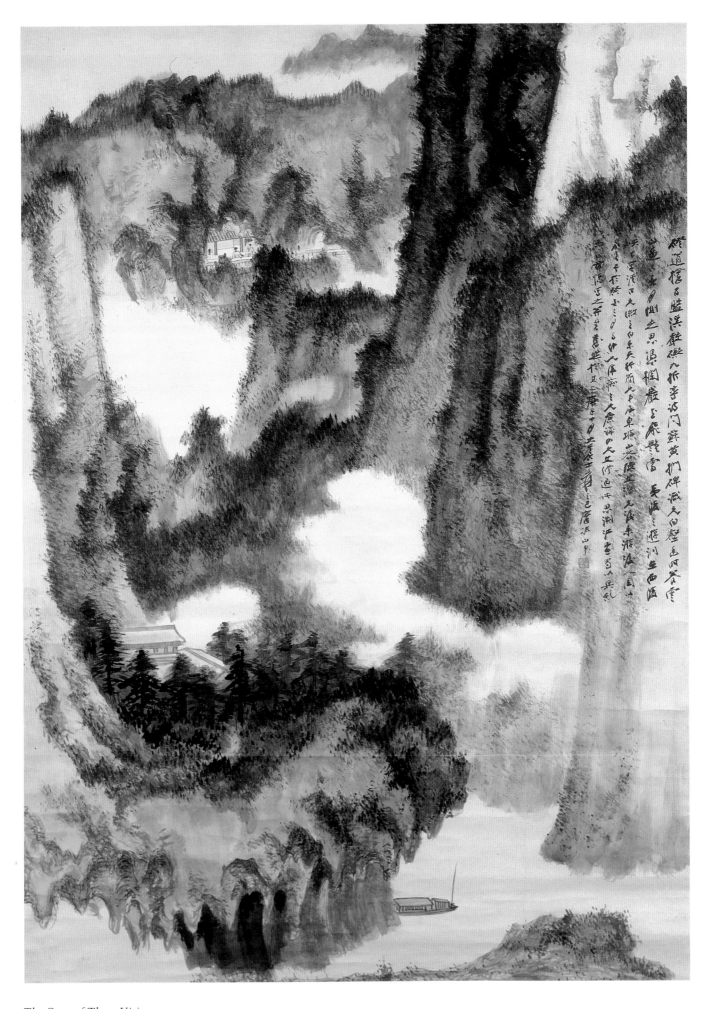

The Cave of Three Visitors

November 19–December 17, 1960
Hanging scroll; ink and color on paper
205.6 x 147.4 cm (81 x 58 in.)
Inscription and signature:
 Full and lush, down it hangs
 above a thousand feet;
 It does not wish to soar the
 clouds and broken cliffs.
 You see where an alchemist's
 stove and cauldron stand,
 To these Lord Xian and Fuqiu
 might some day return.

The overhanging pine on Lotus Blossom Peak is the foremost wonder of the Yellow Mountains. Tenth lunar month of the *gengzi* year; Dai-chien jushi Yuan.
 SDA
Collection of Chang Sing-yi, Brazil

THIS HUGE massif rising above the heavy mist is unquestionably a peak in the Yellow Mountains in Anhui Province. The thick vapor hanging among the pines trees at the bottom edge of the painting is the proverbial "sea of clouds" in the Yellow Mountains. Dense clusters of pine needles float above the clouds like spume on waves of mist. A solitary pine on the mountain summit crawls downward like a dragon descending. The rugged terrain of the Yellow Mountains supports only the most tenacious of trees, whose twisted, eccentric forms testify to the scarcity of sun and nourishment amid the mist-enshrouded, rocky peaks.

Chang's mention of the "alchemist's stove and cauldron" in the inscription adds to the mystical flavor of the landscape. He also refers to Lord Xian, or the Yellow Emperor, a mythological sovereign said to have ruled in the third millennium B.C., and Fuqiu, an "immortal" sometimes said to have been born during Lord Xian's reign.

Overhanging Pine in the Yellow Mountains is one of four huge hanging scrolls that Chang painted in 1960 (see entry 56). The immense scale of the work compels the viewer to study it from a distance, and Chang Dai-chien used dark ink and robust brushwork that shows well from such vantage. For some of the texture strokes that describe the fissured rock, Chang held the brush obliquely, a method he seldom used; the technique is akin to the "ax cuts" of Xia Gui (act. 1200–1250).

Chang Dai-chien indicated in his inscription that the great dragonlike tree was a pine he had seen on a trip to Lotus Blossom Peak, one of the best known summits in the Yellow Mountains. Chang climbed the Yellow Mountains three times, each time staying one month. The mountains' strange peaks and trees were burned into his memory, and during his long career Chang painted them several hundred times. In these works Chang combined his personal observations with influences from Shitao (1642–1707), Mei Qing (1623–1697), and Hongren (1610–1664), each of whom developed an individual style to depict the unique landscape of the Yellow Mountains. Chang first exactingly imitated their works, and then painted in a freer style. He also internalized some of their mannerisms to the extent that it is difficult to say where his imitation of the ancients ends and his own style begins.

Although Chang identified the subject of *Overhanging Pine* as a personal memory, it has strong echoes of Hongren's *Dragon Pine in the Yellow Mountains* (fig. 106), which Chang owned. This painting depicts a twisted, overhanging pine on Lotus Blossom Peak. In his poem on the painting, Hongren likened the tree to a dragon with dense scales and fully grown claws. Hongren painted the tree in profile; its slender limbs extend from both sides of the trunk at close intervals. Chang

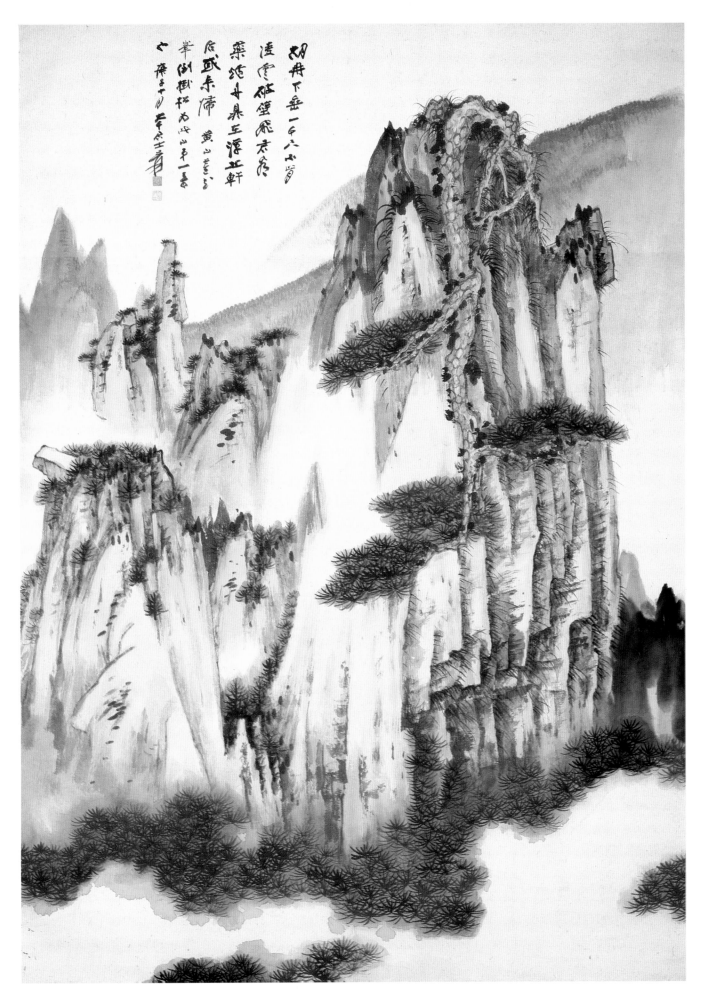

Overhanging Pine in the Yellow Mountains

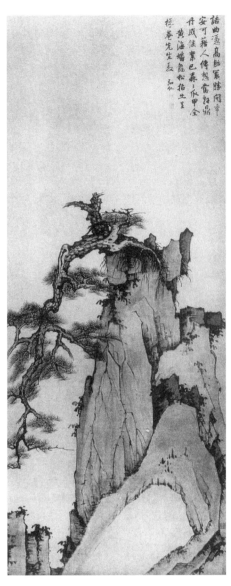

Fig. 106. Hongren, *Dragon Pine in the Yellow Mountains*, ca. 1650–60. Hanging scroll; ink and color on paper; The Metropolitan Museum of Art, New York, gift of C. Douglas Dillon, 1976.1.2.

did not mention Hongren in his inscription, as he usually did when he was consciously evoking ancient masters, but his memory of the pine at Lotus Blossom Peak may have been shaped by his enjoyment of Hongren's depiction. Still, the differences between the finished works are considerable. Chang painted his pine from a frontal view, a more difficult angle than Hongren's because of the foreshortening required, and he gave it fewer branches. While Hongren's manner was spare and he presented Lotus Blossom Peak in crystal clarity, Chang painted the neighboring peaks in full view. Even his brushwork is weightier. Chang often commented on Hongren's skill in capturing the "bones" of the Yellow Mountains; from *Overhanging Pine* we can see Chang's skill in capturing the organic whole.

The influences of early painting in *Overhanging Pine* do not stop with Hongren. Chang's dense clusters of pine needles painted with a worn brush were derived from Shitao. When Chang Dai-chien painted *Overhanging Pine,* more than twenty-five years had elapsed since he had actually seen Lotus Blossom Peak. His Dafeng Tang collection of ancient painting, however, had many examples from Shitao's brush and included Hongren's *Dragon Pine.* It seems natural that this painting should reflect both Chang's personal memory of actual scenery and his study of ancient masters.

58 Self-Portrait in the Yellow Mountains

Autumn 1961
Hanging scroll; ink and color on paper
192.2 x 101.6 cm (75³/4 x 40 in.)
Inscription and signature:

The pines of the Yellow Mountains
 spring aloft like dragons,
The clouds of the Yellow Mountains
 are like steam from a pot;
I climb the vines and creepers
 to where no one's ever been,
But someone is whistling loudly . . .
 sounds like hermit Sun Deng.

Poem by my late elder brother [Chang Shanzi]. In the autumn of the
xinchou year; Chang Dai-chien Yuan.
 SDA
Collection of Chang Sing-yi, Brazil

CHINA HAS had few artists who specialize in portraits, and fewer still who are renowned for self-portraits. Most portraits were executed by professional artists who did not sign their work, and the names of only a few masters, such as Wang Yi (1333–after 1362), Zeng Jing (1568–1650), and Yu Zhiding (ca. 1647–ca. 1707), who were close to their literati patrons, have been preserved. Even artists who specialized in portraits seldom painted their own image. As gestures of personal reflection, self-portraits were better suited to the literati, who believed that the purpose of painting was self-expression and therefore were not primarily concerned with a physical likeness.

The first recorded self-portrait in China is *Facing a Mirror* by the calligraphy sage Wang Xizhi (ca. 307–ca. 365), but no copies are extant. Centuries later Zhao Mengfu (1254–1322), another archetypal literati-artist, is recorded to have painted a self-portrait. In the late Ming and Qing dynasties the popularity of self-portraiture increased, but it was still not common. Xiang Shengmo (1597–1658), Chen Hongshou (1598–1652), Shitao (1642–1707), and Jin Nong (1687–1763) are the best-known scholar-painters who portrayed themselves. Even their self-portraits, however, were usually collaborations in which a professional portraitist was invited to paint the face and sometimes the body while the scholar-artist completed the missing elements (body, background, and accouterments). For example, in Xiang Shengmo's *Self-Portrait* (Wango H. C. Weng Collection), dated 1646, Xiang Shengmo painted his own body and an inkstone, while an anonymous artist actually painted Xiang's face. In a similar arrangement Shitao, whom Chang emulated more than any other artist, collaborated with an artist known to us only as Jiang to paint *Landscape and Portrait of Hong Zhengzhi* (fig. 107), which was Chang's model for *Self-Portrait in the Yellow Mountains*.

Chang Dai-chien used many elements from *Landscape and Portrait of Hong Zhengzhi* in his self-portrait; unlike traditional literati painters, however, Chang needed no assistance for his portrait. Born during a radical transformation of traditional society, when the strict division between professional and literati artists was becoming obsolete, Chang blended the training and commercial trade of a professional artist with art theories derived from the literati canon. When he painted *Self-Portrait in the Yellow Mountains*, Chang combined his conviction that art was self-expression with a technical finesse not previously encountered in literati figure painting.

Chang had painted portraits since his early career, and by the mid-1920s he was confident enough to present his art teachers with portraits he had painted of them. By 1927 he was already painting self-portraits; in these early efforts, Chang often playfully superimposed a recognizable self-por-

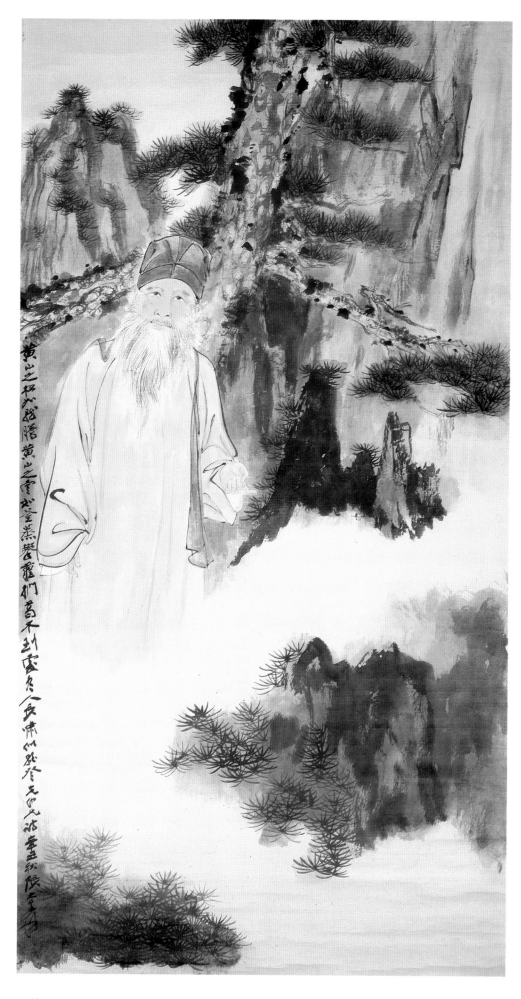

Self-Portrait in the Yellow Mountains

Fig. 107. Shitao and Jiang, detail, *Landscape and Portrait of Hong Zhengzhi*, 1706. Handscroll; ink and color on paper; Arthur M. Sackler Gallery, Smithsonian Institution, Washington, D.C., S1987.205.

trait onto a conventional image of a mythological or famous person, what James Cahill has called a "double image." During the 1920s at a celebration of the Double Fifth Festival, Chang painted himself dressed as the semilegendary Tang dynasty figure Zhong Kui the Demon Queller, with Zhong's attribute, a sword, hanging at his side. Chang's image in *Self-Portrait in the Yellow Mountains,* with the old-fashioned robe and "Su Dongpo" hat named for the famous poet-painter Su Shi (1036–1101), might suggest that this, too, is a double image. But Chang was so thoroughly influenced by Su Shi that he actually wore such a hat and robe as his typical garb.

Although Chang Dai-chien often painted self-portraits, he rarely painted a background in them; the landscape in *Self-Portrait in the Yellow Mountains* was inspired by Shitao but also expresses Chang's personality. Chang painted himself with reserved, elegant brush lines. He demurely shaded the face, intensifying the colors slightly around the nose, mouth, and eyes. The contrast between his image and the robust brushwork of the pine branch just behind it suggests a transference of the pine's rugged strength to the tranquil figure. Associations between plants and human character are commonplace in Chinese art, and in a self-portrait from 1961 Chang depicted himself with a single pine and inscribed a poem by the Song dynasty poet Lu You (1125–1210). The last couplet clarifies the meaning of the pine.

More than sixty years, the pine tree is like this,
Who would know that I am even older than the pine?
SDA

Pine trees are a conventional symbol for longevity and are admired for their ability to remain steadfast in adversity. After Chang Dai-chien turned sixty, he often included pine trees in his self-portraits. In *Self-Portrait in the Yellow Mountains* the pine not only symbolizes Chang's age and strength but also is a realistic detail from the Yellow Mountains, which are famous for craggy pines.

The thick mist also identifies the Yellow Mountains, known for their "sea of clouds." But the three-quarter figure making a spectral rise from the mist and standing before a grand mountain is theatrical in a way that reflects the influence of Shitao's *Portrait of Hong Zhengzhi.* Chang re-created Shitao's visual tension between a realistic figure and a miniaturized landscape in which the figure hovers like an apparition. Shitao used the distortion to suggest the landscape as a metaphor for the pure and lofty personality of the figure. Chang Dai-chien did the same, and in *Self-Portrait in the Yellow Mountains* he shows himself as direct heir to the tradition of Su Shi and Shitao. For both Shitao and Chang, the blurring of landscape, mist, and figure suggests an ideal union between nature and humankind that is a sign of high character.

The poem, composed by the artist's brother Chang Shanzi (1882–1940), emphasizes a mystical union by alluding to a famous recluse of the Six Dynasties period, Sun Deng (act. 3d cent.), who rarely answered questions or spoke with others. When the poet Ruan Ji (210–263) visited Sun Deng in the mountains, Sun refused to speak, and so Ruan whistled loudly and withdrew. Halfway down the mountain, Ruan heard a sound like the voice of a phoenix and knew this was the answering whistle of Sun Deng.

Chang Dai-chien painted this work when he was living in Brazil. Throughout Chang's long career, people frequently requested his self-portrait as a souvenir. In all, Chang painted some one hundred self-portraits, more than has been recorded for any other Chinese artist. Chang's enjoyment of the genre is an indication of his intense satisfaction with his life. This satisfaction is evident in *Self-Portrait in the Yellow Mountains,* as is Chang's vision of himself as part of China's long heritage.

59 The Lake in Bade Garden

November 8–December 7, 1961
Hanging scroll; ink and color on paper
173.7 x 94 cm (68³/₈ x 37 in.)
Inscription and signature:
 Lake of Eight Virtues in the Garden of Mount Mojie; the tenth lunar month
 of the *xinchou* year, Yuan.
Collection of Chang Hsu Wen-po, Taipei

AT THE end of 1953, in the small town of Mogi near São Paulo, Chang Dai-chien bought some thirty acres of farmland that he was determined to transform into a traditional Chinese garden. Chang named it Garden of Mount Mojie, which is both a transliteration of Mogi and a tribute to Wei Mojie, the most famous Buddhist layman in ancient China, whose intellectual and spiritual knowledge made him a favorite among scholars. With the name, Chang created a cultural pedigree for his garden and allied it with the tradition of Buddhist quietude.

By the time Chang painted *The Lake in Bade Garden,* he had nearly finished his garden, having constructed residential buildings for his family and students, a painting studio, and at least one kiosk for viewing the scenery. He had landscaped the property with trees, flowers, and rocks, and in 1961 he initiated the final major project—constructing a lake. Chang excavated the site and used the soil to manufacture miniature mountains, islands, and a peninsula. He named the lake Bagongde, the Lake of Eight Merits and Virtues. Soon the name was shortened to Lake Bade (Eight Virtues). This painting represents an early stage in the construction of the lake.

The name of the lake, taken from a Pure-land Buddhist sutra, reinforces Chang's strong desire to make his garden into a sanctuary that could ease his homesickness for China. The sutra recounts the eight virtues of a pond in the Western Paradise, where believers expect to be reborn enroute to their goal of nirvana. The eight virtues are: clarity, cool purity, sweet flavor, weightlessness, watery smoothness, tranquillity, the ability to satiate hunger and thirst, and the power to restore energy.[1]

Chang was inspired to plant persimmon trees around the lake as he was working on it. He was fond of saying that persimmon trees had eight virtues. The Tang dynasty compendium *Youyang zazu* by Duan Chengshi (d. 863) listed seven assets to a persimmon tree, to which Chang added one more. The values that Duan notes are: long life span, abundant shade, no nesting birds, no insects, a beautiful appearance after a frost, delectable fruit, and broad leaves suitable for writing calligraphy.[2] The eighth virtue, which Chang discovered, was that the steeped leaves make a tonic to cure

stomach aches. In honor of the eight virtues that Chang attributed to both the lake and the persimmon tree, he changed the name of his garden from Mount Mojie to Bade (Eight Virtues) Garden.

Other personal associations with the number eight may also have prompted Chang to change the garden's name. Chang was called "Eighth Brother" by his friends. In addition, Chiang Kai-shek (1888–1975) promoted an eight-point campaign of moral education and good citizenship in Taiwan known as the Eight Virtues. Chang Dai-chien never acknowledged a link between the name of his garden and Chiang Kai-shek's campaign, but the connection is surely in keeping with Chang's pro-nationalist allegiance.

At the same time that Chang was planting persimmon trees and bamboo around the lake, he had five shelters built along its perimeter so that guests could take cover from Brazil's sudden downpours. He began using the name Lake of Five Kiosks (Wuting).

Only one kiosk is visible in *The Lake in Bade Garden.* Chang's students lived in the larger building in the foreground. The aerial perspective of this work suits the narrow format of the painting but gives a false impression of the lake's size and shape. In reality the lake was quite wide, though the sliver in the painting might also reflect its unfinished status.

Chang Dai-chien was familiar with the centuries-old Chinese idea that a garden should be a painting rendered in three dimensions, and he called Bade Garden a "concrete painting." There is some irony, therefore, in recording this "three-dimensional painting" in two dimensions, but its hospitable, tranquil mood invites the viewer to take a mental stroll through the landscape, as if it were three-dimensional space.

As the lake was in progress, Chang Dai-chien composed poems that reveal the multiple layers of allusions he invested in the scenery. In addition to Buddhist connotations, the landscape also reminded him of the confluence of the Xiao and Xiang rivers in Hunan Province—celebrated by painters and poets since the Song dynasty. In October 1961 Chang wrote:

> I didn't plant a taro crop
> nor did I plant mulberry,
> But dug myself a banked pond
> of one full *qing* in size;
> Behind a myriad tall bamboos
> the dust is all held out,
> In his heart, this old man
> keeps the Xiao and Xiang.[3]
> SDA

In the poem Chang mentions his garden's thriving bamboo, which he personally brought from Japan to Brazil. The hot

The Lake in Bade Garden

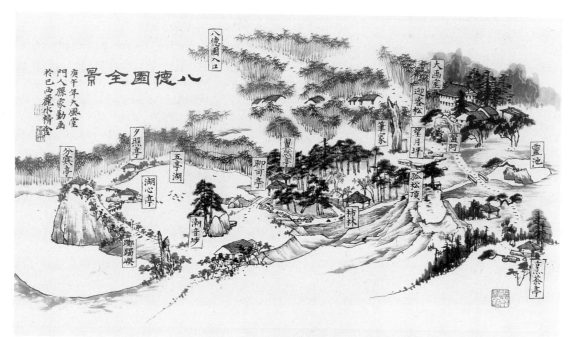

Fig. 108. Sun Jiaqin, *Sketch of Bade Garden,* 1990. Mounted for framing; ink and color on paper; Arthur M. Sackler Gallery, Smithsonian Institution, Washington, D.C.

climate encouraged rapid growth, and eventually the bamboo formed a thick screen around the lake. Chang also began cultivating lotus flowers, which he described in a poem that alludes to the lotuses in the Buddha's paradise.

> Since I recently dug a level pond
> about a hundred *mu* in size,
> I'm waiting for the autumn floods
> to reach the infinite sky;
> When the myriad blossoms of lotus
> open in all their radiance,
> This is where I'll worship Buddha
> under the southern heaven.[4]
>
> SDA

Each morning Chang Dai-chien rose early and walked around the lake accompanied by his gentle and obedient gibbon, who sometimes jumped on Chang's shoulders demanding to be carried. Chang's morning walk was one of his few private moments, though sometimes his student Sun Jiaqin, who was also an early riser, liked to accompany Chang so the two could talk quietly about art. Bade Garden no longer exists except in Chang Dai-chien's paintings. The Brazilian government bought the property, razed the buildings, uprooted the trees, and flooded it to make a reservoir for drinking water. Before the property was destroyed, the author asked Sun Jiaqin to make a maplike sketch of the garden from memory to help document Chang Dai-chien's efforts (fig. 108). Chang's paintings do not reproduce Bade Garden with photographic accuracy; however, *The Lake in Bade Garden*

testifies that Chang built for himself a purely Chinese home on Brazilian soil.

1. Li Yongqiao, *Chang Dai-chien nianpu* (Chengdu: Sichuan sheng shehui kexue yuan chubanshe, 1987), 341 n. 5.

2. Xie Jiaxiao, *Chang Dai-chien de shijie* (Taipei: Shibao wenhua chuban gongsi, 1982), 192–93. Entry 77, n. 1 also discusses using persimmon leaves as "paper."

3. Li Yongqiao, *Chang Dai-chien nianpu,* 339.

4. Chang Dai-chien, *Chang Dai-chien shiwen ji,* ed. Yue Shuren (Taipei: Liming wenhua shiye gongsi, 1984), 22.

60 Strolling Alone in the Autumn Hills

December 27, 1962–January 24, 1963
Hanging scroll; ink and color on paper
191 x 101.5 cm (75¼ x 40 in.)
Inscription and signature:

> During the last lunar month of the *renyin* year, [I] Dafeng Tang amused myself as a long spell of rain was ending and made this [painting] in an exuberantly happy mood; Dai-chien Chang Yuan.

Collection of Richard Hui, Hong Kong

CHANG DAI-CHIEN did not identify the flinty peak in his inscription, but the scene has all the hallmarks of the Yellow Mountains in Anhui Province. The pine tree, with bent boughs and roots clutching the barren rock, is characteristic of the trees in this range. The fingers of mist threading through the pine are the famous "sea of clouds" of the Yellow Mountains. Chang first painted these mountains when he started copying Shitao (1642–1707) during the early 1920s, and he depicted them hundreds of times in his career. *Strolling Alone in the Autumn Hills,* however, is testimony to Chang's passion not so much for the mountain range as for Shitao's way of painting, which Chang followed his entire life.

At the time he painted *Strolling Alone,* Chang was feeling relaxed after a hectic year of travel to Europe, Japan (twice), and Taiwan. The impetus for the work was a break in the Brazilian rainy season that revived Chang's spirits. Chang expressed his joyous mood by freely interpreting Shitao, who had become almost an alter ego. The theatrical-looking scholar and exuberantly tangled mass of vegetation topped by decorative swags of malachite pigment reflect Chang's personal artistic vocabulary, but the dense landscape and rhythmic brushwork derive from Shitao. The blunt roughness of the rock and ragged pine bark are executed in a manner reflecting Chang's preference during the 1960s to paint with a worn brush that could no longer hold a point.

A luminous circle surrounds the figure of a scholar in the lower portion of the landscape. The monolithic peak and dense vegetation outline the opening, which Chang left ambiguous—it could be the mouth of a grotto or a clearing in the brush. The figure is stepping forward into this secret passage, and we see only his face in profile. The lower portion of his body is hidden among the matted branches below the peak. Chang enveloped the figure in white light the way a stage designer spotlights a major actor, and he heightened the effect by painting the scholar's robe in a pale color that seems to reflect the ambient light. A blue cloth tied into his hair as an ornament directs the viewer's attention to the tiny dot of spectral light in this "cave," which is quickly extinguished by the dark colors and ink that Chang used for the surrounding wilderness.

Among Shitao's paintings, an exact prototype for *Strolling Alone* has yet to be discovered; however, a similar work by Liu Haisu (b. 1896) called *Pine Cliff and Foggy Waterfall* (fig. 109) suggests a shared model. Although Liu Haisu's inscription, dated 1964, does not mention stylistic sources, the composition parallels Chang's too closely to have been serendipitous, and Liu, who had remained in China, would not likely have seen Chang's work. Liu might have been familiar with Chang's prototype and may have decided to paint his

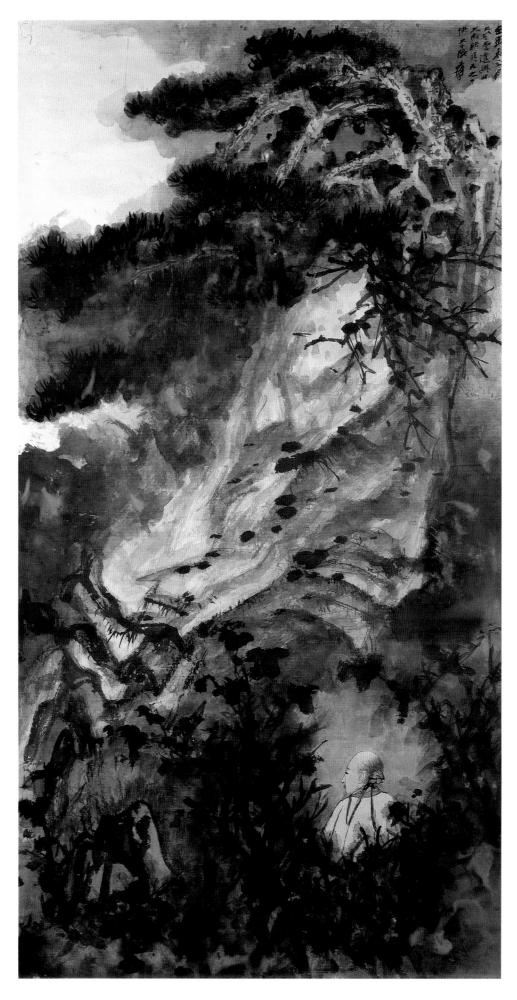

Strolling Alone in the Autumn Hills

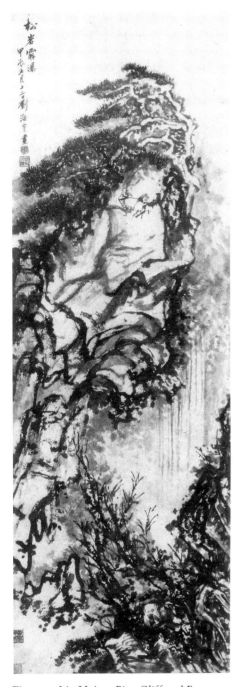

Fig. 109. Liu Haisu, *Pine Cliff and Foggy Waterfall,* 1964. Hanging scroll; ink on paper; collection of Robert H. Ellsworth. From Arnold Chang, *The Mountain Retreat: Landscape in Modern Chinese Painting* (Aspen, Colo.: Aspen Art Museum, 1986), 39, pl. 16.

own Shitao landscape after hearing about Chang Dai-chien's painting—news of Chinese artists overseas filtered into mainland China from Hong Kong during the years of the Cultural Revolution. On more than one occasion Liu Haisu followed Chang's lead, as when he painted a boneless landscape of *Light Snow at Tongguan* a few years after Chang (see entry 29).

Liu Haisu is among the best-known modern Chinese painters, but his debt to Chang Dai-chien has seldom been recognized. Liu began his career painting in a Western style and gradually turned to copying the ancient Chinese masters and developing traditional skills. Unlike Chang, Liu was never systematic in pursuing the past; nonetheless, Shitao was one of his favorites as well. During the 1970s Liu was heralded for his splashed-ink-and-color painting, which in fact had been pioneered by Chang Dai-chien. The increasingly open atmosphere of China afforded Liu ample opportunity to study Chang's work. Yet to this day he has not personally acknowledged the influence of Chang on his painting.

June 28, 1963

Hanging scroll; ink and color on paper

98.2 x 56.2 cm (38⅝ x 22⅛ in.)

Inscription and signature:

> In the fourth lunar month [April 24–May 22] of the *guimao* year I called upon the brothers Baihua and Chen-Hua with his wife, Xuemei, to make a leisurely trip to Mahuo [Mohawk Valley]. After returning [to São Paulo], I brushed this painting and mailed it to "niece" Xuemei as a record of our trip. Three days after the Duanwu Festival; Dai-chien jushi Yuan.

Collection of Mr. and Mrs. Lee Chen-Hua, Westbury, New York

ATOP THE steep incline, a kiosk offers a tempting spot from which visitors can survey the mountain ravine. A group of figures has just arrived; three rest near a pine tree in front of the kiosk and the others are a little farther behind on the path. Below the precipice is a larger kiosk built over the water. Chang Dai-chien used firm, sure brush strokes made with a worn brush and patches of rubbed ink to evoke the ancient, weathered appearance of this valley.

The inscription, which Chang wrote on the smooth surface of the main cliff, recalls the calligraphic inscriptions ancient calligraphers carved into some of China's famous mountainsides. "Mahuo" is a transliteration for Mohawk Valley, and despite the Chinese flavor of this mountain scene, it records a trip Chang and the Lee family made in New York State. Chang painted this scene in Brazil, and so the vista was filtered through time, memory, and Chang's predilection to render all landscapes as traditional Chinese compositions.

While rejecting the notion that his painting had to faithfully document the Mohawk Valley, Chang was nonetheless specific about certain details of the trip. One of the two figures behind the pine tree is clearly identifiable by her hair as a woman. It is rare to find a female among the small figures that Chang routinely painted in a landscape, and this figure is an obvious concession to the presence of Xuemei, to whom the painting is dedicated.[1] The Lees lived in New York, and Chang visited them in April 1963, on his way home from Singapore, where an exhibition of his work had been organized. Chang was a contemporary and close friend of Lee Chen-Hua's father.

Wherever Chang traveled, he routinely organized trips to scenic areas. In his "travelogue" paintings, Chang never felt compelled to record the scene with photographic accuracy but rather stored images in his mind, reworking them at a later date into compositions that often "improved" on nature. The most famous paintings and best brush techniques of past artists shaped Chang's memories of the places he visited, so that each travel painting he produced blended reality and fantasy.

1. Only a few months before Chang painted *Mohawk Valley*, he visited Malaysia with his Hong Kong friend Gao Lingmei and Gao's wife. In the record Chang painted of the trip, it bothered Gao's wife that there were no females depicted, and she jokingly commented that the serving boy in the painting would have to represent her. Chang Dai-chien considered her objections when he painted *Mohawk Valley*.

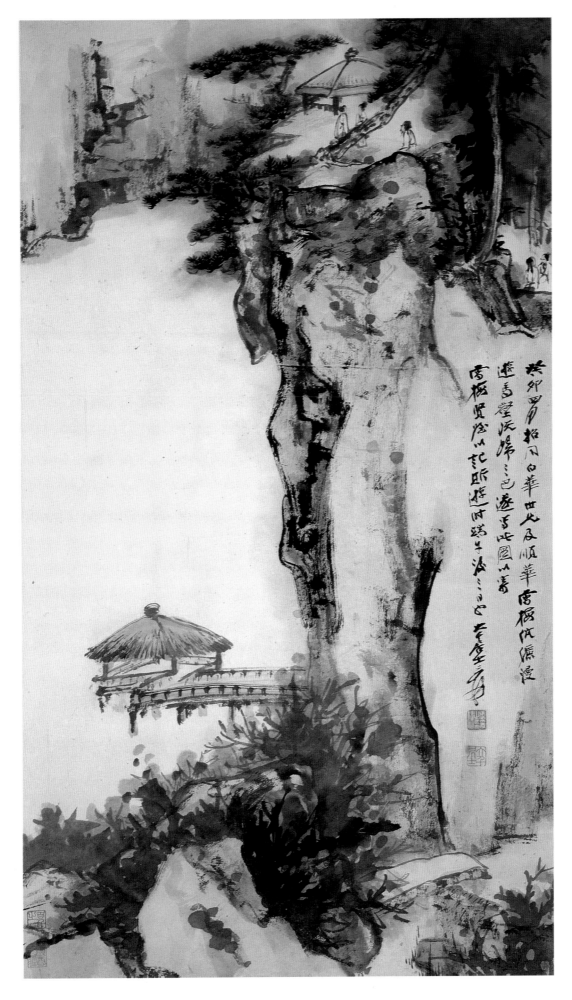

Mohawk Valley, New York

1964
Six rigid-board album leaves; ink and color on silk
Each 31.5 x 40.5 cm (12³/₈ x 16 in.)
Inscriptions and signatures:

Pink Lotus
　Old Man Yuan Dafeng Tang brushed this.
Grapes
　Dhuta [Buddhist monk] Yuan
White Lotus
　Dai-chien Yuan from Shu [Sichuan Province]
Enjoying the View
　Chang Dai-chien Yuan from Shu
Climbing the Hill
　Old Man Yuan
By the Water
　Old Man Yuan

Collection of Pung F. Tao, Los Altos, California

THIS ALBUM epitomizes the best of Chang Dai-chien's early experiments with semiautomatic painting, which he heavily favored during his last fifteen years of painting. Combining bold splashes of ink and color with sharp, elegant brushwork, Chang transformed random patterns into clearly defined subjects. When he painted *Flowers and Landscapes,* he could still move back and forth between using linear brushwork and exuberantly pouring forth ink and colors.

This album, which originally had twelve leaves, was broken up, and Pung F. Tao owns six of the leaves. Chang painted the images on Japanese rigid-board album leaves faced with silk. Usually the silk ground of a painting is millet- or tea-colored, but this silk is unusually bright, making the images look especially fresh.

The first and third leaves of the album depict lotuses, which Chang created using similar techniques. The first is a large pink and ivory blossom surrounded by leaves. The closest leaves are deep gray; those seen behind the flower are paler in tone, hinting at a recession in space. In *Pink Lotus,* Chang washed light ink over darker ink to paint the leaves, and he achieved a similar effect in *White Lotus* by spreading light color washes on top of leaves painted in various tones of gray to black ink. Both paintings balance fullness with the need for empty space: some of the flower petals are painted so that they "read" as both solid form and void, but *White Lotus* is sketchier than a traditional painting. The careful arrangement of petals and brightly colored stamen testify to Chang's careful studies of lotuses in nature.

The second album leaf is a tapestry of light and dark leaves with overlapping bunches of grapes. In contrast to the bold, inky leaves, Chang neatly outlined bunches of grapes on the light unpainted silk, thus representing a solid object by blank

space, just as he did with the lotus petals. The simple, strong brushwork of the vine and the attention to balance among large and small leaves in dense and sparser groupings reveal the hand of a master; such artful manipulation was second nature to Chang Dai-chien. Without having to paint the grape trellis explicitly, he implied its presence by crowding the vines into the top portion of the painting so they seem to hang from an invisible support.

The other album leaves are landscapes, some of which radically depart from tradition. Chang first wet the silk for *Enjoying the View* and then splashed ink on it. The resulting unpredictable patterns challenged him to develop inventive pictorial solutions, and here he turned the unpainted silk into water, adding a contemplative figure. *Climbing the Hill,* which depicts three scholars standing on a summit, is an unusual blend of three separate techniques: splashed-ink-and-color, traditional texture strokes, and controlled color wash. On *By the Water* a large pool of ink fills most of the painting; Chang added to this touches of mineral blue and green, then autumn leaves, water grasses, and a bridge. A landscape emerged, but one that always changes—is the large form a mountain or an open plain?

Chang Dai-chien painted this album with an unusual directness, without poems or references to earlier artists. He used the briefest of signatures and stamped the album's date with a seal of the *jiachen* year (1964) on only one leaf.

Although Chang had been hospitalized for general malaise only months before, the paintings in the album have a vibrant tone. The year had been hectic, with travel from Brazil to Europe, Japan, and then to Taiwan, where he entered the hospital. Upon his release he immediately painted a set of six hanging scrolls without any difficulty, and in the fall he returned to Brazil, where he had relatively few social engagements and could devote himself to painting. He produced works like this album, which represents the first full flowering of his experiments to synthesize Western abstract painting with several styles of traditional Chinese painting.

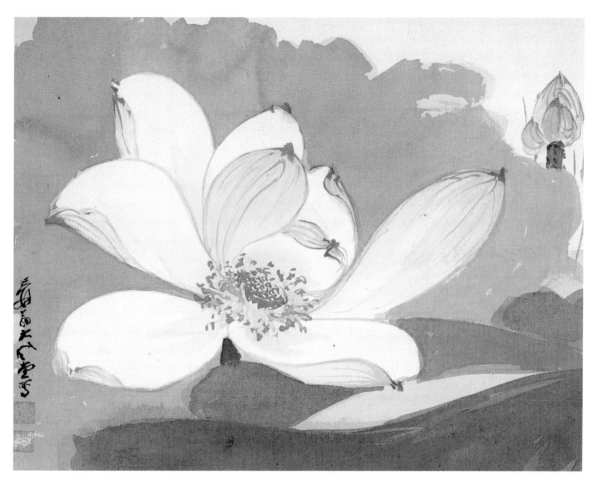

Pink Lotus

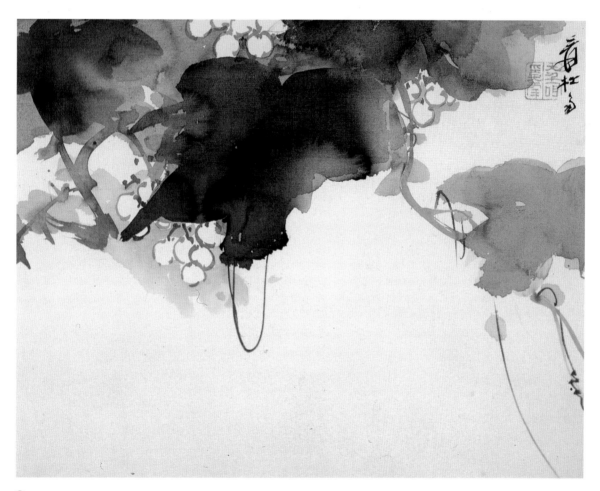

Grapes

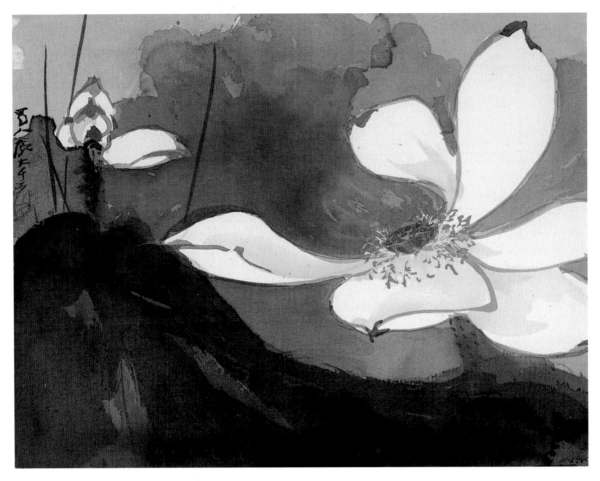

White Lotus

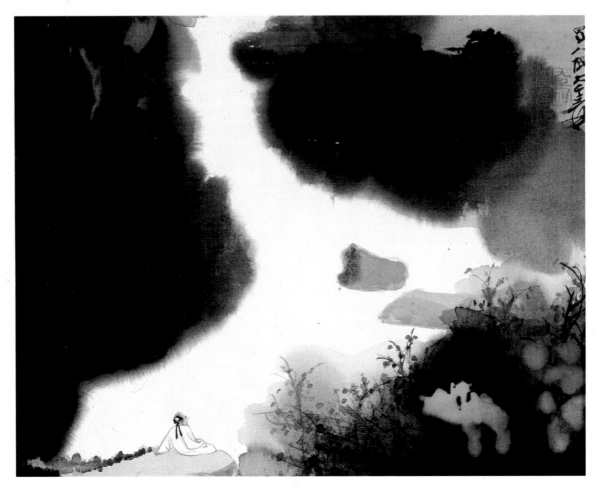

Enjoying the View

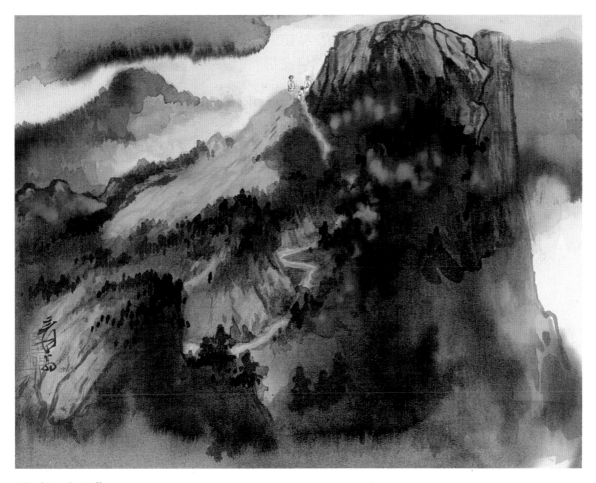

Climbing the Hill

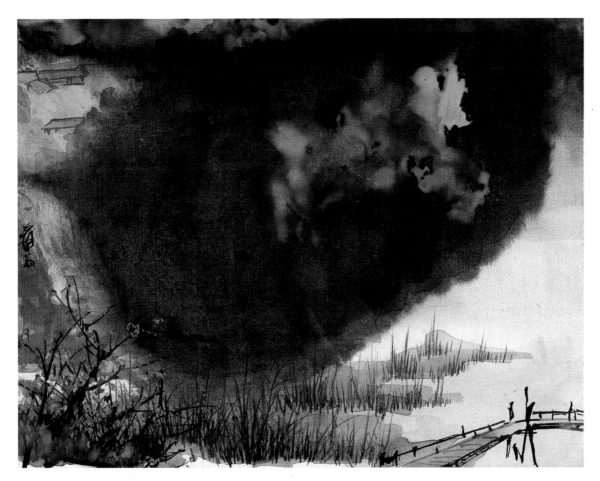

By the Water

63 Sketch of a Woman with Flowing Black Hair

ca. 1964
Mounted for framing; ink on paper
40.1 x 28 cm (15¾ x 11 in.)
Signature:
 Old Man Yuan
Collection of Wilma Chang Ing, Glen Rock, New Jersey

AMONG CHANG DAI-CHIEN's typical repertoire, *Sketch of a Woman with Flowing Black Hair* is a rare exception. Chang enjoyed the challenge of depicting women, a subject he felt required an exceptional degree of diligence and practice. Sometimes he employed detailed brushwork, painting colorful, intricately patterned costumes and elaborate settings. Alternatively, Chang used abbreviated brushwork; sometimes the lines were so cursory that Chang eliminated the contour, depicting instead only the woman's hair, eyes, nose, and mouth. In spite of this variety of techniques, Chang's images of women are rather homogeneous, mostly demure ladies who seem as highly polished and fragile as porcelain dolls. In this fresh and spontaneous painting, however, Chang Dai-chien depicted a strong woman who appears to be intelligent and self-possessed as well as coyly seductive.

Chang conveyed his subject's vivacious character by the strength of the brush lines, which have the vigor of a quickly drawn sketch. Chang originally meant for this work to be used as a study for another more polished painting; however, nothing close exists among Chang's known works. If Chang had painted another work based on this composition, he probably would have used a more refined style and made the woman more genteel. The exuberant, natural quality of *Sketch of a Woman* provides a glimpse into Chang's initial creative impulses.

Chang painted *Sketch of a Woman* on a type of thin, fibrous paper that he seldom used. First he roughly traced the form with charcoal and then corrected and finalized the image using dark ink. For centuries Chinese painters have made quick notations and sketches as a first step in the painting process, a fact that has often been ignored; therefore, Chang's method of making a preliminary drawing in charcoal is not unusual. When ink is applied, however, the charcoal tracing typically disappears, but in this case the underdrawing did not vanish, which must have disappointed Chang. Perhaps he was using a new and inferior brand of charcoal, or the special fibrous paper caused an unexpected effect.

Chang Dai-chien has many other sketches, but they are generally more mannered than this one and display slick, fluent brushwork, rather like his finished paintings. The faces, too, tend to be more delicate and stylized. Most of Chang's sketches display a wider range of ink tones, employing dark ink for the contour lines and pale ink for the eyes, nose, and mouth. The raven black ink used throughout *Sketch of a Woman* makes the image especially striking. Only her thick hair, painted with swift brush strokes that change from light to dark, has softer coloring. He loaded his brush with gray ink and then dipped just the tip into black ink; the resulting color variation evokes a sense of light and shadow.

In 1961 Chang Dai-chien had explained how he prepared to paint an image of a female beauty.

> It is necessary to make a draft when painting human figures, and when painting classical ladies, it is even more imperative to make a draft. . . . One line out of place can completely spoil the whole appearance. When a draft made with charcoal, which has been fabricated from willow branches, is at the stage where the lines are finished, they can then be gone over with pale ink and the charcoal marks can be dusted off without leaving any traces. To convey the special spirit and expression of some subjects is so difficult that the artist will have to go back over his draft as many as five times, correcting mistakes in it, before it becomes unimpeachable. Then he can put brush and ink to paper to make the final image.[1]

Traditional Chinese figure painting has no precedent for the posture of Chang's subject in *Sketch of a Woman*. Chang depicted only the upper third of the woman; her head is tilted at a slight angle and turned to reveal a three-quarter view. Both the woman's pose and her flowing hair reflect Western art and fashion photography. Chang also rarely cropped his figure paintings on three sides, a technique more common in Western painting.

The nod to foreign taste distinguishes this from Chang's early works and suggests that he painted it after living in the West. Chang did not date the painting, but the style of his signature accords with writing from the mid-1960s, and Chang's daughter Wilma, who owns this painting, reaffirms this date. Wilma was present when her father painted *Sketch of a Woman* in Brazil; she recalls that at that time Chang made several sketches of women and that he preferred his other sketches. It was not until Wilma, who liked the distinct emotional tone and engaging quality of *Sketch of a Woman*, asked her father for the work that Chang Dai-chien signed it.

The vivid character captured in *Sketch of a Woman* tempts us to look for Chang's model, but no evidence exists to support the theory that he was drafting a portrait. It is not a likeness of Wilma, nor does she recall her father using a model for this sketch. More likely, *Sketch of a Woman* is another testament either to Chang's stunning memory or to his vivid imagination.

1. Translation adapted from Gao Lingmei, ed., *Chang Dai-chien hua* (Hong Kong: Dongfang yishu gongsi, 1961), 100.

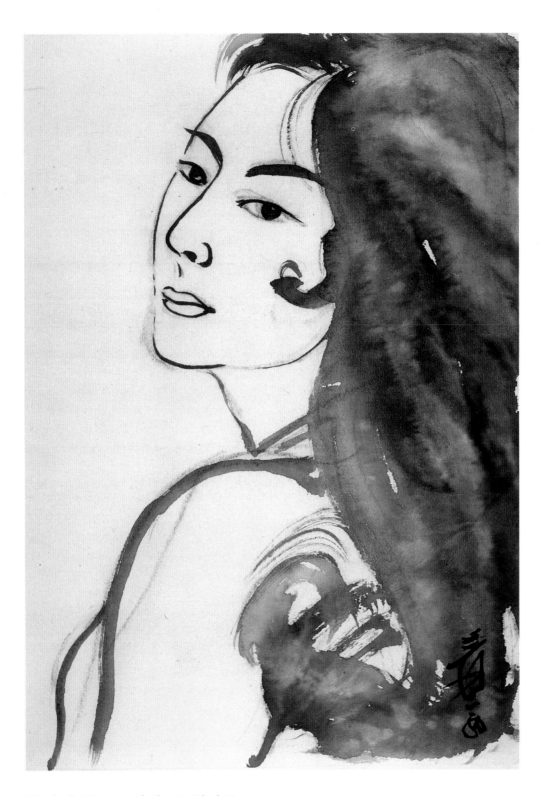

Sketch of a Woman with Flowing Black Hair

64 The Road through Switzerland and Austria

1965
Hanging scroll; ink and color on paper
127 x 61 cm (50 x 24 in.)
Title slip: *The Road through Switzerland and Austria*
Inscription and signature:

Massed clouds whelm the sky,
 all the hills are black,
The dragon which hibernates
 within them cannot hide;
Threatening to rain,
 the wind is on the rise,
And a clap of thunder
 splits the sheer valley.

Old Man Dai-chien splashed ink to make this [picture] and selected [these] twenty-eight characters [for a poem].
 SDA
Collection of Chang Hsu Wen-po, Taipei

I N *The Road through Switzerland and Austria,* a few alpine lodges adorn a rock ledge, which is scooped out of the mountains that soar beyond the limits of the painting. The peaks envelop the scenic hideaway on three sides. Two figures are taking a leisurely stroll and talking. In the distance a waterfall gushes into a stream—the soft din of the rushing water rises to greet the scholar-gentlemen. As the poem Chang Dai-chien inscribed on the painting indicates, a furious storm is coming, with dark clouds massed in the sky.

The Road through Switzerland and Austria exemplifies the traditional Chinese accolade that praises a painting for having "brush and ink." Chang Dai-chien poured and spilled wet ink on the paper to form the mountains and thunder clouds, but he also brushed outlines and tactile descriptive strokes to define the rocks, using moderately moist ink. Chang consciously balanced wet and dry textures in this painting.

Chang wrote the title of the painting on a slip on the outside wrapper of the scroll, but neither the painting nor the poem refers to a specific site. The scene probably represents a memory of one of his trips to Europe. Chang had toured the Alps in the early autumn of 1965 with his friend Zhang Muhan (1900–1980), and to commemorate that trip, Chang painted works whose terrains are similar to *The Road through Switzerland and Austria.*

This is one of Chang Dai-chien's darkest paintings. Usually his landscapes have a radiant, sunbathed effect, achieved with a balance of color and ink. Here Chang rejected his usual luminescence in favor of a brooding darkness that catches the mood of an approaching summer storm, with its pelting rain and earsplitting thunder. He used this theme again in 1967 (see entry 71); that more abstract version is a full flowering of the splashed-ink-and-color method he had developed during the late 1950s and 1960s, building on efforts such as *The Road*

through Switzerland and Austria.

Chang had already been painting for nearly half a century when he created this work, and his willingness to try new subject matter reflects the vitality he still possessed. But while he heralded the new, Chang also encoded a message from the past, for the poem he inscribed here deliberately echoed the famous "Cloudburst at Youmei Hall" by Su Shi (1036–1101).

Beneath the travelers' feet,
 rumbling thunder sounds,
Massive clouds fill the hall
 and cannot be dispelled;
Beyond the sky, a black wind
 blows the ocean upright,
From eastern Zhe, rain comes
 flying across the river.[1]
SDA

Chang Dai-chien thought of himself as a modern Su Shi: both were from Sichuan Province and both practiced painting and calligraphy and composed poetry. Chang even wore a hat and long gown modeled after Su Shi's costume. *The Road through Switzerland and Austria* thus provides a glimpse into the complicated sources of Chang Dai-chien's art, which frequently recasts his personal experience and travel in the light of China's cultural heroes.

1. Ji Yun, ed., *Su Wenzhong Gong shi ji* (Saoye shanfang, 1913), 10.2b. These are the first four lines of an eight-line poem, which Su Shi wrote in Hangzhou at the end of summer 1073. SDA

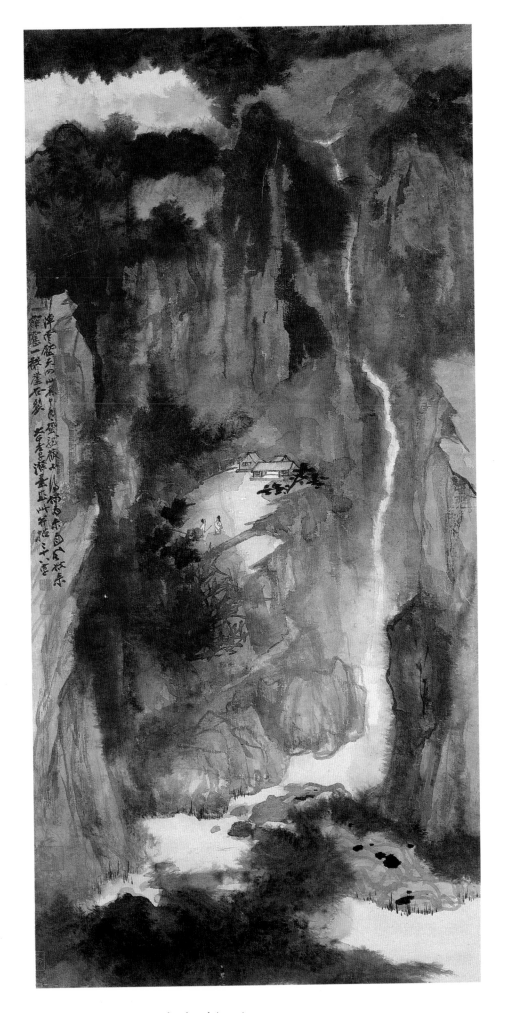

The Road through Switzerland and Austria

65 Ink Lotuses on Gold Screen

July 21, 1965
Six-panel screen; ink on gold paper
155.8 x 363.1 cm (61³/₈ x 143 in.)
Inscription and signature:
 The twenty-third day of the sixth lunar month of the *yisi* year. I paint this the
 day before I am going to plant lotuses in the Lake of the Five Kiosks and
 present it to my fifteenth child, my daughter Xinpei; Old Man Yuan.
Collection of Mr. and Mrs. C. Y. Lee, São Paulo, Brazil

STREAKS OF wet, dark ink dance across the gold paper of this folding screen. The sumptuous black on glittering gold and the exuberant brushwork give the painting decorative appeal. The technical difficulty of creating *Ink Lotuses on Gold Screen* is not apparent in the result. Gold paper does not absorb ink well, making it hard for the painter to control tonality, especially with lighter shades. The working method is quite different from that required by the unsized, vegetable-fiber paper Chang Dai-chien most often used.

When Chang painted on vegetable-fiber paper such as *xuan,* which rapidly soaks up water, he could work quickly and more easily regulate the puddling of colors and ink. He might wait for an undercoat to dry completely before adding a second layer or continue to work while the bottom layer was wet or damp, a choice that gave him some degree of control. But working on gold paper demanded that Chang first outline the lotus petals, wait until they were completely dry, and then start the leaves. Any excess unabsorbed water

Ink Lotuses on Gold Screen

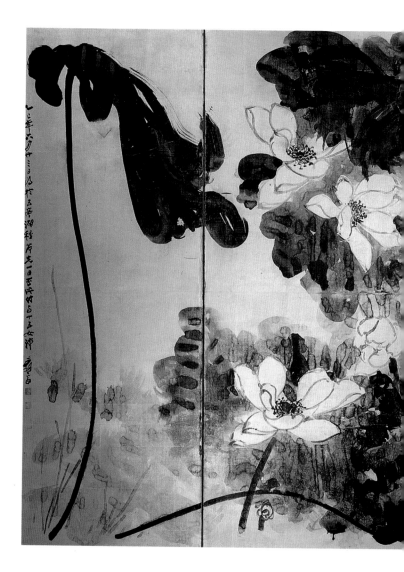

would spoil the painting. Brushing pale ink on the gold paper was even more difficult since the light color was achieved by adding water, and so the areas where Chang used diluted ink dried with a mottled, water-stained effect.

Both the size and vividness of the brushwork in *Ink Lotuses* belie Chang's advanced age; he was sixty-six when he painted this work. Creating the giant lotus leaves and long sweeping stems required powerful physical exertion. The single-line inscription that Chang wrote on the far left of the screen attests to another project that also commanded strength and enthusiasm; Chang was getting ready to plant more lotuses in the artificial lake at his garden-residence in Mogi, Brazil. The thought of replenishing the lotuses put Chang in good spirits. His two favorite flowers were plum blossoms and lotuses, and since plum blossoms did not flourish in Brazil's torrid climate, Chang took great pains to cultivate lotuses. In this inspired mood, Chang let his brush fly across the paper. In some areas he built the ink up thickly; in others he abruptly lifted the

brush to let the gold paper shine through. The variation lends texture to the inky leaves.

The joyful quality of *Ink Lotuses* also reflects the painting's purpose—Chang painted it as part of his daughter Xinpei's dowry. Chang was especially close to Xinpei; she was the only child that he and his wife Hsu Wen-po had been able to bring with them when they left China in 1949, although they were later reunited with the older children. Xinpei married C. Y. Lee the year Chang painted *Ink Lotuses,* and the couple still owns the screen.

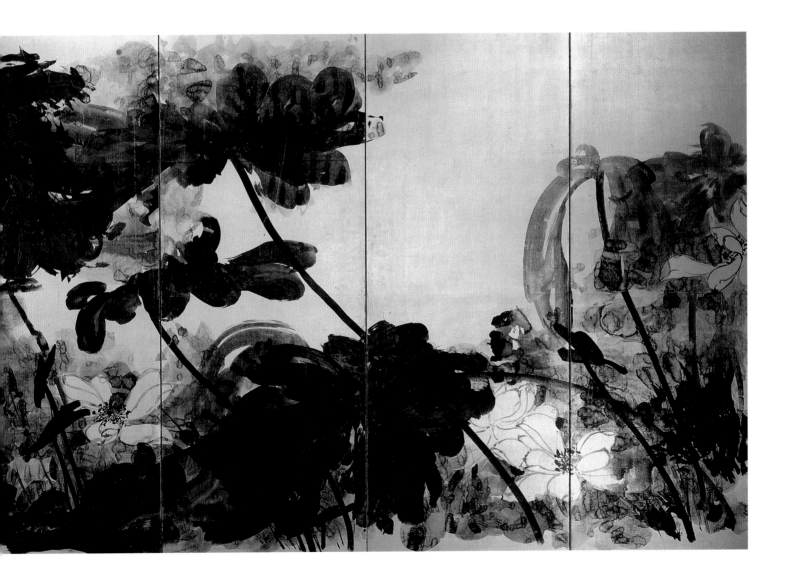

66 Dawning Light in Autumn Gorges

November 23, 1965
Mounted for framing; ink and color on paper
269 x 90 cm (105⅞ x 35½ in.)
Signature:
 First day of the eleventh lunar month in the *yisi* year; created by Old Man Yuan.
Collection of the Dafeng Tang, Taipei

PUDDLES OF ink, a shaft of light, and swags of bright mineral pigments harmonize in an unexpected way in *Dawning Light in Autumn Gorges*. Through the subtle leverage of a few strategically placed brush strokes, Chang Dai-chien turned these random effects of ink and color into one of his most daring landscapes. The scene is a dramatic dawn in a deep mountain gorge, no doubt inspired by Chang's trip to Switzerland the year he painted this work. The intense contrast between light and dark and the predominance of black over color are unusual in Chang's oeuvre. The uniqueness of this work underscores the advantage of Chang's splashed-ink-and-color technique—he never had to fear repeating himself.

To paint *Dawning Light in Autumn Gorges,* Chang first poured and splashed ink on the paper, then scattered and swirled color on top. While the basic forms were accidental, Chang proceeded to transform their abstract shapes into a clearly readable scene. The addition of traditional landscape texture strokes in the spaces between the large pools of ink instantly described these sweeping forms as mountains—sheer cliffs backlit by a rising sun. Chang also used the tall, narrow format of the painting to help create the illusion of height.

The ink and color that Chang daringly flung onto the paper dried with ragged contours; the forms seem to be spreading out in a continual process of capillary action. Like the Western action painters, Chang capitalized on the potential of such random effects to suggest kinesthetic force. But where the action painters had no representational subject to inhibit gestural expression, Chang met the challenge of creating the same dynamic effect within set boundaries. In *Dawning Light in Autumn Gorges*, the ink and color heave against the sides of the painting and threaten to sweep over the edges as one might expect of a vibrant abstract painting, yet the viewer simultaneously accepts the cropping as a natural frame for the landscape, like the effect of a landscape circumscribed by the view through binoculars.

Separating the deliberate elements in *Dawning Light* from the fortuitous ones is difficult, and Chang's genius for mixing both the random and planned effects gives his splashed-ink-and-color paintings strong vitality. For example, the thread of white on the left "cliff" was random; however, the surrounding context so strongly suggests a waterfall that it almost seems to have been planned. Because Chang painted branches in the middle of the work, the irregular splotches of bright red become autumn trees, although the color functions more as decoration than as documentation. The swatch of turquoise oddly poised in the center of the painting is ornamental, yet the viewer can also read the blue as a pool of clear water. The bottom of the painting is entirely random, and yet a landscape is so convincingly evoked that the viewer reads rocks and trees in the color and ink.

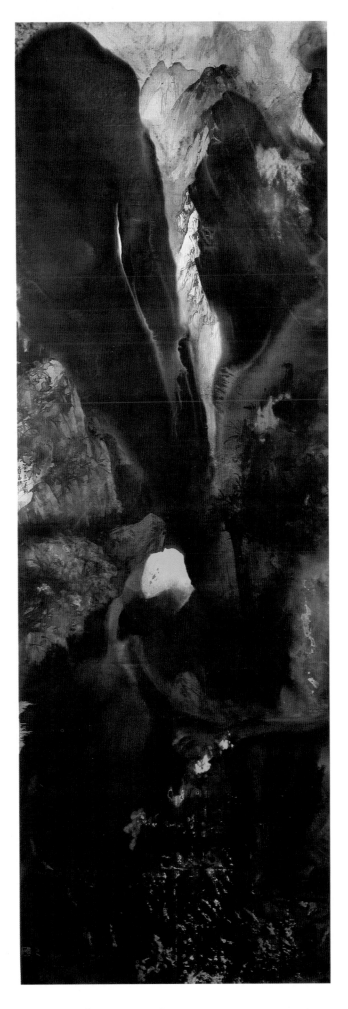

Dawning Light in Autumn Gorges

March 16 and 18, 1966
Rigid-board albums; ink and color on paper

Album A
Eight leaves (four shown)
Each 24.2 x 27 cm (9¹/₂ x 10⁵/₈ in.)
Inscriptions and signatures:

Begonia
Dai-chien jushi brushed this at Lake of the Five Kiosks.

Crape Myrtle
Autumn has turned chill; at the corner of the house the crape myrtle is in full bloom. I happily paint a branch; Yuan.

Bamboo and Chrysanthemum
Chen-Hua has come to São Paulo to visit and we spent the day discussing art and coincidentally talked of painting chrysanthemums; [therefore] I gave it a try and brushed this [flower], Yuan.

Flowering Plum
On the twenty-fifth day of the second lunar month of the *bingwu* year I painted this small album of eight leaves for Chen-Hua, son of my "elder brother." In my country [China], it is now spring but here [in Brazil] it is early autumn; Yuan.

Album B
Eight leaves (four shown)
Each 27 x 24.2 cm (10⁵/₈ x 9¹/₂ in.)
Inscriptions and signatures:

Cherries and Bamboo Shoot
Old Man Yuan

Chestnuts
Dai-chien jushi Yuan

Eggplants
Yuan Po

Spinach
On the twenty-seventh day of the second lunar month of the *bingwu* year, I painted this small album of eight leaves for my "niece" Xuemei.

Collection of Mr. and Mrs. Lee Chen-Hua, Westbury, New York

Lᴵᴷᴱ Mᴀʀᴄᴇʟ Pʀᴏᴜsᴛ in *Remembrance of Things Past,* Chang Dai-chien recalled certain foods and flowers with exquisite pleasure, and when casting about for a subject to paint, he was often inspired by the memory of a tasty bamboo shoot or spinach leaf. The subject matter of these albums is no more formal than this. The paintings are in the *xieyi* style, which literally means "sketching the idea," without rigorous attention to realism or detail. The approach is particularly apt for casual paintings, such as the parade of flowers, fruits, and vegetables here.

Chang Dai-chien was nearly seventy when he painted *Flowers, Fruits, and Vegetables,* yet these albums echo some of his earliest works. As a twenty-year-old in Shanghai, Chang had learned *xieyi* painting under the influence of followers of Wu Changshuo (1844–1927), who then dominated the world of bird-and-flower painting. But Chang's technical precociousness and keen intellectual curiosity soon led him to study the earlier practitioners of *xieyi,* in particular Shitao (1642–1707), Zhu Da (1626–1705), Xu Wei (1521–1593), and Chen Shun (1483–1544), all of whom painted flowers and vegetables in an impressionistic, almost kinesthetic, style with wet brushwork and succulent colors. Toward the end of the 1930s Chang turned to refined *gongbi* painting, and a decade later he had mastered the style of the Song dynasty academic painters. Thereafter he switched back and forth between bold and precise manners of brushwork, depending on his mood, until failing eyesight made it nearly impossible for him to continue painting *gongbi.*

Chang Dai-chien painted these amusing studies of flowers, fruits, and vegetables on Japanese rigid boards faced with a fine-textured paper known as *tori no kami.* The paper has a light yellow hue, and because it does not freely absorb water, these still lifes seem neater than those by Chen Shun and Xu Wei, despite Chang's spontaneous *xieyi* brushwork, which is akin to their moist techniques. Each image is more self-contained, as the ink and colors did not puddle significantly.

Throughout his career, for relief from the physical effort and high concentration required by his detailed and large works, Chang liked to paint everyday still lifes. With the exception of lotus flowers, which he often painted on folding screens or as sets of large hanging scrolls, Chang's flower, fruit, and vegetable paintings are generally small compositions. Their exuberance suggests a happy mood. Sitting quietly at his painting table, Chang found such works almost effortless; these albums, in fact, were accomplished while he talked with friends.

The sensitive variation in brushwork, color, and composition testifies to years of practice. The blank space in each study presents the painted object as a tiny gem to be trea-

sured. Although the accuracy and succulent appeal of the subjects suggest they were painted from life, they are "mind images," as the album's owners can attest. Lee Chen-Hua, son of one of Chang Dai-chien's closest friends, and his wife Xuemei traveled from New York to Brazil in March 1966 to visit Chang. On March 16, Chang painted eight leaves of flowers for Lee Chen-Hua, and two days later he painted eight leaves of fruits and vegetables for Lee Xuemei.

In the album painted for Lee Chen-Hua, Chang modestly wrote in the inscription on *Bamboo and Chrysanthemum* that he "gave it a try" to paint a chrysanthemum. In fact, the flower stalk and blossom display exceptional spontaneity without compromising accuracy. The bamboo stalk is a firm anchor for the sweeping form of the chrysanthemum.

The album for Lee Xuemei presents common fruits and vegetables with a sense of playfulness. The unusual combination of a bamboo shoot and cherries was inspired by Chang's desire to pair complementary shapes, colors, and sizes to create a vibrant image; it is not a still life based on an actual arrangement of objects. In *Eggplants,* one of the most visually witty leaves, two purple eggplants huddle one behind the other, their prickly green stems arched and almost joined. As a counterweight, a circular ivory-colored eggplant sits off to the side, outlined with ink and a band of brownish purple to highlight the unpainted paper within the circle.

In both of these albums, Chang Dai-chien displayed not only his keen observational skills and fondness for nature but also his ability to effortlessly create works of beauty for his dear friends.

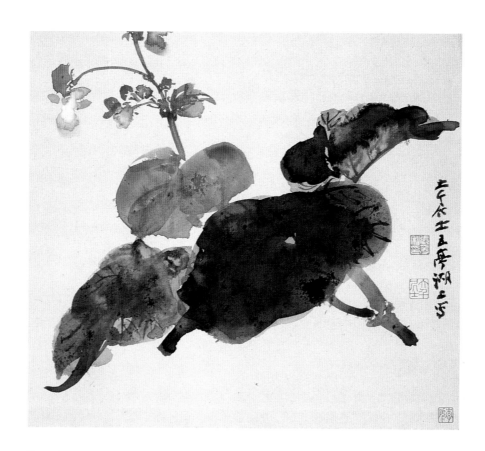

Begonia

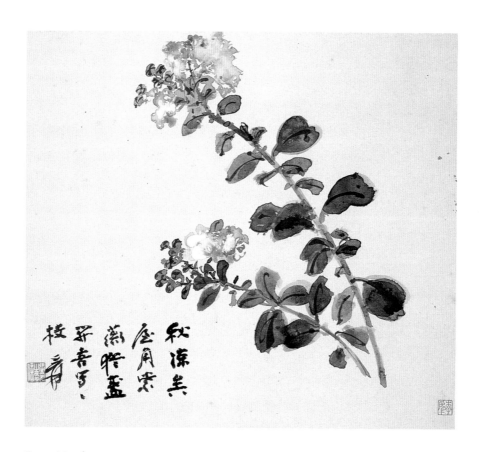

Crape Myrtle

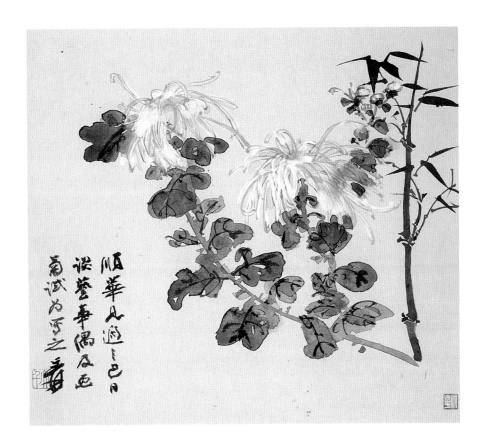

Bamboo and Chrysanthemum

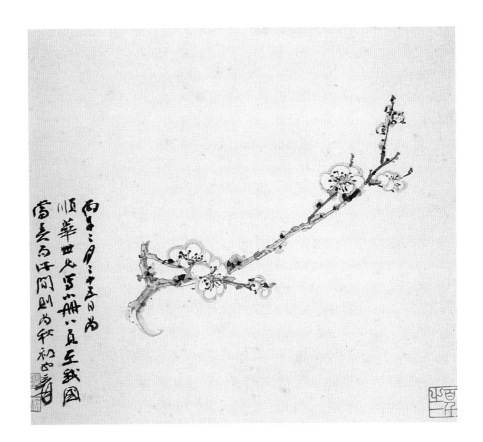

Flowering Plum

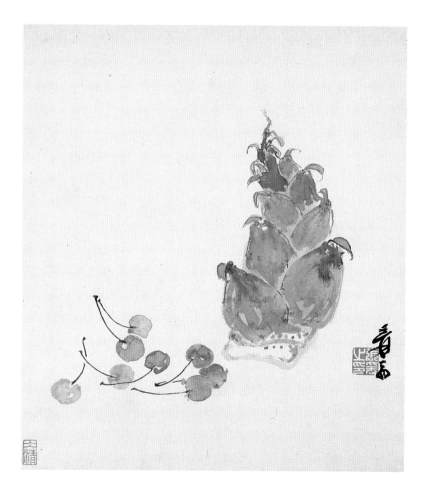

Cherries and Bamboo Shoot

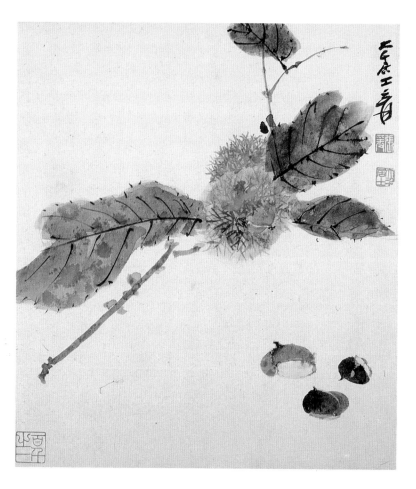

Chestnuts

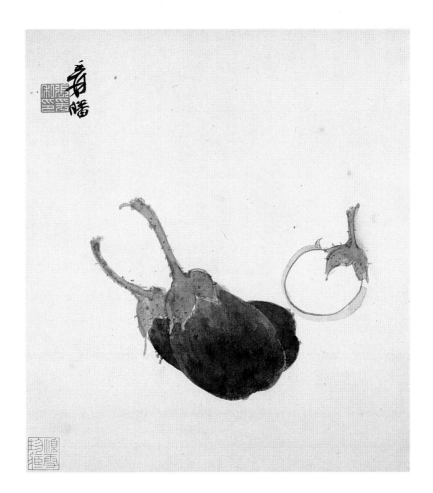

Eggplants

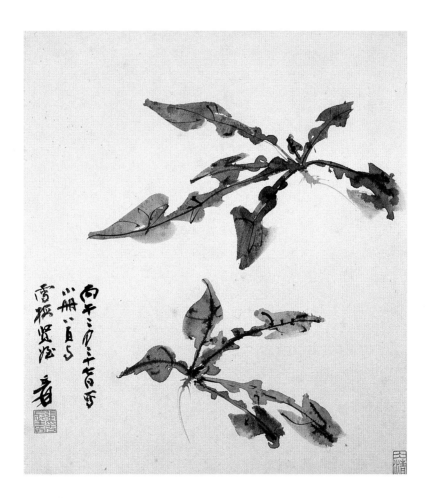

Spinach

68　Nesting in a Pine

May 20, 1966
Mounted for framing; ink and color on paper
53 x 106 cm (20⁷/₈ x 41³/₄ in.)
Inscription and signature:

> Done with hiking a thousand peaks,
> I make this tree my home;
> Hair tousled and disheveled
> creepers and moss cover me.
> You ask what's there to see
> within the mountain depths;
> Birds drop fruit from their beaks,
> planting flowers of plum.

> This is a self-portrait by Dadizi [Shitao]; in imitating it, I've [painted] myself [in his place]. First day of the fourth lunar month of the *bingwu* year; Old Man Yuan.
> SDA

Collection of Chang Sing-cheng, Pebble Beach, California

CHANG DAI-CHIEN painted himself in an improbable pose—sitting cross-legged, high on a pine bough as if he were a bird nesting in a tree—but the image looks surprisingly natural. Chang inscribed a poem that alludes to the idealized life of a hermit covered by creepers and moss, a conventional literary reference for a noble recluse. As early as the "Nine Songs" of ancient Chu, a poetic work that Chang painted on many occasions (see entry 78), lofty hermits are described as clad in the leaves of creeping fig and belted with tree moss.

To paint the eccentric and arrestingly beautiful pine tree, Chang used ink, light color washes, and heavy dabs of two hues of bright mineral blue. Pinwheel clusters of needles overlap each other, and a wash on top of them creates the illusion of volumetric mass. The brush method for the pine strongly echoes the manner of Shitao (1642–1707), and as Chang mentioned in the inscription, Shitao provided the precedent for the composition as well. Vines with an occasional crimson leaf loop over the pine branches and frame the nesting figure, who gazes toward sharp peaks on the distant horizon. The pine roost must be on a tall summit itself to offer such an unobstructed vista.

The idea of combining the familiar elements of man and tree in this unexpected way parallels the unusual juxtapositions of Shitao's compositions. Shitao's inventive solutions are an antidote to the almost overbearing canonical tradition of literati painting that dominated his period. Chang Dai-chien also sought to break through conventional boundaries, and at the same time that he was fashioning paintings with traditional brushwork, he was also establishing new ground with his splashed-ink-and-color creations.

Shitao was not the first artist to depict a figure in a tree; close association between a man and a tree had long been a way to show an individual's harmony with nature. The painter Guanxiu (832–912), for example, once painted a *luohan*, or Buddhist disciple, sitting on a tree root, the trunk and lower boughs forming a niche around the figure.[1] Shitao's compositions centuries later were more astounding—he painted figures high up in trees like birds. And like Chang Dai-chien's, Shitao's figures were self-portraits. The poem Chang inscribed on the painting is a direct quotation from Shitao. The pictorial and poetic image of *Nesting in a Pine* was so potent that Chang Dai-chien painted several versions of this self-portrait during the 1950s and 1960s.

One similar version, which Chang painted in the same month, has a different poem that explains his choice of a pine tree.[2] Shitao did not use pines in his nesting self-portraits; instead, Chang was inspired by Li Bo (701–762), whose last couplet from "Gazing at Wulao Peak in Lushan" Chang inscribed on this other self-portrait.

> The full beauty of Jiujiang
> can be taken in one's grasp,
> Here in this place, I shall
> nest among the cloudy pines.
> SDA

Chang Dai-chien seems to be the first to give visual expression to Li Bo's image. *Nesting in a Pine* evinces Chang's particular brilliance in grafting eclectic images. Borrowing from Shitao and Li Bo, Chang Dai-chien created an independent vision expressing his desire to remain aloft above the dusty world.

1. For an illustration, see the composition as it has been preserved in a stone rubbing from Shengyin Si in Hangzhou, reproduced in Christan Murck, ed., *Artists and Traditions* (Princeton, N.J.: Art Museum, Princeton University, 1976), 107.

2. Illustrated in Gao Lingmei, *Chang Dai-chien hua ji* (Hong Kong: Dong-fang xuehui, 1967), 122.

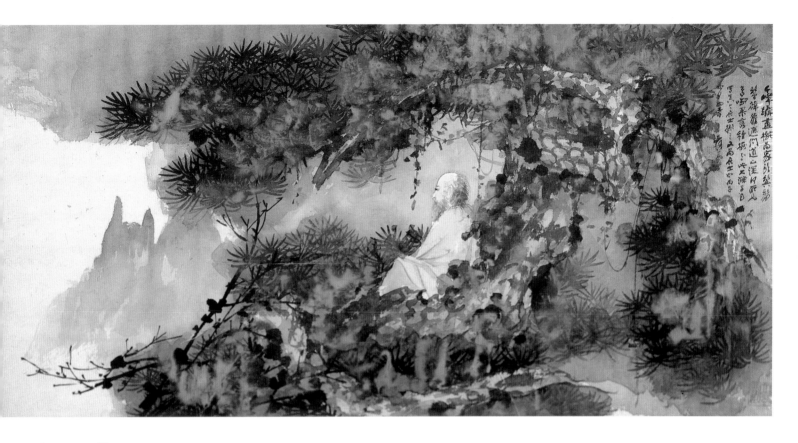

Nesting in a Pine

69 Patriarch Lü Dongbin

Summer 1967
Hanging scroll; ink on paper
90.7 x 54.2 cm (35³/₄ x 21³/₈ in.)
Inscription and signature:
 Portrait of Patriarch Lü Chunyang [Lü Dongbin]; summer of the *dingwei*
 year, Chang Dai-chien Yuan respectfully painted [this] for Lingyun, my
 "elder brother," as an offering.
Collection of Mr. and Mrs. Lee Chen-Hua, Westbury, New York

CHANG DAI-CHIEN painted *Patriarch Lü Dongbin* in Brazil and carried it to New York to give to his old friend from Shanghai days, the collector Lee Lingyun, whose son currently owns the work. The subject is an idealized portrait of Lü Dongbin (ca. 790–862), a semilegendary figure who is popularly worshiped in Daoist temples. Chang executed this portrait with rapid-fire brushwork that captures the brusk fearlessness of Lü Dongbin, who, according to tradition, became an immortal after passing through ten arduous trials.

Chang Dai-chien painted an eclectic range of religious subjects throughout his career. He was born a Catholic and spent several years in parochial school, but as a young man he embraced Buddhism and almost became a monk. During the 1940s he assiduously studied Buddhist painting in the caves at Dunhuang. During his late thirties, he lived for a period in the Qingcheng Mountains at the Shangqing Gong Daoist temple, where he became absorbed in Daoism and painted several Daoist figures for the temple abbot. During that time he developed the range of styles that he used to paint this imagined portrait of Lü Dongbin.

Chang Dai-chien first sketched this image of Lü Dongbin in broad strokes of pale ink, then he added darker lines on top and filled in certain areas with ink wash. The shapes and patterns of the brush strokes reflect Chang's momentum as he plied his brush to such a great degree that the viewer can almost trace the movement of his hand. Chang rendered facial features with abbreviated strokes, and he drew zigzags for the drapery lines, which were created without lifting the brush from the paper. Chang did not try to align the layers of strokes; this effect and the blurred contours from the layering of damp strokes contribute to the impression of speed.

Chang used traditional iconography for this portrait: Lü is shown as a man in his prime, with a short beard and a pleated cap called a Huayang kerchief, and a sword hilt is visible above the shoulder. Lü Dongbin's sword was reputed to have supernatural power, which he used to rid the world of evil. Lü (given name Yan) was from an official family that lived in a small town in Shaanxi Province; he is usually known by his style name, Lü Dongbin, or his sobriquet, Lü Chunyang, which is how Chang Dai-chien referred to him in the inscription. Lü was a degree-holder and served in the literature department of the Tang dynasty court. During a period of revolt, he went to the Zhongnan Mountains, where he devoted himself to Daoist practices. According to the *Official History of the Song Dynasty*, Lü Dongbin excelled at the art of swordsmanship. It was recorded that when he was more than one hundred years old he still looked in his prime and walked in swift strides that could cover a hundred miles in a flash. Legend gradually overtook the known facts of Lü's life, and he became one of the Eight Immortals of Daoist tradition. He was particularly popular among the educated elite because of his service in the literature department, but he is also the patron saint of jugglers and barbers.

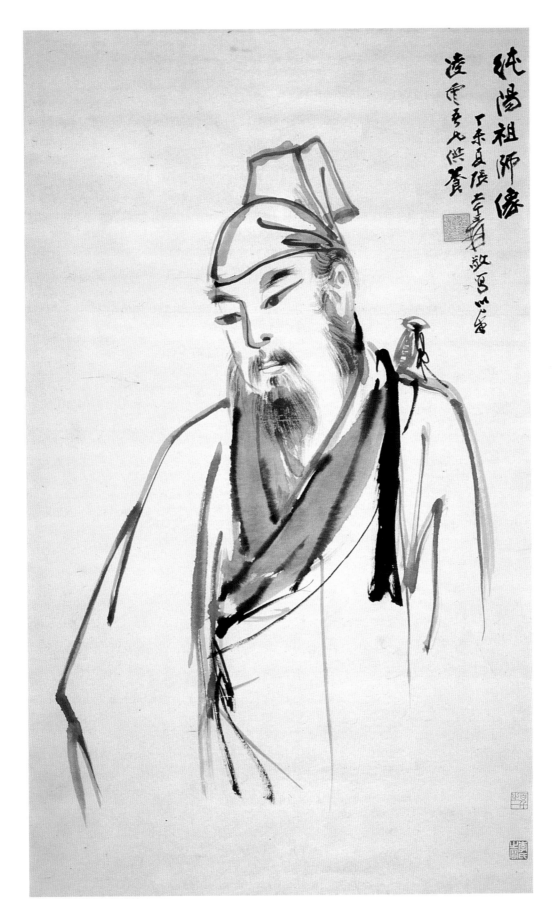

純陽祖師像

丁未且張空青

敬題以

凌雲尋九供養

Patriarch Lü Dongbin

70 Swiss Landscape
71 Approach of a Mountain Storm
72 Snowy Mountains in Switzerland

70 Swiss Landscape
1967
Mounted for framing; ink and light color on paper
74 x 113 cm (29¼ x 44½ in.)
Inscription and signature:
> During the last ten or so years, I visited Switzerland quite often and came to understand the landscape rather well. So I could reflexively paint it. There is no need to point out the name of this place; it can be any mountain. Thus those who appreciate the resonance of this can have a meeting of the minds; Dai-chien zhenyi Yuan.

Collection of Chang Sing-cheng, Pebble Beach, California

71 Approach of a Mountain Storm
1967
Mounted for framing; ink and color on paper
93 x 116 cm (36⅝ x 45⅝ in.)
Inscription and signature:
> As river clouds begin to rise and
> the sun sinks behind the hall,
> The mountain storm is approaching
> and wind fills all the tower.
> Old Man Yuan
> SDA

Collection of Chang Sing S., Kuala Lumpur

72 Snowy Mountains in Switzerland
1967
Mounted for framing; ink and color on gold paper
67 x 92 cm (26⅜ x 36¼ in.)
Inscription and signature:
> Impressions of Switzerland, brushed by Old Man Yuan.

Collection of Paul Chang, Pebble Beach, California

THESE THREE paintings, with blotches of brilliant color and ink and a virtual lack of descriptive, linear brushwork, look more like abstract expressionist art than traditional Chinese painting. However, Chang Dai-chien did not completely ignore historical precedent when creating these works; Tang dynasty artists had painted using a technique called *pomo,* or "splashed ink." By developing a modern style of splashed-ink painting and by introducing the element of color, Chang Dai-chien revitalized Chinese painting and brought it into accord with international art currents.

Soon after he moved to South America in 1952, Chang realized that the Western painting markets were necessary to his financial success, particularly since the postwar Chinese economy was weak. His increasing contact with the United States encouraged him to focus more narrowly on its art markets. Chang was impressed by some of the contemporary Western art he had seen, especially gestural painting with bright colors, and he began adapting his own heritage to fit the tastes of his new Western patrons. At the same time, Chang's failing eyesight hindered him from continuing to produce detailed *gongbi* painting. Deteriorating vision was also a stimulus toward experimenting with bold compositions in the late 1950s and early 1960s.

Accounts of certain eighth-century painters describe how they flung ink to create a picture. Chang Dai-chien seems to have been the first Chinese to fling color alongside the ink. First he perfected the splashed-ink style, and then around 1960 he began in earnest to work in splashed-ink-and-color, painting with wild, kinesthetic gestures akin to Western action painting. By 1965 splashed-ink-and-color was Chang's favorite technique, and he reached a self-proclaimed acme in 1967 and 1968. These three works represent the pinnacle of Chang's international style.

Whether using ink or ink and color, Chang Dai-chien let more of the final picture be determined by random patterns than had earlier Chinese painters, although he always worked a recognizable landscape out of the resulting blotches. Another innovation Chang achieved in these free-form paintings is a lambent effect, the result of capturing the influence of light on color and deliberately using harsh color contrasts.

Although it is easy to imagine that *Swiss Landscape, Approach of a Mountain Storm,* and *Snowy Mountains in Switzerland* were executed quickly, they were actually more time-consuming for Chang than traditional literati landscapes. Because he intervened to partially control the flow of ink and color, Chang went through several steps to complete each painting. Looking for a representational outcome to the

Swiss Landscape

Approach of a Mountain Storm

Snowy Mountains in Switzerland

arbitrary splotches of ink and color slowed his progress. Chang's son Paul has said that some paintings sat idle for months or years while Chang searched them for meaning.

The painting surface for a splashed composition required a preparation different from that of traditional Chinese painting. Chang painted on paper or silk that was temporarily mounted on a board; this method kept the painting ground taut and helped it withstand the stress of Chang's wet, sweeping brush strokes without ripping or wrinkling. A professional mounter, who was a member of Chang's household staff, prepared the surfaces for these works.

Although *Swiss Landscape* is primarily ink with only a touch of light color, Chang followed the same approach he used when painting with heavy color. After the paper was attached to a board, Chang wet it thoroughly and splashed dark ink on the damp surface. Helped by assistants, usually his students and family members, he rotated the board to partially direct the flow of the pigments, thus influencing the final balance and harmony of the ink or ink and colors. He poured on lighter ink next and let capillary action spread and mix the shades of ink; he also used a coarse brush to spread some pale ink wash. When the paper was almost dry, Chang added a few texture strokes borrowed from traditional literati painting, transforming the ink blots into recognizable mountains. Then he finished the work by adding light color.

The open spaces in *Swiss Landscape* have a positive value, and although the painting is technically different from traditional Chinese art, early masters had long known how to harness voids as active elements in a composition. In the lower left, the blank paper reads like thick vapor, which as it floats over the mountain's midriff mixes with traces of blue and gray until it becomes misty rain in a mountain valley.

Chang emphasized the monumentality of the mountain by adding a single, small pine jutting out from the bluff. Similar details appear in Chang's paintings of the Yellow Mountains, but here the tree is more schematic. A few needle-sharp brush strokes in the lower right represent aquatic grasses, subtly filling out the landscape. Chang's inscription on *Swiss Landscape* ties the painting to a particular country, but it also cautions the viewer to resist being too literal.

After settling in Brazil, Chang often traveled to Hong Kong, Japan, and Taiwan. He also visited Europe several times, beginning in May 1956. An exhibition of his paintings in Paris at the Musée d'Art Moderne provided him with a chance to see Europe and visit museums. He returned to Europe once a year from 1959 to 1961 and then again in 1965, touring Switzerland's lakes and mountains each time he visited. The Swiss landscape inspired many of Chang's paintings from the 1960s, but he seldom painted Switzerland after that.

It was only while he relied so heavily on the Western art market for survival that he concentrated on painting European places.

Chang's inscription maintains that this composition was rooted in personal travels, but the wording recalls an inscription Shitao (1642–1707) wrote on a landscape album painting.

I've captured the essence of the Yellow Mountains, but there is no need to point out the name of the place.

Chang Dai-chien borrowed Shitao's sentiment and applied it to *Swiss Landscape,* which has no stylistic connection with Shitao's work.

When painting *Approach of a Mountain Storm,* Chang poured graduated tones of ink onto the paper. Then he swished pools of azurite, malachite, and other rich colors on top. The pigments oozed and covered the paper except for a small patch slightly above and to the right of center. The colors surrounding the unpainted area are so vibrant that the white paper takes on an uncanny glow, like the burning sun in a sky darkened with thunderclouds. In order to ensure that the subject was discernible, Chang brushed a few schematic buildings in the lower left. Thus, the thick blue-black colors around the houses seem to be a dense pine forest.

In the lower right, Chang quoted lines from a Tang dynasty poem and signed his name. He wrote in gold, which may have been a deliberate gesture to connect to the past; Tang dynasty artists often used gold with azurite and malachite, the predominant pigments in *Approach of a Mountain Storm.* Next to the inscription Chang impressed a seal that has the cyclical date *dingwei* (1967). Along with the brilliant blues and greens, the gold calligraphy and red seal create an effect similar to that of champlevé enamel.

Chang's quotation of a Tang dynasty poem exemplifies the marriage between new and old in his splashed-ink-and-color paintings. In traditional Chinese culture, thoughts and emotions are typically expressed in relation to some historical event or person—as though present experience has to be connected to the past to be valid. Therefore, to accompany the innovative painting style of *Approach of a Mountain Storm,* Chang invoked the past through his inscription, lines from "The Eastern Tower of the City Wall of Xianyang" by Xu Hun (act. mid-9th cent.). Yet the relationship between poem and painting is superficial, as the entire verse demonstrates.

Alone I climb the high city walls,
 ten thousand miles of sadness,
Where rushes and the willow trees
 seem like islands in a stream.
As river clouds begin to rise and
 the sun sinks behind the hall,

The mountain storm is approaching
 and wind fills all the tower.
Birds descend to the green bushes,
 it's dusk in the parks of Qin,
Cicadas whir in the yellow leaves,
 autumn's in the palace of Han.
Traveler, do not ask what
 happened in those ancient times!
Eastwardly past realms of
 old the River Wei flows ever on.[1]
SDA

The thrust of this poem is the ephemeral nature of human achievement, but Chang completely ignored this message, and he rejected Xu Hun's melancholy autumnal setting for the lush wetness of summer. Chang must have searched his memory or scanned the many books of poetry he kept at hand to find a line describing the mood of an approaching storm, but he felt no qualms about ignoring the rest of the verse.

The background of *Snowy Mountains in Switzerland* is Japanese gold-foil paper, which shines through some of the colors splashed on top of it. Chang left portions of the right edge untouched so that the luminescent paper remains a powerful compositional element. White, which Chang particularly favored from 1967 to 1969, is one of the dominant colors. Chang used white both by itself and mixed with other colors to soften them. The diagonal bands of white resemble drifts of snow, whereas the white pigment at the bottom edge of the painting has a softer texture, like billowing clouds or snow whirling on the wind.

This painting is more abstract than the other splashed-ink-and-color works from 1967, yet it is still clearly recognizable as a landscape. Literati Chinese painters often textured mountains with "dragon veins," which are channels of energy that transverse the rocks, akin to magnetic fields. Chang's familiarity with "dragon veins" prompted the coarse, irregular brush strokes that he used at the top of the painting to define a mountain form. His technique is similar to but looser than the "lotus-vein" texture strokes of traditional painting.

Snowy Mountains in Switzerland is abstract except for the title and the "dragon veins," which help the Chinese viewer quickly recognize the form of a mountain. The Western viewer, Chang's targeted audience at the time, must rely on the title and the effect of the light reflected from the gold paper, especially along the right edge, which mimics sunshine gleaming on a snowy surface.

The bright upper right corner contrasts with the lower left, which was painted in black ink and heavy, dark blue. Chang arrived at a completely different blue on the right by mixing it with white and applying some of the color with only a light flicking motion. The diagonal pattern in the area gives the impression of raking afternoon light. A specific reference like this to a time of day is rare in traditional Chinese painting. Chang's inscription explains that he was painting a recollection of his travels in Switzerland. In spite of the abstract qualities of *Snowy Mountains in Switzerland*, it nonetheless records an actual mountain and the time of day that Chang observed it.

1. *Quan Tang shi,* vol. 16 (Peking: Zhonghua shuju, 1985), 6085.

73 Splashed Ink on Gold

June 26–July 24, 1968
Mounted for framing; ink on gold paper
95 x 174.5 cm (37³/₈ x 68³/₄ in.)
Signature:
 Old Man Yuan created this in the sixth lunar month of the *wushen* year.
Collection of Chang Hsu Wen-po, Taipei

CHANG DAI-CHIEN created an unprecedented composition in this work by spilling and splashing ink onto gold-foil paper. Where the gold pokes through pools of dark ink, it picks up ambient light and shines likes a gem. This gold-foil paper of Japanese manufacture absorbs water poorly, making the ink almost like an oil slick gliding on its surface; only in a few places did the ink actually soak in. In some areas Chang added more layers of ink while the bottom coat was still damp, creating a fluid design. As in his splashed-ink-and-color creations, he worked with a speed and rhythm akin to Western action painters.

Chang's only deliberate brush strokes are barren branches at the bottom edge of the painting, and these small details make it possible to read the work as a landscape of snow-covered mountains. A pocket of gold paper left in reserve against the pale ink wash and dark "mountain" form becomes a blanket of snow. In *Splashed Ink on Gold*, Chang demonstrated his genius for moving between the realm of pure abstraction and recognizable physical form.

Chang began the composition by randomly spilling ink and rotating the surface of the painting to channel its flow. Although he exercised no direct control at this stage, his intuition about how to shift the surface resulted in configurations amenable to landscape scenes. He also carefully used different shades of ink in all his random splashings. The composition was predicated on "psychological projection"—the same principle that is behind the Rorschach inkblot test. Tang and Song dynasty artists had engaged in a similar practice, recognizing the mysterious beauty of accidental effects by admiring the designs in a "worm-eaten tree" or the "traces on a wall from a leaky roof." But Chang raised this practice to new heights.

The fact that Chang Dai-chien wrote only his name and the date on *Splashed Ink on Gold* is unusual. Generally he wrote fuller inscriptions, but his splashed-ink and splashed-ink-and-color works often have terse signatures, possibly because he felt such Western-style signatures were more suitable for the "international" flavor he hoped to achieve. This signature also marks the first time Chang used the verb *zhi* ("created this") with his name, instead of *hua* ("painted"), *xie* ("wrote"), or *zuo* ("made"). Perhaps he felt he had broached new territory, which warranted the word "creation."

Nearly seventy, Chang Dai-chien was still developing new methods. Chinese painters have rarely been encouraged to experiment, and training has focused on mastering the techniques of the past. Among the previous generation of painters, who were in general much more conservative than today's artists, Chang Dai-chien stands out as singularly imaginative and bold.

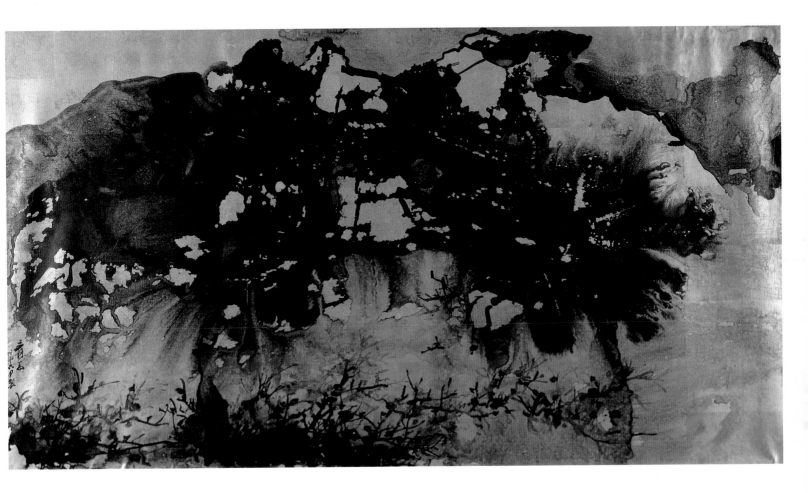

Splashed Ink on Gold

1968
Mounted for framing; ink and color on gold paper
96 x 186.5 cm (37³/₄ x 73³/₈ in.)
Signature:
 Old Man Yuan
Collection of Chang Hsu Wen-po, Taipei

CHANG DAI-CHIEN mixed random blotches of ink and color across the surface of *Spring Landscape in Splashed Color*, and then, with the calculated addition of white accents and a few tree branches, he transformed the abstract design into a rich alpine snowscape. To achieve the effect he wanted, Chang selected old, handmade vegetable-fiber paper whose surface was slightly abraded; thus, the pigments were absorbed unevenly and produced random areas where no color penetrated into the paper and, conversely, areas where the pigment accumulated. What appears at first to be liberally sprinkled dots on *Spring Landscape in Splashed Color* is actually the natural effect of the paper. Chang exploited the effect to convey a sense of tiny drops of moisture in the air. Cool blue and green colors predominate, but Chang used soft earthen tones for the mountain peak. At the bottom right, where the gold paper shows through, he traced the outlines of branches, which seem to glow in the sun.

Chang Dai-chien's mastery of the splashed-ink-and-color technique is abundantly evident in *Spring Landscape in Splashed Color*. In the composition Chang balanced innovation and tradition as well as abstraction and concrete form. He rendered the snowy peak without traditional brush techniques, but the spreading tree is entirely conventional. The painting achieves an internal equilibrium through the pairing of opposites, such as wet and dry, and undifferentiated pools of color balanced against realistic detail.

While using intense colors to depict the buoyant mood of spring, Chang Dai-chien carefully modulated the pigments to avoid a harsh shine. He layered the various colors and ink softly, except for one patch of blue that has the vitreous shine of a mountain lake. Chang's mastery of technique is especially evident in the areas of white. Because he added extra water to make the edges soft, the white that extends from the bottom of the painting to the mountain's waist looks like a vaporous cloud. At the top of the peak, the same pigment applied in a drier state has the appearance of powdery snow.

Instead of writing an inscription on the painting, which was his usual practice, Chang signed only his name along the right border. His cultivation of Western patrons may have inspired him to replicate the Western fashion for short signatures. He did not even write the date on this work but used a seal engraved with the cyclical date of *wushen* (1968).

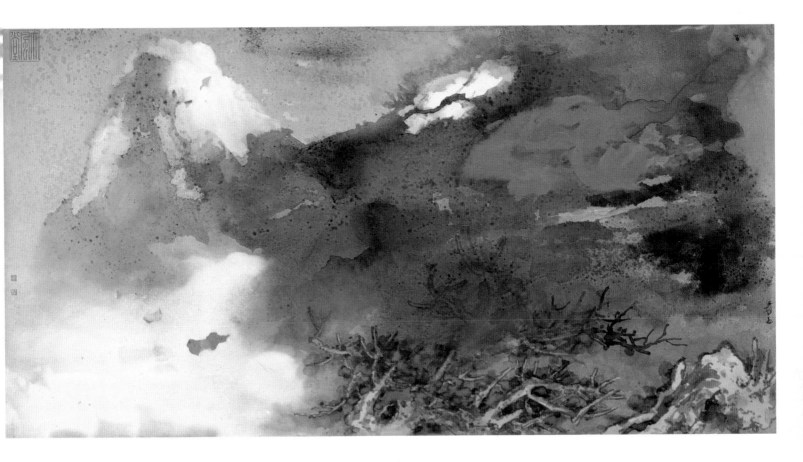

Spring Landscape in Splashed Color

75 Self-Portrait with Saint Bernard

January 8–February 5, 1970
Hanging scroll; ink and color on paper
172.7 x 93.4 cm (68 x 36 ¾ in.)
Inscriptions and signatures:

A

Brushed by Chang Yuan from Shu [Sichuan Province] during the last lunar month of the *jiyou* year, at the Lake of Five Kiosks in São Paulo.

B

At the beginning of the [lunar] New Year, in the *gengxu* year [February 6, 1970], I inscribe this and present it to my son-in-law, Xianjue [C. Y. Lee]; Old Man Yuan.

Collection of Mr. and Mrs. C. Y. Lee, São Paulo, Brazil

CHANG DAI-CHIEN'S fondness for large dogs is obvious in this self-portrait. He conveyed the bond between himself and his Saint Bernard by painting them both with the same blunt, bold brush strokes and in the same range of colors, even whimsically rendering his beard to look like the dog's woolly coat.

Chang Dai-chien's father bred dogs, and Chang's special affection for them began in childhood. In the early 1940s, he developed a fancy for Tibetan mastiffs, after seeing them used as guard dogs by the nomadic herdsmen who camped near the Buddhist caves at Dunhuang (see entries 23 and 24). When he returned to Sichuan Province, Chang brought two mastiffs with him, but the wet climate of Chengdu did not suit the long-haired, powerful dogs, and they soon died.

A decade later, when Chang toured Switzerland, he took a liking to the hefty Saint Bernard, and he again brought a pair of dogs home with him. This time the experiment was successful, and the animals not only prospered but also attracted attention as the first dogs of this breed in Brazil. Chang's family likes to think that all the Saint Bernards in Brazil descended from Chang's two pets. Later, when Chang moved to the United States, the São Paulo zoo took the dogs.

Chang Dai-chien painted his Saint Bernards several times, both before and after this painting, but this is the only known work in which Chang depicted himself with one of the dogs. A few days after Chang had painted this self-portrait he presented it to his son-in-law C. Y. Lee on New Year's Day. Lee is the husband of Chang's daughter Xinpei, the only child Chang and his wife Hsu Wen-po were able to bring with them when they left China in 1949. C. Y. Lee had left Hong Kong and moved to Brazil in the early 1950s, buying a farm near Chang Dai-chien's property. The gift of a self-portrait such as this, which depicts Chang in an unguarded moment of happiness, expressed his fondness for his son-in-law.

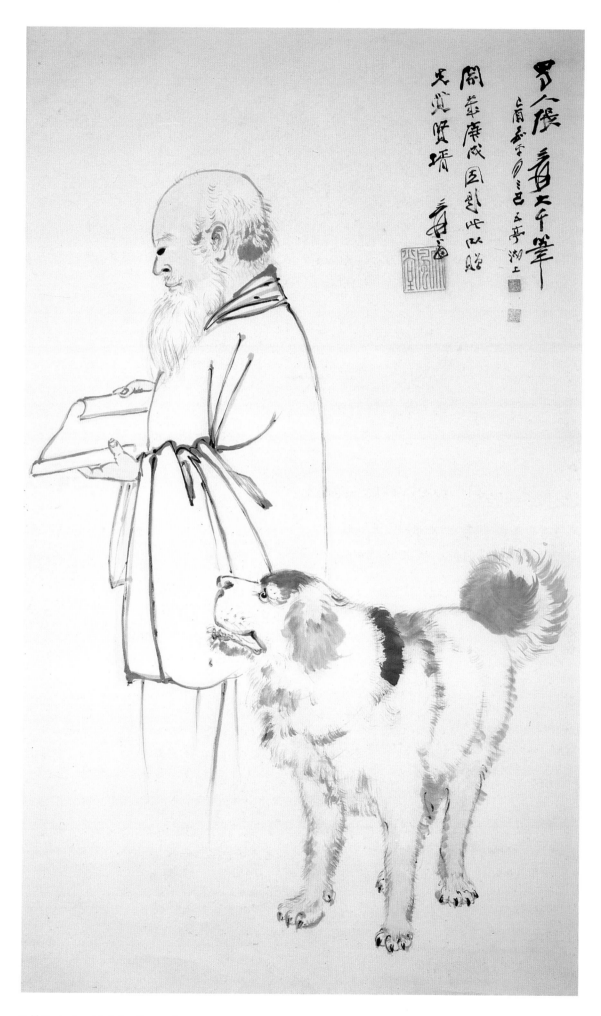

Self-Portrait with Saint Bernard

76 Pineapple

ca. 1971
Mounted for framing; ink and color on paper
46 x 60.5 cm (18⅛ x 23⅞ in.)
Inscription and signature:

> This is a Number Eight pineapple from Jiayi [Taiwan], which I brushed ten years ago. Recently my eyesight has been blurred and my hand trembles; I can never go back and make anything like this again. This is something to treasure like a worn broom. It is enough to make me sigh, overcome with emotion and lament. In my eighty-third year, Old Man Yuan.

Collection of Paul Chang, Pebble Beach, California

CHANG DAI-CHIEN's bejeweled *Pineapple* is an example of what the art critic Clive Bell meant in 1914 when he coined the term "significant form"—the fruit evokes emotion by the very beauty of its line and color. The pineapple was not a traditional subject in Chinese painting, suggesting that although Chang was over seventy years old, he was still looking for new challenges. This is the only known example of the subject in all of Chang's oeuvre.

Chang depicted *Pineapple* so precisely that one imagines he must have had the fruit directly in front of him. The colors—shades of yellow, orange, and russet combined—are exquisitely natural, and the spiked scales, though difficult to render, have an almost photographic accuracy.

Sometimes Chang would start a painting and put it aside to finish much later, which is probably the case here. The plume of leaves is not nearly so realistic as the pineapple itself, and it was probably added at a later date. He painted the fleshy leaves in conventional tones of green, and he outlined them with tiny dots that realistically suggest their prickly edges. The leaves curl and cross in front of each other to suggest three-dimensionality, but the blank background tends to flatten the painting.

Chang Dai-chien inscribed *Pineapple* in 1981, a decade after the painting was completed, when he was reflecting on his health. During the 1940s and 1950s, Chang Dai-chien often painted meticulous *gongbi* compositions of figures, birds, and flowers drawn from life. But after the late 1950s, when his eyesight deteriorated due to complications of diabetes, fine-line works became rare. Chang's comparison of the painting to a worn broom is a conventional Chinese expression: the artist felt a sense of modest accomplishment in this detailed work and treasured *Pineapple* as one cherishes a humble, personal item that becomes more dear after it is used for years. New techniques in ophthalmology gradually brought some improvement to Chang's eyesight, but even so, he seldom achieved the fine detail of *Pineapple*. This painting testifies to the perseverance of his skill.

Chang identified the pineapple as a new hybrid called "Number Eight," which was developed in Jiayi, in southern Taiwan, during the early 1970s. Although Chang did not move to Taiwan until 1976, he visited there in 1969, 1970, and 1973, and he may have painted *Pineapple* at any of these times. After 1970, he was often ill, and in 1979 he wrote his will. Two years later he inscribed this painting—looking at his previous work made him deeply regret that he could no longer paint in this manner. During his last five years he often painted still lifes, but the remainder of Chang's work in this genre was painted in the bold, inky *xieyi* style.

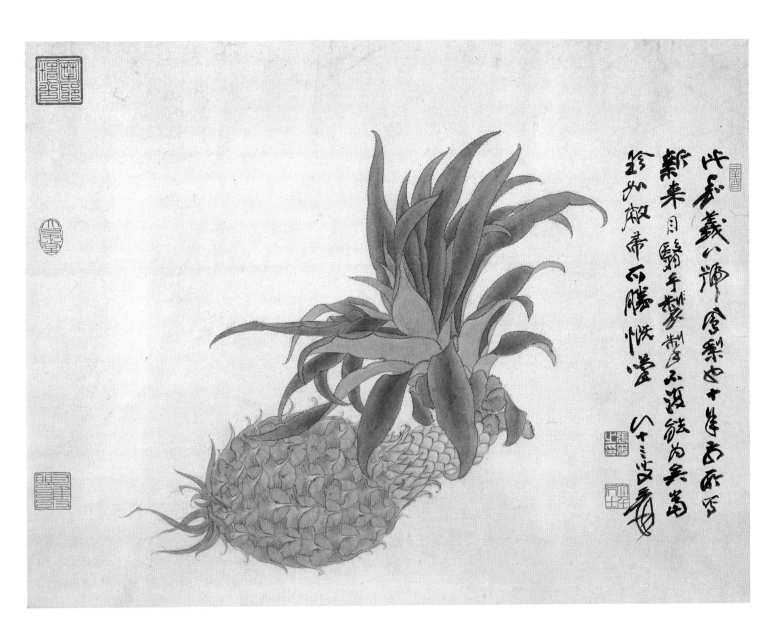

Pineapple

August 1973

Temple in the Mountains
Lithographic ink on paper
67.3 x 52 cm (26½ x 20½ in.)
Signature:
 On an autumn day in the *guichou* year; Old Man Yuan.

Red Persimmons
Colored lithographic ink on paper
55.9 x 76.2 cm (22 x 30 inches)
Inscription and signature:
 Frost is heavy, the cold's intense
 and day is turning to dusk,
 Lush and full, the vermilion fruit
 will set the clouds ablaze;
 But only because its fallen leaves
 can be inscribed with words
 Has the story of Three Perfections
 come down about Zheng Qian.[1]

First day of the eighth lunar month of the *guichou* year [August 28, 1973],
the sixty-second year [of the Republic of China] ; Old Man Yuan.
SDA

Collection of Mr. and Mrs. W. B. Fountain, Piedmont, California

A S AN émigré Chang Dai-chien continued his Chinese lifestyle as much as possible: he spoke his native language, ate a traditional diet, and transformed his farmland in Brazil into a Suzhou-style garden. He also continued to paint classical Chinese themes. But Chang had never limited his interest to any one period or artistic school, and so, after settling in the West, he embraced certain currents of international art. He also tried some new techniques, as these experiments with lithography attest.

Even before he left China in 1949, Chang had combined the orthodox and the innovative. His splashed-ink-and-color experiments, which he began in the late 1950s, are the most spectacular of his syntheses, since they virtually catapulted traditional Chinese painting into modern times. This breakthrough came at a time when most of Chang's patrons were Western, and he was frequently traveling throughout the world. After he moved to Pebble Beach, California, the Avery Brundage Collection (now the Asian Art Museum of San Francisco) organized a forty-year retrospective in 1972, which reflects increasing American interest in his work.

Among Chang Dai-chien's newfound American patrons were Mr. and Mrs. W. B. Fountain, who encouraged Chang to learn lithography. In August 1973, W. B. Fountain commissioned Chang to make a set of five lithographs, for which the artist designed three landscapes, a lotus, and a persimmon branch. Working at a printing studio in San Francisco, Chang completed this set in ten days, during which he was videotaped and photographed (fig. 110). Walter Maibaum pulled the prints, and W. B. Fountain had ninety copies made for sale (there were also ten artist's proofs and twenty-two copies for the collaborators), which were in such demand that he commissioned another set in autumn 1974. This time Chang created two compositions of landscapes, three of lotuses, and one of a gibbon. The wide distribution of Chang's lithographs enhanced his international recognition.

The seventy-four-year-old Chang Dai-chien eagerly took on the challenge of learning a new technique. In lithography the artist draws on a stone with a greasy crayon and tusche, a water-miscible, greasy black liquid that can be applied with a brush. The design itself is washed away with turpentine, but a layer of fatty acid from the crayon and tusche remains on the stone to absorb the printing ink. The rest of the stone repels the printing ink, leaving a blank area. Colored lithographs require an artist to make a key block of the entire design and separate stones for each color to be printed; these are kept in register through careful notations on the key block.

Chang Dai-chien approached *Temple in the Mountains* as he would have a splashed-ink landscape. He liberally applied the tusche and took advantage of the random patterns it cre-

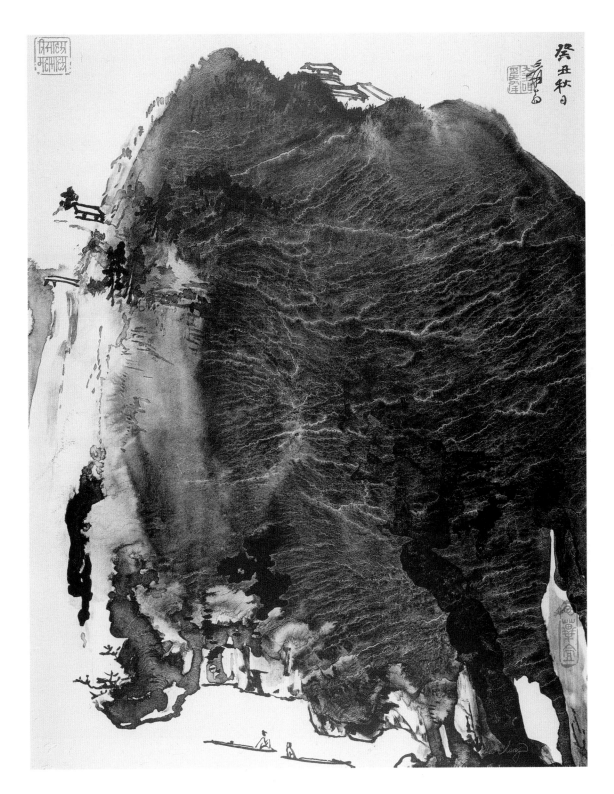

Temple in the Mountains

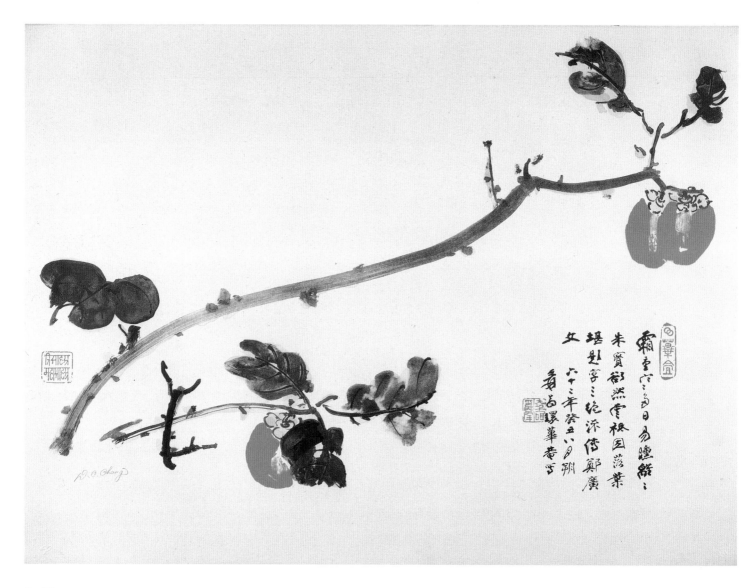

Red Persimmons

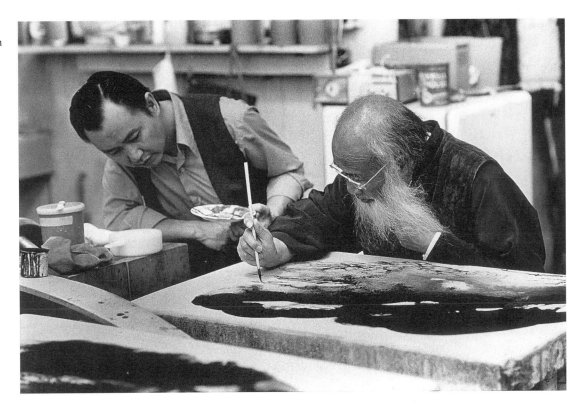

Fig. 110. Chang Dai-chien working on a lithograph with Paul Chang assisting.

ated as it spread, rubbing and smearing the black liquid into the shape of an imposing cliff. Chang added mountain lodges and a bridge over a chasm at the top of the picture while along the bottom he used a few stubby strokes to represent trees. Two skiffs with Chinese-looking scholars complete the composition. Chang used texture strokes on the mountain, and dark dots at its summit suggest vegetation. The white wrinkles on the cliffside were a special delight to Chang, because their effect was not something he could achieve with traditional ink on paper or silk.

Red Persimmons is radical only as a lithograph; its composition, colors, and the combination of painting, poetry, and calligraphy are traditional in Chinese art. *Red Persimmons* looks as if it could belong to *Ten Bamboo Studio,* a well-known set of seventeenth-century Chinese woodblock prints. The sparse composition of ripe persimmons is nonetheless lush because of the brilliant red that Chang used for the fruit, and the leaves are brown, as it is after a frost that persimmons become ripe.

Although sophisticated polychrome woodblock prints were popular in Ming dynasty China, lithography is a Western invention and was entirely new to Chang. At first, he was enthusiastic about learning the technique; ultimately, the complications and need for special materials and collaborators made the effort too cumbersome, and his second set of

lithographs, which lack the vibrancy and immediacy of this first set, was his last.

1. Zheng Qian (d. 764) was a renowned scholar known for his accomplishment in the "Three Perfections" of painting, poetry, and calligraphy. He sometimes lacked the money even to buy paper on which to practice his calligraphy and painting, and so he collected the long-lasting leaves of the persimmon tree to use for this purpose. He once presented Emperor Xuanzong (r. 712–756) with a work done on a persimmon leaf, which the emperor extolled highly.

78 Lady of the Xiang River

January 13, 1974
Mounted for framing; ink and color on silk
169 x 73 cm (66½ x 28¾ in.)
Inscription and signature:
On the waves of the Dongting lake the leaves are falling.

Old Man Yuan recovering from illness; since my fingers and wrist are still weak, I cannot completely finish the painting. The sixty-second year [of the Republic of China] on the twenty-first day of the twelfth lunar month of the *guichou* year, I inscribed this.
Collection of Chang Hsu Wen-po, Taipei

IN *Lady of the Xiang River* a pale woman in a white gown floats numinously against a background of blurred, irregular patches of ink and color. Grayish blue predominates, but in radiant contrast, a pool of dark ink, malachite, and azurite spreads out over the top margin. Ruby leaves rain down like jewels against the cool, watery background. Below the figure, to the right, Chang Dai-chien transcribed a line of ancient verse that identifies the figure as the Lady of the Xiang, an ancient river goddess.

The Lady of the Xiang (Xiang furen) is a semilegendary figure. According to tradition, she was the daughter of Emperor Yao (r. ca. 2357–ca. 2256 B.C.), who gave her as a consort to his successor Shun (r. ca. 2255–ca. 2205 B.C.). She is an elusive goddess, invoked by the ancient shaman during vernal and autumnal rites. According to David Hawkes, a British scholar who has translated and annotated the "Nine Songs," the poetic cycle from which Chang quoted:

> The shaman's love-song as he pursues, through rivers, lakes and wooded islands, a brooding presence which he senses and sometimes believes he can hear, but never, or only in faint, fleeting glimpses, ever sees, evokes for us, with an extraordinary vividness, an ancient, forgotten time in which men loved, even more than they feared, the mysterious world of nature that surrounded them.[1]

"Nine Songs" consists of nine invocations to various deities, plus two ritual hymns. The precise date and origin of the poems are unclear, but they have traditionally been ascribed to the famous poet Qu Yuan (ca. 343–277 B.C.). Modern scholarship suggests that Qu Yuan did not write the original poems but refined songs drawn from oral tradition that were used by local shamans.

Chang Dai-chien's inscription quotes the last line of the following stanza from "The Lady of the Xiang":

> The Child of God, descending the northern bank,
> Turns on me her eyes that are dark with longing.
> Gently the wind of autumn whispers;
> On the waves of the Dongting lake the leaves are falling.[2]

To portray this elusive goddess and evoke the sense of longing that permeates the poem, Chang Dai-chien eschewed the brilliant rouge, lipstick, and silks in which he usually portrayed women and painted with a subdued palette. He chose pale ink for the goddess's facial features and hair: her face is pallid, and she is wrapped in a cocoon of white. The lines of her clothing are faint, the russet lining is too anemic to add warmth, and there is an icy blue wash over the drapery folds. The aggregate effect of these subdued colors and the wet background is unearthly.

When he began painting themes from "Nine Songs" in 1946, Chang Dai-chien was following a long tradition. As early as the eleventh century, Li Gonglin (ca. 1049–1106) had painted the deities in the "Nine Songs," and the subject also found a champion in Zhao Mengfu (1254–1322), whose work influenced Chang enormously.[3] In 1939 Chang Dai-chien had acquired an album of the "Nine Songs" that he believed to be Zhao Mengfu's work (see fig. 104). The album is now in the Metropolitan Museum of Art but is listed as an anonymous fourteenth-century painting.

After Chang studied the Buddhist figure painting at Dunhuang in the 1940s, his skill at copying was so refined that his friend and fellow painter-collector Puru (1896–1963) encouraged him to test his ability against Zhao Mengfu. In 1946 Chang spent several months making a plain-line (*baimiao*) copy of the album *Nine Songs*. It was a stellar performance, as Chang's elegant but strong brushwork successfully re-created Tang and Song dynasty mannerisms.

Chang Dai-chien was nearly seventy-five years old when he painted *Lady of the Xiang River,* and as his inscription attests, his recent health had been poor. The outlines of the figure are still well controlled, although not as taut or as delicate as his earlier work. In *Nine Songs* from 1946 the cadence of each individual brush stroke animated the figures, and line dominated over mass. In *Lady of the Xiang River,* Chang replaced the emphasis on lineation with atmospheric and painterly effects. Perhaps Chang planned to add dark ink details to the figure. But if *Lady of the Xiang River* is incomplete, it is still a haunting portrayal of the elusive goddess and the fleeting visions of the shaman's song.

1. David Hawkes, trans., *The Songs of the South: An Anthology of Ancient Chinese Poems by Qu Yuan and Other Poets* (Middlesex, Eng.: Penguin Books, 1985), 106.

2. Ibid., 108.

3. Deborah Del Gais Muller discusses the tradition of paintings based on "Nine Songs" in "Li Kung-lin's 'Chiu-ko T'u': A Study of the 'Nine Songs' Handscrolls in the Sung and Yuan Dynasties" (Ph.D. diss., Yale University, 1981).

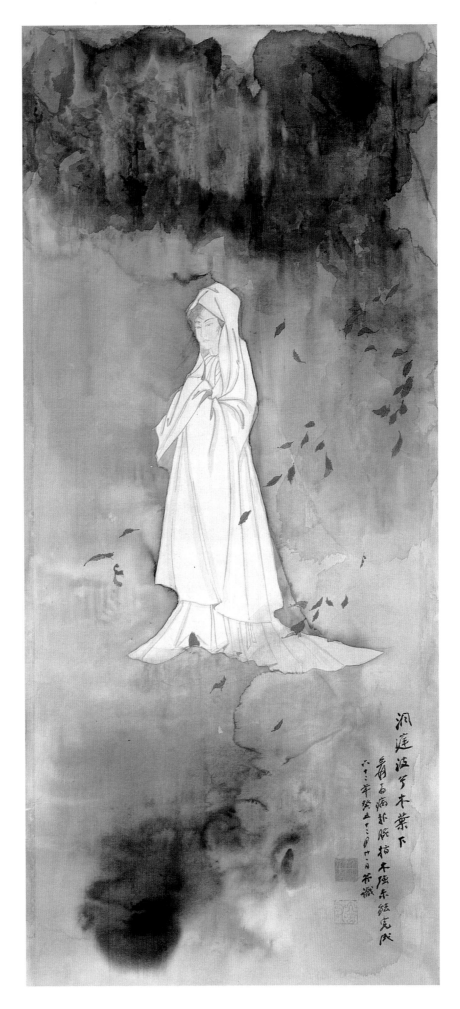

Lady of the Xiang River

March 14, 1975
Mounted for framing; ink and color on silk
87.6 x 140.7 cm (34¹/₂ x 55³/₈ in.)
Signature:
 The sixty-fourth year [of the Republic of China], on the second day of the
 second lunar month in the *yimao* year; created by Old Man Yuan at Huanbi
 An [studio in Pebble Beach].
Collection of Meng-Hua Chiang, Taipei

FIVE DENSELY foliated pine trees in the bottom right corner of *Morning Mist* suggest the limit of the river shore. Across the water a verdant cliff rises majestically, colored with layers of rich blue and green pigments and ink. Beyond, pinkish orange rooftops disclose the location of a secluded village. To compensate for the relatively unabsorbent nature of the Japanese silk, Chang used drenching washes of ink and light color to describe the river and the distant mountains and to depict thick mist evaporating in the morning sun.

At the foot of the mountain Chang left a thin strip of silk unpainted, and its pearly hue suggests white frothy waves lapping over the shore. This image is not found in the repertoire of traditional Chinese landscape elements, and it imbues *Morning Mist* with a special freshness even beyond the originality of Chang's gestural movements and uninhibited application of pigments in his splashed-ink-and-color paintings. Perhaps Chang's innovation was inspired by a view out the window during one of his international trips. From the air, waves beating against a shore look like a clean white line.

Much in *Morning Mist* is seen from a bird's-eye view; however, there is no consistent perspective. For example, Chang depicted the upper stories of some of the village buildings head on, while some of the roofs are drawn from an aerial perspective. Since Chang painted a section near the top of the trees straight on, the viewer sees the pines as if hovering in midair. This multiple perspective invokes a system used by the virtuoso Song dynasty landscape painters, such as Fan Kuan (ca. 960–ca. 1030) and Guo Xi (ca. 1001–ca. 1090). Unencumbered by physical laws or even the sense of body, the observer's mind freely roams through *Morning Mist*, savoring different views of the succulent landscape.

Chang Dai-chien painted this landscape in California after a brief trip to Taipei—diabetes and a related heart condition made him careful of his health, and he sought out Chinese-speaking doctors. Chang and his wife Hsu Wen-po returned to Pebble Beach in March. Not long afterwards, belying any signs of infirmity, Chang produced this landscape, which evokes a wonderful sense of expectancy as mist shifts and vaporizes in the morning air.

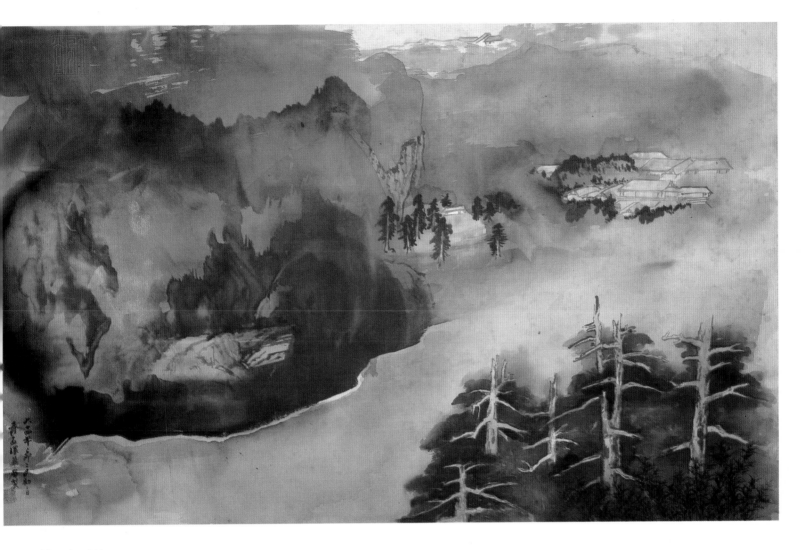

Morning Mist

March 22, 1975
Six-panel folding screen; ink and color on silk
168 x 369 cm (66⅛ x 145¼ in.)
Inscription and signature:
 The blossoms are in modern script,
 the stalks are like seal,
 The leaves are like clerical, the
 grass is done in cursive.
 I spilled the ink out all at once
 and couldn't stop myself,
 So let them laugh at this old man
 if I get looser as I age.

 Written at the Huanbi An [studio in Pebble Beach] two days before Flower
 Day in the *yimao* year, the sixty-fourth year [of the Republic of China]; in my
 seventy-seventh year, Old Man Yuan.
 SDA
Collection of Yon Fan, Hong Kong

LATE IN his career Chang Dai-chien often painted lotuses in his bold splashed-ink-and-color technique but never on such a large scale as this screen. The gemlike red, blue, and green pigments make the painting exceptionally sumptuous. Chang usually painted on screens made of paper, but here he used golden silk to great advantage, leaving about half the surface unpainted to shimmer like a sunbathed pond. The richly colored leaves are abstract enough to be read as pure ornament. When *Crimson Lotuses on Gold Screen* is compared with Chang's early flower paintings, a certain looseness in the brushwork is evident. At this stage of his career, he often bypassed minute details in pursuit of the aggregate effect. Whatever loss of strength and clarity his late paintings reveal is compensated by the vibrant patterns and colors. Just as a musical composition introduces a theme and builds to a climax, *Crimson Lotuses* begins on the upper right with a

Crimson Lotuses on Gold Screen

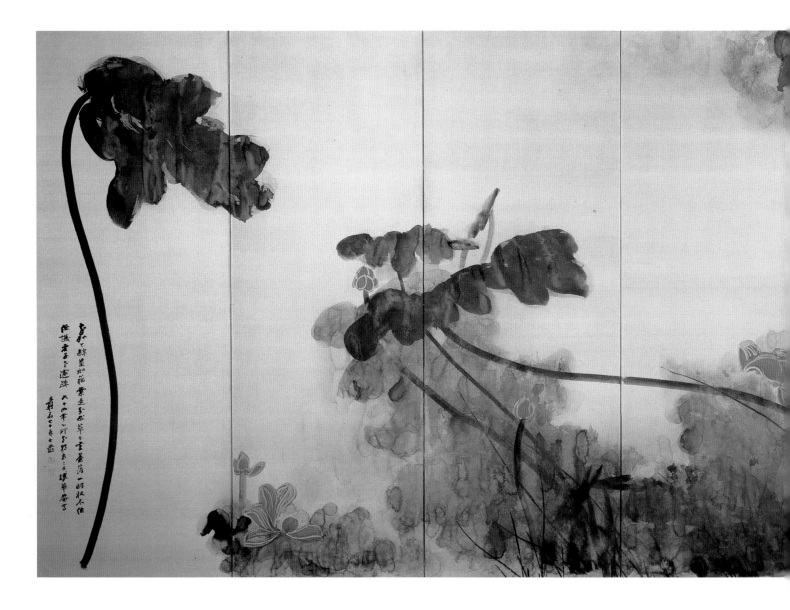

modest display of leaves and flowers, crescendos in the exuberant blossoms on the lower right, and finishes with the giant lotus leaf on the left as the grand finale:

The cluster of leaves and flowers in the upper section point downward to a larger and more concentrated group of blossoms and leaves. Variations in height, direction, and color dispel any sense of overcrowding. Chang overlapped layers of paint to look like different color leaves crossing in space. The unpainted area between these groups broadens as it sweeps to the left, where the towering leaf concludes the composition. The stem runs almost the entire height of the screen; Chang exercised supreme skill in executing the stem in a single brush stroke. Earlier Chang had painted even longer stems, but for those he developed the trick of joining two strokes started from opposite directions. When he connected the strokes, his brush would have already begun to dry out, so he could overlap the ink and blend the strokes together almost seamlessly.

Chang Dai-chien's inscription reveals that even at seventy-six he was still constantly thinking about the methodology of painting. And he repeated its gist in other inscriptions, once prior to *Crimson Lotuses* and once after. Chang based the first half of his poem—in which he compares his painting style to various types of calligraphy—on a famous colophon that Zhao Mengfu (1254–1322) appended to *Elegant Rocks and Sparse Trees* (Palace Museum, Peking), painted circa 1310.

> Rocks as in flying white [*feibai*], trees as in seal [*zhuan*] script;
> When painting bamboo, one should master the spreading-eight method [*bafen*].
> Those who understand this principle thoroughly
> Will recognize that calligraphy and painting have always been one.

Artists following Zhao Mengfu based their painting technique on calligraphy. Ke Jiusi (1290–1343), for example, writing in about 1328, instructed that ink bamboo should be painted entirely as if it were various types of calligraphy.

> When you paint bamboo stems use seal script; for the branches use the method of cursive script. Write out the leaves using the method of spreading-eight clerical script. Or you can use Lugong's [Yan Zhenqing; 709–785] method for making the sweeping leftward diagonal stroke [in calligraphy].[1]

Chang Dai-chien's early teacher Li Ruiqing (1867–1920) encouraged him to think like Zhao Mengfu and Ke Jiusi. Li showed Chang how Zhu Da (1626–1705) had used the method of seal script to paint the stalks of his famous lotus paintings. Zeng Xi (1861–1930), Chang's other early teacher, also emphasized the value of calligraphy as both an independent art and a method of painting. Chang excelled at both, and his first models in painting—Xu Wei (1521–1593), Shitao (1642–1707), and Zhu Da—all painted with calligraphic brushwork. Toward the end of Chang's career, when most of his works were splashed-ink-and-color, Chang still recalled the demands of calligraphy, which required that each brush stroke have an inherent sense of beauty and resonance unrelated to the form it depicted. In *Crimson Lotuses*, haphazard blots of ink and color account for a large portion of the painting, but the rounded, seal-script strokes that Chang used for the stems and the cursive calligraphy he used for the grass add immeasurably to the success of the work. These perfectly executed strokes impart a sense of kinesthetic force that animates the entire screen.

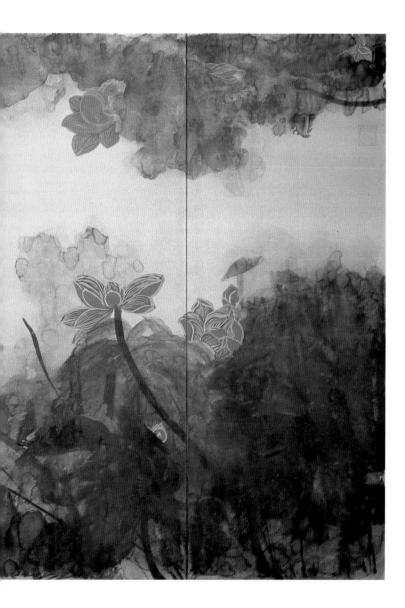

1. Ke Jiusi, "Danqiu tiba," in Yu Jianhua, comp., *Zhongguo hualun leibian*, vol. 2 (Peking: Zhongguo gudian yishu chubanshe, 1957), 1064.

81 Red Flowering Plum

Summer 1978
Mounted for framing; ink and color on paper
50.5 x 100 cm (19⅞ x 39⅜ in.)
Inscription and signature:

A
All alone, I stroll about
 beneath the flowering plums;
Pulling down a branch to smell,
 I am overcome by emotion.
Tomorrow morning, a bitter frost
 is sure to fall,
For the moon at the southern eaves
 is unusually bright.

I've inscribed a poem from memory about the plum trees at my Huanbi An [studio in Pebble Beach]. Painted in the sixty-seventh year [of the Republic of China] at the Moye Jingshe [Abode of Illusion] in Shuangxi to escape the summer heat; in my eightieth year, Old Man Yuan.
SDA

B
For the connoisseur, my kind "elder brother" Chung Kit [Fok], to critique; Chang Dai-chien Yuan, from Shujun [Sichuan Province], at the little Yunhe kiosk.
SDA
Collection of Chung Kit Fok, Vancouver

THE FLOWERING plum, which blossoms while snow is still on the ground, has long been revered by Chinese scholars and painters as an emblem of purity and inner strength, especially in adverse conditions. The flowering plum (*Prunus mume*) was a great favorite of Chang Dai-chien's, and he invested considerable time and money cultivating plum trees as well as painting and writing poetry about them. Chang's calligraphy teachers in Shanghai had long before encouraged this love of plum flowers. Zeng Xi (1861–1930) recommended that Chang practice painting and writing poetry about the delicate blossoms, and Li Ruiqing (1867–1920) was so taken with the beauty of plum flowers that he incorporated them in his cognomens: Mei An ("the plum cloister"), Meichi ("addicted to plums"), and Yumeihua An ("the jade plum flower cloister"). Following Li (though he never acknowledged it), Chang eventually began to call himself Meichi.

Early in his career, Chang Dai-chien already had a preference for a spare, elegant approach to painting plum blossoms. He commented on the history of plum painting:

The ancients painted plums with complicated arrangements of branches and dense flowers and calyxes; this was the essence of beauty to Wang Yuanzhang [Wang Mian; d. 1359] of the Yuan dynasty and to Chen Baisha [Chen Xianzhang; 1428–1500] of the Ming dynasty. Master Dongxin [Jin Nong; 1687–1763] shared the literati view that painting is for personal amusement; he was said to paint in an elegant and tranquil manner, but he also sometimes [painted] lots of branches with hundreds of calyxes, unable to completely shake off past conventions.

During the 1930s Chang followed various plum painters, including Chen Shun (1483–1544), Xu Wei (1521–1593), and Shitao (1642–1707) but he especially admired Chen Hongshou (1598–1652). Sometime around 1943, Chang acquired an album of twenty-four paintings by Chen Hongshou, which included an ink plum and a composition of plum branches and a rock. This album inspired Chang to follow Chen Hongshou's method for portraying the plum, which Chang explained: "To paint a plum tree you must have an old trunk that is iron-hard and has twisting branches."[1]

Chen Hongshou usually painted plum branches against a pure, white background, using immaculate and delicate brush strokes for the flowers. Chang emulated him, making Chen's method so much a personal goal that on a painting influenced by Chen in Michael Sullivan's collection (Britain), Chang wrote in 1966, "The design is my own, you cannot see any past conventions in it." Chang even pruned the plum trees in his garden to imitate Chen Hongshou's painted images, and photographers flocked to Chang's Taipei home to see them.

Since Chang usually favored a sparse approach, *Red Flowering Plum* is strikingly assertive, with its strong color and heavy blossoms, but the layers of dry ink that texture the crusty branch are reminiscent of Chen Hongshou's "iron-hard" trees. After Chang moved to Taipei in his late seventies, he began painting plum trees regularly, and he experimented with a broader range of expression for the theme. Increasingly infirm, Chang found it difficult to work on huge splashed-ink-and-color paintings or render the large lotus flowers that had become his trademark in the 1960s and early 1970s. He turned to moderate-size works, more appropriate for plum blossoms. Since the plum blossom was the national flower of Taiwan, Chang received many requests for these paintings from friends in the government. As Chang's political sympathies favored the nationalist Chinese, he happily agreed to paint plum trees for them.

Chang Dai-chien was as serious about cultivating plum trees as he was about painting them. Wherever he went he planted flowering plums. In 1944, when he moved into the Shangqing Gong Daoist temple in the Qingcheng Mountains, Chang planted several hundred young trees, many of which are still thriving, and he named the area Plum Hill (Mei Qiu).[2] Chang also built a kiosk there, which his friend, the poet Liu Yu, described as surrounded by myriad trees and encompassed by the green of a thousand peaks. In 1953 Chang replaced hundreds of roses at his Brazilian home with the traditional Chinese trio of pine, plum, and bamboo. The

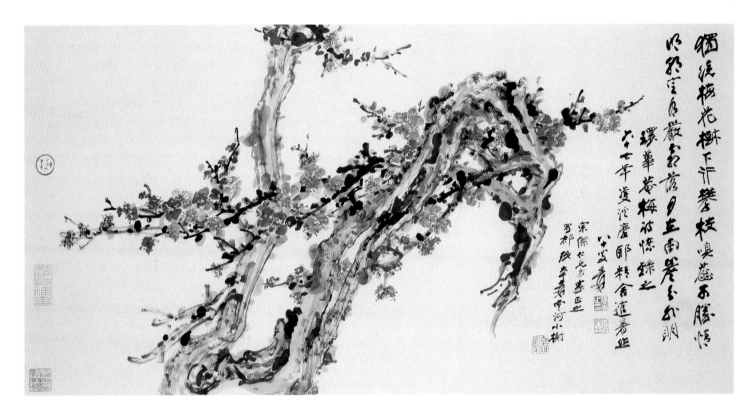

Red Flowering Plum

plums did not thrive in Brazil's torrid climate, and so Chang began to travel to Japan every spring to view and paint the plum blossoms there.

When Chang moved to Pebble Beach, California, he brought plums with him. He planted ninety-nine trees in the garden—fearing one hundred might be too extravagant. On an excursion to the nearby beach in 1974, he saw a rock three meters tall whose shape resembled the island of Taiwan. With permission from the town government, he had it moved to his home. Recalling the Shangqing Gong in Sichuan, Chang wrote the characters "Plum Hill" in his most vigorous calligraphy and had them carved into the rock. When he moved into his garden residence in Taipei in 1977, Chang shipped this rock—weighing three thousand kilograms—to his new home along with some plum trees from the California garden.

Chang Dai-chien's property in Taipei had much to recommend it, including proximity to the National Palace Museum and clean mountain air, but Chang bought it because of an old plum tree that grew there. Wild plums are scarce in Taiwan's hot climate. Chang planted a full hundred plums at his Taiwan home, some of which he had his son Paul bring from Japan. Chang presented some of the imported saplings to the government to plant at major monuments, such as the tomb and memorial hall of Chiang Kai-shek (1888–1975) and the Sun Yat-sen (1866–1925) memorial.

Chang Dai-chien situated the Plum Hill boulder from Pebble Beach among the plum trees in his Taipei garden. On a nearby kiosk he hung a pair of wooden tablets that bore a couplet he composed: "Standing alone, lasting for countless ages; forever will I sojourn on this hill." According to instructions in his will, Chang Dai-chien's ashes are interred beneath this stone.

The flowering plum was an apt motif for Chang Dai-chien. As delicate as some of his poetry and painting, in full bloom, the plum tree's exuberance evokes Chang's strength as a painter and his ability to flourish in foreign lands.

1. Quoted in Gao Lingmei, ed., *Chang Dai-chien hua* (Hong Kong: Dongfang yishu gongsi, 1961), 61.

2. Yang Jiren, *Chang Dai-chien zhuan*, vol. 1 (Peking: Wenhua yishu chubanshe), 376.

82 Misty Mountain Path

September 16, 1979
Hanging scroll; ink and color on paper
80 x 58 cm (31½ x 22⅞ in.)
Inscription and signature:
 It didn't rain on the mountain trail,
 The airy greenery drenched our robes.

 The sixty-eighth year [of the Republic of China], twenty-fifth day of the
 seventh lunar month of the *jiwei* year. Around midnight, I was unable to
 sleep, and since there was some Ming dynasty paper on the table, I ground
 a little Wu Tianzhang ink and, selecting lines by a Tang dynasty poet, I
 painted this. It has a feel to it like that [of paintings] from the Northern
 Song dynasty. In my eighty-first year, Old Man Yuan.
 JS and SDA
Collection of Hugh Moss, Hong Kong

CHANG DAI-CHIEN painted *Misty Mountain Path* with scumbled strokes and layers of ink and color that give the work a rich tactile surface. Chang soaked the paper with water and splashed it with ink. Then he added texture strokes and details such as branches, which transform the abstract shapes into a landscape. Chang spread mottled patches of dark ink over the paper, leaving a cleft of white paper between them. Chang brushed dry texture strokes over the white area to describe the rough surface of the mountain. A scholar and servant climb up tiny steps in the mountainside and stop midway to survey the scene.

Chang Dai-chien wrote the inscription at the top of the painting, using a clean white surface that doubles as a cloud. Chang's poetic couplet was from a colophon in which Su Shi (1036–1101) discussed a poem and painting also entitled *Misty Mountain Path,* which Su Shi attributed to Wang Wei (701–761). Su Shi's colophon reads:

> When one savors Mojie's [Wang Wei] poems, there are
> paintings in them,
> When one looks at Mojie's paintings, there are poems in
> them.
> Mojie's poem said:
> At Indigo Fields, white rocks emerge,
> On Jade River, red leaves are scarce;
> It didn't rain on the mountain trail,
> The airy greenery drenched our robes.
> This is Mojie's poem, although some say it is not; instead, they
> say that it is something a clever person added to the corpus of
> works left by Wang Wei.[1]

Chang referred to the poem as Tang dynasty, not engaging in the fray about authorship. While the poem is not in the original version of the collected works of Wang Wei, it is characteristic of his manner. Critics have been less concerned, however, with the issue of authorship than with Su Shi's observation that poetry and painting are in a sense interchangeable. Su Shi underscored the principle of synesthesia in Chinese art: the vivid colors in Wang Wei's poem can readily be pictured, while bright hues in the painting create a rhythm akin to that of poetry. This bond between painting and poetry was crucial to Chang's personal theory of art, and he often indulged in the conceit that he was a modern-day Su Shi.

In traditional Chinese painting, color rarely provides the basic structure of the pictorial form. Chang Dai-chien often employed this technique, however, in his splashed-ink-and-color works. The pictorial beauty of Wang Wei's poem was built of color, making it a perfect choice for Chang's inscription. Yet *Misty Mountain Path* is one of Chang's least colorful late works; it reflects the tranquil midnight hour when Chang was painting the work and everyone else was asleep. The first line of Wang's poem is tinged with blue and white, while the second line is painted green and red. Even the mist, which we usually think of as clear or white, is described as "airy greenery," probably referring to mist-drenched leaves. Chang bypassed the rich color of Wang's poem to concentrate on the mist-laden air. He relied on the inscribed poetic couplet to provide the color.

Chang inscribed Wang's poem on several paintings, including one dated autumn 1973. Since Chang's splashed ink-and-color technique ensured that each composition would be unique, the painting from 1973 is very different from *Misty Mountain Path,* despite the repetition of a favorite inscription or theme.

1. Su Shi, "Shu Mojie *Lantian yanyu tu,*" in Yu Jianhua, comp., *Zhongguo hualun leibian,* vol. 1 (Peking: Zhongguo gudian yishu chubanshe, 1957), 629. Wang Wei poem translated by SDA.

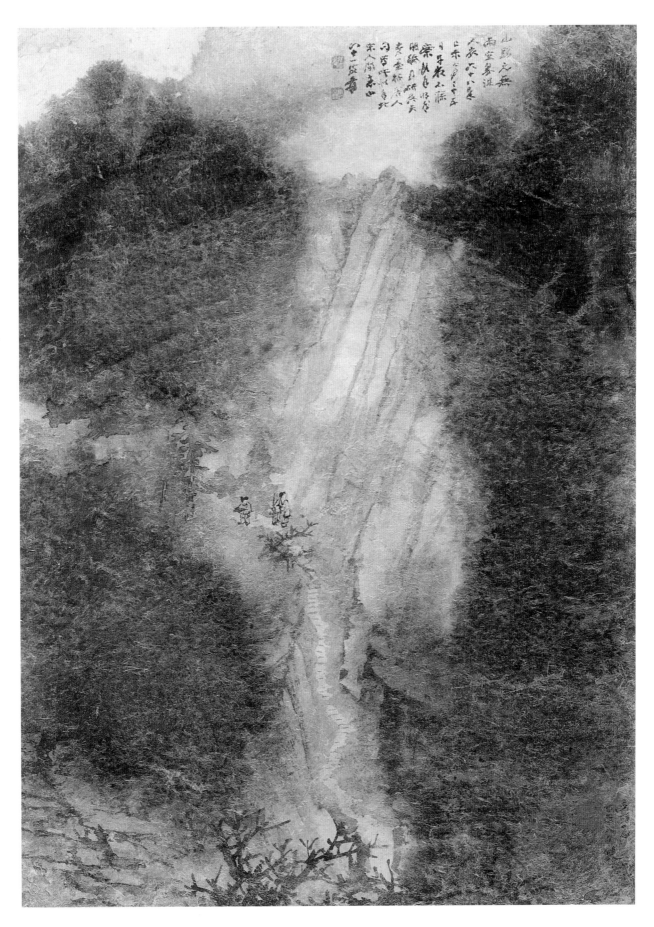

Misty Mountain Path

83 Illustrated Menu

detail with inscription C, *Illustrated Menu*

February 20, 1981, and June 7, 1982
Handscroll; ink and color on paper
Menu: 23.6 x 67.4 cm (9³/₈ x 26¹/₂ in.)
Painting and poem: 23.6 x 135.3 cm (9³/₈ x 53¹/₄ in.)
Wrapper label by Jiang Zhaoshen (b. 1925):
 Auspicious Radiance and Savory Beauty
Frontispiece by Qin Xiaoyi dated 1983
Inscriptions and signatures:

A
Duck-Pad with Scallop Sauce
Pork Shoulder in Hot Sauce
Dried Pork with Green Seaweed
Pork Belly in Oyster Sauce
Sauteed Sturgeon Fin
"Six-in-One" Sprouts and Ham
Fried Sea-Cucumber with Scallions
Bamboo Shoots in Shaoxing Wine
Sauteed Prawns
Steamed Late-Season Cabbage
Steamed Beef with Rice Powder
Vegetable Noodles in Fish Sauce
Scalded Pork and Cucumber Soup
Boiled Rice-Flour "First Moon" Dumpling Soup
Steamed Bean Paste Dumplings
Watermelon Shell Filled with Sweet Fruit Soup
JS and SDA

B
In the seventieth year [of the Republic of China], in the *xinyou* year, on the day after *yuanxiao* [February 20, 1981], I had my household make everything ready and invited my "elder brother" Hanqing [Chang Hsueh-Liang] and his wife [Zhao] Yidi, and Assistant Director Pingqiu and his wife all to come to lunch. My "great elder brother" Yuejun [Zhang Chun] along with his eldest son Jizheng and his wife Dufen also graciously attended, and we enjoyed ourselves together for half the day. In this season the "Dangling Silk" crabapple trees were in full bloom, so both guests and host were happy and well pleased. "Elder brother" Han[-qing] had me write this inscription at the end of the menu; Yuan.
JS and SDA

C
The turnip plant bears a son
 the mustard has a grandchild;
And long ago this old fellow
 swore off any meat or garlic.
The god of his viscera sits at peace
 in his pure and hollow abode;
Would he let a sheep come to trample
 the vegetables in his garden?

When "elder brother" Han[-qing] showed me how he had mounted the menu I'd written, there was an extra [length of blank] paper on the scroll, so I made a few playful sketches to earn his smile. Sixteenth day of the intercalary fourth month in the *renxu* year [June 7, 1982]; Dhuta [Buddhist monk] Yuan.
 SDA
Colophon by Zhang Chun (1889–1990) dated summer 1982
Colophon by Tai Jingnong (1902–1990) dated summer 1982
Colophon by Jiang Zhaoshen (b. 1925) dated autumn 1982
Collection of Chang Hsueh-Liang, Taipei

IN MANY ways Chang Dai-chien was a passionate traditionalist. When he lived in China, he wore a long Chinese gown although most of his countrymen had adopted Western-type dress. Even after he left China he continued to dress like a Chinese scholar from a bygone age. He was also a purist about food; whether in or out of China, he insisted on traditional, fine Chinese cuisine. Distinguished Chinese gentlemen had often been experts in food preparation. The *Analects* indicate that Confucius was knowledgeable about the preparation and rites associated with a meal, and the *Mozi* records that the founder of the Shang dynasty made his cook prime minister. The Chinese cultural preoccupation with food had no better twentieth-century statesman than Chang Dai-chien, but he was not alone in his knowledge of cuisine and fondness for fine food. What distinguishes him is not his interest in eating but his personal excellence as a cook.

Chang Dai-chien usually employed cooks in his home, but he taught them more about food preparation than they could teach him. He also claimed that he personally trained each of his four wives to be excellent cooks. The honor of being a chef in Chang Dai-chien's household was marketable. Cooks frequently left his employ to open their own restaurants, and a chef who could advertise that he had studied with Chang Dai-chien had the best possible endorsement.

Chang Dai-chien traveled widely both in China and throughout the world and was always willing to taste the local cuisine, but the regional style of his home province, Sichuan, remained his favorite. It is probably not just coincidental that his wives were all Sichuanese, since in a culture where eating together creates a psychological bond, it is helpful for a couple to share the same attitudes toward food. In traditional China, food was part of every social interaction, and holiday feasts and banquets for guests were an exacting part of etiquette.

When Chang invited guests for a meal, he personally chose or supervised the menu. He wrote out the menu in calligraphy that was as delectable to the eye as the savory dishes to be put

forth on the table. The menu would be displayed in the dining room of his home, and sometimes Chang noted on it the occasion and guest list. It is not surprising that his guests often asked to be allowed to take the menu home with them and pressed Chang to add a short colophon that would make it a special souvenir. A considerable number of these menus have been preserved among Chang's friends.

The list of dishes testifies to the care with which Chang prepared this menu. The sauteed sturgeon fin and fried sea-cucumber with scallions were prepared following Chang's own secret recipes, revealed only to his daughters-in-law. The boiled rice-flour dumpling soup was a holiday dish custom-arily served to celebrate the first full moon of the New Year, known as the Lantern Festival, which fell the night before Chang's luncheon party.

Chang Hsueh-Liang (b. 1898) was the guest of honor at the party, and after he took the menu home with him, he commis-sioned a mounter to fashion it as a handscroll with blank paper at both ends. Invited by Chang Hsueh-Liang to paint something, Chang Dai-chien used ink and color to create five red radishes, three Chinese cabbages piled together, and a stem of leafy spinach. After the fresh, casual paintings he wrote a witty poem recording his preference for vegetarian food in his old age.

From the very beginning of his career Chang had painted vegetables. He particularly favored the great Ming dynasty painters Chen Shun (1483–1544) and Xu Wei (1521–1593), whose manner of using wet, dark ink to paint fruits, vegeta-bles, and flowers gave these simple subjects an unexpected air of sophistication.

Chang Hsueh-Liang was so pleased with Chang's additions to the menu that he passed it to another of the guests who had been present at the luncheon almost a year and a half earlier. Zhang Chun (1889–1990) wrote a colophon comparing Chang Dai-chien to Su Shi (1036–1101). Tai Jingnong (1902–1990) also wrote a comment in semicursive script, and a few months later, the artist and scholar Jiang Zhaoshen

inscriptions A and B, *Illustrated Menu*

wrote two poems in semicursive script.

Illustrated Menu is equally important as a social document and as a painting. It reveals the friendship that Chang Dai-chien enjoyed with Chang Hsueh-Liang, for whom he had painted *The Sound of Autumn* in 1935 (entry 15) and with whom he became close after 1977. This menu also demon-strates Chang's high spirits only a year before his death.

In 1979 Chang and several friends, including Chang Hsueh-Liang and Zhang Chun, had formed their own gourmet club. Each member hosted a meal once a month, originally in an effort to cheer each other while their friend Zhang Muhan (1900–1980) was hospitalized. The guest list to this Lantern Festival meal included people outside the gourmet group, indicating that it was a special occasion for feasting and friendship. As always, Chang Dai-chien was only too willing to commemorate his friendship through his banquets, paint-ing, and calligraphy.

November 15–December 14, 1982
Hanging scroll; ink on paper
94.5 x 48 cm (37¼ x 18⅞ in.)
Inscriptions and signatures:

A

Master Hanshan in Silent Repose. This could pass satisfactorily as a work by Shi Zizhuan [Shi Ke] or Liang Fengzi [Liang Kai]. In my eighty-fourth year, Old Man Yuan talking in my sleep.
JS and SDA

B

Inscribed in the tenth lunar month of the *renxu* year, the seventy-first year [of the Republic of China], for my "old younger brother" Manshi [Yon Fan], who truly appreciates my work. Dai-chien jushi Yuan at the Moye Jingshe [Abode of Illusion].
Colophon by Jiang Zhaoshen (b. 1925) dated spring 1984
Colophon by Xie Zhiliu (b. 1910) dated spring 1986
Collection of Yon Fan, Hong Kong

WITH A few rapid flicks of the brush, Chang Dai-chien created a figure with moppish hair and straw sandals. Although the face consists of just six expressive strokes, the viewer has a clear sense of Hanshan's unspoiled nature. The partially unrolled scroll, inkstone, and brush indicate that he is lost in thought, trying to compose a poem. Chang Dai-chien's boldly written inscription, which helps frame the figure, reveals Chang's stylistic models, and it identifies the subject as Hanshan.

Hanshan is an important figure in Chan (Zen) Buddhist lore. He was active as a monk during the mid-eighth century and lived on Cold Mountain (Hanshan) in Zhejiang Province. Disheveled and dressed in coarse cloth, he made wild gestures and laughed continually as if he were mad. Shide, a foundling taken in by Buddhist monks and put to work in the monastery kitchen, fed Hanshan scraps. The earliest description of the two appears in a preface to a collection of more than three hundred poems attributed to them, the majority by Hanshan. These eccentrics had an innocent happiness that was taken as a sign of their enlightenment and ability to live in harmony with nature. Hanshan and Shide have had wide appeal in China. Intellectuals were awed by the accomplishments of these two "simpletons," while the common people took them as proof of underlying happiness in an impoverished earthly existence.

During the Southern Song and Yuan dynasties, Hanshan and Shide as a pair were a common subject in painting. Chang Dai-chien painted Hanshan as the quintessential child. Chang's dexterous ink brush strokes paralleled the spirit of the monk—a sort of idiot savant who knew life's secrets. Chang Dai-chien complimented his own success in this painting, feeling that he had achieved the levels of Shi Ke (act. 960–975) and Liang Kai (act. early 13th cent.).[1] Shi Ke, who,

like Chang, was from Sichuan Province, was renowned for expressive paintings of the unexpected, such as the attribution *Two Patriarchs Harmonizing Their Minds*, which shows a man sleeping with a tiger. In 1956 Chang painted an album of "spontaneous ink-plays" inscribed with the comment, "I am the scholar Shi of West Sichuan," so closely did he wish to identify himself with the freewheeling art of Shi Ke.

The other artist Chang Dai-chien spoke of in connection with a spontaneous style was Liang Kai, who reputedly loved wine and was called Crazy Liang (Liang Fengzi). In 1201 the emperor called Liang, who was then a court painter-in-attendance, to come forth and receive the high honor of the Golden Girdle, but Liang refused. His manner was so simplified it is known as "abbreviated brushwork." Together with Shi Ke, Liang Kai initiated a fashion for quick, expressive brush strokes executed in pure ink. The style quickly reached Japan, where it has been continually prized by collectors, but few Ming and Qing dynasty artists in China practiced "abbreviated brushwork," and it was almost forgotten. Chang Dai-chien was one of the few modern fans of this style, having been exposed to the works of Liang Kai and Shi Ke while a student in Japan. In 1931 Chang wrote about *Sixth Patriarch*, attributed to Liang Kai:

All my life I've bowed my head before the divine virtuosity of Liang Kai's abbreviated brushwork, as in his portrait of the sixth Chan patriarch; but the one who first transmitted this "golden needle" of craftsmanship to the world was his forerunner, Shi Ke from western Sichuan.
SDA

In his last two decades as an artist, Chang Dai-chien returned to the relaxed, inky brushwork of *xieyi* painting, which he had often employed in his early career. During the intervening years Chang concentrated on the elegant but vigorous brushwork of Dong Yuan (act. 937–976) and on the rigors of detailed *gongbi* painting. Chang's practice of these styles imbued even his most spontaneous brushwork, as in *Master Hanshan in Silent Repose,* with discipline. The seemingly casual strokes are not loose. Change replaced the detail of his mid-career paintings with abbreviation and whirlwind speed, but he maintained his careful attention to overall structure.

1. When Chang compared his level of achievement in *Master Hanshan in Silent Repose* to the brilliance of Shi Ke and Liang Kai, he did not want to be too brazen; therefore, he signed the painting "talking in my sleep." Some thirty years earlier he had been more audacious: during the 1950s, Chang frequently used Liang Kai's *The Poet Li Bo Strolling and Chanting* (Tokyo National Museum) as the basis for his own compositions entitled *Lofty Scholar Strolling and Chanting.* Chang often signed these with a note such as "Liang Kai was never able to reach this [level]."

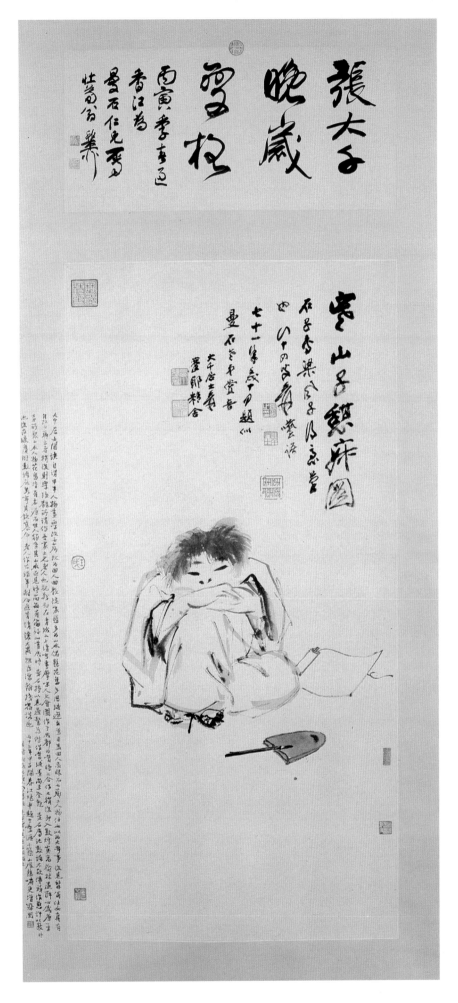

Master Hanshan in Silent Repose

85 Peach Blossom Spring

January 20, 1983
Hanging scroll; ink and color on paper
209.1 x 92.4 cm (82³/₈ x 36³/₈ in.)
Inscription and signature:

> I planted plums and built my house
> beside the Twin Rivers;
> As my years decline I always dread
> the noise of public markets.
> Whoever believes this is the place
> that Achao once had reached,
> Wrongly says there is in the world
> a Peach Blossom Spring.

The plum blossoms are quite profuse at the Moye Jingshe [Abode of Illusion]. Catching sight of them, my old friends gasped and sighed in admiration and delight and likened them to a pleasure beyond this world. [One of them] said to me, "Since you established your residence here above the stream, one person after another has picked you as a neighbor and bought a house. One can hear their chickens and dogs, and see the glare of their lights. Were you really thinking to get away from all the commotion?" We laughed together loudly over this, and since I was painting this picture just at the time, I improvised a little poem to commemorate the fun and laughter of the occasion and inscribed it on [the painting]. It is the seventy-first year [of the Republic of China], the seventh day at the beginning of the last lunar month in the *renxu* year. In my eighty-fourth year, Old Man Yuan.
SDA

Collection of Cemac, Ltd., Edmonton, Alberta

VILLAGE ROOFTOPS are barely visible through the veil of lush foliage in *Peach Blossom Spring*. The atmosphere is dense with moisture and clouds. At the bottom of the soaring cliffs is a grove of delicate, blossoming trees where a rivulet swings into a rock cavern. A fisherman dressed in hat and straw rain cape heads toward this secret passage, which is the subject of the painting. Chang was painting his rendition of the essay and poem "Peach Blossom Spring," by Tao Qian (365–427). Tao Qian's famous allegory is about a fisherman who stumbles on a utopian world.

> A fisherman rowed upstream . . . when he suddenly came to a grove of peach trees in flower . . . it made a great impression on the fisherman. He went on for a way . . . and came to the foot of a mountain whence the spring issued. . . . There was a small opening in the mountain and it seemed as if light was coming through it. [The fisherman went through the opening and found himself in an ideal world where houses were] surrounded by fertile fields and pretty ponds. Mulberry, bamboo and other plants grew there. Roads were bare of traffic and cocks and dogs could be heard calling to each other. All enjoyed working in the fields; old and young joyfully lived in ample happiness.[1]

The ideal world Tao Qian describes contrasts sharply with that of his own era, which was scarred by political strife and the actions of aristocratic families who seized land and forced small farmers into bondage. Disgusted by corruption, Tao

Qian retired from government service to farm a small plot he owned. What he described in "Peach Blossom Spring" was his dream of a past golden age, a time when all people lived in peace and happiness. This vision became a symbol for generations of scholars who sought refuge from the corruptions of public life.

Chang Dai-chien's own era was as troubled as Tao Qian's. His lifetime witnessed the overthrow of the Manchu dynasty, the struggles for power that followed, the long war between China and Japan, and finally the Communist Revolution. Like many before him Chang must have yearned for the Peach Blossom Spring. Shitao (1642–1707), the painter Chang most admired, had brilliantly explored the subject in a painting Chang once owned (see fig. 10). He wrote a colophon on it in 1930 and afterwards frequently painted Tao Qian's literary masterpiece.

In Chang Dai-chien's *Peach Blossom Spring* from 1983, the utopia is set atop a towering peak as if in heaven. The village itself is not portrayed, but its rooftops suggest its existence. The top portion of the landscape is a tapestry of pooled color and ink that Chang splashed onto the paper. He defined this mass of brilliant, wet color by painting steep, neatly textured mountain cliffs on each side. Chang concentrated his traditional brushwork in the lower portion of the painting, where he described the mountains of the everyday world. As the painting moves upward, extravagant color and ink seem to explode, as if to announce that the utopian village is a world altogether different in nature.

Chang Dai-chien's vain search for the tranquillity of the Peach Blossom Spring is evident in the poem and comment he inscribed on a sliver of cliff in the lower right. When Chang Dai-chien first moved to the Taipei suburb of Waishuangxi, only a few farmers lived there, but after he built his garden-residence, the Abode of Illusion, the value of the real estate soared, and expensive houses and new roadways were carved into the countryside. Thus Chang's desire for rustic seclusion was subverted, and he tried to make the best of it.

The inscription is dated January 20, 1983, but Chang actually made the initial splash of ink and color in 1976. In spite of the seven year gestation period of *Peach Blossom Spring*, the painting has an internal coherence and logic. Many of Chang's splashed-ink-and-color paintings took years to complete, as he searched the abstract pools of ink and color for familiar shapes on which to build a landscape and then, as time and inspiration permitted, brought them to fruition.

1. A complete translation and discussion is included in Kang-i Sun Chang, *Six Dynasties Poetry* (Princeton, N.J.: Princeton University Press, 1986), 16–19.

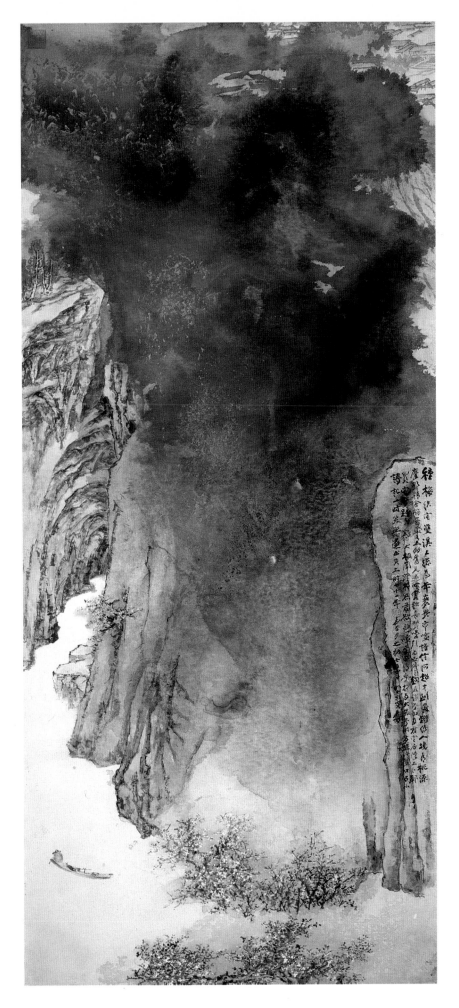

Peach Blossom Spring

86 Vermilion Lotuses

January 14–February 12, 1983
Mounted for framing; ink and color on paper
74.2 x 140.4 cm (29¼ x 55¼ in.)
Inscriptions and signatures:

A

The seventy-first year [of the Republic of China], the last lunar month of the *renxu* year at the Moye Jingshe [Abode of Illusion] in Waishuangxi, Taipei; my family members [ground] imperial Qianlong-period vermilion "ink," Buddha-head blue from Afghanistan, and malachite green from Ajanta, India, which they presented so I could brush this. In my eighty-fourth year, Old Man Dai-chien Chang Yuan.

B

The *Record of Buddhist Monasteries in Luoyang* states, "In the Juncai Ward is the Temple of Guidance to Goodness [Kaishan Si]. As one enters its rear garden, one sees vermilion lotuses standing up from the pool and green duckweed floating on the water."[1] [The author] does not mention red lotuses or white ones, but is astonished and amazed at the rare and wondrous sight, for while such marvelous lotuses actually do exist in the world, they are not at all easy to find. I recall once when I was age twenty-three [*sui*] and going to the three peaks of Mount Emei on the Rongxian road. There was a pond in full blossom in front of a village inn, and the bright light of dawn spread [over the vermilion blossoms] with such gleaming radiance they seemed a wall of crimson or rosy clouds. I dallied taking my time, unable to leave the flowers behind. But my sedan-chair bearers urged me to press on, saying if I tarried over long, there would surely be no place that night for us to lodge. In the sixty years since that time, this has never left my heart. With blurred vision and trembling hand I record this with deep emotion. Yuan again inscribed this.
JS and SDA

Collection of Chung Kit Fok, Vancouver

CHANG DAI-CHIEN painted *Vermilion Lotuses* only a few months before his death. Little in the painting style would identify the artist as an old man of eighty-four, except that his inscription complains of blurred sight and trembling hand. The boldly splashed ink and color that forms a cover of lotus leaves and watery background was a stylistic method that Chang had been using for years, although it is, in fact, well suited to disguise the palsy that accompanies age. In comparison to his earlier work, the gold outlines of the flowers seem less refined. Chang had lost some of his hand control, but the sweeping stem of the left leaf demonstrates that he was still a master of calligraphic movement.

Shortly before he painted *Vermilion Lotuses*, Chang Dai-chien had been working on the gigantic *Panorama of Mount Lu* (entry 87). Although the painting was not finished, Chang agreed to let the National Museum of History in Taipei exhibit it, and while that work was being shown, Chang turned his attention to floral subjects. In addition to *Vermilion Lotuses*, on February 21 he painted a composition of several lotuses. On March 2 he painted a blossoming plum tree as a birthday present for an old friend, which was the last time he painted. A month later Chang died.

Vermilion Lotuses represents the culmination of Chang Dai-chien's splashed-ink-and-color technique. His artful mastery is evident in the decoration, which is lavish but not ostentatious, and which incorporates calligraphic gestures. Chang used the best imported pigments, as he explained in inscription A; in inscription B, the longer text to the right, Chang explained why he was thinking of lotus flowers.

Chang Dai-chien often painted memories of places that had deeply affected him, and this large painting of a lotus pond recalls a specific moment in his life sixty years earlier. Lotuses are usually various shades of pink, so seeing red lotuses in the bright morning sun was a rare treat. To capture the delight he felt sixty years earlier, Chang exaggerated the color in this painting, and he outlined each petal in gold to evoke the sunlight shining on the blossoms. During Chang's long career he often painted lotuses with gold outlines and gold veins, but his inscriptions on this work explain that Chang was trying to preserve not only a portrait of one of his favorite flowers but also an astonishing personal memory.

1. Chang Dai-chien's quotation is somewhat abbreviated and slightly different from the original text, perhaps because he was writing the inscription based on memory. The original quote is actually under the entry for the Hejian (or Ho-chien) Temple; see Yang Xuanzhi, *A Record of Buddhist Monasteries in Lo-yang*, trans. Yi-t'ung Wang (Princeton, N.J.: Princeton University Press, 1984), 196. SDA

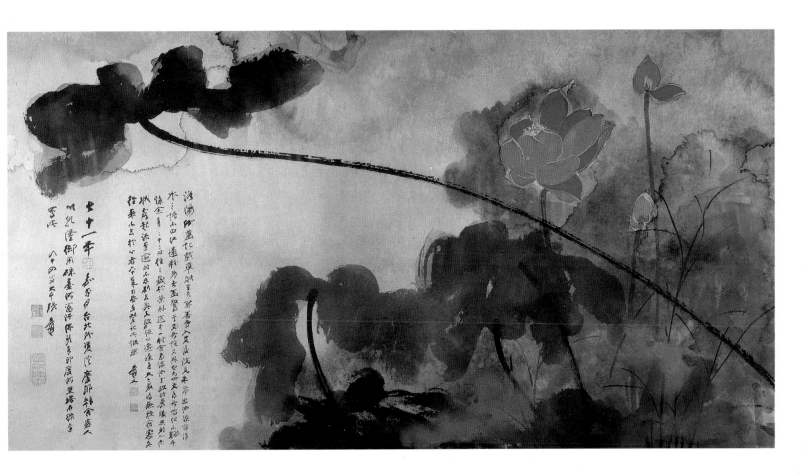

Vermilion Lotuses

July 1981–February 1983
Wall mural in portable scroll format; ink and color on silk
178.5 x 994.6 cm (70¼ x 391½ in.)
Inscription:

Along with you, I look end-on at it
and look at it from the side,
The piling chasms and layered peaks
rise within the murky haze;
It looks like the Immortal of Slopes
is opening his laughing mouth,
You truly do possess Mount Lu
in the fastness of your mind.

Lord Huiyuan has passed along,
and the Lotus Society is gone,
Prefect Tao departed in his palanquin
and never did return;
So I'll wait till all the noxious mist
and evil fogs have washed away,
Then cross the creek and sit ensconced
where I can watch the mountain.
SDA
Collection of the Dafeng Tang, Taipei

ARTISTS OVER eighty might be expected to show a faltering hand or to limit themselves to less robust and more discretely sized compositions; however, like a few other great masters, Chang Dai-chien continued to defy expectations. Three years before he died he accepted a commission for one of the most ambitious projects of his career—a panorama two meters high and ten meters long for a hotel lobby. The result is among Chang's most vibrant paintings. *Panorama of Mount Lu* has swirls of blue and green and pools of gently suffused ink; crusty ink strokes texture the rocks.

Panorama of Mount Lu is both the most important and largest painting of Chang Dai-chien's final years in Taipei. It stands as a perfect conclusion to his career, incorporating the encyclopedic range of styles that made him such a singular artist. Some areas are rendered by splashed-ink-and-color; there are also orthodox texture strokes and controlled washes of ink and light color. Chang's diversity is also evident in the subject and size. The literati had often painted Mount Lu, a sacred peak in Jiangxi Province, but Chang rendered it in the huge size characteristic of professional painters.

Chang Dai-chien had a lifelong proclivity for mixing the tastes and habits of the literati with those of professional painters. Large-scale works were ill-suited to the calligraphic style of brushwork that the literati favored. Professionals, especially painters who decorated temples, often worked on a mammoth scale and designed paintings for architectural settings. During the 1930s Chang began to teach himself to adapt the literati mode to large-scale works: over the course of his career, he painted extremely long handscrolls and giant screens of lotuses; however, *Panorama of Mount Lu*, whose

Panorama of Mount Lu

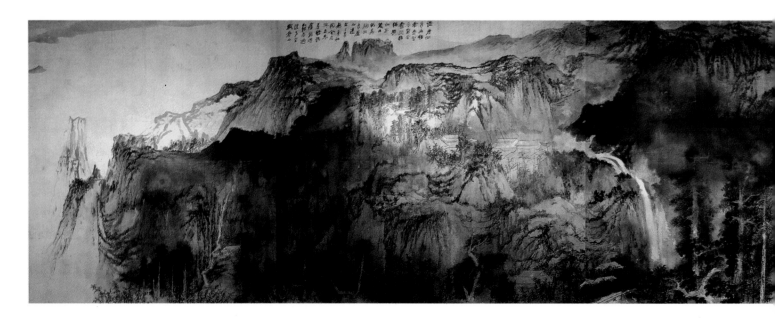

imposing dimensions were fixed by the size of the hotel lobby, was his most ambitious large-scale endeavor.

Ever since Chang Dai-chien saw large paintings in the temples of Sichuan Province at the end of the 1930s, he had been anxious to try that demanding scale. When he studied the Buddhist wall murals at Dunhuang in the 1940s, his interest in painting as an integral part of architecture was reinforced. In addition, his beloved model Shitao (1642–1707), who blended literati traits with a highly individualistic manner, painted exceptionally large compositions by carrying a theme across several scrolls in a set, which further encouraged Chang to experiment. In the 1940s he undertook several large-scale works, but no one would have expected the final work of an ill artist to be this grand.

Like a traditional handscroll, *Panorama of Mount Lu* reads from right to left, but with the caveat that the whole composition was to be visible at once instead of being slowly unrolled. Consequently, Chang had the additional burden of harmonizing and integrating all the elements; whereas, in a traditional handscroll, an artist could make sketchy transitions and abrupt changes in scale.

Although seamless, *Panorama of Mount Lu* has three main sections. Splashed ink predominates in the opening area, but Chang added brush strokes to define the pooled ink and make it a mountain. Clouds move behind and in front, and mist drifts into the nooks and crannies, giving depth to the flat graphic landscape. The middle section has soaring trees and a flying cataract that flows from a plateau topped by a temple. The mountain continues to the left then, in the third section of the painting, makes a sheer drop into a lake, which spreads out toward the horizon. The open expanse of the water provides a necessary counterweight to the dense mountains.

Although *Panorama of Mount Lu* has abstract pools of ink and color, the painting has a lucid structure, and the imposing scale never overrides the sense that this is a specific landscape. With consummate skill Chang provided enough small details to engage the viewer in a mental journey but preserved the scale needed to catch a viewer's eye across a hotel lobby. Like a musician who keeps the clarity and refinement of each note when playing forte, Chang produced a landscape that can be enjoyed like a literati-style handscroll but which seems entirely natural at the expanded scale.

The genesis for *Panorama of Mount Lu* was the commission from Li Haitian, a friend Chang Dai-chien met in the 1950s when he frequently traveled to Japan. Chang often stayed in the Japanese inn Kairakuen, on the shore in Yokohama; the proprietor graciously allowed Chang to use the large formal hall to set up a painting table. For meals, Chang went to Li Haitian's successful Sichuanese restaurant, the Chongqing. The two became friends, and Li began to collect Chang's paintings and decorate the restaurant dining room with the largest ones. In 1980 Li Haitian signed a contract to build and run a joint-venture hotel in Yokohama with the Holiday Inn Corporation. Li used Chang Dai-chien's art as a leitmotif in the new establishment; he had the designs of his favorite landscapes and lotus paintings reproduced on the ceramic tile that framed the elevator doors on every floor of

overleaf, detail from *Panorama of Mount Lu*

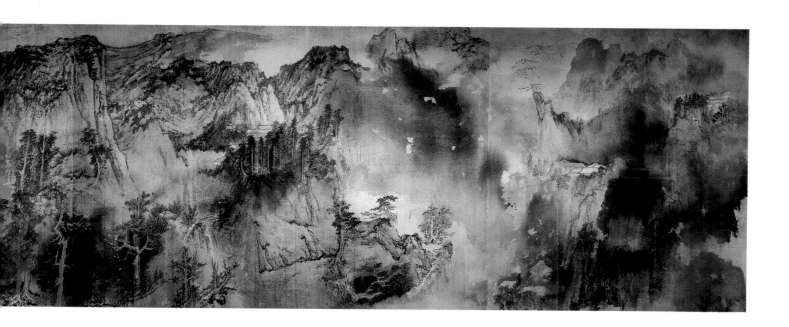

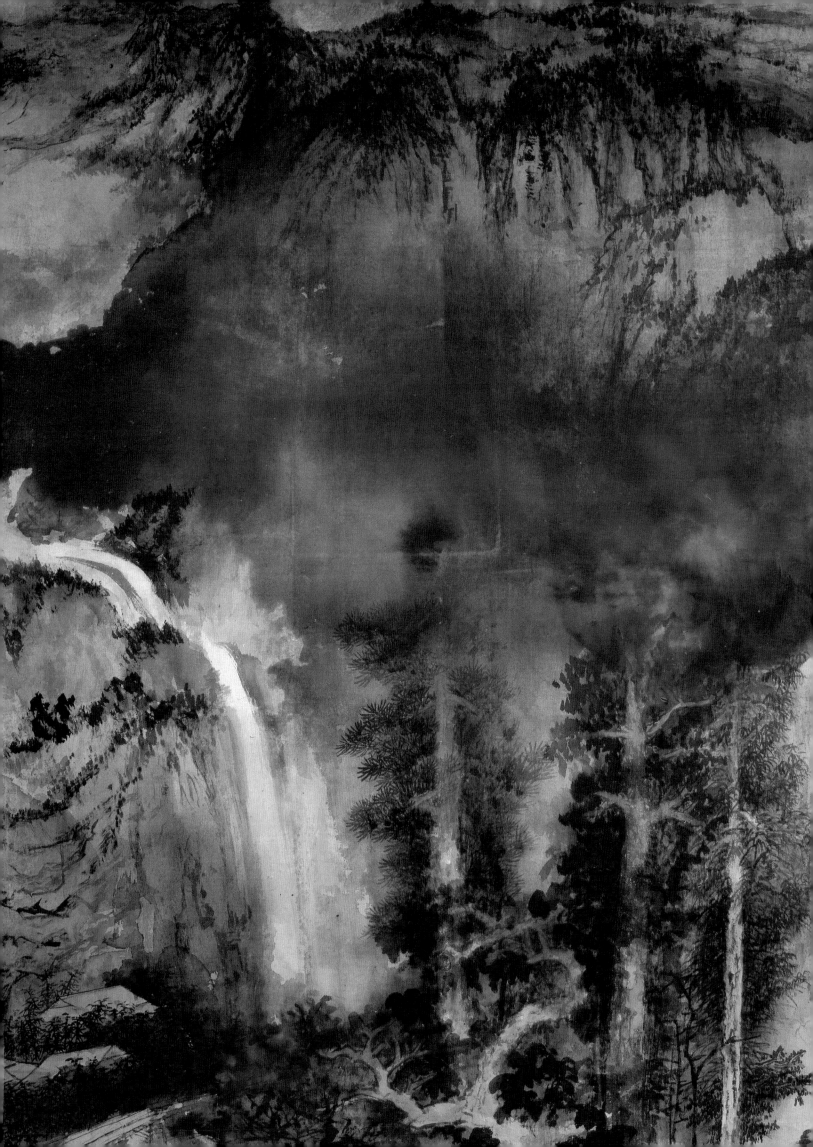

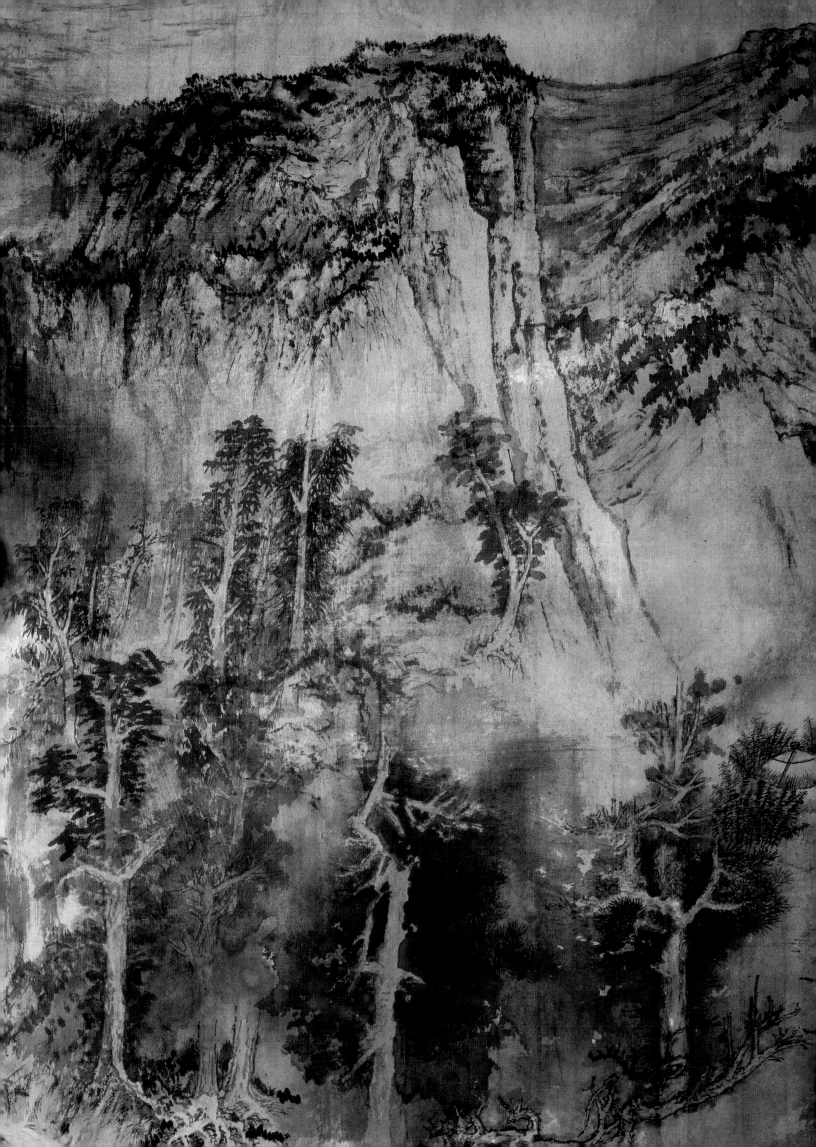

the hotel. Across from each elevator Li hung one of Chang's paintings from his collection. He also decorated the dining rooms with Chang's original works. The grand entrance of the hotel, however, was still blank, so Li commissioned Chang to fill its giant wall. Li's idea was that Chang could paint a set of four landscapes, but the artist felt his mental and physical energies sufficient to paint a single composition custom-made for the space. Chang wanted people to witness that although old, he was not aged. This self-challenging tone characterized Chang all his life. As Chang painted *Panorama of Mount Lu,* it soon became less a commission than a personal defiance of old age.

The preparations for the work began in 1980, but Chang did not actually put his brush to the task until late summer 1981. Li Haitian commissioned in Japan the production of a seamless silk panel the size of the wall, and he had the surface sized to better absorb ink. He sent the silk panel to Taipei, where Chang Dai-chien found a carpenter to build a painting table that could hold the entire bolt unrolled. A pillar in Chang's painting studio had to be removed to accommodate the table, and new beams were constructed to make the modified room structurally sound.

Choosing the subject for this mammoth work came slowly. Li suggested that Chang paint the Great Wall, but as it had few waterfalls, Chang rejected the site. Li then suggested the Three Gorges of the Yangzi River, which Chang had mastered early in his career (see entry 14). Afraid that people might think him repetitious, Chang chose a subject he had rarely painted, Mount Lu. Chang had never personally visited the site in his extensive travels throughout China. His reasons for the choice are obscure. Since he had painted the mountains that he knew best—the Yellow Mountains and Mount Emei—literally hundreds of times, they could not provide him a chance to test himself. Surely he knew the painting would be among his last and he must have desired a subject that would astound everyone.

Since Chang had never seen Mount Lu, the subject provided maximum freedom. He read poems and historical gazetteers about the range, and friends brought him photographs and books to stimulate his imagination. These and the multitude of mountain images stored in his mind enabled Chang to invent a landscape. When he was too familiar with a place he sometimes felt constrained by nature, so Mount Lu served as an invitation to be creative. Yet the landscape he painted corresponds to many of Mount Lu's best-known sites, such as Wulao Peak and the solitary island at the edge of the lake. The group of temple buildings concurs with what Chang read about Mount Lu, and the dramatic waterfall echoes Li Bo's (701–762) description of a cascade there: "The water flies straight downward three thousand feet."

This panorama may also have assuaged Chang's regret over never having scaled Mount Lu's mighty peak. Chinese painters and theoreticians have often paralleled the act of painting with the genesis of the world. As Zhang Yanyuan (ca. 810–ca. 880) said, painting brings the finishing touch to the work of universal creation. Chang had often passed close to Mount Lu on his boat trips between Shanghai and Chengdu, and his brother Chang Shanzi (1882–1940) had been there and described it to him. Before he died Chang Dai-chien no doubt wanted some closer connection with this mountain, which had so long been in his thoughts. Moreover, the poet Su Shi (1036–1101), one of Chang's primary role models, wrote a captivating verse about Mount Lu. Su described the elusive nature of the mountain with its layers of peaks—some soaring high, others dipping low; some pressing close, others extended to the distant horizon. The mutability that Su Shi described fascinated Chang. If there was no single "correct" view of Mount Lu, then the scene would be amenable to his style of splashed-ink-and-color painting. One last motivation may have been that Shitao also painted several versions of Mount Lu, one of which Chang once owned (now in the Metropolitan Museum of Art, New York).

Chang Dai-chien's first painting of Mount Lu was made during the 1940s, when he copied a work that Shen Zhou (1427–1509) painted in 1470, *Lofty Mount Lu* (National Palace Museum, Taipei). In 1979, a few years after Chang had moved to Taipei, he created a horizontal composition in splashed-ink-and-color that he inscribed with a copy of Shitao's poem from the *Mount Lu* he owned. Then in 1980 Chang made another splashed-ink-and-color painting, describing it in his inscription as a bird's-eye view of Lake Gongting from Incense Burner Peak at Mount Lu. The painting is undated except for a seal with the cyclical year, so it is impossible to know in which month it was painted. Its close relationship to the last section of *Panorama of Mount Lu,* however, suggests that Chang may have been painting a working sketch for the huge scroll. *Bird's-Eye View of Lake Gongting* has the same balance of open space and solid form as does the finale of *Panorama of Mount Lu,* although the large painting is ultimately much denser. A dense mass of mountains in the lower right of *Lake Gongting* is juxtaposed with an expanse of open water in the diagonally opposite quadrant. In both works, the water and sky blend seamlessly, and small sailboats ply the waters.

On the day Chang Dai-chien began *Panorama of Mount Lu* he invited some close friends over for a luncheon. Zhang Chun, Wang Xinheng, Chang Hsueh-Liang, and his wife, Zhao Yidi, witnessed the beginning of the work. First Chang

wet the silk, which was spread out on the painting table, and dipped a mammoth brush into a dish of ink; standing on a stool, he began mapping out the general composition. He worked feverishly for several hours before breaking. One month later he was ready to splash and spill color on top of the ink. Chang worked intermittently because of his health; at one point he was hospitalized. *Panorama of Mount Lu* was incredibly demanding, as Chang had to climb onto the table to reach the high spots. Sometimes he had his students and family hold him up over the table to reach a desired area. The exhaustion sometimes affected his heart, and he would have to rest and take medication before continuing. A hired nurse accompanied him through much of the ordeal. She helped him climb up on the table and walked along the painted landscape with him to steady his balance when he stopped to add brush strokes.

Although Chang worked on *Panorama of Mount Lu* for about a year and a half, he described it as only 80 to 90 percent finished when he was asked to exhibit it. Chang's friend Zhang Chun was concerned that Chang's social life interfered with his time to paint, so he placed an advertisement in the newspaper asking Chang's friends not to visit him or invite him out. The artist's progress rapidly improved, although work was slowed again by a typhoon that flooded Chang's painting studio but, fortunately, did not harm the work in progress.

The National Museum of History in Taipei, the major museum sponsor of Chang's painting, arranged to exhibit *Panorama of Mount Lu* and other works in an exhibition opening January 20, 1983. In preparation, Chang added some details and a poetic inscription. Since the work was not finished he did not sign it or write a dedication. The inscription begins by hinting at Chang's success in achieving the wondrous effect that Su Shi had described: when one is in Mount Lu, its peaks are so enveloping that the mountain itself cannot be seen. Chang credited his success to the fact that Mount Lu was in his breast, a traditional idiom used by landscape painters. Originally Chang was going to add that he did not need to rely on the great tenth-century landscape painters, such as Dong Yuan, Juran, Jing Hao, and Guan Tong, but he decided that was too boastful. Indeed his career was indebted to these masters.

The inscription also reflects on a parable known as the Three Laughers of Tiger Ravine. The Buddhist theologian Huiyuan (334–416) lived in the Donglin temple at Mount Lu. One day he met with the famous poet Tao Qian (365–427) and the Daoist sage Lu Xiujing (406–477), whom Chang did not mention. The three walked and laughed together until they realized that in their reluctance to part, Huiyuan had forgot-

ten his vow never to leave his monastery and had crossed the boundary of Tiger Ravine into the secular world. Thus, the three realized that the spiritual purity of a man is not defined by physical boundaries. In the lower midsection of *Panorama of Mount Lu*, a bridge and thatched-roof kiosk represent Tiger Ravine, but no figures are present to suggest this parable. Photographs taken at an earlier stage of the work, however, show that Chang had painted the two scholars Tao Qian and Huiyuan in this spot (see fig. 13). Later he obliterated them with a splash of ink, declaring that Mount Lu was no longer a suitable place for scholars. The inscription continues as a clear statement of his distaste for the politics of mainland China. To the very end of his life Chang wanted to return to China and visit places like Tiger Ravine that he had never seen. But Chang would not return while China was under communist rule.

When the National Museum of History returned *Panorama of Mount Lu* to Chang's painting studio, he added more color. But some of his preliminary underdrawing is still in a raw state. On March 8, 1983, Chang Dai-chien entered the hospital, and he died on April 2. Although Li Haitian's request had initiated the project, the painting has remained in the artist's family and will be donated to the National Palace Museum, Taipei.

Panorama of Mount Lu was Chang's final challenge, and while working on it he forgot his age. He once wrote that he would "do his best, no matter what" to paint this grand scroll, and so he did. Despite its unfinished state, *Panorama of Mount Lu* is a sensational conclusion to a lifetime of painting.

Painting Seals

Seal legends, which appear in italic type, have been rendered according to pinyin romanization; in this system, Chang Dai-chien appears as Zhang Daqian. An "x" means that one or more characters could not be read, either because of a lack of clarity in the photographs used to compile this appendix or because of a problem with the actual seal imprint.

1 **Through Ancient Eyes, Signed as Shitao**
Chang Dai-chien: spurious seal of Shitao, *Achang*
Collectors: Alice Boney (1901–1988), *Pangnai;* John Crawford (1913–1988), *Guluofu, Hanguang Ge;* unidentified, *Tingtongyin Guan zhencang shuhua yin*

2 **Pine, Plum, and Fungus of Immortality**
Chang Dai-chien: *Ji Yuan zhi yin, Daqian*

3 **Set of Hanging Scrolls**
Plum Blossom Studio
Chang Dai-chien: *Zhang Yuan si yin, Daqian*

Boating under the Red Cliff
Chang Dai-chien: *Zhang Yuan, Ayuan, Dafeng Tang*

Composing Poetry beneath a Pine
Chang Dai-chien: *Ayuan, Daqian*

4 **Demon Presenting a Plum Bough to Zhong Kui**
Chang Dai-chien: *Zhang Yuan, Daqian, Dafeng Tang*
Unidentified collector: *Li Kezhai yin*

5 **Scholar Admiring a Rock**
Chang Dai-chien: *Ji Yuan si yin, Daqian jushi*

6 **Wenshu Plateau in the Yellow Mountains, Signed as Mei Qing**
Chang Dai-chien: spurious seals of Mei Qing (1623–1697), *Meichi, Yuangong, Lianhua fengding sansheng meng*
Collectors: Alice Boney (1901–1988), *Pangnai;* Zhu Shengzhai (ca. 1902–1970), *Zhu Shengzhai shuhua ji;* John Crawford (1913–1988), *Guluofu, Hanguang Ge*

7 **Xie An and Musicians at East Mountain**
Chang Dai-chien: *Wangshi Yuan ke, Neijiang Zhang Yuan, Dafeng Tang*
Collector: Chung Kit Fok, *Huo Zongjie*

8 **Four Mounted Fans**
In the Style of Hongren
Chang Dai-chien: *Daqian*

In the Style of Zhu Da
Chang Dai-chien: *Daqian*

In the Style of Shitao
Chang Dai-chien: *Zhang Yuan zhi yin*

In the Style of Jin Nong
Chang Dai-chien: on painting, *Daqian haofa, Dayan Zhai;* on mounting, *Zhang Yuan yin, Daqian jushi*

9 **Majestic Peaks**
Chang Dai-chien: *Mingzhi zhuang ze lao, Kugua zhiwei, Zhang Ji, Daqian,* x

10 **Landscape Album Painted with Puru**
Temple
Chang Dai-chien: *Ji Yuan*
Puru (1896–1963): *Puru zhi yin*
Unidentified collector(s): *Yu tian sheng, Yu Zhen sheng*

Autumn Trees by a Brook
Chang Dai-chien: *Zhang Ji, Daqian jushi*
Puru: *Puru zhi yin*

Moonlight on Autumn Mountains
Chang Dai-chien: *Zhang Ji, Daqian jushi*
Puru: *Puru zhi yin*
Unidentified collector: *Xia Bozi jinshi tushu*

Sailing Past the Temple
Chang Dai-chien: *Daqian*
Puru: *Xinyu*
Unidentified collector: *Pu Zhai*

Strolling on a Mountain Path
Chang Dai-chien: *Daqian*
Puru: *Puru zhi yin*

Kiosk
Chang Dai-chien: *Zhang Ji, Daqian jushi*
Puru: *Xinyu*
Unidentified collector: *Xia*

River Scene
Chang Dai-chien: *Daqian*
Puru: *Puru zhi yin*

Cherries and Bamboo Shoot
Chang Dai-chien: *Zhang Yuan zhi yin*
Collectors: Lee Chen-Hua and Lee Xuemei, *Bing qing*

Chestnuts
Chang Dai-chien: *Zhang Yuan, Daqian jushi*
Collectors: Lee Chen-Hua and Lee Xuemei, *Baiqian zhi yi*

Eggplants
Chang Dai-chien: *Zhang Yuan si yin*
Collectors: Lee Chen-Hua and Lee Xuemei, *Shun Xue zhencan*

Spinach
Chang Dai-chien: *Zhang Yuan changshou*
Collectors: Lee Chen-Hua and Lee Xuemei, *Bing qing*

68 Nesting in a Pine
Chang Dai-chien: *Daqian wei yin danian, Dafeng Tang*

69 Patriarch Lü Dongbin
Chang Dai-chien: *Zhang Yuan si yin*
Collectors: Lee Chen-Hua and Lee Xuemei, *Baiqian zhi yi, Lishi zhi bao*

70 Swiss Landscape
Chang Dai-chien: *Dingwei, Daqian*

71 Approach of a Mountain Storm
Chang Dai-chien: *Dingwei, Daqian wei yin danian*
Collector: Chang Hsu Wen-po, *Zhang Xu Wenbo, Hongbin*

72 Snowy Mountains in Switzerland
Chang Dai-chien: *Dingwei, Daqian wei yin danian*

73 Splashed Ink on Gold
Chang Dai-chien: *Daqian wei yin danian, Daqian shijie, Zhizao guren budaochu*
Collector: Chang Hsu Wen-po, *Hongbin, Wenbo*

74 Spring Landscape in Splashed Color
Chang Dai-chien: *Wushen, Daqian wei yin danian, Wuting Hu, Bade Yuan changnian, Dafeng Tang*
Collector: Chang Hsu Wen-po, *Zhang Xu Wenbo, Hongbin*

75 Self-Portrait with Saint Bernard
Chang Dai-chien: *Dafeng Tang, Zhang Yuan, Daqian jushi*

76 Pineapple
Chang Dai-chien: *Zhang Yuan zhi yin, Daqian jushi, Moye Jingshe, Dafeng Tang, Yizhi yan, Xinyou*

77 Lithographs
Temple in the Mountains
Chang Dai-chien: *Huanbi An, Daqian wei yin danian, Trisāhasra mahāsāhasra* (Sanskrit for "three thousand times infinity")

Red Persimmons
Chang Dai-chien: *Daqian wei yin danian, Huanbi An, Trisāhasra mahāsāhasra*

78 Lady of the Xiang River
Chang Dai-chien: *Qian qian qian, Daqian fu*

79 Morning Mist
Chang Dai-chien: *Daqian wei yin danian, Zhizao guren budaochu, Dafeng Tang*

80 Crimson Lotuses on Gold Screen
Chang Dai-chien: *Zhang Yuan zhi yin, Daqian jushi, Jihai yisi wuyin xinyou, Huanbi An, Trisāhasra mahāsāhasra*

81 Red Flowering Plum
Chang Dai-chien: *Zhang Yuan zhi yin, Daqian wei yin danian, Wuwu, Moye Jingshe*
Collector: Chung Kit Fok, *Xianggang Daodehui renxu nian huizhang Huo Zongjie zhi yin*

82 Misty Mountain Path
Chang Dai-chien: *Zhang Yuan, Daqian jushi*

83 Illustrated Menu
Chang Dai-chien: *Zhang Yuan, Daqian fu, Moye Jingshe, Daqian wei yin danian*
Qin Xiaoyi: with colophon, *Shi'er hang Yuban Shanfang, Qin Xiaoyi, Wushi nian wanggu wenwu jinbai nian wenshi jian jian*
Zhang Chun (1889–1990): with colophon, *Zhang Chun*
Tai Jingnong (1902–1990): with colophon, *Tai Jingnong*
Jiang Zhaoshen (b. 1925): with colophon, *Shuangxi, Jiang Zhaoshen yin, Lüe wu qiu huo*

84 Master Hanshan in Silent Repose
Chang Dai-chien: *Zhang Yuan zhi yin, Daqian jushi, Xichuan Zhang Yuan, Jinshi tongshou, Moye Jingshe, Renxu, Trisāhasra mahāsāhasra*
Collector: Yon Fan, *Zhexian Guan zhencang shuhua zhibao, Yinyong chunfeng shudu, Manshi xinxu*

85 Peach Blossom Spring
Chang Dai-chien: *Moye Jingshe, Zhang Yuan, Daqian fu, Renxu*

86 Vermilion Lotuses
Chang Dai-chien: *Zhang Yuan, Daqian jushi, Moye Jingshe, Zhang Yuan si yin, Renxu, Zhang Daqian changshou daji dali*
Collector: Chung Kit Fok, *Guangdong Xinhui Huoshi Decheng Tang zhencang yin*

87 Panorama of Mount Lu
no seals

Forgeries of Early Paintings

This appendix is a selection of Chang Dai-chien's most notable forgeries from earlier dynasties. Today any scholar or connoisseur who studies ancient Chinese painting must learn to identify Chang Dai-chien's forgeries, because their similarity to genuine works can impair the understanding of antiquity. Some of the paintings listed here have not been questioned before, while many have long been doubted but never before attributed to Chang Dai-chien or even to the twentieth century.

The first list indicates the wide distribution of Chang's forgeries in museums and private collections around the world. The paintings in the second list are all in the National Palace Museum, Taipei. Chang kept them among the genuine ancient works in his Dafeng Tang collection. After his death the collection was presented to the museum by Chang's family, who did not realize the collection included his forgeries.

Forgeries in Museums and Private Collections around the World

SUI DYNASTY

anonymous	*Wukecheng pusa*	Museum of Fine Arts, Boston, 58.1003

TANG DYNASTY

Zhang Xuan	*Emperor Xuanzong Enjoying a Cool Breeze, Attributed to Zhang Xuan* (entry 45)	Private collection
Han Gan	*Horse and Groom*	Musée Cernuschi, Paris
Han Huang	*Five Oxen*	Ohara Museum, Japan
anonymous	*Pavilions in the Western Paradise*	Freer Gallery of Art, Smithsonian Institution, Washington, D.C., 1984.41

FIVE DYNASTIES

Guan Tong	*Drinking and Singing at the Foot of a Precipitous Mountain*	Museum of Fine Arts, Boston, 57.194
Dong Yuan	*Traveling in Autumn Mountains*	former J. D. Chen collection
Dong Yuan	*Myriad Trees and Grand Peaks*	collection unknown
Juran	*Dense Forests and Layered Peaks, Attributed to Juran* (entry 42)	The British Museum, London

FIVE DYNASTIES cont.

Juran	*Temple by Streams and Mountains*	former J. D. Chen collection
Juran	*River Scenery in Evening*	former J. D. Chen collection

SONG DYNASTY

Wang Shen	*Sheer Peaks and Deep Valley, Signed as Wang Shen* (see fig. 15)	collection unknown
Li Gonglin	*The Three Worthies of Wu* (see fig. 89)	Freer Gallery of Art, Smithsonian Institution, Washington, D.C., 57.15
Yi Yuanji	*Two Black Gibbons in a Loquat Tree*	Museum of Far Eastern Antiquities, Stockholm
Yi Yuanji	*White Wolf*	collection unknown
Li Di	*A Winter Bird in a Snowy Tree, after Li Di* (see fig. 40)	collection unknown
Liang Kai	*Sleeping Gibbon, Signed as Liang Kai* (entry 11)	Mr. and Mrs. Myron S. Falk, Jr., New York
Liang Kai	*Sleeping Gibbon, Signed as Liang Kai* (entry 12)	Honolulu Academy of Arts, Hawaii, 2217.1

Forgeries in the National Palace Museum, Taipei

SUI DYNASTY

anonymous *Sakyamuni Buddha*
anonymous *Guanyin* (fig. 111)

TANG DYNASTY

anonymous *Ming Huang on Horseback*

FIVE DYNASTIES

Juran *Broad Shores and Distant Mountains*
anonymous *Laozi Leaving the Pass* (see fig. 42)

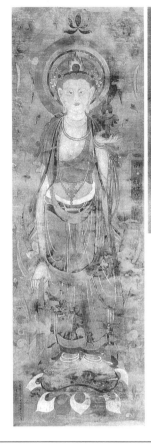

Fig. 111. Chang Dai-chien, *Guanyin*. Hanging scroll; ink and color on silk; National Palace Museum, Taiwan, Republic of China. From *Dafeng Tang yizeng mingji tezhan tulu* (Taipei: Guoli gugong bowuyuan, 1983), pl. 2.

Among the gifts of ancient paintings to the National Palace Museum were several genuine, anonymous works that Chang Dai-chien altered by adding seals and inscriptions to attribute them to famous artists.

PAINTING	CHANG DAI-CHIEN'S ADDITION
Cloudy Mountains	Mi Fu inscription
Dogs and Eagles	Song Huizong signature and seals
Evening of the Qiqiao Ceremony	imperial seals
Flying Quail	Li Anzhong seals
Gathering of Musicians in Ming Huang's Court	Li Dongyang frontispiece
Landscape, Song dynasty	*Xuanwen Ge bao* seal
Landscape, Wang Meng	inscription with Bo Ting and Qiu Yuan signatures
Lofty Reclusion in Summer Mountains	Wang Meng inscription and signature
Misty Mountains	Fang Congyi signature and seals
Sakyamuni Descending the Mountains	Ma Lin signature
Watching the Waterfall	Ma Lin signature
White Rooster and Hen	Song Huizong signature and seals

Gardens and Residences

Laiqing Tang

Between 1929 and 1931, Chang Dai-chien sometimes stayed at Lai-qing Tang (Welcoming the Greenery Hall), "borrowing" the garden from its wealthy owner, a friend surnamed Chen. Located in Jiashan, Zhejiang Province, Laiqing Tang was one of the first classical Ming-style gardens in which Chang Dai-chien had a chance to stay. The garden had walled courtyards in which pavilions and arrangements of Lake Tai rocks and ponds were featured. It was near transportation to Shanghai and Hangzhou.

Wangshi Yuan

Beginning in autumn 1932, Chang Dai-chien and his brother Shanzi intermittently lived in Wangshi Yuan (Garden of the Master of the Fishing Net). This famous garden, in Suzhou, Jiangsu Province, was lent to them by their friend Zhang Shihuang. Shanzi raised tigers there.[1] The garden was divided into two sections, and the calligrapher, bamboo painter, and collector, Ye Gongchuo, who influenced Chang Dai-chien to develop a fine-line style of painting, lived in the other half. Wangshi Yuan represents the best in classical garden design, and its masterful balance between solid spaces (architecture and imitation mountains) and void (open pavement and water) inspired Chang Dai-chien when he later built his own gardens.

Yihe Yuan

In the 1930s, several years after Chang Dai-chien first went to Peking, he rented quarters in the former imperial summer palace called Yihe Yuan (Peace Garden), far to the northwest of the city center. He was particularly attracted to the lotus ponds and aged cypress trees. Chang was only there periodically. His friend Puru was already living in Yihe Yuan when Chang moved in, and they occasionally collaborated on paintings (see entry 10). Within the garden, Chang rented Tingli Guan (Listening to the Orioles Pavilion). The south boundary of Yihe Yuan is Kunming Lake, a place that Chang mentioned in some of his signature lines on paintings from the 1930s. He probably first stayed in Yihe Yuan in 1932 and was there off and on between 1934 and 1937, when the Japanese occupied Peking, and then again sporadically between 1945 and autumn 1948. In the 1940s he often stayed at Yangyun Xuan (Pavilion for Clouds).

Zhaojue Buddhist Temple and Shangqing Gong Daoist Temple

From around 1938 to 1940, Chang Dai-chien divided his time between the Zhaojue Si (Call to Enlightenment Temple), a Chan Buddhist temple on the outskirts of Chengdu, and the Shangqing Gong Daoist temple in the Qingcheng Mountains several hours outside the city. He stayed at both of these Sichuan temples before and after his Dunhuang sojourn, which lasted from 1941 to 1943.

The Zhaojue temple had a collection of paintings attributed to Sun Wei, which Chang was eager to see. Chang enjoyed painting the camellia, cassia, and other flowering trees planted in the temple courtyard, and he was able to raise Tibetan mastiffs, pheasants, panthers, a bear, and Persian cats on the grounds. The abbot allowed Chang to paint in one of the large halls, where he could spread out and work on the large-scale paintings he had begun at Dunhuang. He also produced some of the largest of his early lotus paintings here. Shangqing Gong had beautiful gardens as well, and Chang planted a hundred plum trees there.

Dunhuang

From 1941 to 1943 Chang Dai-chien lived for two and one-half years near the Mogao Caves at Dunhuang, in Gansu Province. The area is a desert, and Chang could not cultivate a conventional Chinese garden there. He lived by the only source of water, a limpid mountain stream that he described in an inscription.

> The road is lined by white willows and a stream meanders in front of my door. I love this place. This spring I brought back from Lanzhou some lotus roots and planted them here, waiting for the southerly winds so I could wave my palm leaf fan, saunter along the winding banks, enjoy the sight of the wind-blown garments and the blue-green canopies [of the lotuses] and say to myself that this is as good as a summer in Jiangnan. Unfortunately, the roots did not grow. I can only watch the clear waves pass by gently and remain silent while I soak my feet.[2]

Tuoshui Cun Jieju

From the spring of 1946 until the following year, Chang Dai-chien rented quarters in Tuoshui, a village on the outskirts of Chengdu, in Sichuan Province. Yu Zhizhen, one of several students who lived and traveled with Chang during this period, described it.

> The garden had camellia and crabapple trees and profuse flowers and greenery. Several groves of white-flowering plum trees gave

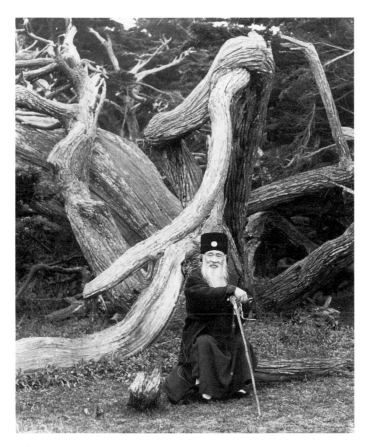

Fig. 112. Chang Dai-chien by a cypress tree in Pebble Beach, California. Photograph by James C. M. and Lucy L. Lo, Princeton, New Jersey.

off a lightly perfumed scent. Pots of herbs and bamboo, which were deep shades of blue and green, looked moist and lush everywhere in the garden. At the back a thick grove of tall, slender bamboo made the spot elegant and wonderfully secluded. Chang raised little monkeys, a fox, cats, dogs, and other small animals under the trees.[3]

Shuiniu An

During the summer of 1949, Chang Dai-chien lived in Jinniu Ba, a western suburb of Chengdu. Shuiniu An (Shuiniu Cottage) was the first garden-residence he purchased.[4] Chang asked his teenage son Paul to go to Guangdong and select flowers to bring back for the garden. Chang also asked Paul to buy some gibbons. Chang's student Yu Zhizhen described Shuiniu An: "In the front Chang Dai-chien planted a lot of hibiscus flowers; he raised a few white gibbons, who swung from the trees and romped among the flowers."[5]

Japan

After leaving China in 1949, Chang Dai-chien frequently visited Japan to get painting supplies and simply to seek solace in a culturally familiar place. The gardens he visited in Japan nourished his painting. He was most impressed with the giant lotuses he saw at the Shinobazu Pond in Tokyo's Ueno Park. They were the models for some of the large lotus images he painted.

A Japanese inn called Kairakuen, just south of Yokohama, was

also important to Chang Dai-chien. He first visited the inn, which was a well-known gathering place for Japanese calligraphers and painters, in April 1931, and it became an important refuge for him during the 1950s and 1960s. The proprietor allowed him to use the large formal hall as a studio (see entry 87). After the 1960s, Chang heard that a real estate development and landfill had destroyed the nearby beach, and so he never returned. Chang often visited the Kyoto gardens and other scenic sites when he traveled to Japan each spring, but he did not mention them by name.

Darjeeling

In May 1950 Chang Dai-chien went to Darjeeling, which is 2,500 meters above sea level on the border between India and Nepal. It reminded him of Mount Emei in Sichuan Province. Darjeeling had been developed by the English as a summer resort and a place to grow tea, and because it was difficult to reach, Chang found it wonderfully peaceful. He liked the cool climate and view of the snow-capped Himalaya Mountains, and he raised Indian gibbons there. He lived in Darjeeling with his infant daughter, Xinpei, and his wife, Hsu Wen-po. With only one wife and child at his side, Chang probably had fewer family distractions in Darjeeling than at any other time in his life. Chang Dai-chien commented on this interlude: "It was the time when I painted the most and wrote the most poetry. My energy was at a pinnacle and my power of sight perfect, so I was able to do very fine, detailed paintings."[6]

Godoy Cruz

In August 1952, Chang Dai-chien, with five of his children and Hsu Wen-po, moved to Godoy Cruz, a small town outside Mendoza, Argentina, at the foot of the Andes. There, they rented a two-story house with a flower garden.

Chang Dai-chien's close friend Zhang Muhan described the garden as being some two acres (*mu*) in size and containing numerous fruit trees, including cherries, plums, oranges, and lemons, as well as various other kinds of trees, such as pines, cypresses, willows, and magnolias, and flowering plants like gardenias and roses. Chang also had six gibbons with him and several cats and dogs of different breeds. Chang featured all these plants and animals in his paintings while he stayed in this temporary abode.[7]

Bade Garden

In late 1953, Chang Dai-chien bought thirty acres in Mogi, Brazil, thirty miles outside São Paulo. He moved there during 1954 and stayed until 1971, although he was frequently away on trips. Throughout this time, he worked passionately to transform the unkempt land into a Chinese garden with courtyards, pavilions, miniature mountains, streams, and a lake (see entries 53 and 59).

The journalist Xie Jiaxiao wrote the following description of Bade (Eight Virtues) Garden.

Originally the garden had more than two thousand roses of all the important varieties—they were very beautiful and of every imaginable color, but Chang Dai-chien did not consider roses to be important Chinese flowers so he eradicated them. Instead he planted flowering plum trees, lotuses, begonias, peonies, and others; everything was a flower that grew in the Far East. For trees and woody grasses, he planted pine, cypress, and bamboo in prominent places. Soon everything was verdant.[8]

Chang Dai-chien imported many of the trees and plants, including the bamboo, from Japan and Taiwan, and he created tray landscapes (*penjing*) using miniature trees, grasses, and table-size rocks. Beyond

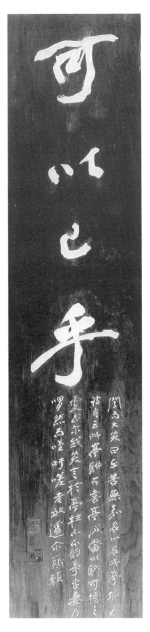

Fig. 113. Chang Dai-chien, *The Will Just Do Pavilion,* 1973. Inscribed set of wooden plaques for the pavilion entrance; collection of Chang Hsu Wen-po, Taipei.

the expense, Chang had to apply to the Brazilian government each time he wanted to import a special plant; as justification, he said he needed the trees and plants as models for painting. The *penjing* collection became so extensive, with several hundred specimens, that Chang hired a Japanese gardener named Suzuki to live in Bade Garden as full-time caretaker for the *penjing* and delicate black pine trees he had imported.

Keyi Ju

While living in Brazil, Chang sometimes traveled to the United States. Several of his friends lived in California. Chang liked the scenery of Carmel so much, especially the pine and cypress trees, that in 1968 he bought a house to serve as a temporary residence when he visited the United States. The garden was small, so he simply named it Keyi Ju (The Habitable House).

Huanbi An

In June 1971 Chang Dai-chien bought a new house with a larger yard in Pebble Beach, close to Carmel, and he named it Huanbi An (Enveloped by Greenery Cottage). Chang was attracted to the area by the ancient cypress trees that grew along the coast, where he occasionally sat on the gnarled roots and reflected on the raw beauty of these trees, protected during the centuries by their twisted shapes unfit for lumber (fig. 112). He stayed at Huanbi An until 1976, when he moved to Taiwan.

In his Pebble Beach garden, Chang planted bamboo, which, along with all the neighbors' towering pine trees, cast a jade hue over the whole garden. Chang cut down a large oak tree in the yard to build a painting studio, and he also dug a pond. He mounded the excavated earth into a small hill, where he made a kiosk called Liaoke Ting (The Will Just Do Pavilion). Chang made wooden tablets to hang in this pavilion; on the tablets he carved the text of a conversation he had had with Hsu Wen-po (fig. 113). The text provides insight into the nature of the garden.

> Simply as it is,
> Will be the end.

> In the winter of the *guichou* year [1973], I was going to build a thatched-roof kiosk on the little hill to the west of my Huanbi An, where I could lie in the moonlight and watch the flowering plums. My old wife strongly opposed [the idea], and when I casually responded that it would simply be as it is, she replied, "People of old did not build houses after sixty, but here you are now, seventy-five years of age, and still adding a pavilion which you can surely do without, won't you ever make an end of it?" I burst out laughing when I heard this and said, "Just now I was feeling upset that I didn't have a good name for the pavilion, but as Su Dongpo's [Su Shi] poem says, 'This pavilion will do just nicely,' so when it's finished I'll make a sign for the 'Will Just Do' Pavilion and even write this amusing conversation of ours on its pillars, won't that be lovely!" My wife then heaved a sigh, "Oh, you old rascal, you're incorrigible!"
> SDA

Some Chinese expatriates who lived in the area of Huanbi An welcomed Chang Dai-chien by presenting him with plum trees. He requested permission from the town government to move a giant boulder from the beach into his garden, and he had the boulder inscribed with large-size calligraphy that translates as "Plum Hill" (fig. 114).

Chang tried to re-create some of his favorite elements from Bade Garden at Huanbi An. He had a stone stela from Bade Garden shipped to his new Pebble Beach residence. The stela was inscribed

Fig. 114. Giant boulder from Pebble Beach, California, with Chang Dai-chen's calligraphy "Plum Hill"; currently situated at his former Taipei residence, the Moye Jingshe. From *Chang Dai-chien's Memorial Residence* (Taipei: Guoli gugong bowuyuan, 1989).

"Tomb of the Brushes" (*bizhong*), which is an allusion to the Six Dynasties period calligrapher Zhiyong, who was said to love calligraphy so much that when his brushes wore out from his diligent practicing, he buried them in a special tomb. He also had some *penjing* shipped from Brazil and built a wooden rack for them in the backyard. The entrance to the garden followed the ancient landscape convention "open the door and see a mountain." To obscure the view of the garden, Chang put a boulder and a huge fanciful tree root at the gate, making it seem mysterious, like a special sanctuary.

Moye Jingshe

Chang Dai-chien became increasingly homesick for China, and he decided to move to Taiwan in 1976. First he lived in a rented apartment in downtown Taipei, and then in May 1977, he bought some property not far from the National Palace Museum, in a suburb called Waishuangxi. Chang Dai-chien called this residence Moye Jingshe, a name that combines a Buddhist word for illusion (*moye*) with a term meaning Buddhist meditation hut. Moye Jingshe is commonly translated as Abode of Illusion. He moved in 1978 and lived there until his death in 1983. The house is now a memorial museum open to the public by appointment.

Moye Jingshe is on a small island in the fork of a mountain stream, and Chang chose it because it had an old plum tree. In addition his close friend and Sichuan compatriot Zhang Chun, an important official in the government, lived eight minutes away. Besides Bade Garden, this was the only other residence that Chang started from scratch. It was nearly a year before he could move in.

Moye Jingshe has a small front and back yard and a rooftop garden with gibbon cages. The backyard has a covered arcade that follows the mountain stream; Chang took a walk along the arcade every morning. The house has four wings that surround a central courtyard, which features water, rocks, and plants arranged like a miniature Suzhou garden. On the first floor the surrounding walls have large glass sliding doors, some of which contain circular lenses that can make the garden seem larger. Chang had a large painting studio on the first floor and a smaller one upstairs, next to a studio for mounting his paintings.

From his Pebble Beach home Chang Dai-chien sent forty cases of *penjing* by air freight, many of which he arranged in the rooftop garden. He also shipped the monolithic boulder that he had found at Pebble Beach and engraved with the characters "Plum Hill." Chang placed the rock in the frontyard and planted plum trees nearby. Small earthen "mountains," willow trees, and a goldfish pond complete the setting. Because the pond was too small to grow lotuses, Chang grew them in ceramic vats.

After Chang Dai-chien's death, his ashes were interred beneath the Plum Hill stone according to his wishes. Plum Hill alludes not only to mountains and flowering trees, but also to his native home, since he first used the name Plum Hill for a garden spot in the Qingcheng Mountains of Sichuan Province. Chang Dai-chien was nearly eighty when he went to Taiwan, and he consciously designed Moye Jingshe as his final resting place.

Notes

1. See Li Yongqiao, *Chang Dai-chien nianpu* (Chengdu: Sichuan sheng shehui kexueyuan chubanshe, 1987), 64; and Bao Limin and Wang Zhen, "Chang Dai-chien nianpu," *Duoyun* 19 (1988): 107.

2. Translation of inscription on *Crimson Lotuses on a Gold Background*, from René-Yvon Lefebvre d'Argencé, *Chang Dai-chien: A Retrospective Exhibition* (San Francisco: Center of Asian Art and Culture, 1972), 50–51, pl. 17.

3. Yu Zhizhen, "Chang Dai-chien laoshi de huaniao hua yishu," in Bao Limin, ed., *Chang Dai-chien de yishu* (Beijing: Sanlian shudian, 1986), 66.

4. Information was provided in conversations between the author and the artist's son Paul Chang.

5. Yu Zhizhen, "Chang Dai-chien laoshi de huaniao hua yishu," in Bao Limin, *Chang Dai-chien de yishu*, 66.

6. Quoted in Xie Jiaxiao, *Chang Dai-chien de shijie* (Taipei: Shibao wenhua chuban gongsi, 1982), 184.

7. Zhang Muhan, "Dai-chien jushi jinwen," reproduced in Zhu Chuanyu, ed. *Chang Dai-chien zhuanji ziliao*, vol. 1 (Taipei: Tianyi chubanshe, 1985), 63a.

8. Xie Jiaxiao, *Chang Dai-chien de shijie*, 193.

Selected List of Names

寶　熙　Bao Xi (Bao Ruichen; act. 1900–1930)

畢　宏　Bi Hong (act. 742–756)

辯　才　Biancai (act. 626–649)

白居易　Bo Juyi (772–846)

白　珽　Bo Ting (1248–1328)

白知退　Bo Zhitui (d. 826)

蔡畫庵　Cai Sean (Chang Dai-chien's contemporary)

曹景陶　Cao Jingtao (Chang Dai-chien's contemporary)

張承先　Chang Ch'eng-hsien (Chang Dai-chien's grandson)

張大千　Chang Dai-chien (Chang Zhengchuan, Chang Yuan, Chang Ji, Chang Jiyuan, Dafeng Tang, Dai-chien jushi; 1899–1983)

張心印　Chang Hsin-yin (Chang Dai-chien's son)

張徐雯波　Chang Hsu Wen-po (Chang Dai-chien's fourth wife)

張學良　Chang Hsueh-Liang (Chang Han-ch'ing; b. 1898)

張君綬　Chang Junshou (Chang Dai-chien's brother; 1902–1922)

張麗誠　Chang Licheng (Chang Dai-chien's brother; 1884–ca. 1970)

張葆蘿　Chang, Paul (Chang Baoluo, Chang Sing-ye, Chang Dai-chien's son)

張善子　Chang Shanzi (Chang Dai-chien's brother; 1882–1940)

張心聲　Chang S. Sing (Chang Dai-chien's daughter)

張心澄　Chang Sing-cheng (Chang Dai-chien's son)

張心夷　Chang Sing-yi (Chang Dai-chien's son)

張為先　Chang Wei-hsien (Chang Dai-chien's grandson)

張文修　Chang Wenxiu (Chang Dai-chien's brother; 1885–ca. 1970)

張心沛　Chang Xinpei (Chang Dai-chien's daughter)

張心素　Chang Xinsu (Chang Shanzi's daughter; ca. 1915–1989)

張心智　Chang Xinzhi (Chang Dai-chien's son)

張正恒　Chang Zhengheng (Chang Qiongzhi, Chang Dai-chien's sister; ca. 1892–1911)

張忠發　Chang Zhongfa (Chang Huaizhong, Chang Dai-chien's father; 1860–1925)

陳從周　Chen Congzhou (b. 1918)

陳定山　Chen Dingshan (1897–1989)

陳洪綬　Chen Hongshou (Chen Laolian; 1598–1652)

陳繼儒　Chen Jiru (1558–1639)

陳巨來　Chen Julai (20th century)

陳　淳　Chen Shun (Chen Baiyang, Chen Daofu; 1483–1544)

陳樹人　Chen Shuren (1883–1948)

陳獻章　Chen Xianzhang (Chen Baisha; 1428–1500)

陳貞慧　Chen Zhenhui (1605–1656)

陳　遵　Chen Zun (Chen Ruxun; act. 1600–1617)

蔣俊憲　Chiang Chun-Hsien (modern collector)

蔣蒙華　Chiang Meng-Hua (modern collector)

莊　嚴　Chuang Yen (Chuang Muling; 1898–1980)

崔　白　Cui Bo (act. 1024–1070)

戴本孝　Dai Benxiao (1621–1691)

狄葆賢　Di Baoxian (Di Pingzi; 1872–1940s)

刁光胤　Diao Guangyin (ca. 855–935)

丁觀鵬　Ding Guanpeng (act. 1742–1754)

董其昌　Dong Qichang (Dong Huating; 1555–1636)

董　源　Dong Yuan (act. 937–976)

杜　堇　Du Jin (act. late 15th–early 16th cent.)

段成式　Duan Chengshi (d. 863)

端　方　Duanfang (1861–1911)

陳繼恩　Dzung Kyi Ung (modern collector)

范安仁　Fan Anren (act. 1253–1258)

范　寬　Fan Kuan (ca. 960–ca. 1030)

范竹齋　Fan Zhuzhai (early 20th cent. collector)

方從義　Fang Congyi (act. 1340–1380)

方介堪　Fang Jiekan (1903–1987)

方以智　Fang Yizhi (1611–1671)

費丹旭　Fei Danxu (1802–1850)

馮幼衡　Feng Youheng (Chang Dai-chien's secretary)

霍宗傑　Fok, Chung Kit (modern collector)

傅抱石　Fu Baoshi (1904–1965)

傅熹年　Fu Xinian (modern scholar and collector)

傅增湘　Fu Zengxiang (Fu Yuanshu; 1872–1950)

改　琦　Gai Qi (Gai Qixiang; 1774–1829)

高鳳翰　Gao Fenghan (1683–1748)

高劍父　Gao Jianfu (1876–1951)

高克恭　Gao Kegong (1248–1310)

高克明　Gao Keming (act. 1008–1053)

高嶺梅　Gao Lingmei (friend and publisher of Chang Dai-chien's work)

高奇峯 Gao Qifeng (1889–1933)

耿昭忠 Geng Zhaozhong (1640–1686)

龔賢 Gong Xian (ca. 1619–ca. 1689)

顧閎中 Gu Hongzhong (act. 943–960)

顧愷之 Gu Kaizhi (Gu Changkang, Gu Hutou; ca. 345–ca. 406)

顧洛 Gu Luo (1763–after 1837)

關良 Guan Liang (1899–1986)

關仝 Guan Tong (act. 907–923)

貫休 Guanxiu (832–912)

郭熙 Guo Xi (ca. 1001–ca. 1090)

郭詡 Guo Xu (1456–after 1528)

郭有守 Guo Youshou (b. ca. 1900)

郭忠恕 Guo Zhongshu (ca. 910–977)

韓幹 Han Gan (ca. 715–after 781)

韓滉 Han Huang (723–787)

寒山 Hanshan (act. mid-8th cent.)

橋口五葉 Hashiguchi Goyo (1880–1921)

橋本關雪 Hashimoto Kansetsu (1883–1945)

何延之 He Yanzhi (Tang dynasty)

洪正治 Hong Zhengzhi (1674–1731)

弘仁 Hongren (Jianjiang; 1610–1664)

侯方域 Hou Fangyu (1618–1655)

胡佩衡 Hu Peiheng (Hu Lengan; 1891–1962)

胡儼 Hu Yan (contemporary)

華嵒 Hua Yan (Hua Xinluo, Hua Qiuyue; 1682–1756)

黃賓虹 Huang Binhong (1864–1955)

黃道周 Huang Daozhou (1585–1646)

黃公望 Huang Gongwang (Huang Dachi, Huang Zijiu; 1269–1354)

黃君璧 Huang Junbi (b. 1898)

黃凝素 Huang Ningsu (Chang Dai-chien's second wife; b. 1907)

黃筌 Huang Quan (ca. 903–965)

黃庭堅 Huang Tingjian (Huang Shangu; 1045–1105)

許晉義 Hui, Richard (modern collector)

惠遠 Huiyuan (334–416)

黃天才 Hwang Tien-tsai (modern collector)

張心嫻 Ing, Wilma Chang (Chang Dai-chien's daughter)

岩崎常正 Iwasaki Tsunemasa (1786–1842)

賈似道 Jia Sidao (1213–1275)

蔣峨士 Jiang Ershi (1913–1972)

江參 Jiang Shen (Jiang Guandao; ca. 1090–1138)

江兆申 Jiang Zhaoshen (b. 1925)

金農 Jin Nong (Jin Dongxin; 1687–1763)

荊浩 Jing Hao (act. 870–930)

九方臯 Jiufang Gao (act. 660 B.C.)

巨然 Juran (act. 960–980)

康有為 Kang Youwei (1858–1927)

柯九思 Ke Jiusi (1290–1343)

孔德成 Kong Decheng (b. 1905)

髡殘 Kuncan (Shiqi; 1612–ca. 1673)

郎靜山 Lang Jingshan (modern photographer; b. 1892)

李正儀 Lee, C. Y. (husband of Chang Xinpei)

李順華 Lee Chen-Hua (modern collector)

李凌雲 Lee Lingyun (father of Lee Chen-Hua)

李雪梅 Lee Xuemei (wife of Lee Chen-Hua)

李安忠 Li Anzhong (act. 1119–1162)

李白 Li Bo (701–762)

李成 Li Cheng (919–967)

李東陽 Li Dongyang (1447–1516)

李公麟 Li Gonglin (Li Longmian; ca. 1049–1106)

李海天 Li Haitian (patron of Chang Dai-chien)

李秋君 Li Qiujun (Li Ziyun; 1899–1971)

李瑞奇 Li Ruiqi (Li Yun'an; act. 1910–1930)

李瑞清 Li Ruiqing (Li Meichi, Li Wenjie, Li Zhongzi; 1867–1920)

李鱓 Li Shan (act. 1711–1762)

李升 Li Sheng (act. 908–925)

李思訓 Li Sixun (651–716)

李協珂 Li Xieke (wife of Paul Chang; 1928–1985)

李昭道 Li Zhaodao (act. 670–730)

梁楷 Liang Kai (Liang Fengzi; act. early 13th cent.)

廖瑩中 Liao Yingzhong (act. 1250–1270)

林逋 Lin Bu (Lin Hejing; 965–1026)

练松柏 Lin, C. P. (modern collector)

林椿 Lin Chun (act. 1174–1189)

林風眠 Lin Fengmian (b. 1900)

林良 Lin Liang (ca. 1430–ca. 1490)

劉寀 Liu Cai (d. ca. 1123)

劉道士 Liu Daoshi (act. 10th cent.)

劉海粟 Liu Haisu (b. 1896)

劉松年 Liu Songnian (ca. 1150–after 1225)

劉太希 Liu Taixi (contemporary)

劉永年 Liu Yongnian (act. 1030–1060)

羅家倫 Lo Chia-luen (1897–1969)

羅桂祥 Lo, K. S. (modern collector)

樓觀 Lou Guan (act. 1265–1274)

陸丹林 Lu Danlin (1897–1970)

呂洞賓 Lü Dongbin (Lü Yan, Lü Chunyang; ca. 790–862)

呂紀 Lü Ji (act. 1490–1506)

陸探微 Lu Tanwei (act. 460–early 6th cent.)

陸修靜 Lu Xiujing (406–477)

盧雪堂 Lu Xuetang (early 20th cent.)

陸游 Lu You (1125–1210)

呂月樵 Lü Yueqiao (20th cent.)

羅振玉 Luo Zhenyu (1866–1940)

馬麟 Ma Lin (act. late 12th–mid-13th cent.)

馬遠 Ma Yuan (act. 1190–1225)

毛大可 Mao Dake (Mao Qiling; 1623–1716)

冒襄 Mao Xiang (1611–1693)

梅清 Mei Qing (Mei Qushan, Mei Yuangong; 1623–1697)

梅堯臣 Mei Yaochen (1002–1060)

米芾 Mi Fu (Mi Yuanzhang; 1051–1107)

糜耕雲 Mi Gengyun (b. 1911)

米友仁 Mi Youren (1075–1151)

牧谿 Muqi (early 13th cent.–after 1279)

永原織治 Nagahara Oriharu (20th cent.)

倪元璐 Ni Yuanlu (1594–1644)

倪瓚 Ni Zan (Ni Yunlin; 1301–1374)

歐陽修 Ouyang Xiu (1007–1072)

龐元濟 Pang Yuanji (1864–1949)

溥儒 Puru (Pu Xinyu; 1896–1963)

齋白石 Qi Baishi (1864–1957)

錢選 Qian Xuan (ca. 1235–after 1300)

秦孝儀 Qin Xiaoyi (contemporary)

邱文播 Qiu Wenbo (Qiu Yuqing; act. 933–965)

仇英 Qiu Ying (Qiu Shifu; ca. 1494–1552)

仇遠 Qiu Yuan (1261–after 1327)

屈翁山 Qu Wengshan (Qu Dajun; 1630–1696)

屈原 Qu Yuan (ca. 343–277 B.C.)

任熊 Ren Xiong (Ren Weichang; 1820–1857)

任薰 Ren Xun (1835–1896)

任頤 Ren Yi (Ren Bonian; 1840–1896)

阮籍 Ruan Ji (210–263)

阮咸 Ruan Xian (234–305)

沈曾植 Shen Zengzhi (Shen Meisou; 1852–1922)

沈周 Shen Zhou (Shen Shitian; 1427–1509)

沈子蕃 Shen Zifan (Song dynasty weaver)

盛茂燁 Sheng Maoye (act. 1625–1640)

盛懋 Sheng Mou (Sheng Zizhao; act. 1310–1360)

石恪 Shi Ke (Shi Zizhuan; act. 960–975)

拾得 Shide (act. mid-8th cent.)

石濤 Shitao (Qingxiang Laoren, Dadizi; 1642–1707)

壽� Shou Xi (Shou Shigong; 1889–1950)

宋徽宗 Song Huizong (Daojun Huangdi; r. 1100–1125)

蘇漢臣 Su Hanchen (act. 1101–1125)

蘇軾 Su Shi (Su Dongpo; 1036–1101)

孫登 Sun Deng (act. 3d cent.)

孫過庭 Sun Guoting (ca. 648–ca. 703)

孫家勤 Sun Jiaqin (Sun Chia Chin; b. 1938)

孫位 Sun Wei (act. 880)

孫雲生 Sun Yunsheng (Sun Jiarui; contemporary)

臺靜農 Tai Jingnong (1902–1990)

譚敬 Tan Jing (20th cent.)

譚鑫培 Tan Xinpei (Skylark Tan; 1808–1887)

唐棣 Tang Di (ca. 1286–ca. 1354)

湯滌 Tang Di (1878–1948)

唐寅 Tang Yin (Tang Ziwei, Tang Liuru; 1470–1524)

陶弘景 Tao Hongjing (452–536)

陶鵬飛 Tao, Pung F. (modern collector)

陶潛 Tao Qian (Tao Yuanming; 365–427)

滕昌祐 Teng Changyou (ca. 850–after 930)

曹仲英 Tsao Jung Ying (modern collector)

羅久華 Upshur, Jiu-hwa Lo (modern collector)

王季遷 Wang, C. C. (Wang Jiqian; b. 1907)

王方宇 Wang Fangyu (modern collector)

王翬 Wang Hui (Wang Shigu; 1632–1717)

王蒙 Wang Meng (Wang Shuming, Huanghe Shanqiao; ca. 1308–1385)

王夢白 Wang Mengbo (1887–1938)

王冕 Wang Mian (Wang Yuanzhang; d. 1359)

汪溶 Wang Rong (Wang Shensheng; 1896–1972)

王詵 Wang Shen (Wang Jinqing; ca. 1046–after 1100)

王時敏 Wang Shimin (Wang Yanke; 1592–1680)

王維 Wang Wei (Wang Mojie; 701–761)

王武 Wang Wu (Wang Wang'an; 1632–1690)

王洽 Wang Xia (Wang Mo; late 8th cent.)

王獻之 Wang Xianzhi (Wang Zijing, Wang Daling; 344–386)

王希孟 Wang Ximeng (1096–1119)

王新衡 Wang Xinheng (contemporary)

王羲之 Wang Xizhi (ca. 307–ca. 365)

汪亞塵 Wang Yachen (1894–1983)

王繹 Wang Yi (1333–after 1362)

王壯為 Wang Zhuangwei (Tongjie Laoren; b. 1909)

文徵明 Wen Zhengming (1470–1559)

王世濤 Wong, Stewart S. T. (modern collector)

吳昌碩 Wu Changshuo (Wu Junqing; 1844–1927)

吳大澂 Wu Dacheng (1835–1902)

吳道子 Wu Daozi (Wu Daoxuan; act. 710–760)

吳湖帆 Wu Hufan (1894–1968)

吳偉 Wu Wei (1459–1508)

吳文英 Wu Wenying (ca. 1200–ca. 1260)

吳鎮 Wu Zhen (1280–1354)

武宗元 Wu Zongyuan (d. 1050)

秘康 Xi Kang (223–262)

夏珪 Xia Gui (act. 1200–1250)

項聖謨 Xiang Shengmo (1597–1658)

項元汴 Xiang Yuanbian (1525–1590)

鮮于樞 Xianyu Shu (1256–1301)

蕭建初 Xiao Jianchu (contemporary)

蕭翼 Xiao Yi (act. 630s)

謝安 Xie An (320–385)

謝赫 Xie He (act. 479–502)

謝家孝 Xie Jiaxiao (modern journalist)

謝覲虞 Xie Jinyu (Xie Yucen; 1899–1935)

謝舜華 Xie Xunhua (Chang Dai-chien's first fiancée; d. 1918)

謝稚柳 Xie Zhiliu (b. 1910)

徐邦達 Xu Bangda (b. 1911)

徐悲鴻 Xu Beihong (1895–1953)

徐渭 Xu Wei (Xu Qingteng; 1521–1593)

徐熙 Xu Xi (act. 937–975)

閻立本 Yan Liben (ca. 600–674)

燕笙波 Yan Shengbo (b. ca. 1910)

晏偉聰 Yan Weicong (husband of Chang Xinsu)

顏真卿 Yan Zhenqing (Yan Lugong; 709–785)

楊貴妃 Yang Guifei (ca. 720–756)

楊昇 Yang Sheng (act. 714–742)

楊宛君 Yang Wanjun (Chang Dai-chien's third wife; 1917–after 1985)

葉恭綽 Ye Gongchuo (Ye Xia'an; 1880–1968)

葉淺予 Ye Qianyu (contemporary)

伊秉綬 Yi Bingshou (1754–1815)

易元吉 Yi Yuanji (act. mid-11th cent.)

楊凡 Yon Fan (Yon Manshi, modern collector)

于非厂 Yu Feian (1888–1959)

俞劍華 Yu Jianhua (1895–1979)

虞世南 Yu Shinan (Yu Yongxing; 558–638)

余叔岩 Yu Shuyan (d. 1943)

于右任 Yu Youren (1878–1964)

禹之鼎 Yu Zhiding (ca. 1647–ca. 1707)

俞致貞 Yu Zhizhen (contemporary)

元積 Yujian (act. mid-13th cent.)

惲壽平 Yun Shouping (Yun Nantian; 1633–1690)

曾鯨 Zeng Jing (1568–1650)

曾克耑 Zeng Keduan (friend of Chang Dai-chien who helped record his discourse on painting)

曾慶蓉 Zeng Qingrong (Chang Dai-chien's first wife; 1901–ca. 1960)

曾熙 Zeng Xi (1861–1930)

曾友貞 Zeng Youzhen (Chang Dai-chien's mother; 1860–1936)

張群 Zhang Chun (1889–1990)

張鼎臣 Zhang Dingchen (contemporary)

張風 Zhang Feng (Zhang Dafeng, Shangyuan Laoren; act. 1628–1662)

張庚 Zhang Geng (1685–1760)

張華 Zhang Hua (232–300)

張靈 Zhang Ling (Zhang Mengjin; act. 1498–1531)

張孟休 Zhang Mengxiu (1912–1986)

張目寒 Zhang Muhan (1900–1980)

張僧繇 Zhang Sengyou (act. 500–550)

張渥 Zhang Wu (Zhang Shuhou; act. 1336–1364)

張萱 Zhang Xuan (act. 714–742)

張彥遠 Zhang Yanyuan (ca. 810–ca. 880)

趙大年 Zhao Danian (Zhao Lingrang; act. 1070–1100)

趙孟頫 Zhao Mengfu (Zhao Ziang, Zhao Oubo, Zhao Wenmin, Zhao Wuxing; 1254–1322)

趙左 Zhao Zuo (Zhao Wendu; 1573–1644)

鄭虔 Zheng Qian (d. 764)

智永 Zhiyong (act. mid-6th cent.)

鍾馗 Zhong Kui (act. 618–627)

鍾繇 Zhong You (Zhong Taifu; 151–230)

周昉 Zhou Fang (Zhou Zhonglang; ca. 730–ca. 800)

周亮工 Zhou Lianggong (1612–1672)

周龍蒼 Zhou Longcang (20th cent.)

周文矩 Zhou Wenju (act. 961–975)

朱耷 Zhu Da (Geshan, Bada Shanren; 1626–1705)

朱德潤 Zhu Derun (1294–1365)

朱芾 Zhu Fu (act. late 14th cent.)

朱古微 Zhu Guwei (Zhu Qiangcun; contemporary)

朱景玄 Zhu Jingxuan (act. early–mid-9th cent.)

朱夢廬 Zhu Menglu (Zhu Cheng; 1826–1900)

朱省齋 Zhu Shengzhai (ca. 1902–1970)

宗炳 Zong Bing (Zong Shaowen; 375–443)

Bibliography

Chinese Language

Ba Dong. "Chang Dai-chien huihua yishu zhi yanjiu" (Research on Chang Dai-chien's painting). Master's thesis, National Taiwan Normal University, 1987.

Bao Limin, ed. *Chang Dai-chien de yishu* (The art of Chang Dai-chien). Peking: Sanlian shudian, 1986.

Chang Dai-chien. *Chang Dai-chien Huangshan shi hua ce* (Album of Chang Dai-chien's poetry and paintings of the Yellow Mountains). Taipei: Hanhua wenhua, 1969.

———. *Chang Dai-chien huashuo* (Discourses on painting by Chang Dai-chien). Preface by Xie Zhiliu, afterword by Mi Gengyun. Shanghai: Shanghai shuhua chubanshe, 1986.

———. *Chang Dai-chien ketu gao* (Painting manual by Chang Dai-chien). Chengdu: Sichuan meishu chubanshe, 1987.

———. *Chang Dai-chien mobi huahui juan* (Handscroll of ink paintings of flowers and plants by Chang Dai-chien), folio. Tianjin: Renmin meishu chubanshe, 1984.

———. *Chang Dai-chien shiwen ji* (A collection of the poetry and prose of Chang Dai-chien). Edited by Yue Shuren. Taipei: Liming wenhua shiye gongsi, 1984.

———. *Chang Dai-chien xiansheng shouxie shi ce* (Volume of Chang Dai-chien's poetry written in his own calligraphy). Taipei: Guoli gugong bowuyuan, 1988.

———. *Chang Dai-chien yizhu Mogaoku ji* (Chang Dai-chien's records of the Mogao Caves). Taipei: Guoli gugong bowuyuan, 1985.

———. *Changjiang wanli tu* (Chang Dai-chien's handscroll *Ten Thousand Li of the Yangzi River*). Taipei: Guoli lishi bowuguan, 1981.

———. *Dai-chien jushi lin Yihe Ming* (Chang Dai-chien's copy of the "Inscription for Burying a Crane"). Taipei: Huazheng shuju youxian gongsi, 1987.

———. *Huangshan ji you: Chang Dai-chien Huangshan xiesheng ceye* (Album of sketches from a tour of the Yellow Mountains), folio. Hefei: Anhui meishu chubanshe, 1985.

———. *Xikang youji* (Excursion to Xikang). Taipei: Guoli lishi bowuguan, 1980.

Chang Dai-chien and Chang Shanzi. *Huashan huaying* (Photographs of Mount Hua). Peking: Jicui shanfang, 1935.

Chang Dai-chien and Hu Chongxian. *Moye Jingshe meihua* (Photographs by Hu Chongxian of the plum blossoms in the Abode of Illusion, inscribed by Chang Dai-chien), 2 folios. Taipei: Guoli lishi bowuguan, [1981].

Chang Dai-chien bi (Paintings by Chang Dai-chien), portfolio. Taipei: Guoli lishi bowuguan, 1977.

Chang Dai-chien hua ce (Paintings by Chang Dai-chien), 2 vols. Taipei: [Zhonghua shuju], [1960].

Chang Dai-chien hua ji (A collection of Chang Dai-chien's paintings). Prefaces by Lu Danlin and Xu Beihong. Peking: Zhonghua shuju boliban, 1936.

Chang Dai-chien hua ji (A collection of Chang Dai-chien's paintings). Afterword by Zeng Keduan. Hong Kong: Donghua sanyuan, 1951.

Chang Dai-chien hua ji (A collection of Chang Dai-chien's paintings). Introductions by Wang Yuqing and Yao Menggu. Taipei: Guoli lishi bowuguan, 1973. Reprint with introductions by He Haotian and Yao Menggu, Taipei: Guoli lishi bowuguan, 1979.

Chang Dai-chien hua ji (A collection of Chang Dai-chien's paintings), folios 1–11. Chengdu: Sichuan meishu chubanshe, 1981–87.

Chang Dai-chien hua ji (A collection of Chang Dai-chien's paintings). Edited by Meishujia chubanshe. Hong Kong: Tsi Ku Chai, 1982.

Chang Dai-chien hua xuan (Selected paintings of Chang Dai-chien). Preface by Huang Miaozi. Peking: Renmin meishu chubanshe, 1984.

Chang Dai-chien hua zhan (An exhibition of paintings by Chang Dai-chien). Preface by Yi Tong-uk. Seoul: Tonga Ilbo sa, 1978.

Chang Dai-chien huigu zhan (A retrospective exhibition of Chang Dai-chien's paintings). (In Chinese and English.) Introduction by He Haotian. Hong Kong: Hong Kong Arts Centre, 1985.

Chang Dai-chien jinian wen ji (Collected essays in memory of Chang Dai-chien). Edited by Ba Dong and Huang Chunxiu. Taipei: Guoli lishi bowuguan, 1988.

Chang Dai-chien jinzuo zhan (An exhibition of recent works by Chang Dai-chien). Hong Kong: Dahui Tang, 1962.

Chang Dai-chien jinzuo zhan (An exhibition of recent works by Chang Dai-chien). Hong Kong: Dahui Tang, 1966–67.

Chang Dai-chien jinzuo zhanlan (An exhibition of recent works by Chang Dai-chien). Prefaces by Yao Hsin-nung (English) and Zeng Keduan (Chinese). Hong Kong: The East Society, 1966.

Chang Dai-chien jinzuo zhanlan (An exhibition of recent works by Chang Dai-chien). Taipei: Guoli lishi bowuguan, 1967.

Chang Dai-chien jiushi jinian zhan shuhua ji (The catalogue of the anniversary exhibition of Chang Dai-chien's ninetieth birthday). Edited by Ba Dong. Taipei: Guoli lishi bowuguan, 1988.

Chang Dai-chien linmu Dunhuang bihua (Chang Dai-chien's copies of the murals at Dunhuang), 2d ed., vol. 1. Taipei: Dafeng Tang, 1982.

Chang Dai-chien linmu Dunhuang bihua (Chang Dai-chien's copies of the murals at Dunhuang). Preface by Ye Qianyu. Edited by Sichuan bowuguan. Chengdu: Sichuan meishu chubanshe, 1985.

Chang Dai-chien shengping he yishu (The life and art of Chang Dai-chien). Edited by Ningxia Huizu zizhiqu zhengxie wenshi ziliao yanjiu weiyuanhui. Peking: Zhongguo wenshi chubanshe, 1988.

Chang Dai-chien shuhua (The paintings and calligraphy of Chang Dai-chien), 2 vols. Preface by Chang Dai-chien. Edited by Guo Wei. Taipei: Zhonghua shuju, 1972.

Chang Dai-chien shuhua ji (A collection of the paintings and calligraphy of Chang Dai-chien), 7 vols. Taipei: Guoli lishi bowuguan, 1980–90.

Chang Dai-chien shuhua liuzhen (Photographs of Chang Dai-chien's paintings and calligraphy). Taipei: Guoji sheying gongsi, n.d.

Chang Dai-chien shuhua yizuo chan (Posthumous exhibition of the paintings and calligraphy of Chang Dai-chien). Hong Kong: Shuhua wenyiguan, 1983.

Chang Dai-chien shuhua zhan (An exhibition of painting and calligraphy by Chang Dai-chien). (In Chinese and English.) Hong Kong: City Hall, 1971.

Chang Dai-chien shuhua zhanlan (An exhibition of painting and calligraphy by Chang Dai-chien). Hong Kong: City Hall, 1974.

Chang Dai-chien xiansheng hua cui (A collection of paintings by Chang Dai-chien). Taipei: Dongfang xuehui, [1968].

Chang Dai-chien xiansheng hua ji (A collection of paintings by Chang Dai-chien). Edited by Guo Wei. Taipei: Zhonghua shuju, [1954].

Chang Dai-chien xiansheng hua ji (A collection of paintings by Chang Dai-chien). Edited by Kuang Zhongying. Taipei: Zhonghua wenwuguan, 1958.

Chang Dai-chien xiansheng jinian ce (Volume of essays in memory of Chang Dai-chien). Taipei: Guoli gugong bowuyuan, 1983.

Chang Dai-chien xiansheng jinian zhan tulu (Catalogue of the memorial exhibition for Chang Dai-chien). Taipei: Guoli gugong bowuyuan, 1988.

Chang Dai-chien xiansheng jinian zhuanji (Special memorial volume of essays in honor of Chang Dai-chien). Edited by Li Lincan et al. Taipei: Shibao wenhua chubanshe, 1983.

Chang Dai-chien xiansheng shuhua yin ji (A collection of Chang Dai-chien's seals on paintings and calligraphies). Hong Kong: Tai Yip Co., 1983.

Chang Dai-chien xiansheng yizuo Dunhuang bihua moben (Chang Dai-chien's posthumously published copies of the murals at Dunhuang). Taipei: Guoli gugong bowuyuan, 1983.

Chang Dai-chien xueshu lunwen ji: Jiushi jinian xueshu yantaohui (Essays from the symposium in memory of Chang Dai-chien's ninetieth birthday). Taipei: Guoli lishi bowuguan, 1988.

Chang Dai-chien yizuo xuan (Posthumously published selected works of Chang Dai-chien). Preface by Ye Qianyu. Chengdu: Sichuan meishu chubanshe, 1985.

Chang Dai-chien zuopin xuan (Selected works of Chang Dai-chien). Tianjin: Tianjin renmin meishu chubanshe, 1984.

Chang Dai-chien zuopin xuanji (A collection of selected works of Chang Dai-chien). Edited by Yao Menggu et al. Taipei: Guoli lishi bowuguan, 1976; reprint 1979; reprint 1981.

Chang Shanzi guohua xuan (Selected paintings of Chang Shanzi), 2 folios. Chengdu: Sichuan meishu chubanshe, 1985.

Dafeng Tang cang Zhao Wenmin Jiuge shuhua ce (The *Nine Songs* album of painting and calligraphy by Zhao Mengfu in the Dafeng Tang collection). Kyoto: Privately printed, 1958.

Dafeng Tang linmu Dunhuang bihua (Chang Dai-chien's copies of the murals at Dunhuang). Preface by Xie Zhiliu. Shanghai: Shanghai shuhua chubanshe, 1987.

Dafeng Tang mingji (Illustrated catalogue of masterpieces of Chinese painting from the Dafeng Tang collection), 4 vols. Edited by Chang Dai-chien. Kyoto: Benrido Co., 1955–56; reprint, Taipei: Lianjing chubanshe, 1978.

Dafeng Tang shuhua lu (Descriptive catalogue of the Dafeng Tang collection). Chengdu: Privately published, 1943.

Dafeng Tang yizeng mingji tezhan tulu (Catalogue of a special exhibition of masterpieces of Chinese painting bequeathed by Chang Dai-chien from the Dafeng Tang collection). Taipei: Guoli gugong bowuyuan, 1983.

Dai-chien jisi zixie xiaoxiang (Chang Dai-chien's 1929 self-portrait with collected colophons). Preface by Zhang Muhan. Afterword by Gao Lingmei. Taipei and Hong Kong: Dongfang xuehui, 1968.

Dai-chien jushi jinzuo (Recent works of Chang Dai-chien), vol. 1. 1947. Reprint, Taipei: Guoli lishi bowuguan, 1980.

Dai-chien jushi jinzuo zhanlan (An exhibition of the recent paintings of Chang Dai-chien). Prefaces by Yao Hsin-nung (English) and Zeng Keduan (Chinese). Hong Kong: Cheung Che Leung, 1967.

Dai-chien yin liu (Seals of Dai-chien). Edited by Fang Quji. Shanghai: Shanghai shuhua chubanshe, 1987.

Feng Youheng. *Xingxiang zhi wai: Chang Dai-chien de shenghuo yu yishu* (The life and art of Chang Dai-chien). Taipei: Jiuge chubanshe, 1983.

Fu, Shen C. Y. "Chang Dai-chien de xiju renwu hua" (Chang Dai-chien's paintings of Chinese opera figures). *Hsiung Shih Art Monthly* 218 (April 1989): 56–61.

———. "Chang Dai-chien's 'The Three Worthies of Wu' and His Practice of Forging Ancient Art." (In English.) Trans. Jan Stuart. *Orientations* 20, no. 9 (September 1989): 56–72.

———. "Shenyang de Dai-chien hua" (Paintings by Chang Dai-chien in the Liaoning Provincial Museum). *Liaohai wenwu xuekan* 7 (May 1989): 369–405.

Gao Lingmei, ed. *Chang Dai-chien hua: Chinese Painting, with the Original Paintings and Discourses on Chinese Art by Chang Dai-chien.* (In Chinese and English.) Hong Kong: Dongfang yishu gongsi, 1961.

———. *Chang Dai-chien hua ji* (A collection of Chang Dai-chien's paintings). (In Chinese and English.) Hong Kong: The East Society, 1967.

Gao Yang. *Meiqiu shengsi Moye meng* (Biography of Chang Dai-chien). Taipei: Minsheng baoshe, 1984; reprint, Peking: Zonghua shuju, 1988.

Lang Jingshan. *Bade Yuan sheying* (Photographs of Chang Dai-chien and Bade Garden). Taipei: Photographic Research Institute, College of Chinese Culture, 1966.

Li Yongqiao. *Chang Dai-chien nianpu* (Chronology of Chang Dai-chien's life). Chengdu: Sichuan sheng shehui kexueyuan chubanshe, 1987.

Lin Weijun, ed. *Huanbi An suotan* (Chang Dai-chien's random discourses while at his Huanbi An home in Pebble Beach). Taipei: Huangguan chubanshe, 1979.

Qi Yijun. *Chang Dai-chien waizhuan* (Biography of Chang Dai-chien). Taipei: Shengwen shuju, 1986.

Qiu Zhuchang. *Huang Binhong zhuanji nianpu hebian* (A biography and chronology of Huang Binhong). Peking: Renmin meishu chubanshe, 1985.

Rongbao Zhai huapu (Paintings by Chang Dai-chien in the Rongbao Zhai collection), vol. 12. Peking: Rongbao Zhai, 1986.

Shuzhong Chang Shanzi Dai-chien xiongdi hua ce (Paintings by the brothers Chang Shanzi and Chang Dai-chien from Sichuan). Peking: Jicui shanfang, 1935.

Sun Yunsheng hua ji. (Paintings of Sun Yunsheng). Taipei: Guoli lishi bowuguan, 1979.

Wang Bingfa. *Chang Dai-chien yanyi* (Novel based on the life of Chang Dai-chien). Xi'an: Weilai chubanshe, 1987.

Wang Ze-i. *Chang Dai-chien Baxi huangfei zhi Bade Yuan sheying ji* (A collection of photographs of Chang Dai-chien's neglected Bade Garden), 4 folios. Taipei: Guoli lishi bowuguan, 1979.

Xie Jiaxiao. *Chang Dai-chien de shijie* (The world of Chang Dai-chien). Taipei: Shibao wenhua chuban gongsi, 1982.

Xin Yifu, *Chang Dai-chien.* Taiyuan: Beiyue wenyi chubanshe, 1986.

Xiongshi meishu (Hsiung Shih Art Monthly) 147 (May 1983): 28–70. (Special issue containing information on Chang Dai-chien, with articles by Chu-tsing Li, Cai Wenyi, Li Lincan, and Shen C. Y. Fu.)

Yang Jiren. *Chang Dai-chien zhuan* (Biography of Chang Dai-chien), 2 vols. Peking: Wenhua yishu chubanshe, 1985.

Zhu Chuanyu, ed. *Chang Dai-chien zhuanji ziliao* (Source materials on Chang Dai-chien collected from periodicals and newspapers), 9 vols. Taipei: Tianyi chubanshe, 1985.

Western Languages

The All-India Fine Arts and Crafts Society. *Exhibition of Paintings by Prof. Chang Dai-chien.* Preface by Chia-luen Lo. Delhi: Goodwill Mission Press, 1950.

Bobot, Marie-Thérèse. *Collection des peintures et calligraphies chinoises contemporaines.* Paris: Musée Cernuschi, 1985.

Chang Dai-chien. (In Chinese and English.) Los Angeles: Ankrum Gallery, 1973.

Chang Dai-chien: Ausstellung chinesische Tuschmalerei. Cologne: Editha Leppich Ostasiatische Kunst, 1964.

Chang Dai-chien 1899–1983: An Exhibition of Chinese Paintings. New York: Frank Caro Gallery, 1984.

Chou Ling. *Tchang Ta-ts'ien, Un grand peintre de la Chine contemporaire.* Paris: Editions Euros, 1960.

Contemporary Chinese Brushwork by Wang Chi-yuan and Chang Dai-chien. Washington, D.C.: Smithsonian Institution Traveling Exhibition Service, 1970.

d'Argencé, René-Yvon Lefebvre. *Chang Dai-chien: A Retrospective Exhibition.* San Francisco: Center of Asian Art and Culture, 1972.

Exhibition of Paintings by Chang Dai-chien. Preface by Hu Shih. New York: Mi Chou Gallery, 1957.

Exhibition of Paintings by Chang Dai-chien. Introduction by James Cahill. New York: Hirschl and Adler Gallery, 1963.

Exhibition of Paintings by Chang Dai-chien. Preface by Basil Gray. Carmel, Calif.: Laky Galleries, 1967.

Exhibition of Paintings by Chang Dai-chien. New York: New York Cultural Center, 1969.

Exhibition of Paintings by Chang Dai-chien. Introduction by René-Yvon Lefebvre d'Argencé. Carmel, Calif.: Laky Galleries, 1970.

Exhibition of Paintings by Chang Dai-chien. Olympia Fields, Ill.: Signature Galleries, 1974.

Exhibition of Paintings by Chang Dai-chien and His Nephew Yixin. Palo Alto, Calif.: Erikson Gallery, 1973.

Grosvenor Gallery. *Chang Dai-chien: Paintings.* Foreword by Basil Gray. London: Graphis Press, 1965.

Kao, Mayching, ed. *Twentieth Century Chinese Painting.* New York: Oxford University Press, 1988.

Lai, T. C. *Three Contemporary Chinese Painters: Chang Dai-chien, Ting Yin-yung, Ch'eng Shih-fa.* Seattle and London: University of Washington Press, 1975.

Li, Chu-tsing. "Chang Ta-ch'ien." In Chu-tsing Li, *Trends in Modern Chinese Painting: The C. A. Drenowatz Collection.* Ascona, Switzerland: Artibus Asiae, 1979: 99–104.

Musée Cernuschi. *Relevés de Touen-Houang et peintures anciennes de la collection Tchang Ta-ts'ien.* Paris: Editions Euros, 1956.

———. *Les Lotus Géants: Grandes compositions de Tchang Ta Ts'ien.* Preface by Vadime Elisseeff. Paris: Musée Cernuschi, 1961.

Paintings: Chang Dai-chien. Preface by Michael Sullivan. Stanford, Calif.: Stanford University Museum, 1967.

Recent Paintings by Chang Dai-chien. Introduction by Wen Fong. Taiwan: Frank Caro Gallery, S. H. Mori Gallery, and Alberts-Langdon Gallery, 1968.

Recent Paintings by Chang Dai-chien. Los Angeles: Cowie Galleries, 1969.

Strassberg, Richard E. *The Abode of Illusions: The Garden of Chang Dai-chien.* Photographs by Hu Chongxian. Pasadena, Calif.: Pacific Asia Museum, 1983.

———. *Master of Tradition: The Art of Chang Dai-chien.* Pasadena, Calif.: Pacific Asia Museum, 1983.

Tchang Ta Ts'ien, peintre chinois. Preface by Vadime Elisseeff. Paris: Musée d'Art Moderne de la Ville de Paris, 1956.

United States Information Service. *An Exhibit of Chang Ta Chien's Paintings* [illustrated brochure in Chinese and English]. Taipei, 1960.

Index

Lenders to the Exhibition

Individuals

Chang Ch'eng-hsien
Chang Hsin-yin
Chang Hsu Wen-po
Chang Hsueh-Liang
Paul Chang
Chang Sing S.
Chang Sing-cheng
Chang Sing-yi
Chang Wei-hsien
Chun-Hsien Chiang
Meng-Hua Chiang
Mrs. Chuang Yen
Dzung Kyi Ung
Mr. & Mrs. Myron S. Falk, Jr.
Chung Kit Fok
Mr. & Mrs. W. B. Fountain
Mr. & Mrs. R. I. C. Herridge
Richard Hui
Tien-tsai Hwang
Wilma Chang Ing
Alice King
Mr. & Mrs. Lee Chen-Hua
Mr. & Mrs. C. Y. Lee
C. P. Lin
K. S. Lo
Hugh Moss
Pung F. Tao
Tsao Jung Ying
Jiu-Hwa Lo Upshur
Wang Fangyu and Sum Wai
Stewart S. T. Wang
Yon Fan

Institutions, Collections, Corporations

Arthur M. Sackler Gallery
The British Museum
Cemac, Ltd.
Ching Yuan Chai
Dafeng Tang
Freer Gallery of Art Study Collection
Honolulu Academy of Arts
The Metropolitan Museum of Art
Musée Cernuschi
Musée d'Art Moderne de la Ville de Paris
Yale University Art Gallery
Private collection

Challenging the Past: The Paintings of Chang Dai-chien

Edited by Mary Kay Zuravleff
Designed by Carol Beehler
Calligraphy by Shen C. Y. Fu
Typeset in Sabon and Frutiger
by BG Composition, Baltimore, Maryland
Production coordinated by Perpetua Press, Los Angeles, California
Printed on Gardamatte Brilliante, 135 gsm
by Grafiche Alma, S.p.A., Milan, Italy

ARTHUR M. SACKLER GALLERY
Smithsonian Institution
Washington, D.C.
November 24, 1991–April 5, 1992

THE ASIA SOCIETY
New York
April 29–July 19, 1992

SAINT LOUIS ART MUSEUM
August 28–October 25, 1992